S. M. EISENSTEIN
Writings, 1934–47

S. M. Eisenstein Selected Works
General Editor: Richard Taylor

S. M. EISENSTEIN

Selected Works

VOLUME III

Writings, 1934–47

Edited by

RICHARD TAYLOR

Translated by

WILLIAM POWELL

BRITISH FILM INSTITUTE

bfi

BFI PUBLISHING

S. M. Eisenstein
SELECTED WORKS
General Editor: Richard Taylor
Consultant Editor: Naum Kleiman
Volume III: Writings, 1934–47
Edited by Richard Taylor

First published in 1996 by the
British Film Institute
21 Stephen Street
London W1P 2LN

The British Film Institute exists to promote appreciation, protection and development of moving image culture in and throughout the whole of the United Kingdom. Its activities include the National Film and Television Archive; the National Film Theatre; the London Film Festival; the Museum of the Moving Image; the production and distribution of film and video; funding and support for regional activities; Library and Information Services; Stills, Posters and Designs; Research; Publishing and Education; and the monthly *Sight and Sound* magazine.

Stills courtesy of British Film Institute, Richard Taylor, Ian Christie.
Cover stills, back left to right: Stepok, the martyred son in *Bezhin Meadow* (1935–7), German atrocities in *Alexander Nevsky* (1938), Nikolai Cherkasov as *Ivan the Terrible* (1943–6); front: sketch for *Ivan the Terrible,* Eisenstein and Chaplin, Eisenstein and Pudovkin: contribution to the war effort!; spine: Eisenstein: the last photograph, 1948.

British Library Cataloguing in Publication Data
A catalogue record for this book is available from the British Library

ISBN 0–85170–530–8

Typeset by Fakenham Photosetting Ltd, Fakenham, Norfolk
Printed in Great Britain by St Edmundsbury Press, Bury St Edmunds, Suffolk

This volume
is dedicated to the memory
of those who lost their lives,
their loved ones, their careers,
in Soviet cinema during the 1930s and 1940s

Contents

Acknowledgments

In this third volume of Eisenstein's writings William Powell has been responsible for the translation from the original Russian. He has once more been fortunate to receive abundant advice from Richard Taylor, whose specialist knowledge and fresh eye have contributed immensely to the accuracy and fluency of the work. His thanks, therefore, are due to him and to the staff of the British Library.

Richard Taylor has been responsible for the annotation. He is grateful to William Powell for restraining him from pedantic excess and for labouring with such perseverance and good humour to produce a lively and highly readable translation of an original that was frequently deeply esoteric. He greatly appreciates the assistance given to him by the secretarial staff of the Department of Politics at the University of Wales, Swansea. He would also like specifically to thank for advice and assistance received: Dr Julian Graffy, University of London; Professor Jeffrey Richards, University of Lancaster; Professor George Boyce, Mr Robert Bideleux, Professor Richard Shannon and Professor Alan Lloyd of the University of Wales, Swansea; Dr Nick Worrall of Middlesex University; and Alan Bodger.

Last but not least, we both owe the usual massive debt to our respective families and friends for their support, advice and sympathy throughout the course of this considerable undertaking.

R. T. and W. P.

General Editor's Preface

Sergei Eisenstein is by general consent the most important single figure in the history of cinema. His contribution to the practice of film-making is universally acknowledged and his films, from *The Strike* to *Ivan the Terrible*, are well known, if not always as widely shown or seen as we might assume. But the bulk of Eisenstein's theoretical writings has remained largely inaccessible and, despite the invaluable efforts of Jay Leyda in particular, the English-speaking world has only a partial acquaintance with the ideas that underlay his films.

It is the primary purpose of this edition to make available the most important of Eisenstein's writings in a comprehensive and scholarly, but nevertheless accessible, form to the English-speaking reader for the first time. The nature of those writings posed considerable editorial problems concerning the organisation of the volumes in the series. Different editions in different languages have resorted to different solutions. In this edition we have opted wherever possible for a chronological approach: the ultimate justification is quite simply that this is the order in which Eisenstein himself wrote and therefore the order that enables the reader most easily to trace the development of his ideas. Sometimes the sheer amount of material has rendered a chronological approach unsustainable, as in the second volume, *Towards a Theory of Montage*: there, understanding is better served by grouping Eisenstein's sometimes fragmentary and often unfinished writings on montage from the 1930s and 1940s together in one large volume. The same is true of the fourth volume, not originally intended as part of this series: there, Eisenstein's reminiscences, written almost entirely during the last two years of his life but covering his whole life and career, are gathered into an even larger volume. But the first and third volumes in this edition follow Eisenstein's career in cinema from his first published article in November 1922 to the end of 1934, and then from his lecture on theatre and cinema delivered in September 1934 to shortly before his death in February 1948. The documents have been chosen not merely to record the development of his aesthetic ideas but also to illuminate the context in which that development occurred. Although each volume focuses on Eisenstein's writings on cinema, the thoughts that he expressed on theatre and the other arts and on politics and current events have been included wherever relevant to illustrate that Eisenstein was not just an artist, but a *Soviet* artist, with all that this entailed in the thirty turbulent years after the October Revolution. Nowhere is that context more important than in the present volume. Nevertheless the reader should bear in mind that the material contained in the second and fourth volumes of this edition was also

written (often, as the Russians say, 'for the drawer') in the years between 1934 and 1948.

This third volume is the last envisaged in the original project. Reasons of space have led to a difficult decision to exclude some pieces. There also remain the unfinished writings on *Direction* and *Mise-en-scène*, scholarly editions of the scripts in their various versions, and above all the diaries which, after almost a decade of *glasnost*, still remain tantalisingly inaccessible to foreign scholars. A truly comprehensive Eisenstein edition is perhaps not a viable proposition in a commercially oriented world. I am therefore particularly grateful to the British Film Institute for allowing this edition to proceed at a time of financial stringency.

It is the aim of this edition to make Eisenstein and his ideas more accessible to the English-speaking reader. If the organisation of the volumes or the quality of the translations or the annotation obstructs that purpose, then we shall not only have failed in our duty to the reader, we shall have failed in our responsibility towards Eisenstein.

RICHARD TAYLOR
Swansea, Wales
January 1995

Note on Transliteration and Translation

Transliteration from the Cyrillic to the Latin alphabet presents many problems and no system will resolve them all. Perhaps the most important is the difficulty of reconciling the two principal requirements of transliteration: on the one hand the need to convey to the reader who does not speak Russian a reasonable approximation of the original Russian pronunciation, and on the other the necessity of rendering for the specialist an accurate representation of the original Russian spelling. There is a further complication in that some Russian names have a non-Russian origin or an accepted English spelling that takes little heed of the two requirements just mentioned. We have therefore used two systems of transliteration in this edition. In the main text and in the index we have used the generally accepted spellings of proper names (such as Alexander Nevsky) or the spellings that reflect their linguistic origins (such as Meyerhold, Strauch and, indeed, Eisenstein), whereas in the endnotes (at least where these names are inflected) we have attempted to cater for the needs of the Russian-speaking specialist. There the names listed above will be found as Aleksandr Nevskii, Meierkhol'd, Shtraukh and Eizenshtein. There are inevitably some inconsistencies in this practice, but we hope that the system we have adopted will clarify rather than confuse the issue.

Eisenstein was unfortunately not always consistent in his use of key terms and the reader should bear this in mind. In this and other volumes the editor and translator have offered a particular version of a particular term, but some degree of ambiguity, if not downright confusion, must always remain. When talking about 'plot' Eisenstein, like other Russian writers of the time, distinguishes between *fabula* and *syuzhet*, which we have normally rendered as 'story' and 'plot' respectively. Naum Kleiman, Consultant Editor on this edition, has offered the following distinction:

fabula: a Formalist concept: the structure of events, what actually happened, the facts.
syuzhet: everything connected with the characters, all the associations, motivations, etc. Formalist critics also used the term to include technical aspects of film-making, such as lighting, camera angle, shot composition and montage.

Other problematic words include the following, and the reader is advised to bear the alternatives constantly in mind:

kadr: shot or frame
kusok: piece or fragment of montage
material: material or raw material

montazh: montage or editing, the arrangement of the shots, frames or sequences through cutting. In Eisenstein's view, as in the view of others, it was *montazh* that distinguished the specificity of cinema as opposed to related art forms such as theatre, literature or painting.

To minimise the risk of confusion, the original Russian word is occasionally given in square brackets.

Lastly, Russian does not have either an indefinite or a definite article and it is a moot point whether one sometimes needs to be supplied in the English translation. We have preferred *The Strike* to *Strike* as a translation of the title of Eisenstein's film *Stachka*, *The Battleship Potemkin* to *Battleship Potemkin* for *Bronenosets Potemkin*, and so on. We have done this in the hope of clarifying the meaning of the original Russian title for the English-speaking reader.

<div align="right">Richard Taylor and William Powell</div>

Abbreviations

ARK *Assotsiyatsiya revolyutsionnoi kinematografii*: Association of Revolutionary Cinematography

ARRK *Assotsiyatsiya rabotnikov revolyutsionnoi kinematografii*: Association of Workers of Revolutionary Cinematography

GIK *Gosudarstvennyi institut kinematografii*: State Cinema Institute, 1930–34

GTK *Gosudarstvennyi tekhnikum kinematografii*: State Cinema Technical College, 1925–30

GUK *Gosudarstvennoe upravlenie kinopromyshlennosti*: State Directorate for the Cinematographic Industry, 1937–46

GUKF *Gosudarstvennoe upravlenie kinofotopromyshlennosti*: State Directorate for the Cinematographic and Photographic Industry, 1933–37

kolkhoz contraction of *kollektivnoe khozyaistvo*: collective farm

Komsomol contraction of *Kommunisticheskii soyuz molodezhi*: Communist Youth League

LEF contraction of *Levyi front iskusstv*: Left Front of the Arts

MTS *mashinno-traktornaya stantsiya*: Machine Tractor Station

Proletkult contraction of *Proletarskaya kul'tura*: Proletarian Culture organisation, 1917–32

Rabis *Profsoyuz rabotnikov iskusstv*: Trade Union of Workers in the Arts

RAPP *Rossiiskaya assotsiyatsiya proletarskikh pisatelei*: Russian Association of Proletarian Writers, 1925–32

TsGALI *Tsentralnyi gosudarstvennyi arkhiv literatury i iskusstva SSSR*: USSR Central State Archive of Literature and Art, now *RGALI* [*Rossiiskii gosudarstvennyi arkhiv literatury i iskusstva*]: Russian State Archive of Literature and Art

VGIK *Vsesoyuznyi gosudarstvennyi institut kinematografii*: All-Union State Cinema Institute, 1934–92

1934

1. Theatre and Cinema[1]

If what we now have before us is a unique synthesis of the experience of every preceding epoch in relation to the technique of stage acting, then, as far as production style is concerned, in the area of form we must move towards the same synthetic realism that in equal measure includes both severity of constructional composition and the whole piquancy of emotionality – not merely human emotionality but also that of the structure of a play as a whole, which was unfamiliar to such elevated theatres.

What is the position with Okhlopkov's theatre?[2] You will recall that Marx wrote about that special charm which, regardless of the succession of epochs, political regimes and so on, preserves antiquity through the ages, by its link, as he put it, to the infantile period of human development. And there are a few elements of that in Okhlopkov's theatre. When some of you were still only so high, this stage [of development]* of the theatre (ca 1922–4) had a quite different approach and a quite different specific character. That was the period of *Sturm und Drang* in theatre. Now, when you recall all those foolhardy or shocking productions we indulged in when we were young, it seems amazing. Okhlopkov's principles and ideas have preserved what we did then. He really has carried on [into the present] the complex of those traditions. True, not the complex of traditions of the theatre of 1922–4, when he was a director, but [of the theatre in which he appeared] only as a young actor. And Okhlopkov's principles and ideas have preserved [to this day] a small slice of that remarkable epoch of the first post-Revolutionary upsurge in theatre. [Therefore] Okhlopkov now seems unique and utterly different from anyone else. ... His theatre is quite unlike any other. But this singularity is not because he was the principal figure, the leader, the pioneer or the innovator. What makes him so singular is that the style and character of his theatre do not represent today's demands or today's theoretical positions: instead he stands wholly and fully by those slogans that were central to the struggle in theatre in the years 1922–4.

Some historical examples may demonstrate this to you. I think that you have read Beskin's reviews of *The Mother*,[3] which indicate the historical succession – not so much succession: in fact rather, borrowing – from productions of the type that I, for example, staged for Proletkult. As far as the introduction of elements of crude naturalism is concerned, this recalls [the production of] *Earth Rampant*,[4] when lorries and suchlike drove through the auditorium and on to the stage. The delightful thing about Okhlopkov's

*Translator's and/or editor's additions are in square brackets.

theatre is that he has preserved, rather as in a museum, a whole series of-principles which were elaborated in the first period of the emergence of [Soviet] theatre. This now has the character of a rather engaging curiosity.

Now Okhlopkov is changing his tack slightly. I met him in Kislovodsk, and asked him how he was going to stage [the play] about the building of the White Sea Canal.[5] I said to him:

> 'If you take your method any further, you will have to watch your pockets, because the actors will be picking the public's pockets before seeing the error of their ways as the play progresses. Perhaps you should even take out life insurance, if there are going to be hardened criminals there.'

'No,' he said, 'that won't happen.'

His theatre extrapolated one set of motifs found in the general break-through associated with the first upsurge in Soviet theatre. These were the characteristics of that period. A number of the principles of the theatre of that period were taken to a point, to an extreme, to the point of absurdity. In those days [for instance] there had been talk of taking theatre out of the auditorium and on to the square.[6] I myself was guilty of that, staging a play in a gasworks, in which the works itself featured as an actor, and where it smelt so strongly of gas that the public fled, not even waiting for the play to end.[7] This was [a move] towards breaking down the conventional parameters of theatre. In *Wise Man* we asked ourselves how we could lay bare the principles of con-struction of a play.[8] In figurative terms Okhlopkov has in the ensuing ten years taken all this to its logical conclusion.

One of the things that concerned us then (I had not even begun writing with Tretyakov at that time) was a so-called 'controversy play', a play whose outcome was to be uncertain. [In the play] there were supposed to be two sol-utions and two casts, and the cast that took the upper hand at certain defined moments of the struggle was supposed to finish the play in its own way. The element of dramatic conflict was brought closer to the point where it gen-uinely became a conflict between the skill and inventiveness of the different casts – also a quite insane idea. We embarked on [the production], began thinking about it and even worked some of it out.

You can see the directions in which theatrical discussions were develop-ing. There were a fair number of ideas of that sort. In fact there was a gen-eral tendency to throw out [a lot] beyond the confines of what were then called the specific parameters limiting theatrical productions. And that gave rise to the first appeals to tear ourselves away from theatre into the next di-mension of means of expression, to move across into cinema.

In this regard, the fact that I had staged a play in a gasworks was very characteristic. The broadening of the palette, the inclusion of real objects, of genuine elements of reality, was one of the key tendencies of the time. Setting a play in a gasworks was naturally to move across to means of expression such as a gasworks, and not just a gasworks but also its surroundings, and the street, the town and the country in our [theatricalised] spectacle. [Hence] it provided a perfectly natural exit to another means of expression – to cinema,

which could seize the gasworks by the scruff of the neck and shove it wher-
ever it was needed, without any stink of gas. That was one of the tendencies
– not one of mine at all, incidentally, although I was the only one who crawled
out of the whole mess of pottage and on to the screen. But precisely the same
thing was going on with Meyerhold, when lorries and aeroplanes turned up
in his productions.[9] [In *Wise Man*] we dragged a live camel on stage. Grandly
we led a camel up the staircases of the Morozovs' bourgeois mansion and it
stumbled into the winter garden and then into what had once been the ball-
room, carrying Glizer in one of her dreadful hats.[10]

[That] was the period in theatre that gave birth to the elements of the
future cinema [which] burst it asunder; then it went bust and people left for
cinema. And there was another period when the opposite influence could be
observed, when the experience of cinema returned to theatre, when – as I
wrote – they dressed the corpse and theatre emerged from the experience of
cinema. Take for example the beginning of Okhlopkov's production of *The
Mother*.[11] This was not a stage production that derived from the nature of
theatre; this was a reverse application of cinematic devices to theatre.

Biomechanics was the thing [then], with the rallying cry that it was not
just an actor's technique on stage; it was a technique for everyday conduct, a
technique for rational movement in life.[12] That was what distinguished bio-
mechanics. And it was even expressed in a play which stretched beyond the
limits of theatrical action. The technique of stage movement became the tech-
nique for everyday movement. Now we can call it a quirk, but then it was a
leap into another dimension. And Okhlopkov's theatre retains the last vestige
of that tendency; he takes it as a stylistic device. He has preserved that tend-
ency as a device for stylistic elaboration.

Even if your knowledge of Constructivism in the theatre is slight, you will
be aware that that also had a very funny rallying cry: the theatre set must be
a machine which the actor works on. You can read an interview in which I
said that the set in my production was a bench which the actor works on. The
maximalism of this position is understandable. After that, we saw sets which
were Constructivist in style; that is, they served as the instrument for the per-
formance. For instance, if you take my play *Enough Simplicity for Every Wise
Man*, there the set was built from bits of machinery. There were two pillars,
a wire stretched between them, and Alexandrov walked along this wire and
held a tense conversation with a girl who was walking beneath the wire.[13] The
set had been reduced to its bare essentials. Then the set was built as follows:
cables and leads – that is, the elements which in the first instance played a
functional role – were stretched out, [and then they began] to acquire a purely
aesthetic decorative character. As we know there was a tendency [to carry the
action] on to the street. Take, for example, Meyerhold's *Dawn*, when at a par-
ticular moment heralds appeared in the town and read genuine telegrams
from the Civil War front.[14] This was a snatch of fragments of reality. There
were two places in the play where communiqués came from the real front,
and this was linked emotionally to the pathos of the play. In Okhlopkov's
theatre, this device now functions purely stylistically. There is no conjunction
with reality; it is [merely] actors in performance.

Or look at the way people are cajoled into a theatre. We once planned to

put on a pantomime in the entrance to the Morozov mansion: even then it would really have been like involving the audience in what we were doing. The agitbrigades working in enterprises were using this approach as well. They would assemble, perform something, and then leave. There was an element there too of capturing reality. But when you have a theatre ticket in your pocket that you paid money for yesterday and people start to cajole you, that is that same element, but it has been stylised. That is where the difference lies. It is the preservation of some living features, features which were fascinating at a certain period, because now you will not find anywhere where you can see a fragment of the moods that Moscow was [then] experiencing. It is in this context that we must see Okhlopkov's theatre.

In 1924 there were no montage constructions like *The Mother* because then montage had only just been recruited for use in cinema. But if you were to take Meyerhold's production of *Lake Lyul* in the Theatre of the Revolution, you would see that a number of scenes were mounted in the same way as in *The Mother*.[15] Everything was taken out to the expanse surrounding the stage. On the other hand, if you were to trace the destruction of the proscenium arch, I took things even further with *Wise Man*. . . .

From the floor: Didn't that lead to Okhlopkov taking the stage into the auditorium?

That always plays a role, but it is the principle that is important here. The principle of montage was taken from *Lake Lyul*, but the transfer [of the action] into the auditorium was partly influenced by *Wise Man*, where [the action unfolded] on all sides, where the fighting took place in the large hall along the ledge, and when we had the fight scene – the clash between the workers and the Fascists – then the fighting moved up the staircase to the ledges of the auditorium. In fact ropes were hung across the auditorium, and one of the actors was suspended above it. He was hanging up there on a rope, while the fighting was going on below. The audience sat here and the corpses lay there. [*He indicates.*] We had a bishop – terrifying, with fiery hair – who was a soldier by profession. In the middle of the fighting he took on four people at once and, when they killed him, he fell and lay in the front row.

The range across which the action was spread was even greater because the whole ceiling was being used. Then a statue (or just a part of a statue) toppled down from the ceiling, and Rabis protested that this could endanger the lives of the young actors. It demanded an end to stunts like that.[16]

Few of you know anything about these things. To find out about them you would have to collect old reviews, very detailed descriptions, because that period, in terms of the quality of the shows, was not like what is being done now. Take my first project, which Smyshlyayev and I did together;[17] we included, among other things, American boxing and we wanted to stage it in the auditorium, only the Fire Commission would not allow us to do it in the middle, but only closer to the proscenium. It ended up with us more or less having the ring between the spectators in the auditorium and those on the stage, as you can see now in *The Human Comedy*.[18] Things like that were quite typical of the period.

From the floor: In the Leningrad Circus in 1932 there was a production which had a fight with carts racing about on a trapeze, the White Guards chasing the Reds, people jumping from the gallery, running among the audience, and so on.

Yes, the same thing was done in the Popular Comedy Theatre in the People's House.[19] And they used the same effects. In *Wise Man*, the auditorium was raked, and all sorts of things went on under the seating.

All this is waiting to be chronicled and described. Incidentally, for the anniversary issue of *Soviet Cinema* I am describing something of the elements of theatre from which I made the subsequent transition to cinema.[20] There for example is my plan for an unstaged play in which the audience were to sit on revolving seats and the stage was to be in the very middle of the entire auditorium. The worst scene – the detective's struggle – was meant to take place on a suspension bridge and for this Alexandrov was to have ridden a motorcycle above the auditorium. He was supposed to learn how to ride a motorcycle on a tightrope to do this. The starting point for this was *King Coal*: Valerian Pletnyov and I did the staging.[21]

From the floor: Why has [contemporary] theatre not taken up these devices and why was there such a resistance to them?

Nowadays the demands on theatre are entirely different. I am saying that that was the period when theatre outgrew its clothes. It made the transition to cinema. That was the basic impetus because there was no development in any other direction. There was no liquidation of theatre, no translation of theatre into everyday life as such. There was no such thing as consistent organisation of mass spectacles. The idea that Yevreinov and Radlov had, when they staged a play on the square in front of the Winter Palace, did not really catch on.[22] This principle of interrupting a show manifested itself in another way: the organisation of popular spectacles. The arrival of the *Chelyuskin* heroes was of this kind, forfeiting the link with the concepts of theatrical art.[23] Nobody would say that the arrival of the *Chelyuskin* heroes was theatricalised or that the emotion it aroused was artificially induced. There was genuine enthusiasm directed into certain organisational forms. This had, in fact, already gone beyond the limits that characterise art. In such cases as the Chelyuskintsy you are no longer dealing with artificially aroused emotion. What made the enthusiasm of the masses of Muscovites manifest itself was the arrival of the Chelyuskintsy and that enthusiasm was a starting point that only needed to be given some sort of form. Hence the artificial introduction of [the actor] into the mass spectacle, which Leningrad was particularly concerned with, was nothing to do with this. This resurrection of mass spectacles was effected by aesthetes, chiefly those who raved about royal processions during the Renaissance, who raved about productions like the mystery plays, [and that is why] productions like this in Leningrad were based on the principles of the mystery play. This form could not be a living one, because the quality of what we understand by mass theatre takes a different form.

It is especially clear – that is, logical – that this breakdown in theatre

should have led into cinema; where the line of art is preserved, where there is no transgression beyond the line of art, but where there is a progression beyond the limits that characterise one stage, on to the next stage in the development of art. We all thought in 1923 that art was finished and that we were its grave-diggers. We thought like that, even though it was only later that the coffins were made. We thought that we had reached the ultimate questions that could be asked about art. But it transpired that this was not the case, that we had merely crossed over into a new kind of art. Take the early *LEF*, the first five issues.[24] This was an interesting, committed group because, whereas *New LEF* was a commercial racket, the *LEF* of the earlier period was oriented towards the transition into everyday life. And many years had to pass before people understood that you could help in the construction [of socialism] with art just as you could with a pickaxe or a mattock.

It was the period of *Sturm und Drang* and in Okhlopkov's theatre now you can see a certain hint of these things.

Varlamov: Okhlopkov's theatre is a dead end.

Why a dead end? It is not a dead end. All I am saying is that it is a continuation of what was done in 1922–4. He is now taking these things to an extreme because after *The Iron Flood* there was no further mileage in that direction, except stealing the audience's watches, hats etc.[25]

In 1924 we took that to its conclusion and left for cinema. That is one part of theatre that has been taken to its conclusion and so, of course, this style has no future.

From the floor: Okhlopkov takes literary works, not dramas, for his productions.

Taking a literary work, he does whatever will bring theatre closer to the sphere where a literary work is more highly respected than a drama. He achieves epic theatre. But the fascination [of his theatre] consists in the fact that it retains some elements of the rowdiness and recklessness that theatre used to have and whose memory you treasure. And you rue the fact that there are no theatres where you can see a camel walking up a staircase.

Further to what I was saying about theatre outgrowing itself and turning into cinema, the question naturally arises: how could I have come back to theatre again?[26]

Theatre grew into cinema before our very eyes along a number of paths, but there were two indicators in particular. The first was the tendency towards montage [*montazh*]; the second was the tendency towards the principle of typage [*tipazh*]. These were the twin elements that characterised the second five-year period in the history of our cinema, [more precisely] the years 1922–4. Were these the only indicators of theatre? Of course not. The other elements in theatre are, roughly speaking, the actor, speech and sound. These have not yet grown beyond the limits of theatre into the new medium of cinema, since sound cinema has not yet made any serious qualitative cultural contribution to the development of cinema, with respect either to acting or to the use of speech, sound etc.

Gardin is a living example of someone who has added nothing new or characteristic of the cinema stage, either in terms of his own performance, or in terms of how film directors have used him.[27] If you compare Gardin with Jannings, Gardin has nothing new over Jannings; he is just a little worse.[28] But the most important thing is not who is better and who worse; but that no new contribution of principle has yet been made. The film *The Storm* and other pictures are well acted in theatrical terms, and they were filmed more or less competently in technical terms.[29] But the problem of an actor's playing on screen and in sound cinema, like the problem of the distinction between speech and sound in cinema, has not yet been resolved.

If we examine questions of montage in relation to *mise-en-scène*, then we can see that here we really do have elements that extend from one area into another, qualitatively new sphere. We can follow the way each indicator changes its appearance, how it exists in a new capacity. If we make a general comparison between montage in cinema and the technique of *mise-en-scène* on the stage we can see, on the one hand, that there is an uninterrupted line of development and, on the other, that it is an entirely new phenomenon at a new stage. In relation both to how sound is used and to the actor's technique [in film], we cannot yet say anything of the kind for the moment. For the time being there is nothing in this area. In the same anniversary issue [of *Soviet Cinema*] I write in detail about how the notion of montage is embedded in the theatre of a particular period – the period of *Sturm und Drang*, how montage constructions arose within theatre and how the elements of typage arose in theatre, although it would appear that nothing could be further from theatre than a reliance on typage. Besides, typage in cinema is an extension of a quite specific feature of the theatre of that period. But so far there has not been the same [transition to cinema] in relation to speech, theatrical dialogue, text and the actor in theatre. We have [for the time being] only the filmed stage play.

I want to say a bit more about typage so that you understand what it is all about.

What form of theatre is the most theatricalised? The comedy of masks. If you compare the principles of the comedy of masks with the principles of typage, you will see that they are two aspects of the same thing.

If you are wearing the traditional mask of Pantaloon, Harlequin or someone else, then you have only to go on stage for everything to be clear to the audience, the audience of a particular period. For instance, we have kept the 'red clown' and, when he goes out on stage, he is hardly likely to be taken for a heroic character.[30] When a traditional mask emerges, the audience knows straight away who it is and what it is. The specific character of the comedy of masks depends not on the revelation of character but on the treatment of it, because a person comes on [stage] with a defined character passport. And *commedia dell'arte* plays on situations between traditional characters.

What is different about typage in cinema? Typage in cinema is different because, instead of seven or eight traditional theatre masks, you have an infinite number of characters, because typage works on them. When a character is shown, there has to be a biography. When the three artisans are shown watching at the start of *The Strike*, everything is expressed in the faces of those three craftsmen and the way they observe the strike. It is perfectly clear

that the whole effect of typage lies in expressing a whole range of possibilities in concentrated form. Moreover the difference between typage and the theatre of masks is that in the latter there are established characters who are then reinforced, stylised, whereas in typage you invariably present a particular audience with a face that expresses everything on the basis of social experience (and not only social but also biological experience).

Take the [scene] in *October* when the Mensheviks speak at the congress.[31] We have absolutely no idea where a particular man came from or where he is going. But that man encompasses within himself quite distinctly all the ideas that in varying degrees bestow a particular political coloration on the man. This has not been taken from our Heavenly Father, but from people's collective experience. I know that, when I present this face, the entire audience will know what is going on. The facial characteristics, the texture of the skin, the way he conducts himself are all influenced by social and biographical factors. Many people will not even have seen people like this, whom I can remember as if they were still alive, but in any event the sum of their physiological features disposes us towards them in a particular way.

It transpires that the most theatrical phenomenon, that is the comedy of masks, is transformed into a feature of the maximal purity of cinema. Compare typage with an actor performing within the traditions of theatre. Naturally, traditional professionalism will be less discernible in typage than in the actor. But typage is not [a matter of a] naturalistic mug shot. It is a realistic face. It is not a chance something that has been fixed in all characters. If you need an old craftsman, you don't go to a workshop and pick out the first craftsman who has been there since before the Revolution. Not at all. Among craftsmen you will look for the one who bears the typical imprint of [the past], and people who think that typage is a sign of naturalism are mistaken. It is true that in some manifestations typage does embrace these signs. For example, the way Vertov selects people represents a naturalistic approach to typage.[32] But when you are looking for the most typical representative of a particular milieu from all the available options you make an enormous artistic selection in typage: that is, [you look for] an element of realistic representation.

It must be said that in the *commedia dell'arte* you find the same thing with just one difference: that within that framework over the decades typical characters have been collectively evolved and then become fixed. For example, the figure of the moneylender was built up over decades and the resultant figure is Pantaloon, a skinflint, a pedant, a shady-looking person. The experience of all the academies of Bologna and the other university cities in Italy shaped the transparent image of the doctor.

When you make a film, you do the same thing only with this difference: by using typage you are presenting an image that summarises all these materials and you sometimes do this in 500 or 600 metres of film which show you just what you need.

From the floor: Are these hieroglyphs?

A mask is always a hieroglyph. And what does a hieroglyph consist of in the

first instance? A hieroglyph, first and foremost, is a [schematic] 'object'. For example, the Egyptian hieroglyph remained at that level. The letter L, for Lion, was a drawing of a lion. For the Japanese and the Chinese, the original old hieroglyph was a crudely drawn realistic representation. In my article on Japanese theatre[33] I cite the example of a small schematic horse which then becomes an abstract conventional drawing because of the technique of writing, since the first was executed with a knife and the second with a brush. There is here a tendency to write quickly, to simplify rather than draw in detail; and the results are not at all alike.

There is the same element of hieroglyphics – deadness – in typage; and the imitators of typage constructions have ended up with just that. Suppose we take something like the repetition of typage schemes. If you are a police colonel, then you must have a mug of – that sort. The principle of typage, at a particular stage in its development, went no further than hieroglyphics. This led to conventionality because typage may get stuck in a rut – that is, pass over into hieroglyphics, lose its pictorial effectivity – and on the other hand it may dissolve into naturalism, become no more than a face, plain and simple, rather than a typical, collective face. As always, there are two possible extremes. You can see a typage construction of this sort in [the weeping] over Vakulinchuk, in *Potemkin*. I am taking a case where typage remains even in the most actorly genre of cinema, that is, when you have a feature film where the emotional effect of the performance is based on the symphony of the reacting group.

Whatever sort of picture you make, scenes will always be possible in which someone leaves for the front and there is a group of people seeing him off. If we make typage the central element here, then in other parts of the picture the typage remains a secondary element; like the group seeing him off, which is not personalised but orchestrated like a background. In the scene of the weeping over Vakulinchuk, you have a whole series of living characters. Not one of them has ended up as a hieroglyph, and not one has dissolved into a chance image.

From the floor: That is the influence of painting.

Painting influences all cinema.

From the floor: But isn't it expressed in the attraction of typage?

The influence of painting is just the same in typage as is the influence of music, because the typage in a farewell scene is orchestrated; that is, each face is seen not from the perspective of painting, but from that of the emotional signifier, the overtone, that is present.[34] And you arrange these elements for the most part not on the basis of their painterly signifier, which would enable you to set them in one particular sequence; instead you combine them in accordance with their tonal resonance.

With the extension of theatre directly into cinema, typage takes the theatre of masks into cinema. My life shows me to have been guilty in this genre. My theatre reached the very limit of theatricalisation. Take *Wise Man*,

which was entirely constructed on the principle of a contemporary comedy of masks. We had the whole range of comic and tragic clowns. As soon as I crossed over into cinema, I threw myself into typage, because there is much in common in the method of work: the same desire to find type as in the theatre of masks. There is even typage in the construction of screenplays. Just as a face was chosen, in that period of cinema an event was chosen without any attempt to master it through acting. This is taken to an absurd extreme in *October*, which is nothing more nor less than newsreel. The trick with *Potemkin* consists in choosing an episode and presenting it in such a way that it looks epic. The typicality of the event was represented and grafted on to a dramaturgical skeleton. From [this] point of view the dramaturgy of the screenplay for *Potemkin* remains unsurpassed. You can take it, put it on and watch it, and then you will see that it is a perfectly classically constructed tragedy in five acts. But it has also preserved the typicality of the event and nothing else has been introduced.

You will appreciate that typicality is not the signifier of the characters of a particular period; it is the signifier of the entire construction obtaining at a particular period. Hence the unity of style in *Potemkin*, where that same principle guides the representation of the entire event and of each separate detail. The whole plot has been shot in typage terms. This has caused a fracture in a very great number of other pictures, which have tried to present the conception of the performance of the screenplay through a typage actor. For example *The General Line*, where the role of Marfa Lapkina is essentially an acting role but one that is performed in typage terms.

I am deliberately illustrating all this by referring to my own works but you can take any picture in which the principle of typage has been suppressed in works involving acting and 'God knows what the result will be. If an actor looks better than he should for the part he is playing, then his acting should be made weaker. I could point to an example from *The Mother*, in which Pudovkin's secondary characters – the craftsman, the strikebreakers and the general public – were well chosen in typage terms; that was just as it should have been. His mistake, however, was that he also made them act, whereas he should have used a single camera angle, a single setting, to show these people. That would have been enough to say everything. He had to go and do something crass, when an ugly mug had already said it all. It was over-egging the pudding.

From the floor: Doesn't this strengthen the dramaturgic effect?

No. It does not strengthen it, it seems too insistent. Once you have shown this person's ugly mug, you have said it all. If you still want to show him in action, you must from an artistic point of view cut out a portion of the action from the completeness of the face, otherwise you have a superfluity of these things. There were those bearded, freckled men who, when they acted, were unconvincing because their facial appearance said so much that there was nothing left for them to say. The result was mere phrase-mongering – a popular enough vice. *Potemkin* approached events through typage and worked on that typage. *The Mother* should have been resolved in a different way. Batalov

is absolutely brilliant in this film: he offers a general typage outline and he rounds it out with his actions. That is why Baranovskaya to some extent acts less well than he does: her appearance belongs to a somewhat more artificial, theatrical genre.[35] Batalov is ideal. Baranovskaya, though, tends towards a more correct, more theatrical style. Which is why types in Pudovkin cry out for a different picture where they could simply be shown, and not forced to do anything.

We have at a certain stage typage not just in the *dramatis personae*, not in a single actor, but as the style of the work. This is one general tendency which Vertov, Kuleshov, I and others have interpreted in different ways. This common element is typical of the whole period. During the third period of Soviet cinema nothing of this earlier period remained, although its exponents were still alive. Kuleshov, the main opponent of theatre, introduced the rehearsal method and he did so with such consistency that features of theatre leap from the screen in *The Great Comforter* [Velikii uteshitel']. Take [the films] *The Storm* [Groza], *A Petersburg Night* [Peterburgskaya noch']:[36] they all have other characteristics. Typage has vanished. Montage has vanished. The typage approach towards events has vanished. Emotional drama has emerged. This is witness to the fact that the third five-year period in Soviet cinema is marching under a different banner which is interpreted in its own way in those works that put it into practice.

We have established that typage as principle is the expression of an attitude towards reality of a particular group of creative workers at a particular stage of historical development. Why does this happen? Think yourself into the psychology of a person who films in typage terms. This will not be easy. I will tell you what I felt, what I thought was fundamental. The fundamental thing is to allow only minimal interference of your will with what is happening. The actor represents the maximum intrusion of the organising will into a theatrical figure.

When I use typage, I look for a face, I find a face, I film it and I do not distort it. On the contrary: I try to capture it as it is. I try not to break or scare off what is characteristic of it. You do the same thing in relation to events. You try not to break up an event but to transfer it to the screen, losing as little as possible. But this still does not settle the question whether this will be Naturalism, Realism or Convention. The style in which you do it is confined within this general framework. The Naturalist takes a face at random without distorting it. The Realist seeks out a typical face. The 'Conventionalist' takes someone from the labour exchange and asks: 'Who are the generals there?'

And the 'Conventionalist' takes his models [*naturshchiki*] for definite, prepared genres, as in American cinema, where you have a list of addresses for kind-hearted doctors and malicious lawyers. When you want to show an unpleasant character in a court, you can take a list and call people out. The villain, the romantic lead – whatever you want, they are all there. This approach [leads] to a formulaic solution. If you know the actors available through Rabis,[37] you know which actor will come up to you and say: 'I can play the general, I've got the medals.'

Another might say: 'I've got a tail-coat, I'm used to being a dinner guest at the governor's ...'

And a great many directors do things that way. They go to Rabis and say: 'We need five guests in evening dress.'

That is also a formulaic, conventional solution. But it does not change anything as far as the style is concerned. The attitude of the group as a whole to this phenomenon is the same: don't touch, don't interfere, don't intervene in the passage of events; preserve it intact, if at all possible.

If the aim is minimal intrusion into what you are portraying, then what kind of premiss is there for this? Is this the action of someone who senses the event within himself, or not? No, it is the attitude of someone who has been confronted with events and who sees things not so much from within (or hardly sees things from within) as from a distance, with detachment. That is one feature.

And there is a second feature. That is the indicator of the greatest piety, the greatest awe which is expressed in the approach of a person to what he sees; it is the ultimate respect for what he has encountered. Take a group of people who at a particular stage in cinema gave expression to the Revolution in this way. You know that these were people who took part in the Civil War. True, they held technical or auxiliary positions, not posts of command or leadership. Take any of our lives. I built warehouses in the north, or erected wire fencing near Dvinsk. I was not in a position of command. Take Kuleshov, who made films. Take Tisse, who filmed newsreel.[38]

This was a group of people who took part, but who had [only just] come to [the Revolution]. They were people who had not joined the Party collective and who regarded their surroundings almost from the perspective of the specialist. [In this there was an] element, on the one hand, of complete acceptance [of the Revolution], of a desire to be more closely associated with it, while at the same time not having 'entered' it. That is an element that was stylistically very characteristic of the mood of those years. Let us take the relationships between the first directors of that period and the new hero of film – the workers. They were people from different groups. They were meeting one another for the first time. The directors met for the first time both the raw material for their work – production, the worker – meeting him as a leading figure, as the representative of the leading class. Hence there was this rapprochement with him and minimal intrusion into the matter. Through scrutiny and study [of the new hero] the director began to understand and capture [him].

Now, when I analyse those relationships in retrospect, I can remember very well how we felt. In an aesthetic mould too. This is how it manifested itself. It seemed then that life and the new order were so beautiful that they should not be distorted but captured as they were. That was the extreme position of the 'Cine-Eye': capture it as it is.[39] Let us say that a man is so interesting that the inclination is to take him as he is at a first approach, at a first meeting, or, to go further, let us say at first love. How were the Revolutionary events presented by the first directors? These people had no experience of the underground: they belonged to that group of the intelligentsia which latched on to the Revolutionary cause. They were not young workers like you.

The first group of film-makers was still, as it were, moving over to the Revolutionary cause and their attitude, their sense of these events from

13

within, had not yet taken shape. It may seem mad to you, but look at what happens later. Later, these people who came over to the Revolution ended up accused of being on the sidelines, of being fellow travellers.

If you remember, that was RAPP's basic line.[40] People moved towards the Revolution by their own methods, trying to penetrate it, assimilate it, understand it, and ran up against a barrier. And RAPP was the last excess on this road. With the rejection of that point of view, these people, the technical intelligentsia, became after 23 April 'one of us', participants in the building of socialism with equal rights.[41] So the point of view of 'one against the other' in one form or another was succeeded by a situation in which these people were placed in the same ranks. The notion of a view from the outside and of rapprochement was replaced by the view from the inside. You can see a big shift in the style and in everything else that was done in the artistic sphere. I refer to 23 April as a document that gave shape to this whole trend. There is now a definite change of direction towards examining all new phenomena emotionally, internally, psychologically and not visually or figuratively. If the first stage can be summed up as the influence of painting, that was after all understandable: painting shows the surface, the exterior. When the new began to be assimilated psychologically, there was a terrible jolt towards theatre. Whereas we initially had in cinema a borrowing from painting, a painterly influence, stylisation as in painting and then an assimilation of the plasticity of the screen, then, as far as [contemporary] cinema is concerned, we can say that you are still studying borrowing from theatre rather than working out your own cinematic plan for the exposition of the same thematic material.

With this example you have had a small slice of the history of the movement of styles in Soviet cinema. And I have tried to reveal, to the best of my knowledge, what the psychological premisses for this were. You are aware that psychological premisses are based on particular social premisses, and the creation of the first round of Soviet cinema was defined by the composition of the people concerned.

So two indicators of cinema have appeared in stage practice: montage and typage. After the decree of 23 April there was a change in the relationships [between theatre and film] and reality. New demands arose, and a new opportunity to approach these demands emerged. In addition, there was a technical revolution. Sound cinema came along. And when you have to address these questions, what do you have to do? You are familiar with mythology, you know about Antaeus. It was Antaeus who wrestled with Hercules. It should be mentioned that he acquired his strength through contact with the earth because he was a son of the earth. This aspect of Antaeus is very important in the relationship between film and theatre too. When new elements have to be worked out in cinema, you could do worse than come down to Mother Earth, return to and soak up the nature of the actor and sound in theatre, so that these principles may be developed to the next stage; that is, to the application of these same phenomena in cinema.

1935

2. Speeches to the All-Union Creative Conference of Soviet Filmworkers[1]

First Speech[2]

Being greeted with applause is terribly disconcerting; it comes as an advance payment, which makes you worry even more about what will happen as the speech draws to its conclusion.

You know my speech-making is a poor affair and I talk badly. I had hoped to get away with just a few words in this speech but, as our preparatory conference and indeed Sergei Sergeyevich showed,[3] I shall have to speak about a whole range of matters which I should have thought had long since sunk into oblivion, but which continue to trouble people from time to time and even to insinuate themselves into discussions long after they have, properly speaking, ceased to exist. And that is why I shall have to talk about something after all and re-examine some of the positions I once held: see how they sound in their new capacity; establish what has happened to them, and all that sort of thing. Perhaps some of them will have had crosses erected to them, and then again. . . .

From the floor: Minute the fact that Eisenstein was smiling as he said that.

No, absolutely no stage directions, it is just not honest.

There have been many discussions about my attitude to our cinema legacy in connection with the fifteenth anniversary of Soviet cinema. You know that there have been all sorts of arguments about this and that my view on these matters is fairly well known, but even this has been turned into all manner of conclusions which come nowhere near addressing the issue.

I should like to begin with what I feel about the fifteenth anniversary of our cinema. I think that there was a reasonably precise statement of my attitude to cinema as a whole in *Izvestiya*, in my last article.[4] I have no negative, 'mud-slinging' comments to make about any period, nor do I hold a low opinion of any of its stages. It sets out my view of the whole anniversary quite distinctly. I should at this point say that in *Izvestiya*, by virtue of the cramped 'living-quarters' I was assigned there, some parts of my article were cut; and it is possible that the full depth of the images that the anniversary inspires within me failed to emerge in sufficiently pronounced fashion. But I made the point that the change of styles and the general structure by which our cinema has progressed, the process of its advance and development, is a kind of distinctive, complex image reflecting the revolutionary course that our history itself has taken.

Our cinema begins with the mass, elemental 'protagonist'; the mass is the hero. Then, towards the end of its first fifteen years, the elemental, mass style of the first period grew more individualist on the screen, with a series of separate images, separate figures. A whole series of individual figures and characters appeared who were Bolsheviks, shown in the whole diversity of their struggle, be it underground or revolutionary; their battles on the fronts during the Civil War and their work for the cause of building socialism. At the same time the overall picture of the fifteen years seems to symbolise this unity of leaders, heroes and mass in one entire and all-embracing image. I should like to mention this amendment and adjustment.

I also wrote that the very process that is happening within the subject matter of our cinema, a process of transition from revolutionary generalisations 'as a whole' towards the theme of Party and Revolution, is a kind of symbol not only of our cinema – it is a distinctive symbol of the Bolshevisation of the masses in the West too that began with the United Front against Fascism, with which we are all familiar.

That is my general feeling about the whole fifteen years of cinema. And it hardly merits attack.

But, when we turn to an analysis of the different phases in our cinema, their sequence and our approach to our latest achievements, I devised a three-column schema, which, I have to say, elicited a barrage of attacks, backstage discussions, insults, irritations and so on. I would not say that the schema I devised was exhaustive. Like all schemas it was somewhat conditional, and of course . . . schematic. But in essence I think I had pinned down and accurately captured some of the tendencies of the movement in the development of cinema that we have experienced. Taking this further and developing it, we ought to give an account of the achievements and shortcomings of the different stages we have passed through: what, from what we have experienced, was right and what wrong; which phenomena and points of view were right, but only for their own time; and which elements might be developed in a new capacity. In short, it is time to draw some conclusions.

I had thought that a whole range of formulations that existed earlier had been eroded to nothing some time ago and no longer existed as topics for debate. Nevertheless, as conversations with comrades and as Dinamov's speech have made clear, a large number of questions have still to be agreed upon. And so I shall allow myself to re-examine some of our earlier tendencies which still continue to serve as objects for concerned analysis.

You know that I conventionally divide our cinema into three stages,[5] whereby the third, or fourth if you like, is the synthetic stage which has now begun and which has already brought particular achievements such as *Chapayev*, *The Youth of Maxim*, *Peasants* and Medvedkin's *Happiness*.[6]

I divided it up as follows: 1924–29 can be defined as the years when *typage and montage* were the prevailing aspirations. The next stage lasts from 1929 to the end of 1934. This stage may be distinguished by its approach towards the problems of *character and drama*. This meant that character no less than drama were essentially the next stage of development of what had figured, in embryo, in the earlier period as typage and montage.

What were the chief goals of this first period, 1924–29?

I would say that the question of typage was foremost. I do not see it as a feature of different works by different masters; I see it as one of the biggest general tendencies which dominated all cinema art of the period.

I understand typage here in the very broadest sense. It took its special flavour, its special characteristics, from different masters and different groups, although its fundamental tendency was the same. And the tendency was such that those facts and people that our contemporaries showed or presented in that period were shown in a minimally 'processed' or refined form. The tendency was refracted differently, at the hands of different masters. The slogan of the 'Cine-Eye' adopted an extreme position: it allowed absolutely no interference.[7] This was like a programmed setting. We know that in other cases (Kuleshov's workshop) the actor became a model [naturshchik].[8] In Pudovkin's work, the professional actor worked as one particular instance of a person, as one particular instance of a model. . . .

In my works, the principle of typage in this understanding of typage was upheld perhaps with particular consistency, and towards the end of my works from that period I reached the point where Marfa Lapkina[9] begins acting; that is, we have the other extreme: a type used as an actor. (What emerged from that, you know all too well.)

The key problem was neither to transform nor to recreate within the limits of what was artistically viable: it was to 'demonstrate' the person we were showing on the screen. It was a kind of 'non-interference' in what we had taken. This was the distinguishing feature of that period.

We had a similar attitude to raw material, for example a historical event; that is, this feature extended not only to the individual person we were showing, but to the character of the events we were recreating. We strove to take historical events as they were without, as far as was possible, rearranging the way that they happened into a drama.

This method of treating typage played a key role: it became sharply stylistic. Indeed, once something tries to remain immutable and not subject to modification at the whim of the person shaping it, then there is only one means left – the juxtaposition of these undistorted objects, i.e. what we call montage. And we can see that over this period refinement (in both the positive and negative senses of this word) in the field of montage comes close to the basic methods for reproducing reality. Montage and the internal character of the shot coexisted perfectly, harmoniously in many works of this time. But equally we know that montage itself played a pretty nasty trick on those who were trying to distort things as little as possible.[10] In the first place, it was montage that became the very means by which people began to rearrange and modify the raw materials of reality that they had tried to preserve inviolate. To some extent, montage has got its paws on every element of cinema. For example, the writings I published at the time were so maximalist as to make some people think that I completely underestimated the so-called internal content of the shot [vnutrikadrovoe soderzhanie], even though that would have been patently absurd. But people still took it that way and, if you please, ascribed such dogmatism to my writings. Nevertheless it is obvious that the emphasis, the centre of gravity of research then, was located in the problem of juxtaposition, in montage.

Things developed so that the process of juxtaposition in cinema montage as a whole became the general focus of attention; I proposed the formula that the actual *linking process*, the order of the sequence of shots, might even become the content of the picture; that is, what we then called intellectual cinema, where the actual process of the series of successions and changes could serve the work (to the extent that it was somewhat abstract) by making it embody an abstract concept.[11] That was, perhaps, the ultimate point to which the conception of montage could be taken. The argument there concerned the general conception, which was then popular. It has been my lot to stress this tendency as far as possible. To the ultimate point.

But what was intellectual cinema? (I shall have to talk about it because it is spoken of as though it were a norm of some sort which has supposedly retained a certain relevance and drives a large number of people to similar work.) First of all this concept should be clarified from the inside. The fact is that, in the process of vulgarisation, people tried to attach the label 'intellectual cinema' to any kind of film which did not have an emotional element! When a nonsensical film came along, it would invariably be described as intellectual. In fact, in practice there are only a few individual parts of *October* which contain practical suggestions for the *possibilities* of an intellectual construction in cinema, which then manifested themselves as *a certain range of theoretical possibilities.**[12]

It is quite wrong to apply the term 'intellectual cinema' to, let us say, a lack of emotional warmth in *The Old and the New*, which there might be in the picture. Rather it is really the other way round: when we spoke of intellectual cinema, we meant first and foremost a construction that might convey an idea to the audience and at the same time perform the particular function of *emotionalising the thought process*. Dinamov alluded to this in his quotation from my lecture at the Sorbonne.[13] If you remember my article 'Perspectives', in which this was discussed, it was precisely the emotionalisation of thought that was one of the key problems.[14] That was just how we conceived the matter. So, alongside the justifiable accusations levelled at my utterances against the role of 'living man' in cinema,[15] there comes this utterly unfounded charge about a rupture between emotion and intellect! Quite the opposite! I wrote: 'The new art must set a limit to the dualism of the spheres of "emotion" and "reason" ... It must restore ... to the intellectual process its fire and passion. It must plunge the abstract process of thought into the cauldron of practical activity', and so on.[16]

This aspiration keeps in very close step with another that is characteristic of that same period: the negation of imagery and image that is closely tied up with the Constructivist 'aesthetic'. You know that the whole film documentary movement has preserved this tradition to some degree, right up to the present day. Their mistake was to be so busy propagating fact that they forgot that in this period a fact was at the same time an *image*. A revolving wheel was not only a fact, it was at the same time an image, a figurative representation of our country which was emerging from a period of ruin.

*Kerensky's ascent of the staircase, the 'gods' sequence, and suchlike. (E's note)

This actual vagueness about what they were doing (whether it was a fact, or more than a fact) left a certain impression on the documentarists' subsequent methodology.

We made similar mistakes underestimating wherein lay the '*key*' to where we had succeeded and to what had reached the viewers.

It seemed to us that the image of a man and the image of his actions could be replaced entirely by . . . a screen image of his thought!

It is curious that in practice we have made broad use of other means of influence as well!

Just remember Marfa Lapkina.

But when analysing my own work, I sometimes put the centre of gravity in the wrong place. On the other hand a whole series of formal possibilities was opened up in *Potemkin* and *October*, which, although not serving as the key influence, nevertheless were enticing, as a possibility, and as a new possibility; naturally they turned my head and their value was perhaps exaggerated.

I have been much interested in the question of how to explain the specific nature of this period. Why, in particular, did cinema have this character at just that time; and why was it that this character was in the forefront, so to speak, since we know there were other stylistic tendencies at the time?

Of course, in order to answer this question we can turn to the research that has been undertaken. Anisimov, for example, has written in this area, explaining that film-makers belong to the technical intelligentsia.[17] Sutyrin has on occasion advanced his judgment on the situation, explaining it in terms of the extreme mental disorder of the people who made films then.[18] But I do not think these explanations were very authoritative or convincing.

When I tried to understand what, exactly, were the real prerequisites for our seeing and representing the world around us in precisely that way, I was left with only one option: to reassess, honestly, my emotions that dictated the form in which I was trying to express our content. Here I must say that a key factor was the very curious attitude that many creative workers then had towards the events of the Revolution. The majority of people (and here I am talking about myself, but also broadening matters beyond my own personal experiences) approached cinema having, for the most part, passed their probation during the Civil War. It should also be noted that our participation in the Civil War and in the Revolution in many cases, indeed in the majority of cases, was more a technicality than a matter of long-term dedication. It could be said that we were in the same position that the 'fellow-travellers' in literature were later to find themselves in.[19] It was only with the end of the Civil War that, properly speaking, we saw for the first time the full scale of what we had been party to (perhaps without fully realising it) and this left a unique imprint on our attitude to the raw material of reality. I see the socio-psychological precondition for our perception of the phenomena and people of our revolutionary reality as 'types', something inviolable, in the fact that when we returned from the Civil War we were encountering these phenomena for the first time. Like it or not, we felt a profound respect at our first meeting, and this even determined our efforts not to interfere with, to re-arrange or to alter what we were depicting: what we were meeting, en-

countering consciously for the first time, was so overwhelming, so new and unexplored. And in fact this applied not only to the history we were experiencing, but to prehistory too – the revolutionary past that our eyes had also been opened to for the first time.

My assertion may be open to dispute, but to a certain extent I am talking about this autobiographically. I think that this, probably, is true not only of myself. Many of you, if you think yourselves back into the relationship that then existed between ourselves and revolutionary reality, would agree with me on this point. After all, in essence the people who happened to make the films of that period were largely those who had approached the Revolution in the position of those who had been 'fellow-travellers' in literature. Moreover, cinema did not have a distinct seam of 'fellow-travelling', as such. But this 'fellow-travelling' was expressed in the specific nature of the style we are examining within the works themselves, rather than as a separate, independent file of 'fellow travellers', advancing *close by*.

What was the next step? In terms of its ultimate development, this feeling, this approach and 'sideways glance' were gradually pulverised. There is an increasingly noticeable movement of creative qualified workers towards active participation in what they had previously only contemplated. We know that this process, the process of rapprochement, of drawing us in, culminated in the decree of 23 April [1932], which provided a comprehensive formulation of the creative workers' sense of participation, with equal rights, in the building of socialism. This delivered a colossal jolt – rather, it formulated a colossal shift in the world view and world sense of Soviet film-makers, radically changing the previous state of affairs. From this new world sense, from this new self-awareness, there develops a completely new feeling, a new thirst to embody reality in a new way. Whereas we earlier emphasised epic portrayal, our creative cadres later moved gradually towards a position where epic form, so prized at the outset of cinema, became an ever remoter phenomenon, turning into dramatic form – drama. The same thing happens with the individual elements: the fleeting contemplativeness that characterises the typage vision develops into something new: it grows into the portrayal of character, into the making of character, into the revelation of phenomena even when in flux, and not at a moment of contemplation. The same thing happens with montage. The 'molecular drama' of the collision of montage fragments grows into a full-blooded collision of the passions of the participants in the drama, the participants in the event and not only [a collision] of the events themselves, in relation to each other, as was the case earlier.

Formally, there was nowhere further for 'intellectual cinema' to go in this respect. It was fully formulated in the summer of 1929. What more could be done with it or the actual ideas of intellectual cinema? For this, I need to say a few words about myself, about my later work after 1929. Here the situation is not easy because statements about works which were completed after 1929, and which encompassed the whole range of positions expressed earlier, are unknown to the consumer and unknown to you. Thus, for example, at the Preparatory Conference Comrade Yutkevich pointed out that a series of defects in the compositional aspect of *The Last Masquerade* were perhaps the direct result of the positions on intellectual cinema that I once expounded.[20]

This remark above all epitomises Yutkevich's failure to grasp the very question of 'intellectual cinema' completely. He is not alone in this, as I have already indicated. But here there is something more curious.

That is, it is precisely this example that shows how far, in fact, I have already moved from my one-sided theses. I have, to my great amusement, kept the shorthand notes of the recommendations I made as consultant on this very film.[21] I was then in the Caucasus, familiarising myself with plans for future films and expressing my opinion on them. I am not going to read through all my shorthand notes, but I can say that it was my recommendation to concentrate in one place the location for the action (which one screenplay had flung far and wide), restricting the unfolding action to one group of people concentrated within the same yards and buildings and showing with this group, 'as in microcosm', the whole diversity of revolutionary events in their development.

I found that the interest of the subject matter would consist in the way the different characters and different people's motivations changed with the course of revolutionary events. I went on to say that the most interesting figure here was the figure of the emerging Bolshevik, and that he was a subject of particular interest because he was a Georgian Bolshevik, and that would enrich the gallery of our film images with another character yet to find expression in Soviet cinema: that is, the character of a Bolshevik with a strongly pronounced national character.[22]

Then I said that the key achievement would be a portrayal of a monumental group of people in high relief. And finally, as far as the external dramatic action was concerned, a more detailed and profound development of the plot was desirable.

All these remarks relate to 1932 – to the time when *Counterplan* came out (I was in the Caucasus then)[23] – and they fly in the face of my earlier work, my article 'Perspectives'.[24] How can I explain this radical change of mind? By the fact that between the opinions expressed in the article and this case of consultancy, I was working on a reasonably long and serious creative assignment; an assignment which, sadly, nobody ever saw and which you will have to take on trust.[25]

After *The General Line*, when I began thinking about the development of my work in the future, I took a creative approach towards characterisation and depiction. Introducing Marfa Lapkina into *The General Line* could be seen as an 'embryonic' demand for a 'hero' in future works. This coincided with my journey overseas. These concrete plans relate to my work on screenplays in Hollywood (the summer and autumn of 1930).[26]

The ideas I devised there, which are partially to be found in the screenplays, concerned the depiction of important personalities and major characters, not merely 'static' but undergoing very serious change. We had three screenplays which will one day be printed purely because they provide historical information and an interesting treatment. One subject was Captain Sutter, his discovery of California, and his death in the heat of the gold rush fever of 1848, based on the novel by Blaise Cendrars, *L'Or*. Then the *best* episodes from the Haitian Revolution, what was to have been *The Black Consul*, and which was at the outset based less on the figure of Toussaint

L'Ouverture than on the character of another revolutionary general, who went on to govern the Republic of Haiti. His story developed like a Shakespearean tragedy, however: there followed a breach between him and the Haitian revolutionary masses, and the death of the erstwhile leader, caused by his increasing remoteness from the revolutionary masses. This role was created for the remarkable black actor Paul Robeson, whom we welcomed here as our guest not so long ago.[27]

The third large-scale work, which was nearly made, was Dreiser's *An American Tragedy*, where the whole objective had become the presentation of human character in its most complex form as it emerged and grew. I was interested in the subject of the gradual demoralisation of a twentieth-century lad who, finding himself at a loose end and in a range of situations typical of bourgeois societies, drifts into crime. This subject was interesting as a kind of negative counterpart to the type of twentieth-century youth that could only be created in our country.

These were the main works that filled those years.* Was this a listing towards a new latitude, towards a new understanding of the phenomena that were somehow individual to me, personally?

Of course not. This, like the characteristics of the first period of our cinema, was a general tendency, and in 1932, when I was already on my way home from Mexico via New York, with a whole series of subjects both elaborated and conceived in my baggage, I came across the first picture to emerge from here which, despite my being physically cut off from it by a whole hemisphere, worked with the same watchword. It was *The Golden Mountains*,[28] by that same Yutkevich who had attacked me; during my journey through New York it was released there for the first time and I had the pleasure of presenting it to the American public. In fact, in that very introductory talk I expressed roughly the same thoughts as I am now expressing in connection with the anniversary; that is, about how our first period – the mass-elemental – was being succeeded by a new understanding and interest in man in the collective, and not in the abstract collective itself, or mass, as was the case in our first works. This speech gave me a chance to say some harsh words about the emptiness and shallowness of American works, contrasting that with the problematic and deeply philosophical issues which, admittedly, are minor and embryonic, but at least touched upon in *The Golden Mountains*. In the same speech I mentioned the enhanced subject matter of ideology as the single and crucial means of escape from the dead ends of form and production, which was where American cinema was logically heading. You will appreciate the political significance that this speech had especially in the American context: the American press reacted quite violently to my statement.

So we can see that the crystallisation of films about different characters and different heroes has followed a perfectly normal historical path, although I do not agree with the point of view put forward by Zarkhi that the period that has now been ushered in by *Chapayev* could have followed seamlessly from the period when *The Mother* was made.[29]

*Because these works were composed in such a tendentious fashion they have remained unmade in America, as you are all aware. (E's note)

It is my profound conviction that the school of *Counterplan* and the whole series of pictures that emerged was extremely necessary, because they posed Party political issues in a new and more complex way: these films were not revolutionary at all – that was much more typical of the period of the first flourishing of silent cinema, which is where *The Mother* belongs.

I think that this intersects in a very interesting way with the revolution in that period on the philosophical front.

I think that this emergence of the images of Bolsheviks in feature film corresponds with the movements of art and imagery that were developing on the philosophical front under the watchword 'the Party spirit in philosophy'.

All would be well if the processes of development flowed smoothly from one stage to the next, but the trouble is that we know that development follows the path of a well-known formula of negation and the stage marked out to follow immediately afterwards cannot emerge straight away. There has to be a period of conflict between the first stage and the emerging second stage.

I am not going to reproach or accuse anyone. I think that it was perfectly natural for a whole series of formal achievements and special features, which our cinema had by this time elaborated, to be relegated to the second division during the swing towards a more ideological sophistication of the subject matter and sophistication of the theme of the Party, together with the colossal advances in the area of plot and content. I am not going to accuse anyone, but this fact is beyond contention. When these pictures were being devised there were bound to be clashes, increased tension between the warriors of the first period and those of the second period. The former were troubled by the question of a decline in resources and in the culture of cinematic expression which the first period not only radiated, but positively flaunted. What troubled them was that the means of expression were far removed from the apex of the ideological subject matter of the new content, and were in many cases on the same level as very mediocre Western standards, which it had taken Soviet cinema a great deal of effort to overthrow. This led to a lot of arguments among the various masters and, in fact, these flared up not because of an underestimation of the gravity of the subject matter and the problems of what the first period was doing (which some colleagues want to juggle with!) but over the primarily general, culturally expressive worth of our cinema.

We know that *Counterplan* made a huge difference, that it established for the first time and with such care the image of the new man in our cinema; but we also know that formally, in many respects, it left a great deal to be desired. There were a lot of attacks and sorties, as you know, against both *The Storm* and *A Petersburg Night*,[30] also because of their cinematic orthodoxy. But I must come out in defence of this, and I must distance myself from my personal tastes because here it would be quite erroneous to close our eyes and hysterically bewail our 'downward tumble' into the classics, our obsession with the 'old fogeys' and so on.

I think this period of cinema was for the same reason entirely correct from a very specialised point of view; in approaching the creation of images of our people, it is naturally not necessarily the same masters but perhaps their neighbours who studied how the masters of the past gave expression to the same characters and people. I repeat that I take issue, quarrel with and

dispute a great many of these things, with regard to their formal realisation and (inadequate) artistic merits; but I very much hope that these disputes and this occasionally violent criticism will not hide the fundamental theses of my assessment of the phenomenon of Soviet cinema as a whole. I have tried to set them out again for the benefit of those who persist in misconstruing them. You now have a clear picture of my attitude to those phenomena as such. But this attitude in no way rules out criticism. Each tendency set a perfectly defined standard for its requirements; if you judge the works by examining their absolute quality, from positions which one tendency or another expressed, then there are grounds here for criticism, and for very grave criticism too. I think that as far as the fulfilment of those intentions that one or another stage set themselves is concerned, it must be said that the first stage – of 'typage and montage' – worked more passionately, more desperately, more intensively; and as a consequence it realised 100 per cent of the programme that it set itself, albeit in a limited, one-sided but nevertheless pretty consistent fashion.

The second period, when questions of character, plot and story-line became paramount, in many cases fell short, and by many paragraphs, of its slogans. And judging some works of the period 1924–29 by the laws which they set themselves, we can see that they were not always on top of the situation.

I think that in this respect the period that starts with *Chapayev*, *The Youth of Maxim*, *The Peasants* at the end of 1934 can be seen as the period which begins to achieve a complete realisation of its goals.

For this (incipient) period is the one I call synthetic. This period absorbs, and will absorb, all that culture, all the results of the creative work carried out in the preceding periods, and rather than 'summing them up', it endows them with new qualities and raises them to unprecedented achievements.

Now that we have shrugged off the portion of the baggage that does not belong to the new stage, it would be worthwhile to look at which elements and principles from the pre-*Counterplan* days will carry over into the new, synthetic stage in the history of Soviet cinema that is even now taking shape.

I think that saying only that 'montage needs to get a bit better' or that 'people should start thinking more about the shots too' is very shallow and superficial.

What is needed is for cinematic means of expression to become the conduits for the central and key points in the drama. Sergei Sergeyevich [Dinamov] already observed as much in passing, when he said that the most powerful places in Shakespeare in terms of content and idea were at the same time those that were the best designed and constructed. He cited *King Lear*.

It is plain enough that in the new stage any notion of 'cinematic' scenes being eased into the overall course of a work that is not cinematically resolved must be eradicated. And that, to some extent, is precisely how elements of cinematic expressiveness appear in the staging of, say, that same *Counterplan*. They can be seen there as something of a 'guest contribution'; only the 'white nights' stick out like an 'island', when elements of cinematic expressiveness were suddenly recalled. In cases where problems of plot and drama are of paramount importance, elements that are primarily theatrical become the

means of their expression; cinematic means are pushed into the background.

In the new period, it will not be enough simply to confine yourself to doing the montage well, or worrying a lot about the shot. I hope for something more from this period. I think that a number of elements that were characteristic of the first period will become part of what is taking place now, but in a new capacity. And here, in this part, I want to talk about some problems confronting my own works, but I am not going to open up this part of my speech for discussion yet. Let us agree to consider all this as no more than a series of notions I am currently thinking about. They are perhaps still debatable, perhaps not yet properly formulated: they are merely the raw material I am working on. These are not positions I am yet ready to defend. For the moment this material has not been reinforced with all the necessary evidence; until it has, I will tell you 'on credit' what I think.

Having dwelt on that last matter, which was what point 'intellectual cinema' had reached, it is interesting to see what could be done further with the notions then expressed. Should they be jettisoned wholesale; or do they have some potential for transformation into another quality, and could they, somewhere, in a quite different manner and interpreted differently, go on to play a positive role in the future?

I should like to start by saying this: it is very curious that certain theories and viewpoints, the expression of scientific and theoretical knowledge in one historical period, lose their scientific value in the next; but they persist, possible and admissible not as science but as art and imagery.

Take mythology. We know that at any one stage mythology is, properly speaking, a complex of the science of phenomena set out in a language that is mainly figurative and poetic. All those figures from mythology that we regard as no more than allegory were at one stage an imagistic summary of our knowledge of the world. Then science moved away from figurative narratives and towards concepts, even though the arsenal of earlier, personified, mythological and symbolic beings continued as a series of stage images, of literary metaphors, lyrical allegories and so on. They cannot endure forever even in this role, however, and wind up in the archives. (Consider, perhaps, contemporary poetry in comparison with the poetry of the eighteenth century.)

Or take another example: the position, for instance, of *a priori* ideas which Hegel wrote about vis-à-vis the universe. For a certain period, this was the zenith of philosophical knowledge. Then this zenith became of no consequence. Marx turned the proposition on its head as far as the understanding of actual reality was concerned. But if we look at our works of art, we virtually have Hegel's formula in art. The author, saturated with ideas and predisposed towards them, is bound in fact to determine the whole progress of the work, and if each element of the work fails to embody the original idea then we shall never achieve a work of artistic integrity. It can be seen that the artist's idea is not itself something that springs fully formed from his head; it is a socially refracted reflection of social reality. But from the moment a point of view and an idea take shape within it, this idea becomes the determining element of the whole factual and material structure of his work, the whole 'world' of his work.

Let us take one more area, such as Lavater's *Physiognomy*.[31] In its time,

26

it seemed an objective, scientific system. But physiognomy is not a science. That same Hegel derided Lavater, even though Goethe, for example, was still collaborating with him, albeit anonymously (Goethe, for example, wrote an anonymous study on physiognomy devoted to the head of Brutus). We do not ascribe any scientific value to it objectively, and yet the moment we have to show a typical characterisation of external appearance on a par with a three-dimensional depiction of the character, we start using faces in the same way as Lavater did. We do so because we need in this instance an impression, a subjective impression of the appearance and not the objectivity of the correspondence between the appearance and the essence of the character. So Lavater's scientific viewpoint has 'emerged' in art, where it is needed as an image.

Why am I saying all this? Because this relationship between science and art has an interesting analogy in art itself; there are similar cases there with regard to content and form. Among devices in art, it sometimes happens that those features that are logical for the construction of form are mistaken for the elements of content. Logic of this kind is quite possible and may be necessary as a method and a principle of the construction of form; but it would be disastrous if this logic of construction were to be taken at the same time as a comprehensive means for containing the subject (you can see now where it will finish up).

To give the full picture, I want to cite one more example from literature. It concerns one literary genre you are, of course, all familiar with – the detective story. We all know what the detective story represents and which social formations and aspirations it expresses. Only recently Gorky spoke about this at the Congress of Writers.[32] But what is interesting is the derivation of the formal structure of certain features of this genre, of the sources from which it derived its raw material and from which the ideal vessel of that typical 'detective form' has emerged as the embodiment of specific aspects of bourgeois ideology.

It turns out that the detective story numbers among its precursors one that particularly helped to attain the full early blossoming of its specific features at the start of the nineteenth century, a novel about the life of the North American Red Indians by James Fenimore Cooper.[33] From an ideological point of view, this type of story which elevated the deeds of colonialism follows the same course as the detective novel, being one of the oldest means of expressing the ideology of 'ownership'. Balzac, Hugo and Eugène Sue all wrote about the link between early detective fiction and Cooper's 'Pathfinder', and contributed a fair amount in this respect; this was the raw material from which the familiar detective story was developed.

Setting out in letters and notes the ideas that guided them while they were constructing plots involving investigation, flight and pursuit (*Les Misérables, Vautrin, The Wandering Jew*),[34] all recorded that what so captivated them was Fenimore Cooper's dense forest and that they wanted to transpose that image and the analogous action to the labyrinthine alleyways and streets of Paris. The assembling of clues was borrowed from the same method of the 'pathfinders' whom Fenimore Cooper portrayed in his works.

So the 'dense forest' and the 'pathfinders' technique from Cooper's

works served for great novelists such as Balzac and Hugo as the initial metaphor for the adventurous constructions in the Paris labyrinth and the intrigues in the detective work. It helped give form to the ideological tendencies that lay at the heart of detective fiction. It gave rise to a whole, independent type of plot construction. But on a par with this use of Cooper's 'legacy' in that dynamically understood qualitative construction there is one other aspect: that of literal transposition, literal application. Ridiculous and far-fetched it is, too! Thus, for example, Paul Féval[35] wrote a story with real redskins in a real Paris, and there is one scene where three Indians scalp someone in a cab!!!

I mention this so that I can return to 'intellectual cinema'. The specific nature of 'intellectual cinema' was proclaimed as the content of a film. The progress of ideas and the movement of ideas were represented as a comprehensive basis for what was happening in the film; they were a substitute for the plot. Intellectual cinema is not justified in terms of a comprehensive basis. Furthermore, it is not justified even in terms of the less maximalist aspects of its application. You know that 'intellectual cinema' had a minor sequel in the theory of inner monologue. The theory of inner monologue warmed the ascetic abstraction of the progress of ideas by transposing things into a more plot-related depiction of the hero's emotions. But even with this things did not improve, although in statements about inner monologue the slight reservation was expressed that *the method of inner monologue could be used to construct things that did not merely depict inner monologue.* There was the peg, albeit in parentheses, on which it all hung.[36] These parentheses should now be opened up. And this is the most important thing I have to say. 'Intellectual cinema', taking on comprehensive content with disastrous results, played a very serious role in identifying a number of the most fundamental structural particularities of the form of a work of art in general. And this lies in the particularities of that syntax, whereby inner, as opposed to uttered, speech is constructed. This inner speech, the progress and the emergence of a way of thinking that is not formulated in the logical structure whereby formulated thoughts are expressed, has its own special structure, based upon a number of quite distinct laws. And what is noteworthy about that, and why I am talking about it, is that *these laws for constructing inner speech are, it transpires, the same laws that lie at the basis of the whole diversity of laws according to which the form and composition of works of art are constructed. And there is not one formal device that could fail to be a copy of one of the laws whereby inner speech (as distinct from the logic of external speech) is constructed.* It could not be otherwise. We know that emotional and figurative thought lie at the basis of the creation of form.* After all, it is inner speech that achieves an imagistic and emotional structure, without approaching the logical construction in which it is

*This last postulation is by no means new. Both Hegel and Plekhanov speak in equal measure of emotional thought [*chuvstvennoe myshlenie,* which might also be translated as 'sensual thought' – Ed.]. What is new here is the constructive recognition of the laws of this very emotional thought, which the classics did not go into. Without it, however, there can be no effective application of these actual assertions to artistic practice and to the teaching of our craft. The following formulations, materials and analyses set out to provide something that will be useful in practice. (E's note)

shrouded, and emerging in the form of logical speech. It is notable that, just as logic follows a whole number of laws in its constructions, so too inner speech, emotional thinking, obeys laws and structural characteristics that are equally distinct. These laws are well known and, in the light of the ideas I have expressed, they represent a complete set of laws for the construction of form. But from this point of view artistic practice has for some reason never recognised this or taken it on board in its aims. At the same time, the study and further analysis of this material has the most enormous significance for our penetration of the 'secrets' of the mastery of form. We are acquiring for the first time a firm foundation of premises showing what happens to the original thesis of a subject when it is transposed into a chain of emotional images. We are finding, for the first time, an area for the study and analysis of the laws for this transposition.* The actual field for the study of this area turns out to be even greater than could have been imagined. The fact is that forms of emotional, pre-logical thinking, preserved as inner speech among peoples who have reached a sufficiently advanced level of social and cultural development, are at the same time generally speaking the rule for mankind on the threshold of cultural development; that is, the laws which govern the flow of emotional thinking are the same for them as 'routine logic' would be in the future. Rules of behaviour, rites, customs, speech, modes of expression and so on are constructed in accordance with these laws and, turning to the colossal reserves of folklore and those forms and norms of behaviour that have survived up to the present and that are encountered among societies on the threshold of development, we discover that what for them was or is a rule of behaviour and common sense is precisely what we use as 'artistic devices' and 'mastery of form' in our own works.

I do not have time now to present you with a detailed report on early forms of thinking. Time does not permit me now to sketch out for you its specific principles which reflect the definite forms of the early social organisation of these social structures. I do not have the time to pursue the evolution of the different characteristic signs and forms of construction of ideas from these general premises. I shall merely cite a few examples which will make it clear that a particular moment in the practice of the creation of form is simultaneously a moment of routine practice at those stages of development when ideas are still constructed according to the laws of emotional thinking. I stress here that such an approach is far from exhaustive. On the contrary, from the very earliest time there has been a simultaneous, evolving current of practical and logical expediency from that construction, flowing from the practice of working processes; a flow which gradually expands and pushes back these earlier forms of thinking and gradually encompasses all areas not just of work, but of other intellectual activity, leaving the earlier forms to the sphere of emotional phenomena.

★　★　★

*This phrase should not be taken in the crude sense of a mechanical 'translation' of a particular slogan into the image of a work! The process of creation comes from 'both ends', but the interconnection between the formulation and the image of the same subject is just as I set it out below. (E's note)

Let us take, for example, an extremely popular artistic device such as the so-called *pars pro toto*. Everyone is familiar with the force of its effectiveness. The doctor's pince-nez in *The Battleship Potemkin* are etched on the memory of everyone who saw it. This device consists of replacing the whole (the doctor) with a part (his pince-nez) which plays him; at the same time it turns out that it plays that role with a much greater emotional intensity than the whole (the doctor) could have done, had he merely been shown a second time. And it turns out that this device is a very typical example of the cognitive forms from the arsenal of early thinking. At that stage there was no notion of the unity of whole and part as we now understand it. At that stage there was no differentiated thinking: the part *is* simultaneously the whole. There was no concept of the unity of the part and the whole. The later understanding of this unity did not yet exist as the dynamic representation of unity, but as the static perception of equality, sameness: the whole and the part are considered as one and the same thing. And at that stage (in all cases when this applies to the simplest day-to-day practice such as eating, and so on) for any cognitive operation it makes absolutely no difference whether it is the part or the whole. It always acts as both the totality and the part, in equal degree. Thus, for example, if you were given an ornament containing a bear's tooth, that would mean you were given a whole bear, or the strength of a whole bear, which in those circumstances was one and the same thing. This was before the stage of diffuse thinking which could make the distinction between 'strength' and 'the thing that the strength is invested in'. In the circumstances of today's daily practice, such a thing would be absurd. Nobody, receiving a button from a suit, would imagine that he was wearing a three-piece suit. But as soon as we enter the sphere where emotional and figurative constructions play a decisive role, the sphere of artistic constructions, this same *pars pro toto* immediately begins to play an enormous role. The pince-nez, offered in lieu of the whole doctor, do not only fulfil his role and place entirely: they do so with a colossal emotional and sensory gain in intensity of effect that is significantly greater than could have been obtained by the reappearance of the entire doctor!

As you can see, in order to achieve an emotional artistic effect, we have used one of the laws of early thinking which at that stage constituted the norms and practice of daily behaviour, as a compositional device. We have used a construction of emotional thinking, and consequently obtained a sensory emotional effect, instead of a 'logically informative' one. We do not register the fact that the doctor has drowned; but we emotionally react to that fact through the particular compositional way in which it is presented.

Furthermore, it is interesting to note that what we have examined in relation to the use of close-up in our example with the pince-nez is by no means merely a device peculiar to cinema. It also occurs, and is methodologically applicable, to literature, for example. *Pars pro toto*, in literary form, is what is termed *synecdoche*. Let us indeed recall Potebnya's definition of the two types of synecdoche.[37] The first is 'the presentation of a part instead of the whole'. There are five kinds:

1) singular instead of plural ('slave' instead of 'slaves');

2) a 'collective noun' instead of its constituent parts;
3) the part instead of the whole ('under the master's eye');
4) the definite instead of the indefinite ('I've said a *hundred* times...');
5) species instead of genus.

The second series of synecdoches gives the whole instead of the part. And there are three kinds, and so on. But, as we see, both types and all the examples and subdivisions correspond to one and the same fundamental position, namely the identity of the part and the whole; hence the 'equal status', the equal significance of the one which replaces the other. We find equally striking examples of the same thing in painting or drawing, where two points of colour or one cursive loop in a line can provide a full emotional substitute for the whole object. What is interesting here is not the list but the fact that is confirmed by this list. Namely, that what we are dealing with here is not individual devices, peculiar to this or that area of art, but rather the specific progress and condition of thinking that gives form to things – with emotional thinking, for which the given construction is one of the laws. 'Close-up' used in a special way, synecdoche, a dot of colour or a line – these are only individual cases where the same law of pars pro toto (characteristic of emotional thinking) is present, depending on which particular area of art it acts in as the embodiment of the creative design.

Another example. We are all very well aware that each embodiment must correspond in strict artistic terms to the plot situation being embodied. We know that this involves the costume, the sets, the accompanying music, light and colour. We know that this correspondence involves not only the demands of being routinely convincing but, perhaps to an even greater degree, the demands of maintaining emotional expressiveness. If a dramatic scene 'resonates' in a certain key, then all the elements that embody it must resonate in that same key. *King Lear*, which I have already cited here, provides a classic and unsurpassed example of this. The storm on the heath, raging about him on stage, echoes his inner storm. Equally well-known are examples of reverse construction. In contrast: when the height of a storm of passion is resolved by deliberate stasis and immobility, for example. But in this case too all the elements of the embodiment are maintained in just as strict a way as will correspond with the theme, even though it is done in the opposite way.

This requirement also extends to the structure of shot and montage, which must similarly repeat in their methods and respond to the same fundamental compositional key in which the piece and the scene as a whole are worked out.*

In this instance it transpires that this element, which is fairly familiar and widespread in art, is at a certain developmental stage also an inescapable and compulsory condition of behaviour in everyday life. Here I shall cite an example from Polynesia. This practice has changed little up to the present. When any Polynesian woman goes into confinement, it is an iron rule that

*The great mastery achieved in this latter sphere by our silent cinema declined significantly from the moment of transition to sound cinema, as may be seen from the majority of our silent films. (E's note)

all the village gates be opened, all the doors thrown open, all the inhabitants (including the men) take off their sashes, aprons, headbands; all knots that are tied must be untied, and so on; that is, every circumstance, all concomitant details, must accord with, correspond to, the fundamental theme of what is happening: everything must be opened, untied, to give the greatest assistance to the newborn child's entry into the world!

Let us turn to another area. Let us take the case where the actual artist is the raw material for the creation of form. This also vindicates our theses. More than that: in this case, there is not only a construction of a completed composition which is a virtual imprint of the construction of the laws that emotional thinking obeys. In this case we also have a situation in which the object and subject of creativity, united in this case, completely replicate the image of the psychic condition and the ideas that correspond to early forms of thinking. Let us once more compare two examples. Every researcher and traveller is always particularly astonished by one characteristic of early forms of thinking that is quite incomprehensible for someone who is used to thinking in categories of practical logic. This characteristic is that a person, while being himself and recognising himself as such, at the same time considers himself to be something or someone different; and he does so just as clearly, concretely and materially. In specialist literature on the subject, one of the Indian tribes of northern Brazil is often cited as an example.

The Indians of this tribe, the Bororo, maintain for example that although they are people, they are at the same time a particular species of red parrot that is found widely in Brazil. They do not mean by this that they will turn into these birds after death, nor that their ancestors were once parrots. Nothing of the sort. They assert directly that they really are these very birds. This is not a question of a similarity of names or ancestry, but a full, simultaneous identity of both.

However strange and unusual this may sound to us, there are masses of material we can cite from artistic practice that would sound almost literally the same as the Bororo notions about a simultaneous double existence in two utterly different and disparate – and nonetheless real – images. You have only to look at the question of how the actor feels when he is creating or acting a role. The problem immediately arises of 'I' versus 'he', where 'I' is the individuality of the performer and 'he' is the individuality of the image of the role being performed. This problem of the simultaneity of 'I' and 'non-I' in the creation and performance of a role is one of the central 'mysteries' of an actor's creativity. The solution will oscillate between a complete collateral subordination of 'he' to the actor's 'I', and the complete subordination of the actor's 'I' to 'he' (a complete transubstantiation). If the current illumination of the problem in its formulation approaches a fairly distinct dialectical formula of a 'unity of interpenetrating opposites, the actor's 'I' and the image's 'he', where the image is the leading opposite, then the matter is nowhere near as clear-cut and well defined for the actor with a concrete feeling of self. One way or another, the 'I' and the 'he', 'their' relationship, 'their' connections, 'their' interactions, will inevitably figure at every stage in the creation of the role. The actor 'of his own accord' and the 'actor in the image', regardless of the fact that they are embodied in one and the same physical person, figure

nevertheless as two separate entities. Let me cite just one example from the more recent and popular opinions on this subject.

The actress Serafima Birman[38] (an advocate of the second extreme) writes:

> I read about a certain professor. He did not celebrate either his children's birthdays or their name days. He celebrated the day when his child stopped talking about herself in the third person – 'Lyalya wants to go for a walk' – and said, 'I want to go for a walk.' For the actor, the parallel celebration is that day, and that minute of the day, when he stops talking about 'she' and says 'I'. For this new 'I' is not the actor's or actress's personal 'I' but the 'I' of their image . . .[39]

No less revealing in the memoirs of a large number of actors are descriptions of their behaviour when they put on their make-up, or don their costumes. These moments are often accompanied by the whole 'magical' operation of a 'transition', with the whispered phrases 'I am no longer myself'; 'I am already so-and so'; 'There, I am turning into him', etc., etc.

In one way or another, a more or less controllable simultaneous duality while playing a part is bound to be present in the creativity of even the most dyed-in-the-wool advocates of 'transubstantiation'. The history of theatre has seen too few cases of an actor leaning against the 'fourth' (missing) wall! It is characteristic that the audience has the same slippery, dual perception of action on stage as both reality and make-believe. And in this unity of duality lies the correctness of the perception that prevents the viewer from killing the stage villain, reminding himself that he is not a reality,* but also making it possible for him to laugh or shed copious tears, forgetting that he is only watching a performance.

Let us note another example in passing. In his *Elemente der Völkerpsychologie*, Wilhelm Wundt[40] quotes examples of how early forms of speech construction, its turns of speech and exposition, are what we are used to (we are not concerned here with Wundt's own views, just with a properly authenticated documentary example that he cited). The sense is: 'The Bushman was at first received kindly by the white man, so that he would herd his sheep. Then the white man beat the Bushman, who ran away from him.' This simple idea (and the situation is too simple, given colonial manners!) takes approximately the following form in the Bushman's language:

> Bushman – there – go; here – run – to white man; white man – give – tobacco; Bushman – go – smoke; go – fill – tobacco pouch; white man – give – meat – Bushman; Bushman – go – eat – meat; stand up – go – home; go – happily, go – stand;† herd – sheep – of white man; white man – go – beat – Bushman; Bushman – shout – much pain; Bushman – go – run – away from white man; white man – run – after Bushman . . .

*Although we are familiar with such episodes: let us recall the children in Chapayev firing their catapults at the White Guards attacking on the screen (!!). (E's note)
† i.e. 'stop'. (E's note)

This lengthy sequence of graphic single-unit images, an almost asyntactic series, is astonishing. But the minute we attempt to stage or film the original idea encapsulated in the two lines of narrative, our construction, surprisingly, comes out very similar to the Bushman's. Asyntactic it may be, but nevertheless ... supplied in numerical order, it is something we are all very familiar with ... a shooting script [*montazhnyi list*]; that is, the same transposition of fact, abstracted into a concept and back into a chain of concrete single actions, which also happens to be the process for translating stage directions into actions. 'Ran away from him' in the Bushman's language is an orthodox montage phrase made up of two parts: 'the Bushman runs', 'the white man runs' – a montage in embryo for an American 'chase sequence'!

The abstract 'received kindly' is expressed by the most valuable concrete things whereby the idea of a friendly reception is built up (smoking, a tobacco pouch, meat, and so on): this is another example showing that as soon as we need to make the transition from information to real effect, we invariably pass over to the system of laws that correspond to emotional thinking, which plays the dominant role in images characteristic of early development.

I cannot fail to mention one more very similar example. It is well known, for instance, that there are not yet any generalisations and generalised 'all-pervasive' concepts at this same level of development. Lévy-Bruhl (again cited here because of the factual raw material of his research, rather than for his theoretical understanding) provides examples of this in regard to the language of the Klamaths.[41] There is no concept of 'walking' in their language. But they do have an endless number of designations for each particular type of walking. Striding. Waddling. Shuffling. Creeping. Etc., etc. Each, with the subtlest of nuances, has its own meaning. We may find this strange, but only until we have to realise the bracketed stage direction 'He approaches' in any play as a series of approaching steps by one actor towards his partner. The most brilliant comprehension of the recognised term 'walking' is immediately found wanting. And if the actor's (and the director's) conceptual 'walking' does not instantly set in train a whole range of possible and well-known individual cases of one person approaching another, from which he can choose the one that best suits the situation, then his performance will end in a most dismal and tragic fiasco!*

You can see how distinct this is, even in trivial matters, by comparing different versions of a writer's manuscripts, the finished edition and earlier drafts. The 'polished style' of many works, particularly poetry, very often involves a seemingly unimportant transposition of words; but it is a transposition that is conditioned by laws of a similar order.

Let us take an example from Gogol's *Taras Bulba*. Taras saved Yankel's life in a pogrom, telling him to hide in a string of carts. But Yankel was a little slow: he set up his stall and began trading. To Taras's surprise, he said, 'Stop

*The difference between both examples here will be the details of the gait and the chosen movements, no matter how refined they might be. With an accomplished master they will always convey the generalised content of what he is producing in any particular embodiment. That is doubly the case when his task is the complex recreation, from a simple 'approach', of a play between psychological conditions. Neither the typical, nor realism, is possible without this. (E's note)

talking ... I'll catch you and the soldier up; for now, I'm going to sell these morsels for less than food's ever been sold before. You'll see.'

'*Bulba shrugged his shoulders and rode off to his detachment.*'

The last lines in the finished version go like this: 'Shrugging his shoulders, Taras Bulba marvelled at the irrepressible nature of the Jew and rode off to camp.'

I. Mandelstam quotes both versions.[42] He observes that it is the transposition of the object before the subject that creates the greater effect. He does not point out that Gogol uses this 'stylistic device' with great frequency. One of the explanations for this is Herbert Spencer (*Essays*),[43] whom he quotes as explaining the greater effectiveness of such a positioning by way of 'the economy of attention'. He does not, however, trouble to explain why it is 'more economical'. Still less when he tries to explain the same thing for this particular case of Taras:

> Through this switch a new element is introduced that is missing from the earlier draft: there is a new expression of something subjective, about Taras ... 'Shrugging his shoulders, Taras Bulba marvelled at the irrepressible nature of the Jew and rode off to camp' – and the whole moment is more expressive.

I can only agree with the last bit. But it is an explanation using the very terms which were meant to be explained!

There can be no doubt that the second (definitive) version is more emotionally expressive, as are the majority of cases where the object precedes the subject. And the reason for this again lies in the fact that such a juxtaposition corresponds to the cognitive situation of the early forms of thinking that I was talking about earlier. This time, it is Engels who provides a characterisation of this particular situation:

> When we consider and reflect upon nature at large, or the history of mankind, or our own intellectual activity, at first we see the picture of an endless entanglement of relations and reactions, permutations and combinations, in which nothing remains what, where, and as it was, but everything moves, changes, comes into being and passes away. We see, therefore, at first the picture as a whole, with its individual parts still more or less kept in the background; we observe the movements, transitions, connections, rather than the things that move, combine, and are connected.[44]

So, such a juxtaposition of words, where the description of movement and action (the verb) precedes the description of who is moving or acting (the noun), corresponds more closely to the primeval structure. This is probably beyond the bounds of our Russian language, which is as it should be, since it is connected first of all with the specific nature of the structure of thought. In German, '*Die Gänse flogen*' [the geese flew] has a dry, informational ring to it, whereas something like '*Es flogen die Gänse*' [there flew the geese] has, in its very turn of phrase, something lyrical or poetic that is not used in everyday

colloquial speech. (The neutrality of the primeval perception of flight as such is shown here with particular force through the indeterminate form '*es flogen*'. In English, this would be rendered by the form 'there is', 'there was' and so on, which plays exactly the same role.)

Engels' comments on and description of the above-mentioned phenomena, as phenomena of the approach, and return, to forms characteristic of earlier stages, are well illustrated by those cases where we have a graphic and proven picture of psychical regression. For instance, in well-known cases of brain operations, when a similar phenomenon of regression may be observed. I had the opportunity of observing some fascinating cases in the neurosurgery clinic in Moscow which specialises in operations in the area of the brain.

For instance, in the case of one patient, his verbal definition of an object gradually but distinctly went back through those phases noted above, in proportion to his psychical regression. Here, they go from *naming an object to the definition of the motive function of an action that is produced with the help of this object.*

If, for example, you took a glass, then the question 'What is it?' would be answered, in proportion to the extent of the regression at the various stages of this phenomenon, as follows: 1. 'A glass' (in a healthy case); 2 'With a glass' or 'with a *lash*', 'with a *pencil*', depending on what was held up. (But in all cases with a distinct tendency towards a functional description, albeit one not yet separate from object description.) 3. Giving a clear picture of a description not of the object, but of the action and movement that have wholly replaced the concept which arises later of '*what* it is that is moving'. When a glass is shown in this case, the answer would be 'drink tea'. Numerous such examples could be given. This expands the picture as I set it out here. But let us go back to our immediate theme: to emotional thought in the form that it takes in art.

In the course of my exposition I have more than once had to operate with the term 'early forms of thinking'. To illustrate my ideas with images of concepts that exist among peoples on the threshold of culture. It has already become traditional for us to be on our guard in all cases that deal with these areas of research. And with good reason: these areas have been well and truly muddled by proponents of 'racial theories' or by the less covert pontifications from apologists for the colonising policy of imperialism. So it would do no harm to make it quite clear here that the ideas expressed here are of a quite different nature. Usually the structure of so-called early thinking is seen once and for all as a fixed system of forms of thinking, belonging to so-called 'primitive' peoples, innate in them racially and not prone to any sort of variation. Put like that, it is a scientific apologia for the methods of enslavement that these people were subjected to by white colonists, since, allegedly, these people were 'in any case doomed' as far as culture and cultural interaction were concerned.

Even the famous Lévy-Bruhl cannot in many respects claim to be innocent of such a conception, despite the fact that he does not consciously set himself similar aims. We are indeed fully justified in attacking him, since we know that forms of thinking are the conscious reflection of the social formations through which a particular social collective passes historically. But many

opponents of Lévy-Bruhl fall into the other extreme of trying to ignore altogether the specific nature of the peculiarity of early forms of thinking. One example is Olivier Leroy,[45] who on the basis of an analysis of the sophisticated logic of the productive and technical inventiveness of so-called primitive peoples, comprehensively denies the difference between their system of thinking and ideas and our generally accepted logic. This is wide of the mark, and amounts to a concealed repudiation of the dependence of a system of thinking on the specific nature of the productive relations and the social premisses underpinning it.

But the basic error, apart from that, for both camps has its roots in the failure adequately to sense the gradation between these apparently irreconcilable systems of thinking. They completely disregard the qualitative aspect of the transition from one stage to the next. Underestimating this very circumstance often scares us too, as soon as early forms of thinking are involved. This is all the more strange, as Engels in literally three pages of the work quoted earlier sets out a comprehensive exposition of all three stages of the structure of thought through which mankind passes during its development: from early diffuse-complex, which the partial quotation I cited above describes, through the formal-logical stage which 'negates' it; and finally to the dialectical, which absorbs the two preceding stages 'in an embrace'. A dynamic perception of phenomena like that cannot of course exist for a positivist approach such as Lévy-Bruhl's. It is not just the content of the thinking, but the very progress and form of its process that can often be qualitatively quite different for someone of a definite, socially determined type of thinking, depending on his situation at a particular moment. The distinction between the types is not fixed and even a mild affect may be enough to cause perhaps an extremely logical and rational person suddenly to start reacting with the ever-ready arsenal of forms of emotional thinking and the rules of behaviour that derive from it. When a girl you have deceived tears your photograph to shreds 'in a temper', destroying 'this cheat', for a moment she is repeating the purely magical operation of destroying a man by destroying his likeness (based on the early identification of object and image).

In some parts of Mexico, when there is a drought, people still drag out of the churches the statue of the relevant Catholic God that has replaced the old one who was responsible for the rain, and on the boundary path ... they flog him for his idleness, imagining that this will be a means of exerting influence on what the likeness represents. During her momentary regress, this girl is taking herself back in a fit of passion to the stage of development where such an act would have been quite normal and would have had real consequences.

Equally we know of not momentary, but rather (temporarily!) irreversible manifestations of a psychological regression of a similar type when a whole social system is in regression. Then this is called reaction, and the fires of the Nationalist-Fascist *autos da fé* – burning the books and portraits of undesirable writers on the squares of Berlin – are a brilliant elucidation of this![46] In any event, examining any cognitive structure in isolation is profoundly misguided. This quality of sliding from one type of thinking to another, from one category to another, and, even more, the simultaneous

presence in varying proportions of the earlier stages and the need to reckon with this circumstance, are as important, explanatory and revelatory as in any other sphere:

> An exact representation of the universe, of its evolution, of the development of mankind, and of the reflection of this evolution in the minds of men, can therefore only be obtained by the methods of dialectics with its constant regard to the innumerable actions and reactions of life and death, of progressive or retrogressive changes...[47]

In our case the latter bears directly on transitions to the forms of emotional thinking that sporadically occur in fits of passion or related conditions, and the images constantly present in elements of form and composition, based on the laws of emotional thinking, as I tried earlier to prove and demonstrate. I will not pile on any more examples. I have only one more thing to add.

After investigating the immense wealth of material of similar phenomena, I naturally came to a question that might also excite you. That is, that art is nothing other than an artificial psychical regression to the forms of earlier emotional thinking; in other words, a phenomenon identical with any form of intoxicant, alcohol, shamanism, religion and so on! The answer to this is extremely simple, but also extremely interesting.

The dialectic of a work of art is constructed upon a most interesting 'dyad'. The effect of a work of art is built upon the fact that two processes are taking place within it simultaneously. There is a determined progressive ascent towards ideas at the highest peaks of consciousness and at the same time there is a penetration through the structure of form into the deepest layer of emotional thinking. The polarity between these two tendencies creates the remarkable tension of the unity of form and content that distinguishes genuine works. All genuine works possess it.

It is in this remarkable fact and in the peculiar feature of a work of art that you can find the infinite difference in principle between it and all close, similar, analogous and 'related' areas where there are also phenomena peculiar to 'early forms of thinking'. It is the indissoluble unity between these elements of emotional thinking and conscious intellectual effort and elevation that makes art unique and inimitable in those fields which require comparative examination for a correlative analysis. That is why, bearing this basic thesis in mind, we should not balk at an analytical examination of the most basic laws of emotional thinking and never lose sight of the essential unity and harmony of both elements, which can create a work of integrity only through this unity.

This is indeed so: a work of art loses its integrity if one or other element prevails. If the balance tips in favour of logic and theme, the work will be dry, rational, didactic. The eminently forgettable 'agitpropfilm' was just like that.[48] But to err on the side of emotional forms of thinking, regardless of logic and theme, is equally fatal for the work, which is then doomed to be emotionally chaotic, wild and delirious. Only the 'dyadic' interpenetration of these tendencies can maintain a genuine tension, a unity of form and content.

And if after huge victories (as evidenced by the most recent films) we are

now embarking upon the ideological assimilation of the first element, then as far as the technique of our craftsmanship is concerned we must dig ever more deeply into the questions of the second component too. The notes that I was able to set out here, albeit briefly, will also serve this purpose. Our work here is not complete: it has only just begun. But working here is extremely important for us. Studying these fields, in order to answer these questions, is very important for us.

It is through the study and assimilation of this material that we learn an extraordinary amount about the laws of formal constructions and about the internal laws of composition. And you know that, when it comes to knowledge of the laws of formal construction, we are lacking. For, apart from the extremely dubious formula of 'defamiliarisation',[49] almost nothing has been said on this. But we are now probing in those areas some fundamental laws that are rooted in the very nature of emotional thinking which earlier were given over to the free revelry of capricious defamiliarisation. If we compare ourselves to music or literature, we have next to nothing; if we analyse a whole series of questions and phenomena, we accumulate precise knowledge in the area of form, without which we have no hope of reaching that overall ideal of simplicity that we all have in mind. To attain that ideal and realise it, it is extremely important to guard with the utmost resolve against the other, possible, extreme: that is, simplification. There is no point in dwelling on this here. The question has been debated enough in literature. But there is a tendency here in cinema which some people already want to express as filming 'simply', or, ultimately, as 'it doesn't matter how'. This is terrible: we all know that it is not a matter of filming in a way that is mannered and 'stylish' (and it only turns out mannered and 'stylish' when the film-maker does not know what he wants to film or how to film what he wants). *But the question is how to film expressively.* We must move towards *ultimately expressive and expressing form and to the most sparing and economical form for expressing what we have to express.* But a successful approach to these questions requires very serious analytical work and very serious inside knowledge of the nature of an artistic form. So we must not attempt a mechanical simplification of the matter but a systematic analytical exegesis, which holds the secret of the very nature of effective form. I have merely indicated to you the direction of my current work on these matters. And if we now recall 'intellectual cinema', we shall see that 'intellectual cinema' had one merit, despite its natural tendency towards absurdity, and that is its claim to a comprehensive style and a comprehensive content. This theory posited the possibility of our having not a unity of form and content, but an identical coincidence between them. The beauty of this was that it was no easy matter to examine the unity to see by what means the effective embodiment of ideas had been constructed. But once these things had been 'hammered' into the one, we discovered the course of internal thought as the fundamental law of construction of form and composition. Now we can use these newly discovered laws not for 'intellectual' constructions, but for fully rounded, imagistic, narrative constructions and any others you care to mention, since we already know several 'secrets' and the basic laws of the construction of form and effective constructions in general.

I shall finish with this. You can see from what I have examined of the

past, and what I am working on at present, that there is one qualitative difference. The fact is that, when we proclaimed the priority of montage, or of intellectual cinema, or of documentary cinema, or of any other militant programme depending on what school we belonged to, this had above all a tendentious character. What I am now trying to get across to you, to hint at, is that what I am working on now has a completely different character. It does not have a specifically tendentious character ('Futurism', 'Expressionism', or some other 'agenda') – it delves into *questions of the nature of phenomena*; that is, a field that is of equal importance to any genre of constructions within our unified and general style of Socialist Realism. Questions deriving from ten-dentious interests begin to develop into a heightened interest in the very cul-ture of that field in which we work; that is, tendentiousness here turns into academic research. I have experienced this not only in my creative work but in my life too: from the moment when I began to be interested in these basic problems of the culture of form and the culture of cinema, I found myself working not in production but in the Academy of Cinema which was then being formed and is just developing, and the route to that was laid by my three years' work at the State Institute for Cinematography.[50] What is also in-teresting is that the above-mentioned phenomenon is far from unique, and this new quality is far from being a feature specific to our cinema. We can see that a whole series of theories and tendencies is ceasing to exist as an original 'current' and beginning to be considered in its variations and developments as questions of methodology and science.

I could quote here an example like Marr's teaching, and the fact that his teaching, which once constituted a 'Japhetic' tendency in the science of lan-guage, underwent Marxist revisionism and entered practice not as a tendency this time, but as a generalised method for the study of language and thought.[51] Because it is not by chance that academies are being established on almost all fronts around us now, or that arguments are going on in other fields: in architecture, for example, it is not a narrow choice of tendencies (Le Corbusier or Zholtovsky),[52] and this is not what people talk about. The topics of debate are the synthesis of the 'three arts', more profound research, the very nature of the phenomena of architecture, etc.

I think that a similar thing is happening with us now in cinema. For at the present stage, in contrast to the past, we masters have no differences of prin-ciple or disputes about a whole series of programmatic postulates. But there are individual nuances within a single overall understanding of the unified style that is Socialist Realism. And this is far from being the sign of 'deathli-ness' as some might interpret it: 'If they don't fight, they're dead.' Quite the opposite: it is precisely here and in precisely this that I find a great and most interesting sign of the times. I think that now, with the onset of cinema's six-teenth year in our country,[53] we are entering a special period. These signs, which can now be traced in allied art forms and which now have a place in cinema, herald Soviet cinema's classical era after all kinds of periods of dis-agreement and controversy, because the features of those interests and that characteristic approach to a whole series of problems: that drive for synthesis, that postulation of and demand for the complete harmony of the elements, from plot to the composition of the frame 'without making allowance for

poverty', the requirement of integrity and all the features which our cinema is acquiring – these are signs of the greatest flourishing of art.

And I think we are now entering a most remarkable period: our cinema's era of classicism – the best period, in the highest sense of the word. In conclusion, I shall say that at a moment like this it is not possible to remain outside production. When spring comes, I shall plunge into production work as vigorously as I conduct my academic work, so that I shall have my place in this embryonic classicism and make my contribution to it as well. (*Applause.*)

Closing Speech[54]

It is no easy task to undertake the closing speech for a quite exceptional event such as our creative conference has been. I am no orator. Further, almost all the speeches that have been made here have expressed such lofty principles; and Comrade Blyakhin's[55] speech, dedicated to the great attention shown us by the government decree of 11 January of this year, had such a profound effect on us all that it is particularly difficult to return once more to a whole series of specialised questions, which I nevertheless have to say something about.

One of the remarkable features of our Conference was that disputes were conducted in an elevated key and there was none of what Lenin used to call 'nit-picking'. None of us differs on the basic issues, and that is the most remarkable thing about our Conference. But I must use this opportunity to dispute Comrade Yutkov's[56] definition of 'classical', which I should like to apply to the epoch of cinema that began with this Conference. The fact is that there was a bit of 'nit-picking' in Comrade Yutkov's speech and it did not sound good when he allowed himself to interpret my definition of 'classical' as a sort of substitute for the concept of Socialist Realism! And I want to make my objections quite clear to him on this matter. The fact is that there was no opposition of concepts here.

There are people who when you say 'classical' to them see the inevitable Corinthian capital, or the Ionic flourishes, or a painting by Louis David[57] with figures posed as in death. I am not talking about that classicism. Here I am talking about the term 'classicism' in its quite definite meaning of a model representing the highest quality.

Since here the argument may be philological, please let me quote to you one passage concerning this word from a report entitled 'The Problem of Cognition in a Historical Materialist Light', read at a session of the Institute of Philosophy of the Communist Academy devoted to the twenty-fifth anniversary of the publication of *Materialism and Empiriocriticism*.[58] It contained the following:

So we all use the term *classical*. 'Classical' in the sense of a perfect model. But how many people know the true, original sense of this concept? The fact is that since the formation of the class system in the ancient world, 'classicus' meant 'class'; the first class proudly bore the title 'classis'; 'classicus' meant everything that pertained to the representatives of the first, highest class which stood in opposition to all other classes, in par-

ticular the ancient Roman 'proletariat'. Needless to say a *class ideology* emerged at the same time, while 'classical' meant 'perfect' only by virtue of the fact that it referred to *the qualities of the highest class.*

Everything that was the product of the *work and creativity* of this class was *perfect*, exemplary.

We can see that for Gellius *classicus* was the opposite of *proletarius*.

For example, Gellius uses the phrase 'a classical writer' as the opposite of 'a proletarian writer', who is of little worth by virtue of the fact that he belongs to the lower classes – the 'proletariat'. But we, for example, when we talk of a 'first-class writer', do not suspect that we are falling into a trap and mean a writer who belongs to the first, highest class of society.[59]

Comrades, *the first, highest class of society is now the proletarian class.* (*Applause.*) The right to use that term, the term 'classical art', now belongs to the highest art of the highest class.

In this connection I would like to say the following: at the opening session of the conference we heard a report from someone who is not a film specialist. I mean to say that until this conference he was not a specialist, but now that this conference is over, *he has become one of the leading specialists* (*Applause*), leading because Sergei Sergeyevich Dinamov managed to accomplish the most important thing: he contrived in his remarkable report to unite all the themes which trouble cinema without belittling any one of them; and it has to be said that our comrades, who are professionals, in many cases did not scale such heights. ... There were times when the emphasis was wrong and not enough was said on particular questions. Despite the fact that I have already commented on the extraordinarily high and principled significance of these speeches, there is one thing I would like to draw your attention to: namely, a possibly dangerous element which could be detected here and there in our discussions and speeches.

We have all remarked, with unbounded delight, that cinema has developed tremendously in its world view. All the more dangerous, then, is the occasional, fleeting mood that this is comprehensive and all that needs to be said. This came out in several speeches by directors. Today I must comment, with great delight, that the cameramen have put the matter somewhat to rights. They may not have spoken for as long or as well as many of the directors, but they managed in a series of speeches to give the crank that extra quarter turn which, to quote Kozintsev, Moskvin does for his director, after which it turns out very well.[60] This concerns the colossal responsibility and importance of all the elements of culture from which a synthetic work of cinema is assembled. I want to be very precise on this, since, Comrades, it is a danger and an error into which theoretical thought has already fallen once.

These moods seemed to be gathered in the last phrase of Comrade Yutkevich's speech, which was taken from the letters of George Sand and aimed directly at me. You remember how he finished: 'That is what George Sand wrote ... to Eisenstein.' These were the words:

You read, study, work more than I, more than a great many others. You

have gained an education such as I will never have. You are a hundred times richer than all of us. You are rich, but you complain like a beggar. 'Give to a beggar, whose mattress is stuffed with gold, but who wants to feed on beautifully turned phrases and choice vocabulary.' But you are a fool who roots around in his straw and eats his gold. Eat the ideas and emotions found in your head, in your heart; the words and phrases, the form which you are so full of, will themselves appear as a result of digestion...[61]

Comrade Yutkevich has co-opted George Sand as his assistant; I wonder which girl I should take as an accomplice? (*Laughter.*) But when I began looking for a way to get at Yutkevich, I thought that possibly that same Sand could assist me too. I looked and looked and finally I found ... the very same phrase that Seryozha[62] quoted. The point being that while he referred to her in his speech, George Sand referred to a whole series of earlier writings where it was expressed in this way: be healthy; everything else will take care of itself. Or, 'But rather seek ye the kingdom of God; and all these things shall be added unto you.'[63]

I have allowed myself this terse formulation because in this phrase you can detect what Vladimir Ilyich once stigmatised in relation to Proletkult. I had to work in Proletkult myself at that time when there existed a similar point of view: 'Belong to the working class, be a young worker. And...'

From the floor: All these things shall be added unto you.

And I had to fight this position in 1920–1. You will not believe what was going on then in the theatre, when directors would sit down and do their utmost for a spontaneous, expressive revelation to show itself as a perfect manifestation, before one young student, the Simonov worker Antonov,[64] or someone else, and everyone would endeavour not to interfere in this: how he spoke, how he understood things – that was how it had to be. At first I sat there too, staring and thinking: 'Perhaps it really is like that?' But later I took a slightly different approach and began to analyse it: what was the point? In a great many cases it transpired that the hoped-for originality was nothing more than a refrain, and not a refrain from a lofty cultural bequest either, but from the most wretched models to which the workers from Simonov and other districts, in their thirst for culture and art, had been condemned when the tsars were still in power. Then we tried turning on another tap, referring to what Vladimir Ilyich had to say about Proletkult, which was that all the material and *all the models of the most perfected forms of culture, the most perfected mastery and technique should be given to these young workers who have come to us*, to the Proletkult studios and theatres.

In order to avoid repeating possible errors in this direction, I also consider it my duty to recall this today. This very phrase of George Sand is directed at Comrade Yutkevich for another reason. And I have here to deal not with her writing, but with sentiments expressed by her victim – Flaubert. In fact, Flaubert can claim credit for the brilliant riposte that an imperfection of form is a sure sign that the idea has been inadequately conceived and ex-

pressed. But I do not want to use this as polemic against Comrade Yutkevich. I have said here, and he has agreed, as indeed we all have, that *Counterplan*, for all the remarkable, high quality of its ideas, is not the ultimate definition of perfection.

Are we agreed?

Voices: Of course.

I am not going to draw from this the opposite conclusion that, if it is not perfect in every one of its compositional merits, that is due to the artist's insincerity. I respect the work and the authors too much, and in their interests I should prefer to drop the quotation from George Sand as my theme, and return more closely to what Lenin taught us in relation to Proletkult.

This brings me to a question that has also been bandied about here, which is that we still somewhat underestimate research work on the technique of our art, work on resolving the specialised problems of our mastery and art.

Nobody has had as many compliments paid to his wisdom and towering intellect as I have. Almost everyone who has spoken of this has done so with great kindness: 'My dear Sergei Mikhailovich, your intellect is astounding.' And when a particular work by Sergei Mikhailovich was under discussion on this front, then there would always be just as much backslapping, and cries of 'What unusual stuff you're doing. In your study, and at the Academy. We must make pictures. But all your work there is – well...'

I think that I must make a picture, and I will make pictures, *but I feel that this must be worked on in parallel with equally intensive theoretical work and theoretical research.*

Voice: Well said. (*Applause.*)

I want to say something about this to Sergei Vasiliev:[65] in your speech you came out and said, 'I speak to you as a pupil to his teacher.' Permit me to talk to you as a teacher to his pupil.

When you talk to me about my Chinese robe with its hieroglyphs, which I am supposed to wear as I sit in my study, you make one mistake: there are no hieroglyphs. Nor do I gaze at a statuette in abstract meditation when I am sitting in my study. I work at the problems that will confront the up-and-coming generation of film-makers. And, if I sit in my study, that is so that you do not lose time sitting in studies, but may go on to make further pictures just as remarkable as your *Chapayev*. (*Prolonged applause.*)

We all know about 'ivory towers'. And if we are talking about ivory, then let me move not into a tower, but imagine that I live in one of the tusks: that is what is needed to punch through the themes in our cinema. If my work over the last few years has been with the one tusk – the theoretical and academic – of the methodology, theory and practical education of directors, then henceforth I shall start working with both – *production work and theory*. (*Prolonged applause.*)

Which leads me on to another matter, which will be of great interest to you and which is not openly talked about. I want this matter to be brought into the open. It is the point in the government decree about the awards on the occasion of the fifteenth anniversary of our cinema that concerns me.

What are our feelings, mine in particular, about this decree?

I think, Comrades, that this document is the most edifying thing that we

have received from the Party and the government. And to the extent that it concerns me, it is perhaps more wisely conceived than any others. That is exactly how I feel about it. The point is that, as you know, I have not engaged in operational, direct production work for some years and I interpret the decree, to the extent that it concerns me, as the most important sign from the Party and government that I should engage in production too.

I am a director and a teacher. There may be cases where I have acted without realising that I might break someone's heart.

Comrades, my heart has not been broken, *and it has not been broken because no heart that beats for the Bolshevik cause can be broken.* (*Prolonged applause, standing ovations.*)

Comrades, you have all given me so much credit for my brain; please, from today, I ask for credit for my heart. (*Applause.*)

Is it chance that Comrade Yutkevich dropped the remark here that *The Battleship Potemkin* and films like it are written with the blood of the heart? And what I am telling you now I am saying to put an end to all that gossip and talk, about what has been avoided or underestimated, among some people and groups. *These conversations must be torn straight from your hearts with the utmost Bolshevik decisiveness.* (*Applause.*) They stop you from working. The work that we are doing for the Party is not ephemeral but historical and this work will always reveal itself. In this lies the greatest honour that we could have.

I want to say in conclusion that the great historic events in cinema that are taking place during these very days must mobilise us to tackle all the colossal working problems that our impending classical period of Socialist Realism will set before us. It is classical because in fact from now on it is establishing the correct norms and correct paths for research, the correct relationships between our subject matter and the forms of our art and of all our work in general. It is the period of the greatest internal harmony. It does not mean that we will sleep as in the Garden of Eden, without watchfulness or struggle. Much has been done, but so much more is ahead of us! But this does mean that our struggle for the purity of the methods of Socialist Realism will advance on a higher plane; we shall speak with a fuller voice, we shall speak on the basis of film-makers' more mature socialist world view, which never existed on this scale before.

It is possible, Comrades, that the emphases here have not always fallen in the right place; scriptwriters may be hurt to be paid such scant attention, and so may directors, actors and cameramen. Comrades, it is not like that. Perhaps we have not spoken about this in every speech but we feel it, and we know that *only an uninspired collective can exist by stifling one creative individuality with another.* (*Applause.*)[66]

And, Comrades, we must not forget at this very meeting the colossal role which our immediate leadership plays in our work. You know that we have argued and squabbled in our speeches and on the pages of the press with Comrade Shumyatsky.[67] But yesterday at the awards ceremony, Comrade Shumyatsky and I embraced and Friedrich Ermler[68] said that henceforth a new stage was starting in all our work, a stage of immediate proximity filled with the sense of *one common cause between creative workers*, whom I had the

honour of representing, *and the leadership, which was represented by the Party and which would lead the Bolshevik cause with us all. (Applause.)*

Comrades, I have yet to make the concluding remarks about everything that has happened here. I think that we can happily deny ourselves a concluding speech that would summarise all those premises yet again. *I believe that, although this is only the first conference, we can say that we have been present at the most powerful conference about art that has ever taken place. Why? Because we have, in our formulations and concluding speeches, documents of inestimable historic importance such as those that we have read in recent days on the front pages of our newspapers: the words which the Central Committee of our Party and the government of the Land of the Soviets have addressed to us.*[69]

It would be impossible to find better closing speeches, better programmes for future action, and to translate these speeches into the language of our cause would provide the same socialist beauty with which Comrade Dinamov began his speech.

I think, Comrades, that we can close our conference at this point. We are all too well aware of what we must do in the future. (Tumultuous applause.)

3. The Truth of Our Epoch[70]

Art must belong to the people. Art must be rooted in the broadest strata of the working masses. This was Lenin's teaching.[71]

There is no art to which these great words could be better applied than our Soviet cinema. Our cinema truly belongs to the people, the workers and toiling masses of the world.

Our cinema is truly rooted in the broadest strata of the victorious working class.

Together with the young Socialist state, our cinema was born on the front lines of the Civil War and comes down to us through early newsreel footage, the most treasured documents of our struggle. Time and again the record of our newsreels reflects our powerful growth, the victories of Socialist society.

But our cinema reaches its peak on the fiction-film front, which broadcasts to the world, with bright images and generalisations, the truth about our country and the people who are building Socialism.

Cinema is celebrating its fifteenth anniversary with a massive display.[72] A series of remarkable films is coming on to the screens and they are greeted with lively excitement by the many millions of Soviet cinemagoers. Informed by a great sense of purpose, our cinema has won over the proletariat of the entire world and hearts and minds even beyond our border.

And today, when those who work in cinema are so favoured by the attentions of Stalin, our Party, our government and the whole country, we can sense that it is only thanks to the vital link with all of them that our cinema can say that on its fifteenth birthday cinema has really become the most important of the arts, as Lenin had ordained.

4. Wolves and Sheep: The Director and the Actor[73]

I believe very strongly in the principle of collectivism in work. I think it is utterly wrong to crush the initiative of any member of the collective. Moreover, at the All-Union Conference on Cinema[74] I put it quite bluntly: 'Only an uninspired collective can exist by stifling one creative individuality with another.'

But in this matter the battle is being fought on two fronts. There are sometimes cases where the director's 'rod of iron'[75] is not only legitimate, but necessary.

Everyone will agree that the overriding requirement for joint creativity between actor and director[76] is unity of style, unity of stylistic preconception and of realisation of the work. In the case of a work of great stylistic (but not stylised!) clarity, this requirement is particularly urgent. Within this unity, any collaborative creative interrelationship is possible. And this does not just apply to actor and director. It applies just as much to director and composer. And perhaps the greatest pairing of all is that between cameraman and director. I mean here above all a cinema in which all these problems are more intense, more intensive and more complex. This occurs within the unity of stylistic conception of the collective as a whole.

So when is 'conflict' reasonable? When is the director to be allowed his 'evil way'? Above all, in a case where an inadequate stylistic understanding on the part of one of the members of the collective who enjoys equal rights manifests itself. For, looking beyond any talk of dictatorship and so on, it is the director who bears the responsibility for the integrity, unity and stylistic composition of the work. That, after all, is his function. The director is, in this sense, the unifier. It is possible, even desirable, for this stylistic unity to be worked out by the collective as a whole. This is where theatre has the advantage. The rehearsal is based upon collaborative development and work around and within the production. Each individual grows into an overall conception, into a uniform image of the work.

In cinema things are much more complex. The preconception, secured in a numbered iron screenplay,[77] and its complete inflexibility once it has been fixed on film, mean that there are none of those 'discoveries' at the last rehearsal. It is more complex because of both the type of work and the level of participation and because of the degree of [stylistic unity] in the picture. And perhaps most of all because of the difficulty the actor himself has in coming to terms with a resolution of his performance that corresponds to the

style of a number of specific elements in cinema which are only occasionally comprehensible and intelligible to the actor: the line of composition of, for example, shot and montage must obviously be in complete harmony with the other elements. Not every pitch in music, not every nuance in his treatment of the role, not every shot construction and not every element in the montage will correspond one with another. Each of these elements in a creative combination loses its autonomy. It can no longer be 'off-key'. If it is, bedlam will inevitably ensue. Add to this one more specific characteristic of film work. It is impossible for the performer to witness all the stages in the progression of the shooting, whereas in theatre, for example, creative participation is not only desirable but also obligatory, even if it does only involve being present at every stage of the production as it emerges in rehearsal.

For this reason the film actor needs an even greater intuitive sensitivity to the style and the key in which the production as a whole is constructed. There must be minimal intrusion of his own, stylistically opposed [notion] into a conception that embraces in a single key and style even the compositional outline that pervades the whole chain of the plastic form of the shots (to the point of filming a field of rye or of the quality of night lighting). Because a different note of intonation, a different rhythm of motif composition, is often not a difference within the general plan of the role at all, but an element 'from a different opera' – an element of another plan; a plan, moreover, which meets the requirements of . . . a different picture!

An actor's sensitivity, confirmed by the director's explanation, demonstration and, above all, stylistic questioning, suggests to the performer a superficial shift in which the other elements have also apparently been resolved. An intonational structure that matched the style of the very popular Shishkin 'She-Bear with Cubs'[78] would hardly be consonant with a film in which a Serov-style construction[79] would be stylistically appropriate! This too must resonate in the texture of the orchestration. A composer does not confuse his timbres. A realistic folk melody does not necessarily have to be performed naturalistically – on a folk instrument.

And the reasons for the attacks on the allegedly dictatorial bearing of certain directors lie in precisely this. This group of directors has pretensions in the best sense – not to be limited purely by representational authenticity, but actually to strive for a stylistically graphic unity of composition. This requires a very sensitive ear. Sometimes this ear is tone-deaf, like Shishkin's bear. Then the director must issue a correction. Having your stylistic manner corrected can bruise your self-esteem. As a result the director acquires a reputation for being a dictator.

That is how the problem of director and actor presents itself to me.

5. The Battleship 'Potemkin' 1925. From the Screen to Life[80]

Every phenomenon has a chance, superficial manifestation. And underlying it is a profound feeling that reason has dictated it. So it was too with the film *Potemkin*. A grand epic *1905* was conceived by Agadzhanova-Shutko[81] and myself in preparation for the twentieth anniversary of 1905; the episode of the mutiny on the battleship 'Potemkin' was to have been just one among the many episodes in that year of the revolutionary struggle.

The 'chance events' began. The preparatory work of the Anniversary Commission dragged on. Finally there were complications with filming the picture as a whole. August came, and the anniversary was due in December. There was only one thing for it: to choose one episode from the whole epic that encapsulated the integral sense, the feel of that remarkable year.

Another fleeting chance. In September, you can film outdoors only in Odessa and Sevastopol. The mutiny on the 'Potemkin' was played out at Odessa and Sevastopol. But then came something preordained: the episode of the mutiny on the 'Potemkin', an episode which Vladimir Ilyich had earlier singled out for special attention, was also one of the most representative episodes for the whole year. It is curious to recall now that this historical episode had been more or less forgotten: wherever and whenever we talked of the mutiny in the Black Sea fleet, we would immediately hear of Lieutenant Schmidt, and the 'Ochakov'.[82] The 'Potemkin' mutiny had somehow been erased from memory. It was less memorable. Less talked of. So it was all the more important to resurrect it once more, to focus attention upon it, to re-mind people of this episode which embodied so many instructive elements of the technique of revolutionary uprising, typical of the period of a 'dress rehearsal for October'.

But the episode really was resonant of almost all the motifs characteristic of that great year. The triumph on the Odessa steps and the bestial retribution find their echo in 9 January. The refusal to fire upon their 'brothers'; the squadron letting the mutinous battleship through; the general mood of solidarity that took hold of everyone – all these were repeated in countless episodes during that year right across the Russian Empire, communicating the quaking of its foundations.

One episode is missing from the film – the 'Potemkin''s last voyage, to Constanţa.[83] This is the episode that drew the attention of the whole world to the 'Potemkin' in particular. But this episode was played out beyond the confines of the film; it was played out in the fate of the film itself, in that journey

across the capitalist countries which we find so inimicable and which the film lived to see.

The picture's makers went on to enjoy the greatest satisfaction that work on a historical revolutionary canvas can bestow, when events on screen are transferred to life. The heroic mutiny on the Dutch warship 'Zeven Provinzien', where the sailors taking part in the mutiny showed that they had all seen the film *Potemkin* – that is what I want to remember now.[84]

The battleships seething with the same revolutionary zeal, the same hatred of exploitative power, the same deadly malice towards those who, while arming themselves, call not for peace, but for more slaughter, for a new war. The greatest evil, whose name is Fascism. And I really want to believe that, at Fascism's order to invade the socialist motherland of the workers of the world, its steel dreadnoughts and superdreadnoughts will reply with a similar refusal to fire; their reply will not be the fire of weapons but the fire of mutiny, as the great heroes of revolutionary struggle responded – namely, 'Prince Potemkin of Tauride' thirty years ago and the glorious Dutch vessel 'Zeven Provinzien', right before our eyes.

6. Happiness[85]

Today I saw our laughter on the screen. And for the second time in only five days I cannot resist responding with enthusiasm to our latest film achievement.[86]

Today I saw Medvedkin's comedy *Happiness* and I cannot keep quiet about it, so to speak.

Today I saw a Bolshevik laughing.

You can begin your comedy with an announcement that Chaplin is not in it. And in fact it turns out that Chaplin was not in it.

But you can make a comedy without thinking about Charlie, and it turns out that he is in it.

It is not him. It does not borrow from him. It is Chaplin as an indicator of degree. Chaplin as a specific kind of approach. Chaplin as something profoundly specific.

Chaplin 'in a new quality'.

That is what I felt today, watching Medvedkin's *Happiness*.

This picture has not yet been released. It is not yet finished. It has not yet been through all the proper procedures. Not yet been approved. Not yet been tried out on an audience.

It is easy to praise *Chapayev*[87] on the crest of the wave of enthusiasm that greeted this remarkable film.

But it is harder to write about what I saw in that small, dark preview room, sitting between the nervous author and two friends who had dropped by.

Nonetheless I have to speak about this film as I would of something remarkable.

About its author as an extremely interesting individual.

And about the genre of the film as revealing and confirming a completely original person and a completely idiosyncratic conception of our understanding of film comedy.

It is hard not to laugh at Khmyr, shearing the ears of corn. But he is not just a fool. He is not an idiot. This is the 'idiocy of rural life',[88] of the kind, and in the forms, that we have left permanently behind. That life which seems a hundred times more idiotic in the era of collective farms and combines.

It is hard not to laugh at Chaplin.

I want here to express my delight at the means, the level of the understanding deployed by Medvedkin to resolve these remarkable things.

A Chaplin gag is individually illogical.

A Medvedkin gag is socially illogical.

Chaplin is always walking away. Chaplin always walks away into the distance. The plot takes Chaplin away. The plot has no solution. One leg is here. The other there. An individual cannot be motivated.

But the collective can. And Khmyr begins where Chaplin leaves off. He is an outsider. Alone. Remote. And Khmyr is motivated. A wife. The head of the Political Department. The scene of the action. And Chaplin, who has become Khmyr, comes forward from all those far-off points to which Khmyr-Chaplin vanished in the endings of all his films.

That's how it is. And here's another opposition for you.

Khmyr is given a rifle. Khmyr stands guard over the collective farm's granary. The granary is on stilts. Kulak riffraff have a grudge against the granary. A kulak releases his goat into Khmyr's vegetable patch: Khmyr throws stones from his hillock to chase the goat away. Khmyr is more interested in his own good than that of the collective. He stands with his back to the granary. The kulaks are underneath it. They stand up. The granary is lifted off its stilts. It rests on the kulaks, on the feet of the priests and their henchmen. It does not stand still: it moves. It does not move: it runs. Khmyr turns round, having chased the goat away, and sees that there is no granary on its stilts. The granary is scuttling over the fields on the kulaks' legs. Khmyr chases after the granary and so on. Into a chain of new diversions.

Taking a little house off its foundations is nothing very new in the worldwide realm of gags. The best 'Western' gag was another house: Chaplin's in *The Gold Rush*.[89]

The cabin where Chaplin spends the winter with another gold prospector, Big Jim McKay, was snatched up by a storm. At the very moment when Chaplin's delirious friend sees him as . . . a chicken (*sic*) and wants to carve him up. There is a long scene, with winds buffeting the opponents. At last the blizzard lifts the cabin up. It flies through the air. And comes to rest suspended on the edge of a precipice. Just walking around the cabin causes it to rock. The cabin is the deck of a ship. It flies and rocks, and so on.

And again. That was funny and this is funny. There was a struggle there, and there is a struggle here. But there the struggle was one against the other. Here the struggle is inside the character. And the struggle is between yesterday's money-grubber[90] and today's guardian of the collective's property. Chaplin's gag is simple. At heart, it comes from the question of class. As a metaphor brought to life, with big fish devouring small, it is out of Breughel.[91] And the device has become a sign of the expression of the socialist attitude to property. Money-grubbing has the upper hand. But that was not the end of the story. There was a new scene like the one where the sheriff's philanthropy allows the prisoner to go abroad.

The kulaks' malice continues, growing in intensity. Goats and granaries are no longer enough. Now it has to be a stable: a kulak herds all the kolkhoz horses there, to burn it down with them inside. And Khmyr's hut is burnt down by a kulak so that Khmyr will not stop him from burning the stable.

And there is a brilliant scene: two fires and two flames. Khmyr's own little hut is ablaze. And the flame is taken from the kolkhoz stable. Medvedkin achieves something remarkable: his Khmyr rushes between the two – and it is comic! And he does not know which to deal with.

Finally he runs to the kolkhoz property – he saves the horses from the fire, and so on.

But he rushes to right and left. There is an inner conflict. Two flames: money-grubbing, and the sanctity of kolkhoz property are comically resolved – sheer brilliance. I know of only one scene on a par with this, from a Fatty Arbuckle comedy (it was on in Moscow).[92] Fatty played the hero. He had saved the heroine. But the baddies to the right and left had stolen their way to the shack where he has taken her. Fatty came out of the door. He looked right – there stood a bad guy. He looked left – and there was another bad guy. He looked at his hand – he was holding a double-barrelled gun. Resting the weapon on his knees, he bent the barrels, one to the right and the other to the left. He squeezed the trigger. Two shots sounded out, one right and one left. Both baddies fell dead. One on the right and the other on the left.

Two brilliant scenes. Superficially similar. But in terms of their significance and their essence, a gulf of interpretation divides the two.

You can chuckle at Fatty. He is undoubtedly remarkable. But you do not just chuckle at Medvedkin. The first laugh makes you feel awkward. At the second you feel a remarkable sense of uplift.

These are just elements. These are just fragments. This is just using Medvedkin to illustrate my fundamental thesis.

That a comparison between the mature achievements of the mastery of two classes may give substantive food for a corresponding comparison...[93]

What we have is not just a superlative thing.

We have a remarkable master.

We have a real, original, mature individual.

The first thing I noted was the principle.

It is not a transplant of a gag. Not appropriation. Not filching ideas from the Americans.

But a genuine assimilation and reinterpretation.

A resolution of the most important thing. Not a gag in isolation. Not a gag for its own sake. It is a quest for what this gag may serve to symbolise.

What conceptual and ideological content in the comic interpretation is expressed through this *seemingly* traditional device?

I have worked quite a lot on this. There are several devices in my own stock of creative work that could contend with Medvedkin.

Sometimes I watch some film or other quite unaroused and feel quite downhearted. Should I have taken my comic work to its conclusion? Today, I am at peace and glad. I feel that joy that is also possible only in a country where money-grubbing can serve as an object of laughter. I am glad that Medvedkin has resolved the problem of our humour in the same way that I would have done, had I been filming and making it!

It is a pity when things are done purely for entertainment, etc.

In conclusion I would like to share my sincere delight about one other scene in Medvedkin's film that is worthy of Shchedrin.[94]

One of the old guard.

Could you, after applauding a scene of a psychological onslaught, imagine a comic scene comparable to it?

Medvedkin has done this.

Khmyr gave up money-grubbing as a bad job.

Fine. It did not work for him. One person ends up doing all the work. No matter how much you get, everyone else helps themselves to it.

Khmyr decides to die. Khmyr hews some planks. Khmyr knocks a coffin together.

Universal panic. Whom will they exploit? The kulak. The priest. The powers that be.

The priest runs up. He terrifies Khmyr with the Holy Scripture. Khmyr planes away, measuring himself up for the coffin. A policeman shouts at Khmyr. Khmyr makes some adjustments. The Metropolitan runs up with the priest. The view of the low hill. The village. Galloping hussars. A flying carriage. Senators, civil servants, chiefs of police, district police officers. And hussars, hussars, hussars. Everyone is flying – just to stop the peasant from dying.

Khmyr eats his last crust and looks gloomily into the coffin. And then, from behind the low hill, comes row after row. Men in black with rifles. With a terrible, strictly measured pace – the tsar's soldiers. Everyone trying to stop Khmyr from dying. The troops come nearer. Black, like the Kappelites.[95] Mechanised, like them. Further away than them. And a brilliant grotesquerie: soldiers wearing masks. They all had the same face. Big-eared, with their mouths stretched open in a yawn. Small moustaches that formed a loop. This synthetic image of the old army gave me the creeps. It is the most remarkable moment in the film. Medvedkin here scales the heights of genuine grotesque. Beneath the savagery and absurdity of a cardboard jowl reproduced on every soldier, you could discern the terrible, moribund face of the regime. Pure Shchedrin.

Khmyr was not allowed to die. Khmyr was allowed to live. But this is only half the story. He was flogged until he was half dead for his attempt at dying 'by his own hand'. By ending this section with groups of soldiers with cardboard-box faces bashing out a tune on an accordion – groups of soldiers with cardboard faces dragging Khmyr to his execution – Medvedkin attains an effect worthy of Goya.

7. To the Magician of the Pear Orchard[96]*

How should I begin an article about a great artiste, whose popularity is so great that his portrait – a statuette or photograph – is to be found wherever a Chinese heart beats, remembering its native country, even far beyond the Chinese borders? Whether in a family of Chinese intellectuals in San Francisco or in a small, brightly coloured stall in New York's Chinatown; whether in a fashionable Chinese restaurant in Berlin or in the 'Golden Pheasant' inn in Itzamale on the Yucatán peninsula, washed by the sky-blue waters of the Gulf of Mexico – Mei-Lan-Fan is known everywhere.[97] His portraits and likenesses are lovingly preserved everywhere. You can find impressions everywhere of those statuesque poses with which, in accordance with Chinese theatrical tradition, Mei-Lan-Fan concludes the episodes of his remarkable dance dramas.

But it is not only his countrymen who accord him this remarkable love and popularity. His art is so great that it captivates people from quite different countries, cultures and traditions.

The first rapturous reports of Mei-Lan-Fan came to me from Charlie Chaplin, whose stories introduced me to the remarkable craft of the Chinese artiste.

And I would like to begin this piece about Chinese theatre, on the occasion of the arrival of the person who elevated it to the greatest heights of perfection, by recalling one of those elegant and highly improbable legends about the origins of theatre in China – and, like any other nation, it has plenty of them.

It is the legend about the siege of the city of P'ing-Ch'eng in 205 BC. One of the legends about the origin of marionettes is connected with it.

The Emperor's troops were hidden in this city, besieged by the armies of Hun. Their general Mao Tun surrounded three sides of the city, entrusting the command of the rest of his troops to his wife, Yin Shi. The besieged city was already beginning to starve and suffer all manner of deprivation. But General Chen Ping, who was defending the city, managed to save it from the siege by means of cunning.

Having learned that Yin Shi, Mao Tun's wife, was extremely jealous, he

*'The Pupils of the Pear Orchard' is the ancient name given to Chinese actors who studied in that part of the Imperial Palace. Mei-Lan-Fan's official title, the 'First in the Pear Orchard', signifies that he occupies the supreme place among the actors of China. (E's note.)

ordered that a large number of wooden, female dummies be made which bore a startling resemblance to living women. He deployed these models along the part of the wall that faced the troops led by the jealous and warlike lady. When activated by means of a clever contrivance, these models began moving and dancing, and their gracious movements astonished those who saw them. Seeing them from afar, Yin Shi mistook them for real women – women with the most seductive attributes. Knowing her husband's frivolous character, she was naturally worried that after the city had fallen he would very soon become involved with these dangerous rivals. It would weaken Yin Shi's influence over her husband, and so she hastily withdrew her forces from the city walls. Thus was the encirclement broken and the besieged city spared.

This is the legend that has built up around the event; although historians, naturally, attribute the victory to Chen Ping, whose strategic brilliance saved the city for the young Han dynasty that had just assumed power, rather than to the ingenious plan.

This is one of the legends about the origins of marionettes. The same marionette that was later to be replaced on stage by a living person. But the Chinese actor preserved the generic name of 'a living doll' for a long time to come.

This legend is particularly apposite as a prelude to the spectacle that Mei-Lan-Fan is bringing to us. To the skill that is linked to the most ancient and best traditions of the great art of Chinese theatre, which is in turn inseparable from the culture of marionettes and their unique dance.

This dance has left its mark even today on the idiosyncrasies of Chinese movement on stage.

There is another reason to mention this legend: it contains one of the figures who have become part of the gallery of characters represented by Mei-Lan-Fan which we find unusual.

It is the female commander, the female warrior. With the same unsurpassed skill that he demonstrated in executing the lyrical female roles, Mei-Lan-Fan portrays this type of warrior maiden perfectly. As, for example, in the play *Mu-Lan in the Army*, where, playing the lead role, he depicts the war adventures of a girl who has dressed up as a soldier to take the place of her aged father in battle.

Descriptions and articles about Chinese theatre are normally constructed on the principle of enumerating 'oddities' which stagger the superficial and ill-prepared traveller who has become used to the routine of the Western European stage. Further, he never seems to link these oddities with what Western European theatre and art in general represent.

The mutual enrichment between our Soviet theatre and the Chinese theatre is well enough known.

More than that: there is a link with oriental theatre in the entire brilliant period of our theatre's past. But I would not want to go into this again, nor quote again and again the descriptions of and the key to all those perfect surprises which Chinese theatre has in store for the unenlightened spectator. Rather than providing a list of the conventions of Chinese theatre, it would be more rewarding to go further than what amazes the unquestioning tourist who does not investigate their meaning but merely marks them out as

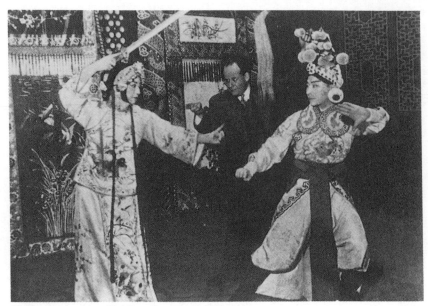

Eisenstein watching Mei-Lan-Fan in rehearsal, 1935.

'exotica' only worth recalling to divert people who have never seen these spectacles and who will enviously listen to the travellers on their return.

The staggering system and technique of Chinese theatre deserves better than to be catalogued as a series of 'oddities' and conventions. It deserves to be considered as part of that structure of thought which is embodied in forms that seem so remote but deep down are somehow close to us and, if they are not always intelligible, are nevertheless in profound sympathy with ours.

That is the only explanation for the magnetic force of creativity which [Mei-Lan-Fan] has made famous far beyond his national boundaries.

You only have to take the time to investigate the meaning of his art more deeply for the oddities to become natural and the conditional deeply conventional.

How many foreigners have been amazed, for instance, by the seating of auditoria, where the audience sits sideways on, at long tables abutting the edge of the stage and at right angles to it? And yet this is only to be expected in that ancient tradition whereby it is the ear, not the eye, that must be directed at the stage. People did not go so much to watch ancient theatre as to listen to it. And we too once had a similar tradition in theatre in the Moscow Maly Theatre.[98] And the older generation can still remember Ostrovsky,[99] who never watched his plays from the auditorium but always listened to them from the wings, judging the merits of the performance by the perfection of the delivery of the spoken texts.

In this respect it is perhaps particularly appropriate here to recall one of the great services Mei-Lan-Fan has rendered the culture of Chinese theatre.

In its most ancient periods, the spectacle of Chinese theatre was

synthetic: dance was inseparable from song. Then a split occurred: the vocal source became dominant in the north, at the expense of the plastic, and the culture of visual drama flourished in the south. And language has preserved this in idiom: northerners say they are going to 'hear' a play, while southerners go to 'watch' a play.

The task of *synthesis* fell to Mei-Lan-Fan. Mei-Lan-Fan resurrected this as the most ancient tradition.

Studying ancient stagecraft, this great artiste – who is to no less an extent erudite and expert in his national culture – has restored the actor's skill to its former synthetic quality. He has resurrected the visual aspect of spectacle, and its complex, recherché combination of movement with music and the luxury of the ancient costumes.

But Mei-Lan-Fan is not a mere restorer. Recreating the perfected forms of the old tradition, he is able to combine them with a renewed content. He is trying to broaden the subject matter. In hundreds of plays with Mei Lan-Fan you find plots dealing with the difficult social position of women, the exploitation of the poor and so on. Some of them deal with the struggle against backwardness and religious superstitions. These plays, performed in the old, conventional style but depicting problems of a contemporary subject matter, acquire an especial piquancy and charm.

The theme of woman in its most diverse aspects runs through his plays.

Mastery of different kinds of female roles is again a special feature of our artiste's skill. There is usually a narrow specialisation and limitation within the framework of roles. Mei-Lan-Fan, however, can command a whole series of them with perfection.

More than that: he has contrived to bring to the traditional treatment of each role a whole series of recherché refinements, while adhering rigorously and strictly to the style. And, with equal brilliance, he portrays different types in accordance with the fundamental subdivisions of female roles.

As a rule, the tradition acknowledges six fundamental types of women for the stage:

1. 'Cheng Dan' – this is the kind matron, the faithful wife, the charitable daughter.
2. 'Hwa Dan' – usually a younger woman from the demi-monde, sometimes a servant. Generally, if Cheng Dan is positive and charitable with the lyricism and melancholy prevalent in song, then Hwa Dan is a girl of dubious morals. In her role, the centre of gravity lies in her ebullient and mobile acting on stage.
3. 'Kwei Men Dan' – an unmarried girl. Gracious, elegant and charitable.
4. 'Wu Dan' – as distinct from the latter, this type is heroic and warlike: a girl warrior and general.
5. 'Tsai Dan' – a callous type of woman: a schemer, a treacherous servant.
6. 'Lao Dan' – a very old lady. Often a mother. She is played with great tenderness. The most realistic of the characters.

The hieroglyphic concept 'Dan' appears in all these names of female roles.

It is usually translated as 'performer of the female role' or 'representing the female'. However, such a definition falls far short of covering the concept invested in it. Mei-Lan-Fan himself particularly stresses that this definition has a completely specialised sense, a wholly exclusive notion about the naturalistic reproduction of women's characters. First of all it means an extraordinarily conventional construction which has as its primary task the creation of a definite aesthetic abstract image as far removed from everything particular and personal as is possible.

The spectator delights in the seemingly idealised and generalised features of the female character. The naturalistic portrayal or recreation of commonplace female figures is not part of the actor's role. Here we come up against the first main peculiarity of everything that is produced and portrayed on stage in China.

Realistic in its special sense, able to touch upon not only episodes from history or legend that are universally known, but also social problems, Chinese theatre, by its very form – from the most subtle elements of the treatment of characters and types to the last scenic detail – is conventional in equal degree.

So, if we take a list of conventional elements from any description of a theatrical production, we can see on each of them that imprint of idiosyncratic understanding which we noted in our approach to the depiction of female roles. Each situation, each subject is always abstracted in its nature and frequently symbolic: pure realism has no place in the production, and realistic settings have been banished from the stage.

I shall list a few examples of the traditional attributes:

'Ma Pen' – a whip. An actor who carries a whip is to be imagined as riding on horseback. Mounting and dismounting are shown by established conventional movements.

'Ch'e Ch'i' – a carriage. Portrayed with the aid of two flags with painted wheels. A pair of servants hold the flags by the sides. The passenger moves or stands between them.

'Ling Chien' – a herald's arrow. In the past, a commander dispatching a herald would give him an arrow as proof that the news was real and as a sign that the order had to be executed with the speed of an arrow.

Hence the portrayal of the corresponding situation on stage also came to be accompanied with the handing over of an arrow.

These same features are also present in behaviour on stage. So if an actor has to depict someone walking through a doorway, he confines himself to lifting his foot as if crossing the threshold. If he has to convey the idea of opening the door as he does so, then he swings his arms apart. Closing the non-existent doors, he brings them together again. These conventional movements are the same for all cases involving doors. For entry or exit. For outer doors, for communicating doors, doors into the garden, and so on.

The realistic portrayal of sleep was considered to be unaesthetic. If sleep

has to be shown, then the performer merely rests lightly on a table. The depictions of battles and fights are characterised by the following key feature: the art of single combat on stage consists primarily in not touching the opponent at all. Thus a fight consists of a mad succession of strictly synchronised rhythmic movements giving a conventional representation of single combat.

Sometimes even the notion of real time is abstracted: one of the most amazing scenes of the single combat in *Rainbow Crossing* proceeds as if filmed for cinema using slow motion. The whole battle progresses at a greatly reduced speed. The effect of this is amazing. The more so as, psychologically, it echoes perfectly correctly the meditation into which the treacherous Sin Tun-Fan falls during combat with her enemy, the murderer of her husband, bewitching him with her beauty and falling in love with him. (A curious precursor of those motifs to be found in the story of Joan of Arc!)

Finally, the concept of food was never portrayed in ancient theatre. A bowl of rice or dinner was replaced by ... a chorus or some tunes on a flute which meant that a character was eating.

These examples typify a certain symbolic association of definite meanings with definite objects. More interesting is the case where the meaning is flexible. Where one and the same subject can have as many different meanings as you like, depending on how it is treated. Examples are a table, a chair and a horsehair brush. These are actually mentioned. A table or 'cho-tsu', perhaps more than any other object, can represent the most diverse of things. Now, a tea-room. Now, a dinner table. Now, a courtroom. Now, an altar.

Furthermore, if it is necessary to show an ascent up a mountain or the scaling of a wall, then a table can be used for this too. A table is given all sorts of possible roles: it may be inverted, put on its side, and so on. The table is also treated as 'i-tsu'. When the table is put on its side ('tao-i'), that means that someone is sitting on a cliff, on the ground, or in an awkward position. If a woman is going uphill, she stands on the table. A few chairs, placed together, signify a bed.

'Ing-chen' – the horsehair brush – has even broader functions. At one extreme it is an attribute of a semi-divine order. It belongs only to gods, demigods, Buddhist monks, Taoist priests, divine beings and spirits of various categories. At the other extreme, in the hands of a serving girl, it is merely an item of daily use for brushing away the dust and so on. Generally speaking, a brush is extremely widely used in Chinese theatre, and may stand for one of any number and quality of objects.

In a less categorical form, such a definition of the 'instability' of stage meanings obtains for other stage attributes and actions too. This feature of shifting meanings is perhaps even more striking than the actual use of conventional stage attributes. What is most remarkable is that this is by no means a feature of the specific nature of the theatre. Its sense has much deeper roots. It is peculiar to the profoundest Chinese thought and the structure of general notions. The special features of stage construction are only a particular instance, if you like, of their realisation in a specialised area.

You must not by any means think that by using the term 'Chinese thought' I mean anything like a structure of thought defined by national or racial premisses! By using this term I wish only to indicate the complex of

notions and the intellectual structure that the Chinese employs – and primarily in the humanitarian and cultural areas. The uniqueness of this structure of thought has its roots deep in the history of the succession of social formations that China has passed through. And of that unique social phenomenon whereby the forms of reflection in the consciousness of earlier stages of social development are not replaced by later ones, but are canonised by tradition and enriched by the experience of subsequent stages; and are not to be displaced, out of respect and piety for an adequate perfection.

I repeat that this relates first and foremost to cultural and humanitarian areas, the parameters of which, however, are sufficiently wide since they include the structure of speech, moral codes, and so on and so on.

In this unique complex, the underlying premiss of a pre-feudal structure of ideas has been preserved perfectly distinctly. They were carried over into the unique hierarchical system of the feudal epoch which followed and which the pre-feudal structure seems to mirror. And the imperial period of history provided that final formulation of symbolic association. The further development of the system of ideas and the development of intellectual forms in humanitarian areas were artificially arrested on the brink of the perfection of these achievements.

The much admired perfection of past experience becomes the criterion and rule for future actions and manifestations. Since the Han dynasty, which sought to legitimise its empire through the rules of the past, this same principle has been central to the theory and practice of state administration. The subordination of the standards of the present to the forms of the past has been made the guiding principle.

Ton Chong-Chi in the second century incorporated these theses into a philosophical system and an integral doctrine.

To some extent, this preservation of continuity is characteristic of any way of thinking. Of artistic thinking, in particular. But the question is, to what extent? And in the context of Chinese culture, the presence of these features is so noticeable that it is they that create the principal, crucial impression, even beyond social questions. Even at the first encounter.

They determine the extremely complicated premises for understanding the recherché hieroglyphs and symbols of China. And it turns out that the multiple meanings and the flexibility, which we find so amazing in their theatrical accessories, are key features typical of any mode of expression in China. The tradition of pre-feudal structures of thought and representation has left a particularly distinct impression upon these features as well as upon a whole number of other elements.

You are bound to come face to face with all these penetrating features the minute you attempt a closer acquaintance with any of the laws that have led to the creation of the remarkable monuments of Chinese culture.

Starting with the first means of cultural communication – speech. Here, this feature is to be found in literally every word. Chinese belongs to the so-called monosyllabic languages; that is, it consists of a definite number of monosyllabic words (460) which, in speech, are left unchanged, without any prefixes or suffixes.

These monosyllabic words acquire definite meaning only when they are

pronounced with a certain stress and intonation. Each monosyllable can be pronounced in five different intonations and so from the 460 undefined different sounds there are roughly 2,000 so-called roots, each of which has a definite meaning. But since this number is extremely small for the requirements of speech, a large number of words – homonyms – has appeared that have the same sound. So each word has from four to twelve different meanings.

Such meanings, for example, as 'talkative', 'fire', 'bowl', 'boat' and 'fluff', which are all expressed in Chinese by the same word, 'chou'. Or the Chinese word 'hao' can simultaneously mean 'good', 'to love', 'mercy', 'friendship' and 'very'. So it is clear that the same word in Chinese does not only have the most diverse meanings, but also the most diverse nature: noun, adjective, adverb or verb. In the spoken language, it is quite difficult to distinguish one meaning from another. You have to be guided by the general sense of the context or the word order.

It would be apposite here to recall that we find a similar phenomenon in related areas within cultures that are extremely remote from China. Take English, for example – the language of a country that is also strongly traditional and that has preserved a series of traditional forms and conventions from the past.

English also has a fair number of combinations of letters which have an utterly different phonetic pronunciation in different words. Each individual pronunciation in a particular case does not depend on the combination of letters but must be learned anew for each different case. Let us remember the ending '-ough' because there are more than seven pronunciations, depending on the word: borough, plough, through, cough, hiccough, rough, though, lough.

In writing, it is easier to agree on the meaning of a word thanks to a system of additional, key marks. But even this does not reduce the flexibility of the actual nature of the concept being depicted.

If that is the nature of the words themselves, then the structure of syntax is exactly the same. Chinese syntax has not yet frozen into a fixed set of rules governing word order, but is still almost entirely at the level of rhythm. That is, the rhythm of the way a phrase is pronounced entirely determines its syntactical 'sense'. The phrases themselves are still entirely 'whatever you like', rather in the way of the horsehair brush in the theatre.*

Rhythm has not yet solidified into a definite set of rules for word order, which is the next stage of syntax.

Exactly the same picture emerges with respect to the mathematical interpretation of counting. Here we have a situation where counting has not yet become an increase or decrease of units; what matters is one quantitative complex as a whole, as opposed to another quantitative complex. The difference between even and odd numbers lies not in the quantity of unpaired units, but in the fact that they belong in principle to different orders, sources

*We should not forget that to a certain extent, albeit a significantly lesser one, this is found in other languages too. The forms of an exclamation, question or statement are often all the same in writing. A special indicator is needed to invest the required sense with rhythm and intonation. (In Spanish, the exclamation mark comes at the start of the phrase!) (E's note.)

and principles, and so on. We can see everywhere that word, sign, object, phrase do not serve as a distinct formulation, a finely honed idea of a concept. They have a different task. And that task consists primarily in their working as emblems to create an impression, as elements of influence that are known by the complex of their final effectiveness. At the same time as 'Western' logic is trying to establish a precise, conceptual definition of a given meaning, Chinese meaning is pursuing an entirely different aim.

The Chinese hieroglyph serves first of all as a definite emotional means of making an impression upon the perception through the whole complex of concomitant notions that it might provoke. Therefore, the aim of the hieroglyph or the aim of the symbol (which is the subsequent, composite stage in terms of quantity, after the single sign – the hieroglyph) is not at all to convey a finely honed concept. Quite the opposite: its primary role is diffuse, imagistic and mainly calculated for spontaneous effect. It is the role of an image with multiple meanings, where each perception is able to deposit or instil its own quantity of emotional and cognitive experience, while only corresponding with its neighbour in its most general and all-embracing elements. Communication through these generalised, emotionally significant complexes, without the sharply defined individualisation of a precise, particular conceptual order, is entirely possible when there is a common, dominant cultural stock. More than that: the field for communication is even broader in this way: it is interesting to note that this method puts a premium on an emotional generalisation represented as a symbol, at the expense of intellectual acuity and precision: had it had these latter properties it could have become the means of communication for the countless populations of the East. The spoken dialects of northern and southern China and the different provinces in between – indeed, whole countries like China and Japan – are so different in their language as to be mutually unintelligible.

But the generalised system of symbols in these dialects is one and the same for the whole extent of the huge land mass, whether it concerns the particular hieroglyphs with which the inhabitants of countries, unable to intercommunicate in their different languages, can make themselves understood, or the whole complex of notions united in an entire symbolic depiction.

Elements of art and elements of theatre are thoroughly imbued with these same purposes. And in the light of these aspects and considerations, all those unexpected features of Chinese theatrical technique sound perfectly natural.

But what practical lesson and experience can we gain by studying this theatre? It is hardly enough for us merely to admire its perfection. We search it for means of enriching our experience. Furthermore, our position is quite different. Our artistic aim is realism, and realism of the very highest form and development. Socialist realism. The question arises, can we learn from an art that is entirely conventional, symbolic, and seemingly incompatible with our premise of an intellectual system? And if so, what?

Whenever we look at the enrichment of our experience with some especially highly developed artistic cultures, which do not spontaneously lend themselves to direct appropriation, we must always take account of where the link might be: what might be the common language, and in what branch of our creativity a common image of art that is more or less characteristic for us

may be close at hand. That was the case with the technique of Japanese theatre, Kabuki, for example. It found an echo, in an entirely idiosyncratic way, in the aesthetic of sound cinema.[100] More accurately, with the programme of aesthetics in sound cinema. An aesthetic that, to our great misfortune, has not yet been recognised by the practice of sound cinema.

The instructive nature of Chinese theatre is even broader and deeper. It broaches an extremely interesting problem that is and will continue to be a question connected with the growth of our art. Chinese theatre is a sort of *ne plus ultra*, in its final stages of generalisation, taking features characteristic of any work of art to their limits.

The complex of features, the sum of which defines the fundamental core of a work's artistry, is its imagery. The problem of imagery is one of the central problems of our incipient, new, practical aesthetic. Although it can master man's character and image, the manner and image of his actions, our art nevertheless has far to go when it comes to representation. But the artistry of a work is not established by, or confined to, this. The artistry of form also presupposes the imagery to mould what representatively corresponds to the phenomenon depicted.

I say again that the culture of this field of artistic form is still in its earliest stages of development.

And here Chinese culture, and its particular manifestation – Chinese theatre – shows its most interesting side.

It is the virtual opposite of pure representation.

It is the virtual exaggeration of figurative generalisation at the expense of concrete, realistic representation.

It attains a degree of imagery where image is forged into the next stage of semantic definition – into a conventional symbol.

The unity of concrete representation and figurative generalisation is sacrificed in Chinese art in favour of the multiple meaning of a generalisation. And this loss is diametrically opposed to the situation where unity is sacrificed for exaggerated representation, which is the case with our art in many respects, as it is of any great art of the future when it is in the throes of emerging independently. This type of development is the same first step towards realism that we have seen in Chinese art, a sort of step or a few steps beyond the limits of realism.

And can these polarised approaches ever be reconciled?

Not at all. They are only extremes in the development of those features; the most sophisticated images of perfected realism in a harmonic, interlocking unity. And this extreme, embedded in the high cultural traditions of China's past, is especially invigorating and has much to teach us about the patterns of pure imagery that are impressed upon it and which attain the multiplicity of meanings that symbols have.

The system of creating images in earlier Chinese culture (I am talking here about the traditional past only, which has survived to the present in the best examples of Chinese art) is, historically, indissolubly linked to us as well. Fossilised in the wealth of those traditions lies a stratum from an age of diffuse and complex notions, which emotional thought has always and will always handle as it advances historically, evolving according to successive social

65

formations, just as the whole ideological superstructure of knowledge and logic reflects them.

The rigid traditionalism of Chinese culture has in the same way brought us splendidly wrought monuments to a system of ideas and thought, the emotional stage of which every culture goes through at a given stage of its emergence.

We stand before a coruscating phenomenon, possibly the most perfect monument to a complex system of emotional and imagistic thought; one that has deliberately retained all its fundamental laws, instead of being instilled into a subsequent stage of logic (which is typical of the West, which took its form from other social conditions and aspirations). And so it grew, in all its splendour and luxuriance, not onwards to the next stage, but outwards, into the rich and refined system of an emotional and imagistic intellectual approach to phenomena.

It showered us with endless scatterings of models for applying this approach to any aspect of culture, from primitive skills, via the specific structure of music and mathematics, to models of what should be a collection of theses on understanding the world from the positions of the emotional and figurative thought process. What philosophy should have become, in the specific premises of this canonised stage of the development of thought, beyond the limits of which tradition cannot release artistic and philosophical thought.*

As you become more aware of the system whereby these arts were constructed, you seem to penetrate magnificent subterranean halls in whose gilt work you can find a vision of the stratum through which every history of artistic thought has passed.

It is as though you can see, objectified, those stages and peculiarities of an internal process which the creative current always flows through, fuelling the creative act.

They appeal with particular clarity to creative workers. For an investigation of the course and structure of the figurative aesthetics and symbolism of Chinese expressionism reveals to you in their fixed, objective patterns all those strange twists and turns which the process of fantasy and figurative composition undergoes at that most remarkable stage of creativity which occurs after the conception of an idea and before its realisation. This stage of an image's acutely sensed self-awareness seems to have been cast in the idiosyncratic canon and structure which permeate Chinese artistic thought; and images, which have embodied its idiosyncrasy in their form.

That is to say, in the whole multiplicity of its different manifestations, which are admired as the condition of a creative imagination fixed in reality, and the stages of a creative act that a creative imagination passes through, from an idea that has once struck it and borne fruit, to the realistic work that has been destined to reveal the perfected imagery of a work of high realism, in the unity of what is specifically representative and emotionally effective.

It is in these areas that the charm of Chinese culture and art resides.

*It is quite evident that I am here dealing only with that area of the humanities and aesthetic practice that relies on tradition and scrupulously reproduces it in those forms in which it was historically assembled and in those same historical stages in which these traditions were amassed. (E's note.)

It is in these areas that it proves an extremely rich vein for realising the most subtle processes of imagistic movement in creative work.

It is there that we have most to gain from association with this culture, even beyond the limits of theatre – especially in cinema, and in sound cinema above all.

But will the internationalism of cinema, which was lost with the transition to national dialogues, really be resurrected (apart from its subject matter) in all its richness through the audiovisual imagery of the cinema of the future?

Surely the crucial factor in the construction of recorded speech in film is its rhythmic structure and the melodics of its intonation, which alone are capable, beyond the barriers of syntax and language, of welding the viewer's heart to the unfolding drama so as to appeal, through image and through emotions, to those ideas that are brought to life by the whole structure of the artistic work?

Surely the structure of Chinese writing and of the emotional symbols of the Chinese aesthetic, which serve to link provinces and populations divided by the specific nature of individual national languages, is none other than a unique model for how, through emotional images filled with proletarian wisdom and humanity, the great ideas of our great land must be poured into the hearts and emotions of the millions of nations speaking different languages!?

Surely the images of our literature and our arts are great bonds, linking together what is best in people, regardless of borders, boundaries and continents, acquainting them with the best ideas of progressive mankind?

The experience of Chinese culture and art on this remarkable level must give us plenty of material for study and for the enrichment of our artistic methodology which has been decided and resolved in completely different ways and means.

And so our heartfelt greetings and joy at our meeting with the first bearer of the perfected images of Chinese classical culture, throwing to us a bridge that enables us to experience it directly and vividly.

Our greetings to the great master who represents the best that Chinese culture has created – to our friend

MEI-LAN-FAN.

8. Bolsheviks Do Laugh (Thoughts on Soviet Comedy)[101]

It was the beginning of spring, 1930.

Paris.

Not that friendly Paris which our country is working with in peaceful politics worldwide.

It was the Paris after the Kutepov campaign.[102] When our plenipotentiary lay in hourly expectation of attack. When it was daily expected that diplomatic links between the two countries would be severed.

An ominous tension hung in the air.

In that extremely tense atmosphere I had to give a lecture at the Sorbonne.[103]

Not so much a lecture; more a few words of introduction before a showing of the film *The General Line*.

Half an hour before the start, the screening was cancelled by police action.

But the hall was already full.

I could not cancel my speech.

I could only extend my introductory speech into a self-contained lecture. Even so it would not be enough for a whole evening. And the showing of the film after the speech would have to be replaced by a game of questions and answers between the lecturer and his public.

It can be a risky but amusing game. Particularly when the auditorium also contains people trying to catch you out with an innuendo, a direct attack or a tricky formulation. As later became clear, the Sorbonne was surrounded by police. There were lorries full of *flics*. Chiappe himself[104] was hovering in the courtyard. A clash seemed to be in the offing, and a set-to with the police who had banned the showing. They were counting on the confusion to 'remove' anyone they wanted from the auditorium, because the audience had another side which went right up to Cachin.[105]

The game went on successfully for half an hour, an hour, an hour and a half. Questions clashed with answers. The mood of the auditorium was perfect. A succession of *mots justes*. But the time came to end it, and I was feverishly hoping for a question to bring the debate to a conclusive end.

At last!

A pale, lean, spiteful-looking man stood up in the gallery.

'Why doesn't your country make comedies? Is it true that the Bolsheviks have killed off laughter?'

A deathly hush.

I am not at all quick-witted, especially in front of a big crowd.

But I saw a beacon of light.

I did not answer the question, but instead burst out laughing.

'There will be even more laughter in the Soviet Union when I tell them your ridiculous question!'[106]

We ended the lecture – now a political meeting – with a tide of laughter.

And we crossed the courtyard of the old Sorbonne.

It looked like a fortress under siege.

But no uproar occurred.

Having conducted the whole debate in an atmosphere of seemingly light-hearted dialogue, we brought the meeting to its conclusion in an outburst of laughter.

There were no objective grounds for police intervention in such out-bursts. You can't arrest someone just for laughing....

The next day's papers said: 'Beware of Bolsheviks with smiles on their lips, not daggers between their teeth.'[107]

Come to think of it, I did not read the papers that day.

I spent the whole day being dragged around the security forces, the police, the Prefecture. Removing me from Paris. Ordering me to leave Paris. But that is by the way. I do not mean to write about that, but about laughter, and I ask myself the question: do we laugh? Our laughter will come, but what sort of laughter will it be?

How will our laughter turn out? With particular reference to the screen. Many people have asked that question. Many people have tried to answer it. Simply. Too simply. Others have been more subtle. Too subtle.

Several years ago, I was working on the screenplay for a comedy.[108]

I work in a very academic way. I throw up ramparts of erudition to ac-company the work. I have debates with myself about points of programme and principle. I do the accounts, the computations and draw conclusions. I like to imagine the music as I work. Sometimes I get ahead of myself. Then it does not work out but is lost in boxes of ideas in principle. The screenplay halts and pages of film research build up instead. I do not know which is the more useful. But the cross that I often have to bear is that problems of cre-ative production extend into matters of scientific analysis. Often, when I have decided upon the principle, I lose interest in its application!

Which is what happened with the comedy. What I learned and realised as I did it went into a book, not into cinema.

Perhaps I was not destined to make a Soviet comedy.

But one thing remains clear: I belong to the tradition of black humour. The laughter of destruction.

The destructive whistling of a lampoon has already been heard in my attempts at comic writing which pepper *The General Line*. This whistling is even more piercing in the comedy I failed to complete at that time.

But the time was not wasted.

I was able to work out one point of principle for myself.

What makes Chaplin so remarkable?

What puts Chaplin above all the poetics of comic film?

Chaplin's profound lyricism.

The fact that each of his films makes you shed, at a certain point, tears of genuine, warm humanity.

Chaplin is a queer fish. An adult who behaves like a child.

Chaplin and the prospects for our comedy.

What is the quickest way to cheap vulgarisation, not to say – ghastly plagiarism?

Give the actors new costumes, give the situation a new name, and hide the chief thing that was Chaplin's original contribution to the culture of film genres.

This might be all very well as an experiment to entertain visually.

But it is not of course our route.

And by harnessing logic and inspiration, I was able to find something equivalent that might appear in the genre of our cinema.

I do not think that lyricism and sentimentality – in the best sense of the word – will ever characterise what is remarkable about our elevated film genre.

But what replaces them?

If we love our fellow man, share our younger brother's afflictions and mourn those brought low, insulted and passed over by fate, then a social emotion will replace them. But a social love of humanity does not exist in sympathising but in recreating, so that a comedy scene does not become individually lyrical, but socially lyrical. And social lyricism is pathos. The lyricism of the masses at the moment they merge into one being – that is an anthem. And this shift in comedy, not towards lyrical tears but tears of pathos – that is where I saw the guiding principle for the contribution that would turn our cinema to film comedy.

And another thing. It will not consist solely of a generalised, collective character. Like Chaplin. But a character that figures simultaneously as a concept. The concept of sitting down. The concept of shaving. The concept of taking off his hat and pulling a blanket over himself.

We all start life as exploiters. The mother's womb feeds us for nine months. We suckle for many months.

Childhood is a time of exploitative consumption, during our biological development.

Within its own confines it is both appropriate and charming. Beyond that, however, it is revolting; at best an adornment for idiots.

At some stages exploitative social relations were promoted by progress. The emergence of the bourgeoisie was progressive. The mutual relationships of the exploiters were socially infantile. And the horror of these relationships is immediately conveyed as soon as mankind finds its feet. Or, to put it more truthfully, simultaneously with their emergence!

That very feature will be the object of our laughter: social infantility, caught up in an age of social adulthood, socialist adulthood.

It is hard not to laugh at Chaplin, the decorator, using the huge wallpaper shears to clip his nails, but Chaplin's trick is in itself alogical.

There are different kinds of laughter. And the terms 'ours' and 'not ours', for all their triteness, clearly do refer to different things.

The action may be the same, but the interpretation is widely different.

Let me give an example not of idiocy but of lyricism, sentiment and emotion.

One of the best scenes in Chaplin's comedies is the finale of *The Pilgrim*.[109]

The escaped convict – Chaplin – has stolen a priest's vestments. The vestments dictate his fate. He falls into the grip of . . . parishioners. He has to give a sermon. He does so brilliantly, playing out the encounter between David and Goliath. It is one of the funniest scenes in Chaplin's repertoire. Then the church funds go missing. Chaplin's identity is revealed. But he has not stolen the money; quite the opposite. He found the money and returned it. The sanctity of property is observed. But Chaplin is a convict. The sanctity of the law must also be observed. The sheriff, on horseback, leads the wretched little figure of the man along the dusty road – he is under arrest. But the sheriff turns out to be the great-grandson of the detective Xavier, from Victor Hugo's *Les Misérables*. Convinced of the utmost nobility of Jean Valjean, whom he spends half a lifetime pursuing, Xavier fails to do his duty for the first time in his life and abandons his post. He lets Valjean go. Valjean is free.

The sheriff is sentimental. The sheriff wants to let the noble convict – Chaplin – run off. And therein lies Chaplin's genius. The sheriff takes him near the Mexican border. But the noble convict does not even think of taking a step to the right and entering a free Mexico. And the sheriff completely fails to hint as much to him. Chaplin does not escape. And there is a wonderful scene where the sheriff asks the convict to pick a flower for him – a flower growing on the other side of the border. The flower is actually in Mexico. Chaplin obligingly crosses the border. In relief the sheriff spurs on his horse. But . . . Chaplin catches up with him with the flower.

The film ends with a kick up the backside and a shot of Chaplin running off with one foot in the USA and the other in Mexico. In the middle is the border. There is no solution. . . .

We know how Bolsheviks fight.

We know how Bolsheviks work.

We know how Bolsheviks conquer.

We see today how Bolsheviks laugh.

'Our laughter' and 'their laughter' are not an abstraction. The two are divided by the difference in the social interpretation.

The young proletarian class that took power in October, and carries it onward in its firm grip to decisive victories, brought comedy and laughter into the world, but what are they like?

Will its laughter be the laughter of idle amusement, happily passing the time after a good meal, or a means of escaping from life's hardships?

Will it be mere gentle irony, depicting the entertaining setbacks experienced by an eccentric character as he winds up in humorous situations?

No. That is not the tradition of Russian humour.

The tradition of Russian humour is different.

It is marked out by such names as Chekhov, Gogol, Saltykov-Shchedrin.[110]

And the distinguishing feature of this humour was the inevitable element of social indictment.

From the gentle ironising of Chekhov to the bitterness of Gogol's 'laughter through tears' and, finally, to the whiplash of Shchedrin's lampoon and satire.

And what will the humour be like that will come to succeed the humour of Chekhov, Gogol or Shchedrin?

Will it follow the idle chuckle of American humour, or will it carry on the tradition of excoriating humour established by nineteenth-century Russian comic writers?

We must all involve ourselves and participate in creating the new kind of humour, in filling in a new page in the world history of humour and laughter, just as the very fact of the existence of the Soviet Union has inscribed a new page in the history and diversity of social forms.

It is early days yet for us to chuckle idly.

The task of building socialism is not yet finished.

There is no place for random frivolity.

Laughter is merely a new kind of weapon.

Laughter is simply a light weapon whose strike is just as deadly and which can be deployed where there is no sense in bringing in the all-crushing tanks of social wrath.

Whereas, in the oppressive atmosphere of nineteenth-century tsarist Russia, or in the twentieth century anywhere except the Russia that is now the USSR, lampoon, satire and laughter have been the skirmishers of social protest, in our country the role of humour remains the conquest of the enemy, just like the infantry that floods the whole line of the enemy's trenches when the heavy artillery has cleared the way for the stab of bayonets.

Serving as the start of the battle there, the conqueror's laughter surges at the approach of victory in our country.

That is how I picture laughter in the most recent clashes with the class enemy, who tries by means of every conceivable and inconceivable device to oppose the progress of socialism in its victorious advance.

A comic personality, a comic type, a comic character in the tradition of the West can be no more than the comic representative of its social environs, going no further than chauvinistic and nationalistic mockery.

At least this is so in cinema, where every effort and resource is devoted to banishing the traits of a militant class humour.

It is only possible to rise above the constraints of crude slapstick and schoolboy humour by aspiring to understand perfectly the social significance of the ugly mug you direct your laughter at.

The comedy of social mask, and the force of social mockery, must and do lie at the basis of the forms of that militant humour that our laughter must constitute.

And that, I think, is what laughter, when we have reached the last decisive battles for socialism in one country, must and will be.[111]

1936

9. Teaching Programme for the Theory and Practice of Direction. How to Teach Direction[1]

Basic Theses

As the basis for the study of the multi-faceted areas, knowledge of which gives rise to the specific character of the director's craft, we shall take Lenin's thesis:

> ... from co-existence to causality and from one form of connection and interdependence to another that is deeper, more general.[2]

That is the only way that allows us to grasp all the varied and, at first sight, independent themes and sections that constitute the actual discipline of direction.

At the same time, at the basis of the method of covering all the stages of the director's knowhow lies the strict observation of the thesis that we have:

> ... a repetition, at a higher level, of those known features, characteristics, etc., from a lower. . .[3]

The areas, sections and themes of the director's discipline are therefore regarded as stages in a single general process of development and complication. Their specific character is seen as a logical progression, with qualitative leaps between the different areas and aspects.

Hence each individual section and each separate theme within these areas is set out in such a way that its distinctive features are identified as qualitative aspects and manifestations of the same laws that relate to the particular area as a whole.

(For example: a small shot – shot – montage; or: *mise-en-scène* – gesture – intonation, etc.)

Each distinctive feature, at a new stage of development of its forms and variations, is seen as the extension of the specific nature of the previous stage and of all its features into a new quality.

In this interplay of graduated development they are seen both as entire areas and as separate elements within each one.

(Theatre and cinema. An expressive manifestation in movement and a manifestation objectivised into a work. *Mises-en-scène* and mime repeating

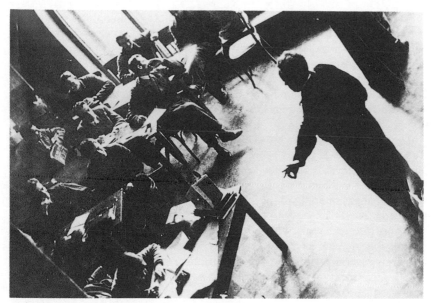

Eisenstein teaching at the Film Institute.

their interrelationships at a higher stage in the form of a combination of montage and shot, etc.)

This approach, starting with the most obvious and simple forms and manifestations – tracing their development and increasing complication as they approach areas of more complex development – is the only way of ensuring that you can consciously find your bearings when confronted by the knottiest problems of director's knowhow and craft.

Only this approach guarantees a unified theoretical grasp of all the most complex variations of the subject of direction, while fully typifying the specific character of each individual section.

It is only by taking this approach that we may come step by step to master culture critically, and to advance it.

> Criticism must consist in comparing and contrasting the given fact with another fact and not with the idea; the one thing of moment is that both facts be investigated as accurately as possible, and that they actually form, in respect of each other, different moments of development; but most important of all is that an equally accurate investigation be made of the whole series of known states, their sequence and the relation between the different stages of development.[4]

If this is directly applicable to all areas of the director's activity, then this very activity, with regard to related areas right up to the highest form of creativity – the practical reconstruction of social reality[5] – is not examined in isolation. At each stage, digressions into the corresponding phases of other branches of creatively constructive activity, which follow the same elements and laws in other spheres and areas, are essential.

Hence, at each stage of coverage, the subject of direction comes into organic contact with, and extends in a planned way into, neighbouring disciplines where each branch is already being studied in depth under the guidance of specialists.

This determines the interrelationship between all the disciplines of the Faculty as a whole and eliminates that chaotic interference from irrelevant, or irrelevantly studied, disciplines, which usually typifies programmes for artistic education.[6]

Teaching Method

None of the generally accepted academic methods of teaching is adequate for the study of the director's craft.

This does not apply to the sections covering the acquisition of specialist knowledge, in which direction comes into contact with other subjects of instruction (the first year), but it does apply in the first instance to its fundamental specific character, namely the very development and education of a creatively inventive and creatively constructive activity and craft.

In fact, direction in its specifics differs even from other creative specialisms, despite having a number of features in common with them.

The basis of a director's activity consists in disclosing, exposing and setting out in all their contradictions even the images and phenomena of a reality that is reflected and realised through class.

To teach this, neither the lecture nor the seminar method is adequate.

That is why, by way of an introduction to each section of lectures on the theory of a particular question, we shall bring in a special type of study: practical direction.

Practical direction aims to find a creative solution to problems in collaboration with a tutor from the appropriate section of creative practice, on the basis of the group discussion method.

Through the conflict between the different points of view held by people who actually believe in them – the members of the student collective – and hence through the comprehensive elucidation of the problem and the critical selection of the theoretical proposals, the student is gradually able to gain a comprehensive critical understanding based on the circumstances of his own individual work in invention and composition.

Thus each new stage of progress through the discipline, after the most essential theoretical postulates, begins with a practical resolution of the simplest problem taken from a cycle of themes encompassed by the particular section (layout, acting, frame, montage, etc).

At every stage of the work, the teacher directs his audience towards a correct treatment of the questions, whose solution will ensure a concrete resolution of the problem.[7]

Through the collision of the various correct and incorrect answers from the audience, the teacher demonstrates:

1. How to deduce the entirely correct and creatively compositional solution for the particular circumstances;
2. Arising from this individual concrete resolution, the teacher will

reveal the general law underpinning it, striving in the particular 'cell' of an individual creative resolution to reveal the general elements of the dialectical process of creation, which is connected with the particular stage, thereby following Lenin's instructions on the study of the dialectic as a whole, namely, '... in *any* proposition it is possible (and necessary), as in a "cell" or "cellule", to reveal the rudiments of *all* the elements of the dialectic'.[8]

3. Develop in front of the students the appropriate section of theory as theoretical generalisations: the moment when practical work organically translates into attending a course of theoretical lectures on a particular area of the director's craft.

The next phase of teaching is the student's independent, individual work within the particular section, to be reinforced by the appropriate supervised assignments.

Work is to be criticised collectively, under the guidance of the lecturer on the basis of the section of theory that has just been studied; after this the tutor provides a theoretical résumé of the work that has been done and moves on to the next stage of teaching.

This particular method ensures that:

1. For the whole group there will be a single pool of originally acquired concrete experience of practical resolutions for a particular branch of work.

 As study of the discipline advances, this enables the tutor to operate with a common stock of practical resolutions that the whole group is equally familiar with.

2. The actual process of invention and conception will open up a kind of 'slow motion' [*Zeitlupe*] before the audience; that is, the 'creative flash', which is no more than the process of selecting the solution that best meets the needs of the particular individual circumstances, squeezed into a single moment. A distinct realisation of these defining conditions and the ability to find the solution that satisfies them lie at the heart of a director's craft.

 With the aim of conducting these studies in a particularly graphic and vivid way, the tutor is recommended, if he is a sufficiently experienced director, to prepare only the basic, key stages of the resolution through which he will take his audience, and to offer a maximum of inventive and compositional work jointly with the audience *in situ*, in order to demonstrate this process graphically and tangibly in the work of an actual master.

3. It will teach a disciplined way of thinking 'essentially', in a manner that can be applied to a particular case and problem. Knowing how to play a 'leading' role, how to draw your listeners into voicing creatively

inventive opinions, and how to direct the discussion along strictly rational lines, is one of the basic tasks facing the tutor if he is to plan a selection of consecutive problems for studies of this kind.

4. Finally, this method ensures the fullest and most comprehensive revelation of individuality, of the train of thought of both intellectual and creative bent and predisposition, of the growth and progress of each individual within the collective of the audience.

THE FIRST YEAR
Semesters I and II

Basic Theses

The task of the first year is to instil in the student the qualities, and to equip him with the specialised knowledge, that are in equal measure essential for any creative activity and profession. Elements that are specifically necessary for a future director will gradually be added to these.

Hence the year naturally falls into two groups of studies, namely:

1. Studies which attend to educational and training needs.

2. Studies which aim to provide an initial store of knowledge for a future creative and productive specialism.

The first group of lectures aims to teach the student the basic rules and objectives that are necessary for every creative worker in general: from the basic attentiveness of an agent[9] observing daily life, and simple temporal and spatial orientation, to a class-determined orientation in the surrounding social reality and its phenomena.

This is achieved by means of instilling in the student the necessary psychological and physiological prerequisites and developing his ability to expose, using concrete plastic material, the reality of the general political and socio-economic theses that he studies in the social sciences course.

The second group of subjects aims to use lectures:

a) to familiarise the student with the general features of creative reality and practice, in various areas of creatively constructive activity as a whole;

b) to reveal to the student a general impression of his future activity, in production and creation, in the specific field of film production.

Teaching Methods in the First Year

These general provisions also determine the special method of studying the subject of direction in the first year.

Many subjects are studied in modules, under the guidance of specialists in these fields. However, they are all regarded as component parts of a single discipline and are studied, in strict coordination, under the immediate supervision of the principal lecturer responsible for teaching the theory and practice of direction, in accordance with his instructions and the assignments he sets, since all these modules have no independent significance but are necessary preparatory subjects for the specifics of composition and expressive movement in direction, the technique used being the director's actual demonstration.

Section I. Work on Oneself

Developing the Necessary Physique
1. Physical strengthening of health and the organism. General physical training.
2. Training in the proper principles of movement:
 a) boxing, training in balance and precision work on motor reflexes;
 b) Rudolf Bode's expressive gymnastics, or Meyerhold's system of biomechanics.[10]
3. Voice training and the principles of diction.
4. Temporal and spatial orientation:
 a) taking a geodesic shot using eye measurement, using a soldier's land chart and a free sketch;
 b) training in a sense of time;
 c) training in rhythm (special exercises and dance) as a synthesis of temporal and spatial orientation.
5. Drawing and sketching (the arrangement of space in basic composition; proportions, perspective, drawing from memory, etc.).

Developing the Necessary Data for Guided Perception[11]
1. Problems of reconstructing reality:
 a) the general and the particular;
 b) distortions in 'eyewitness' accounts;
 c) the role of traditional templates;
 d) using our inheritance;[12]
 e) objectivity and tendentiousness.[13]
2. The technique of guided factography.[14]

A. The work of analysis and synthesis, illustrated by examples from literature (belles-lettres and factual material).

B. Analytical work
 1. The scout-observer [*razvedchik-nablyudatel'*].
 2. Prospecting:
 a) observation;
 b) categorisation and classification;
 c) semantic portrait.
 3. Questions:
 a) examination and interview;
 b) interrogation and the consequence;
 c) investigation work.
 Practising analytical work:
 a) gathering information on definite fields, places and events (using material from reality, as well as museum or bibliographical sources);
 b) description and classification of 'typage';
 c) practical interviewing.

C. Synthetical work
 1. Reportage and correspondence.
 2. Overview.
 3. Sketches and topical satire.
 'A headline as a possible montage list.'
 4. The same methods in a similar specification for cinema (newsreel and film-train).[15]

Practical work in the guided reconstruction of events and phenomena.[16]
 1. Deconstruction of the phenomenon:
 a) the overall plan of the event;
 b) the physiognomy of the event;
 c) the defining details. The literary source material: notes by Leonardo da Vinci, Zola, Gogol.[17]
 2. Generalisation and exposition of the event:
 a) the viewpoint towards the phenomenon;
 b) the tonal sensation and concretisation of it on the basis of the material;
 c) the montage of the elements of the event being expounded;
 d) the consolidation of the expounded event through the work of the practical sketcher.

The Creative Process
 A. General theses.
 1. Characteristic features and qualities that define a creative personality.
 2. Creative concepts and technique of working.
 3. Quantity, quality and planning of work.
 4. The method and scale of accumulation of a stock of source material.
 5. Using our inheritance – creativity v. plagiarism.
 6. Creative failures. Mistakes, self-criticism, overcoming them and experimenting, mistakes and failures.
 7. The processes of creation and the creative lives of eminent creative personalities:
 a) Lenin, Marx, Engels;
 b) Edison, Ford;[18]
 c) Flaubert, Zola, Balzac, Maupassant, Gogol, Tolstoy.
 8. Western and Soviet masters of theatre and cinema and their creative experience.
 9. The creative collective. Individual and collective creativity.*

 B. Practical work in the creative process.
 1. Training in the prerequisite data essential for creative activity.
 2. The creative regime and creative self-discipline.

*On this point, in addition to the analysis of monographs, I foresee also the living exchange of experience through individual papers and lectures delivered by the appropriate masters. (E's note)

(Points 1 and 2 under the guidance of specialists in Stanislavsky's method, but only to the extent of its original steps.)
3. Accumulating a stock of creative material:
a) the notebook;
b) the collection of iconographic material.

Working in the Collective and in Production
Tact and tactics for treating people.
1. Bourgeois methods, deriving from the bases of bourgeois society.
2. The proletarian approach:
a) collectivism, and the principles of collective work;
b) how Lenin handled people, his style of leadership;
c) the specific features of working in the circumstances of Soviet society. The work of the head of the political department, the mass organiser, etc.

Section II. Working on Film
The Director in Production
Familiarisation with the phases in the process of film production, the places of work and the activity of all specialist fields which constitute this particular process.

1. The thematic planning of the production;[19]
2. The organisation of production (the system used by GUKF and the film trusts of the national republics);[20]
3. The screenplay department and the work of screenplay writers;
4. The director and the director's group:
a) the director's screenplay;
b) the preparatory period;
c) the rehearsal period;
d) the production and shooting period;
e) the editing [montage] period;
f) the release of the picture and the public screening;[21]
g) the rental and distribution of the picture.
5. The interplay between the director and the other creative workers:
a) the director and the screenplay writer;
b) the director and the cameraman;
c) the director and the composer;
d) the director and the artist;
e) the director and the actor.
6. The director and the studio workforce.[22]
7. The director and the administrative and financial system of the studio.
8. The director as a worker in society (mass screenings).

The Director in the West and in the USSR[23]
The viewing of a number of pictures purely from the standpoint of direction and familiarisation with the models and examples of directorial cinema cul-

ture that are essential as illustrative material for specialised semester courses.

A. Western cinema:
1. Adventure films;
2. Comic films;
3. Melodrama and naive realism;
4. Comedy;
5. Historical films;
6. German Expressionism;
7. The 'Avant-garde';
8. Other variations.

B. Soviet cinema:
1. The old masters;[24]
2. Post-Revolutionary masters, trends and genres.

Practical Work for the First Year
Theory studied in the first year is inseparable from practice, and in order to master this section fully, practical work is also done outside the Institute.

This practical work must train the student to be able to apply the methods of practical examination of reality that the first year should have taught him.

The student does practical work so that in a familiar and recognisable environment he can find his bearings in practice and characterise the social significance of what is happening; mark out concrete people performing a concrete action; describe conceptually the relevant sectors of Socialist construction with which he has to come into contact.

This is all reinforced in the form of a brief investigation, in the selection of characteristic features, photographic material, notes, sketches and typical data with the intention of imagining this in a concrete, socially meaningful, *factual* way, thus foreshadowing the future artistic and figurative form for the portrayal of Socialist reality.

In the first year, practical work of this kind is done in the summer vacation, so the work chosen by the student may be conducted in an environment that is especially close and familiar to him.

The student is offered a choice of subject, which depends on the specifics of the environment and conditions in which he finds himself during his vacation. (Work on a mass-circulation newspaper at a large enterprise. A collective farm. The campaign to raise a loan. The penetration of Stakhanovite methods.[25] An MTS.[26] Red Army section camps. Forestry work. There is an endless number of real, concrete facts and people for him either to find himself amidst, or to join, taking part consciously.)

In cinema terms this trains what we might call the *cine-scout* [*kino-razvedchik*].

The qualities instilled during this year are equally necessary at all levels of the creative assimilation of reality. The student who confines his education to this may be assigned the qualification of *technical assistant to the director* as a professional title.[27]

THE SECOND YEAR
Semester III
Expressive Manifestation

Section I. The Practice of Expressive Manifestation

Mise-en-scène raisonnée[28]
The practical reordering of a line of a very simple expressive exercise in a screenplay, or of a situation in a chain of dramatic events and actions. The methods of collective, consensual selection and invention.

1. Analysis of the situation: the social definition of the characters and the treatment of plot and emotion. Establishing the initial nodes of expression.
2. Organising events in space:
 a) Familiarisation with the technique of three-dimensional graphic notation;
 b) Laying out a static set and lighting;
 c) The expressive movement of one figure within a stationary set.
3. Organising an event in space and time:
 a) Familiarisation with the technique of four-dimensional graphics;
 b) Laying out a dynamic milieu; a dynamic light source;
 c) Coordinating the expressive activity and the interchange between a number of characters;
 d) Laying out a crowd scene.
4. The specialised organisation of an event in space:
 a) Laying it out in a circle (as in a circus);
 b) In a ring (surrounding the audience);
 c) On a gantry;
 d) On a point (the transition to the concept of the shot).
5. The specialised organisation of an event in time: views on the transition of *mise-en-scène* to a primitive montage list.
6. The specialised organisation of an event in sound. The specific character of a radio play and a radio production.
7. The practical realisation of similar *mise-en-scène* tasks as homework, to be solved by groups of students.

Group (not brigade) collective discussion work as the intermediate stage between plenary sessions and the individual resolution of problems.

8. Individual tasks.

General Theses Derived from Practice

A. Creative:
 1. The creative phenomenon at its real extent. The full picture, one and the same for all areas of creativity. Practical participation in this (collectively and individually).

2. A theoretical digression into the field of existing doctrines and systems:
 a) Their one-sidedness, understood as the hypertrophy of the separate phases of a normally continuous creative process;
 b) The social and historical explanation for this;
 c) The fallacy of the mechanical division into 'external' and 'internal' technique. The fallacy of a mechanical 'synthesis'. The genuine unity in an integral creative process. Its methodology;
 d) The rational use of existing systems applicable to specific phases of the creative process and the cultivation of it.

B. Compositional:
 1. The concept of treatment.
 2. The law of subordinating the parts and particularities to the unity of the concept of the integral resolution.
 3. The device for translating the semantic and figurative specification into an image of the action.
 4. The bankruptcy of formal logic and the inadequacy of 'common sense' (F. Engels) in solving problems of artistry.[29] Obvious examples. The analysis of mistakes of this kind. The dialectics of the correct solution.
 5. Translating the basic, completed melodramatic solution through a re-treatment into a plan of comedy and pathos. The devices for this translation, based on a brief digression into the nature of comedy and pathos (a detailed examination of these questions is one of the subjects for the seventh semester).
 6. The organisation of expressive manifestation in a person. Gesture, mime viewed as *mise-en-scène* focused on a person. *Mise-en-scène* as a manifestation of mime, exploding into a three-dimensional spatial phenomenon.
 7. The same concept extended to intonation too. The transition to the planning of dialogue and monologue, spatially and intonationally.
 8. The graduated logic of the development, and the compositional symbiosis of the different elements of the expressive manifestation.

Section II. The History of the Development of Expressive Manifestation

A. The study of motif:
 Motif as the inspiration behind the manifestation.
 The reactive response: the complex and the differentiated.

B. Expressive manifestation as a struggle between motifs:
 Pursuing this phenomenon, from the struggle between a few motifs to the contradictory reaction to a single motif.

1. The lowest stage:
 a) the expressive manifestation of plants: heliotropism and geotropism;
 b) the tropism of the lowest life-forms and the specific features of their reaction as distinct from plants. The reaction of an embryo.
2. The stage of reflexes:
 The extension of the traditions of preceding stages and a new qualitative assimilation of the particular stage.
3. Arbitrary movement:
 Reaction in a fully developed process of manifestation. The new qualitative specifics of the particular stage.
4. Human social and psychological reaction:
 This particular survey provides a brief history of the qualitative development of expressive phenomena, from the stage of the simplest reactions of the lowest organisms to the fullness of the socially conscious reaction of man as a social unit.
 In this it derives from the material of the preceding special discipline of human psychology and behaviour, and this forms a special adjunct to the specific field of expressive manifestations.

Section III. The Theory of Expressive Manifestation

A. A brief history of the question of the laws of man as expresser.
 A critical analysis of studies of man's expressive movement:
 1. Plato; 2. Aristotle; 3. Lucian; 4. Quintilian; 5. Cicero;
 6. Theological 'explanations' and 'acts of God'; 7. Descartes;
 8. Spinoza; 9. Lessing; 10. M. Engel; 11. Duchenne; 12. Gratiolet;
 13. Darwin; 14. Bekhterev; 15. Giovanni da Udine and Havelock Ellis; 16. James; 17. Ludwig Klages (precursors: Piderit and Carus; followers: Prinzhorn and Rudolf Bode, Konstamm and Krukenberg);
 18. Cannon; 19. Freud; 20. Leshley; 21. The teachings of Pavlov as an adjunct to the question of expressiveness.[30]

Note: Obviously fallacious theories, such as Delsarte's, and those of his publicists (Prince Sergei Volkonsky) and imitators are only to be considered as offering degrees of contrast.[31]

B. The fundamental theoretical errors of a number of selected doctrines are at root conditioned socially, since they are of bourgeois origin and bear the corresponding imprints of one-sidedness and narrowness. Each has its own errors and positive contribution to add, therefore, in the matter of approaching the (still) inexhaustible theses on this question.

Section IV. The Process of Expressive Manifestation [32]

A. The problem of expressiveness in the conditions and achievements

of the present day. The general laws. Their historical premisses, the general theoretical and practical confirmation of them.

The graduated interrelationship of different types of expressive manifestation.

B. Expressive manifestation as the discovery of oneself from outside and the expressive manifestation as a means of social intercourse and interaction.

C. The role of imitation in expressive manifestation.

D. Organicity as the basic condition for influencing expressive manifestation. The organic laws of expressive manifestation. Philogenesis, and its role. The social determinant of expressive manifestation.

E. The conditions in which and under which expressive manifestation continues. The pathology of expressive manifestation. The reconstruction of expressive manifestation (reproducing it) as a transition to an expressive work.[33]

Semester IV
General Theses
The third semester is dedicated to expressive manifestation, from the viewpoint of producing it in so far as it is a particular expression of general human conduct.

The fourth semester is dedicated to an examination of expressive manifestation especially from the viewpoint of interaction, and also as a special adjunct to its manifestation in art.

Accordingly, expressive manifestation is examined in two of its aspects:
1. Expressive manifestation, inseparable from the producer in the process of interaction and interdependence (an actor's performance; an orator's speech, etc.).
2. Expressive manifestation, capable of existing independently of the producer, in the form of so-called works which can serve independently as objects of consumption (a 'work' being a painting, a sculpture, a literary work, and so on).

There is a key difference in the process of perception between these two aspects. This requires a basic division of the fourth semester into two sections:
 a) the individual image;
 b) the image of the work.

Expressive Movement
The study of expressive movement as an element of an actor's performance.

Part I. Introductory Practice
Working out problems of the kind met in the third semester, but taken to the next stage of their resolution; that is, the detailed elaboration of the mime and gesture aspects. This is carried out in the form of a demonstration production of a performance fragment by the director/supervisor, with one or two qualified professional actors, and the details of this problem worked out in rehearsal.

Part II. The Theory and Practice of an Actor's Expressive Movement
 A. The study of expressive movement:
 1. Simple, utilitarian movement.
 2. Actual expressive movement.

 B. The structure of expressive movement:
 1. A selection of different schools and methods of the actor's craft.
 2. The expressive manifestation of the actor and the technique of movement in acting:
 a) The centre of the body, and the periphery. The basic laws;
 b) Mime with the body as a whole;
 c) Mime with the body in expressive areas: facial mime; mime with the arms; vocal mime (intonation);
 d) The coordination and composition of expressive manifestation in conditions of artistic reproduction;
 e) Acting work by the students themselves, as a demonstration of directing, within the parameters of the execution of the set fragments on the basis of the technique of expressive movement and intonation.

Studying the Image
Section I. On Individual Image

Introductory Practice
 1. The process of creating an actor's image takes place in the form of illustrative demonstrations by professional actors of finished roles (with all the trimmings of their stage or screen realisation). A detailed exposition of the history of the emergence and the process of creating a concretely demonstrated image. The demonstration of auxiliary material or the recreation of the separate stages of the evolution of the role.

 2. Spatial, motor, mimic and intonational planning of dialogue and monologue using the image evolved.

 3. Theoretical generalisation:
 The creative act of producing an actor's image as a particular aspect of the production of an image in general. The specific nature of creativity. The evolution of an image-role. Analysis and criticism of existing theories.

The Image of the Actor
1. Image as the unity of form and content of the character being portrayed.
2. The social causality in the image.
3. Type, image, mask, typage.
4. The practical work of independently creating an image from the set role. Analysis of the role and auxiliary material.
5. The actual creation of an image (the complete, independent authorship of an image, directly created from the raw material of reality).

Realising the Image of the Actor
1. The process of performing a role as a repetition in the narrow sense of the evolutionary process of a role.
2. The working process of an actor's performance. Psychological and physical condition. Routine discipline and training.
3. Practice in performing a created image as a demonstration of directing by the students themselves, on the basis of the set role.

Working with the Actor
1. Tact and tactics in working with the actor. Forms of collaboration between actor and director. Working with an actor of the same school.
2. Casting an actor, the exposition of the play and the role. The specific form of the exposition of the director's plan and intentions to the actor.
 Working with the actor on the role and in rehearsals.
3. The demonstration method and the narrative method.
4. Working with actors of different schools and outlooks. Working with children. The terminology of the various schools and the specifics of the director's approach, according to the various systems.
5. Practice and practical work by students in the Faculty of Direction with actors in the third year of the Faculty of Acting. Staging short pieces through the joint efforts of the students of both Faculties.

Section II. The Image of a Work
1. The artistic image as the formal embodiment of the content and image of an idea:
 a) the social causality;
 b) the creative product as the concretisation of the image of the thought based on particular material;
 c) the creative process as the practice of its realisation.

2. The image of the work as the unity of form and content:
 a) form as the logic of content, developed into emotional thought. Unity in the interpenetration between both aspects of thought in an integral work of art;
 b) the Formalists' mistake and the theory of *ostranenie* [defamiliarisation];[34]

c) the creative act of perception.

3. Imagery and representation:
 a) their graduated connection; their interaction and organic symbiosis in the completed composition;
 b) hypertrophied representation: the so-called 'Leningrad School' of cinema, etc.;[35]
 c) hypertrophied imagery: the theatre of Mei-Lan-Fan and others;[36]
 d) the link between plastic imagery and 'linear speech' (a term used by Academician Marr);[37]
 e) depiction – image – cryptogram – symbol;
 f) examination of this particular question in different fields.

4. From the idea of the work to its external form. The factual process of the evolution of the work.

5. The general laws of expressive manifestation as an adjunct to the creation of an image. The graduated link with the principles of expressive movement. A new quality.

6. Creating an image. Its social and psychological meaning. Its social application.

Having completed the second year and received pass marks for his summer practical work, the student is entitled to be called a *qualified assistant director for art work.*

THE THIRD YEAR
Semesters V and VI
N.B. At the start of this year it is assumed that the student is familiar with the various concepts of montage and practical montage skills gained from the models provided in films and anthologies of film concepts.
(Studied as a special course, parallel with the fourth semester study of theory.)

Section I. Practical Film-making
Translating a simple *mise-en-scène* into an orthodox montage list.

General Theses
1. From an expressive person to an expressive film.
2. The specificity of cinema in comparison with theatre. New elements, and elements of theatre and the other arts in a new quality.
3. The gesticulatory and motor process, subject to montage.
4. The montage flourish [*roscherk*] gathered within the frame of the shot.
5. General provisions concerning the creation of an image in their resolution through the specific methods of cinema.

Practical Work
1. *Mise-en-scène* and *mise-en-cadre*.
 The practical work of composing the shot to fill the frame (the European tradition of composition): a) with a draft plan; b) with real objects.
2. Montage nodes and the montage compositional group.
3. Montage elements within the compositional group.
 Practical work cropping the shot with the frame (the Japanese method of composition): a) with a draft plan; b) with real objects.[38]
4. Rhythm – spatial and temporal.
5. The appropriateness of repetition of a single compositional schema using all the expressive elements and means, examined on [the basis of] the elements of cinema.
6. The interpretative intent that conditions this schema. The social causality of treatment and composition.
7. The practical work of montage composition of a complex scene, resolved by means of a preliminary *mise-en-scène*. The full process of montage construction.

Section II. The Specialised Elements of Film-making

General Theses
1. From traditional cinema to Revolutionary cinema. Single set-up cinema and multiple set-up cinema.[39] Silent and sound film.
2. The class viewpoint of a phenomenon and its realisation in cinema through the special methods of cinema. Viewpoint. Treatment. Camera angle. Montage.

3. The elements of cinema, examined in their graduated interconnection:
 a) title;
 b) title – shot;
 c) shot;
 d) montage and its premises:
 the basic phenomenon of cinema:
 the shot as the process of montage combination of cells [*kletki*], minute shots [*kadriki*]; montage as a new quality in the development of the montage cell; the shot in isolation; sound and its place in the general conception of film montage;
 e) the importance of a similar understanding in order to establish a single law of composition that is qualitatively suitable for the various elements of cinema.

Specialised Section
1. The general premises of plastic composition. The analysis of models of composition in paintings.
 Studied through the special discipline of art criticism and at a number of joint courses held by the section heads of Direction and Art Criticism.

2. The shot:
 a) primitive cropping of the frame;
 b) camera angle and light;
 c) the expressiveness of lenses and filming speeds;
 d) from cropping to image;
 e) primitive frame image and symbol;
 f) practical work by students of the Faculty of Direction and students of the Faculty of Film Photography on the shot.

 Photographic work. Static material (man, object, space, milieu).
 Film work. Dynamic material (man, object, etc., in motion).

3. Montage.
 Types of montage in a kinetic series:
 a) metric;
 b) rhythmic;
 c) tonal (melodic);
 d) overtonal;
 e) intellectual, as a new quality in the development of overtonal montage towards semantic overtones.[40]

 The graduated interdependence of the types of montage and their contrapuntal symbiosis.
 Types of montage in a semantic series:
 a) montage parallel with the developing course of an event (primitively informational montage);

b) montage parallel with the course of several actions ('parallel montage');

c) montage parallel with the sense (the montage of primitive comparisons);

d) montage parallel with the sense and meaning (figurative montage);

e) montage parallel with the ideas (montage constructing the concept).

The graduated interconnections between the individual types of montage and their contrapuntal symbiosis.

4. Sound
 a) concealed sound;
 b) sound itself;
 c) the imagery of sound;
 d) sound in sound film;
 e) sound montage and its characteristics;
 f) practical work with a sound technician on sound constructions while recording sound and using a microphone.

5. The composition of the elements of a film:
 a) the graduated link between theatre and cinema, in terms of the combination of elements;
 b) audiovisual counterpoint (principles);
 c) concepts of audiovisual counterpoint and various combinations.

Section III. The Construction of a Film

On the Structure of a Work
From expressive movement to the completed expressive work of dramaturgical form.
 1. The dramatic resolution.
 2. Consolidating the dramatic resolution into a dramatic type or structure.
 3. A brief historical digression into the evolution of structures of type. Their social and psychological premisses. Type situations.
 4. A brief survey of specific varieties of cinema genres (in anthologies).

The Practical Work of Constructing a Film
Collective creative work stage by stage on creating a finished film (the same method as in other practicals):
 1. Finding a theme.
 2. From theme to plot [*syuzhet*].
 3. From plot to screenplay.
 4. From screenplay to montage lists.

(Jointly with students who are graduating from the Faculty of Scriptwriting or professional scriptwriters.*)
5. Elaborating the characters and working with the actor.
(Jointly with students and graduates of the Faculty of Acting or professional actors.)
6. Shooting.
7. Montage.
(Jointly with students or graduates of the Faculty of Film Photography or professional cameramen.)

The individual sections and stages of the making of the film as a whole are carried out by the students working individually and serve as assessment indicators.

N.B.: the techniques of filming and montage have hitherto been studied practically in specialised study modules.

The Overall Plan
a) the overall plan – creative and compositional;
b) the overall plan – costing the production;
c) the form and technique of drafting the overall plan;
d) practical work transposing the film project into a complete overall plan.

Creativity, Technique and the Labour of Directing in the Concrete Conditions of Production
a) The hygiene and rationalisation of creative labour. The production norm. Creative economy. Collectivism in creative work; methods of exceeding the norms.
b) The montage of a programme that is feasible from the production angle;
c) Creative preparation for shooting. Rough sketches of the plan. The essential fluidity of the concept. Its limitations. Alternatives and variations.
d) Creative work through the successive stages of the realisation of the concept.

The work is completed by a summary assessment and characterisation of the creative process and the instructions necessary for the transition to individual creative performance.

This brings the students to fourth-year work, which is spent assimilating their chosen specialisms, the genres and schools of the leading masters, in which the students are examined at diploma level.

Those who complete the third year and pass the relevant practical examinations in production receive the right to the title *qualified assistant director*.

*The presence of students from other Faculties is recommended at all stages of work but their direct creative participation is envisaged at the points indicated. (E's note)

THE FOURTH YEAR
Semesters VII and VIII
The preceding sixth semester teaches the future director all the different aspects of the complete process of making a film in all its creative phases and at every stage.

When realised in a particular type of cinema – the feature film – this work also gives a general picture that is typical of the training for the making of any type of film.

This material must be presented as objectively as possible, dealing with the greatest possible range of problems that might be encountered. In this process it is very important to avoid the specifics of narrow genres and minority interest (what is recommended is polygenrism within the sample).[41]

The objective of the seventh semester is to familiarise the student with his chosen cinema specialism, the subdivisions of genre and the creative predispositions within them.

There are three such specialisms:
a) Director of feature film;
b) Director of publicity and newsreel films;
c) Director of scientific and educational films.

The student chooses the section he wishes to specialise in, and attends the relevant general disciplinary modules applicable to all.

The student completes his project for his diploma according to the chosen genre and objective under the supervision of the relevant expert.

Direction Specialism

Director of Feature Film
Compulsory seminars for all students in this section:
1. Constructing a film of *pathos*:[42]
 a) The nature of *pathos*.
 b) The specific quality of a pathetic construction, deriving from social and historical premises. Consideration of the different fields of art.
 c) The construction of a pathetic work, using cinematic means. General postulates. Analysis of existing models. Practical instruction. Practical work.
 d) The Revolutionary film of *pathos*.

2. Constructing a comic film:
 a) The nature of comedy. The link between comedy and *pathos*.
 b) The specific quality of a comic construction, deriving from social and historical premises. Consideration of the different fields of art.
 c) The construction of a comic work, using cinematic means. General concepts. Analysis of existing models. Practical instruction. Practical work.
 d) Soviet comedy.

3. A brief general discussion of other genres of feature film: the thriller, the psychological film, the detective story, etc.

Completion of the work for the diploma, according to the chosen genre within the specialism, under the supervision of the cinema expert appropriate to that student's choice. Each expert should take on no more than six or seven students who have taken his course, and he organises the fulfilment of the diploma work requirement and takes responsibility for passing it as appropriate.

Director of Publicity or Newsreel Films
Familiarisation with the trends and genres in publicity or newsreel film:
 a) newsreel film and the film sketch [*kinoocherk*];
 b) the technique and composition of a newsreel;
 c) documentary film;
 d) the travelling editorial office and the film-train.[43]

The procedure for the submission of diploma work is the same as for those directing feature films.

Director of Scientific and Educational Films
 Familiarisation with the genre and various aspects of this sector:
 a) general pedagogic disciplines;
 b) the methodology of scientific work;
 c) scientific film;
 d) technical film;
 e) educational film;
 f) educational film for the military;
 g) children's film;
 h) educational film for schools.

The procedure for the submission of diploma work is the same as for those directing feature and publicity films.
 Fourth-year work must be so organised that all lectures in specialised disciplines come to an end, and all preparatory diploma work is completed, during the seventh semester, so that the whole of the eighth semester can be devoted to the completion and defence of diploma works.
 Diploma work in all specialisms consists of a detailed and comprehensive project for a film production in the chosen genre and specialism, offered in the form of a fully elaborated overall plan.
 For the director of a feature film, the draft of the overall plan should consist of the following elements:

1. A general treatment. Deriving from a critique of the work as a whole and based on Marxist analysis and evaluation.
2. A detailed analysis and description of the different characters in the particular work. A social and psychological description: exterior, dress, make-up. Detailed description, sketches, explanatory

diagrams, models of the iconographic material, etc.

3. Staging. A detailed plan of the layout and décor of the set and of the individual *mises-en scène* of the key moments (graphic diagrams and descriptions, notes explaining the sense and the action by means of detailed stage directions, description of the action accompanying the different elements of dialogue, cues and the actors' movements).

4. Filming. The montage list, produced on the basis of the acting *mise-en-scène*. Key moments of the montage list shown by means of consecutive diagrams of individual shots (a consecutive graphic representation of the composition of the successive editing fragments).

5. Working with the actor. Apart from his written notes, the diploma candidate must provide an interpretation of the roles in his oral report to the examining board. These must be sufficient, in both scope and form, for the actor to understand his character and his particular features.

 The diploma candidate must provide a practical demonstration of movement, gestures, intonation and general behaviour in their application to the characters he has developed within the scope and method of his director's exposition.

6. Shooting and montage. The practical execution of parts of the projected assignment, in the form of excerpts and the montage of individual fragments of the projected film.

7. The projected production budget and schedule. In addition to the aspects of artistry and creativity that have been enumerated, the diploma work must also include a plan for the budget, a schedule and a plan of operations.

N.B.: Familiarisation with this area should be acquired from a special module, parallel to the main subject.

The submission and defence of the diploma project entitles the candidate to the be called *qualified co-director*.

Following submission and defence of the diploma project, the student graduating from the Institute must see through as trainee assistant or co-director at least one entire work in production.

After this production experience and a detailed account of it, the student graduating from the Institute receives his diploma and the title *qualified director*.

1937

10. The Mistakes of *Bezhin Meadow*[1]

How could it have happened that more than ten years after the victory of *The Battleship Potemkin*, on the twentieth anniversary of *October*, I came to grief with *Bezhin Meadow*? What caused the catastrophe that overtook a picture I had spent about two years working on? Where lay the original error in my world view that flawed the work, so that, despite the sincerity of my feelings and my dedication, it turned out to be patently groundless politically; and anti-artistic in consequence?

Asking myself that question again, and with much soul-searching, I have begun to see my error and to understand it.

My error is rooted in a deeply intellectual, individualist illusion. An illusion which starts off on a small scale but can lead to major and tragic mistakes and consequences. An illusion that Lenin did not approve of and that Stalin has constantly unmasked. An illusion that you can make something that is genuinely revolutionary purely 'off your own back', rather than in the thick of a collective, marching resolutely in step with it.

That is where the mistake lurks. And that is the first thing I should admit

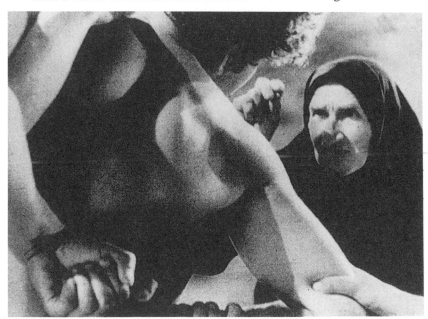

The old woman blesses the young saboteur, *Bezhin Meadow (1935–7)*.

when asking myself in all seriousness about the origins, not just of the mistakes in the present work, but also of a series of mistakes in past works.

This intellectual illusion explains for the most part the flawed Quixotic detours and erroneous diversions and the failure to set questions and answer them properly. This leads to a summation of the individual diversions which constitutes a political distortion of the event portrayed and a politically incorrect treatment of the subject.

The spirit of elemental revolution lies where Bolshevik consciousness and the disciplining of that consciousness are long overdue – that is where mistakes are born; despite all good intentions and endeavours, that is where what is subjectively flawed and simply objectively harmful can break out, surface with increasing frequency.

What happened to me, in my understanding of the teaching of realism, sprang from the same source.

My stylistic endeavours and my inclinations draw me strongly towards the general, the generalised, towards generalisation. But is that the generalisation, the 'general' that Marxist doctrine has taught us? No. Because in my work, generalisation absorbs the particular. Instead of being detected through what is concretely particular, the generalisation dissipates into fragmented abstraction. That was not the case with *The Battleship Potemkin*. The strength of that film lay in the fact that through this particular, single event I managed to convey a generalised idea of 1905 as a 'dress rehearsal' for October. This particular episode could absorb what was typical of that phase of the revolutionary struggle. And what was selected for this episode was typical, and the interpretation of it was generalised, characteristic. This was in no small measure because *Potemkin* was first conceived as one episode in a major epic about 1905, only later becoming an independent work, but one that absorbed the whole build-up of emotions and resonances that had been intended for the larger film.

This did not happen with *Bezhin Meadow*. Even the episode that lies at the heart of it, the dramatic episode, is not in the least bit characteristic. The kulak father murdering his son, a Young Pioneer, is not an impossible episode: such things had happened. But it is not a typical episode. Quite the opposite: it is exceptional, unique and uncharacteristic. Furthermore, its position at the centre of the screenplay confers upon it the status of something independent, self-sufficient and generalised. This confusion completely distorts a valid and realistic picture of the state of the class struggle in the country. This is concealed behind a pathologically distended portrayal of the father's 'execution' of his son which is more reminiscent of Abraham's 'sacrifice' of Isaac than it is of the themes which are bound to stir the viewer: the final battles to ensure the lasting triumph of collective farming. From this perspective the first version of the screenplay was entirely flawed, since it treated this episode as the key and central one.

The second version of the screenplay and its treatment tried instead to stop the drama between father and son from becoming 'a thing in its own right' and to show it as an episode in the general progression of the class struggle in the countryside. This was not done thoroughly or decisively enough: the break with the original concept was not entirely final, either in the

screenplay or in the director's realisation of it.

And if a social situation has been accentuated wrongly, that is bound to lead to a false psychological interpretation. The psychological question of infanticide becomes the focus of attention. And this generalised question pushes the main problem – the depiction of the struggle between the kulak and the forces of collectivisation – downstage. The situation is resolved in a psychological abstraction, not by a realistic examination of reality.

The first version removes every last trace of humanity from the father: it is an unconvincing and stilted show of brutishness. The second version goes too far in the opposite direction: class hatred of the kulak, whose unbridled anger even leads him to murder his own son in his fight against socialism, lies beyond the 'human drama' of the murder and vanishes from view.

Abstracted from reality, the psychological conception results in political bankruptcy: hatred of the enemy evaporates and the psychological ramifications extend the theme to that of a father murdering his son 'in general'.

The mistakes – the isolation of a concrete event from reality – of generalisation within the actual theme are just as jarring in the methods of its realisation.

The first thing is the isolation of an idea from a concrete example of it.

And this leads to an underestimation of man and inattention to the creator of the image of man in a picture – the actor.

Hence also attention is focused not on the people whose roles are politically significant, but on those who have the most interesting personalities.

The brutish appearance of the father gives him a disproportionately important role. The head of the political section is pale, dull and pompous.

At the same time the village Pioneer, the hero of the film, is exaggerated beyond any realistic measure of his social significance. This produces the impression that the class struggle in the countryside is being waged only by Pioneers – or in our picture by only one Pioneer (this is true of the first version in particular).

The same thing applies to the artistic structure of the film. Once attention is no longer focused entirely on one person, on his character and actions, then the role of props and secondary means grows enormously. Hence the exaggeration of the expressiveness of the surroundings: a lair instead of a hut; a distorting camera angle and unnatural lighting. Set, shot and lighting do the acting instead of the actor. Even in regard to the appearance of the cast. These were not living faces but masks: the ultimate generalisation of 'typicality',[2] as distinct from a real face. In their behaviour, the emphasis was on stasis, where the static frozen face was like 'the mask of a gesture' just as a mask was the ultimate generalisation of a dead face.

All these elements in the realisation, which were so justifiably severely criticised, especially in the first version of the film, derived entirely from the premises enumerated at the beginning.

I can write about this with complete frankness because over the course of two years' work I myself, helped by the unremitting criticism of those in charge of the film industry, tried to overcome these features. But I could not do so entirely. Everyone who has seen all the footage of the film, from beginning to end, has commented that there was an undoubted shift towards real-

ism and that the complex of 'night' scenes demonstrates that the author was already abandoning the weak positions he had adopted while working on the first version.

The exaggeration of generalisation, detached from a particular event and from concrete reality, inevitably sent a whole system of images flying in the only possible direction: towards figures and associations fashioned after mythology (Pan, Samson – the destroyer of the Temple – the 'lad' in the first version). If, in the 'rout of the church', this was done with conscious irony – biblical associations clashed with actions that were not characteristic of them (once I had abandoned the attempt at a realistic portrayal there was nothing for it but to work on a game of speculation) – in the serious part this sent the images and characters to their destruction without the author being conscious of it. The full-blooded comprehensiveness of a tragic collision petered out into monochromatic 'black and white' melodrama; the reality of a class struggle turned into a cosmically generalised battle between 'good and evil'. To imagine that the author consciously aimed at myth is simply not reasonable. We see once again how a method for a workable portrayal of reality, which was not fully realised or assimilated in practice, took the author's mistake well beyond the limits of aesthetics and artistry and caused the work to strike a false note politically.

But who made the first mistake? And can it be said that a political flaw is a 'disaster' and the consequence of a flawed creative method? Of course not. The flaw in the creative method takes its source from the flawed world view.

The flaws in the world view lead to the flaws in the method. The flaws in the method lead to objective political error and bankruptcy.

If this is logically apparent for every even minimally aware creative worker in our country, myself included, then in order not merely to understand that finally, but to feel it all in the whole depth of my emotions, I needed the withering and harsh criticism with which the catastrophe of *Bezhin Meadow* was discussed in the press and among the activists of GUK and Mosfilm.[3]

Extended viewing at Mosfilm of all the reels of the picture laid bare for me too the flawed perspective from which I had viewed the subject. The criticism of my comrades helped me towards a clear perception of how wrong my slant on the matter had been.

What had led to this? The failure to uncover the principal motive forces and the actual situation of the class struggle in the villages. The situations of the film did not flow from these presuppositions. Quite the reverse: the film's situations were self-referential. All in all, this was not only incapable of conveying the positive revolutionary effect present in the author's emotions and purposes. Quite the reverse. The errors on this level were capable of arousing an objectively opposite effect on the viewer. This was compounded by errors in the method: the unrealistic treatment of the overwhelming majority of the material (with the exception in particular of the last third of the material for the new version, which shows a shift in method). Even if you had not seen all the material, you might reach a similar conclusion about it from the screenplay and a description of the reels alone.

Blindness, negligence and absence of vigilance can be attributed to all

those who guided and carried out the work. Work should have been stopped. No amount of takes or retakes could have saved it. I can now see clearly that not only a series of details, but also the conception of the work as a whole, were flawed. It grew out of a screenplay, but the director's interpretation could not stand up to those elements and went on to repeat the original errors despite the possibilities offered by the second version.

The unfolding course of discussions about *Bezhin Meadow* further enlightened me on the principal questions: how could it have happened that an obviously incorrect conception could develop in production?

I shall be clear and direct in my answer. In recent years I have become self-absorbed. I have retreated into my shell. The country fulfilled its Five Year Plans. Industrialisation took giant steps forward. I remained in my shell. My alienation from life was, it is true, not complete. It was in those years that I was intensively involved with the younger generation, devoting all my energies to my work at the Institute of Cinema.[4] But this was also a retreat within the walls of an academic institute; there was no broad creative exit towards the masses, towards reality.

The twentieth anniversary of Soviet cinema has given me a real shock. In 1935 I threw myself into my work. But the habit of self-absorption and alienation had already taken hold. I worked shut away with my film crew. I created the picture not out of the flesh and blood of socialist reality, but out of a tissue of associations and theoretical conceptions relating to that reality. The results are obvious.

And that is the upshot of this harsh criticism, criticism that is truly Bolshevik; that is, friendly and intended to help, well-intentioned not malicious. Speeches by our Mosfilm collective of workers saved me from the worst – saved me from being wounded by everything that occurred as a result of my errors in *Bezhin Meadow*. The collective helped open my eyes above all to my own mistakes, to the mistakes in my method and the mistakes in my socio-political conduct. All this overshadows even the natural grief over the loss of two years' work, to which I had devoted so much energy, love and effort. Why am I firm and calm? I understand my own mistakes. I understand the meaning of the criticism, self-criticism, examination and self-examination which grips the whole country following the decisions of the Central Committee of the Party.[5]

I feel very acutely the necessity finally to overcome the errors of my world view; the necessity for a radical reconstruction [*perestroika*] and mastery of Bolshevism.

And in this light I face the question: how may I do all this in the fullest, most profound and responsible way?

This is not possible in isolation from concrete and practical tasks and perspectives. What should I do?

Work seriously on my own world view and delve deeply into new themes from a Marxist angle. Study reality and the new man in concrete fashion. Direct my attentions towards a concretely chosen, strong screenplay and subject.

There is only one possible subject for my next work: spiritually heroic, following the Party's ideology, treating of war and defence, and popular in

style – independently of whether the material will be about 1917 or 1937 – it will serve the triumphant passage of socialism.

In preparation for the making of this film, I see the path through which I shall obliterate the last traces of elemental anarchy from my world view and my creative method.

The Party, the cinema's leadership and the creative collective of film-makers will help me to make the new and accurate pictures that we need.

11. From the History of the Making of the Film *Alexander Nevsky*[6]

Pushkin lay dying.

First he was struck by a bullet, skilfully aimed by the man who inspired a political intrigue, under the guise of a duel masking a simple murder. But when the bullet failed to carry the great man away, medicine finished off this political assassination. The wrong kind of treatment, the wrong steps. A secret instruction to the doctor. And one hundred years ago the great Russian writer, Pushkin, died at the hands of assassins.

Pushkin lay dying.

The death of a soldier should be seen among the details of battle. A sword. A banner. Or a weapon or a machine-gun should be seen nearby.

The death of a writer should be seen connected with a book.

And Pushkin's last day actually is connected with a book. On the last day of his life he was reading a book. A book that, according to his own testimony, met with his full approval and delighted him.

We open this book, the last one this poet of genius was to hold, a hundred years after Pushkin.

It was a history book about Russia, written for children, by Ishimova: *Tales from History*. 'Today I accidentally opened your *Tales from History* and began reading it, involuntarily. That is how to write . . .' Pushkin wrote on 27 January 1837 (!).[7]

What was it about this book that captivated him?

We start reading it. A lot has been left out. Other things have been distorted. The evaluation of events is contentious. Sometimes wrong. And there is, of course, absolutely no satisfactory philosophical conception. . . .

So what captivated the poet?

Pushkin himself was a historian. He was strict to the point of fussiness (see for example his critique of *Yuri Miloslavsky*).[8] Precise to the point of pedantry. Although he never forgot that he was a poet and able to make poetic departures from arid narrative, knowing that at times there was more historic truth and verity in that than in the most documentary of recreated annals. And at the same time Ishimova's book captivated him, for all that it has a fair amount of 'ladies' handiwork' about it, and that it is of doubtful veracity.

So how is that?

Leafing through the book, you begin to understand. It is the remarkable depth of the author's love for the theme she has chosen that so charms. The

theme is her homeland and her people. Her love for her homeland and the Russian people is the captivating thing which stands out from the pages of Ishimova's history.

This is not the jingoism of hired scriveners penning the histories of official institutions. This is not the cloying sentimentality of counterfeit margarine history, which flourished so revoltingly under the aegis of the later Romanovs. This is genuine patriotic feeling. The patriotic feeling of genuine and deep love for your nation which was lacking in the historical literature of the other extreme which succeeded jingoism. That literature took a thoughtless scalpel to the history of its past, its people, its homeland, without a scrap of love, without a scrap of genuine feeling, without feeling that it was the flesh of its flesh, the blood of its blood. Instead of the living recreation of the past, the result was lifeless *a priori* sociological outlines. Ishimova's book is not merely a history textbook – it is much more: a textbook of love for history and homeland, which can take pride in such a nation and such a homeland. Granted, for those times; granted, as it was in Pushkin's epoch; granted, from the perspective of the beginning of the nineteenth century. She breathes genuine love for her nation and homeland; through the archaism of her language and the rhetoric of her forms of exposition, she infects us to this day with that evergreen feeling of genuine sincerity as she captured that great martyred poet on the day when agonising death delivered the *coup de grâce* to his persecution at the hands of the forces of black reaction. It is those living emotions, without which it is criminal and impossible to approach the great theme of the past of our people, even today. The panoply of the materialist method alone is inadequate when it comes to history. Without these emotions, our approach to history is void.

If it is not infused by a genuine love, fervour and the feeling of a blood tie with the past, our approach will be as infertile as any unscientific, speculative ramble into our past and just as remote from true Marxism-Leninism, which indissolubly interweaves angry passion or the thrill of battle with the subtlety of strictly scientific analysis. And that is why, when beginning to talk about one of our oldest national heroes, Alexander Nevsky, I find myself involuntarily turning to the pages of Ishimova's book...

12. An Image of Great Historical Truth and Realism[9]

The film is beautiful. I do not think there can be any question about that. And like any genuinely beautiful work, it must have been the result of a combination of the collective creative impulses of everyone who worked on it. I should like to dwell upon three achievements of this remarkable work.

The first is the image of Lenin, and Shchukin's remarkable effort.[10] I am, unfortunately, one of those people who never had occasion to meet Ilyich.[11] But I had to devote a fair amount of work to the question of his appearance and image, and this entailed studying the considerable quantity of materials that had been produced and made available ten years ago. And on that basis, the image created by Shchukin seems to me an image of great historical truth and realistic authenticity.

It is extraordinary that in the film *Lenin in October* the remarkable actor Shchukin, and also the director who knew how to expose situations through the production, and the scriptwriter who contrived to highlight the appropriate circumstances in the screenplay, were able to detect that very image of Lenin in the mass audience that we all carry in our hearts because of the enthusiasm we feel for the deeds and creativity of that great man. This remarkable work has achieved not only the truth of what Lenin was, but also the higher truth of how we, the many millions who continue his work, want to picture Lenin, standing before us in our mind's eye.

The second achievement must be that of the scriptwriter, although even in this case he is of course inextricably bound up with the whole collective.

The theme of October develops round an unusually successful choice of collisions. I would say that the key drama lies within the struggle for victory in the October Revolution. The vile treachery of Kamenev and Zinoviev,[12] who were deservedly executed by the proletarian courts, which serves as the nerve of the dramatic construction, reveals to maximum effect, not merely for twenty years ago but also for many years to come, the baseness and historical doom awaiting all those who do not stand with Lenin in the final and decisive battle. More than that: the historical and political subject matter is treated especially correctly, deeply and acutely, and resolved in a particularly emotionally warm and gripping way in terms of both plot and situation. This subject could have been dressed up in any situation, in the circumstances of any plot. But choosing precisely these situations and circumstances over any others testifies to the skill of the collective, this time led by Alexei Kapler,[13]

who caught so sensitively the deepest of those emotions that fill our people, our mass audience.

What emotion seizes us now, as never before? What word does not merely flicker upon the pages of our newspapers, but daily, hourly, more frequently than any other, bursts into our consciousness and emotions? What is it that fills the speeches of our best people, during the Supreme Soviet elections?[14]

It is speeches about caution, care, preservation. Speeches about our achievements are followed immediately by speeches about the preservation and careful defence of what has been fought for and won. About the defence of achievements recorded in the Constitution;[15] about the defence of the country and its borders, about the defence of the leaders, defence of the purity of Marxist-Leninist doctrine, the preservation of the memory of the great Lenin.

And remarkable situations showing care for Ilyich, protecting him, defending him as our most valuable asset during the days before October and the October battles, have been taken as the raw material to embody the subject of the film *Lenin in October*. And it is these very features that have found the warmest and most powerful echo in the hearts of all those who stand guard over the achievements, the great memory and the continuation of Lenin's cause. The fact that the screenplay plays upon precisely these emotions shows the very greatest craftsmanship in the construction of the film; or perhaps, more than craftsmanship, a complete merger with the many millions, the collective of our people; for only in this merger with it is it possible to pick up the deepest, most subtle of emotions that rule the lives of the many million-strong collective. And here one should acknowledge complete admiration for the director's work too.

I have seen the film several times. And each time I was enthralled by the amazing rhythm to which Romm set the scenes, at first glance seemingly so simple, in which Lenin appears. It is not only the content of the situations, it is not only Shchukin's acting: it is a perfectly captured rhythm in which these situations are developed by the director, and in which this performance is guided by the director. I twice surrendered to this effect. On the third occasion I wanted to investigate where this rhythm that governed the action came from, where it could be detected and heard. It quite faultlessly enthralled everyone who watched it. And again it transpires that this feature was detected in the beating of the audience's hearts when it came close to the image of Ilyich, or to the memory of Ilyich. Romm managed to anticipate, to foresee in what frame of mind the audience would begin to watch *Lenin in October*, what the audience would feel when it encountered Ilyich on the screen; and Romm contrived to make the rhythm of the screen effects fall into exactly the key that would correspond absolutely to the audience's emotions as they followed, tensely, the deeds and fate of the screen Ilyich. I would call this the rhythm of reverence and of that particular trembling warmth, the kind of pure, filial concern that affects that part of all of us that is linked to the memory of Ilyich. Okhlopkov embodies this emotion on screen and he guides it with such love and tact that every member of the audience sees in him one who carries his dearest personal feelings, and is eternally grateful to him.[16]

What can I say in conclusion?

I think there is only one thing. The film's exceptional achievement lies not only in the collective collaboration of all the members of the creative collective (it is not possible to write about all of them, and so I must express my gratitude and admiration to them – to the co-director, the cameraman and sound engineer and actors – as a whole). The film's exceptional achievement lies in the apparently most profound unity between this creative collective and our people. This organic merger with the people, with their feelings, with all the shades of their emotions about the memory, the deeds and the continuation of the cause of Ilyich, was uniquely capable of teaching the scriptwriter and the director, the leading actor and the whole collective that fundamental and unrepeatable phenomenon that makes this film so enthralling.

That is what should be studied in this remarkable and momentous film.

1938

13. Alexander Nevsky and the Rout of the Germans[1]

Bones. Skulls. Scorched earth. The charred remains of human habitation. People led away to slavery in a distant land. Ruined towns. Human dignity trampled underfoot. Such is the terrible picture of the first decades of the thirteenth century in Russia that confronts us. The Tatar hordes of Genghis Khan had rounded the southern shores of the Caspian and penetrated the Caucasus. Destroying the flourishing culture of Georgia, this horror, death and insanity – the source of their strength – launched themselves on Russia. The rout of the Russian soldiers who had come to meet them, in the battle of Kalka in 1223, was only a prelude to the bloody epic of Khan Baty's invasion which stirred up all Europe.

Russian princedoms and towns were ready, one after the other, to repulse the terrible enemy. But they had not reached the stage of maturity to realise that a powerful state, capable of opposing any invasion, cannot be created amid civil strife and infighting. Disunited and solitary, town after town showed itself a model of great fortitude. But one after the other, they fell in unequal struggle. The Tatars advanced with terrible force and threatened to rout Europe. In a Europe driven mad by horror, isolated calls for a collective rebuff were made. But these appeals hung in midair. Germany was not moved by a summons to universal armament. Germany was immersed in factionalism and political competition between the Emperor and Rome. Only the Slav peoples undertook the defence and salvation of Europe from the Tatars. The Russians sacrificed themselves and their towns to this cause.

And – an irony of fate! – it fell to the Czechs to save Germany from death and destruction. The Czech king Wenceslas was her saviour from Baty's hordes; with his regiments he blocked off the route into Germany. The Czech warrior Jaroslav of Sternberg, during the siege of Olmütz, brought down destruction upon Baty's troops.[2]

The Ukraine, and other constituent parts of the future great land of Russia, lay for long years beneath the Tatar yoke, suffering all the victor's greed as he stood upon the ruins of the Russian principalities that he had routed and crushed. Such was the fearful face of long-suffering Rus of the thirteenth century. Without a complete picture of all of this you will not understand the full magnitude of the heroism with which the Russian people, enslaved by an Oriental barbarian, was able with Alexander Nevsky as general to rout the Western barbarian – the Teutonic Knights who were trying to tear off a slice of enslaved Russia. But where had these Knights come from?

At the start of the twelfth century the 'House of the Teutons' arose first in Jerusalem and then in the setting of the Crusaders' siege of Ptolemais.[3] This House, like the 'Brown House' in Munich all those years later,[4] was destined to be the cradle of one of the most terrible scourges of humanity; like leprosy, it held Western and Eastern Europe in its rapacious grasp.

The 'House of the Teutons' represented at first nothing more than a field hospital; however, the German marshals of the Crusades took the most active part in it. On 6 February 1191, with the blessing of Rome, a new order of knights came into being. On 12 July of the same year, Ptolemais fell to the Crusaders. The new order took possession of a sizeable share of the spoils and the ownership of the territory, by settling in number on the land that had been conquered. It could now easily go about its business of organising itself, and the Teutonic Order became a focus for German influence not only in Palestine, but in the whole of Europe. Its composition was uncompromisingly nationalistic and aristocratic: only Germans who were also members of the oldest of the noble families were entitled to join. The political importance of similar little islands of German orientation in various countries was as clear to the politicians of the thirteenth century as it is to the masters of contemporary Germany. Initially, the Knights confined themselves to starting to trade on their military strength and strategic skills. They began to play a policing role, as guard dogs for the various rulers of Europe.

But there soon began a prolonged and systematic invasion of the East. One by one, Prussians, Livonians, Estonians, Zhmuds fell prey to them.[5] Vying with the Tatars in cruelty and ruthlessness towards their subjugated peoples, the Teutons had by this time joined forces with other, monastic orders who were no less rapacious and considerably more terrifying than the Tatars.

The Tatars were satisfied with incursions, pillage and destroying the subjugated lands; they did not settle them, but went back into the heartlands of Asia or to the khanates in the south-east, extorting a heavy, and sometimes crippling, tribute.

It was quite a different matter with the Teutonic and Livonian 'Knights'. We are dealing here with a consistent colonisation in the form of a complete enslavement of its subjects and the destruction of the features of their aboriginal religious and social structures which characterised the colonists' plunder for centuries to come.

With military techniques and an organised military strength that was superior to that of their subjects, the 'devout brothers' would stoop to any tactic: the first was the widely established system for recruiting traitors. The chronicles have brought to us not only the names of our country's heroic defenders, but also those of its vile betrayers. There is the prince, Vladimir of Pskov, and his son Yaroslav Vladimirovich who was such a traitor. Here at last is also the colourful figure of the governor of Pskov, Tverdila Ivankovich, who betrayed Pskov to the Germans out of selfish personal interests.[6]

The centre, where the first defence of the Russian lands against the Western barbarians – and later the organised counter-attack against them – originated, was then Novgorod, 'Lord Novgorod the Great', as it was christened in those days.[7] The glorious name of Novgorod has forever been linked

with the heroic defence of the land of Russia and the rebirth of its national in-
dependence which especially farsighted and vigorous princes had fought for.
Pride of place among them belongs to the Novgorod prince Alexander
Nevsky, whose strength lay not only in his personal genius but in his deep
inner bond with the people's volunteers, 'Russian muzhiks' (as Marx wrote of
them), whom he led in victorious campaigns.[8] His closeness and his blood tie
with the people set his unerring course through the complex international
politics of the day. It enabled Alexander to choose the one historically correct
political line. Currying favour with the Tatars and trying by all means poss-
ible to 'cope with' them, Alexander thereby set his hands free to deal with the
West: there lay the greater menace to the people's originality and the first
growths of the national self-awareness which was emerging as a natural reac-
tion to the incursions from the West and the East. Alexander launched his
main strike against the West.

Alexander and the armed forces of Novgorod attained the high point of
their military success and glory in the defence of the nation in this way, in the
battle on Lake Peipus, famous as the Battle on the Ice, which took place on 5
April 1242. It was the finale of a brilliantly conceived military campaign
against the invaders and involved regaining Coporia from the Germans, win-
ning back Pskov, skirmishes with the Germans at Izborsk and a raid along the
shores of Lake Pskov (which was joined to Lake Peipus) with the aim of
smashing the Germans' plans – they wanted to keep Alexander's main troops
at Izborsk, so that they could trap his principal forces in an encirclement.
Alexander guessed the Germans' plan; in an unexpected manoeuvre he used
his vanguard to cut off their route on the west bank of the lake, somewhere
near the Embakh estuary. These advance troops, led by the valorous Domash
Tverdislavich and Kerbet, suffered defeat at the hands of superior German
forces. But Alexander retreated on to the ice of Lake Peipus; without going
on to the eastern, Russian shore he faced the Germans' strike at Raven Rock
near the narrow strait connecting Lake Peipus with Lake Pskov. The
Germans advanced in a terrifying formation, a cavalry wedge.[9]

We will try to imagine what that hitherto invincible military formation
was like. Picture the prow of a modern battleship or a very powerful tank, en-
larged to the size of a hundred armoured knights on horseback. Imagine this
gigantic iron triangle galloping at full tilt, building up furious energy. Imagine
this force cutting through a circle and into the mass of the enemy, who are
dumbstruck by the terrible, impersonal mass of iron bearing down upon
them. The knights' faces cannot be seen; instead there is a wall of iron with
small slits forming a cross, for them to see and breathe. The 'wedge' breaks
up the enemy's front and immediately divides into separate 'spears'. The
'spear' – a knight in armour, the prototype of the 'tanketka' [small tank] –
bursts into the mass of living flesh of the enemy scattering them left and right.
Penetrating even deeper, the 'spear' is not only a knight; it may be a whole
group, sometimes as many as thirteen men, a military crew: armour-bearers,
pages, and horsemen comprising, with a knight at its centre, one whole.

To face an onslaught from a 'wedge' head on, in an open field, with the
state of troops being what it then was, was as unthinkable as trying unarmed
to stop a tank would be now.

And Alexander got even with the Germans using the same manoeuvre of genius that Hannibal used, covering himself with undying glory, at Cannae.[10] Knowing that the centre ('forehead') could not resist an onslaught by a 'wedge', he did not even attempt to resist: he deployed all his strength on the flanks (the regiments of the 'left' and 'right' hand). The intentionally weakened centre yielded to the wedge's attack, but at the same time encouraged its pursuit. Alexander was successful. To the envy of future warriors who aspire to realise the dream of all commanders of all ages, he accomplished a complete encirclement of the enemy from both flanks. We have information that a detachment lying in ambush even cut into the enemy from the rear. The treacherous enemy, crushed on all sides, was subjected to a complete rout. Never before had there been such a battle. The Germans had never known such defeat. The din and the groans of the unforgettable conflict come to us through the pages of the chronicles: 'the crack of shattering lances, the clash of swords – it was as though the frozen lake was moving. ... The ice was hidden, everywhere awash with blood ... and the Russian soldiers cut them to pieces, pursuing them as though through the air, and there was nowhere for them to hide.... They slew them on the ice, over the seven versts[11] to the Subolich shore ...'

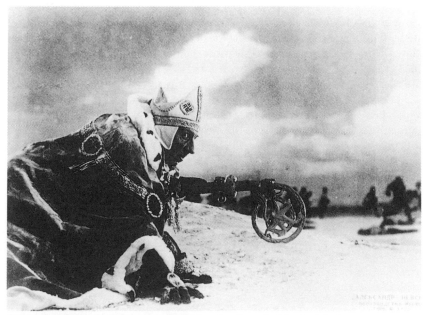

White as symbol of evil. The German bishop in *Alexander Nevsky* (1938).

We must explain why the battle took place on the ice. There are many theories about this. First, the smooth surface of the frozen waters made it possible to meet the enemy in battle face to face; there would be none of the unexpected ups and downs of the shoreline (and Russians were used to fighting on the smooth surface of frozen lakes). Then there was the possibility [for Alexander] of deploying the sections of his troops skilfully. Third, the slippery surface made the going harder for the horses. Finally, there was the

consideration that the ice would have to give beneath the weight of the more heavily armed Germans. This actually happened, chiefly during the pursuit; the April ice, thin near the shore, could not support the weight of the knights who were gathering in large numbers by the western bank, whose steep sides made a quick flight impossible. The remainder of those fleeing perished in the waters that opened up beneath their feet. But, just looking at the map, we can see that the key thing here is not the icy surface of the lake but its geographical location. The boundary of the Russian lands follows the eastern shore of the lake and the surface of the frozen lake is in the first place not our territory. The ice, in contrast to the eastern shore, is a foreign expanse, a foreign land. And the decisive rout of the invaders in the battle on Lake Peipus was determined to no small extent by this circumstance.

The actual rout on Lake Peipus was an unexpected and staggering miracle. The chronicles sought to explain it by supernatural phenomena and some sort of heavenly force that was said to have taken part in the battle. But the answer does not lie of course with these dubious precursors of aviation. The only miracle in the battle on Lake Peipus was the genius of the Russian people, who for the first time began to sense their national, native power, their unity: a people able to draw from this awakening self-awareness an indomitable strength; able to advance, from their midst, a strategist and commander of genius, Alexander; and with him at their head, to defend the motherland, having smashed the devious enemy on foreign territory and not allowed him to despoil by his invasion their native soil. 'The swine were finally repulsed beyond the Russian frontiers,' wrote Marx. Such will be the fate of all those who dare encroach upon our great land even now.[12]

For if the might of our national soul was able to punish the enemy in this way, when the country lay exhausted in the grip of the Tatar yoke, then nothing will be strong enough to destroy this country which has broken the last chains of its oppression; a country which has become a socialist motherland; a country which is being led to unprecedented victories by the greatest strategist in world history – Stalin.

14. My Subject is Patriotism[13]

This is the inscription on the scrap of paper on which I jotted down my first ideas about my next picture when I was given the task of recreating for the screen the thirteenth century, with its great national struggle of the Russian people against aggression, and of depicting the figure of that remarkable commander and statesman Alexander Nevsky.

My subject is patriotism – the phrase was constantly in my mind and in the minds of our entire collective, during the shooting, the sound recordings and the montage.

And it appears that this slogan, which in creative terms determined the whole picture, also resonates in the finished film.

The great ideas of our Socialist Fatherland endow our art with unusual fecundity. We have tried to serve these great ideas of our Socialist Fatherland in all the films we have made in the course of nearly fifteen years. These were themes about the underground struggle, collectivism, the October Revolution, collectivisation.[14] And now, in this picture, we have approached the national and patriotic theme, which dominates the attitude of Socialist creativity not only in our country, but in the West as well, for the guardians of national esteem, pride and independence and true patriotism throughout the world are none other than the Communist Party and Communism.

The bourgeoisie, in mortal fear for its existence these last years, has betrayed its previous ideals, its countries and its peoples, endeavouring at any price, by means of all sorts of manoeuvres and deals both secret and open, to erect a barrier against the rising wave of the working people's final, decisive battle for freedom and independence.

It is impossible to view the world today without feelings of horror. I do not believe that any period in history has witnessed such an accumulation of outrages against every human ideal as has resulted in recent years from growing Fascist aggression. The suppression of the independence of the so-called small countries – Spain soaked in blood, Czechoslovakia torn to pieces, China gasping in a fearful struggle – these realities appear like a gory nightmare.[15] It seemed that nothing could be more terrible. But each day brings us news of greater abominations, greater atrocities. It is hard to believe your eyes when you read of the unbridled ferocity of the Jewish pogroms in Germany, where the whole world watches as hundreds of thousands of people, denied their rights and deprived of human support, are being wiped from the face of the earth. The Communists have led, and are leading the front line against this bloody nightmare, standing for recovery, for the creation of a barrier against it, for the mobilisation of resources for the struggle.[16] The mighty voice of the

Soviet Union is the only one to have rung out unwaveringly, insistently and uncompromisingly for a decisive struggle against this obscurantism. The struggle for the human ideal of justice, freedom and national identity, even for the very right to national existence, originates precisely with the Soviet Union. All that is finest in thinking humanity cannot fail to add its voice to this appeal.

Naturally Soviet art could not ignore these all-important themes – not just those themes joined in blood with the struggle waged by the Soviet Union in defence of its integrity and inviolability against constant acts of aggression, but also broader themes, going beyond the frontiers of our country and including the fate, not merely of small countries, but also recently of great powers such as France which, by its own hand, or rather by the criminal hands of its political leaders, has reduced itself to the position of a second-ranking state.[17]

The theme of national defence is one which at the present time arouses equal interest in all corners of the world where human dignity has not been lost, where belief in human ideals still remains. This theme should find an echo in the colonies, not to mention the numerous blood-soaked countries, where the world bourgeoisie is preparing – at the expense of hundreds of thousands of people – to do its sordid deals in an attempt to postpone the destruction of this doomed class, if only for a short while.

The theme of patriotism and national defence against the aggressor is the subject that suffuses our film. We have taken a historical episode from the thirteenth century, when the ancestors of today's Fascists, the Teutonic and Livonian knights, waged a systematic struggle to conquer and invade the East in order to subjugate the Slav and other nationalities in precisely the same spirit that Fascist Germany is trying to do today, with the same frenzied slogans and the same fanaticism.

When you read the chronicles of the thirteenth century alternately with current newspapers, you lose your sense of the difference in time, because the bloody terror which the conquering Orders of Knighthood sowed is scarcely distinguishable from what is now being perpetrated in Europe.

This is why the picture, even though it deals with a specific historical epoch, with quite specific historical events, was intended as and – according to the testimony of those who have seen it – appears to be, a contemporary picture. So close are the feelings that inflamed the Russian people in the thirteenth century, when they repelled the enemy, to those that inflame the Soviet people at the present time, and, without doubt, to the feelings that inflame those towards whom the predatory claws of German aggression are stretched out.

In the thirteenth century on the ice of Lake Peipus the Russians routed the Teutonic and Livonian knights.

This put a shattering end to German expansion in the Slav lands of the East. After devouring all the small peoples on the way in its shattering offensive, the wave of German aggression rolled on towards Slav territory. Despite the fact that, eighteen years earlier, Russia had experienced the terrible invasion of the Tatars, who had devastated almost all the Russian lands so that only the north-western part, with ancient Novgorod as its centre, remained,

the Russian people found the strength to gather sufficient troops to prevent the German invasion, to prevent the imposition of the German yoke, which was even more terrible than that of the Tatars. Whereas the Tatars were interested only in tribute, the Germans, just like the Fascists today, sought to destroy utterly all traces of national identity, of national independence and national character that distinguish the countries which they subjugated.

Just as today the Fascist curs are tearing Czechoslovak culture to shreds, destroying the language, the schools and the literature, destroying the Czechoslovak intelligentsia and the distinctive Czechoslovak working class, so too the cur-knights of the thirteenth century utterly eradicated everything that each nation or nationality regarded as distinctive and vital to its own character, in all those countries that had the misfortune to fall into their hands. The knights' paths of conquest were marked with blood and fire. Cities, villages and people were destroyed – until Alexander Nevsky and the Russian levies met the Germans on the ice of Lake Peipus,[18] and destroyed the legendary 'wedge', a special fighting formation, in which the highly organised knights advanced, crushing every military obstacle in their path with an iron cavalry wedge.

Alexander Nevsky, with the genius of a great military leader, repeated Hannibal's manoeuvre at Cannae;[19] he succeeded in squeezing the hitherto invincible wedge in the vice of crushing blows from the flanks and in rounding off its defeat with the aid of the peasant levy, which engaged the 'wedge' from the rear.

The blow struck against the Germans was crushing and merciless, not just because of the physical blow but also because of the terrible moral defeat of a force that had seemed indestructible and invincible. Before their defeat in the Battle on the Ice, an aura of invincible and indestructible might had surrounded the knights. There are many weak or faint-hearted people who likewise blindly believe in the invincibility and indestructibility of the brazen diplomatic and military adventurism practised in the world arena by Hitler and world Fascism.

We want our film not only to mobilise even more those who are in the very thick of the worldwide struggle against Fascism, but to bring spirit, courage and confidence to those parts of the world where Fascism seems as indestructible as the Order of Knights appeared in the thirteenth century. May the faint-hearted not waver in the face of Fascism, may they cease kneeling submissively before Fascism, may they cease their persistent policy of appeasement and tribute to the insatiable monster. Let them remember that there is no force of ignorance and darkness that can resist the united forces of all that is best, healthy, progressive and forward-looking in humanity.

These emotions and passions and this strength are inspired and led by the most wonderful country in the world, now experiencing the vigorous surge and development of the great Stalinist epoch and which has recently repaid Japan's aggressive efforts with the same ruthlessness with which it defeated German aggression in the thirteenth century.[20] The best forces in the world must convince themselves that ruthless determination in struggle always brings victory, and the best forces in the world must be mobilised for this victory.

[Now, as I write this article, the picture *Alexander Nevsky* is finished.[21]

Our entire collective, imbued with the lofty ideas of the picture, worked on it enthusiastically; we are sure that the close of the film, Alexander Nevsky's splendid speech, will resound in our day as a terrible warning to all enemies of the Soviet Union:

Should anyone raise his sword against us, he shall perish by the sword. On this the Russian land stands and shall stand!

These words express the feelings and will of the masses of the Soviet people.][22]

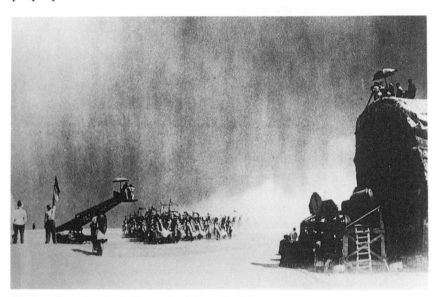

Filming *Alexander Nevsky*. Raven Rock is on the right.

1939

15. We Serve the People[1]

An artist in this country lives without threat of economic crisis or unemployment. He is never haunted by the fear that tomorrow his work will be of no use to anyone; that he will have to find other work, not compatible with his aspirations and talents, to earn his crust.

Disasters and deaths, the destruction of cultural values that have built up over the ages, unemployment and the tragedy of unjust wars – all these are foreign to the artist working in the USSR. He is surrounded by the young, healthy Soviet people engaged in creating a Communist society and their enthusiastic activity elevates the artist, giving his talents a broader creative sweep.

And the artist does not only perceive and transmit the pressurised force of the people's creativity through his works: he is physically and morally tied, by millions of threads, to everyone he works with, everyone to whom he transmits his energy and whose mouthpiece he considers himself to be.

Writers, directors, actors, painters, sculptors, composers and film-makers are guaranteed perpetual living contact with workers in industry and agriculture, soldiers and commanders of the heroic Red Army and Navy and representatives of the most diverse sections of the intelligentsia. The people have become involved with the work of their artist. They surround him with love and concern, suggesting themes and furnishing helpful criticism and advice.

When the remarkable Soviet film-maker Alexander Dovzhenko[2] had just embarked on producing the film *Shchors*, he was inundated with the reminiscences of veterans of the Civil War in the Ukraine and with documents from people who knew that period in our history. It seemed that the whole country was trying to help Dovzhenko in his work on the film.

While I was thinking out my film *Alexander Nevsky*, I received a flood of letters in just the same way. Professors, students, amateur historians, even schoolchildren who had recently read the earliest chapters of Russian history – they all wrote to me.

And now that newspapers have made a fleeting reference to our next film *Perekop*, we have already begun assembling documents sent by people who fought in those heroic battles, or people who are well acquainted with that period in our struggle with the White Guards and intervention during the Civil War.[3]

Living in conditions that are exceptionally conducive to creativity, unlike artists and craftsmen in the West, our artist does not always realise the extent to which these conditions oblige him to rise to the occasion. We often pull our

punches in our creative work, fail to do enough, think enough about how to educate cinema cadres, for which the demand is growing by the day.

Soviet craftsmen do not squirrel away their knowledge, experience and creative methods, which is what artists in capitalist countries are forced to do. And in offshoots of art education where this practice is well established, such as music, we have achieved brilliant successes. By educating cadres of directors and actors for stage and screen, these successes will inevitably be equalled.

We all feel that we are at the point of intersection between the past and the future. This great synthesis, the path we have trodden and the path which we are yet to tread, inspires Soviet artists, unearthing in their work strata that hitherto had always remained untouched.

When a Soviet artist is able to express in his work the thoughts and emotions of the people, then there is no one who appreciates the artist more warmly, more gratefully than the Soviet reader, spectator or audience. And the government, expressing the wish of the people, marks out such an artist for great rewards.

1940

16. The Problems of the Soviet Historical Film[1]

I do not know if it is proper for me to be the first to speak, especially with the lofty appellation of principal speaker, because I am not going to give a solemn speech, nor one that generalises broadly; instead it will be fairly down-to-earth and cover a wide range of matters which are often ignored. It will be about the particular individual problems that have arisen in connection with historical films and that we are now able to discuss. Theoretical abstractions have no place in this discussion, which is based upon the different elements that have arisen in our historical films.

The question of historical films is one that must be examined: first, because of what they tell us about history; second, because the cycle of historical films over the last five years has done much to develop Soviet cinema in general; and third, because of a large number of specific problems connected with historical films which [these films] have touched on, raised, or revealed. I shall have to refer to some pictures, to talk about them, but that does not mean that each of these pictures has solved these problems in one way or another. However, some of these films have posed these problems, and to some extent raised these questions.

The films we have seen are not of equal value, if considered from these three standpoints. I think that one big mistake in the evaluation of our films is the way that films are always assessed in an undifferentiated way. If a film is good in general, then the tendency is to think that all its elements are faultless and fine. This was once a perfectly accurate device for confusing the critics, and the dictum about the unity of form and content was used as a distraction to prevent the valid examination of a wide range of creative problems that a film might throw up. The rule was that if a film was generally good, then it was considered bad form to talk about individual elements in the film which fell short of the mark.

But if a film is considered from different points of view, that is, what it contributed, what it introduced, what it did, in different areas, then it must also be evaluated with respect to these different areas. For example, we know what happened with the reviews of *Stepan Razin*.[2] When we read two different reviews of the same film, the evaluations concerned different aspects of the film and, I think, if we are to examine our films, it is worth adhering to this procedure.

There is a similar discussion (sadly a rather subdued one) about a quite indisputably fine work – *Lenin in 1918*.[3] A number of criticisms have been

made by comrades which are seldom voiced on platforms, which are spoken of fairly frequently, and which for some reason are not raised at public debates, but remain outside criticism, rather than being incorporated into an academically rigorous system: namely, that the picture *Lenin in 1918* is in some elements, such as the historical-revolutionary, irreproachable and faultless, whereas in regard to some aspects of the construction of the film as such it has definite shortcomings.

I had frequently to sit in on discussions and to defend *Lenin in 1918*; the picture was attacked with extraordinary harshness by the panel at Dom Kino, who took no account of the fact that it was, by the standards it set itself, of extraordinarily high quality.[4]

I think that we must return to this question in the future: when we examine a picture we must not let ourselves be distracted by how good, or faultless, it may be from the standpoint of what it teaches us about history, but from the point of view of the interpretation of the historical landscape, for example, and whether that is flawed.

That is the first stipulation I should like to make.

I do not think that it is worth spending too much time on the question of the importance of the study of history for the present and for building the future: everyone knows that much. I shall only say that there is a very good Party document: the resolution of the Council of People's Commissars and the Central Committee of the All-Russian Communist Party (Bolsheviks) of 16 May 1934.

It explains, states precisely, that the final aim of this study is the Marxist understanding of history, and it indicates the routes towards this aim: the correct selection and generalisation of historical events. The essential conditions: the accessibility, clearness and concreteness of the historical material. It also indicates the essential premises in studying: '... observing a historical and chronological consistency in setting out the historical events, and students of important historical phenomena must have the historical figures and chronological dates fixed in their minds.' All this in a lively, engaging style.

This document even indicates errors which were allowed earlier: an abstract quality, sketchiness, vagueness in defining a socio-economic structure, and so on.

If we take education as the principal and fundamental purpose of a work of art, then these provisions are of crucial importance for works of art too. We know that a work of art pursues the same aims, but does so using figurative and artistic means.

Hence the importance of these guidelines, including the note about chronology. We can remember individual elements of history, but chronology helps by establishing the date and showing us where concurrent episodes intersect, and allows us a much fuller appreciation of the epoch.

For example, if we remember that Shakespeare was born in the year Michelangelo died, that he was thirty when Ivan the Terrible died, that Giordano Bruno perished at the stake between the premieres of *Twelfth Night* and *Hamlet*; that the historical Boris Godunov died a year after the premiere of *Lear* and *Macbeth*; that the Three Musketeers turn out to be contemporaries of Ivan Susanin, etc. – a whole number of things, when seen in their

chronological perspective, give an unexpected twist to one's sense of what the world was like at that time.[5]

You might remember that Goethe died three years after Griboyedov.[6]

The difference between a history textbook and a historical film is that a history textbook summarises and generalises a given period after describing it.

The key thing about a historical film is for the generalising summary to emerge from the vivid play of passions and the unfolding events that pass before the viewer.

Poor films belong to the first type: they are built upon a moralistic script or a special dialogue which generalises the events. In this respect they become history textbooks, at the same time that a vivid history textbook will convey the essence, in images, of the events which it sets out.

I have attended lectures in higher mathematics whose delivery made you wish you had studied the history of literature. But Goldschmidt's biology textbook *Ascarides* almost turns biology into a novel, without sacrificing scientific rigour.[7]

The basic, essential premise for a historical film is historical truth. All societies are interested in their history. And each class aims at interpreting its past so that it can justify the rationale for its existence.

In these cases, the bourgeoisie is compelled to lie about the past and distort it, as it looks for justifications for its existence which it cannot justify at all.

One of the most outrageous examples of a class lying about history is *Viva Villa!*, a very well constructed film that is dramaturgic in other respects too. It had to prove that the people cannot govern the state, and this is demonstrated with great vividness in the closing episodes.[8]

Two historical figures have been brought into the single character of Villa himself, although essentially they are mutually exclusive. There is the charming Villa, who can do almost anything, and who has a vague programme which satisfies the interests of the Mexican farm labourers. It should be said that the actual Villa was an adventurer, a general who staged a putsch. But his agrarian programme, which to us seems more or less feasible, has been taken from the programme of a completely different kind of peasant leader, Emiliano Zapata.[9]

The union of these two figures in one character is not merely false: it also discredits Zapata's programme, which in many of its provisions approached the Communist programme.

Not to mention the figure of Madero, who was incredibly distorted, and who was one of the most implausibly repellent historical figures of Mexico.[10]

This example shows how the bourgeoisie is forced to distort and twist historical material to make it justify the methods by which it works.

This gives rise to the notorious motto, 'History is politics projected into the past', which sums up bourgeois attitudes to history.[11]

Our attitude, as a class, to history is the objective veracity and the objective truth [that] historical truth can only be revealed on the basis of Marxist historical science. There is no divergence between the objective truth and our understanding as a class.

But historical truth should not be confused with historical naturalism. In some cases a naturalistic, simple twisting of the facts and a realistic interpretation of the past may become almost mutually exclusive.

Here I can refer to the example of *Potemkin*. We know the mutiny on the 'Potemkin' was crushed as a single instance. It could be considered a defeat, but nevertheless in the film we consciously ended with a [different] scene on the 'Potemkin', the moment of victory, bearing in mind that what was important to me was to discover the generalised idea, the valid realistic meaning: a great victory in the general movement in the history of the Revolution, and not the fate of a battleship which would have had, a few weeks later, to have been returned to the tsarist government.

It must be said that most of our historical films have grappled particularly successfully with the first aim – to educate and make aware. There are no distortions of history.

The next question I wanted to touch on is the role of historical films within our cinema.

When we started to take a particularly strong interest in history, when that turn towards the study of history happened, cinema reacted; and very soon after the government's decision it managed to respond with the first historical films.

But, apart from this, the historical film has another great role to play.

The main task facing us is to make contemporary films. And it is in the creation of contemporary films that the experience of a historical film is of colossal importance, because we would rather see a contemporary film not as a self-contained episode from the present day, nor as individual characters, but as individual characters elevated to major historical generalisation. [It is necessary] to know how to show a historical fact not as a solitary fact, but as a major generalised event.

Approaching this in *A Great Citizen*, we had to study this experience in the past, in its sweep of events and grasp of individual images and individual *personae*.[12]

So it must be said that the role of the historical film is vital precisely for making contemporary films and, generalising the experience of historical films, it should always be borne in mind that this material can be used for making a contemporary film too. It is natural in this respect to look at the way that different masters treat the materials of the historical past.

If we look at current bourgeois traditions in this matter, then we can see that on one the hand there are buskins; and on the other, a dressing-gown and nightcap. On the one hand, the past is elevated to extraordinary heights, and idealised to an extraordinary degree; and on the other hand, the attempt is made to bring it as low as possible.[13]

This is nothing new. Marx wrote about this in *The Eighteenth Brumaire of Louis Bonaparte*, and Pushkin wrote about it apropos the publication of notes by Samson the executioner.[14]

Pushkin wrote:

After the seductive *Confessions* of eighteenth-century philosophy came the no less seductive revelations about politicians. We were no longer

content with seeing famous people in their nightcap and gown; we
wanted to follow them into their bedrooms, and beyond.[15]

If we look at [German] cinema, during the years of social democracy, we
see that it was just then that the films *Bismarck* and *Fridericus Rex* enjoyed
their greatest success.[16]

There has been a sharp increase in the practice of cutting down great fig-
ures from the past to commonplace proportions. This has given rise to the
publication of intimate diaries, and also a film about Parnell, where the leader
of Ireland is shown primarily from the perspective of the amorous escapades
that led to his death.[17] He has lost his aura as a historical figure.

Both approaches represent, as I say, an artificial levelling of previous
epochs with our own.

Carlyle writes about this – and none too badly, incidentally – in his book
on Oliver Cromwell.[18]

He writes about England, for example, thus:

The Genius of England no longer soars Sunward, world-defiant, like an
Eagle through the storms, 'mewing her mighty youth', as John Milton
saw her do: the Genius of England, much liker a greedy Ostrich intent on
provender and a whole skin, mainly, stands with its *other* extremity
Sunward; with its Ostrich-head stuck into the readiest bush, of old
Church tippets, King-cloaks or what other 'sheltering fallacy' there be,
and *so* awaits the issue.[19]

Carlyle tended to heroicise the past, but he could not see leaders and
heroes in the light in which he should have seen them.[20]

I will not keep you any longer with this: you can read it for yourselves.

We have a different attitude to events and historical figures, since we can
converse with past epochs on equal terms. We do not need to reduce the
heroes of the past, nor do we need to stand on tiptoe in order to seem their
peers.

I think that the best example for understanding heroes in our sense would
be Chapayev in our cinema.[21] [Chapayev] is remarkable precisely because he
was shown as a heroic figure whom everyone felt he could identify with.

And had somebody else fallen into that same situation, he would have
been that Chapayev. The absence of buskins was one of the achievements of
this magnificent film, and contributed something new to our cinema.

The key task facing our films is to elevate our theme of the present to the
heights of historical generalisation. So far this has only been done in approx-
imation. But I must say that in many cases we have not wholly brought this
off.

What, then, is our aim when we work on film?

Pushkin once neatly formulated this aim. He asked: 'What is unfolding
in a tragedy? What is its purpose? Man and the people. The fate of a man,
the fate of a people.'

This latter is especially true today.

If we look at our films from that angle, we see a remarkable division.

Let us take *October* and *Lenin in October*.[22] Some of the elements concerning the masses and [the situation of] Petrograd in 1917 appeared in the film *October*, but there are no historical personalities or a historical leader; on the other hand, the film *Lenin in October* omits those very elements present in the film *October*. After watching the film *The Strike*, the actor Saltykov characteristically said: 'That should all have been a background for me.'

This wounded me at the time, but it has to be said that he was to a certain extent right. *The Strike* and *October* are undeniably canvases that lack a major historical figure. These days we have the major historical figure, but no historical canvas. This is particularly true of films about the Civil War.

When I had to study materials about Frunze, I was unexpectedly struck by the scale of the Civil War.[23] I realised that I had become used to seeing the Civil War in our films in the images and on the scale that our films have given it. You always have the feeling that *Chapayev* and *Shchors* are excellent; but the colossal resonance of the epoch is missing. Our films do not convey this scope. They are better at conveying the man than the historical sense of the scale of the events. When it happened that I saw real events, it seemed that 10,000 men fell in one assault near Perekop. We know that steamships left with Wrangel. I thought there would have been about a handful. But it was 150 vessels, carrying 150,000 men. If you add up the number of people travelling southwards across Russia to the northern Crimea during the Civil War, there were six million men headed for southern Russia during the Civil War.

With no disrespect to our pictures, I ask you: do our films give you the sense of such a colossal sweep of events? That does not mean that you should film crowd scenes six million-strong; but our films about the Civil War give no feeling of the scale on which these events took place.

They depict individual people perfectly, but this approach prevents us from showing the colossal scale.

What models does historical film have to learn from? I think that a brilliant work to study would be *Boris Godunov* – a national drama about Tsar Boris, which supplies two examples of depicting a character: the monologue 'I have attained the greatest power', and the famous 'the people is silent'.[24] These are the ultimate limits of the work of the solo artist and the chorus; and, furthermore, 'the people is silent' is open to several different interpretations. The fact that this passage has been discussed in the history of literature shows to what extent this stage direction gave the masses an image. I do not want to talk about how the dismembered image of the crowd, who come on at the end, has been apportioned amongst all the possible types of characters who pass through the tragedy. It is a concentration at the finale [of the tragedy]. If we measure our films against *Boris Godunov*, then it must be said that some of them incline towards the 'greatest power'; and others [towards] 'the people is silent'.

If we take *Peter the First* and *Alexander Nevsky*, it is obvious that the former is very close to *Boris Godunov*, and the latter is the opposite.[25] This happens because the films set themselves somewhat different aims. It was important to define the image of Peter and give an idea of the national movement in the eighteenth century, and this is connected with the traditions from which they came. *Peter the First* came from literary and dramaturgic traditions

connected with the activities of the author, whereas *Alexander Nevsky* fol-
lowed cinema epic. *Minin and Pozharsky* had to combine these two elements
within itself, as it drew on both literary and filmic traditions.[26]

Unfortunately, the synthesis proved inadequate but [I repeat] our films
have done much to facilitate the principal task: to construct films about the
present.

These are the general issues that I wanted to touch on here. I also want
to dwell on particular questions that have arisen within the context of our his-
torical films.

The first thing to mention is the connection between cinema and litera-
ture. A lot was said about this at one time. Now less is said, and so one should
pay particular attention to this because, if our cinema tends to fall into two
genres – film drama and film epic, then both of these are linked extremely
closely with literature, albeit in different ways. The fact is that the film epic is
fundamentally linked with the method of literary forms. You may recall that
we have spent much time thinking about metaphor in cinema and a whole
series of things connected with the internal mechanism and the internal life of
literature. When we adopt the position of film drama, then it must be said that
there the closeness of the work to literary form [is also essential]; without close
contact with the experience of literary forms, the plot of a drama cannot ad-
vance further. If we take the majority of successful films, we see that the most
successful images (and I stress this) occur when there are literary prototypes
available. Let us begin with *The Mother*,[27] *Chapayev* and *Peter the First*. Even
individual images from *Alexander Nevsky*, which were based on prototypes,
always turned out full of life. The same thing happened in American cinema.
Take the hit *Juarez*.[28] That was based on the play *Maximilian and Juarez*. *The
Trial of Zola*, which was shown in [the thirties].[29] I know this very well be-
cause Paramount's first proposal was that I direct *The Trial of Zola*. It was the
same with *The Coward*, etc.[30] Why is this so important? Because this gives the
director one possibility he would not otherwise have. If the author is the in-
terpreter of life, then the director does not only interpret these phenomena on
the basis of his own experience, he interprets the work as well. It is fascinat-
ing that a director's real creative fulfilment [occurs] when he is wrestling with
the author's conception; when he tries to comprehend, discern it. Anyone
who has worked with high-quality plays or novels will know the colossal cre-
ative enjoyment and fulfilment you feel when you analyse the various twists
and turns, guess at the [author's] intention, discover the meaning there. If we
were to consider not the image of man, but the image of an epoch, we might
mention *Potemkin*, which managed to capture a whole year, 1905. How did it
do this? Because *Potemkin*, as anecdotes about its history have made common
knowledge, was constructed from one half of the second part [of the film as
originally conceived]. But the various episodes of *Potemkin* succeeded in
amassing the generalising features of 1905. If we take the Odessa Steps [se-
quence], that did not merely depict an episode that took place on the Odessa
Steps, but an infinite number of similar episodes that typified 1905. That is,
the result was a synthetic depiction of 1905 in general.[31]

Successes in our screenplays, like *Shchors*, or *Maxim*,[32] or *A Great Citizen*
or *Lenin*, occur when the scope and time of the work are on the same grand

scale as for a high-quality literary work.

What is the Achilles' heel of screenplays? It is that they must be extremely laconic. A screenplay has to depict both the character of an epoch and the character of the *personae* in two or three decisive strokes, because there is so little time and film footage. There is a simple approach: you take stroke 1, stroke 2 and stroke 3 and you splice them together, and nothing, other than a living image, will result (my own experience has taught me this, so no objections, please). But there is another means whereby the image of a living man and the image of his epoch are created and then everything is reduced to two or three decisive scenes. I know, for example, how we spliced *Nevsky* and joined it together, but I cannot say why neither you nor I was satisfied with it. It is of course true that the part where there was to have been a Shakespearean turn in the character was cut out – the ending, to do with Alexander Nevsky's journey to the enemy. But this is a local affair, and not worth going into in detail here.[33]

It should therefore have been interpreted as a historical actor would have interpreted it. We know that in a film, an image should be created when working with an actor. Then this [invented] image can act out various situations. Does this make sense? It is not a question simply of rehearsing the five or six episodes shown in the film, but of building a person capable of performing these five or six scenes in character. And for the screenplay, it would be proper to devise a person who could then provide two or three crucial features. In relation to Chapayev's character, literary and dramatic works proved of great advantage when it came to creating a cinema image that was to outdo Chapayev's image in literature or drama.

Hence it must be said that episodic roles are often done very well in screenplays; episodic, because there is no complex character, only a couple of crucial features. So they usually work well.

All this is to say that we would remain for the most part audiovisual symphonists, were it not for the experience of literature. We have very obligingly already learned how to do this; but it does not of course satisfy us to any extent. Because, referring again to American literature, it must be said the strength of American cinema is that there are mountains of relevant literary genres behind almost every genre and every model of film play. The theme, approach and solution of some or other situational passages have already been resolved down to the finest detail. There is an unbelievable abundance of genres, and an unbelievable abundance of models within these genres. It must be said that genres in these areas – these prototypes – are not in any way appropriate in our case; but we should make our literature work for us, and think about literary prototypes that are appropriate for us.

I want now to move on to an entirely specialised question: namely, how you should rework the various elements of a historical film; how they should be made. And this is something very narrow – how to work with a historical landscape, with a character, music and the various scenes, and so on. In fact, it is obvious here that the fundamental rule to be obeyed is seemingly one and the same for all the elements, and we can begin with the simplest and the most convenient.

I shall permit myself to begin with the historical landscape – I shall talk

about my feelings on this, and cite several examples. Scenes from *Minin and Pozharsky* that stuck in my memory were when Minin stood above the Volga, and when Roman was galloping along on his horse; and also that scene from *Alexander Nevsky* showing the frozen boats. Why are these scenes memorable, and what do they remind you of? It is the feeling that they have not been perceived historically. When I saw my landscape of frozen boats and little fir trees, I could see that it might have been a market selling fir trees, or, at best, an ice-rink at Sokolniki,[34] but it certainly did not make me think of the thirteenth century.

You might be wondering what this is about, and whether you can talk about the historical feeling of fir trees, and unhistorical feelings?

There is an anecdotal story about Ilya Repin and the scholar Bruni,[35] who had criticised one of his paintings with the words: 'You've caught plenty of the genre there; those bushes are very alive, ordinary-looking, like the ones growing at Petrovsky. (But Repin had brought his *Diogenes*.) The rocks, too ... This is no good at all for a historical scene ... historical pictures need historical landscapes.' The advice Bruni gave the young Repin does not withstand criticism. He said: 'Go to the Hermitage, pick any landscape by Nicolas Poussin, and copy the part you need for your painting.'[36] We sometimes do that ourselves, but the crux of the matter lies elsewhere. What is the essence of the thing? The first question you should ask is whether the landscape has its character; only then can you say that it must have a historical image. About the image of landscape, I shall quote some passages from the young Engels. In his *Wanderings in Lombardy* (1841), Engels writes as follows:

> Where nature displays all its magnificence, where the idea that is slumbering within it seems, if not to awaken, then to be dreaming a golden dream, the man who can feel and say nothing except 'Nature, how beautiful you are!' has no right to think himself superior to the ordinary, shallow, confused mass.[37]

In another work from 1840, *Landscapes*, Engels wrote (and I apologise for quoting at such length, but it will help me say less on my own account):

> Hellas had the good fortune of seeing the nature of her landscape brought to consciousness in the religion of her inhabitants. Hellas is a land of Pantheism; all her landscapes are – or, at least, were – embraced in a harmonious framework. And yet every tree, every fountain, every mountain thrusts itself too much in the foreground, and her sky is far too blue, her sun far too radiant, her sea far too magnificent, for them to be content with the laconic spiritualisation of Shelley's spirit of nature,[38] of an all-embracing Pan. Each beautifully shaped individual feature lays claim to a particular god, each river will have its nymphs, each grove its dryads – and so arose the religion of the Hellenes. Other regions were not so fortunate; they did not serve any people as the basis of its faith and had to await a poetic mind to conjure into existence the religious genius that slumbered in them. If you stand on the Drachenfels or on the Rochusberg at Bingen,[39] and gaze over the vine-fragrant valley of the

Rhine, the distant blue mountains merging with the horizon, the green fields and vineyards flooded with golden sunlight, the blue sky reflected in the river – heaven with its brightness descends on to the earth and is mirrored in it, the spirit descends into matter, the word becomes flesh and dwells among us – that is the embodiment of Christianity. The direct opposite of this is the North German heath; here there is nothing but dry stalks and modest heather, which, conscious of its weakness, dares not raise itself above the ground; here and there is a once defiant tree now shattered by lightning; and the brighter the sky, the more sharply does its self-sufficient magnificence demarcate it from the poor, cursed earth lying below it in sackcloth and ashes, and the more does its eye, the sun, look down with burning anger on the barren sand – there you have a representation of the Jewish world outlook.[40]

... To continue with the religious character of various regions, the *Dutch* landscapes are essentially Calvinist. The absolute prose of a distant view in Holland, the impossibility of its spiritualisation, the grey sky that is indeed the only one suited to it, all this produces the same impression on us as the infallible decisions of the Dordrecht Synod.[41] The windmills, the sole moving things in the landscape, remind one of the predestined elect, who allow themselves to be moved only by the breath of divine dispensation; everything else lies in 'spiritual death'. And this barren orthodoxy, the Rhine, like the flowing, living spirit of Christianity, loses its fructifying power and becomes completely choked up with sand. Such, seen from the Rhine, is the appearance of its Dutch banks ...[42]

That is how Engels wrote about the feeling of images of nature.

It is easy to see that he has made it a twofold question: on the one hand, in this case a system – Calvinism, say – gives him a perfectly distinct, plastic sensation; on the other hand, the landscape fits into a synthesising physiognomy, a synthesising image, and it finds a correspondence to the image which the landscape is talking about; the image which the idea is talking about and which he himself is thinking about, and that is one art which we must master.

What particular task must the image play in the historical landscape? I think that one circumstance characterises the historical landscape. That is the feeling of remoteness. I think that the problem of remoteness may be embodied in the landscape because in a historical landscape the first things that must be preserved are those elements which are connected with the landscape when it is viewed from a distance; that is, one of the first conditions is a small number of details that may be seen in this landscape. That is the quick answer. Or if more detail is required, then landscape has to work in a historical picture through its generalised and generalising features.

If we take pictures by Roerich or Serov, Serov does, in essence, venture into historical pictures.[43] If you take a prehistoric painting by him, *The Rape of Europa*, and remember the landscape in it, the principal impression it leaves is of some generalising circular movements depicting the movement of the primordial sea that this charming bull is swimming in.

If we progress from this prehistoric landscape to a more historical one (*Odysseus and Nausicaa*) – the horizon is set extraordinarily low, the sea and

the smooth bank with its two figures are shown in two or four strokes and spots – then we can see that this condition of remoteness and generality has been observed once again. You could of course say: Greece – well, that's what it's like, you can't do anything about it. But Serov observes that same law in a less emphatic way when he comes to show a historical landscape with a royal hunt, where our ordinary, mundane Russian landscape is given in the same elements, brought into extraordinarily sharply defined generalising features.

If that is the aim for middle-distance works, then for close up they must preserve the same law; that is, the film must not be filled with an excessive number of defining details if it is to preserve the elements of generality.

A very curious question arises here, about the tasks of so-called stylisation in historical films. These tasks have the aim of showing the natural environment through contemporary eyes, as the people of the epoch we are portraying would have seen them.

That of course is the limit of what is permissible, and one thing here is to be avoided at all costs, namely second-hand stylisation. That is when the artist's feeling is not his spontaneous interpretation of nature at that time, as he believes it was seen, but when he uses somebody else's interpretation. We are all guilty of that: some do it in the style of Roerich, others in the style of Surikov, and this is hard to avoid.[44] Indeed, it is impossible not to think of *Boyarina Morozova* when you've got an old-fashioned type of sleigh.

But there is another question too. I ran up against it when I was travelling to Uzbekistan.[45] Everyone is familiar with Persian miniatures and the large number of features characteristic of them. A figure, sitting on a rug, stretches forwards so that the entire length of his body lies, flat, within its borders. I always thought that if you could begin filming like that, then it would be in the style of Persian artists.

But when I reached Uzbekistan, it turned out that there was no distortion of reality at all. That is merely the way the various things and objects are arranged there. And if you look directly at what you can see, there really does turn out to be a colossal quantity of things there, which you can see set out like that. [...]

If you go to an old, good teashop, and drink tea on the fourth platform up, then you will be able to see all the figures arranged like that sharply defined miniature.

If you ride out to the paddy fields, which are also arranged in terraces, you will get the same impression.

We are all used to the stylised forms of trees in miniatures – circular, oval and so on. But if you go past mulberry trees of a certain period, you will see that they have been pruned in just that way.

You can see in a miniature a ram, half white and half black; or a horse, with its patches of colouring arranged with almost geometrical precision. I must say that I have seen both a ram and a horse like that.

So miniaturists, without losing their eye for other types of painting, were able to look at the special features of points of view which were created around them.

The same thing happened with me and a painting by Van Gogh.[46] His

cottages, rivers and skies appear with absolutely pure tonality. If you find yourself in Van Gogh's native country and travel around Holland, you could be convinced that they are little short of photographic fragments, so pure the tonality and so transparent is the air there.

This aspect should not be baulked at when it is shaped by nature and not by the idiosyncrasies of one particular artist.

It is worth examining another example. If you have anything to do with landscapes of the Quattrocento,[47] you will be struck by the great size of the figures relative to the architecture, which is shown in the distance and uniformly small, never taller than knee height.

The explanation for this is that at that period they were not able to draw the elements of buildings: one door, one window, one portico. At that time, they could not separate the various elements in their all-embracing perception and the buildings had to be shown in full. And since they would not fit as they were, they had to be reduced in size, hence the effect of distance.

In this respect I have something to say about our films.

There are times when you are showing a real landscape, but its image does not correspond with what you feel. There are two pictures about the Far East: *The Volochayev Days* and *Aerograd*.[48] In *Aerograd* it is the shots filmed in the Crimea that most convey the feeling of the Far East. *The Volochayev Days* always conveys the feeling of Pargolov. You can of course tell me that the foliage and tree size reproduce the flora of the Far East precisely; but in this case as a lowbrow viewer I did not sense the character of the Far East.

The landscape in *Minin and Pozharsky* is done superbly in this respect, capturing the historical sense – the flight from Moscow, with the racing sleighs. It was done superbly. And why? Because here the sense of distance and separation is conveyed.

In *Alexander Nevsky* we tried to follow this for the city landscape, and the landscape of Pereslavl. The ultimate was achieved on Lake Peipus, with the ice and grey sky. Try to examine it when you see this scene.

Actually, if I had to film such a battle on ice – and the Red Cavalry fought roughly the same sort of battle at Bataisky, near Rostov – the need would immediately arise not to denude the landscape of details as I did at Lake Peipus, but to fill it with a wealth of details coming nearer, details in close-up.

If we are talking about foliage and tree size, a generalised tree form will be a lot of use in a historical film whereas it is the foliage that says more in a genre film.

If we take the film *Engineer Kochin's Mistake*, a fine film in relation to the genre, [we can see that] for the first time, foliage has been filmed very well in this work.[49] But the eyes would soon weary of historical films filled with foliage of this sort.

Let me omit two sections, on the historical character and the historical subject. Let us move on to battle scenes.

The greatest experience that we have gained from historical films concerns battle scenes, and since we will have to make a great many historical films with a great many battle scenes, then something can be learned now, and this should be mentioned at this point.

Battles were treated and fought differently at different stages of history.

I do not say this because the picture should reproduce the way of fighting in a given period; but so that there is a clearer idea of the principal notions.

Originally, a battle was the totality of single combats. In Mexico I saw a Spanish dance that showed how the Moors won control of Spain. Thirteen people stood in a row facing another thirteen and they moved together: those in one row engaged their opponents in armed combat, always successfully.

Then battles developed into combat between organised masses; and the third type was battle as single combat, the harmonious action of military formations using a different kind of weaponry.

There are three types of construction in this respect.

The first is when the battle is shown as a montage of the various single encounters. The last act of *Macbeth* illustrates this very well, and [there are examples] in other plays by Shakespeare. I have a detailed copy of the fifth act which shows how the various scenes follow one another, and how the various fights follow one another. There is no need to read this out now; it will be provided in the shorthand transcript.

Let us move on to the second type, the second scenario – the battle scenario, where large masses come into conflict.

Incidentally, there are some very interesting devices here, which Pushkin used to good effect in the battles in *Ruslan and Lyudmila*.

This is how it is done: the separate, different episodes are depicted as though they were one act of single combat; that is, he shows the twists and turns of one duel; he provides several battle scenes, but they are so put together that it seems there is just one duel happening – this is the battle against the Pechenegs.

> They met – and the battle commenced.
> Sensing death, the steeds reared up,
> There was the ring of swords on plate,
> A cloud of arrows hissed upwards,
> And the plain was awash with blood ...

That is a perfectly succinct opening.
The comparative element: the excited horses and the sound of the
 swords.
Then there is the upwards motion.
Then the downwards motion.

It goes on:

> The riders were racing full tilt,
> Cavalry sections were mingled;
> Unit was hacking with unit
> In a regular, close-knit block.

Infantry and cavalry. Next comes the battle with cavalry and infantry:

> Then foot-soldier grapples with knight;

The terrified steed hovers there . . .

Close examination of these lines shows a possible outcome of the battle: [whether] the knight or [the foot soldier] will be killed.

There Russian fell, there Pecheneg

The possible outcome: either the Russian or the Pecheneg died.
Then it abandons the close-up.
The reason I stress this so much is that we all tend to forget these connecting passages of middle shot, being so carried away by the intensity of a scene.
The last moment is the finale: the foot-soldier is slaughtered. But this moment is underlined with particular skill: the horse crashes down on the shield with all its force.
The composition of an entire battle might in some cases be constructed on just such an element. And when we talk about the clarity of a picture, this is precisely the kind of thing that should be remembered.
Milton's *Paradise Lost* provides examples of the combination of different kinds [of battle]. There, battles are done brilliantly from the point of view of a battle picture. I regret reading Milton after I had made *Alexander Nevsky*, as I could have taken some elements for the scene where the ice gave way.
Last, the 'triumphs' of the types of weaponry.
I had the opportunity to apply this in *Potemkin*. When cannon are before the cameras, the engines are not shown; when the engines are on, the sea is not shown; when the sea is on, the battleship is not shown. This was also observed with fairly strict consistency in the 'Battle on the Ice', both when the cavalry wedge broke through, and in the individual phases of the battle where the functions of the battle were distributed evenly. When the cavalry is winning, the infantry is kept out of view.
One more characteristic device is that of the chance participant or the civilian in a battle.
In *War and Peace*, Tolstoy provided the classic example of this: Pierre Bezukhov.
I did a scene which has not been shown: we wanted [to show] the liberation of the Winter Palace through the character of an officer. There was a lieutenant, Sinegub, who recorded how everyone left the Palace and [how] he was the only worried one. I wanted to show all the elements of the life and destruction of the Palace through him.
And also through one participant who found himself with a regiment in the Winter Palace. He was a civilian who had absolutely no connection with the battle. He was walking through the Palace, looking at things, and at last reached Nicholas's study where he found an album of titillating pictures.
Some general compositional features of a battle scene.
The first essential is a distinct sense of the images of the battle – how it is going to look. There should be a perfectly precise mental picture of the feeling that the battle as a whole must transmit, not merely as a description of the events, but as an emotionally figurative complex. Without this, the most im-

portant thing will remain out of reach and there will be no coherence in the course of the battle. Coherence in the course of the battle is the coherence of the successive phases.

For example, the conflict in the 'Battle on the Ice', which was much too drawn-out (although this was not my fault; I was not allowed to cut 200 metres), was constructed from the horn of the Germans which brought the whole mass together, to the horn which leads them off into the water. And the theme – the leitmotif of the horn – informs this whole story. And the sense of this outline was dictated by the succession of phases in the battle. It was left insufficiently distinct, since I had not been allowed to cut almost 200 metres.

The second condition is clarity: who does what to whom and when; because the majority of scenes so confuse the action that you lose track of it and do not know whom to follow. At that point you should amend the situation, from the point of view of screenplay and plot, and this is a powerful point of emphasis. Or you should pay attention to the plastic elements. In this regard, I could refer to the beautiful use of 'colour' in *Shchors*, and to the distinction made in *Alexander Nevsky* where there is always black-and-white colouring.

Apart from plastic and plot elements, there are also the characteristics of rhythm. Here I could mention the metaphorical battle on the Odessa Steps, where there is the characteristic of rhythm, both of the soldiers and those who escape to safety off the steps. And in *Chapayev* there is rhythm on the one hand, and broken rhythm on the other; that is, you can recognise the opponents not only by their surnames, but by the rhythmic leitmotif which each side has been given.

There is another important circumstance: the clarity of dislocation and of the strategic battle picture. This is what decides the fate of the struggle because, if it is not clear, then there can be an implausible mixture of ideas on stage. Here, the means of revelation are various, but the universally used means is the council of war, with people talking either looking at a map or simply clarifying what is going to happen. But we endeavoured with *Alexander Nevsky* to show this council in a different way, and we stuck to narrative. I was interested in what made Alexander think about a wedge being pressed from two sides. We spent a long time looking, looking for a material subject that could supply the basis. We even took an axe and went walking on the ice, but nothing satisfied us until I remembered the tale of the Vixen and the Hare.

It was not possible to rely on this episode as the episode that could give the picture its strategic plan. If we could have spent another month working on it, then we would have found a solution that met all the requirements.

A map can play a very important role and, if there is a map, if it is possible from time to time to show how a phase of the battle is turning out, using a bird's-eye view, that is better still. In this regard, battle pictures of all ages have much to offer, including those of Callot,[50] who showed the siege of the Breda fortress where the foreground – medium shot and close-up – showed the combatants, the middle distance had the small embattled groups, and the background had a map showing where the different sections were positioned. Cinema demands skilful montage cuts, and one should know how to make them easy for the audience.

One very important matter is that the crowd scenes should also work fig-
uratively in the shot; that is, the movement of one mass against the other, their
encounters and so on, should be done not only in close-up, but should be
clearly shown in long shots too. I learned this at my own expense. I had to re-
take an entire crowd scene, since one body was not clearly shown to be ad-
vancing or moving into the other body, and this did not give the impression
of a real fight.

A few more words about emotionality. The first thing to be taken into ac-
count is that all manner of emotional devices should prepare the way for the
battle. I cannot agree with Part Two of *Peter the First*, where the whole thing
just starts with the battle of Poltava. Seventy-five per cent of the emotional
charge that will be developed in the battle is lost to no purpose, because you
cannot expect the audience to remember everything that they saw in Part One
eighteen months ago.[51]

Well, there is no mystery about the need to vary not only the phases of
the battle but also its rhythmical characteristics. Unchallenged in this respect
is Pushkin's battle of Poltava, which can be studied as an ideal screenplay that
can be used to examine a battle.[52]

In conclusion, I should like to reiterate that our fundamental, chief and
general aim is the depiction of the present, of contemporary man, elevated to
a broad, historical generalisation. The historical film is of great use in this, and
I am certain that we will succeed in showing our great epoch thus.

17. The Incarnation of Myth[53]

This article is neither my initial thoughts on the staging nor a *post factum* attempt to justify the premises underlying the final staging.

There was not enough time for the former: I began work no more than nine days after the proposal that I stage Wagner's *Die Walküre* in the Bolshoi Theatre.

And I am sending this article to the printers while we are still rehearsing.

The plan for the staging came to me immediately after I first heard the music. This article conveys the key features of the plan in reasonably full detail, and includes the various ideas that occurred to its author during the actual period of work.

It is hard to predict to what degree these plans will be realised. Much is dropped 'en route'. Much cannot be done because of technical difficulties. Furthermore, there is bound to be some discrepancy between what is planned and what is realised. But that makes it all the more interesting to preserve intact the store of good intentions that pave the road to you-know-where.

I

A people's genius nourishes art. Genuinely great creations rest upon a national, collective genius. And only an art whose roots penetrate deep into the people can endure the centuries.

That is why we hold epic works in such profound reverence, especially those that fully embody the spirit of the nations who populate our Union: *Igor's Host, David of Sasun, Dzhangar, Manas* and works by Rustaveli, Alisher Navoi, Nizami....[54]

But our interest in national epic is still broader: it spills over our country's borders; and we can admire epic poetry created by the genius of foreign peoples.

The Bolshoi Theatre of the USSR is now attempting to bring Germanic and Norse epic closer to us. This task is all the more appealing since a great epic has in this case found a genius able to express it in music.

Wagner, who saw an artist's greatest achievement as the ability to realise a people's creative will;

Wagner, who asserted that a great, real, genuine work of art could not be the work of one artist alone;

Wagner, who wrote that 'the tragedies of Aeschylus and Sophocles were the work of Athens as a whole'.

Wagner himself, in his four-part cycle *Der Ring des Nibelungen*, did for

the discrete, epic legends of the Germanic peoples what Homer did for antiquity with *The Odyssey* and *The Iliad*, or what Dante did for the early Renaissance with *The Divine Comedy*.[55]

These themes attracted Wagner in their original form of legend and myth; in their virgin, almost prehistoric purity, and not in their more recent reworkings that were characteristic of particular historical epochs.

> I had already been drawn to the magnificent image of Siegfried, but it was only when I managed to free him from his later trappings that I was able fully to admire his purest human essence. It was only then that I saw the possibility of making him the hero of the drama: this had not occurred to me earlier, when I knew him only from the mediaeval *Nibelungenlied*.[56] . . .

Hence, unlike all the others who tried to dramatise the story of the Nibelung, Wagner's source was not the *Nibelungenlied* (a typical product of the eleventh century): he went straight to its original, almost undatable sources in the legends and tales of the *Edda*.[57]

Wagner's aspiration is fully justified, for he considered that the oldest of myths and popular legends, containing universal images and born of popular wisdom ('the people, and only the people, have always been the true creator', as Wagner wrote), may enable each new generation, each new epoch to interpret these great images historically in its own way.

By this same token, he denied even the Christian legends their original universal purity and humanity:

> *Lohengrin* too is an ancient human poem, rather than one that derives from a purely Christian perception. We err gravely if we yield to our superficial view and consider the specifically Christian perception to be the original creative inspiration behind its images. Not one of the most important, most unsettling of the Christian myths is a fundamental creation of the Christian spirit as we usually understand it: it inherited them all from the purely human beliefs of the prehistoric age and merely adapted them to suit its own particular aims. To liberate these myths from the contradictory essence of Christian thought and to restore the eternal poem of pure humanity to them – that is precisely the task confronting the researcher in most recent times, and the poet has only to complete the task.[58]

In his article 'The Nibelungs', Wagner tried to show how the idea at the core of the 'Nibelung' epic has been reinterpreted throughout the centuries.

Trying with unflagging attentiveness to realise the epic and national character in his work, Wagner simultaneously found in it universal concepts and ideas that extended far beyond merely national limits.

What general ideas were realised poetically in Wagner's works? There are the ideas Wagner held as a young man, the ideas of the revolution of 1848, a revolution which Wagner personally took part in, and whose ideas he then largely subscribed to.[59]

Of primary consideration of course is the central theme of the whole *Ring of the Nibelung.*

The curse of the 'Rhinegold', stolen from its guardians; the curse of the 'treasure and the ring' stolen in turn from gods, dwarves, dragons and heroes; the curse, manifest in a chain of murders, deaths and crimes – researchers of any background would be able to ascribe any meaning they liked – was principally defined by Wagner as *the curse of private property*:

> The myth of the 'Nibelung' allows us to trace an unusually well-defined picture, showing the relationships between all those generations of men who created, developed and enriched it, to the principal theme: the essence of possession – Property.
>
> If ancient religious notions depict this treasure as the wealth of mineral resources that have become man's domain, then later we can see it as the poeticised gain of the hero and as the reward for his outstanding feats....
>
> Nothing could be more natural or simple for the very earliest times than the notion that to each should be given according to his needs; but with the arrival of warlike peoples with a large amount of accumulated property, it was just as natural that the distribution should be decided according to the abilities of the more glorious of the warriors: their strength and courage.
>
> In the historical institution of *feudal rights*, in its initial, pure form, this principle of *providing for a man* according to his *personal* abilities and merits can be clearly seen in action. From the time when feudal rights became hereditary, both man and his *personal merits*, his deeds and actions, lost their value and the *value passed to property*. Having become hereditary, it was this property and not man's merits that became critical: man's worth diminished, while the significance of property grew....
>
> This hereditary property, and later property *in general* ... became the basis of everything that existed and could be achieved; hence it became his property that gave a man rights.... [Etc.][60]

Generally speaking, a hatred for private property informs Wagner's writings through every stage of his life. No matter that he was later to fall prey to reaction or that his works were to embody mystical and religious elements or that he was later to speak of his adolescent infatuation with the revolution in terms of a childish delusion, or that, finally, he tried, absurdly, sometimes to conceal the *primary principles* of this evil: the 'leitmotif' of hatred for the institution of private *property* invariably and persistently informs most of his writing, even the so-called purely aesthetic.

He first attacked this evil in his earliest speeches, for example at the assembly of the Union of the Fatherland (*Vaterlands-Verein*) in 1848. He called for the final exposure of 'the primary cause of all the calamities of contemporary social life'. Here he attacked property in the form of money ('the pale metal, to which we are obsequious lackeys'; 'our god is money, and our religion is the acquisition of it'). But in an excerpt taken from the 'Nibelungs',

written in the same year, he attacked the enemy, now calling it by its proper name.

In 'The Art-Work of the Future', he wrote that the task of the contemporary state is 'to preserve the inviolability of property throughout the ages, and that is precisely what has impeded the creation of a free future.'

In 'Opera and Drama', he continues the idea that it is precisely 'property which, by a strange confluence of circumstances, is supposed to be the basis of good order, but has caused all the crimes in myth and history....'

Wagner's hatred of property never wavered, even in his very last years.[61]

In his article 'Know Thyself' (1881), he again writes that 'private property, that has become the basis of state apparatus, is a stake driven into a man's body and the cause of that agonising death to which he is doomed....'

But, of course, this hatred finds its strongest expression in music and poetry – in the tragic fate of Wotan, a god who had been *enslaved by property* and condemned to carry all the curses associated with it; a god who cried out from the depths of his despair:

I have touched Alberich's ring –
I have clung avidly to the gold!
The curse I fled from
does not now fly from me:
what I love I must forsake,
kill what I hold most dear,
deceitfully betray
him who trusts me![62]

But who actually was Wotan, this uncontrollably grief-stricken god of Wagner's work?

According to ancient mythology, he was one of the trio of elemental forces of nature. Where the element of Water belonged to the German Poseidon, Chenir, and the element of Fire belonged to the German Hephaestus, Loki, Wotan was given the element of Air, and he took the place that corresponded to the Greeks' Zeus. And afterwards, when the Olympus of the ancient Germans was categorised, Wotan's role was extended to the eldest of the gods, the Father.

This is also reflected in the chief characteristic attribute of the costume he is accorded: a blue cloak, its colouring merging with the sky, and seemingly dissolving in the element of air.

Air remains his element here too. But since this element can only be perceived when it is *in motion*, Wotan also personifies *movement in general*. Movement in all its variety – from the mildest breath of a breeze, to the tempestuous rage of a storm.

But the consciousness that created and bore myths was not able to distinguish between direct and figurative understanding. Wotan, who personified movement in general and primarily the movement of the forces of nature, at the same time embodied the whole compass of *spiritual movements*: the tender emotions of those in love; the lyrical inspiration of a singer and a poet, or, equally, the warlike passions of soldiers and the courageous fury of the heroes of yore.

At the same time, Wotan is also the image of restless, inquisitive searching, thirsting for wisdom and knowledge.

Interestingly, thanks to this feature the legend pictures him as having ... one eye.

It cost him one eye to acquire the knowledge of the other world, to penetrate the secrets that lay beyond the clouds and beneath the waters.

His having only one eye was reflected in the succession of the two discs of the sun: one, at dawn, was dazzling as it ascended the vault; the other, at sunset, was mysteriously swallowed up by the watery expanses of the Ocean....

Such was that ancient god, who personified the strength and power of the human soul that are indissolubly linked with the power of the forces of nature.

But that was not the god of Wagner's drama, for Wagner, as a great artist of his time, could not show these life-affirming strengths of man and nature, human will, initiative and passions as anything other than as they were in his epoch: an epoch when all mankind was being enslaved; an epoch which he stigmatised, calling it 'a world of murder and theft legitimised by lies, deceit and hypocrisy' (1882).

So Wagner's Wotan is a character tragically enslaved: the life-giving forces of nature, mankind's will and ideas, are enchained. Fettered by the curse of an inhuman social structure. By that curse, the being who personified these forces must also have been fettered in his day and age. And another fettered giant of legend and myth springs unbidden to mind – Prometheus.[63]

But Prometheus dared to try to lift mankind to the freedom of the divinities, who could govern the forces of nature, having given mankind the primary means to do so – divine fire, which he had stolen from heaven. Wotan, on the other hand, was a god who had allowed himself to descend to the vile level of earthly passions, and to the most unworthy of them – greed and acquisitiveness – thereby consigning himself to eternal damnation.

The one had brought mankind a blessing: freedom, through fire. The other had brought a curse to the gods: the slavery of gold. One was torn by an eagle, sent by the vengeful gods. The other was torn by inner discord, forever linked with the curse of the 'Ring', the curse of property. And this is how Wagner saw the core of the drama of the human soul during his lifetime – eaten away by the vilest of curses. The only escape from it that he could conceive of lay in the distant future, once the ground had been purged by the fire of revolution. He saw the way out in the appearance of a certain man in the future whom he passionately awaited, just as Wotan was so passionately excited by the prospect of Siegfried.

'Look well upon this figure,' Wagner wrote to Röckel in January 1854.[64] 'Wotan resembles us, down to the smallest detail. He is the focus of all the intelligence of our epoch, while Siegfried is our longed-for hope of the future whom we cannot create, but who will arise from our ruin....'

In the destruction of the social order that surrounded him, Wagner saw only escape from the bewitched circle of the Ring.

The image of Siegfried, who was to save the world from the curse of the Ring, acquires a profound meaning that has not previously been read properly: a dream about a man who has thrown off the yoke of property.

Siegfried's nobility and love of life and people attain the lofty ideal of an all-pervasive humanity.

Having lost hope of surviving until the great, liberating revolution, Wagner, before his religious and mystical departures (*Parsifal*),[65] used artistic means to judge and punish the world around him, magnificently concluding *The Ring of the Nibelung* symbolically with *Götterdämmerung* [The Twilight of the Gods], a shattering image of the destruction of the world he loathed.*

Funnily enough, I entertained the idea of producing a film epic of *The Twilight of the Gods* in 1932.[66] When I was travelling through Berlin, I was even interviewed about it: the film was to show the decline of capitalist society, and I proposed to base it on the sensational stories about the recent disappearance of the 'match king' Ivar Kreiger, Loewenstein, the financier who threw himself out of an aeroplane, and a number of other sensational catastrophes that overtook the representatives of big capital.

I then found the name *The Twilight of the Gods* ironic; nor was I then wholly taken with Wagner; nor did it occur to me that Wagner's *The Twilight of the Gods* could surpass the events that we had witnessed in our country and that are inevitable throughout the world!

★　★　★

But Wagner's characters are not abstractions or mouthpieces for declaiming the author's programmatic statements. They are intriguing, multi-faceted living beings who, in addition to their philosophical significance, also embody a complex of living human emotions which are revealed in the element of Wagner's incomparable music. And so they can be interpreted in different ways. But the most Wagnerian path here would be that followed by Wagner himself in his own interpretations. For Wagner's skill in reading the fantastical patterns of an ancient epic, through the eyes of a contemporary, must serve as an example also for those trying to interpret his own works today. And of the multitude of possible interpretations of Wagner's works, the one that comes closest to the spirit of Wagner will be the one that harmonises with the progressive ideas of the present day.

The ancient myth about the Nibelung as interpreted by a man of the 1840s is especially resonant to us, the people of the 1940s, in *Die Walküre*, about which Wagner wrote to Theodor Uhlig on 31 May 1852: '... *in it, my view of the world found a particularly definitive artistic realisation.*'

Against the general background of *The Ring* tragedy, it is *Die Walküre* that contains the scenes that Wagner defined as being the most important for *The Ring* cycle as a whole, in a letter to Franz Liszt (3 October 1855).[67] These are the scenes in Act Two that depict the fundamental conflicts: the collision of the three moral and ethical systems embodied in the views and actions of

*Romain Rolland comes to exactly the same view of the idea behind *Götterdämmerung*. Citing the place in Wagner's letter of 12 November 1851 to Uhlig, where he says that the Ring cycle as a whole should be staged 'after the Great Revolution', Romain Rolland writes, '... at last he creates *Götterdämmerung*, and Valhalla, together with contemporary society, will perish in the catastrophe, giving way to a reborn humanity.' (*Musiciens d'aujourd'hui: Wagner*). (E's note)

three of its characters. It was the story of the love between the twins Siegmund and Sieglinde, Siegfried's parents, that caused the conflict.

Like any epic or myth, this story reflects (in a poetic interpretation) a particular stage in the development of social relations at the very dawn of the emergence of human society, when marriage between brother and sister was one of its most natural forms.

A prohibition was subsequently pronounced on such relations. They began to be seen as immoral. It is the cause, for example, of the tragedy of Byblis in Ovid's *Metamorphoses*.

> Byblis is an example that the love
> Of every maiden must be within law.
> Seized with a passion for her brother, she
> Loved him, descendant of Apollo, not
> As sister loves brother; not in such
> A manner as the law of man permits.

<p style="text-align:center">★ ★ ★</p>

> And yet, while feeling love so, when awake
> She does not dwell upon impure desire;
> But, when dissolved in the soft arms of sleep,
> She sees the very object of her love,
> And blushing, dreams she is embraced by him.

<p style="text-align:center">★ ★ ★</p>

> ... There can be
> No witness in my sleep. There cannot be
> Harm in imagined joy...

<p style="text-align:center">★ ★ ★</p>

> The gods forbid! Yet gods loved sisters! Truth
> Declares even Saturn married Ops, his own
> Blood-kin, Oceanus his Tethys, Jove
> Olympian his Juno...

<p style="text-align:center">★ ★ ★</p>

After long hours of torment, Byblis reveals her love for her brother in a letter to him:

> ... The servant chose
> A time appropriate, and to her brother
> He gave the secret love-confession. This
> Her brother, grandson of Maeander, read
> But partly, and with sudden passion threw
> The tablets from him. He could barely hold
> Himself from clutching on the throat of her

Fear-trembling servant; as enraged, he cried,
'Accursed pander to forbidden lust,
Be gone! – Before the knowledge of your death
Is added to this unforeseen disgrace!'

Her brother was thus more 'progressive', rejecting love of this sort, and:

Or as the frozen water at the approach
Of a soft-breathing wind melts in the sun,
So Byblis, sad descendant of the Sun,
Dissolving in her own tears, was there changed
Into a fountain, which to this late day
In all those valleys has no name but hers,
And issues underneath a dark oak-tree....[68]

The fateful plot of *Die Walküre* does not relate to that stage of the development of primitive society when conjugal relations between brother and sister were still recognised as moral, but to a *transitional* stage; that is, to a stage when *a prohibition had been placed* on these relations already but this new morality had not yet entered the 'flesh and blood' of the members of society. That was precisely the case with Ovid's Byblis: her brother, Caunus, was already adhering to the provisions of the new morality, while Byblis herself clung to the old ideals, envying the gods: 'It was better for the gods! The gods had no qualms about loving their sisters. . . .' In essence, this envy was not so much directed at the gods she referred to, as at the morality of earlier (later deified) generations; Engels cites examples of this in his work 'The Origin of the Family, Private Property and the State':

1. THE CONSANGUINE FAMILY, THE FIRST STAGE OF THE FAMILY.

Here the marriage groups are separated according to the generations: all the grandfathers and grandmothers within the limits of the family are all husbands and wives of one another; so are also their children, the fathers and mothers; the latter's children will form a third circle of common husbands and wives; and their children, the great-grandchildren of the first group, will form a fourth. In this form of marriage, therefore, only ancestors and progeny, and parents and children, are excluded from the rights and duties (as we should say) of marriage with one another, and *precisely for that reason* they are all husbands and wives of one another.[69]

The tragic story of Siegmund and Sieglinde's love reflects that historical shift towards regulated forms of marriage and to the establishment of the bases of the normal family which lay at the heart of the tragedy of Oedipus. The only difference here was that Oedipus broke the prohibition on conjugal relations between different generations, in this case between parents and offspring – a prohibition that was already in place, as we have just seen, even in

a family built on blood relationships (this is the point of the Bible story about the judgment of Lot and his daughters).[70]

Wagner has Sieglinde leave her husband, Hunding, and go to her brother Siegmund.

She thereby violates in two ways the newly created institution of regulated marriage: not only does she break up the family but she becomes her own brother's wife, which was now to be considered a crime.

And three points of view collide when her action is evaluated.

The first point of view is anarchic and recognises no laws or norms; it is the one held by Wotan.

The second point of view is that of Fricka, his wife, the Juno of ancient Germanic epic, the protectress of the home and of strict conventions and rules of human behaviour. It is a narrow, formal point of view which denies living, human emotion any kind of movement. This is a moribund and suffocating morality, so typical of the official morality of the bourgeois society of the future.

But at this stage of development of human society, this intransigence was historically progressive and necessary. And Wagner is historically correct when he shows Wotan's elemental force conflicting with it and suffering defeat. Submitting to his wife, Wotan was forced to grant victory in the combat between Siegmund and Hunding, the aggrieved husband, not to his beloved son Siegmund but to the aggrieved Hunding.

This was the order Wotan gave to Brünnhilde, the Valkyrie who carried out his will.

But Brünnhilde is remote from both Fricka's moralising formalism and Wotan's anarchic love of freedom alike. The only law she recognises is human emotion, humanity. This is the third point of view.

Touched by Siegmund's great love, his readiness for Sieglinde's sake to deny himself all the other-worldly blessings of the ancient Germanic paradise, Valhalla, Brünnhilde wilfully decides to disobey her father Wotan's order and is prepared to grant victory to Siegmund, who has violated the formal law.

But this resolution of the problem would have been unthinkable both in the conditions of ancient antiquity when this legend emerged and in the middle of the nineteenth century, when Wagner created his music drama.

As I have said, for the time when the epic was created, the formation of rules prohibiting primitive forms of family relations was a progressive phenomenon. Failure to comply with these rules was then really a punishable offence, since it inhibited mankind's advance.

But there could not have been any other resolution even in the epoch in which Wagner was working, because by that time the soulless, formal 'morality of Fricka' had become the means of crushing the free human individual; formal morality at this stage inhibits mankind's advance.

Wagner the young revolutionary fought these forces with greater energy than success, and only Wagner the musician defeated them.

Brünnhilde, the Valkyrie who represents the ideas of mankind, is of course the ideological victor in this one-armed combat.* However, as a char-

*It is no coincidence that Wagner, having first wanted to call this drama *Wotan*, later named it *Die Walküre*. (E's note)

acter in the drama, Brünnhilde (and there are two historical instances of this) is bound to be defeated. Brünnhilde becomes a sacrifice to Wotan's anger, and he strips her of her divine features and qualities because human emotions have dared to find voice within her. But Brünnhilde thereby becomes closer to the epoch which, for the first time in many centuries, took as its highest criterion the greatest degree of humanity: our Communist epoch.

The young Wagner dreamed about a time like this. He wrote in 1849:

> Perhaps you have grown inclined to think that, together with the waning of our situation today and the waxing of a new, Communist world order, history and the historical life of mankind will come to an end?
>
> The exact opposite: genuine, freely evolving historical life will only then begin. . . .

Can we, with any degree of certainty, maintain that in these remarks Wagner meant precisely those Communist ideals that had been expounded a year earlier by the founders of scientific socialism in *The Communist Manifesto* – that Song of Songs of Marxism?[71]

Of course not, because if Marx and Engels were concentrating primarily on creating a new society in place of the remnants of the bourgeois order that had been swept away, Wagner was more inspired by the rebellious spirit of the anarchic destruction of that order's loathsome institutions. And although Wagner later joined the court of a royal patron at Bayreuth,[72] we can nevertheless respond to the seething emotions of Wagner's social protest of 1848;[73] emotions that called into being his most powerful works, his most passionate dreams and statements about the future.

It was only in the distant future that Wagner saw an end to the art of which he contemptuously wrote: '. . . its true essence is industry;* its moral aim is profit; its aesthetic pretext is to entertain the bored.'

He also assumed that his dream of seeing his works realised on stage would happen in that same distant epoch:

> I find it doubtful in the extreme that my good reputation, which has now suddenly taken hold, would ever give me the chance to stage *The Nibelung*. In my view, the matter is linked to a fundamental change in the whole contemporary order of things, both in art and in life.[74]

Wagner wrote that only a great revolution could restore true art to us.

This great revolution came and opened up unprecedented vistas for art.

Now and only now can we approach a synthesis of art and that synthetic theatre of music drama that Wagner made his goal as he worked on his inspired creations.

The epic itself, and the element of Wagner's music that is indissolubly

*In this particular case, by 'industry' Wagner means standardisation and hack-work. (E's note)

linked with it, point the way towards the realisation of the idea of a synthetic, theatrical spectacle that Wagner could only dream about.

The legend that inspired Wagner was born at a time when man had not yet become a discrete part of the whole natural world that surrounded him; when an individual had not yet attained independence within the collective; when man did not pit himself against community.

Fittingly for this depiction of the epoch, Wagner had both men and nature exist on stage, equally and enjoying equal status. His conception of a synthetic spectacle, which had been dreamed of by the most eminent artists of all ages, materialises here. But only at a time when nations have been freed from the age-long curse of private property and have united in a single, fraternal union could art open up the path to a merging, a synthesis.

The entire collective of the *Walküre* production approached the solution of these most difficult and absorbing tasks with great enthusiasm.

The profound humanity of popular epic, and the magnificence of Wagner's music, filled the director, the conductor, the set designer, the fine actors of the largest Soviet opera theatre, the orchestra and the technicians alike with the joy of creation.

In this joy of creativity that the Revolution liberated, we again find an echo of Wagner, who managed, even in the years of hardship, to throw down to the centuries a magnificent challenge to life-affirming joy: 'If you meet a man who does not know delight – kill him! Anyone who finds no charm in life is unworthy of it.'

II

That, then, is how I have understood *Die Walküre*. Of course no director can avoid a derivative interpretation of the work, nor even research. However, for everyone who tries to embody Wagner's works on the stage, the be-all and end-all must be his notable comments on music: 'It sounds out, and let what it sounds out be revealed to us on stage.'

Listening closely to *Die Walküre*, immersing myself in its music, I tried to capture not only the dramatic structure of this 'most tragic of works', as Wagner called it, but also to sense how it should be disclosed on stage.

And the sense of the music dictated the way it should appear before our audience.

Acutely visual, but not a luxuriant spectacle which is not supported by the severe austerity of the libretto; a visual quality that almost approaches the tangibility of what is taking place on stage: that was what I saw as being absolutely essential to a staging of the music of *Die Walküre*.

This music wants to be visual, to be seen. And its visibility must be sharply defined, tangible, frequently changing, material.

It was not for the parts of *The Ring*, but for Tristan and Isolde, who were so immersed in the vicissitudes of their own inner experiences, that, together with an external world that no longer impinged on their sensibilities, the set design too had to appear evanescent, insubstantial, non-existent.

The reality of their surroundings, for Tristan and Isolde, floats into

illusion. Which was why the designer Appia was right to warn against using theatrical illusions to create the semblance of reality on stage.[75]

This was why the staging of *Tristan* by the former Marinsky Theatre in St Petersburg in 1909 reduced all external action to the minimum. Following Wagner's comment that almost nothing happens in *Tristan* apart from the music, the producers gave the spectacle an atmosphere of elusive, obscure generalisations.

It was the *flatness instead of depth, the bas-relief instead of three-dimensionality and the horizontal positioning of the stage mirror*, which almost became the flatness of a screen, that played a key role in creating the sense of the *immateriality and inertia* of the setting.

The dream of Tieck, the Romantic, was realised.[76] He argued against the idea that 'theatres are deep and high, instead of being broad and shallow like a bas-relief.'

But that was not what was needed to embody the first day of the *Ring* cycle – *Die Walküre*.[77] Although all activity and passion may be fettered, they may not be internalised: passion, erupting and bursting on to the exterior; passion, turning into action, into disobedience, into a conflict of wills, into combat and the thunderous intervention of the highest forces in the storm of elements and passions ('ein furchtbarer Sturm der Elemente und der Herzen' [a terrible storm of the elements and of hearts], as Wagner wrote to Liszt on 30 March 1856 from Zürich).

Reaching its highest point with the whirlwind flight of the Valkyries, the first day of *The Ring* dictates the stage resolution of *visibility, objectivisation, material tangibility and activity*. Activity, resolved on stage vertically upwards, and spatially by a rush towards the real *back of the stage*.

The activity in the stage action is resolved by the *mobility of man and set, the eloquence of the plastic* mise-en-scène, *the play of light and fire*.

That was how I first sensed *Die Walküre* on listening to the music.

And it was reassuring afterwards to find academic support for this feeling by contrasting *The Ring* to *Tristan*; a contrast that had been made by no less an expert on Wagner than Houston Stewart Chamberlain:[78]

Although formulae should be avoided, I nevertheless feel that this formula which I outlined to myself is correct in many respects.

The *Ring of the Nibelung*: visual quality – action, deed, gesture.

Tristan: intellectuality – thought.[79]

The exigencies of *Die Walküre* demand theatre that is realistic, not conventional.

And so I came to the idea of creating a spectacle that was realistic *in essence*, mythological *in structure*, epic in its generalising *forms*, emotional in the constant diversity of the musical and plastic *design*.

This enables an approximation on stage to what John F. Runciman, one of Wagner's biographers, conveyed so accurately in relation to the feeling of the music of *The Ring*:

Besides being magically picturesque, the music is also continuously in a

high degree dramatic, and it has yet another quality: it is charged with a sense of a strange, remote past – a past that never existed. No archaic chords or progressions occur, but by a series of miraculous touches the atmosphere of a far-away past is kept before us.[80]

* * *

But, speaking of the realism of Wagner's staging, you should avoid the mistake made by some (many, even), who suppose that realism is to be equated with the everyday. A realist interpretation of Wagner's works should not be understood as meaning that Nordic, Frankish or ancient Germanic daily life should be reproduced with historical and ethnological precision on the stage of an opera theatre. It is obvious that any hint of the mundane would stand in glaring contradiction to the nature of the fantastic celestial beings whom Wagner depicted on stage.

It is of course the case that the gods were created by man in his own image and likeness,* and this must be shown in their appearance and in their simplest actions. However, a great deal of the behaviour of these supernatural beings, in their surroundings on stage, calls for realism of an utterly different order.

The sensation of reality, which we want to convey on stage, is produced by a precise knowledge, not of reality and nature, but of the emotional complex that connects primitive man with the whole diversity of natural phenomena.

He sees nature as an independent, living being; now welcoming, now harsh; now echoing his emotions, now contrasting with them; now friendly, now hostile towards him.

All this was first embodied in *mythological beliefs*. Later, as primitive man attained greater degrees of cultural development, these beliefs were transformed into *mythological poems and epic*.

It is this system of images that also gave rise to the musical and poetic discoveries of Wagner's works. *Mythology and folklore* formed the catalyst that precipitated the image, characterisation and action of the event being realised on the stage.

The means of achieving this was *to penetrate not only the characters of those depicted on stage, but also the character of the consciousness that created these superstitions, images and ideas: having recreated the forms in which the creator of the myths imagined the reality, it would be possible to realise through them the content that he carried with him.*

This ensures that the form is appropriate to this fully real content of consciousness.

So we shall find a stage characterisation that corresponds to the inner meaning of *Die Walküre*.

Thus, exploiting our visual effects, music and plot in equal measure, we

*Wagner himself writes about this in his *Communication to My Friends*: 'It was not a god, but man, who created the legend of Zeus and Semele, and a person in his purely human incarnation. Who suggested to a man that a god could suffer in love for a woman living on earth? Man himself, of course ...' (Wagner, *Eine Mittheilung* ..., p. 355) (E's note)

shall be able to stir the layers in the depths of our own consciousness where thought is still powerfully imagistic, poetic, emotional and mythological. And, having stirred them, we can make them vibrate in harmony with the power of Wagner's music.

This will provide us with a system for using our means of expression, which will be subordinate to it.

III

Act One stands in opposition to the other two acts, which I have broken up into four self-contained scenes.

This is not even Act One, but the Prologue.

This is where all the plots are laid, and from where all things take their source.

It is tempting to equate it with the first prologue of *Faust* – the Prologue in Heaven – except inverted.[81]

I should stress the word *inverted* because here *it is action, and not a discussion* about morality, that serves as the content of the prologue – the remainder of the drama is devoted to an *effective discussion* of the theme of the Prologue.

And 'inverted' also because this Prologue is a *prologue on Earth*, and the action of Earth-bound people is what provokes trouble amongst those who dwell in the Heavens, in contrast to *Faust*, where the Celestial Being and Satan come to an agreement over the experiment with the Earthling.

The fleeting revolution of the 1840s put man first, set him at the apex, and Wagner gave him, man, the prologue of the first day after assigning to the god in *Das Rheingold* the cosmic foundation for the start of the whole tetralogy.

So in any event Act One is *Earth*, and Act One is a *Vorspiel** of a kind to the whole drama.

Which is why its appearance, even in terms of style, seems to stand in opposition to everything that happens above the Earth, and on the threshold of the Heavens and Valhalla during the course of the acts and scenes.

Act One is the world *seen by man, from the Earth*, the world limited by the horizon of his original superstitions, notions and feelings.

That is why the 'trunk of a huge ash tree' (in Wagner's stage direction), serving as nothing more than 'a support for Hunding's hut', grows into a powerful tree that takes up the entire expanse of the stage. Hunding's hut nestles in the roots at its base, and is the wretched dwelling for a family built upon a husband's violence to his wife. But the heart of the tree has been made ready for those who come to know true and free love in the celebration of love and spring.

This tree is no longer just a solitary trunk, made to serve as a prop for the sloping roof: it is the powerful Tree of Life, the ancient Yggdrasil of the *Edda* legends, whose trunk supports the *worlds* that shelter in its luxuriant foliage.[82]

This is how this *Welt-Asche* [World Ash]* looks, described in the *Edda* (I quote from Karl Simrock):

*In German in the original.

Its name means 'the Bearer of Sacred Horror'. And Wotan himself, in one of the ancient legends, calls himself the fruit of this tree. This tree is the most mighty and powerful of all trees: its boughs stretch over the whole world and hang far above the clouds. In its entirety, this Ash is an image of the whole world. And its crown floats higher than the dwellings of the gods – Valhalla. And three maidens live at its base. They weave peoples' fates, and they are called the Norns. Deep beneath one of the three powerful roots, pointing at the people, lurks the terrible serpent Nidhogg, who gnaws at the foundations of the Ash. The Ash's foliage is full of independent life. Here, among its branches, Heidrun the goat grazes; her milk nourishes the immortal heroes whom the Valkyries have carried up into Wotan's mansions. It is here, amongst its boughs, that one stag runs with four others through the leaves, eating the Ash's young shoots and buds. An eagle perches on the branches: an eagle who knows much. Between its eyes there sits a hawk. And a squirrel leaps from branch to branch, carrying words of hatred and anger from the eagle above to the snake below and back again.[83]

There are various interpretations of these inhabitants of the World Ash: some see it as the idea of the world's self-destruction; others as the forces of nature personified. Subterranean, volcanic forces are embodied in the serpent Nidhogg; the four cardinal wind directions are represented in the four stags; the eagle is air, and so on.

In one of the initial versions of the script, in the scene of Siegmund and Sieglinde's love duet, the tree really was transformed into a likeness of the Tree of Life – Yggdrasil. With the gradual convergence of the music and the lyrical tension of the duet, the tree grew, became covered with young foliage and came alive with flowers. Beasts and birds darted through its luscious greenery; by the end, the tree was to have been encircled by a ring of entwined bodies of countless Siegmunds and Sieglindes, who had also experienced the languor, the thrill and the triumph of love.

There was something Dantean in this conception of a gigantic tree that came alive with clusters of human bodies; now only male, wrapped in bearskins; now only fair-haired females; and now both together, intertwined.

And it was the music itself that suggested this Dantean motif: working on *Die Walküre*, Wagner wrote to Mathilde Wesendonck (30 August 1855) that he 'now, each morning, before starting work', read 'one canto from Dante'.*

'The horrors of Hell' accompany him 'on his working out of Act Two and Wotan's terrible despair'. Equally distinct are the motifs of 'Purgatory', which turns from the 'circles of Hell' into the expanding 'circles of Paradise' when the mythological tree gives sanctuary to those in love. In terms of composition, the close-knit embraces of the tree's branches seem to bring the Prologue to its conclusion.

*Wagner's first acquaintance and fascination with Dante relates to precisely this time. He was delighted that Liszt was working on a symphony on the same subject; and Liszt's 'Dante Symphony' [dedicated to Wagner – Ed.] was always to remain Wagner's favourite work: he saw in it the musical 'embodiment of the spirit of Dante's poetry in its purest lucidity'. (E's note)

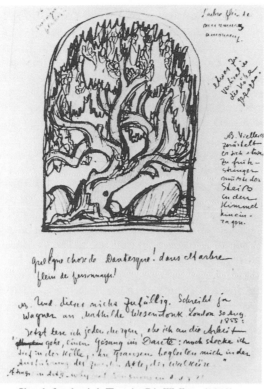

Sketch for the Ash Tree in *Die Walküre* (1940).

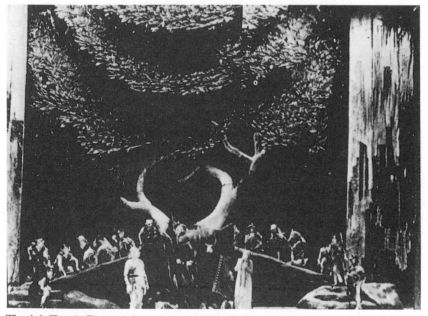

The Ash Tree in Eisenstein's production of *Die Walküre* at the Bolshoi.

An event has occurred which makes the family of gods shudder. The golden summit of a mountain, like a golden throne, then emerges from the clouds that have descended on the Earth. Wotan and Brünnhilde are on it; and the drama proper begins with the appearance of Fricka.

What is interesting is the subsequent development of the very ancient image of the tree.

The early Renaissance also provides us with images of the Tree of Life. But what is interesting is the characteristic shift in the meaning of the concept 'life'.

The *Edda* represented through the tree a *system* of the world; *a principle of life in general, an image of the process of life.*

But here the tree has been made to serve not as a framework for life in general, but as a specific, 'personal' life; one might call it a personal life story. As in everything else, the Renaissance put personality centre-stage.

Although this actual personality is only hypothetical and although the phases of its biography have primarily an abstractly mystical 'sense' and meaning, these are nevertheless stages of the 'dramatised' history of the life of a particular person.

I mean the trees in paintings of the early Italian Renaissance, whose branches and boughs are supports for successive scenes from the life of the central character of the New Testament.

Subsequent 'humanisation' leads to the trees becoming ... genealogical; that is, the influence *through the image* of the tree itself *is replaced* by the use of boughs and branches as a *schema* showing family 'branches' and inter-relationships.

This is exactly how these meanings themselves, which at one point were both metaphorical and imagistic (like all figurative words), sound less like poetic turns of phrase than purely utilitarian designations that may be found even in the language of commerce and officialdom.

A similar family tree brings together the whole of Zola's Rougon-Macquart series of novels. But in one of these novels – *La Faute de l'Abbé Mouret* – the Abbé Mouret dreams about a similar tree in all its primeval, cosmic force, and with its purely mythological power it smashes the fetters of the church's vaults and breaks out into a pantheistic freedom.[84] It is far removed from the pessimism of Garshin's palm, which broke the glass fetters of the cupola only to die from the severe frost outside; it is closer, rather, to the motif of the exuberant image of Whitman's tree which grew up to the sky.[85]

But I do not have these trees in mind. The trees that interest me are described in detail by Thode in his book *Franz von Assisi und die Anfänge der Renaissance* [Francis of Assisi and the Beginnings of the Renaissance] (Henry Thode, Berlin, 1904).[86] He found the oldest model for this tree in an ancient picture kept in the Accademia in Florence, obviously influenced by Giotto.[87] The painter had reproduced in detail a description of a tree given by Bonaventura in his *Lignum Vitae*, resurrecting this ancient image in Italy (Bonaventura himself is depicted at the foot of another and similar tree, in a painting by Taddeo Gaddi in the refectory of Santa Croce in Florence).[88]

Interestingly, this ancient model that Thode described in such detail has

our 'grandparents', Adam and Eve, standing at the foot of the tree, seemingly completing a circle of images that were familiar to Siegmund and Sieglinde.

Adam and Eve echo Plato's original Androgyne, whose *divided halves* search each other out; Siegmund and Sieglinde are the *separated twins*, pining for each other until fate brings them together in Hunding's hut.

There is a very poetic and modern variation on this theme in Maurice Maeterlinck's *The Bluebird*.[89] It comes from the scene 'The Kingdom of the Future', which is not performed on stage, in the shape of the two 'insep-arables' – those two still 'unborn souls' fated to enter the world separated and to search for each other in it.

Péladan (*Les Idées et les formes* [Ideas and Forms]) considers the Chinese to have the oldest conception of this image; it is set out in El-Ya's dictionary, which Plato might have known of in a Greek translation; and Moses, via the Egyptian [translation].[90] But it is hardly necessary to link this circle of fam-iliar images by a chain of 'borrowings'. It is far more reasonable to suppose that an identical level of social development, when the same phenomena of nature and reality came into collision, gave rise to similar conceptions and no-tions. This is brilliantly proven by the works of Professor Marr in the area of language.[91]

* * *

Only at the end of Act One does the image of the tree grow into a pantheistic emblem of the creation, as it appeared to primitive man. But throughout the whole of Act One the tree does not embody the whole *image of the creation*, but only the *spirit of nature* that is all-pervasive.

But as we have established, this spirit is Wotan.

So, throughout Act One, the tree is Wotan.

In a pantomime representing Sieglinde's story about her father, Wotan emerges from the tree's trunk and hides in its crown. However, the tree is as-sociated with the theme of Wotan a long time before this happens. We can sense this as early as Siegmund's story ('My father has vanished'), which magically attracts all the characters to the mysterious rustling at the crown of the tree: this rustle alarms Hunding and also causes Siegmund's and Sieglinde's passionate impulse – not towards each other, but towards the mysterious force of nature that leads to their embrace.

This theme is emphasised in the scene where Siegmund is left alone. Siegmund reproaches his father for not fulfilling his promise to help his son, and the tree seems to want to speak; a rustling moves through the crown of the tree, with a blur of light: the foliage nods, the trunk mysteriously becomes incandescent, the crown of the tree is illuminated by a wondrous light, and the miracle-working, all-conquering sword – Notung – arises from the very core of the trunk. The tree's – Wotan's – performance reaches its climax when it merges with the theme of spring in an image of the creation of the world, and opens up its centre for Siegmund and Sieglinde's ecstasy of love.

The image of tree as divinity is one of the commonest images of mythol-ogy worldwide, and we can find countless examples of this in Chinese or Greek, Siberian or Australian, Mexican or ancient Germanic folklore. There

is volume upon volume of descriptions and research about this. Let us here just recall one of them which relates to one of the oldest of world mythologies – Osiris, to whom the ancient Egyptians attributed a position comparable with that of Wotan. Frazer writes about him in *The Golden Bough* (Vol. II, Ch. 4, in the English edition):

> But Osiris was more than a spirit of the corn; he was also a tree-spirit, and this may perhaps have been his primitive character, since the worship of trees is naturally older in the history of religion than the worship of cereals. . . . The character of Osiris as a tree-spirit was represented very graphically in a ceremony described by Firmicus Maternus. A pine-tree having been cut down, the centre was hollowed out, and with the wood thus excavated an image of Osiris was made, which was then buried like a corpse in the hollow of the tree. It is hard to imagine how the conception of tree as tenanted by a personal being could be more plainly expressed.[92]

All mythologies are full of people who become trees and trees who become people.

The solitary Cypress, or the story of Philemon and Baucis.[93]

> . . . when age
> Had enervated them, with many years,
> As they were standing, by some chance, before
> The sacred steps, and were relating all
> These things as they had happened, Baucis saw
> Philemon, her old husband, and he, too,
> Saw Baucis, as their bodies put forth leaves,
> And while the tops of trees grew over them,
> And while they still could speak, they said, 'Farewell,
> Farewell, my own' – and while they said farewell
> New leaves and branches covered both at once.

Shakespeare's *The Tempest*, or the ironic interpretation of this idea in Charles Sorel's *Le Berger extravagant* (seventeenth century), right up to Robert Eyre's 1938 novella *Mr Sycamore*, where a *postman* turns into a tree![94]

It would perhaps be apposite here to recall the will of the American Michurin – Luther Berbank – in which he asked to be buried beneath a mighty fir, so that 'this tree might draw upon my remains and he would continue to live on, in the image of this evergreen.'[95]

I could conclude this digression about trees by recalling that they are all particularly close to the *Edda*. That legend holds that the first people on Earth – Ask and Embla – were created from two trees by Wotan and his brothers.[96] Wotan gave Ask and Embla a soul and life and his brothers gave intelligence, the desire to move, a face, speech, sight and hearing.[97]

The role of the tree, mirroring all the twists and turns of Act One, continues into the next act too, involving mountains and cliffs. Thus, during

Siegmund and Hunding's fight in Act Two, the cliffs lift the enemies up and collapse beneath them before finally lowering Siegmund's corpse to the ground. And the sky, across which Wotan floated in a black cloud, enters the action straight after the cliffs. In Act Three, trees join in, falling at Wotan's feet and then rising up once more.

Nature's participation in human affairs is shown to particular effect in the opera's last scene. Here the emotion of the characters, poured into the element of music, is personified by a fire which engulfs the entire firmament.

Tongues of flame, the transition of shades of fire, the bubbling volcano and the bronze portals glimmering with reflected fire – all these follow the movement of the music, blend with it, to create a picture of the sound and colour of the final magic of fire (*Feuerzauber*). The idea running through the whole spectacle – the synthetic merging of emotion, music, action, light and colour – here perfects the image of 'non-indifferent nature', as it appears to man's imagination in the process of creating legend and myth.

The attempt to enter the structure of thoughts and feelings of such a man evokes a series of other elements within the production, which anyone used to traditional and orthodox productions of Wagner's works will perhaps find surprising.

This is primarily the *visibility* of everything spoken about or at least mentioned during the course of the action.

For mythological thinking, stories are as material as facts themselves. And this is because at this level of consciousness it is not the *actual fact* that matters, but primarily the *corresponding emotional complex* that this fact creates. Under hypnosis, we too can experience that level of consciousness where a few words from the hypnotist describing a real fact, rather than the fact itself, are enough to create a valid, emotional experience.

But surely the features of this consciousness have been retained in creating, where a chance word can evoke a whole series of concretely sensible images, actions and events?

Thus in Act One (and precisely in this most earthbound and human of the acts) there are pantomime visions, whose purpose is to give visual expression to Siegmund's stories – vital to our understanding of the action – about a girl whom he tried to save; about Wotan's appearance [on Earth]; and about the sword which he [Wotan] stuck into the 'old trunk of the ash tree'.

This sword shall belong to him
Who is strong enough to tear it out.

Curiously, in this respect I have followed in Wagner's footsteps, because the plot of *Die Walküre* itself in the original conception of *The Ring* was no more than a *story included in 'Siegfried'*.

Wagner himself wrote eloquently in his letter to Liszt of 20 November 1851 about how these stories that were originally concerned with actual events later evolved into an independent dramatic work.

According to him, he reached this 'necessity' not only from the very

'depths of [his] artistic convictions' but chiefly 'as an artist, overawed by the effect of the plots of the stories themselves'.

★ ★ ★

And thus another element of the spectacle comes into being – the idiosyncratic *mime choruses*. Their purpose is to represent the various references and thoughts scattered throughout the whole work.

So the massed flight of the Valkyries becomes a spectacle: quivering, winged warrior maidens surround Wagner's eight Valkyries in the scene of Wotan's wrath; they form the funeral procession after his parting from Brünnhilde.

Fricka arises in the midst of the rams who speed her chariot along. And floating ahead of Hunding is the huge, many-legged and shaggy body of his pack of dogs, filling Sieglinde with terror and horror as they chase her.

This should also extend to the treatment of the inner conflict of the characters, sublimating these internal experiences into actions and deeds.

And I think that the 'immobility' of which Wagner was accused in *Die Walküre* owes much to the fact that in the first stage versions no attempt was made to transmute the characters' passions into song, or even into action – into deeds, movements and displacements. And I have tried here to bring to the surface this entire complex of inner emotions and the mutual relations that grip Wagner's heroes, and to make them plastically tangible and visible. Such are the mutual relations within the 'triangle' of Act One: Wotan and Fricka's dialogue. The scene of the pursuit in Act Two. It is not for us to judge whether this added any dramatic dynamism to the action: the audience will determine whether we were right....

★ ★ ★

The intent behind the introduction of mime choruses was to convey one more feeling that was characteristic of man at the time when epic was born, namely that man does not yet see himself as an independent unit, apart from nature, as an individual who has acquired independence within a collective.

And so, at certain moments, a number of characters are wrapped up, as it were, in the appropriate choruses and seem inseparable from them, resonating at the same time with them, experiencing the same thing.

Thus Hunding thinks in the way you would expect of a representative of the coarsest, most atavistic level, of the kind that is closer to a pack, a flock, a herd. That is why he comes on, surrounded by the many-legged, shaggy body of his pack – a body that seems like a pack of hounds when supine, but when standing appears as Hunding's entourage – relatives, armour-bearers and servants.

Fricka, his protectress and defender, appears amidst the golden-fleeced chorus of half-rams, half-people, neither domesticated animals nor human beings, who have betrayed their personal passions and voluntarily assumed subject status instead.

Softened by Wotan's lyrical attitude towards the amorous escapades of

his son and daughter ('But are they at fault, now that spring is here?'), they extend a cautious hand to Fricka, begging her not to judge Siegmund and thereby invoking her wrath. But in addition she addresses her tearful (too tearful, to be sincere) complaints about Wotan's inconstancy to these golden-fleeced confidants, between the outbursts of jealous rage which come much more naturally from this powerful goddess who secures Siegmund's death. Fricka's shattering reproaches petrify them. And they, at last, prostrate themselves like vassals before hastening her angry and victorious chariot from the stage, to the whistle of her whip.

A third image stands in contrast to Hunding's pack and Fricka's retinue – that of Wotan, whose warlike spirit, indomitable will and enormous mental energy also seek a broader embodiment in an equally idiosyncratic chorus. This mime chorus even has individual singers – soloists.

And if the body of the first two mime choruses to come to Earth forms a layer on the Earth's surface, then Wotan's ungovernable spirit is embodied in the warlike images of the Valkyries, and whirls them upwards, far beyond the clouds.

Indomitable and wild, like their father – the Valkyries are the embodiments of Wotan's will ('What are you, but the weapon of my will?' he asks), and first and foremost among them is his beloved Brünnhilde, who rebels against him.

The thought that led to these mime choruses being given a part on stage simultaneously dictated the character of their behaviour as well.

Virtually representing, as they do, the life, emotions and will of *one* dominant character, *distributed* amongst a group, their actions echo his without being individualised or personified. They *echo, without acting*, collectively: it is only the ebb and flow of clashing emotions that bind the various representatives of groups to their plastic leaders who sometimes break up and sometimes weld together the various groups, but in such a way as never to break away into the colourful 'genre' of independent 'mini-scenes', but always to present a single body, a united chorus, without losing the key feeling – a fluid unity with the thoughts and emotions of the central person, whose undulating agitation flows over them.

This must be particularly clearly conveyed in the performance of the Valkyries in Act Three.

IV

But one more particular task faces these choruses in a purely plastic way: they must serve as a kind of group connecting link between the individual human being and his milieu; that is, between the soloist and the material organisation of the stage space.

Coming on as an undifferentiated, mobile mass between the immobile mass of the set and the individualised, mobile soloist, they form a kind of intermediate link to create the plastic unity of the spectacle.

And it is not easy, in the final analysis, to say which of the motives I have mentioned proved decisive for the introduction of mime choruses into the action – it was probably the combined effect of them all.

In any case, this last motive played a key role. Looking at photographs and studying descriptions of earlier stage productions of Wagner, the inescapable impression is that the people brought on stage, the people of the nineteenth century, were far removed from the people of the myth, the legend of ancient times, whose secret Wagner managed to penetrate!

A bourgeois person of the capitalist nineteenth century was always alone, always isolated, living in hostile insularity from his neighbour and his surroundings, out of harmony with the world and in irreconcilable discord with human society. That is how these people looked, dressed in their plumed helmets. They underlined their hopeless insularity from their stage surroundings with the real fur of their costumes and their weapons gleaming like household cutlery.

What I wanted to achieve in my plastic treatment of this spectacle was to overcome this rupture, to have, in contrast, *the unity of the original harmony* between man and his surroundings.

But this general sweep of action should extend into the theatre itself, rather than be confined to the stage. Yet this was to be done not by entrances and exits 'through the auditorium' or by interweaving the audience space with the acting space, but by welding together, through sound and form, the two collectives participating in the spectacle: the actors and the audience.

Spatially this problem was solved by a tree, whose branches extended under the roof of the auditorium, floating above the traditional 'harlequin'.[98]

In terms of *sound*, I saw the resolution of this problem in the following way: the music of the 'Ride of the Valkyries' should envelop the entire auditorium via a system of loudspeakers, reverberating 'as if in flight' from the rear of the stage to the back of the auditorium and back; and roll around the auditorium, up the steps and along the aisles and corridors. But I was not able here to overcome the traditions of the opera theatre!

The third means of merging things – *light* – was applied during the finale of Act One: the golden rays of Siegmund and Sieglinde's rising celebration of love shone into the auditorium.

<p style="text-align:center">★ ★ ★</p>

But it was not just these choruses and rides that had to unify music and stage. Nor the movable sets, which played a direct part in the performance: the mountains that wrestled with the heroes; the tree, trying to speak through the rustling of its branches; the fire, enfolding Brünnhilde in its embrace.

Penetrating far more deeply, the successive 'runes', marked out by the actors' stage movements, had to bind together the fate of man on stage with his environment.

I did not call them 'runes' – the marks of ancient Germanic script – by chance, or mistakenly, for the *mises-en-scène* of such a spectacle would have to be as superficially simple yet internally complex as these signs which have simple outlines but are imbued with profound meaning and content.

That was why the content and the most plastic outline of the spatial movements had to be taken far beyond the confines of the ordinary 'separation' of artists in an opera and had to *embody the content within its actual plastic form* and the unity of the drama, which encompassed equally the play

of the light and of the orchestra; the performance of man and the play of passions raging within him.

Here, as perhaps nowhere else, the *mise-en-scène* had to become more than the simplest, utilitarian necessity and attain the level of genuinely agitated *plastic speech*; *the plastic speech* of the performers who change places in their relationships *with respect to one another*, with respect to the *spatial environment*; with respect to *the flow of the musical element* that is broken up by their movements.

So here the *mise-en-scène* is purely poetical, or, in any case, that is how it should be. And its poetry should be primarily *figurative and musical*, springing from the same ground as the music, the drama in the speeches, the words that are uttered and the eloquence of the phrasing.

Hence the equally strict system of 'plastic leitmotifs', which intermingle with the leitmotifs of the orchestra.

Hence the orchestration of plastic actions and movements that is as strict as the music.

Hence the harmonic regularities: the plastic repeats, the 'reprises', the thematic divisions, the motifs elaborated plastically, and the harmonies of counterpoint.

Hence the spatial and figurative complexes, preconditioned by the different themes of the action. Complexes that can be sensed almost completely, but which at the same time remain images that are discernible primarily to the senses rather than to the intellect.

Hence the plastic subtext of symmetry echoing the theme of the twins in the first and second acts.

Hence also the theme of Wotan's gradual submission to the will of Fricka and the tragedy of the fallen Wotan.

★ ★ ★

A similar approach to the *mise-en-scène* and the plastic pattern of the action, born of the music, acquires a particular importance in view of the Bolshoi Theatre's stage. Here, the orchestra is not hidden from the audience, as at Bayreuth.[99] Instead it occupies the gaping 'jaws' of the divide between actors and audience. And if it unites both, through the magic of the music, physically it keeps the two far apart. I could not help remembering Grock, the famous musical clown, and his best trick where he warily approached the ramp from the back of the stage and looked down into the pit.[100] He would repeat this movement, in a state of horror, twenty times or so, each time differently, and say in the utmost panic, with unsurpassable comedy, the same phrase over and over: 'I looked into the abyss...'

But somehow or other the sense of the actor's feelings and actions has to carry across this 'abyss'. And here a figurative *mise-en-scène* can plastically resolve that which lies ultimately beyond the scope of the quivering nuances of mime and gesture.

So, without lapsing into stasis, immobility and the semantic hieroglyphs of an ancient mask, a figurative *mise-en-scène* can enable you to solve a portion of the problems previously solved by the ancient mask.

However, the very severity of a *mise-en-scène* understood this way has another, extremely important, aim.

Using the system of plastic action to break up utterly the flow of music, this *mise-en-scène* even manages to divide the different expressive phases of the general flow of sound, with a system of 'close-ups' (as we would say in cinema!) in relief.

In this visual presentation of the individual successive musical links, the actual *music begins to take on that visual tangibility* which is also a production principle for *Die Walküre*.[101]

These are the first experiments to be conducted in this area, but I think this should become part of the production method for operas, and not only for Wagner.

<p style="text-align:center">★ ★ ★</p>

The set should serve not simply as a decoration or adornment for the stage, not only as an indication of where the action takes place, but also as a synthesis of the whole poetic play of plastic transitions that is to come and for which it serves as the basis.

And, being so closely connected with them, it should be not merely *superficially expressive* but, more important, it should have a *figurative meaning*, which emerges from the depths of its *inner content which it has been devised to portray*.

And just as the incomparable music, bringing to life all the events in the drama as a whole, provides an aural support for the plastic action, so another such support is needed.

Such a basis for the action which is connected with it by a thousand threads, hundreds of plastic motifs and movements (partly movements which are picked up and, so to speak, extended by the set; partly those which, to the contrary, are created by the set; and partly those which unify the actors and the set) – a set of this kind could only be solid and three-dimensional. And at the same time it could not be constant and unchanging because that would fundamentally contradict Wagner's eloquently shifting music element. And Wagner maintained that 'the true essence of the world is encapsulated in its infinite variety'.[102]

The idea of the set as a figurative basis for the dynamic bearer of the actor's thought and feeling, which would plastically embody the dramatic content of the music, determined the shape of the set.

The sets would have been the part of the one dynamic whirlwind that the music had brought to life; the part destined to solidify into the expanse of the stage with its platforms and colours, steps and precipices, surfaces and flats, in order to support the performers' actions and movements.

Exactly as the dramatic whirlwind of the theme hovering before Wagner's spiritual gaze found voice in the brass, woodwind and string sections of the orchestra and provided the overall basis for the entire action of the music drama as a whole.

Hence in my sets I tried to come as close as possible to architecture, in the sense that Goethe understood it: he saw it as 'frozen music'.[103]

This requirement (which flowed organically from Wagner's music) of the sets places the director and the designer of the production in a completely unique relationship one with another.

Here they virtually echo the same complete merger that Wagner himself demanded of the musician and poet, librettist and composer, for the creation of an opera.

Ideally, this would be one person.

Like Wagner himself.

In my collaboration with as accomplished and excellent an artist and theatre technician as Pyotr Williams, we reached such a profound understanding of each other that it seemed that we achieved the complete unity of the plastic and figurative sound of the production's dynamic as a whole.[104]

We achieved a similar harmony with Wagner's music – but it is for the audience, not us, to judge this.

But ... I shall stop here. I shall not lift the last layers and expose the secrets of all the details, intentions and schemes, or 'tear off Isis's last vestment'.[105] I shall not use 'interpretation' to bring into the realm of reason what properly belongs to emotion, and which was intended to act upon the emotions and to speak to them directly.

I shall follow Wagner's counsel in this too:

I suppose that it was a perfectly true instinct that saved me from an excessive yearning for clarity. I see distinctly that too frank a revelation of the author's intention may merely cloud one's understanding.[106]

★ ★ ★

One more feature demands comment. It seemed to insinuate itself into the interpretation of the faces and the style of the production, spontaneously and almost of its own accord. This was the note of *Hellenism* that sounded insistently. In the treatment of Fricka, in the Valkyries' helmets, in which chicken feathers were replaced with a severe pattern in bronze, in the shields and in the structure of the groups, in the severity of the cut of the cloaks, this 'subtext' of ancient mythology was everywhere discernible in the original Germanic myth.

I think that we were right to let this note be heard. Not only because this had the effect of extending the sense of myth still further, taking it beyond national boundaries.

Not only because the sense of understanding a myth *per se* is, for us all, inseparably linked with associations of antiquity.

But particularly because saw the epic uniqueness of these myths as one profoundly affected by the spirit of antiquity, the spirit of Hellenism.

In the most diverse myths and legends that underlie his works, Wagner always saw their Greek antecedents. In his *Communication to My Friends* he wrote:

We have already seen that the chief features of the legend of *Der fliegende Holländer* [The Flying Dutchman] are clearly in evidence in the Hellenic

Odysseus: Odysseus, rushing to tear himself free from Calypso's embraces and fleeing Circe's charms, was searching for the woman who was human and dear to him and of his homeland, who expressed the basic elements of a desire familiar to the Greek spirit: the desire that we rediscover in *Tannhäuser*, but in an infinitely intensified form, enriched with new content. In exactly the same way we find in Greek myth of not particularly ancient provenance the key features of the legend of Lohengrin. Who does not know the story of Zeus and Semele? The God loved a mortal woman and, because of this love, appeared before her in human form. But Semele learned that her admirer had come to her in an assumed form and, overcome by an access of genuine love, asked her husband to reveal himself in the whole sensual briliance of his essential being. Zeus knew that he would have to leave her, that his real image would mean her destruction. He was racked by the knowledge that Semele's fatal demand would have to be met. He carried out his own death sentence when the brilliance of his godly appearance, fatal for humans, destroyed his lover.[107]

In *Opera and Drama* he devotes whole pages to an analysis of the characters of Oedipus and Antigone.

He treated the orchestra as an extension of the role played by the chorus of ancient times.

And finally his entire conception of a single, organic spectacle that *synthesised* the whole commonwealth of the arts appeared to him as a kind of more elevated *recreation of the original harmony that existed in the merging of the arts in Ancient Greece.*

The profound link between Wagner's world view and aesthetic opinions and the ideals of antiquity informs all his works. Anyone who is interested in this problem can find much that is fascinating on this topic in research by Georg Brashovanov, *Rikhard Vagner i antichnost'* [Richard Wagner and Antiquity].[108]

It was enough for the producer to experience the sensation that affects Wagner's works themselves above all and, if you like, those few lines that Wagner wrote to August Röckel, apropos *The Ring of the Nibelung*:

I formed the conception of this work when my concepts of Hellenic optimism had crystallised into an entire world.[109]

★　★　★

And in conclusion, perhaps there is one apparent contradiction that needs to be straightened out.

Why did a *film* director *stage* Wagner?

Of course, it was not because it would have been easier for a film director to overcome the notorious 'stasis' of Wagner's opera.

At best, that could only have justified *inviting* a film director to do this.

But what made him actually *leap* at Wagner?

It goes much deeper, and strikes at the principles.

It is closely connected with the *problem of a synthesis of the arts,* which I have touched upon a few times already in the course of this article, and, in particular, with the problem of creating an *internal unity of sound and vision within the spectacle.*

Audiovisual cinema is thinking about these problems and experimenting, and it has amassed a fair amount of experience (various fragments in *Alexander Nevsky,* such as 'the knights' charge', or some scenes from an animated film, such as Disney's *Snow White*).[110]

Not much has been done in this direction.

And the creative encounter with Wagner is of twofold interest here. First, the experience of audiovisual cinema enables the execution of the special tasks that face the producer of a Wagner opera on stage.

And, second, because of the nature of Wagner's music, these same tasks would be bound to create a whole series of audiovisual problems, and to solve these would be extremely rewarding and could, in its turn, enrich sound cinema, especially by the time that this cinema starts to become not simply audiovisual, but even in colour and stereoscopic.

Wagner's unusually *figurative music* poses with particular acuteness and complexity the question of seeking and finding an appropriate *visual image.*

And the unusual emotional saturation of this music makes this problem particularly fascinating, exciting and creative.

The encounter between Wagner's music drama and the element of audiovisual cinema benefits both immensely.

Born of the traditions of theatre, the early aesthetic of cinema was at first amorphously merged with theatre.

At the next stage, it set itself up in sharp opposition to theatre, ruthlessly abandoning everything that might serve as a reminder of it, right down to the continuous plot of drama and the performing, human actor.

And so, after a period of intensive 'retheatricalisation' of cinema, which is just as great a bastardisation as the mechanical 'cinematographisation' of theatre, there comes a new, beneficial cross-fertilisation of film and theatre at the juncture between audiovisual cinema and Wagner's opera, where the independence and difference of both are unchallenged, but where both are used to solve more and more new problems.[111]

It is not for me to judge how successfully the film director has achieved this in practice, directing an opera in a theatre: the Soviet audience will have the final say.

18. Twenty Years[112]

If someone were to commission me to write a history of our cinema, I would approach the task not as a historian but as an artist.

A war artist.

I would unfold a succession of broad canvases showing fierce battles.

In the first place, there would stand the united armies of new, revolutionary ideas, fighting against the old, reactionary ideas; large crowd-scenes in long-shot [*obshchii plan*].

There would be bloody encounters between the different regiments, for example the so-called Moscow and Leningrad schools, or poetic cinema versus the prosaic, etc.

The fighting would be all the more brutal since, as they were heading for the same final goal but taking diametrically opposed paths, each of these regiments would have been obliged to reveal its strategy: medium shots [*srednie plany*].

There would have been clashes between the various detachments, fighting over this or that redoubt or position, especially over the more sharply accentuated tenets of principle: close-ups [*krupnye plany*].

There would have been scenes of single combat between the standard-bearers of this or that particular and partial problem where no quarter would be given.

Frenzied combat. For, posed in a one-sided manner, these problems are not recognised as being equally necessary, when the time comes for a high-quality synthesis of all the different elements and varieties of cinema.

And this picture would show the most stubborn battles – those at night. Silent and invisible. No projector rays of polemic or debate could pierce them. This is no longer one against one, 'against the enemy'. But each versus himself. The most brutal combat, in order to wring out of oneself, to 'purge' oneself of, the last traces of what is dead or alien; what holds you back rather than draws you forward; what leads to defeats, and not to victories.

There would be the broad waves of forward rushes and the ebb of partial repulses. There would be the single flights of individual illuminating thoughts, moving far beyond the general movement of the mass of troops as a whole.

And there would be the invariably constant, unstoppable movement of the collective advance, the unerring movement of the collective experience, which is always right and is always moving forward.

That is the last and uniquely dependable support for any solitary combatant – no matter whether he has rushed too far forwards, or fallen to the

rear, or has been knocked to one side, away from the general, historically correct way forwards.

I would use bold strokes to mark out the general direction of this unswerving movement towards the final goal.

And I would mark on it the network of branches and intersections followed by the various armies, detachments and units.

I would use spots of light on these paths to indicate new thoughts, new ideas, born of our unique time.

But I would not fail to point out the dead ends on this path, where some overheated imaginations wound up. Nor would I leave out the pitfalls. Concealed with the brightest colours of triumphant self-deception, they sometimes filled up with stagnant water and it would be difficult to pull yourself out of its deadly embraces once you had fallen in.

As the final goal, I would identify the citadel of Socialist Realism, where these armies, detachments, people were heading – even though they often were not aware of it themselves, sometimes following an imaginary or inaccurate compass, or even working against their wishes for the inevitable advance of the mass. Because these twenty years of movement in Soviet cinema have unswervingly led to the final victory of Socialist Realism in cinema.

It has appeared to us in different forms at different times in the history of our cinema.

But always – albeit vaguely, often elusively, but always inexorably – we saw it as the final goal, the final ideal, the crucial internal tendency of the whole varied, incomparable, unforeseen and unexpected work that our filmmakers were engaged in.

For it was always and invariably the chief and decisive task facing every film-maker to reflect our socialist actuality with his full creative powers, no matter how baffled he might be, on occasion, by the prospect of representing this realism.

A wealth of personal creativity has not always meant, at the same time, a complete, well-rounded reflection of reality.

And as well as the closest possible approximations to genuine Socialist Realism, the past twenty years have also brought with them a whole cavalcade of fantastically varied 'realisms' which are seen in a two-dimensional, one-sided way – not as a synthesis.

But we are confronted by an equally strange picture if we look at the succession of styles and the struggle of tendencies in the other, non-cinematic areas of the history of art in general.

Each school, each tendency has negated and rejected the preceding one with one and the same battle-cry: draw closer to reality. The whole question was where and how they perceived this 'crucial' reality.

They dismissed the conventions of the preceding type of 'realism' with the slogans of a 'realism' that had been understood only partially, and differently each time.

And, being successful in this in one area, they simultaneously paid a forfeit in terms of the new strict conventions demanded in others.

... Alfieri has a keen sense of the comedy in the asides; he slays them. But

then he goes and drags his monologues out, imagining that he is revolutionising the system of tragedy; such childishness! (Pushkin, writing to Rayevsky.)[113]

Perhaps the succeeding tendencies do not call themselves 'realisms' – indeed, it is often quite the reverse – but consider such diverse phenomena as Zola's Naturalism and Mallarmé's Symbolism, which aspired to that same one true reality at different times. The point of it all is that the one saw a better approximation of reality in the hypertrophy of the individual at the expense of the general, while the other built his feeling of 'realism' solely upon the nuances (which are, indeed, completely real) of the emotions of verbal and figurative combinations of sounds, at the expense of any concrete reality in content and meaning.

Impressionism saw reality only in the single and unique occurrence, a fleeting aspect of a phenomenon caught. And 'Academicism' only cedes the laurels of Realism to the 'unsurpassable' materiality of a phenomenon that has been stripped of all its fleeting outward appearances, and momentary 'optical' transformations, which do not alter its briefly stated 'essence'.

One tendency in painting, wishing to convey as much reality of movement as possible, has reached the point where it depicts 'eight-legged' people, and calls itself Futurism.[114] Another sees the sole reality of pictures in the physical material of the paints put on the canvas; and a third, taking this a logical step further, calls itself 'Tactilism' and proselytises a new method for perceiving such 'realities': examining pictures with the aid of touch – prodding it with your fingertips.[115] True, none of these three movements calls itself Realism. And Fernand Léger, seeking to justify his conceptions which were at a considerable remove from Surikov's or Serov's, directly invoked his right to his 'own realism' which resulted from the 'fluidity' and 'changing face' of 'realisms in general'.[116]

Each epoch has its own realism, called into being (! – SME*) to a greater or lesser degree depending on preceding epochs. Sometimes they stand in contradiction to them. Often they take their line and extend it. The realism of the primitives was not the same as the realism of the Renaissance, and Delacroix's realism is diametrically opposed to Ingres's (see: *The Painter's Object*, London 1938, p. 15. A collection of writings by Picasso, Léger, Ozenfant, Max Ernst, de Chirico and others, setting out their artistic aims).[117]

In the name of the reality of what happened on stage, 'pseudoclassicism' forced the action on stage into the straitjacket of the 'three unities', straining one's credulity to breaking point as it brought into the same place and time things that were incompatible in time and place.

See how boldly Corneille acted with *Le Cid*. Do you want the 24-hour rule? Be my guest! – and then he piles on enough events to last four months.[118]

And elsewhere, talking about *Boris Godunov:*

*E's interpolation – Ed.

'But the time and the place are too capricious, and this is the cause of so much awkwardness, cramping the place of the action. The conspiracies, the declarations of love, the state council meetings, the festivities – everything happens in the same room! The excessive speed and the constriction of events, the confidants – *a parte* equally incompatible with reason. ... Would it not be quicker to follow the Romantic school, where there are no rules, but there is art?' Pushkin exclaimed.[119]

However, even Romanticism, which smashed the fetters of Classicism in the name of a single reality – the reality and truth of passions – was itself soon to fall victim to its own 'freedoms', becoming entangled in the ever growing improbability of the facts that framed this 'single truth' of passions – of passions, often invented, borrowed or translated from foreign soil (medievalisms, Germanisms in the case of France, exoticisms in the case of Europe, etc.)

Between the battle scenes, when each of these 'realisms' came as the subject of rejection, only later to retreat as the object of it, almost all these incomplete 'realisms' experienced moments of passing triumph, some lasting longer than others.

For the play of these changes is by no means the free play of the imaginations of their leaders or standard-bearers, of their heralds or their drummer-boys.

The one-sided flourishings of the one-sidedly understood tasks of Realism could not have been different at those historical periods when society itself, sensing its development and movement but being hidebound by its class limitations, sketched out for itself a false, erroneous and incomplete picture of its future perspectives.

This, however, did nothing to stop its unwavering progress along its historically ordained path, class displacing class, so that, by our era, its foremost ranks had reached the point where they could reject the very principle and institution of classness [*klassovost'*].[120] And it was only at this time that Socialist Realism displaced the pleiad of one-sided 'realisms', which had achieved historically accessible forms of perfection when they fully embodied the might of the new classes succeeding one another. This new [Socialist] Realism is already multi-dimensional and all-embracing, able for the first time to imbue each phenomenon not with just any kind of generalisation, but with socialist generalisation.

It is a commonplace to say that, in the cycle of their own development, children repeat the phases of the evolution of mankind.

Cinema is the undisputed offspring of the whole constellation of earlier and associated arts.

Younger, but more progressive in its scope, potential and technique.

And, since we are talking about our cinema, then it is also more progressive in the realisation of its ideas and in its ideas themselves.

It is worthwhile tracing the twenty years of cinema's movement towards the definitive principles of an all-encompassing and Socialist Realism, and observing how it seems to repeat the same leaps and diversions that art as a whole has undergone in its own development throughout the centuries.

And just as each leap, with the advantage of hindsight, seems to us an

amusing deviation or an inexplicable excess, it set for its own moment – perhaps in its own way, perhaps incompletely, inadequately, one-sidedly, perhaps even erroneously, but nonetheless inevitably and invariably – it set as its aim a realism that it could understand in its own way; the task of a realistic reflection of reality![121]

The job of the historian is to investigate each of these phenomena, to define the factors that preconditioned them, to establish the reasons for their limitations, to weigh and measure accurately the progressive contribution that each of these phenomena has made to the overall advancing path of our cinema as a whole.

I would devour a book like that – it would be much more interesting than the history of the peripeteia of the leading tendency in our art as a whole as it progressed through cinema.

This is so much more fascinating than the portraits and biographies of the different masters or the different films, each described in the same way as the various representatives of the animal kingdom were described, before Darwin's *The Origin of Species*!

But it is the job of industrious historians to combine my desire for a similar unifying 'montage' picture showing the movement and development of cinema with adequate 'intra-shot' detailed information [*'vnutrikadrovaya' obstoyatel'nost' informatsii*] about the units that constitute that shot.

Now I am acting as a war artist.

I am fascinated by the dynamic course of the general outline.

And all these sallies, movements and approaches towards the goal, and retreats and withdrawals from it, the new surges, and the unexpected dead ends where you may end up if you take one of the false trails on the route to Socialist Realism, might constitute the content of those battle canvases that I was occupied with at the outset!

I should say that the regiments wore different types of uniform: there was a variety of genre forms, and there were various forms of pictures. The regiments neatly avoided a number of attempts to make them have the same turnout and 'khaki'; they tried to get away from the uniformity that threatened to overcome them in the battles of the 1930s.

The regiments fought with a variety of weaponry and waged war in a variety of styles.

The style of some was primarily like the activity of sappers. Frequently they would pull off a display of pyrotechnics, only to vanish into thin air along with their declarations.

Others stubbornly and doggedly pursued their goal, wending their way between the landslides and slips, patiently awaiting their chance to break out on to the surface and be recognised.

A third kind were like flame-throwers, setting the audience's emotions (not always their worthiest ones) afire, and then becoming invulnerable – until, that is, other groups, implacable as a tank assault force, overran their raised standards and focused the enthusiasm of the audience's admiration in ever new directions.

But these armies knew whole generations of experienced quartermasters, who skilfully tailored Western uniforms to our immediate needs.

For when the elbows and knees of our themes wore through this alien covering, they knew how constantly to adapt new varieties of Western cloth and stitching.

However, the further these phenomena went, the rarer they became, and the more distinctly did our individual and national identities emerge. The annals of the brilliant Trans-Caucasian raids of Chiaureli or Shengelaya have become major causes for celebration in our memories; not only what Arsen did in the pictures, but the pictures themselves broke the established rules, replacing them with their own new ones.[122] As in the days when the Ukraine led into battle the film sons of Dovzhenko, her grey-haired bard who contrived to bring into our own age a structure for myth-creation that was worthy of the minnesingers.[123]

Each detachment and regiment saw the realist ideal in a different way.

It seemed that it could be achieved by means of the simple topicality of the theme, never mind how antediluvian were the acting and the form. And the 'antediluvianism' was the inheritance of the pre-Revolutionary films made by Drankov.[124]

Dissatisfaction with this led to opposition. The other extreme. The 'reality' of American cinema began to seem to be Realism. But the Americans' 'system of realism' which we borrowed sounded ultraconventional on our own home ground.[125]

Then a frontal assault was made against this same ground. Some people wanted to see documentarism, the undistorted copy of an individual fact, as a realistic likeness of our life.[126] For a time it seemed as though the truth lay here. So documentarism also played a progressive role.

In fact, documentarism, which was impressionistic to the extent that the material was chosen by chance, was at the same time extremely naturalistic in relation to the material as such.

But it began to side with the decadent '*théâtre moderne*' as it became increasingly remote from the lapidary honesty of portrayal of the *Kinopravdas*[127] and twisted the materials of the document in a fantastic dance of invented montage embellishments.[128]

However, our cinema experienced other excesses of a different kind. There was a time when the only reality in cinema seemed to be not what could be physically sensed, but the physiologically sensed montage leap from fragment to fragment. And there was a time too when reality was taken to mean the structure of the associations derived from the various fragments, and it was in the combination of these associations in the break from the coherent narrative of the actual fragments that it was hoped the basis for a new cinematic 'realism' could be seen.

But the mainstream of cinema did not of course tread these paths, where at any moment one might fall into ravines of arrant nonsense.

Two films appeared in quick succession on the high road of our cinema, at the very dawn of its emergence. One – exactly in the tradition of the Romantics – saw realism in the authenticity of the emotion of the social milieu, not as it was depicted, but as it actually was in the milieu that evoked the depiction. The other looked for realism by stressing the person depicted, the vehicle of the emotion and passion. The former sought this in the actual

element of socialist history; the latter in a work of classic socialist literature. The first was *Potemkin*; the second *The Mother*.[129]

The combination of an event laden with the passion of those taking part in it began to crystallise as one point of a programme. And *Chapayev*,[130] which achieved this synthesis, created a new problem: how to apply this aim to the portrayal of the present day, to the Bolshevik of today, to our present. And in the search for this highest stage of realism, our cinema promptly turned to ... the past, to the literary past: again and again it strove to understand how the great realist masters of the past (Ostrovsky, Shchedrin, Pushkin) 'drew a man'.[131] And it turned to the historical past, trying through a complete examination of data about man's past to recreate him in a realistic way and to learn thereby how to create the people of today.

So *Peter the Great*, in its organisation of a screen image, taught us how to organise [the screen image] of the heroes of succeeding generations.[132] Soon after, attempts were made to 'capture' directly on film man as Bolshevik (e.g. *The Peasants*).[133] Man had already given himself up: it was harder with the Bolshevik. But then came the idea of embodying not an invented, but an authentic, image of a perfect Bolshevik; one who had existed, and who continued to exist forever in our hearts – Lenin; Lenin, and his closest comrades-in-arms.[134] And after this ultimate image of a unique and inimitable Bolshevik, cinema began to study the rank-and-file members of the Party.

In three parts it traced the most important thing: what made a Bolshevik in the period before the Revolution (the Maxim trilogy).[135] In two parts [it showed] how the power of an ordinary citizen increased and developed with the victory of the Revolution, transforming him into a great citizen.[136]

Unique and inimitable, the typical and commonplace transition of the second into the first. The contemporary and the past. Contemporaneity by means of the past. And the future, by means of the present.

It is in such diversity that the Bolshevik approaches the twentieth anniversary of his screen incarnation.

Each detachment of genre and style toils away on its patch, adding its response to this collective task, just like our army, building its invincibility not only by virtue of the sophistication of a particular piece of weaponry, but above all through astute joint cooperation and collaboration in all its aspects.

And the diversity within our united cinema is so great that a patch that has somehow escaped the attention of one detachment can then become the very centre of another's field of vision. Thus, together with a greater penetration into the core of man, the line of so-called 'canvases' continues to pulse, its epic sweep transforming the fates of peoples on the surface and in breadth.

We from Kronstadt, which carried the traditions of *Potemkin* through a period of the most intimate searches in the field of cinema,[137] apart from whatever other aims it had; *Alexander Nevsky*, which developed my own traditions and new fields of means of expression and strictness of style and form, resolving the problems of cinema in the organic nature of music and the unity of the audiovisual image, just as thirteen years earlier *Potemkin* had also solved the problem of the 'non-indifferent landscape' both of the medium and of the entire plastic image of the work.[138]

Of course, apart from their direct and immediate aims, both are indissoluble in the one creative breakthrough that resolved them.

Similarly with *Shchors*, whose heroic scope brought to the screen the whole sweep of Ukrainian might.[139]

Pictures such as these do not allow the screen to shrink or diminish, although there are times when it faces the risk of losing its all-encompassing plastic breadth and depth; its musical sonority.

For the overall good, of course, you need some detachments to penetrate all the ins and outs of human psychology, and others to penetrate into the depths of Party psychology, some into the topicality of the subject matter, others into the depths of history perceived in the full piquancy of topicality. Into plot, tautened with intrigue; or plot, developed on an epic scale to fill a plastic canvas.

You need some to reconnoitre into dialogue and the nuances of human intonation, and the semitones of speech, into the image of hero and man.

And you need others to penetrate into the equally subtle musical imagery of the whole film and the image of the work as a whole, for each achievement (aside from the personal victory) is yet another resource for the future.

I see in the perfect portrayal of man today the screen's reflection of those greatest achievements which have already been resolved by our activity. He has become one, and merged with his people, his country and his time, elevated in his image and in the image of his time to the heights of universal historical generalisation.

The collective experience, the contribution of each creative unit to the common cause, are already so great that we are able to undertake any task.

Five years ago, in my closing speech to the First All-Union Conference of Filmworkers on the occasion of our fifteenth anniversary, I said: '... I think that now, with the onset of cinema's sixteenth year in our country, we are entering a special period... Soviet cinema is entering its classical period after all kinds of periods of disagreements and controversies.'[140]

We can now say that our cinema has successfully completed the first five-year period of its classical existence. And, returning to the canvas of my battle-scene depicting the twenty years of Soviet cinema, only one thing remains for me to do: to finish this picture with a grand apotheosis.

I would depict the victorious genres and styles, covered in dust and sweat, but proud and joyous, as they entered the citadel of Socialist Realism.

Already occupying the outer buttresses and walls, already crossing the moats. You can glimpse in these moats the titles of films now gathering dust on the shelves, winding like black snakes, kilometres of wasted film; lists of failures, gradually fading from memory: they were the price paid to ensure victory.[141]

To the sounds of bugles, through their different gates – each through its own – these genres also correspond to the stylistic features of our cinema. They are equally valid and simultaneous, because their goal is the very heart of the humbled city. Their routes have been clearly marked out and their final success is guaranteed. In a planned and logical way they have come to the final goal, each by its own path, each through its own gates, and they achieve the final victories of Socialist Realism exactly as all who uphold them move

along their own unique, personal path towards the Communist ideal.

Equally valid and recognised as such, the varied styles of our cinema advance into the fifth five-year period of their history.[142] And the fact that our cinema's styles and genres – fixed in specific works, not programmed achievements, within a single and universal style of Socialist Realism – are equally valid and are treated as such seems to me the most perfect and characteristic symbol of what has been achieved in the twenty-year history of our cinema.

So far, *Shchors* has not trodden on *Volga-Volga*'s corns; *Tractor Drivers* lives in harmony with *The Great Citizen*.[143] *The Teacher* has not done *Alexander Nevsky* out of his crust of bread, and the unforgettable pages of the history of Lenin's actual deeds do not upstage the trilogy of the realistically conceived life of Maxim or Peter Shakhov.[144] We should also pay our respects to the attempts made to find a form for the Soviet thriller, *Engineer Kochin's Mistake*, and quests for a musical comedy.[145]

'That's all very well,' the dogmatists will exclaim, 'but where is today's "leading genre"?'

'What?!' rejoins the pedant. 'Are you saying that there is no "leading team" today?'

'Heresy!' they wail, in the unearthly chorus of the outmoded tunes of 1935, 1930 or 1925, when this or that genre, with a varying degree of success, ousted another; when this or that type of cinematic narrative briefly occupied the dominant position, in order to drive each battalion of our cinema along its own individual road to that one, final goal, arriving via a multitude of paths.

Of course, there is a leading characteristic of today.

But it does not lie in one separate sort of genre, beyond all the other sorts.

The leading characteristic of today is noteworthy for lying not outside, but within. And, moreover, within each genre. And the leading characteristic of today is not qualitatively different from this or that genre, but it is qualitatively perfected, achieved in its own distinct sector.

The 'distinction' of genre today is understood as a derivative not from the word 'distinctiveness' but as the mark 'distinction' (as in 'passed with distinction').

And what is characteristic of today is not the degree of distinction in the style of one film from the style of another. This distinction, it is appropriate to say, has never achieved such a razor-sharp edge as it has today, but this degree lies in the perfection with which the artist is now solving those principled tasks that he set himself in the sector of style and genre which he has occupied, in order to advance the general movement of cinema.

Virtually all genres, virtually all individual styles, approach the twentieth anniversary with a work that is the embodiment *par excellence* of the programme theses of their own particular kind of representation of reality.

So, by the twentieth year of cinema's existence, each stylistic direction within the field of cinema has achieved what was made available to each son of our great Motherland: the ultimate reflection of oneself, the ultimate development of the powers and potential placed within one, the richest fruition. But it is not just this most perfect situation, presented to us by the Soviet

Constitution, that seems to embody the unusual position in cinema that I have sketched out and which crowns its twentieth anniversary.[146]

In the picture I have drawn, which will surprise dogmatists and pedants, you can see perhaps the reflection of the most characteristic feature of our entire epoch as a whole.

Autumn 1939 – a genuine Boldino autumn for our country, if one can see in this extremely rich page from Pushkin's life a symbol of every kind of creative surge, every kind of creative flourish, every kind of creative fruitfulness.[147]

Autumn 1939 is an unbroken chain of victories in our country. There is the victory of our military might in Mongolia.[148] There is the victory of our wisdom in diplomacy at a time of extreme complexity in the international arena.[149] There is the victory of the agricultural exhibition.[150] And there is the victory of the practical and theoretical creation of a state, in the new phase of the development of the Soviet state.[151] There is the victory on the road to the emancipation of our oppressed brethren abroad, the victory pouring into the family of our peoples – thirteen million suffering in Western Belorussia and Western Ukraine.[152] Finally there is the victory of the Fergana Canal – the first victory of tomorrow's forms of Communist labour, introduced into the present by the victorious collective farm system.[153]

Indeed, even the glorious history of our country has few such sparkling pages, where so many unheard-of historical events have been crammed into the course of two or three months. Unheard-of, diverse and literally encompassing all corners of human endeavour, embodied in state form.

And it would be difficult for the poet of the future to determine which word could define this memorable autumn of 1939. As an autumn of diplomatic, or of military and defensive victories, or of a just war of liberation of our brothers or an autumn of victories constructing the Fergana Canal.

And the poet will have to refrain from designating this epoch in honour of the 'leading' sector of achievements and victories, and he will be compelled to speak of this epoch as of an epoch of unprecedented perfection in the achievements of each individual sector of the victorious Soviet state. In the achievements of a Soviet Union that is diverse in its manifestations, although uniform in the spirit and style of its stage of completion and perfection in every sector of its creative life and activity.

And if this is the outline of the life of the Soviet Union in these memorable days, then it cannot be by chance that the same characteristic features are pervasively reflected in the political superstructures of the country's cinema. For cinema, unlike any other of the arts, can capture and reflect with the greatest clarity and resourcefulness both the leading tendencies and the subtlest nuances and shades of the progressive movement of history, not only through its content, but also in its whole structure. And this is probably because one and the same genius is tirelessly nourishing both the most progressive movement of the whole country and at the same time the arts that reflect this movement – above all, cinema.

That genius lies in the genius of our great people and in the genius of the wise leadership of the Bolshevik Party.

1941

19. The Heirs and Builders of World Culture[1]

This year has seen a particular kind of surge in those working in art.

Each minute that we have devoted to our beloved cause has helped our country to become stauncher, mightier and more powerful. Each unit of our activity adds up to a million creative efforts by our multinational people, to bring the country to unprecedented achievements. That is what fills all our emotions, when we consider the creative and ideological power of workers of our country.

The land around is aglow. Thanks to the wisdom and foresight of the Soviet government and Comrade Stalin, our Union is the only place in the world where the artist can create in peace, where the builder can build in peace, and the inventor can solve his problems in peace. The rest of the world is in the furnace of war.

The Red Army guards our borders, like an insurmountable wall. And the Soviet people stand in reserve, like an insurmountable wall. And among their number stand the detachments of those who work in art.

And now, until the signal calls us to our rifle or our tank, to our aircraft or our mortar, our contribution to the defence of our country consists of using our pen, chisel, brush, camera and cello to perform to the maximum of our capacities.

A great task lies before us, the artists of the land of the Soviets: to continue and advance the cause of world culture. For, we apart, there is no one in the world working at this; everything beyond our Soviet soil is aimed at the annihilation and destruction of culture.

Let our ranks stand all the more firmly together! We shall carry out our task with a new strength and a new energy!

I shall wholly devote my personal creativity in the coming year to the creation of a film about the great builder of the Russian state in the sixteenth century: Ivan the Terrible.

S. Eisenstein
Film Director and Stalin Prize Winner[2]

20. Cinema Against Fascism[3]

In the West, anti-Fascist literature has produced hundreds of works directed at the new savages, ranging from pamphlets to novels, from journalism to the most detailed military and economic research papers.

The best artists and caricaturists echo this theme with hundreds of posters and thousands of cartoons.

And British and American cinema is in the forefront.

Abroad, anti-Fascist films can be divided into three groups.

The first group comprises films of pitiless realism, which so characterises American cinema when it drops abstract invention and strives to recreate life in all its genuine and unvarnished truthfulness. The best film in this group is without doubt *Confessions of a Nazi Spy*.[4] This picture came out a few years ago, and the material for it was the sensational trials in New York, which uncovered the subversive activities of Hitler's spies and saboteurs in the USA. Step by step, with an almost official precision, a detailed picture unfolded before the audience, showing the vile activities of Hitler's lackeys amongst the Germans living in America. 'Brownshirt' clubs were shown, where the unbridled demagoguery of their rantings confused the impressionable youths. Also shown was the recruitment of these young people for base acts of spying and sabotage, behind the back of the country which had offered them shelter, given them jobs and accepted them into its midst.

That is what had happened. Then measures were taken to crush these vermin.

★ ★ ★

The second group of films used a different weapon against Fascism. This weapon was laughter.

Every child in the West is familiar with the word 'adenoids'. And from childhood, many remember that it is connected with some kind of unhealthy growth in the throat which can kill, and that, in general, adenoids should be removed.

The remote assonance of 'adenoid' and 'Adolf' was enough for Chaplin to brand forever the bloodthirsty maniac of Fascism, Adolf Hitler, in a deathless caricature of an image: the dictator Adenoid Hynkel.

Chaplin based the plot of his remarkable new film *The Great Dictator* on the theme of the double.[5] In this case, the doubles were 'the great dictator' Adenoid Hynkel and a little barber from the Jewish ghetto.

The little barber, who was concussed in World War One and had spent

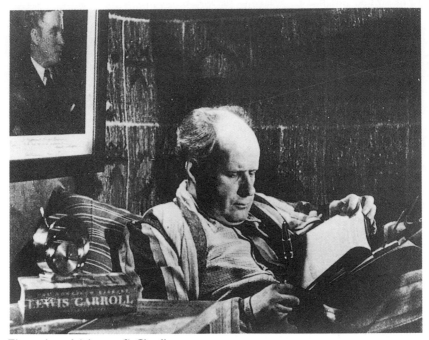

Eisenstein and (picture of) Chaplin.

the years that followed in a distant hospital, knew nothing of what had happened in the world during that time. He was fed up with the hospital. And one fine day he sneaked off home. He conscientiously put his small barber's business in order. He was particularly put out by the white stripes which someone had dared to smear across the panes of his shop. He painstakingly wiped them off. As he did so, he failed to notice that these stripes were not at all placed at random, but made up a word. And in a country that lay under the heel of the 'great dictator', this word was the most terrible of all: 'Jew'.

And because the little barber had dared to erase this chalked brand, the whole ghetto was stormed and routed by the 'dictator's' stormtroopers.

The barber succeeded in escaping, aided by his sweetheart. He fled to the Osterlich (Austrian) border, not even aware that this country too was in Hynkel's power.

That same border guard was expecting the 'dictator's' arrival, and this is the pivotal point of the film: the little barber is mistaken for his double – for Adenoid Hynkel. He is hauled to the microphone and asked to make a speech on the radio.

And there occurs a sudden miracle: the small, downtrodden being squares his shoulders and delivers into the microphone a speech that is full of courage; a call to arms; a speech that is full of confidence that the bloody nightmare will pass and happiness will reign on Earth.

★ ★ ★

The third group of anti-Fascist material, which is perhaps the most damning for Hitler, comprises material of actual documentary footage showing the German ogres.

Primitive savages adorned themselves with the skulls of captives they had devoured.

Shown with lingering voluptuousness are boundless views of black smoke above burning Warsaw, the ruins of Dunkirk and Ostend, hundreds and thousands of bridges destroyed in Norway, Belgium, Poland and France.

The ancient washed columns of ruined Greek temples show white on the screen. Ascending the steps towards the Acropolis, the heart of Athens, is a group of Fascist officers. This band of murderers is posed 'picturesquely' in a group against a background of white pillars. And it is as though the ancient marbles, like our hearts too, are ready to explode in anger at the sight of this monster in human form.

Watching this outrageous documentary footage, when you see the boundless cynicism of the bloody buffoon, Hitler, taking pleasure in the signature on France's declaration of surrender, you want again and again to cry out with all your heart: 'Death to Fascism! We shall not lay down our arms until this scourge of mankind has been destroyed; these ogres who dream of conquering the whole world.'

1942

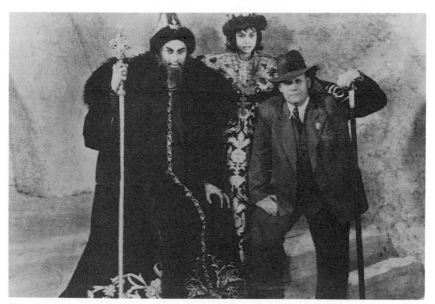

Eisenstein on the set of *Ivan the Terrible* with the two Ivans, old and young.

21. *Ivan The Terrible*: A Film about the Sixteenth-century Russian Renaissance[1]

Certain historical figures have fallen prey to the cruel jokes of literary tradition and legend.

In England there was an honest commander. He even excelled in battle. He was a hero. He lay beneath the vaults of his family tomb, gloried to the skies. But it so happened that a certain poet was looking for a surname which would suit the monumental figure of a rogue, glutton and voluptuary, and he found just the right harmonious word-formation he was looking for in the surname of that noble, deceased Englishman.

Falstaff is such a close pun on 'false stuff' that it was hard to resist the name; the memory of the historical bearer of that worthy name was besmirched and it became forever linked with the immortal figure of a Shakespearean hero whose morality was diametrically opposed to his own!

It was Balzac who undertook to defend the memory of the unfortunate historical Sir Falstaff; and at the very moment when, in an unfinished fragment of a novel, he was himself about to set the record straight concerning the historical figure of a major politician and intellect.[2]

In *Lost Illusions* he wrote about the queen whose shrewdness in matters of state was for many years lost among a welter of melodramatic details about her immediate activity.

The name Catherine de' Medici immediately conjures up all the attributes from Dumas' novels: the poisoned gloves, the poisoned candles, the poisoned flowers, the poisoned pages of the Bible.

And bloodsoaked reflections would start to cast the terrible flames of St Bartholomew's Eve on to her face. . . .[3]

Balzac wrote: 'You dare . . . to recreate the beautiful, magnificent figure of Catherine de' Medici whom you have sacrificed to prejudices which still weigh heavily upon her.'

For him, testimony to her beautiful splendour was her pioneering role in the creation of the French nation's golden age in the epoch of the Sun King, in the seventeenth century.[4] Balzac wrote about this elsewhere: 'Voltaire continued Pascal's work. Louis XIV continued the work of Catherine de' Medici and Richelieu. . . .'[5]

★ ★ ★

My hero is this type of historical personage, whose reputation has suffered considerably at the hands of literary tradition.

Historians of a certain slant and writers of a certain strain have branded this contemporary of Catherine de' Medici as a madman of senseless cruelty.

And this is so widespread that there are few who would believe that it was he, famous in history as a lunatic and sadist, who made a very perspicacious criticism of his contemporary, Catherine, for the senseless brutality of precisely these burnings on Bartholomew's Eve!

This is exactly what the hero of my completed screenplay and of my future film – Ivan the Terrible! – wrote in his letter to Emperor Rudolf concerning St Bartholomew's Eve. [6]

This man had a remarkable history.

When he was a child, nobody took a personal interest in him, but he was to be the cause of a bitter struggle between different court factions.

The same thing happened to his reputation in history.

Few people dug deep into the essence of his magnificent statesmanship – which even in its minor details was superior to what Peter the Great triumphantly achieved.[7]

Instead they angrily seized upon his enigmatic and sometimes ominous figure – with polemical intent.

In the decades when tsarism, senile and historically superannuated, needed only the powerful gusts of the October Revolution to blow it away into shattered fragments forever, liberal historians and littérateurs saw in the image of Ivan – the first crowned tsar of Russia – and his unusual character a worthwhile target for an attack on contemporary tsarism. That is, as something that had outlived itself, was about to depart the stage, and so hung on to power all the more feverishly.

At the same time they forgot that different historical periods require different approaches, and what might be progressive for the epoch of the Russian Renaissance of the sixteenth century could turn out to be highly reactionary for the end of the nineteenth and the start of the twentieth centuries!

The concentration of state power solely in the hands of an absolute monarch was, at that time, the only precondition for the salvation and viability of a country and state that was riven by the personal interests of feudal alliances, just as now the sole guarantee of viability and triumph for peoples who have joined the mortal battle against Nazism is the unity of their endeavours under the guidance of leaders, freely and democratically elected as heads of state, to whom they have entrusted their lives and their future.

Obscurantism and bloodthirstiness are two charges that will be levelled against anyone who, in the great age of the democratic freedoms of the twentieth century, uses the devices of a medieval feudal scoundrel dishonestly to seize power from his people, sending his own people into a new slavery, and makes his goal the submission and enslavement of his peaceable neighbours and other countries.

He will be laughable, being nailed to the shameful cross of history in the image of Adenoid Hynkel, in Chaplin's comedy of genius.[8] He will be repulsive and evil, in the prototype of Adolf Hitler, in the bloody tragedy that he inflicted upon both hemispheres of our planet.

And at the same time this will not in the least hinder our grasp of the fact that these paths to the unification of the state and the centralisation of power could turn out to be historically progressive and positive for their own time. This process moved along these paths everywhere in the fifteenth and sixteenth centuries, and was made historically famous by the dramatic conduct of Louis XI, Charles VIII, Queen Elizabeth I, Catherine de' Medici, or Tsar Ivan the Terrible.[9]

A band of enemies, crushed by Ivan in his historic struggle for the state of Muscovy, did all they could to blacken the memory of the person who, when he was alive, had crushed their reptilian heads underfoot.

Where the spears of interventionists had shattered against his iron inviolability and the daggers of hired assassins had broken into fragments, there the venomous pens of fugitive traitors, exiled spies and neutralised mercenaries of hostile states obligingly poured forth streams of libel.

That is precisely what constituted the first 'impartial' items of information on Muscovy and the history of Ivan the Terrible's rule, which appeared in his own lifetime beyond the borders of what was then Russia.

One of them was by Prince Kurbsky, Ivan's former friend and his closest comrade- in-arms, whose ambition and envy, skilfully manipulated by foreign agents, forced him to join Russia's enemies after he treacherously lost the battle at Nevel.[10]

His history of Ivan's rule, which was filled with venom and loathing, was released at the moment when Ivan hoped to be chosen as king of Poland.

Put together with all the demagogic brilliance of the pre-election leaflets typical of today, it had but one purpose – apart from venting the traitor's spleen, for he could not derive the advantage he sought from his treachery – namely to frighten the Polish electorate and set them against Ivan. (In this, incidentally, equally with his other reasons, Prince Kurbsky was entirely successful.)

Another source – the records of two Germans, Taube and Kruse – was intended to serve as 'justificatory material' for the intervention into the state of Muscovy that was then being planned.

A third source was the notes of Staden, a German *oprichnik* [11] who had been in the service of Ivan; his notes, which are a staggering display of Nazi cynicism by an unscrupulous mercenary, were intended to be no more than an appendix to a detailed plan of the 'occupation of Muscovy' which Staden presented to Emperor Rudolf II, etc., etc.

Add to this a mountain of anti-Ivanist pamphlets from the time of the Livonian War, which were printed just as readily in Riga (!!) as in Nuremberg (!!!) in the sixteenth century, and which bewailed the 'Russian atrocities', showing Russians hacking women into pieces (!) and eating babies (!), and you will see the original corpus of materials that helped create the legend of the 'wantonly brutal maniac, Ivan'.

If we turn to a more objective historical source – the works of Russian chroniclers of the sixteenth century, the annalists – then we find quite a few terrifying and brutal acts in our hero's life. But we look in vain for even one page showing them as wanton and unjustifiable.

Ivan really did march against Pskov and Novgorod.

He really was brutal in his repressions.

But an objective chronicler equably explains why this retribution was so brutal.

And this 'trifling' cause turns out to be the readiness, and the consent of the governing elite of both these cities and regions – *despite the wish of the people!* – to secede completely from the state of Muscovy and to cross over to neighbouring Livonia, pursuing their own interests and for their own personal gain!

And so – step by step, page by page – the historical records open up before us not only a profound rationale, but also a simple and historical necessity for Ivan to act in the way that he did, in his dealings with those who sought to ruin, sell off cheap, or betray their fatherland for their own selfish ends.

The fatherland, which the great, statesmanlike mind of Ivan the Terrible had gathered up, strengthened and victoriously led into battle.

It was not my intention to whitewash him in the collective memory, or to turn Ivan the Terrible* into Ivan the Sweet!*

But to repay a debt to an ancient hero: objectively to show the full scope and sweep of his activity. For only this can explain all the features, unexpected or mysterious, sometimes harsh and often terrible, which must distinguish the statesmen of so passionate and bloody an epoch as the sixteenth-century Renaissance, be it in sun-drenched Italy, or in England – which had become the queen of the seas under Queen Elizabeth; in France, Spain, or the Holy Roman Empire.

The fundamental aim of the film was to show Ivan in the whole range of his activity and the struggle for the state of Muscovy.

And it should be said straight away that this activity and struggle were colossal and bloody.

But I do not intend to wipe one drop of blood from the life of Ivan the Terrible.

Not to whitewash, but to explain.

I want to preserve the titanic activity of this man, who achieved the unification of the Russian state around Moscow, by making it comprehensible.

And the viewer today – Englishman, American or Russian – has to understand the decisive actions, the necessary cruelty and the occasional ruthlessness of a man charged by history to create one of the strongest and largest states in the world!

For today, at a time of war, it is obvious as never before that anyone who invites ruin upon his homeland deserves death; that anyone who crosses over to the side of his motherland's enemies deserves punishment; that those who open up their country's borders to the enemy must be ruthlessly dealt with.

Thus, without hiding or embroidering anything in the history of Ivan's actions, and without encroaching upon the terrible romanticism of this splendid image of the past, we can present him whole before the eyes of the whole world. And this image, which is frightening and attractive, charming and terrifying – tragic, in the full sense of the word, in his inner struggle against him-

*In English in the original.

self, a struggle he waged that was inseparable from the struggle against his country's enemies – becomes an image that is close and comprehensible to today's audience.

We tried to recreate around him the whole array of his enemies and associates, the people of the sixteenth-century Russian Renaissance who have never yet been shown on the screen in the full scope of their political passions and interests, the people of the 'Third Rome', as they liked to call Moscow of that time, seeing in it the heir to the leading historical role that had formerly belonged to the Byzantine and Roman Empires.[12]

Images of Russian feudal princes and boyars come before the viewer's gaze; they stand as equals to Cesare Borgia and the Malatestas, princes of the church, whose authority was as great as that of the Roman popes, and whose political intrigues were like those of Machiavelli and Loyola; and Russian women who bear comparison with Catherine de' Medici and Bloody Mary.[13]

The united and powerful state of Muscovy that 'suddenly' sprang up in the sixteenth century took the West by surprise. 'Whence did this Tsar of Muscovy suddenly appear; whence this most powerful Eastern state?' diplomats, scholars, princes and kings of the West wrote to each other in alarm.

We – the people of twentieth-century Moscow – have sensed a similar astonishment in the West, as it gradually 'discovered' the Soviet Moscow of the twentieth century; just as once, indignantly, the surprised West unexpectedly 'stumbled upon' the forebears of our heroic Red Army, which Hitler has now so unexpectedly (for him!) 'discovered' and recognised, to his horror and ruin.

To show who our forebears were, to show the Russian people of the past, to show them in the living images of their statesmen, their passions, their struggle, the entire historical scope of their past – that is our task.

To show the great tradition of patriotism, love for the Motherland, the ruthlessness of the struggle with our enemies, wherever and whoever they may be – that is the purpose behind my film.

When you become better acquainted with someone, naturally you want to meet him, and introduce him to your wife, your cousin, father, mother, or grandmother.

If it happens that your great-grandfather is alive too, that is perfectly good for mutual relations.

And so it is with the friendship of nations: drawing ever closer, as now, with our British and American allies, we want to know each other better and more closely.[14]

And in this regard, acquainting each other with the historical past of our nations, with our great-great-grandparents, is one of the best and most profound ways of understanding each other as we wage, in a holy alliance, the finest and most enlightened campaign that an advanced and progressive mankind has ever waged.

Our film about the era of Ivan the Terrible is working in precisely this direction!

22. Dickens, Griffith and Ourselves[15]

'The kettle began it!'

That was how Dickens opened *The Cricket on the Hearth*.[16]

'The kettle began it!'

What could be less cinematic than that, you might ask! Trains, cowboys, chases and ... *The Cricket on the Hearth*?

'The kettle began it!'

But strange though it may seem, this is where cinema began.

It is from this point, from Dickens, from the Victorian novel, that the very first line of development of American cinema's aesthetics, which is associated with the name of David Wark Griffith,[17] derives.

And, however surprising this might seem at first glance, however much it jars with every notion we have about cinema, and particularly American cinema, this is indeed the case, and, as we shall see later, this link is furthermore entirely organic and 'genetically' logical.

Biographers and film historians have preserved for us Griffith's remarks on the link between his method of work and that of Dickens.

But before going any further, let us look closely at the element that, if it did not actually give birth to cinema, was where it first matured, on an unprecedented and unforeseen scale.

We know where cinema originated as a worldwide phenomenon. We know that it is inextricably linked with the development of ultra-industrialised America.

We know how the capitalist sweep and structure of the United States of America are reflected in its manufacturing, its art and its literature.

American cinema reflects the state of American capitalism in the clearest and most typical way.

You would not believe that this Moloch of modern industry, the dizzy rush of its cities and its underground railways, the roar of competition and the hurricane of stock-exchange speculations, could have anything in common with the peaceful, patriarchal Victorian London of Dickens' novels.

But let us begin with this 'high speed', this 'hurricane' and this 'roar'.

Actually, only people who know America from books – only a small number of books, at that – and from an incomplete selection, depict it in that way.

A visitor to the United States will not be amazed for long by the sea of lights (which really is limitless), the massive maelstrom of the stock-exchange gambling (which really does have no rival), the deafening roar (which really does drown everything else).

With regard to the speed of traffic, the streets of large cities cannot excite, for the very good reason that speed is unknown. This is a funny contradiction: there are so many ultra-high-speed cars and sports cars that they stop each other from moving; and they have to crawl, from block to block, at an ultra-snail's pace, stopping for ages at each intersection; and at literally every step you come across an intersection of avenues and streets.

So, sitting in your ultra-powerful car, and moving at a snail's pace through a sea of densely packed fellow human beings, who sit in their equally ultra-powerful but barely moving cars, you naturally start thinking about this duality: the dynamism of America as it is depicted, and the underlying interdependency of this duality in and of everything in America.

As you jolt from block to block along the ultra-busy street, you find yourself looking up and down the skyscrapers.

'Why don't they look tall?' the thought idly occurs to you.

'Why do they look homely and provincial, despite their height?'

And you realise that the 'trick' of skyscrapers is that, although they are many floors high, each storey is itself actually low. And suddenly the towering skyscraper seems to be made up of a number of poky provincial houses set one on top of another. And you only have to drive outside the city limits – or in some cases outside the city centre – to see those same small houses set not forty, sixty or a hundred and twenty high one on top of the other, but strung out in an endless line of one- and two-storey cottages that border the dull central roads (the famous Main Streets), or the semi-rural sidestreets.

Here you can race along at full tilt, if you are not scared of the 'cops', although, since you are a foreigner, you can convincingly pretend that you do not understand the signs: here the streets are empty, there is little traffic and, unlike the streets of the metropolis where the placid traffic pauses for breath in the stony vice of the city's grip, the occasional car races along like a hurricane, to avoid succumbing to the vacant lethargy of the upstate American provinces.

Ranks of skyscrapers have marched deep into the country's heart, the steel nerves of the railways form a tightly woven network across the land; and yet equally the small farmsteads of upstate America seem to have overwhelmed all but the very centres of the cities: sometimes, you have only to round a corner behind a skyscraper to find yourself face to face with a small colonial-style house, seemingly spirited from the deep savannahs of Louisiana or Alabama into the very heart of a busy town.

But where this wave of provincialism has not lashed us with a small house or a little church (gnawing away at the corner of a monumental modern Babylon – Radio City)[18] or a cemetery, unexpectedly lying at the very centre of the city, or the hung-out laundry of the Italian quarters behind Wall Street, then this provincialism has turned inside the apartments, where it is tied in a ball by the fireplaces, is set into the soft old-fashioned armchairs with their lace antimacassars, and encompasses the marvels of modern technology: refrigerators, washing machines and radiograms.

But the power of the provincialism that has subtly insinuated itself into these and other marvels of technology goes much deeper.

It is even more firmly ensconced under tortoiseshell boxes, in the

columns of journals of record and the homilies of radio sermons and broad-
cast quackery where, year after year, it has been defined as something you
have absolutely no need to go and look for ... 'Way Down East', but which
you can find under the waistcoat or top hat of countless businessmen in this
age of ultra-industry – where you normally keep your heart, or your brain.[19]

The abundance of upstate provincial patriarchalism is astonishing in
America first of all, and most of all – it permeates routine and custom, morals
and philosophy, the limit of the ideas and the way of life of middle America.

To understand Griffith, you need to remember this other America: this
link between Griffith and Dickens will not then seem so strange. Existing
alongside the hurtling motor cars, the flying steamboats and the racing ticker-
tapes and production lines, there is a traditional, patriarchal, provincial
America.

These two Americas are bound together in Griffith's manner and indi-
viduality, like his utterly whimsical parallel montage.

But what is more curious is that Dickens proved the guiding influence on
both tendencies in Griffith's style, reflecting both of America's inseparable
images – America the provincial and America the ultra-dynamic.

We can easily agree to accept this for the 'intimate' Griffith, for the
Griffith of America's modern or past way of life, where Griffith is profound:
for the pictures that Griffith himself told me were 'made for my own sake and
invariably failed when released ...'

But we are a little surprised that Dickens should turn out to be the source
of the guiding experience for the 'official', magnificent Griffith; the Griffith
of hurricane speeds, dizzy action and stunning chases! Nevertheless that is
precisely what he is.

But first something about Dickens, the 'intimate'.

Thus: 'The kettle began it!'

Once you see this kettle as a typical 'close-up', you exclaim: 'Why didn't
I spot that before? It is just like Griffith! I've seen close-ups like that at the
start of so many episodes, scenes and films in his work!'

Incidentally, we should not forget that one of Griffith's first films was
none other than *The Cricket on the Hearth*![20]

The New York Dramatic Mirror of 3 December 1913 carried an extrava-
gant advertisement announcing it.

It is the twentieth, in sequence, of the 150 minor pictures, and some
'major' ones, like *Judith of Bethulia* (the first American film to last four whole
reels) that Griffith made between 1908 and 1913.[21]

This kettle of course is the most typical, most *Griffithian* of close-ups.

A close-up saturated – we can now see this clearly – with the peculiarly
Dickensian atmosphere with which Griffith imbues, with equal mastery, a
severe depiction of a way of life *Way Down East* or the *freezing chill* of his
characters' moral outlook, as they drive the guilty Lillian Gish on to the shift-
ing surface of a swirling *ice-floe*.[22]

Surely Dickens creates an equally unpitying *atmosphere of chill* in, for
example, *Dombey and Son*. Mr Dombey's character is revealed through his
frigid formality. And that *impression of cold* lies on everything, everywhere and
in everything. Mr Dombey is surrounded by an icy atmosphere: his son's

christening party is cold, the room is cold, the frozen guests are greeted coldly. Books on shelves stand to attention, as if frozen. Everything in the church is cold, the dinner is cold, the champagne is cold as ice, the veal is cold as lead, and so on.[23]

Always and everywhere the 'atmosphere' is one of the most typical means for revealing the internal world and moral outlook of the actual characters.

We see Dickens' method even in Griffith's inimitable cameo roles – people who seem to have been filmed straight from life. I have already forgotten who is talking with whom in the short street scenes in *Intolerance*.[24] But I will never forget the mask worn by the passer-by, walking like a maniac, with his hands behind his back, his nose stretching out between his glasses, and his drooping beard. As he passes, he interrupts the climactic point of the conversation between the suffering youth and the girl. I can hardly remember these characters, but the passer-by, for the moment that he flickers across the frame, remains before me as though he were alive, and it was about twenty years ago that I saw that film!

Sometimes these unforgettable people really have got into Griffith's films straight from the street. There was that puny little actor, who grew into a star in Griffith's hands; there was a person never again filmed like that; there was ... the distinguished maths professor asked to play the terrible executioner in *America*, the late Louis Wolheim, who later brilliantly played a soldier in *All Quiet on the Western Front*.[25]

Finally, exactly in the tradition of Dickens, there are those dear old men, and these noble and slightly one-dimensional, unfortunate adolescents, and fragile little girls, village gossips and assorted eccentrics. Dickens made them particularly believable, when they were presented in brief scenes. Chesterton writes:

> The only other thing to be noticed about him [i.e. Pecksniff] is that here, as almost everywhere else in the novels, the best figures are at their best when they have least to do. Dickens's characters are perfect as long as he can keep them out of his stories. Bumble is divine until a dark and practical secret is entrusted to him – as if anybody but a lunatic would entrust a secret to Bumble. Micawber is noble when he is doing nothing; but he is quite unconvincing when he is spying on Uriah Heep, for obviously neither Micawber nor anyone else would employ Micawber as a private detective. Similarly, while Pecksniff is the very best thing in the story, the story is the worst thing in Pecksniff.[26]

Griffith does not suffer from this limitation and his characters expand equally convincingly from brief episodes into those charming and perfected images of living people, who are so numerous in Griffith's films.

But now we are losing sight of the wood. We should rather be looking at how the second side of Griffith's creative mastery – the wizard of tempo and montage – is entirely derived, not unexpectedly this time, from that same Victorian source.

To tell the truth, any surprise at this unexpected development might be

attributed to nothing more than our ... ignorance of Dickens.

We all read him when we were children, but hardly noticed that what made him irresistible was not only the all-embracing peripeteias of the child-hood lives of his heroes, but also the spontaneous childlike narrative, typical alike of Dickens and American cinema, whose amazing ability to influence derives from infantile traits in its audience. Still less were we interested in Dickens' compositional technique – that was beyond us: captivated by the de-vices of this technique, we feverishly pursued his characters for page after page, now losing sight of them at the most critical moment, now catching up with them once more among separate links of a second line of action, which was progressing in parallel to the first.

Being children we paid no attention to this.

And as adults we rarely re-read his novels.

And, having become film-makers, we have no time to glance beneath the covers of these novels to see why they so enthralled us, and how it was that these unbelievably lengthy volumes could unfailingly command our attention!

Griffith turned out to be more circumspect.

But before revealing what the steady gaze of an American film-maker could discern in Dickens, I want to recall what he – David Wark Griffith – meant to us, the young film-makers of the 1920s.

Let us recall the early days of our cinema, in the first years after the October Socialist Revolution. The fires 'by the hearths' of our home-grown film producers had burned out, the *Nava's Charms* of their productions had lost their power over us, and, whispering through their pallid lips 'forget the hearth', Khudoleyev and Runich, Polonsky and Maximov had departed to oblivion, Vera Kholodnaya to her grave and Mosjoukine and Lisenko to life in emigration.[27]

The young Soviet cinema had collected impressions of revolutionary reality, the first experiment (Vertov), the first attempts at systematisation (Kuleshov), so that in the second half of the 1920s, in a unique explosion, it became an independent, adult, original art, instantly winning worldwide acclaim.

The screen itself was then a meeting-point for the most diverse varieties of cinema.

Two fundamental tendencies began gradually to break clear of this strange medley of the old Russian pictures and the new, still un-Soviet ones, that strove to continue 'their tradition', or foreign films that had been irregu-larly imported or had been overlooked here. First there was the cinema of neighbouring post-war Germany. Artistic mysticism, decadence and dark fantasy followed the failed putsch of 1923. These moods were also reflected in cinema.

Nosferatu the Vampire, The Street, the enigmatic *Warning Shadows,* the mystic-criminal *Doctor Mabuse,* reached out to us from the cinema of a country that had arrived at the limits of horror, awaiting not a future but an endless night, one filled with mystical shadows and criminality...[28]

The somewhat later pictures *Looping the Loop* or *The Secrets of a Soul,* which reflected the same moods, were characterised by the chaos of multiple exposures, dissolve sequences, and intercut images.[29] The bewilderment and

chaos of post-war Germany also seemed to be reflected in them.

All these tendencies were knitted together in the famous *Doctor Caligari* (1920), a barbarous celebration of the self-destruction of the healthy, humane basis of art, a common grave for healthy cinematic principles, a combination of the dumb hysteria of action, an assortment of painted canvases, daubed sets, made-up faces, and monstrous chimeras, unnatural breaks and actions.

Expressionism left almost no trace on Russian cinema.

This daubed and lacerated 'St Sebastian' of cinema was too alien for this young rising class, healthy in body and mind.

Interestingly, the shortcomings in our cinematic technique at that time were a blessing in disguise. They helped restrain people of a certain bent from taking a wrong step in this dubious direction.

The dimensions of our studios, the lighting equipment, the make-up material, the costumes and the set prevented us from burdening the screen with such a phantasmagoria.

But the main factor was something else: our spirit drove us out into life, among the people, into the seething reality of a country in the throes of re-generation.

Expressionism was a powerful factor in the formation of our cinema: it was a warning.

The role of another film-factor – running through a series of films like *The Gray Shadow*, *The House of Hate* and *The Mark of Zorro* – has turned out differently.[30]

The exact sequence of dates on which the releases were distributed need not concern us here: the names are of use more for denoting types than as titles of individual pictures.

In these films there was a world that we did not understand, but at the same time it did not warn us off; in fact, in its own way thrilling young and future film-makers just as much as it did young and future engineers, it simultaneously brought us samples of machine technology that we had not seen before, from that distant country across the seas.

The films themselves did not enthral us so much. It was the possibilities. Just as the exciting potential for cultivating the collective farms in the future was waiting to be realised by ... a tractor, so the boundless excitement and tempo of these surprising (and surprisingly redundant) works from an unknown land conjured up visions of a profound, rationalised and class-oriented usage of that marvellous instrument, equipment and armament which cinema appeared to be.

Griffith stood out as the most fascinating figure in this field. Because his works did not use cinema as a mere amusement or pastime but contained the rudiments of the art that, in the hands of a constellation of Soviet masters, was destined to cover Soviet film-making with undying glory in the pages of the history of world cinema, thanks to the novelty of the ideas, the unprecedented plots and the perfection of form in equal measure.

The intense curiosity about *construction* and *method* at that time soon identified the source of one of the most powerful influences of Griffith's pictures.

It was in the hitherto unfamiliar field that bears a name that we know of

not from art, but from engineering and electronic equipment, and that appeared for the first time in the most progressive art – cinema.

This field, this method, this principle of construction and assembly was *montage*.

Montage, whose principles underlay American film culture, but which owed its full development, definitive interpretation and world recognition to our cinema.

Montage, which played a vital role in Griffith's works, and brought him his most glorious triumphs.

Griffith approached it through the device of parallel action and, essentially, he progressed no further, making it possible for film-makers from the other half of the globe, from another epoch and with a different class structure, to perfect the matter definitively.

But I am getting ahead of myself. Let us look at how montage came to Griffith – or Griffith came to montage.

Griffith came to it through the device of parallel action. But it was none other than Dickens who gave Griffith the idea of parallel action!

Griffith himself testifies to this.[31]

Even a superficial acquaintance with the work of the great English novelist is enough to convince you that Dickens could, and did, give cinema a much greater lead than merely the montage of parallel action.

That Dickens should be so close to the features of cinema – in his method, his manner, in his particular way of seeing, and in his exposition – is truly amazing.

And perhaps the nature of these very features, common to both Dickens and cinema, contains a part of the secret of that massive success which those particularities of exposition and style – quite apart from themes and plots – have earned for them both.

What were Dickens' novels, for their time?

What were they for his readers?

There is one answer: the same as cinema is now for those same sections of the population.

They made the reader experience the same passions, making the same appeal to the good, the sentimental; like film, they made him shudder at vice, and provided the same escape from the humdrum, prosaic and everyday into something unaccustomed, unusual and fantastic. And at the same time it appears as nothing other than the everyday and prosaic.

And, illuminated by the reflection from the pages of novels to life, this ordinariness came to seem romantic, and the dull people of everyday life were grateful to the author for making them aware of potentially romantic figures.

Hence there was the same fascination for Dickens' novels as there is now for film. Hence each of his novels enjoyed the same thunderous success. Let Stefan Zweig – who opened his essay on Dickens with a description of just that mass popularity – now take over:

The love Dickens' contemporaries lavished upon the creator of Pickwick is not to be assessed by accounts given in books and biographies. Love lives and dies only in the spoken word. To get an adequate idea of the in-

tensity of one's love, one must catch (as I once caught) an Englishman old enough to have youthful memories of the days when Dickens was alive. Preferably it should be someone who finds it hard even now to speak of him as Charles Dickens, choosing, rather, to use the affectionate nickname of 'Boz'. The emotion, tinged with melancholy, which these old reminiscences call up, gives us of a younger generation some inkling of the enthusiasm that inspired the hearts of thousands when the monthly instalments in their blue covers (great rarities now) arrived at English homes. At such times, my old Dickensian told me, people would walk a long way to meet the postman when a fresh number was due, so impatient were they to read what Boz had to tell. They had hungered for this day ever since the previous month, hoping, wondering, disputing as to whether young Copperfield would marry Dora or Agnes, delighting in the prospect of Micawber having to face another crisis in his affairs, which they knew well enough he would get through safely with the help of hot punch and good temper. How could they be expected to wait patiently until the letter-carrier, lumbering along on an old nag, would arrive with the solution of these burning problems? When the appointed hour came round, old and young would sally forth, walking two miles and more to the post office, merely to have the issue sooner. On the way home they would start reading, those who had not the luck of holding the book looking over the shoulder of the more fortunate mortal; others would set about reading aloud as they walked; only people with a genius for self-sacrifice would defer a purely personal gratification, and would scurry back to share the treasure with wife and child.

In every village, in every town, in the whole of the British Isles and far beyond, away into the remotest parts of the earth where the English-speaking nations had gone to settle and colonise, Charles Dickens was loved. People loved him from the first moment when (through the medium of print) they made his acquaintance until his dying day....

The first time Dickens gave a reading, the first time he came face to face with his public, was an occasion for an extraordinary demonstration. The hall was packed, people clambered up the pillars, crept under the platform, did incredible things in order to hear the voice of their beloved author. In the States, despite the wintry cold, people would camp in front of the box-office, catching what rest they could on the mattresses they had lugged along with them, satisfying their hunger with food brought to them by waiters from a nearby restaurant. No hall proved large enough to accommodate the crowds, so that in the end a church in Brooklyn was converted into a huge reading room for this most popular of authors.[32]

The dizzy mass success of Dickens' novels was, for their time, comparable in scale only with the whirlwind success that greets this or that sensational film.

And perhaps the secret is that what links Dickens to cinema is the astonishingly plastic quality of his novels. Their astonishing visual and optical quality.

Dickens' characters are just as plastically visible and ever so slightly

exaggerated as the screen heroes of today.

These heroes deeply affect the viewers' emotions with their visible image: these villains are remembered for their twisted expressions, these heroes are invariably associated with that special, slightly unnatural shining gleam with which the screen lights them up.

Dickens' characters are just the same – that gallery of Pickwicks, Dombeys, Fagins, Tackletons and others that have been unerringly plastically captured and sketched with pitiless sharpness.

We can see this feature of Dickens, his ability to write, his particular way of seeing, in Stefan Zweig's highly colourful description. (For our subject it also performs the service of ... objectivity because the problem of 'Dickens and Cinema' never worried Zweig nor even occurred to him!):

His powers of penetration are almost miraculous. Dickens was a visualising genius. Look at the portraits we have of him in youth and, better still, as an elderly man. The whole countenance is dominated by those wonderful eyes. They are not the eyes of an inspired poet, they do not roll in a fine frenzy or veil themselves behind an elegiac melancholy, they are not soft and yielding in expression, nor are they the fiery orbs of a visionary. They are essentially English eyes: cold, grey, sharp, like steel. They were as steely as a safe within which a treasure is locked, whence it cannot be stolen or lost, where neither fire nor air can penetrate to destroy; and this treasure consisted of all that he had observed once and put away, yesterday or many years ago – the sublimest side by side with the most trivial of items. It might merely be a sign over a shop which had caught his attention as a little chap of five; or a tree with its fresh young leaves nodding in at the window. Nothing escaped these eyes; they were stronger than time; carefully, laboriously, they hoarded impression upon impression in the storehouses of memory, ready for the day when the master should have need of them. Nothing dribbled away into forgetfulness, nothing became pale or blurred; everything lay there awaiting his good time, full of the sap of life, colourful and distinct; nothing died or faded. This visual memory of Dickens' was unparalleled.

He cuts through the fog surrounding the years of childhood like a clipper driving through the waves. In *David Copperfield*, that masked autobiography, we are given reminiscences of a two-year-old concerning his mother with her pretty hair and youthful shape, and Peggotty with no shape at all; memories which are like silhouettes standing out from the blank of his infancy. There are never any blurred contours where Dickens is concerned; he does not give us hazy visions, but portraits whose every detail is sharply defined. His powers of depiction are so overwhelming that the reader is not called upon for any effort of imagination ... Place them in the hands of twenty different illustrators and demand a portrait of Copperfield or of Pickwick. What will be the result? We shall be given twenty pictures almost incredibly similar, showing us a kindly old gentleman in a white waistcoat, tights and gaiters, and a pair of beaming eyes twinkling behind glasses; or a shy, fair-haired lad sitting upon the box-seat of the Yarmouth coach. Dickens portrays so clearly,

so minutely, that his readers see what he makes them see, much as if he had hypnotised them. His is not the wizard's eye of a Balzac which allows the characters at first to struggle out of chaos and to take shape by slow degree amid the fiery welter of their passions. Dickens' vision is a purely terrestrial one; it has something of the seaman's keenness, of the hunter's alertness, of the falcon's sharpness of discernment, for the tiniest human foibles and virtues. But as he himself once said, it is the little things that give meaning to life. He is, therefore, perpetually on the watch for tokens, be they never so slight; a spot of grease on a dress, an awkward gesture caused by shyness, a strand of reddish hair peeping from beneath a wig if its wearer happens to lose his temper. He captures all the nuances of a handshake, knows what the pressure of each finger signifies; detects the shades of meaning in a smile.

Before he took to the career of a writer, he was parliamentary reporter for a newspaper. In this capacity he became proficient in the art of summary, in compressing long-winded discussions; as shorthand writer, he conveyed a word by a stroke, a whole sentence by a few curves and dashes. So in later days as an author he invented a kind of shorthand to reality, consisting of little signs instead of lengthy descriptions, an essence of observation distilled from the innumerable happenings of life. He has an uncannily sharp eye for the detection of these insignificant externals; he never overlooks anything; his memory and his keenness of perception are like a photographic plate which, in the hundredth part of a second, fixes the least expression, the slightest gesture, and yields a perfectly precise negative. Nothing escapes his notice. In addition, this perspicacious observation is enhanced by a marvellous power of refraction which, instead of presenting an object as merely reflected in its ordinary proportions from the surface of a mirror, gives us an image clothed in an excess of characteristics. For he invariably underlines the personal attributes of his characters...

This extraordinary optical faculty amounted to genius in Dickens. He cannot, as a matter of fact, be regarded as a great psychologist. Not his the special power of one who plumbs the depths of men's minds, to find there the seeds of light or of darkness, out of which to conjure up the shapes and colours of things, as if able to stimulate a mysterious process of growth. His psychology began with the visible; he gained his insight into character by observation of the exterior – the most delicate and fine minutiae of the outward semblance, it is true, those utmost tenuosities which only the eyes that are rendered acute by a superlative imagination can perceive. Like the English philosophers, he does not begin with assumptions and suppositions, but with characteristics. He lays hold of the most inconspicuous and corporeal expressions of the soul, and by the magic of his method of caricature he brings the whole personality visibly and palpably before our eyes. Through traits, he discloses types: Creakle had no voice, but spoke in a whisper; the exertion speech cost him, or the consciousness of talking in that feeble way, made his angry face much more angry, and his thick veins much thicker. Even as we read the description, the sense of terror the boys felt at the approach of this fiery

blusterer becomes manifest in us as well. Uriah Heep's hands are damp and cold; we experience a loathing for the creature at the very outset, as though we were faced by a snake. Small things? Externals? Yes, but they invariably are such as to recoil upon the soul.[33]

When he was working, Dickens actually did see before him what he was describing: he heard around him what he was writing. Dickens' biographer, Forster, quotes from his letter:

'... when, in the midst of this trouble and pain, I sit down to my book, some beneficent power shows it all to me, and tempts me to be interested, and I don't invent it – really do not – *but see it* and write it down.'[34]

Dickens' visual images are inseparable from the auditory ones. The English philosopher and writer George Henry Lewes (in an article dated 1872) testifies that Dickens *distinctly heard* every word uttered by his characters.[35]

His ability really to visualise what he was describing produces not just *absolutely precise detail but even an absolutely precise picture of the conduct* and actions of his characters. And this holds good for both the minutest details and the overall picture of a character's conduct – that is, the principal generalising description of an image – as a whole.

This extract describing Mr Dombey's behaviour, caught intuitively, could serve as a comprehensive stage direction for an actor or director:

He had already laid his hand upon the bell-rope to convey his usual summons to Richards, when his eye fell upon a writing-desk, belonging to his deceased wife, which had been taken, among other things, from a cabinet in her chamber. It was not the first time that his eye had lighted on it. He carried the key in his pocket; and he brought it to his table and opened it now – having previously locked the room door – with a well accustomed hand.[36]

This last phrase is striking. From the point of view of description it is clumsy. However this 'insert' – 'having previously locked the room door' – is 'cut' as though suddenly placed there by the author as an afterthought, in the middle of another phrase instead of being placed where it ought to be, following the sequence of a logical description: that is, before the words 'and he brought it to his table'. It is not mere chance that it appears where it does.

In this rationalised 'montage' transposition of consecutive description, the *fleeting furtiveness* of an action has been caught brilliantly – it slips in between the preliminary action and the act of reading a letter meant for someone else, which are both carried out with that absolute correctness that a gentleman, such as Mr Dombey, is able to impart to his every action and deed.

Here in the actual (montage) position of the phrases, the 'performer' is given a precise indication of how to 'act' the opening of the door, with a nuance of a completely different shade of behaviour; one that is distinct from

the decorous and confident opening of a writing-desk. Incidentally, that same 'nuance' requires the unfolding of a letter also: and Dickens clarifies that part of the performance not only by the expressiveness of the word-order, but by a very precise description too:

> From beneath a heap of torn and cancelled scraps of paper, he took one letter that remained entire. Involuntarily holding his breath as he opened this document, and, 'bating in the stealthy action something of his arrogant demeanour, he sat down, resting his head upon one hand, and read it through.[37]

The actual reading passes in an atmosphere of the gentleman's absolutely cold formality:

> He read it slowly and attentively, and with a nice particularity to every syllable. Otherwise than as his great deliberation seemed unnatural, and perhaps the result of an effort equally great, he allowed no sign of emotion to escape him. When he had read it through, he folded and refolded it slowly several times, and tore it carefully into fragments. Checking his hand in the act of throwing these away, he put them in his pocket, as if unwilling to trust them even to the chances of being reunited and deciphered; and, instead of ringing, as usual, for little Paul, he sat solitary all the evening in his cheerless room.[38]

I quote this small extract describing Dombey's actions because it did not make it into the novel from the manuscript.

Taking Forster's advice, Dickens cut it out in the interests of suspense; Forster preserved it in his book on Dickens, commenting on the ruthlessness with which Dickens 'excised' things which it cost him great pains to achieve.

This ruthlessness also throws into harsh relief the clarity of depiction, which Dickens used every resource to attain; he tried to say what was necessary with all the brevity of cinema. (This, however, did not in any way prevent his novels taking on colossal proportions.)

I do not balk at lengthy descriptions or fear reproach for any digressions, because I only need to substitute the names of two or three characters and replace Dickens' name with that of the hero of my article, to attribute virtually everything written here to Griffith.

From the steely glint of his penetrating gaze, which I remember from personal meetings with him, right up to the fleetingly caught key details or objects that define a character, Griffith has all of this Dickensian acuity and keenness, just as Dickens has the cinematic sense of 'opticality', 'shot', 'close-up' and the distorting expressiveness of some special lenses!

I cannot help recalling my own first impression of my first meeting with Griffith, who was cinema's first classic:

> The 'shot' could have been an extract from one of his early films.
> ... A hotel on Broadway. In the very heart of New York ... It was here that I had my meeting with Griffith, who for thirty years had stayed faithful to the place he loved.

So it was at five or six in the morning. The grey dawn over Broadway. Metal trashcans. Street-sweepers. A huge empty hall. In the early light, it seemed to have no windows, and empty Broadway was pouring into the sleepy hotel. The chairs were stacked up. The carpets rolled back. Cleaning. At the back of the hall a porter moved through the gloom carrying keys. Next to him was a figure in grey. The grey stubble stood out against his grey complexion. Bright eyes with a steely gaze. Piercing. Unwaveringly fixed on one point: a trolley between the stacked chairs and the rolled-up carpets. There were two medical orderlies on the bare slabs. Behind them, policemen. There was someone covered in blood on the trolley. A bandage. Blood. Nearby the palms were being dusted. Mountains of paper were being swept out under the windows. There had been a fight. Someone was brought to the hotel. Bandaged up. Taken out. The grey street. Grey people. And the grey man at the back. How many times did he, Griffith, recreate for us such scenes of American banditry... It is like watching all this on the screen: the colour has vanished, leaving just a spectrum of shades of grey – from the white spots of paper on the street, to the almost total darkness where the hotel staircase ascended...*

You should not pursue analogies and similarities too far – they lose their conviction and charm and begin to sound contrived or garbled. I would hate it if my comparison between Dickens and Griffith were to lose its persuasiveness, by allowing this abundance of common features to slide into a game of anecdotal semblance between distinguishing features.

The more so as this examination of Dickens no longer concerns Griffith's skill as a film-maker, but has begun to touch on the craft of cinema in general.

But that is precisely why I have to dig more and more deeply into features of Dickens' cinema, using Griffith to show how instructive they were for future cinema.

So I shall expect indulgence if, when leafing through Dickens, I find 'dissolves'. How else can one term this description from *A Tale of Two Cities*?

Along the Paris streets, the death-carts rumble, hollow and harsh. Six tumbrils carry the day's wine to La Guillotine...

Six tumbrils roll along the streets. Change these back again to what they were, thou powerful enchanter, Time, and they shall be seen to be the carriages of absolute monarchs, the equipages of feudal nobles, the toilettes of flaring Jezebels, the churches that are not my Father's house but dens of thieves, the huts of millions of starving peasants![39]

How many such 'cinematic' surprises must be lurking in Dickens' pages!

But I shall gladly restrict myself to the chief constructs of montage which were shown crudely in Dickens' work, and later flourished as elements of film composition in Griffith's.

*I am quoting here from my article about my meeting with Griffith published in the newspaper *Kino* on 5 July 1932. (E's note)

Let us take a peek under the curtains, at this rich and hitherto useful resource, by opening the first novel that comes to hand.

Oliver Twist, for example.

Let us open it at random. Suppose it is Chapter XXI.

We read the start:

*Chapter XXI**

1.

It was a cheerless morning when they got into the street; blowing and raining hard; and the clouds looking dull and stormy.

The night had been very wet: large pools of water had collected in the road: and the kennels were overflowing.

There was a faint glimmering of the coming day in the sky; but it rather aggravated than relieved the gloom of the scene: the sombre light only serving to pale that which the street lamps afforded, without shedding any warmer or brighter tints upon the wet housetops, and dreary streets.

There appeared to be nobody stirring in that part of the town; the windows of the houses were all closely shut; and the streets through which they passed, were noiseless and empty.[40]

2.

By the time they had turned into the Bethnal Green Road, the day had fairly begun to break. Many of the lamps were already extinguished;

a few country waggons were slowly toiling on, towards London;

now and then, a stage-coach, covered with mud, rattled briskly by;

the driver bestowing, as he passed, an admonitory lash upon the heavy waggoner who, by keeping on the wrong side of the road, had endangered his arriving at the office a quarter of a minute after his time.

The public-houses, with gas-lights burning inside, were already open.

By degrees, other shops began to be unclosed, and a few scattered people were met with.

Then, came straggling groups of labourers going to their work;

then, men and women with fish-baskets on their heads;

*For purposes of clarity I have broken the beginning of this chapter into smaller fragments than did its author, and numbered them. (E's note.)

donkey-carts laden with vegetables;

chaise-carts filled with live-stock or whole carcasses of meat;

milk-women with pails;

an unbroken concourse of people, trudging out with various supplies to the eastern suburbs of the town.[41]

3.

As they approached the City, the noise and traffic gradually increased;

when they threaded the streets between Shoreditch and Smithfield, it had swelled into a roar of sound and bustle.

It was as light as it was likely to be, till night came on again, and the busy morning of half the London population had begun . . .[42]

4.

It was market-morning.

The ground was covered, nearly ankle-deep, with filth and mire;

a thick stream, perpetually rising from the reeking bodies of the cattle,

and mingling with the fog,

which seemed to rest upon the chimney-tops, hung heavily above . . .

Countrymen,

butchers,

drovers,

hawkers,

boys,

thieves,

idlers,

and vagabonds of every low grade,

were mingled together in a mass;[43]

5.

the whistling of drovers,

the barking of dogs,

the bellowing and plunging of oxen,

the bleating of sheep,

the grunting and squeaking of pigs,

the cries of hawkers,

the shouts, oaths, and quarrelling on all sides;

the ringing of bells

and roar of voices, that issued from every public-house;

the crowding, pushing, driving, beating,

whooping, and yelling;

the hideous and discordant din that resounded from every corner of the market;

and the unwashed, unshaven, squalid and dirty figures constantly running to and fro, and bursting in and out of the throng; rendered it a stunning and bewildering scene, which quite confounded the senses.[44]

How often have we encountered this construction in Griffith's work!

Using a similarly strict development and acceleration of pace, with the same play of light, from the burning street-lamps to those that are extinguished; from night to dawn and from dawn to the brightness of full daylight ('It was as light as it was likely to be, till night came on again'); with its considered succession of purely visual elements interspliced with auditory ones, so that the initial indefinite rumble, echoing from afar the gradual dawn, turns into a full-blooded roar, and into constructions that are purely auditory, and already concrete and objective (see section 5 of my breakdown), and with the same vignettes inserted *en passant* – like the coachman dashing for the office before it opens; and finally, with the same amazingly typifying details, such as the reeking bodies of the cattle, from which the steam rises and forms a common cloud with the morning fog, or the close-up of the foot that was 'nearly ankle-deep, with filth and mire', conveying a complete picture of a market better than a dozen pages of description could!

While these examples from Dickens overwhelm us, we should not forget one more circumstance, connected with Dickens' work in general.

As we think about him, and 'cosy' old England, it is easy to forget that Dickens' works stand out from English literature, and indeed from literature from all over the world at that time, as works by a city artist. He was the first to bring factories, machinery and the railways into literature.

But the features of Dickens' 'urbanism' do not only lie in the subject matter: they are also to be found in ... the giddy rush of succeeding impressions, with which Dickens depicts a city as a dynamic (montage) picture. And the rhythm of this montage gives a sense of the greatest speed possible in those times – 1838 – the feeling of a rushing ... stagecoach!

> As they dashed by the quickly-changing and ever-varying objects, it was curious to observe in what a strange procession they passed before the eye. Emporiums of splendid dresses, the materials brought from every quarter of the world; tempting stores of everything to stimulate and pamper the sated appetite and give new relish to the oft-repeated feast; vessels of burnished gold and silver, wrought into every exquisite form of vase, and dish, and goblet; guns, swords, pistols, and patent engines of destruction; screws and irons for the crooked, clothes for the newly-born, drugs for the sick, coffins for the dead, churchyards for the buried – all these jumbled each with the other and flocking side by side, seemed to flit by in motley 'dance'.[45]

Does this not anticipate the 'symphony of a big city'?[46]

But here is another aspect of the city – the direct antithesis, which seemingly preceded the American film-maker's description of the city by eighty years.

> It contained several large streets all very like one another, and many small streets still more like one another, inhabited by people equally like one another, who all went in and out at the same hours, with the same sound upon the pavements, to do the same work, and to whom every day was the same as yesterday and to-morrow, and every year the counterpart of the last and the next.[47]

England in 1854 (*Hard Times*) or King Vidor's *The Crowd*, 1928?[48]

If the examples cited above contain prototypes of the *montage expositions* that are characteristic of Griffith, we have only to read *Oliver Twist* carefully to encounter straight away another montage method typical of Griffith – *the montage progression of parallel scenes, intercut.*

For this let me turn to the set of scenes in the famous episode where Mr Brownlow, to show his faith in Oliver, chooses him to return books to the bookseller; and where Oliver again falls prey to Sikes the burglar, his friend Nancy and old Fagin.

These scenes unfold in a way that is utterly Griffithian, both in their internal emotional content and in the unusual way that the characters stand out – their delineation; in the uncommon richness of their dramatic and comic features; and, finally, in the typically Griffithian montage of parallel splicing of all the links between the separate episodes.

Let us look in particular detail at this last characteristic; it seems so un-expected in Dickens, and so typical of Griffith.

Chapter XIV

Comprising further Particulars of Oliver's Stay at Mr Brownlow's, with the remarkable Prediction which one Mr Grimwig uttered concerning him, when he went out on an Errand

'Dear me, I am very sorry for that,' exclaimed Mr Brownlow; 'I particularly wished those books to be returned to-night.'

'Send Oliver with them,' said Mr Grimwig, with an ironical smile; 'he will be sure to deliver them safely, you know.'

'Yes; do let me take them, if you please, sir,' said Oliver. 'I'll run all the way, sir.'

The old gentleman was just going to say that Oliver should not go out on any account; when a most malicious cough from Mr Grimwig determined him that he should; and that, by his prompt discharge of the commission, he should prove to him the injustice of his suspicions: on this head at least: at once.[49]

Oliver is prepared for his errand to the bookseller.

'I won't be ten minutes, sir,' replied Oliver, eagerly.

Mrs Bedwin, Mr Brownlow's housekeeper, gives Oliver directions and sends him off.

'Bless his sweet face!' said the old lady, looking after him. 'I can't bear, somehow, to let him go out of my sight.'

At this moment, Oliver looked gaily round, and nodded before he turned the corner. The old lady smilingly returned his salutation, and, closing the door, went back to her own room.

'Let me see; he'll be back in twenty minutes, at the longest,' said Mr Brownlow, pulling out his watch, and placing it on the table. 'It will be dark by that time.'

'Oh! you really expect him to come back, do you?' inquired Mr Grimwig.

'Don't you?' asked Mr Brownlow, smiling.

The spirit of contradiction was strong in Mr Grimwig's breast, at the moment; and it was rendered stronger by his friend's confident smile.

'No,' he said, smiting the table with his fist, 'I do not. The boy has a new suit of clothes on his back, a set of valuable books under his arm, and a five-pound note in his pocket. He'll join his old friends the thieves, and laugh at you. If ever that boy returns to this house, sir, I'll eat my head.'

With these words he drew his chair closer to the table; and there the two friends sat, in silent expectation, with the watch between them.

This is followed by a short 'insert' in the shape of a digression.

> It is worthy of remark, as illustrating the importance we attach to our own judgments, and the pride with which we put forth our most rash and hasty conclusions, that, although Mr Grimwig was not by any means a bad-hearted man, and though he would have been unfeignedly sorry to see his respected friend duped and deceived, he really did most earnestly and strongly hope at that moment, that Oliver Twist might not come back.

And again a return to the two gentlemen:

> It grew so dark, that the figures on the dial-plate were scarcely discernible; but there the two old gentlemen continued to sit, in silence, with the watch between them.[50]

The twilight tells us that a considerable period of time has elapsed; but the *close-up* of the watch, which has already been shown *twice* lying between the old gentlemen, tells us that a great deal of time has passed already. But then, at the same time as not only the two elderly gentlemen but also the kindly reader are drawn into the game of 'will he/won't he return', the worst apprehensions and the vague premonitions of the old lady are justified by the cut to a new scene – Chapter XV: 'Showing how very fond of Oliver Twist the merry old Jew and Miss Nancy were'. (This begins with a short scene in the public house between Sikes the bandit and his dog, old Fagin, and Miss Nancy, who was to spy out Oliver's place of residence.)

> 'You are on the scent, are you, Nancy?' inquired Sikes, proffering the glass.
> 'Yes I am, Bill,' replied the young lady, disposing of its contents; 'and tired enough of it I am, too. . .'[51]

Then comes one of the best scenes in the whole book – at least, the scene which I remember best from childhood, together with the evil figure of Fagin: the scene in which Oliver, walking along with the books under his arm, is suddenly

> startled by a young woman screaming out very loud, 'Oh, my dear brother!' And he had hardly looked up, to see what the matter was, when he was stopped by having a pair of arms thrown tight around his neck.

With this polished manoeuvre, Nancy restores the desperately resisting Oliver – her 'prodigal brother' – to the bosom of Fagin's gang of thieves, while the whole street looks on in sympathy.

The same chapter finishes with the now familiar montage phrase:

> The gas-lamps were lighted; Mrs Bedwin was waiting anxiously at the open door; the servant had run up the street twenty times to see if there

were any traces of Oliver; and still the two old gentlemen sat, persever-
ingly, in the dark parlour, with the watch between them.

In Chapter XVI, Oliver has been reinstated in the thieves' den, and subject-
ed to ridicule. Nancy rescues him from a beating:

> 'I won't stand by and see it done, Fagin,' cried the girl. 'You've got the
> boy and what more would you have? – Let him be – let him be – or I shall
> put that mark on some of you, that will bring me to the gallows before
> my time.'

(Incidentally, these sudden bursts of generosity from 'morally degraded'
types are typical of both Dickens and Griffith and they unfailingly, if senti-
mentally, act upon even the most sceptical audiences and readers!)

At the end of the chapter, Oliver is in agonies, exhausted, and falls 'sound
asleep'.

Here the physical unity of time is broken up – that evening and night are
filled with events; but the montage unity of the episode that binds Oliver to
Mr Brownlow, on the one hand, and Fagin's gang on the other, is not broken.

In Chapter XVII there follows the visit of the church beadle, Mr Bumble,
responding to the announcement about the missing little boy, and Bumble's
appearance at Mr Brownlow's, who is again in Grimwig's company.

The content and sense of their conversation is revealed by the chapter
heading: 'Oliver's Destiny continuing unpropitious, brings a Great Man to
London to injure His Reputation'.

> 'I fear it is all too true,' said the old gentleman sorrowfully, after look-
> ing over the papers. 'This is not much for your intelligence; but I would
> gladly have given you treble the money, if it had been favourable to the
> boy.'
>
>> It is not improbable that if Mr Bumble had been possessed of this in-
>> formation at an earlier period of the interview, he might have imparted a
>> very different colouring to his little history. It was too late to do it now,
>> however; so he shook his head gravely, and, pocketing the five guineas,
>> withdrew.
>>
>> Mr Brownlow paced the room to and fro for some minutes; evi-
>> dently so much disturbed by the beadle's tale, that even Mr Grimwig
>> forbore to vex him further.
>>
>> At length he stopped, and rang the bell violently.
>>
>> 'Mrs Bedwin,' said Mr Brownlow, when the housekeeper appeared;
>> 'that boy, Oliver, is an impostor.'
>>
>> 'It can't be, sir. It cannot be,' said the old lady, energetically.
>>
>> 'I tell you he is,' retorted the old gentleman. 'What do you mean by
>> can't be? We have just heard a full account of him from his birth; and he
>> has been a thorough-paced little villain, all his life.'
>>
>> 'I never will believe it, sir,' replied the old lady, firmly. 'Never!'
>>
>> 'You old women never believe anything but quack-doctors, and

lying story-books,' growled Mr Grimwig. 'I knew it all along. Why didn't you take my advice in the beginning; you would, if he hadn't had a fever, I suppose, eh? He was interesting, wasn't he? Interesting! Bah!' And Mr Grimwig poked the fire with a flourish.

'He was a dear, grateful, gentle child, sir,' retorted Mrs Bedwin, indignantly. 'I know what children are, sir; and have done these forty years; and people who can't say the same, shouldn't say anything about them. That's my opinion!'

This was a hard hit at Mr Grimwig, who was a bachelor. As it extorted nothing from that gentleman but a smile, the old lady tossed her head, and smoothed down her apron preparatory to another speech, when she was stopped by Mr Brownlow.

'Silence!' said the old gentleman, feigning an anger he was far from feeling. 'Never let me hear the boy's name again. I rang to tell you that. Never. Never, on any pretence, mind! You may leave the room, Mrs Bedwin. Remember! I am in earnest.'

And the whole elaborate montage complex of the entire episode ends with the phrase: 'There were sad hearts at Mr Brownlow's that night.'[52]

It is no accident that I have allowed myself to quote such detailed extracts, concerning not only the composition of the scene but also the delineation of the characters, for, in their very modelling, in their description and conduct, there is much that is typical of Griffith's style. This applies equally to his 'Dickensian' suffering, defenceless beings (think of Lillian Gish and Richard Barthelmess in *Broken Blossoms* or the Gish sisters in *Orphans of the Storm*) and to the characters of the two elderly gentlemen and Mrs Bedwin, who are no less typical of him; and finally to the cronies of Fagin – the merry old Jew – who are entirely characteristic of Griffith.[53]

With respect to our immediate task of analysing how Dickens organises the montage progression of the plot composition, the results may be set out in accordance with the following table:

1. *The elderly gentlemen.*
2. Oliver's departure.
3. *The elderly gentlemen and the watch. It is still light.*
4. Digression about Mr Grimwig's character.
5. *The elderly gentlemen and the watch. Gathering twilight.*
6. Fagin, Sikes and Nancy in the public house.
7. The street scene.
8. *The elderly gentlemen and the watch. The gas-lamps have been lit.*
9. Oliver is back with Fagin.
10. Digression at the beginning of Chapter XVII.
11. Mr Bumble's journey.
12. *The elderly gentlemen* and Mr Brownlow's instruction that Oliver be forgotten forever.

As we can see, we have before us a typical and, for Griffith, a model of the parallel montage of two storylines; the presence of one (the waiting

gentlemen) emotionally heightens the suspense of the other (Oliver's misadventure) – which is dramatic enough as it is.

It is in the 'rescuers' who rush to save the 'damsel in distress' that Griffith earns his greatest laurels in the field of parallel montage!

But what is most curious is another 'insert' at the *very heart* of the episode we have chosen – a whole digression at the beginning of Chapter XVII which I have deliberately kept quiet about. Why is this digression noteworthy?

Because it is an idiosyncratic 'treatment' of the principles of that very same montage plot-construction, here executed so beautifully, that has passed from Dickens to Griffith.

Here it is:

> It is the custom on the stage, in all good murderous melodramas, to present the tragic and the comic scenes, in as regular alternation, as the layers of red and white in a side of streaky bacon. The hero sinks upon his straw bed, weighed down by fetters and misfortunes; in the next scene, his faithful but unconscious squire regales the audience with a comic song. We behold, with throbbing bosoms, the heroine in the grasp of a proud and ruthless baron: her virtue and her life alike in danger, drawing forth her dagger to preserve the one at the cost of the other; and just as our expectations are wrought up to the highest pitch, a whistle is heard, and we are straightway transported to the great hall of the castle: where a grey-headed seneschal sings a funny chorus with a funnier body of vassals, who are free of all sorts of places, from church vaults to palaces, and roam about in company, carolling perpetually.
>
> Such changes appear absurd; but they are not so unnatural as they would seem at first sight. The transitions in real life from well-spread boards to death-beds, and from mourning weeds to holiday garments, are not a whit less startling; only, there, we are busy actors, instead of passive lookers-on, which makes a vast difference. The actors in the mimic life of the theatre, are blind to violent transitions and abrupt impulses of passion or feeling, which, presented before the eyes of mere spectators, are at once condemned as outrageous and preposterous.
>
> As sudden shiftings of the scene, and rapid changes of time and place, are not only sanctioned in books by long usage, but are by many considered as the greatest art of authorship: an author's skill in his craft being, by such critics, chiefly estimated with relation to the dilemmas in which he leaves his characters at the end of every chapter: this brief introduction to the present one may perhaps be deemed unnecessary.

There is something else of interest in this quoted 'treatment': we have, in his own words, a description of Dickens' direct link with theatrical melodrama.[54]

Dickens hereby seems to establish himself as the connecting link between the future art of cinema, which could not have been guessed at, and the recent (for Dickens) past – the traditions of 'good murderous melodramas'.

The patriarch of American cinema could not have failed to notice this 'treatment', and his works often seem to rehearse the wise advice handed

down to the twentieth-century film-maker by the great nineteenth-century novelist. Griffith is right not to conceal this, but to pay Dickens' memory a fitting homage.

Griffith used a similar construction on screen for the first time in the film *After Many Years* (a screen adaptation of Tennyson's *Enoch Arden*, 1908).

This film is also famous because the close-up was applied *meaningfully*, and *utilised*, for the first time.

These were the first close-ups in America since Edwin Porter's celebrated *The Great Train Robbery* [USA, 1903], produced five years earlier, which had one close-up at the most, and that was used for purely sensational effect: the criminal was shown shooting point-blank into the auditorium!

Eric Elliott, in his book *Anatomy of Motion Picture Art*, mentions one other film from that same epoch of the early Vitagraph company, called *Extremities*, in which each scene featured only ... the actors' feet – Clara Campbell Young and Maurice Costello.[55]*

But that is not what is important. The important thing is *how* Griffith used close-up *for the first time as montage*.

For those days, it was bold to *show only the face, taken in close-up*, in the scene where Annie Lee is waiting for her husband to return. This was enough to move the Biograph Studio's owners to protest – Griffith worked there then. But it was much bolder immediately after that close-up to cut to the person Annie Lee was thinking about expectantly – her husband Enoch, a castaway on a desert island.[56]

This provoked nothing less than a storm of indignation and censure, because nobody would understand such transferred action (cut-back).†

Interestingly, in his defence of his invention, it was none other than ... Dickens whom Griffith cited.

Linda Arvidson (D. W. Griffith's wife) quotes a characteristic snippet of dialogue in her memoirs:

'How can you tell a story jumping about like that? The people won't know what it's about.'
 'Well,' said Mr Griffith, 'doesn't Dickens write that way?'
 'Yes, but that's Dickens; that's novel writing; that's different.'
 'Oh, not so much, these are picture stories; not so different.'[57]

If these were only the first glimpses of what Griffith was to become famous for, his next production – *The Lonely Villa* [USA, 1909] – shows the new method fully developed. And here begins parallel montage, which so increased the suspense in the final scene of 'saving the victim at the eleventh hour'. The burglars break in; the family is gripped by terror; the father rushes to rescue his wife and children – all this is intercut as a prototype for what appeared with renewed force in *The Birth of a Nation* [USA, 1915], *Intolerance* and *Orphans of the Storm*, *America* and many other examples of Griffith's developed montage.

*The logically informative close-up can be found even earlier, e.g. in the same Porter's *The Life of an American Fireman* [USA, 1903] where the fire alarm is shot in close-up. (E's note)
†In English in the original.

But Griffith could have traced the montage family tree even further back, and found another glorious ancestor for himself and Dickens in the shape of another Englishman: Shakespeare.

However, the theatre that Dickens mentions was nothing other than a typical vulgarisation, in the shape of cheap, early nineteenth-century melodrama, of the great traditions of Elizabethan theatre, or of that theatre itself, acted in the melodramatic manner of the early nineteenth century. Forster testifies that Dickens' earliest childhood impressions of theatre related to the performance of Shakespeare's tragedies that are, incidentally, closest to melodrama: *Macbeth* and *Richard III*.

I shall confine myself to one example of Shakespeare's montage structure that is perfected in this area.

It is Act V of *Macbeth*: I shall briefly run through it.

As far as montage is concerned, Act V is one of the most brilliant models to be found in Shakespeare's montage. It is as though *the individual short scenes are fighting amongst themselves* in a solid block of montage, in order to break down, in Scene 7, into a group of *duels between the individual characters*.

Let me briefly recall the movement of the scenes:

Macbeth. Act V
Act V begins with the famous sleepwalking scene with Lady Macbeth.
Then follow scenes in single combat [*poedinok*],[58] which turn into single combat between the characters.

Scene II. The country near Dunsinane.
News of the approaching English forces and the place of combat – Birnam Wood.

Scene III. Dunsinane. A room in the castle.
Macbeth remembers the prophecy of Birnam Wood 'that no man born of woman' shall defeat him.
News of the ten thousand troops advancing on the castle.

Scene IV. Country near Birnam Wood.
Malcolm orders his soldiers to camouflage themselves with cut branches.

Scene V. Dunsinane. Within the castle.
Lady Macbeth is dying.
News that Birnam Wood is moving towards Dunsinane. Macbeth goes out on to the field.

Scene VI. A plain before the castle.
Malcolm, Macduff and the old Siward with the army. The order is given to throw down the 'leavy screens' and attack.

Scene VII. Another part of the plain.
And here the scene breaks down into individual duels.

Macbeth is alone (about his opponent, 'What's he that was not born of woman').

The duel with Young Siward. Macbeth kills him. ('Thou wast born of woman'). Exit.

Dunsinane Castle surrenders (Old Siward tells Malcolm the news). Exeunt.

Macbeth is alone. Refusal to commit suicide (a new twist in the theme of the enemy 'being of no woman born').

Macbeth and Macduff. A duel. Macduff was 'from his mother's womb untimely ripp'd'. Exeunt, fighting.

An 'insert' to heighten the suspense. A repeat of Young Siward's duel, as Ross relates the story to Old Siward.

Enter Macduff with Macbeth's head.

Finale. Malcolm is hailed as king.

The last act of *Richard III* would equally repay examination; not only for its battle scenes, but for the whole range of 'double exposures' of Richard's victims, as they appear before him the night before battle.

But if one is going to look for prototypes for these cinema devices – dissolves and double exposures – in Elizabethan theatre, it would be best to turn to Webster, whose *The White Devil* provides us with two models that are unsurpassed in this regard.

Act II, Scene 2

Enter BRACCIANO with one in the habit of a Conjurer.

Bracciano: Now sir I claim your promise, – 'tis dead midnight,
The time prefix'd to show me by your art
How the intended murder of Camillo,
And our loathed duchess grow to action.

Conjurer: You have won me by your bounty to a deed
I do not often practise...

... pray sit down,
Put on this night-cap sir, 'tis charm'd, – and now
I'll show you by my strong-commanding art
The circumstance that breaks your duchess' heart.

A dumb show.

Enter suspiciously, JULIO and another, they draw a curtain where BRACCIANO's picture is, they put on spectacles of glass, which cover their eyes and noses, and then burn perfumes afore the picture, and wash the lips of the picture, that done, quenching the fire, and putting off their spectacles, they depart laughing.

Enter ISABELLA in her nightgown as to bed-ward, with lights after her, Count LODOVICO, GIOVANNI, and others waiting on her, she kneels down as to prayers, then draws the curtain of the picture, does three reverences to it, and kisses it thrice, she faints and will not suffer them to come near it, dies; sorrow express'd in GIOVANNI and in Count LODOVICO; she's conveyed out solemnly.

Bracciano: Excellent, then she's dead, –

Conjuror: She's poisoned,
 By the fum'd picture, – 'twas her custom nightly,
 Before she went to bed, to go and visit
 Your picture, and to feed her eyes and lips
 On the dead shadow, – Doctor Julio
 Observing this, infects it with an oil
 And other poison'd stuff, which presently
 Did suffocate her spirits.[59]

This influence can be traced from the Elizabethans and Shakespeare through the vulgarisation of their words in lowbrow English melodramas of the early nineteenth century and, through Dickens, to Griffith.

Melodrama, which had attained its richest and most perfected form on American soil at the end of the nineteenth century, had a great influence on Griffith at this high point in its development, and the firm foundations of Griffith's films contain a considerable number of its astonishing and characteristic features.

What did American melodrama look like, and what was it, in the period directly preceding Griffith?

The most curious thing about it was the close interlacing, on stage, of *both sides* as was so characteristic later for Griffith's future work: *two sides*, as was typical of his style and manner, of which I spoke earlier.

I shall try to illustrate this with the individual example of the stage version of what was to be filmed as *Way Down East*.

The stage producer of this melodrama, William A. Brady, has preserved something of this story in his reminiscences.[60] They are of interest as they describe the emergence and popularisation of a genre called 'home-spun'* – the melodrama of locale.

His memoirs offer an equally interesting insight into the stage performance of these melodramas on the actual boards. For, in many cases, this purely theatrical representation quite literally anticipates not only the themes, the plots and their interpretation, but also the theatrical devices and effects that we always thought of as being 'pure cinema': unprecedented and ... born of screen!

For this reason my account of the conditions and the manner in which *Way Down East* was put together and achieved its success in the 1890s is

*In English in the original.

followed immediately by a description, in no less bold relief, of the stage effects in the melodrama *The Ninety and Nine*, which played to packed houses in New York in 1902.

A variety actor named Denman Thompson in the late 'seventies was performing a sketch on the variety circuits called *Joshua Whitcomb* ... It happened that James M. Hill, a retail clothier from Chicago, saw *Joshua Whitcomb*, met Thompson, and persuaded him to write a four-act drama around Old Josh.[61]

That was how the melodrama *The Old Homestead** was born; its production was financed by Mr Hill. The new genre was slow to catch on, but clever advertising and publicity did their stuff: they know how to set in train sentimental dreams and reminiscences about the good old family hearths, now alas left behind; about the good old life of provincial America, and ... the play was not taken off the stage for twenty-five years, making Mr James M. Hill a millionaire over this period.

Another successful play with similar subject matter was Neil Burgess's *The Country Fair*.

That production was especially noteworthy since here, for the first time in the history of theatre, on stage there were real ... races. The horses galloped on a ... moving treadmill, remaining in view throughout.[62†]

The novelty and attractiveness of the subject matter, combined with such stage devices, quickly created a universal vogue for this kind of home-spun drama.

Another long-lived earthy melodrama was *In Old Kentucky*, which with its Pickaninny Band made a couple of millions in ten years for its owner, Jacob Litt ... Augustus Thomas tried his hand writing a trio of rurals – *Alabama*, *Arizona*, and *In Mizzoura*.[63]

And it was not long before literally every state had its home-spun melodrama, based on its own material.

At that time the manuscript of the play *Annie Laurie* fell into the hands of the enterprising Brady. Sensing that he had something good, he acquired full ownership rights to this play for $10,000, and handed it to Joseph R. Grismer for 'remedial treatment'. Grismer released a final version of the play with the now famous title *Way Down East*.[64]

But the play was a complete failure. No amount of advertising could save it. Losses of up to $40,000 were recorded. Then William A. Brady describes what happened next:

*In English in the original.
†A description of the technical design of this highly complex piece of stage equipment is to be found in the journal L'Illustration, 14 March 1891. It shows an arrangement of three parallel treadmills on which real horses can gallop in the racing scene from some revue on the stage of the Revue des Variétés theatre. (E's note)

One night a well-known minister dropped in and he wrote us a nice let-ter of appreciation. That gave us a cue. We sent out ten thousand 'min-ister tickets' and asked them all for tributes and got them. They all said it was a masterpiece – made long speeches from the stage to that effect – and followed it up with sermons from their pulpits. I hired the big elec-tric sign on the triangle building at Broadway and Twenty-third Street (the first big one in New York). It cost us a thousand dollars a month. How it did make the Rialto talk! In one of our weekly press notices, which *The Sun* printed, it stated that *Way Down East* was better than *The Old Homestead*. That gave us a slogan which lasted twenty years . . .[65]

Despite all this, the tour of the provinces was once again a dismal failure. So, on the return to New York, the most extreme and heroic measures were taken:

Grismer and I put our heads together and decided on a huge production, including horses, cattle, sheep, all varieties of farm conveyances, a mon-ster sleigh drawn by four horses for a sleigh-ride, an electric snowstorm, a double quartette singing at every opportunity the songs that mother loved – forming, all in all, a veritable farm circus. It went over with a bang, and stayed in New York a full season, showing profits exceeding one hundred thousand dollars.[66]

And then came the second model for the stage spectacles that so excited New York at the turn of the century:*

On October 7, 1902, a rousing melodrama *The Ninety and Nine* made its first appearance in New York, providing thrills of a sort that, in the ab-sence of motion pictures, only stage spectacles could provide. Let *The Theatre Magazine*'s account of this scene explain the picture: 'A hamlet is encircled by a raging prairie fire and three thousand people are threat-ened. At the station, thirty miles away, scores of excited people wait as the telegraph ticks the story of peril. A special is ready to go to the res-cue. The engineer is absent and the craven young millionaire refuses to take the risk to make the dash. The hero springs forward to take his place. Darkness, a moment of suspense, and then the curtain rises again upon an exciting scene. The big stage is literally covered with fire ... In the midst of it all is a massive locomotive, full sized ... almost hidden from view. In the cab is the engineer, smoke grim'd and scarred, while the fire-man dashes water on him to protect him from the flying embers.[67]

The facts speak for themselves: here is the tension of parallel action, the race and the chase; the necessity to get there on time, to break through a fiery ring of obstacles; here is the moral sermon, capable of inflaming a thousand preachers; here is the response to the audience's keen interest in an unfamil-

*I am quoting from the book *The American Procession. American Life since 1860 in Photographs* (New York & London, 1933), which contains a photograph of the moving rail-way engine from this production. (E's note)

iar way of life, depicted in all its 'exotic richness'; here too are the irresistible tunes connected with memories of childhood and 'dear old ma'.

In short, the entire arsenal that Griffith later used to subjugate his audience, just as irresistibly, can be found here.

But, if we wish to move from general statements about montage to its *narrowly specific* features, Griffith might find other 'montage ancestors' for himself in this case too, and without even having to look further than his native American soil.

I am not talking about the grandiose montage conceptions of Walt Whitman.[68] It has to be said that Griffith did not continue Whitman's *montage tradition* (despite the fact that Whitman's line about 'the cradle of time endlessly rocking' was used unsuccessfully as a refrain in his *Intolerance*, of which more later).

I want rather, in connection with montage, to refer to one of Mark Twain's most amusing and wittiest contemporaries, who wrote under the name of John Phoenix. This model of montage is dated . . . 1853 (!) and is taken from a parody in which he made fun of a novelty of those days: the appearance of the first illustrated English journals.

This journal parody was called the *Phoenix Pictorial;*★ Mark Twain later included it in a collection of works by the best humorous writers of his day (*Mark Twain's Library of Humor*, 1888) with a typically Twainian 'Apology from the Compiler': 'Those selections in this book which are from my own works were made by my two assistant compilers, not by me. This is why there are not more! Mark Twain.'[69]

Here is the line that interests us:

Fearful accident on the Camden & Amboy Railroad ! ! Terrible loss of life ! ! !

In this line, by juxtaposing four *sign-templates* [*znaki-shablony*], one of which is *inverted* and another *perpendicular*, John Phoenix, 'in accordance with all the rules of the art of montage', evokes an image . . . of the 'fearful accident on the Camden & Amboy Railroad!! Terrible loss of life!!!'

The method of montage is obvious: the *juxtaposition* of immutable and even unrelated *details* of the shots creates the desired image of the *whole*!

Especially delightful are the false teeth in 'close-up', shown next to a 'long shot' of the upturned carriage; both are shown *the same size*, that is, exactly as would have been the case had they been shown 'filling the whole screen'!

The author who hid behind the resonant pseudonym of Phoenix – Colonel George Horatio Derby – is also interesting.[70] He was one of the first

★In English in the original.

major American humorists of the new type. Some writers hold that he is virtually the 'father' of the whole new school of American humour. Others say that he was the main influence on Mark Twain.

Be that as it may, it is quite evident that John Phoenix was one of the undisputed forebears of the 'violent humour' that reached its apogee in cinema with the Marx Brothers, for example.*

I shall just recall John Phoenix's anecdote, 'Tushmaker's Toothpuller', about a tooth-pulling machine which

> drew the old lady's skeleton (!) completely and entirely from her body, leaving her a mass of quivering jelly in her chair! Tushmaker took her home in a pillow-case. She lived seven years after that, and they called her the 'India-Rubber Woman'. She had suffered terribly with her rheumatism, but after this occurrence, never had a pain in her bones. (!!)[71]

The exuberant Colonel Derby, who was a military engineer rather than a humorist by profession, died of sunstroke in 1861, sustained while erecting lighthouses on the Florida coast . . .

Such was one of the first American forebears of the miraculous method of montage!

I do not know about the reader, but I have always derived comfort from repeatedly telling myself that our cinema is not entirely without an ancestry and a pedigree, a past and traditions, or a rich cultural heritage from earlier epochs. Only very thoughtless or arrogant people could construct laws and aesthetics for cinema based on the dubious assumption that this art came out of thin air!

Let Dickens and the whole constellation of ancestors, who go as far back as Shakespeare or the Greeks, serve as superfluous reminders that Griffith and our cinema alike cannot claim originality for themselves, but have a vast cultural heritage; and this causes neither one any difficulty in advancing the great art of cinema, each at their moment of world history. Let this heritage serve as a reproach to these thoughtless people with their excessive arrogance towards literature, which has contributed so much to this apparently unprecedented art, and most important, to the art of viewing – and I mean *viewing*, in both the senses of this term – not *seeing*.

This extension from the aesthetic of the *cinematic eye* towards the aesthetic of the *figurative embodiment of the viewing of a phenomenon* was one of the most significant processes in the development of our Soviet cinema. It had major repercussions for the development of world cinema as a whole. A special understanding of the principles of film montage, which has been so characteristic of the Soviet school of cinematography, can claim credit for much of this.

Nevertheless, Griffith played a colossal role in refining the system of Soviet montage.

Griffith's role was colossal, but our cinema is neither his poor relative nor his insolvent debtor. The spirit and content of our country and its subject matter have not just been our theme and plot: they could not have been other-

*The Marx Brothers are well-known American clowns. (E's note)

wise, being so far ahead of the ideals that were accessible to Griffith and the artistic images that reflected them.

The tender-hearted morality of his films never rises above Christian denunciation of man's inhumanity, and his films never protest against social injustice. His films are without challenge and struggle.

In his best works, he preaches pacifism and acceptance of fate (*Isn't Life Wonderful?* [USA, 1924]) or philanthropy 'in general' (*Broken Blossoms*). Here in his reproaches and condemnations, Griffith is sometimes able to ascend to magnificent pathos (in *Way Down East*, for example).

In those of his works that have a more dubious subject matter this involves a defence of ... Prohibition (*The Struggle*)[72] or a metaphysical philosophy of the eternal origins of Good and Evil (*Intolerance*).

The Sorrows of Satan, based on the novel by the popular English writer Marie Corelli,[73] is a film steeped in metaphysics.

Finally, in those of his films that repel (and there are some) we see Griffith brazenly defending racism, and erecting a celluloid monument to the Ku-Klux-Klan (*The Birth of a Nation*).

But even in this last case, he keeps to the traditions of British imperialism – the obverse of the kind characters in Dickens.

Montage thought is inseparable from the common ideological grounds of thought as a whole.

The social structure that finds reflection in the concepts of Griffith's montage is the structure of bourgeois society. It really is like Dickens' ironic 'side of streaky, well-cured bacon'; it is genuinely, and not jokingly, woven from irreconcilably distinct layers of 'white' and 'red' – the rich and the poor. (This is an eternal theme in Dickens' novels, but it progresses no further than this division. *Little Dorrit* is thus divided into two parts: 'Poverty' and 'Riches'.) And this society, realised as no more than a *contrast between the haves and the have-nots*, finds no more profound reflection in Griffith's consciousness than the image of an intricate race between parallel lines.

Accordingly, the only point of contact between these two eternally discrete lines is also reflected: namely, the pitiless struggle as the fighters spasmodically seize one another by the throat; as opponents stab each other in hand-to-hand combat. This is where the image of two intersecting lines comes from: in their course, they drive each other to their bad and unhappy ends. Griffith too could not fail to sense this, and in order to rid himself of these ideas, he contrived a forced happy ending for his films!

And the classic Griffith montage method is like an imprint of the society that stood (and still stands) before his eyes!

Griffith is first of all the greatest master of the most obvious feature in this field – *parallel montage*.

Griffith is above all a great master of montage constructions, which create a direct acceleration and *increase in tempo* (seen to best effect in the above-mentioned forms of parallel montage).

Griffith's school is above all a school of *tempo* not of *rhythm*.

He was in no shape to compete with the young school of Soviet montage, in an arena where rhythm was the means of expression and merciless influence, and whose aims far exceeded the aims and limits of tempo alone.

These very features of *devastating rhythm*, as distinct from the effects of *tempo*, were noted in our first Soviet films in America.

Reacting to the themes and ideas in our works, the American press in 1925–26 sang the praises of this very feature of our cinema.

But true rhythm presupposes above all an organic *unity*.

It is not a successive alternation of opposing themes, mechanically cross-cut or spliced into each other, but above all a unity that reveals its organic pulse in the play of internal contradictions, and through the succession of the play of tensions, that lies at the heart of rhythm. It is not the outer unity of plot – the classic image of a chase sequence also has that – but that special inner unity which can be realised through montage as a completely different system of constructions, among which so-called parallel montage figures as one of the highest, or particularly profound, individual variants.

It is characteristic that of all the diverse forms of montage that our own montage paraded in whatever dire straits, our classic stock of models has fewer examples of 'parallel montage', in its narrow sense, than of any other type. This particular form of montage, which is the most characteristic of Griffith, caught on least of all with us, although it would appear that, in terms of borrowings, it was precisely that feature that should have developed into something particularly magnificent in our cinema.

But that did not happen, and for a very good reason. That 'side of streaky, well-cured bacon' of irreconcilable parallels, that Dickens wrote of, is a prototype for Griffith's montage.

The dualism in the basic premises of this kind of montage thought is obvious.

But as I said earlier, montage thought is inseparable from the common ideological grounds of thought as a whole.

And Griffith's unavoidable dualism (the product of the social system reflected in his consciousness) is also unavoidable in his artistic methods, which arise directly from his way of thinking.

As we have seen, Griffith's social vision was limited to a division of society into the rich and the poor.

The bourgeois ethic, morality and sociology teach us that these two immanent categories were practically ordained by God.

According to this point of view – which we find both primitive and ridiculous – there are 'the poor' and 'the rich' existing as two independent parallel phenomena, which are also, incidentally . . . inexplicable!

We find this formula laughable.

But that is exactly how bourgeois theoreticians discuss it, and those grey-haired magnates who philosophise on 'social themes' imagine it in precisely those terms!

I think that they probably *imagine* it otherwise, and much more accurately, but they persist in making their sciences and arts depict this 'version' as best they can.

And everything is done to conceal the real state of affairs, namely that 'the poor' and 'the rich', so far from being *two independent,* unrelated *parallel phenomena,* are actually *two sides of the same phenomenon* – a society built on exploitation.

These two phenomena have the same unitary basis that dualism cannot comprehend, just as the presence of ideal and material phenomena, which are by no means mutually exclusive, does not deny the existence of the other and least of all 'affirm' the position of dualism.

A unitary phenomenon, considered in all its contradictions, the division of a unitary phenomenon into two, and a new reassembly in a new understanding – that is what lay, and still lies, at the basis of the ideological weaponry of the other part of the globe that stands in opposition to the bourgeois world.

A different consciousness, a different mode of thought – and hence a different interpretation of phenomena and a different conception of artistic methods.

It is not therefore surprising that Griffith's conception of montage, as montage that is primarily parallel, should seem to bear the imprint of his dualistic world view, which drives the rich and the poor along their two parallel lines towards some hypothetical 'reconciliation' at the point where ... the parallel lines intersect, that is, in infinity ... which is just as unattainable as the 'reconciliation' itself!

And it is just as natural that our conception of montage should arise from a completely different 'image' of an understanding of phenomena which was opened up to us by a world view that was both monistic and dialectic.

Our microcosm of montage could only appear as a unitary picture, split into two by the internal pressure of its contradictions, only to reassemble in a new unity on a new plane, which is qualitatively improved, perceived figuratively in a new way, and reassimilated.

There is a difference of principle between Griffith's conception of montage, and that of Soviet cinema.

It fell to me to attempt a theoretical expression of the *general tendency* of our understanding of montage. I expressed it in the article 'Beyond the Shot' in 1929, although at that time the degree to which our method of montage contrasted with Griffith's, both genetically and in principle, was not one that interested me.

It was set out in the form of the *developmental link* between the shot and montage.

I wrote of the thematic unity of content in a film, a section, the 'shot':

The shot is by no means a montage *element*.

The shot is a montage *cell*. Beyond the dialectical jump in the *single* series: shot – montage.[74]

Montage is the development of the conflict within the shot (for 'conflict' read 'contradiction'), first into a conflict between two adjacent fragments:

Conflict within the shot is:
potential montage that, in its growing intensity, breaks through its four-sided cage and pushes its conflict out into montage impulses between the montage fragments ...[75]

Then the conflict disperses into a whole system of planes, by means of which 'we reassemble the disintegrated phenomena into a single whole but from our own perspective, in the light of our own orientation towards the phenomenon.'[76]

That is how the *montage unit* is fragmented into a *chain of bifurcations*, which are *once more brought together into a new unity – a montage phrase*, which embodies the *conception of the image of the phenomenon*.

Interestingly, the very same process is at work in the history of language in relation to word ('shot') and clause ('montage phrase'), which underwent the same primitive stage of 'word-clause', which only later 'splintered' into a clause made up of separate, independent words.

V. A. Bogoroditsky wrote that 'in the very beginning, mankind expressed its thoughts in single words, which were also a primitive form of sentence.' [77]

I set out earlier the specific features of *our* view of montage.

However, the difference between our montage conception and that of the Americans may be seen at its clearest and most distinct if we look at the same difference of principle in understanding of another novelty that Griffith introduced to cinema and that was also interpreted in a completely different way in Russia.

I am talking about the so-called 'close-up'.

This difference of principle begins, essentially, with the actual term.

In Russian we talk about an object or a person being shot 'on a large scale' [*krupnym planom*], i.e. *large*.

An American says: *closely* (the literal meaning of the term 'close-up').*

Americans talk about the *physical* conditions of seeing.

But we talk of the *qualitative* side of the phenomenon that is linked to its significance (just as we talk about a *large* talent, to denote one that stands out from the common sort, or about *large* print to distinguish what is most essential or significant).

For an American, the term is associated with *vision*.

For us, with the *evaluation of what is seen*.

We will see how profound the difference here is when we have investigated how our cinema uses 'large' shots in its method and application, as distinct from the American use of 'close-up'.

This comparison immediately shows up the most important function of the 'large' in our cinema: not merely, and not so much to *show* or to *present*, as to *mean*, to *denote*, to *signify*.[78]

And this was one of the particular features of our own very rapid realisation of the very nature of the 'large', after it had barely been noticed as a means of showing in American cinema practice.

Its amazing feature – the creation of *a new quality of the whole, by juxtaposing it with the part* – was what instantly attracted us to the method of the close-up.

Whereas Griffith's isolated close-up was often a 'crucial' or 'key' detail, in the tradition of Dickens' teapot; whereas the succession of facial close-ups

*Griffith himself, in his famous announcement in *The New York Dramatic Mirror* of 3 December 1913, used *both* terms: 'The large or close-up figures'. But typically it is the latter term that in habitual American film usage has been retained. (E's note)

was a silent-film anticipation of future synchronised dialogue (incidentally, Griffith contributed not a single device to sound cinema) – we put forward the idea of a *principally new qualitative fusion* that resulted from the process of *juxtaposition.*

For example, virtually my first spoken and written declarations during the 1920s described cinema primarily as the 'art of juxtaposition'.

Whereas, if Seldes is to be believed, Griffith himself came to the point of seeing 'that by dovetailing the ride of the rescuers and the terror of the besieged in a scene, he was multiplying the emotional effect enormously; the whole was infinitely greater than the sum of its parts',[79] for us this was not enough.

It was not enough for us, this *quantitative growth* – even if you were to *multiply* it: we sought for, and found, something much greater in our juxtapositions: a *qualitative leap.*

It transpired that this leap was *beyond the potential* of theatre – it leapt *beyond the limits of situation,* into montage *image*, montage *concept*; montage as a means primarily for revealing an *ideological concept.*

Incidentally, in one of Seldes's books one can find his lengthy condemnation of American cinema of the 1920s for losing its spontaneity in its pretensions to 'artiness' and 'theatricality'.

It is written in the form of 'An Open Letter to the Movie Magnates'. It opens with the juicy salutation: 'Ignorant and unhappy People' and ends with the following notable lines:

> ... and then the new picture will arrive without your assistance. For when you and your capitalizations and your publicity go down together, the field will be left free for others ... Presently it will be within the reach of artists. With players instead of actors and actresses, with fresh ideas (among which the idea of making a lot of money may be absent) these artists will give back to the screen the thing you have debauched – imagination. They will create with the camera, and not record ... it is possible and desirable to create great epics of American industry and let the machine operate as a character in the play – just as the land of the West itself, as the corn must play its part. The grandiose conceptions of Frank Norris* are not beyond the reach of the camera. There are painters willing to work in the medium of the camera and architects and photographers. And novelists, too, I fancy, would find much of interest in the scenario as a new way of expression. There is no end to what we can accomplish....
>
> For the movie is the imagination of mankind in action.[80]

Seldes looked to some unknown and ever-cheaper films for cinema's glorious future, made by some no less unknown 'real artists', and to epics devoted ... to American hyper-industry, or American grain. But his words found their justification in a completely different quarter: they turned out to

*Frank Norris was the author of epic novels about the USA. To his pen belongs the famous scene in the novel *The Octopus* (1901), devoted to the epic of wheat, in which a big grain speculator drowns in a sea of wheat piled high in a grain elevator. Norris (1870–1902) wrote under the strong influence of Emile Zola. He was also the author of *McTeague*, from which Erich von Stroheim made his magnificent picture *Greed* [USA, 1923–5]. (E's note)

be a virtual prophecy of what was then (the book came out in 1924) being prepared on the other side of the globe, later to be realised in the glittering constellation of the first Soviet silent films, which were destined to exceed all expectations.

For only a new social structure that freed art forever from narrowly commercial aims could fully realise what progressive Americans could only dream about!

At the same time, an entirely new interpretation found its way into montage technique.

Our cinema opposed the parallelism and alternation of American close-ups with their unity in fusion: the MONTAGE TROPE.

Philologists define trope as 'the use of a word in a sense other than that which is proper to it, for example a *sharp* wit (instead of a *sharp* sword)'.[81]

Griffith's cinema does not have any montage constructions of this type. His close-ups create atmosphere; they show his characters' features; they switch from hero to hero during dialogue; they heighten the suspense of a chase sequence. But in all these cases, Griffith remains at the level of *depiction* and *object*, and nowhere endeavours to convey *sense* and *image* by a juxtaposition of shots.

Come to think of it, there is one such attempt made, and on a grand scale too, in Griffith's work. That is, *Intolerance.*

One American film historian justifiably calls it 'a giant metaphor'. With equal justice, at the same time he calls it 'a magnificent failure'.[82]

For, if *Intolerance*, in its American part, stands as a brilliant example of Griffithian montage (which Griffith himself never bettered), it also utterly fails to make the desired transition from *mere narrative* to *generalisation, metaphor and allegory.*

But this historian was wrong to say that cinema had *no potential for figurative narrative at all*, by not allowing the assimilation of metaphor, simile, etc., to move beyond the text of the titles!

The failure was caused by something different.

Namely, Griffith's inability fully to understand that it is *montage juxtaposition* rather than the actual *figurative montage fragments* that constitutes a metaphorical and figurative style.

This is why the repetition of the shot in which Lillian Gish rocks the cradle fails as a refrain. Griffith did not transpose the Walt Whitman extract[83] that so inspired him into a structure, the *harmonious recurrence of a montage expression, but into an isolated picture*, so that the cradle could not be *abstracted* into an image of *eternally reborn epochs*: instead it was bound to remain *just a cradle*, provoking the audience into derision, surprise or anger.

There is an almost analogous blunder in our cinema: the notorious scene of the 'naked woman' in Dovzhenko's *The Earth*.[84] There was that same failure to realise that a film fragment must be *abstracted from routine depiction* if it is to be 'manipulated' *figuratively, beyond the day-to-day.*

The close-up can, in certain circumstances, provide this abstraction from the day-to-day.

A healthy, blooming woman's body may actually be elevated to an image of *the life-affirming principle*, which was what Dovzhenko needed to provide a

montage collision with the funeral in *The Earth*.

A skilfully executed montage combination of Rubens-like *close-ups*, isolated from the everyday and abstracted in the necessary direction, is quite capable of being elevated into a similarly 'sensuously tactile' image.

But this whole construction in *The Earth* was doomed to failure, since the director intercut the funeral with a *long shot* of the hut and the naked woman rushing about inside; and the viewer is quite unable to isolate from this concrete, ordinary woman the *general sense of lush fertility and vitality* that the director wanted to convey in this scene of nature generally, pantheistically contrasting with the theme of death and burial!

This intention is thwarted by the oven forks, the pots, the stove, the towel, the benches, the tablecloths – all these commonplace articles, from which a *cropped frame* could easily have freed the body, so that a *representation of the everyday* would not have interfered with the realisation of the *figurative metaphorical* intention.

But let us return to Griffith.

If his blunder was caused by not thinking in terms of montage, in his treatment of the recurring 'waves of time', using instead the plastically unconvincing symbol of a rocking cradle, he errs towards the other extreme when he puts all four of the film's themes together.

Interweaving the four epochs was a brilliant invention.* This is what Griffith had to say about it:

> ... the stories will begin like four currents looked at from a hilltop. At first the four currents will flow apart, slowly and quietly. But as they flow, they grow nearer together and faster and faster, until in the end, in the last act, they mingle in one mighty river of expressed emotion.[85]

But the effect did not come off.

Because again it was a combination of *four different stories* and not a *fusion of four phenomena in a single figurative generalisation*.

Griffith called his future work *Intolerance* 'a drama of comparisons', which *Intolerance* has remained, rather than a *unified, powerful, generalising image*.

This shows the same defect, an inability to abstract a phenomenon; and it therefore lends itself to no other treatment than the *merely representative*. Therefore, he was unable to accomplish any of his '*hyper*-representative' and 'figurative' (*metaphorical*) aims.

Only after divorcing 'warmth' from a *thermometer reading* can you talk of a 'warm feeling'.

Only after abstracting 'depth' from 'yards' and 'fathoms' can you talk of a 'deep feeling'.

*The first cautious attempts at such a composition were made by Porter, in *The Kleptomaniac* [USA, 1905], and by Griffith himself in *Judith of Bethulia*. The former showed two thefts: one committed by a wealthy lady, the other by a poor woman, stealing a crust of bread. The action was interwoven in parallel and led finally to a court investigation. (E's note)

Only after disengaging 'falling' from the *formula expressing the acceleration of a falling body* $\left(\dfrac{mv^2}{2}\right)$ can you talk of a 'sinking feeling'!

But the elements of *Intolerance* failed to 'merge' for another reason: the four episodes chosen by Griffith are genuinely incompatible.

And their formal *failure* to merge into a *single image* of Intolerance is only a *reflection of a thematic and ideological error.*

Can a tiny common feature – the common outward appearance of a metaphysical and irrational Intolerance – with a capital letter! – really unite in your consciousness such historically diverse phenomena as the religious fanaticism of St Bartholomew's Eve, and strike-busting in a major capitalist country? Or the bloody pages of the struggle for mastery over Asia, and the complex process of the internal colonial struggle of the Jewish people, during their enslavement by the Roman city-state?

And here we find the reason why Griffith's montage repeatedly comes unstuck over the problem of abstraction.

The secret here is not technical and professional, but ideological and intellectual.

It is not that representation cannot be elevated, given the proper service and treatment, to a metaphorical, comparative or figurative construction.

It is not that Griffith here is trying a different method, or professional skill.

But that he is trying unsuccessfully to do it, without being capable of a genuinely interpreted abstraction of phenomena: of *deriving a generalised interpretation* of a historical phenomenon from diverse historical events.

History and economics needed Marx's colossal work, and that of his followers, before we could achieve an understanding of the *laws of the process* that stand beyond the multiplicity of *single facts.*

Before science could abstract *the chaos of individual features* that characterised a phenomenon *into something general.*

Before Marxism, as a perfected implement for cognition, could carry out, on a new level, the same revolution in *the highest areas of cognition* that humanity carried out when it produced the first manufacturing tools, which provided the opportunity for *the original abstraction,* man's first encounter with *'figurative' concepts.*

There is an excellent professional term used in American film studios: 'limitations'.* The 'limitations' of a particular director are musical comedies. The 'limitations' of a particular actress are high-society ladies. A particular talent cannot break through these 'limitations' (in most cases for very good reasons).

Risking departure from these 'limitations' sometimes produces unexpectedly brilliant results; but generally, as a commonplace phenomenon, it ends in tears.

Using this term, I would say that, as far as *montage imagery* is concerned, American cinema wins no laurels for itself; and this is because of its ideological 'limitations'.

*In English in the original.

This is not a matter of technology, scope, scale, capital investments, nor the scale of capital investments.

The question of montage imagery presupposes a certain structure and system of thought: it may be defined and has been defined only through collective consciousness, which is the reflection of a particular, new (socialist) stage of human society and the result of an ideological and philosophical intellectual training that is inseparably bound up with the social structure of this society.

We, and our epoch, are *acutely ideological* and *intellectual* and could not fail to see that a shot had, first and foremost, the properties of an *ideological cipher*; could not fail to detect in the *juxtaposition of the shots the emergence of a new, qualitative element*, a new *image*, a new *concept*.

Having spotted this, we were bound to take it to extremes.

In my film *October*, we inserted harps and balalaikas in the scene of the Mensheviks' speeches. And these harps were not harps, but a figurative symbol of the mellifluous speeches of Menshevik opportunism at the Second Congress of the Soviets in 1917. The balalaikas were not balalaikas but an image of the tiresome strumming of these empty speeches in the face of the gathering storm of historical events.

By placing a Menshevik and a harp together, and a Menshevik and a balalaika, we *extended the parameters of parallel montage into a new quality, a new area:* from the sphere of *action* to the sphere of *meaning*.

This phase – of rather naive juxtapositions – passed fairly quickly. Similar solutions may have been somewhat 'baroque' in form, and in many respects tried (albeit none too successfully!) to use the accessible, palliative methods of silent film to anticipate what music was to do with ease in sound cinema!

They soon disappeared from the screen.

However, the important thing remained: an understanding of montage not merely as a means of producing effects, but above all as a means of *speaking*, a means of *setting out* ideas and of setting them out by means of a special kind of *film language*, a special form of *film speech*.

The approach to a *concept of a normal film speech* naturally enough passed through this *stage of excess in the use of the trope* and *primitive metaphor*. Interestingly, we found an echo here of methodological devices from remotest antiquity! For example, the 'poetic' image of a centaur is nothing other than the combination of man and horse, in order to express an *image* of an idea that is *directly inexpressible through a picture* (namely, that people from a particular locality 'moved quickly', were fleet of foot).

So the actual evolution of simple concepts arose as a process of juxtaposition.

Thus in montage the *play of juxtapositions* possesses the same deep-laid, real means of influence. On the other hand, it is precisely through the initial *naked juxtaposition* that a system had to be evolved for complex inner (externally illegible) juxtaposition, i.e. each phrase of ordinary, normal, coherent montage speech.

But this same process also works for producing *any speech* at all. And

above all for *verbal speech*, the way we talk. It is well known that a metaphor is an abridged simile (A. A. Potebnya).[86]

In connection with this Fritz Mauthner has made the following highly subtle observation on our language:

> Any metaphor is essentially a witticism. The language that a people speaks today is the sum of millions of witticisms, the collection of millions of anecdotes, the history of whose creation has been lost forever. In this respect, we must imagine that the people from the period when languages were being created were even wittier than today's wags who live off their wits... A witticism makes use of remote similes. Close correspondences could be identified immediately, by concepts or words. But the shift in the meaning of words consists in annexing a word, that is, metaphorically and wittily extending a concept to particular similarities.[87]

A. A. Potebnya writes equally categorically about this:

> ... simile is the starting point of language and conscious thought ... language derives from the growing complexity of this original form.[88]

And simile, trope and image stand at the threshold of the creation of language:

> All meanings in language are figurative in origin, and each may become non-figurative with time. Both states of a word, its figurative and non-figurative, are equally natural. If the nonfigurativeness of a word was considered as something original (whereas it was always derivative), that occurred because it is a temporary resting-place of thought (whereas figurativeness is its next phase), and motion attracts more attention, and invites more analysis, than rest.
>
> When examining a finished figurative expression or a more complex poetical construction, the calm observer may recall a corresponding non-figurative expression that corresponds better to his (the observer's) mode of thought. If he says that this nonfigurative idea is *communis et primum se offerens ratio* [the common meaning, and the one that first suggests itself], then he is attributing his own condition to the creator of the figurative expression. It is akin to expecting to find, in the midst of a fierce battle, the same calm contemplation that can be devoted to a game of postal chess. If you were to swap places with the actual speaker, it would be easy to reverse the assertion of the dispassionate observer and decide that *primum se offerens* [the first thing to suggest itself], even though it may not be *communis* [common], is figurative.[89]

In his study of metaphor, Werner similarly places it at the very cradle of language, albeit for other reasons.[90] He links it not to the tendency to learn about new areas, assimilating the unknown through what is known, but the reverse: the tendency to *conceal*, to replace, to substitute what is unmentionable in practice – 'taboo'.

It is interesting that the very 'fact of a word' is *in essence* the rudiment of a poetical trope:

Irrespective of the relationship between original and derivative words, any word, as a sound symbol of meaning, is based on the combination of sound and meaning, simultaneous or consecutive, and hence is metonymy.[91]

And, if anyone even thought of indignantly objecting to this state of affairs, he would immediately find himself in the position of the pedant from Ludwig Tieck's novella, *The Painting*, who exclaimed:

When someone merely compares one object with another, he is already lying. 'Rosy-fingered dawn.' It would be hard to think of anything more stupid. 'The sun sinks into the sea.' Fiddlesticks! ... 'Morning has broken.' But how could it have? It is nothing but the hour of sunrise. Damn! The sun does *not* rise – it's all just so much nonsense and poetry. If I had any power of language, I would give it a good clean-up! Damn! Clean up! In this eternally false world, it is impossible to avoid talking nonsense![92]

This also finds echo in the *figurative* reinterpretation of a simple *representation*. Potebnya, again, has put it well:

The image is more important than what is depicted. The story of the monk who avoided eating roast suckling pig during his fast by incanting 'Turn from pork to perch' over it – this story, stripped of its satirical character, shows us the universal historical phenomenon of human thought: word and image is the spiritual half of the matter, its essence.[93]

One way or another, primitive metaphor invariably stands at the very dawn of language; it is closely connected with the period of evolution of the first figurative concepts – by which I mean concepts of sense, rather than merely motor or object concepts; that is, with the period when the first tools came into being, as the first means of 'transferring' the functions of the body and its activity, from man himself to the tool in his hands. So it is to be expected that at the period when the articulated, montage speech of the future came into being, it had also to pass through an acutely metaphorical phase, characterised by the abundance of not always entirely valid 'plastic witticisms'!

But these 'witticisms' were very soon felt to be excesses and affectation of a certain 'language'. And attention gradually shifted from curiosity *about the excess* towards an interest in the *nature of this language itself*.

Hence the secret of montage construction is gradually revealed as the secret of *the structure of emotional speech*. For both the very principle of montage, and its idiosyncratic structure, the essence is *an exact replica of the language of emotionally excited speech*.

You have only to read a description of such speech to be convinced, without further commentary, that this is the case.

Let me turn to the relevant chapter of J. Vandryes' excellent book, *Language*:*

> The main difference between affective language and logical (intellectual) language lies in the construction of phrases. This difference is obvious if you compare written and oral language. Written French is so very different from spoken French that you could say that nobody speaks as he writes in France, and hardly writes as he speaks ...
>
> The same elements that written language tries to contain in a coherent whole are separated in speech, disconnected and disarticulated: the very order of these elements is completely different. The logical sequence of ordinary grammar has gone: there is an order that has its own logic, but it is primarily the logic of emotion, wherein thoughts are placed not according to the objective rules of consistent reasoning, but according to the significance the speaker ascribes to them, and which he wishes to make his interlocutor feel.
>
> In speech, the concept of phrase, in its grammatical sense, does not exist. When I say, 'The man whom you see sitting there, on the beach, I met yesterday at the station', I use the devices of written language and compress my thoughts into just one phrase. In speech, I would say, 'See that man? Over there. Sitting on the beach. Anyway, I met him yesterday. He was at the station.' How many phrases is that? It is difficult to say. Suppose I pause after each full stop or question mark: in that case, the words 'over there' comprise an individual phrase, just as if I was answering the question 'Where's that man?' 'Over there.' And even the phrase 'Sitting on the beach' could easily be divided into two phrases, if I pause between its two component parts: 'Sitting – there on the beach' or 'There on the beach – that's where he's sitting.' The line between these grammatical phrases is so elusive that it is better not even to attempt to define it. But from a certain point of view, there is just one phrase here. The verbal image is one, although it also develops cinematically, as it were. But at the same time that this image is immediately obvious in the written language, the spoken language breaks it up into fragments, whose number and force correspond to the impressions that the speaker has, or to the way in which he wishes to influence his listener.[94]

This is surely a replica of what happens in montage. And surely what has been said about the 'written language' could be said about the clumsy 'long shot' when it attempts to show something *dramatically*: it is always hopelessly like an elaborate, awkward phrase, weighed down by the subordinate clauses, participles and gerunds of 'theatrical' *mises-en-scène*, to which it condemns itself!?

Having said that, I do not mean that a 'montage hotchpotch' is the answer in every case. What the Slavophile Alexander Shishkov wrote about

**'Le Langage' par J. Vandryes* was finished in 1914 and published in Paris in 1921. The Russian translation appeared in 1937 and this is from page 142. (E's note)

words may here be applied to *phrases*: 'Both long and short words are necessary in language: for with no short words, it will be like the sustained lowing of cattle; and with no long words, it will be like the chattering of magpies – a series of stuttering, identical sounds.'[95]

With respect to the 'logic of emotion' that Vandryes wrote about, and that lies at the basis of speech, montage was very quick to grasp that it contained the key; but, if it was to discover the whole wealth of its system and laws, montage had to carry out a number of serious creative 'raids' before learning that the code of these laws was also applicable to a third variety of speech: not written or oral, but *internal*, wherein affective structure is to be found in its fullest and purest form. But the structure of this *inner speech* is inalienable from what is called *emotional thought*.

Thus we have reached the original source of the internal laws that govern not only the structure of montage but the internal structure of any work of art, the fundamental *laws of art as a whole*, the general *laws of form* that lie at the heart of a work, not only of cinema, but of each and every art as a whole.

But of this ... elsewhere.

I shall now revert to that historical stage when in our country montage became a *montage trope*, and trace the path of development that it followed in creating the unity of a work, which is inseparable from the process in which it became conscious of itself as an independent language.

Thus, in my view, montage came about in the very earliest days of our cinema's independent (as opposed to imitative) existence.

It is interesting that, even at an intermediate level, between the old cinema and ours, attempts were made at *juxtaposition*. Even more interesting is the fact that at this level they were essentially distinguished by being ... *contrasted*. So they bear first and foremost the stamp of 'contemplative *disarticulation*', instead of the *emotional fusion* into a certain 'new quality' that characterised the first attempts of Soviet cinema to find its own language. For example, the film *The Palace and the Fortress*[96] is full of such speculative playing with contrasts, effectively raising the principle of contrast from the title of the film into the very style of the work. Here all these are still constructions of the *non-intersecting parallel lines* model: 'here and there', 'before and now'. It is exactly in the spirit of the posters of those days, which used a sheet of paper, divided in two, to show a landowner's house *before* (the master, serfdom and floggings) on the left – and on the right *now* (school and nursery, in that same house).

We find exactly the same type of collision of shots in the film as well: a ballerina *en pointe* (*the Palace*) and Beideman's feet in chains (*the Fortress*). The combination of shots is also offered speculatively *as a parallelism* – Beideman behind bars, and... a little canary in a cage in the commandant's room.

This motif can be found at a much a higher level of meaning in the image of Hopelessness used later by Pudovkin in *The Mother*,[97] in the scene where the mother talks to her imprisoned son, which is intercut with shots of a cockroach, which the Guard's finger prevents from crawling out of the sticky mass.

These and other examples do not yet include the tendency to *unite representations into a generalising image*. Neither unity of composition nor – more importantly – unity of emotions brings them together: they are offered in an even narrative, rather than at a stage of emotional excitement when it would be only natural for a figurative turn of phrase *to appear*, as soon as it is heard.

But if it is uttered at the wrong emotional stage, or reached after the appropriate emotional preparation, an 'image' invariably sounds ridiculous. When Hamlet says that he loves Ophelia as 'forty thousand brothers could not', this rings out with pathos and enthrals. But just try to lower the emotional key of this phrase, and transpose it into the context of a common daily conversation, that is, ponder the immediate objective content of this image, and nothing but laughter will result!

The Strike (1924) is full of first 'drafts' of the whole range of this new and independent direction. The mass shooting of the demonstrators in the finale, intercut with bloody scenes from municipal slaughterhouses, merged (in the infancy of our cinema, this sounded fully convincing and produced a great impression!) into the metaphor of a 'human slaughterhouse', absorbing the memory of the bloody repressions carried out by the autocracy. Here are none of the simple 'contemplative' *contrasts* of *The Palace and the Fortress*, but something more: a logical and conscious effort at juxtaposition, albeit in a crude and lapidary form.

A juxtaposition that strove to tell of the shooting of workers, not only by an image, but also through a generalising 'plastic turn of phrase', which approached the literal image of a 'bloody slaughterhouse'.

In *The Battleship Potemkin*, three *unrelated* close-ups of *different* marble lions, in *different* positions merged into *a single* lion, leaping to its feet, and furthermore into another *cinematic dimension*, the embodiment of a metaphorical exclamation: '*The very stones roared!*'[98]

In Griffith's film there is an icebreaker moving at speed.[99] Lillian Gish is running, hurrying across the ice. Barthelmess jumps from ice-floe to ice-floe, saving her.

But the parallel *course of the icebreaker* and the *humans' actions* nowhere come together into an image of '*a human torrent*', a mass of people smashing their fetters, a mass of people rushing onwards in an untameable onslaught, as happens, for instance, at the end of *The Mother* by Gorky, Zarkhi and Pudovkin.

Of course, there were excesses in this direction too; and there were, simply, frustrations; of course, there were also plenty of examples to show how good intentions came to nought owing to a failure to allow for the laws of composition and a sufficient underpinning for the context. Then, instead of a coruscating unity of image, a wretched trope remained an unrealised fusion, an unthinking syllepsis, like 'she left the room in a flood of tears and her glasses'.

But in any event, the dualistic *parallel rows* that characterise Griffith's work came together in our cinema on the way to realising themselves in a future *unity of the montage image*, at first in a whole series of plays of montage comparisons, montage metaphors, montage puns.

These were the more or less tempestuous floods that swept everything to

one side, so that what was most important in the montage aspect of a work – ensuring within it the complete dominion of *the image, the unified montage image, the image that embodies the theme and is created by montage* – would be increasingly clear as the final goal. This was achieved in the 'Odessa Steps' in *Potemkin*, in the attack of the Kappelites in *Chapayev*,[100] the whirlwind in *Storm over Asia*,[101] in the 'Dnieper' sequence from the prologue to *Ivan*,[102] and more weakly in the naval landing in *We from Kronstadt*,[103] and with re-newed energy in Bozhenko's funeral from *Shchors*,[104] in Vertov's *Three Songs of Lenin*,[105] and 'the Knights' attack' in *Alexander Nevsky* . . . the glorious, in-dependent path of Soviet cinema is the path of *the creation of a montage episode-in-image, a montage event-in-image, a montage image of the film as a whole*, with the same status and influence and the same responsibility in the finished film as *the image of the hero, the image of man, and of the people*.

This path, and these aims, were never dreamed of by our American film-'forefathers'. Deprived of their socialist soil, those incitements, those searches, those conceptions and the final aims, for which we live – and we are alive! – could never have come into being there.

For this general collective striving towards *unity of image* was dimly re-alised by way of, and by means of, the reflection, not just in the *themes* but in *the artistic method*, of *the greatest unity*, the unity that defines our socialist sys-tem, whereas a society based on class is doomed to dissent and antagonism.

Our conception of montage has far outgrown Griffith's classical dualist montage aesthetic, symbolised by the gulf between the two parallel, inter-spliced, thematically differing strands with prospects for the reciprocal inten-sification of the entertainment, the suspense and the tempo.

For us, montage has become the means of attaining *unity of the highest order* – the means of *using a montage image to achieve the organic embodiment of a single conception of an idea that contains all the elements, particulars and details of the cinematic work.*

And, thus understood, it is much broader than the concept of purely cin-ematic montage; thus understood, it contributes much that is fruitful and en-riching to our understanding of artistic methods in general.

For our montage as a method is not a reflection of *the struggle between two opposites* – an image representing the class struggle – but a reflection of *the unity of these opposites*, an image attained by destroying the notion of class, by building a classless society, by making socialist *unity* shine through the multi-national *diversity* of our Soviet land, come to replace all the ages and epochs of antagonism.

And accordingly, the principles of our montage ring out as the principles of *unity in diversity*.

It finds its ultimate artistic unity in the solution of the problem of the unity of audiovisual synthesis – a problem that we have now solved, and a problem that is not even on the agenda for American research.

Stereoscopy and colour are being achieved before our very eyes.

And the moment is at hand when, not just through the method of mon-tage but also through the synthesis of *the idea, the drama of the actor, the screen portrayal, the sound, the three-dimensionality and the colour*, that same great law of *unity in diversity* will show itself in the *unity of the entire screen image*: this

law underlies our thinking, underlies our philosophy, and in an equal measure penetrates the montage method, from the minutest link to the fullness of the montage image of the film as a whole.

1943/4

23. A Few Words about My Drawings. For the Publication of the Screenplay of *Ivan the Terrible*[1]

It is said that in 1812 Moscow caught fire from all sides at once.

'The fires of revolt must everywhere ignite the Rus that Ivan has made,' Kurbsky, the traitor, cries out in the screenplay.[2]

And above the rumble of thunderclaps sing the prophetic voices in the overture:

> On the bones of our foes
> The Russian Empire shall rise
> On all sides ...

Whether those were the words the historical Kurbsky used,
whether Moscow did catch fire like that –
is hard to establish.

But there is one process which is invariably like that: immediate, simultaneous and instant, it starts from all sides, on all sides.

It is the process of making a film.

The finished film is a huge assemblage of the most diverse means of expression and influence that defy comparison with anything else; the historical conception of the subject, the situation in the screenplay and the overall course of the drama, the life of the character portrayed and the performance of the actual actor, the rhythm of the montage and the plastic construction of the shot, the music, the noises and the rumblings, the *mises-en-scène* and the interaction of the texture of the different threads, the lighting and the tonal composition of the speech, etc., etc.

In a successful work all this is blended into a single entity.

One law governs everything. And the apparent chaos of the incommensurability of its various aspects and dimensions is moulded into a single, organic whole.

But how does this future whole come into being, when you undertake to realise the theme that has just infected you?

Like the fire of Moscow, it starts everywhere on all sides.

And in the most unexpected and unforeseen of quarters.

Both within the various aspects brought together,

and in relation to the work as a whole.

The dramatic character of the film about Tsar Ivan immediately flared up in a scene set somewhere around the second half of the screenplay.

The first episode to occur to my imagination – the episode that turned out to be the key in stylistic terms – was the confession scene. Where and when it came to me I can no longer say.

I only remember that it was the first to do so.

The second scene was the prologue: the death of Glinskaya.[3]

In a box in the Bolshoi Theatre.

The first sketch of the scene was on the reverse of my ticket, showing a memorial silhouette.

The epic coloration of the screenplay came about with the third episode: the candle above Kazan.

Immediately after the song about the capture of Kazan has been read.

And within the individual aspects.

In the movement of the drama:
first somewhere near the end;
then, suddenly the prologue,
then, unexpectedly, the middle.
And in the life of the character.

Here he is in one scene in old age,
then suddenly, he is in his childhood,
and then, in the bloom of youth.

And in the different, contrasting aspects.

In one scene you can see the living appearance of life,
another you act,
a third you hear,
a fourth you see as a shot,
a fifth as a system of montage junctures,
a sixth as chaotic spots of colour.

And scraps of paper are covered first with fragments of dialogue, now a layout for the characters' positions on the platforms, then a 'memo to the artist' concerning soft edges on the vaults; now '… to the director' on the rhythm of a scene that is yet to be written, then 'ideas for the composer' about the four figurative components of the leitmotif for Ivan, now 'for the poet' about the character of a bawdy song and the couplets of the future Thomas and Erema.

Then, suddenly discarding all words and drafts, the scraps of paper begin to be covered feverishly with drawings.

Without a concrete perception of people in action, in motion, in relation to one another, it is impossible to record their steps on paper.

They move continually before your very eyes.

Sometimes it is so tangible that, without opening your eyes, you seem

able to commit them to paper.

They will not be standing before the film camera for a year, or two or three.

You try to record the most essential elements.

Sketches spring up.

They are not illustrations for a screenplay.

Still less are they decorations for a little book.

They are sometimes the first impression of how a scene feels, which is later to be assembled and recorded in a screenplay based upon them.

Sometimes, they afford consolation, enabling you even at this preliminary stage to glimpse how the characters who develop will behave.

Sometimes they are a concentrated record of the sense that should derive from the scene, but most often they are searches.

And what endless searches: the course of the stage action, the sequence of the scenes and the successions of cues within the scene are broken twenty times.

Sometimes the scene being filmed in advance will appear to have nothing in common with these searches.

Sometimes it will turn out to be virtually a reanimated sketch, done two years previously.

Sometimes, together with the pile of rough sketches for scenes, they will not even make it into the screenplay.

Sometimes, together with the scene, they remain outside the working screenplay.

But sometimes, concrete directions for the construction of the set are born from these sketches.

Sometimes, one particular feature of the make-up, or the line of a costume.

Sometimes they define the image of the future shot.

Sometimes they provide a prescription for the trajectories of movement that the actor will follow at some future date.

These drawings, transient rather than finished, often make sense only to their author.

The pattern that emerged in them: three shots of Ivan in the scene of his repentance before the fresco of the Last Judgment are extracted from the hundreds of sketches.

Participants in the process of visual and dramatic assimilation of the subject, these sketches are probably capable of helping the reader too to acquire a fuller sense of the author's intention, which so far has been committed only to paper.

Notwithstanding their professional inadequacy, these drawings are published with this sole aim.

Another two thousand or so of their confrères are lying in folders. Together with those that are being printed, they crave the reader's indulgence: visual shorthand is all they claim to be.

24. Charlie the Kid*4

Charlie the Kid.† I think that the name of Chaplin's most popular work sits comfortably next to his own:⁵ it helps us to understand his character just as the epithets 'the Conqueror', 'the Lionheart' or 'the Terrible' define the inner image of the William who conquered the island that was to become Great Britain; the legendary brave Richard of the Age of the Crusades; or the wise tsar of Muscovy, Ivan Vasilevich IV.

> Not the directing.
> Not the devices.
> Not the clever tricks.
> Not the comic technique.
> These are not what interest me.
> I do not want to delve into these.

When I think about Chaplin, I want to look first at the strange cast of mind that sees phenomena in such a strange way and responds to them with such strange images. And also inside this cast of mind: at the part that is no more than a view of the surrounding world and has not crystallised into an outlook on life.

Briefly put, I am not writing about Chaplin's outlook on life, but about his way of looking at life, which gives rise to the unique and inimitable conceptions of so-called Chaplinesque humour.

<p style="text-align:center">★　★　★</p>

The twin fields of vision of a hare intersect behind its head. It can see behind itself. Disposed more to flight than pursuit, it has no complaints. But they do not intersect in front. For a hare, there is an invisible expanse ahead. And as it runs away, it might run into an obstacle in its path.

A hare's view of the world is different from our own.

And the eyes of a sheep are so situated that their fields of vision do not overlap at all. A sheep sees two worlds: the right hand one and the left, and these do not visually merge into one.

A different way of seeing entails the different pictorial and imagistic results of this way of seeing. To say nothing of the higher development from *seeing* [*vidénie*] into *viewing* [*vzglyad*] and subsequently into *perception*

*'kid': American colloquialism, meaning 'child', 'lad'. (E's note)
†In English both times in the original.

[*vozzrenie*], after we rose above sheep and hares and reached the level of humans, with a whole context of social factors that definitively moulded all this into an *outlook on the world* [*mirovozzrenie*].

How is the eye set – in this case, the eye of thought,

how does this eye look – in this case, the eye of the image of the thought;

how does this eye see,

the unusual eye,

Chaplin's eye,

the eye that can see Dante's inferno or the Goyaesque *capriccios* of the theme of *Modern Times* in the forms of carefree mirth?[6]

That is what interests me,

that is what puzzles me,

that is what I want to solve:

with whose eyes does Charlie Chaplin look at life?

⋆ ⋆ ⋆

Chaplin's distinctive feature is that, grey hair notwithstanding, he has retained a 'child's eye view' and a direct way of perceiving phenomena.

Hence his freedom from the 'fetters of morality'[7] and his ability to see the funny side of something that makes other people's flesh crawl.

In an adult, such a trait is called 'infantilism'.

Hence, the comedy of Chaplin's constructions is based 'principally' on an infantile device.

On this point we need to make two qualifications:

this is not Chaplin's only device;

and these devices are not peculiar to Chaplin alone.

It is true that, rather than looking at his devices, we tried to guess the 'secret of his eyes' – the secret of his views, as a cradle, from which any devices might grow.

But first let me say why, of all the means and paths of achieving comic effect that are available to man, Chaplin employs precisely these, and this course makes him the figure most representative of American humour.

And this is particularly so because it is this feature of infantilism in his humour that makes him the most American of American humorists. Although it is far from true that the development of the average American has never progressed beyond the intellectual development of a fourteen-year-old, as some people say!

In his 'list of gospel truths' Flaubert never mentioned the word 'infantilism'.[8]

Otherwise he would have written, as he did of Diderot: 'Diderot – and after him, always comes d'Alembert....'[9]

Infantilism – and after that always comes a 'departure' from reality.

In this case, this is particularly apposite, for the actual stimulus to flight, which drove Rimbaud from Paris to Abyssinia or Gauguin to Tahiti, is of course capable of driving somebody from modern-day New York to somewhere much further afield.[10]

The fetters of 'civilisation' have now been flung so far that today you can find Ritz-like hotels (and not only hotels!) in any big city in Europe or North America and even in the deepest recesses of the island of Bali, or in Addis Ababa, in the tropics, or among the eternal snows.

Increased air travel has clipped the wings of geographical escape. Evolutionary escape is left: descent through your own development. The return to ideas and feelings that belong to a 'golden childhood', indicated by those foreign-sounding words – 'regression into infantilism' or going back to your own childhood.

In a particularly ordered and regimented society, this [desire to] escape to freedom from the fetters of 'a once and forever strict regime' must be especially strong.

I always recall two things whenever I recall America: the driving test, and a story from a college newspaper about a humanities exam. Both are concerned with exams.

For the first one, you are given a sheet of paper with questions on it.

The questions are so phrased as to require only 'Yes' or 'No' answers.

The question does not read: 'What is the maximum speed at which you may drive past a school?' But: 'May a driver pass a school at more than thirty kilometres an hour?'

'No' is the expected answer.

'When a minor road crosses a major road, may the driver cross the major road without stopping at the junction?'

'No' is the expected answer.

Other questions of the same type expect the answer 'Yes'.

But nowhere on the page will you find the question: 'What do you do when a minor road comes to a junction with a major road?'

The examinee is at no point required to think independently or to make an independent *deduction*.

Everything is designed for *an automated memory*: for Yes/No answers.

No less interesting is the automation when the sheet of paper is collected.

One grid is laid over its boxes, with squares cut out to correspond to the 'Yes' answers.

Then the second grid: all its squares must show the 'No' answers.

The examiner need only take two glances.

Do only 'Yes' answers show through the holes of the first grid? And do only 'No' answers show through those of the second?

A miraculous contrivance, you might think, for standardising the driving test!

But. . . .

In the student paper, there was a funny story about one class's university exams.

They were all listening with bated breath.

They could hear the clatter of a typewriter . . . belonging to a blind student.

Two strikes of the keys. Then three.

The whole auditorium scribbled away feverishly.

In the first case, the two letters spelt 'No'.

And in the second case, the three letters spelt 'Yes'.★

It was the same system as for cars. The same grid. The same 'Yes' and 'No' game.

A mechanical graph and a blind student – a guide for the sighted – merge into a single symbol.

The symbol can be taken as the key to the whole mechanical and automated intellectual system.

Something like an intellectual assembly line.

You can understand the desire to break out of it.

If Chaplin achieves a physical escape from the trammels of machinery [*mashinizm*] with his jerky movements in *Modern Times*, then he achieves the same thing, intellectually and emotionally, by means of infantilism, which allows the same liberating leap beyond the bounds of a mechanical intellectualism.

And in this respect Chaplin is a pure American.

The general system of a philosophy and the applied interpretation of its various fields always reflect the fundamental emotional nostalgia lurking deep down in the heart of a people or a nation with a particular social system.

'By their theories shall ye know them', you can say, just as surely as this is said about actions.

Let us look at the typically American interpretation of the secrets of comedy. At the same time, I should state that, like all theories and explanations of comedy, the American ones are local and relative. But in this case I am not remotely interested in the degree of objective truth in this interpretation of 'the mystery of humour'.

I am interested in the specific American position on the question of comedy, just as Kant and Bergson's interpretations are interesting, primarily as personally and socially grounded 'documents of an epoch', rather than as universal truths and theories of what is funny, objectively covering hilariously tiny areas of discussion.[11]

Which is why for our purposes I shall begin by seeking out the most American type of *source* for a theoretical exegesis of the principles of comedy.

In our search for the 'German' approach to what constitutes 'funny', we might head straight for the metaphysician. In our search for the 'English' approach, we turn to the essayists, who in the words of Meredith supposed humour to be a privilege for select minds.[12] Etc. Etc.

Searching for the 'American' approach, and for the 'most American' understanding of humour, we turn not to metaphysicians or to ironists, nor to philosophers or essayists.

We turn to . . . those who practise it.

In philosophy, American pragmatism reflected this avid search for what above all is *usefully applicable* to everything that interests the American.

Hence the countless number of books teaching you how to 'make friends and influence people through humour'.

I have read dozens of pages explaining how to make a lecture or a sermon more interesting by using wit; how humour can be used to increase the contributions to the church when the faithful go round, plate in hand; and

★'No' and 'Yes' are in English in the original.

how a good commercial traveller can inveigle a customer into acquiring a vacuum cleaner, or a washing machine, that he does not need in the least, through a series of strategic jokes.

The prescription is powerful, unerring and effective.

Everything is reduced to a form of appealing flattery, if not actually to more primitive forms of common bribery!

Sometimes the prescription is furnished with a brief theoretical justification.

It is from such a purely American book that I shall quote what is probably the most American understanding of the fundamentals of the attraction of humour.

We shall see that the most American comedian (despite all his international significance) perfectly fits this interpretation in his method.

I shall not baulk at a number of quotations. Apart from their actual content, the fact that this and other similar books have been published is the clearest proof of the 'Americanism' that in turn gives rise to the special form of comic methodology that helped precisely this type of 'Americanism' to escape from nature.

The book was written in 1925 by Professor Harry Overstreet, Head of the Philosophy Department of New York City College.

It is called *Influencing Human Behaviour.*

The book is made up of a cycle of lectures in response to a precisely formulated, specific request directed at the author by a group of his students.

As the author himself notes in the Foreword, the question itself was 'unusual'.

And indeed the request was phrased cogently, seriously and led to 'a course indicating how human behaviour can be changed in the light of new information gained through psychology'. The authors of the petition 'have in common an interest in understanding and improving the social conditions'. But apart from that, and perhaps of prime importance, they wrote, 'We desire to utilize as a part of our everyday technique of action such knowledge as modern psychology can furnish us. Our interest is not academic. We wish actually to function with such knowledge as we might gain.'

In his Preface, the practical psychologist's reply is worthy of the technicality of the request:

The object of these chapters is to discover how far the data of modern psychology can be put to use by each of us in furthering what really is the central concern of our lives. That central concern is the same whether we be teachers, writers, parents, merchants, statesmen, preachers, or any other of the thousand and one types, into which civilization has divided us. ... In each case the same essential problem confronts us. Obviously it is to be, in some worth while manner, effective within our human environment.

We are writers? Then there is the world of publishers, some of whom we must convince as to our ability. If we succeed in doing that, then there is, further, the reading public. It is a bit of sentimental nonsense to say that it makes no difference at all if a writer convinces not a

single soul of his pertinence and value, so be it only that he 'express' himself. We have a way of being over-generous with so-called misunderstood geniuses. True, this is a barbarian world; and the fine soul has its hard innings. But the chances are that a writer who can convince no single person of the value of what he writes, probably has nothing of value to write. At any rate, as his manuscripts come back, he might well cease putting the blame on philistine publishers and public long enough to ask himself whether, indeed, he is not deficient in that very elementary art of making the good things he has to say really understandable.

We are businessmen? Then there are thousands of potential consumers whom we must induce to buy our goods. If they refuse, then bankruptcy. . . .

We are parents? It may seem somewhat far fetched to say that the chief concern of a parent is to be accepted by his children. 'What!' we cry. 'Aren't they are *our* children; and aren't children required to respect their parents?' That, of course, is all old philosophy; old ethics; old psychology as well, coming from the day when children, like wives, were our property. Nowadays, children are persons; and the task of parents is to be real persons themselves to such an extent that their children accept them as a convincing power in their lives. Hence the parent is no parent simply by right of his or her procreative power. For parent, in unnumbered cases, substitute 'tyrant', 'autocrat', 'sentimentalist', 'boor'.

We need not specify further. As individuals, our chief task in life is to make our personality, and what our personality has to offer, effective in our particular environment of human beings. . . .

Life is many things: it is food-getting, shelter-getting, playing, fighting, aspiring, hoping, sorrowing. But at the centre of it all it is this: it is the process of getting ourselves believed in and accepted. . . .

How are we to become intelligent about this? . . . Not by talking vaguely about goals and ideals; but by finding out quite specifically what methods are to be employed if the individual is to 'get across' to his human fellows, is to capture their attention and win their regard, is to induce them to think and act along with him – whether his human fellows be customers or clients or pupils or children or wife; and whether the regard which he wishes to win is for his goods, or ideas, or artistry, or a great human cause. . . .

To become skilled artists in the enterprise of life – there is hardly anything more basically needful than this. It is to their problem that we address ourselves.[13]

It takes all my self-control to stop myself breaking up each pearl in this litany of practicality with a system of exclamation marks: it lumps together writers, traders and parents and merges consumers with wives and goods with ideas!

However, we shall move forward through the pages of Professor Overstreet's manual, which in places reads like the best pages of Labiche or Scribe.[14] Here, for example, is the chapter called 'Yes-response technique':*

*In English in the original.

The canvasser rings the doorbell. The door is opened by a suspicious lady-of-the-house. The canvasser lifts his hat. 'Would you like to buy an illustrated History of the World?' he asks. 'No!' and the door slams....

In the above there is a psychology lesson. A 'No' response is a most difficult handicap to overcome. When a person has said 'No', all his pride of personality demands that he remain consistent with himself. He may later feel that the 'No!' was ill-advised; nevertheless, there is his precious pride to consider! Once having said a thing, he must stick to it.

Hence it is of the very greatest importance that we start a person in the affirmative direction. A wiser canvasser rings the doorbell. An equally suspicious lady-of-the-house opens. The canvasser lifts his hat. 'This is Mrs Armstrong?'

Scowlingly – 'Yes.'

'I understand, Mrs Armstrong, that you have several children in school?'

Suspiciously – 'Yes.'

'And of course they have much home work to do?'

Almost with a sigh – 'Yes.'

'That always requires a good deal of work with reference books, doesn't it – hunting things up, and so on? And of course we don't want our children running out to the library every night ... better for them to have all these materials at home.' Etc., etc.

We do not guarantee the sale. But that second canvasser is destined to go far! He has captured the secret of getting, at the outset, a number of 'yes-responses'. He has thereby set the psychological processes of his listener moving in the affirmative direction.[15]

* * *

Page 260 of this 'manual' sets out the key not to an abstract understanding of the principles of humour in general, but to the American understanding of the secret of humour; or rather, to that understanding of the nature of humour that works most effectively when applied to Americans.

Professor Overstreet begins by correctly observing:

It is almost the greatest reproach to tell a person flatly that he has no sense of humour whatever. Tell him that he is disorderly, or lackadaisical, or homely, or awkward, he will bear up under these. But tell him that he has no sense of humour: it is a blow from which even the best of us find it difficult to recover. People have a most curious sensitiveness in this regard.[16]

I can confirm the truth of this observation with the most perfect example in the field of humour – Chaplin himself.

I find the task of writing theoretical essays tedious, and so I am grateful for any excuse to slip out of argument and into personal reminiscence.

An evening in Beverly Hills. Hollywood.

Chaplin paid us a visit.

We were playing a typical Hollywood game.

A cruel one.

This game is typical of a place where, concentrated within a few square kilometres, there is so much self-esteem and self-love – be it deserved or undeserved, justified or unjustified, exaggerated or underestimated, but in all cases so morbidly highly strung that there would probably be enough for three-quarters of the globe.

This game is a version of the well-known game of 'opinions'.

With just this difference: that here the opinions are responses to a set 'questionnaire', where marks are to be awarded: for example: intellect, 5; wit, 3; charm, 4 – and so on.

The person being assessed by the others takes the questionnaire away with him. He must fill it in and award himself marks, at his own discretion . . .

'A game of self-criticism,' as we would say in Moscow.[17]

The more so as the whole effect of the game here does not consist in the answers, but only in the extent to which the marks awarded by consensus differ from those awarded by the person who has left the room.

A cruel game!

Especially as pride of place goes to the square for 'sense of humour'.

The 'King of Comedy' trooped off to the kitchen and, putting on his glasses, filled out the list of questions somewhere near the refrigerator.

Meanwhile, a surprise was being planned for him.

By common consent, the 'King of Comedy' was awarded a four for 'sense of humour'.

Did he appreciate the humour of this situation?

No!

The guest took offence.

The distinguished guest did not have sufficient humour for self-irony: the four seemed to have been deserved!

Why, asks Professor Overstreet, are people so sensitive to doubts that they have a sense of humour?

He answers:

Apparently, the possession of humour implies the possession of a number of typical habit-systems. The first is an emotional one: the habit of playfulness. Why should one be proud of being playful? For a double reason. First, playfulness connotes childhood and youth. If one can be playful, one still possesses something of the vigour and the joy of young life. If one has ceased to be playful and lively, one writes oneself down as rigidly old. And who wishes to confess to himself that, rheumatic as are his joints, his mind and spirit are really aged? So the old man is proud of the playful joke which assures him that he is still friskily young.

But there is a deeper implication. To be playful is, in a sense, to be free. When a person is playful, he momentarily disregards the binding necessities which compel him, in business, morals, domestic and community life. . . .

Life is largely compulsion. But in play we are free! We do what we please....

Apparently there is no dearer human wish than to be free.

But this is not simply a wish to be free *from*: it is also, and more deeply, a wish to be free *to* something. What galls us is that the binding necessities do not permit us to shape our world as we please. ... What we most deeply desire, however, is to create our world for ourselves. Whenever we can do that, even in the slightest degree, we are happy. Now in play, we create our own world....

To imply, therefore, that a person has a fine sense of humour is to imply that he has still in him the spirit of play, which implies even more deeply the spirit of freedom and creative spontaneity.[18]

All the remaining practical prescription writing emerges entirely from these premisses.

For the specifically American position on humour, Professor Overstreet's notions are very appropriate and have been correctly inferred from the principles of – American – psychology.

Thousands of American comedians fit the parameters that he sketched out.[19]

And the most polished of them does so in the most complete degree, for his service to this principle does not only rest in the infantilism of the gag and the stunt, as such, but in the subtleties of the method, which – by means of an infantile 'prescription' for imitation – psychologically immerses the viewer, who has become infected by this infantilism, into the golden age of the infantile paradise of his childhood.

The short hop into infantilism serves even Chaplin himself as a psychological escape beyond the bounds of the measured, planned and calculated world of activity that surrounds him.

Pining for freedom, in one of his interviews Chaplin defines the artist's only complete means of escape from all restrictions through his art. It is where he talks about ... the cartoon.

'... the cartoon is the only real art of today, because in it and only in it the artist is absolutely free to use his phantasy and to do whatever he likes to do with the picture.'[20]

This, of course, is a lament.

A lament for the most perfect escape beyond the fetters of the conventions and necessities of everyday life, which Professor Overstreet so obligingly enumerated earlier.

In his 'plunging' into the golden age of infantilism, Chaplin finds partial satisfaction for his nostalgia for freedom.

And it is also found by those among his audience whom he involves in his magical journey into the realm of fiction and carefree nonchalance, which prevailed only when they were in the nursery.

America's businesslike formality is in many respects the younger brother of Dickens' stiff Mr Dombey. And it is not surprising that there was in England an inevitable uniquely infantile reaction. On the one hand, this was expressed by the way that children became part of the plot and the subject

matter: it was in England that a child was for the first time taken into the realm of literature and it was in England that whole novels, or significant parts of them, devoted to portraying the spiritual condition of young children, were the most popular. Going back to the pages of the novel, Mr Dombey becomes *Dombey and Son*, and Dickens devotes many pages to little Paul, David Copperfield, Little Dorrit and Nicholas Nickleby, to confine ourselves to the most popular English writer.[21]

On the other hand, it was England that gave rise to the most luxuriant flourishing of infantilism in literature, which went by the name of 'nonsense'. The richest examples of this style are still to be found in Lewis Carroll's immortal *Alice* and Edward Lear's *Book of Nonsense*, although it is well known that Swinburne, Dante Gabriel Rossetti and even Ruskin have left no less amusing examples of poetic nonsense, in limerick form.[22]

'A departure from reality...'

'A return to childhood...'

'Infantilism...'

These words are not in favour here in the Soviet Union.[23] We do not like these concepts. And we have no sympathy for the fact itself.

Why?

Because the practice of the Soviet state has been to approach the problem of how to liberate man and the human spirit from an entirely different angle.

On the other side of the globe, people have one thing left: to retreat, psychologically or fictionally, to the carefree charm of immersion in childhood.

On our side of the globe, we do not escape from reality into a story, but we make the story a reality.

Our task is not to immerse an adult in childhood, but to make the child's paradise of the past something that is accessible for an adult, for every citizen of the Soviet Union.

For in fact, whichever paragraph of the Constitution we take, we are constantly amazed to see in essence the features, regularly set out and legitimised by the state, of the same thing that constitutes the ideal of the golden age.

'The right to work.'

How often has that seemingly paradoxical formulation about labour come as a surprise to those for whom work is invariably associated with the notion of an irksome responsibility and a weighty necessity.

How new and strange-sounding does the word 'work' itself sound, in the context of 'right', 'prowess' and 'honour'!

But this thesis, which reflects our existing provision for the complete absence of unemployment, guaranteeing a job for every citizen in our country, is in a psychological sense a marvellous rebirth of that same provision, in a new, perfect – the most perfect – phase of human development, as it appeared, at the very dawn ... of mankind's childhood ... in the golden age of the past, to man in his primeval, natural and direct understanding of the phenomenon of work and the rights and responsibilities associated with it.

It is in our country that the way has been cleared for the first time for every creative ambition to move in the direction for which the soul longs.

Belonging to a certain echelon of the aristocracy is not a prerequisite for entering the diplomatic corps.

Being entered at birth for a privileged educational establishment, when being outside this network means that access to a particular political career is inevitably closed, is not a prerequisite for occupying a government post.

Taking up a commission in the army involves no privileges of family or class, etc., etc. In such a degree and in such number, this has never been the case, anywhere.

And so mankind's dream from the oldest times of the 'omnipotentiality' of what he might become had to be translated into aspirations, myths, legends and songs.

* * *

Even more has been done in our country: wise measures to protect the old have removed one more terrifying burden from our people – the burden of perpetual worry about the future, the burden of emotions that are alien to beasts, fowl, flowers and little children at an utterly carefree age, during the first years of their life.

Our people have been relieved of the worries about dreaded 'security',* which weigh heavily upon every American, regardless of distinctions of property and his position on the rungs of the social ladder.

And that is why Chaplin's genius could only be born and flourish on the *other* side of the globe, and not in a country where everything has been done so that the golden paradise of childhood might become reality.

And that is why Chaplin's genius could only shine where comedy of his method and type was a necessity: where the realisation of a childlike dream in an adult world was bound only to run up against disappointments.

* * *

'The secret of his eyes' was undoubtedly revealed by *Modern Times*. Throughout his series of fine comedies, which showed good and bad, small and large people in collision – which seemed by chance to happen simultaneously to both rich and poor – his eyes laughed and wept in unison with his subjects. But when, in the most modern times of the American Depression, the good and bad characters suddenly turned out to be actual representatives of irreconcilable social groups, Chaplin first blinked, then frowned, but stubbornly continued to look at *modern* times and phenomena *as he had done before*: he seemed to go against his own subject. This led to a bifurcation in the style of his work. In his thematic treatment, this led to something monstrous and grating. In the inner image of Chaplin himself to a full exposure of the secret of his eyes.

In what follows, I do not mean that Chaplin was unconcerned about what was happening around him, or that Charlie failed (even partially) to understand everything. I am interested in how he feels. How he looks and

*In English in the original.

sees, when he is 'inspired'. When he encounters a series of images of phenomena that he can laugh at, and when what he perceives is transformed by laughter into comic situations and stunts; and what eyes you need to see the world, in order to see it as it appears to Chaplin.

A group of charming Chinese children are laughing.

In one shot. Another. Close-up. Medium shot. Close-up once more.

What are they laughing at?

Apparently, at the scene unfolding at the back of the room.

But what is happening there?

A man has fallen on to a bed. Seemingly drunk. And a small Chinese woman is slapping him on the face with unremitting energy. The children are seized by uncontrollable laughter.

Although the man is their father. And the small Chinese woman is their mother. And the big man is not drunk at all. And the small woman is not hitting him in the face for drunkenness.

The man is dead.

And she is hitting the corpse in the face just because he has died, and abandoned her, and these small children laughing so melodiously, to starve to death.

This is not of course from a Chaplin film.

It is from material mentioned in passing in André Malraux's remarkable novel, *The Human Condition*.[24]

Thinking about Chaplin, I always see him in the form of this happy, laughing little Chinese boy, looking at the way the big man's head flops from side to side in such a funny way from the blows of the small woman's hands.

It does not matter that the Chinese woman is the mother. That the man is the unemployed father. And it does not matter in the least that he has died.

This is Chaplin's secret. In this rests the secret of his eyes. This aspect of him is inimitable. In this lies his greatness.

... To see the most terrifying, the most pitiful, the most tragic phenomena through the eyes of a laughing child.

To be in a condition to see the image of these phenomena, immediately and unexpectedly – without interpreting them morally or ethically, without evaluating, without judging or censuring, but as a child looks at them in a burst of laughter – that is what makes him different, inimitable and unique.

This unexpected spontaneity of vision gives rise to a funny sensation. This sensation is worked into a conception.

The conception is often threefold.

The phenomenon is genuinely harmless – and Chaplin's perception clothes it in its inimitable Chaplinesque *buffo*.[25]

The phenomenon is personally dramatic – and Chaplin's way of seeing gives rise to the humoristic melodramatism [*melodramatichnost'*] of the best examples of his individual style: the combination of smiling and crying.

A blind girl can cause a smile, when she pours water over Chaplin without realising it.

And when the girl has recovered her sight she can appear melodramatic when she does not fully realise by a touch of her hand that standing before her is the man who loves her and who restored her sight.

And that same melodramatism within the same work may be comically stood on its head – the scenes with the *bon viveur* whom Chaplin saves from suicide echo those with the blind girl: this time the *bon viveur* recognises his saviour and friend only in the 'blindness' that is induced by alcoholic vapours.

Finally, *the phenomenon is socially tragic* – it is no longer a child's amusement, not a problem for a child's mind, not a child's toy – and the laughing child's way of seeing gives way to the terrifying series of shots in *Modern Times*.

A drunken encounter with unemployed robbers in a store. . . .

The scene with the red flag . . .

The episode of the unintentional provocation at the gates of the striking factory . . .

The scene of the prison revolt . . .

Chaplin's view gives rise to the spark of a comic vision.

It is mediated through an ethical tendency in *The Kid* or *City Lights* by the sentimental arrangement of Christmas Eve in *The Gold Rush* and by denunciation in *A Dog's Life*.[26]

Successfully in *The Pilgrim*,[27] with genius in *City Lights*, inappropriately in *Modern Times*.

But this is the actual ability suddenly to see through the eyes of a child. A direct way of seeing. A primeval way of seeing, without moral and ethical awareness and explanation.

That is what is striking.

The juxtaposition and the application.

The elaboration and the arrangement.

Conscious or unconscious.

Separable, or inseparable from the original 'fuse'.

Purposeful or aimless.

Simultaneous or successive . . .

All this is secondary. Accessible. Learnable. Achievable. Professional. Craftsmanlike. Common to the whole comic epic of American cinema.

The ability *to see as a child* is inimitable, unique and peculiar to Chaplin personally.

Only Chaplin sees like that.

It is precisely this characteristic of Chaplin's eye which sees and amazes constantly and penetratingly, regardless of all the contrivances of professional treatment.

Everywhere, and in everything: from *A Night in the Show*[28] to the tragedy of the present in *Modern Times*.

★ ★ ★

To see the world like that, and to have the courage to show it on the screen, is the stamp of genius.

Come to think of it, he does not even need courage.

For that is the only way in which he sees.

Perhaps I am making too much of this point?

Possibly!

We are people with a 'conscious task'.

And inevitably 'adult'.

We adults have forfeited the ability to laugh at what is funny without taking into account its possibly tragic sense and content.

We adults have lost that time of 'lawless' childhood, where there were no ethics, no morals, no higher system of values, and so on and so forth.

Reality itself plays into Chaplin's hands.

The bloody absurdity of war for Chaplin can be seen in *Shoulder Arms.*[29]

For *Modern Times*, the new era of recent times.

Chaplin's partner is not a grown man, terrifying, strong, ruthless and fat, who runs a restaurant in Hollywood in his time off from filming.

Throughout his entire repertoire his partner is someone different.

Even taller, more terrifying, stronger and more ruthless. Chaplin and reality itself, the two together, 'a couple', perform for us a never-ending series of circus tricks. Reality is like the serious 'white' clown.[30] It seems earnest and logical. Circumspect and prudent. But in the final analysis it is reality that looks the fool, the object of derision. Its partner, Chaplin, guileless and child-like, comes out on top. He laughs carelessly without even noticing that his laugh slays reality.

And, just as a young chemist conducting his first analyses adds every conceivable and inconceivable ingredient to the pure water that has been cunningly placed before him, so everyone can interpret in his own way the pure water of infantilism that is a direct way of seeing something funny.

When I was a child I saw a conjurer. He moved about on a darkened stage in the vaguely phosphorescent form of a ghost.

'Just think who you would like to see,' this fairground Cagliostro cried from the boards, 'and you will see him!'

And people see things too in this small, happy little man, himself a magician and a wizard. They see what he never put there.

An evening in Hollywood. Charlie and I were going to Santa Monica, to Venice Beach, the national pleasure ground. We were going to take shots at clockwork pigs. Hit apples and bottles with pellets. Chaplin, putting on his glasses in a businesslike way, kept a careful count of how many points he had scored so that, instead of a number of trivial prizes like plaster models of 'Felix the Cat', he could take one large one, such as an alarm clock. And the lads slapped him familiarly on the shoulder. 'Hello, Charlie!'

Then we got into the car. He shoved a small book my way. It was in German.

'Please, find out what it is about.' He did not speak German. But he did know that there was something in the book about him. 'Explain it, please.'

The book was by a German Expressionist, and in the cosmic cataclysm of the finale – it was a play, of course – there was Charlie Chaplin, using his little cane to penetrate the newly resurrected chaos and showing the escape route from the confines of the world, and doffing his bowler hat.[31]

I confess that I got bogged down in my interpretation of this post-war nonsense.

'Please, find out what it is about' – he could have spoken for ages and ages about what was said about him.

It is amazing how every piece of metaphysical devilry clings to him!

I remember one more thing said about him.

It came from Elie Faure, the author of a multi-volume history of art.[32]

He wrote of Chaplin:

He hops from foot to foot – and what sad and ridiculous feet they are! – and thereby shows the two extremes of thought: one is called knowledge, the other desire. As he hops from foot to foot, he is trying to find the point of equilibrium for his soul, which he loses again immediately afterwards. . . .

However, irrespective of the author's will, the social fate of his milieu brings out unerringly the true interpretation.

And one way or another, in the West truth has selected the little man with the funny way of looking to expose through his humour what, by its nature, often lies beyond the category of ridicule.

Chaplin works 'hand in hand' with reality.

And what a satirist has to bring inside his work on two levels, Chaplin the comic does on one level. His laugh is not mediated. Satirical mediation is created from the combination of Chaplin's grimace with the conditions that caused it.

★ ★ ★

'Do you remember the scene in *The Kid*, where I scatter food from a bucket for the children of that poor family, as if they were chicks?'[33]

This conversation took place on Chaplin's yacht. For three days we were his guests on the waves off Santa Catalina Island, surrounded by sealions, flying fish and underwater gardens, which you could look at through the glass hull of special steamboats.

'Well, I did that out of contempt for them. I do not like children.'

The author of *The Kid*, which made five-sixths of the world weep at the fate of an abandoned child, does not like children. He must be a monster!

But who does not like children *normally*?

Only . . . children themselves.

The yacht sailed on. Its motion reminded Chaplin of an elephant's swaying gait.

'I despise elephants. All that strength, and submissively obedient. . .'

'Which animals do you like?'

'Wolves,' comes the immediate response. And his grey eyes and the grey fur of his brows and hair do look wolf-like. His eyes were fixed on patches of sunlight in the Pacific sunset. Destroyers in the American Pacific Navy were sliding across these patches.

A wolf.

Forced to live in a pack. And always be alone. How like Chaplin this is!

Forever in conflict with his pack. Each is an enemy to the other, and an enemy to all.

Perhaps what Chaplin thinks is quite different from what he says. Perhaps this is a slight 'pose'?

But if it is a pose, then it is probably the same pose in which Chaplin lights up with his unique and inimitable conceptions.

Six months later, the day of my departure to Mexico, Chaplin shows me *City Lights* – the sound track has not been added, and it has only been roughly edited.

I sit in Chaplin's own black oilskin chair. Chaplin himself is busy, on the piano, or talking, he supplies the film's missing sound track. Charlie on the screen has saved the life of a drunken bourgeois who had wanted to drown himself. The rescued suicide only recognises his saviour when he is drunk.

Funny? Tragically.

It is Shchedrin. Dostoyevsky.[34] The big man hits the little. He is crushed. First, it is one person by another. Later it grows: one person by society. From the solitary policeman in *A Dog's Life* to the regular avalanche of policemen in *Modern Times*. From the carefree gaiety of *A Night in the Show* to the theatre of horrors of *Modern Times*.

The production line shown in the film is an endless rack, a motorised Golgotha, but the minuet Chaplin dances on the rack is worthy of Mozart.

The handle, which in one turn changes the speed of the conveyor belt, gives you goose-pimples.

But here the performance on this handle causes convulsions of laughter!

Once, a very long time ago, there was a widely popular photograph which may have been from the London *Graphic* or *The Sketch*.

'Stop! His Majesty the Child!' announced the caption under it.

The photograph showed a frantic stream of traffic heading towards Bond Street, the Strand, or Piccadilly Circus, suddenly brought to a stop by a 'bobby' lowering his arm.

A little boy is crossing the road, and the streams of traffic wait meekly until His Majesty the Child has crossed from one pavement to the other.

'Stop! His Majesty the Child!' you feel like exclaiming to yourself when you try to approach Chaplin from the standpoints of social ethics or morality, in the broad and deep meaning of the word.

'Stop!'

We shall accept His Majesty for what he is!

★ ★ ★

Chaplin's situations are just the same as those that absorb children in their stories, where the collection of tortures, murders, terrors and horrors are an indispensable collection of accessories.

The favourite hero is the fearful Barmalei ('he eats small children'). Carroll's Jabberwocky. Baba-Yaga and Kashcha the Immortal.

Stories take a long time to read. And their quintessence, for easier consumption, is distilled into verse.

A cheerful obituary to ten negro children, who died one after the other,

couplet by couplet, from every imaginable kind of death, has been lurking in British and American nurseries from time immemorial (*Ten Little Nigger-Boys*).*

And with no sense of guilt, nor even any hint of justification at all!

A bumble-bee stung one, and then there were five.

Five little nigger-boys going in for law;
One got into chancery, and then there were four.

Four little nigger-boys going out to sea;
A red-herring swallowed one, and then there were three.

Three little nigger-boys walking in the zoo;
The big bear hugged one, and then there were two.

Two little nigger-boys sitting in the sun;
One got frizzled up, and then there was one.

One little nigger-boy living all alone;
He got married, and then there was none.

Of the remaining seven, one chopped himself in two.
Six were left.
Of the remaining three, one was ... eaten by a bear, which left two.
The worst fate of all awaited the last: he married!
So there were no more nigger-boys left...

Incidentally, perhaps this last line contains the whole 'meaning' of the poem: marriage means the end of the infantile existence of childhood: the last nigger-boy dies, and an adult negro emerges!

In any event, the collection by Harry Graham, *Ruthless Rhymes for Heartless Homes*, shows this particular tendency in an even more pronounced way.[35]

This dedication serves as the foreword:

With guilty, conscience-stricken tears
I offer up these rhymes of mine
To children of maturer years
(From seventeen to ninety-nine).
A special solace they may be
In days of second infancy.[36]

The verses themselves, addressed to those who have sunk into their second childhood, obey all the rules of what was dear during their ... first childhood.

The Stern Parent
Father heard his Children scream

*In English in the original.

So he threw them in the stream,
Saying, as he drowned the third,
'Children should be seen, not heard!'[37]

Mr Jones
'There's been an accident!' they said,
Your servant's cut in half; he's dead!'
'Indeed!' said Mr Jones, 'and please
Send me the half that's got the keys.'[38]

Necessity
Late last night I slew my wife,
Stretched her on the parquet flooring;
I was loth to take her life,
But I had to stop her snoring![39]

You could write a whole dissertation about Anglo-Saxon humour in contrast to the 'Slav soul', if you remember in relation to the last example the dramatic treatment of Chekhov's 'Sleepy'.[40] There, the nanny, herself a child, also smothers the child entrusted to her care, because he cries at night and does not let her sleep. And this whole scene is lit by the gentle, warm glow cast by the little flame from the icon-lamp of green glass.

But the chief aspect of a child's psychology and a child's soul, which Lev Tolstoy[41] noted a long time ago, is set out in one way or another in the dramatic sketch of the teenage girl, in the fantastic structure of the fairy tales by the Brothers Grimm,[42] and also in the light-heartedly funny 'Ruthless' rhymes.

It was Maxim Gorky who noted Tolstoy's words on this matter:

Andersen was very lonely. Very. I do not know his life; I think it was a dissolute one, and he travelled a lot; but this only affirms my feeling: that he was lonely. Which was precisely why he addressed himself to children, mistaken though this was: he thought that children would have more sympathy for someone than adults do. Children have no pity for anything; they do not know the meaning of the word. . . .[43]

And experts in child psychology talk about this too.

And what is interesting is that this is precisely what lies at the heart of children's jokes and stories.

Ye. Kononenko wrote about some Moscow children:

'Grandpa, will you see the new Moscow? What do you think – will you live that long?' Vladilen asked cruelly.

And I saw that he was suddenly embarrassed, intuitively understanding that he should not have asked an old man that question. . . .

Clearly he was slightly ashamed and felt sorry for the old man. Generally speaking, he does not feel sorry for old people: when the children outside joked that glue was made from old people, he laughed until

he cried, and asked me archly how much glue grandpa would make.[44]

Kimmins writes about American and English children. The author relies on a great amount of statistical work for his claims. In the section of the work called 'What young children laugh at', we read:

The misfortunes of others as a cause of laughter are frequently referred to by young children and form the basis of many funny stories. With children of seven years of age, about twenty-five per cent of the boys' stories and sixteen per cent of the girls' are of this nature. At eight years of age, there is a decrease to about eighteen and ten per cent respectively. At nine and ten, there is a further very considerable reduction.[45]

However, this concerns only *stories*. The description of similar *facts* retains its humorous effect for longer:

They are in special favour during the period of rapid growth from twelve to fourteen years of age.[46]

In another work concerning a child's attitude to life based on analysis of children's stories, Kimmins cites this typical children's story, relating to average age:

A man was shaving, when a sudden knock was heard at the door; this startled him and he had the misfortune to cut off his nose. In his excitement he dropped his razor, which cut off one of his toes. A doctor was called in and bound up the wounds. After some days the bandages were removed, when it was found that the nose had been fixed on to the foot and the toe on to the face. The man made a complete recovery, but it was very awkward because every time he wanted to blow his nose he had to take his boot off.[47]

This situation is entirely in keeping with the pantomime about the English Pierrot (English, precisely, and typically English) that so struck Baudelaire, who was accustomed to the French Deburau.[48]
But here is his description:

It was a giddy round of hyperbole.
Pierrot strolls past a woman busily scrubbing her doorstep; after having rifled her pockets, he tries to push into his own her sponge, her broom, her pail and even the water...
For some misdeed or other, Pierrot was to have his head chopped off at the end. Why the guillotine instead of hanging in England? I have no idea: doubtless to bring about what follows ...
After struggling and bellowing like an ox that smells the slaughterhouse, Pierrot finally submits to his fate. His head came away from his neck, a big white and red head, rolling down with a thump in front of the prompter's box and exposing the bleeding neck, split vertebrae and all

the other details of a piece of butcher's meat, just cut up for the shop window. And then suddenly, the truncated torso, driven by the irresistible monomania of thieving, got up, triumphantly filched its own head, like a ham or a bottle of wine, and, being cuter than the great St Denis, rammed it into his pocket![49]

To complete the 'bouquet', perhaps Ambrose Bierce's story could also be told.[50]

The cruel 'humoresques' of this author are entirely apposite here, for they are entirely typical of Anglo-American humour, which is the present topic, and they have a common ancestry:

The Man and the Goose

A Man was plucking a live Goose, when the bird addressed him thus:
'Suppose that you were a goose; do you think you would relish this sort of thing?'
'Suppose that I were,' said the Man; 'Do you think that you would like to pluck me?'
'Indeed I should!' was the natural, emphatic but injudicious reply.
'Just so,' concluded her tormentor, pulling out another handful of feathers; 'that is the way that *I* feel about it.'[51]

The collection of gags in *Modern Times* are in exactly the same spirit!

'Only children are happy, and even that's not for long,' says Gorky's wise Vassa Zheleznova.[52]

And not for long, because the strict 'don't' of guardians and future norms of behaviour begin to impose their prohibitions on the freedom of a child's desire from his very first steps. Anyone who cannot submit to these bonds in time, and make these limitations work for him, anyone who continues to remain a child after becoming a man – will invariably be unprepared for life, will everywhere look foolish, be ridiculous, laughable.

If the method of Chaplin's childlike vision resolves the choice of subjects and treatment for his comedies, then, as far as the plot is concerned, this is almost always the comedy of situations, the innocent childlike approach to life colliding with stern adult reproof.

It was Chaplin, among the scrapheaps and alleyways of the East Side, who turned out to be the true and touching 'Holy Innocent', whose image the ageing Wagner dreamed of: not Wagner's *Parsifal*, surrounded by the splendour of Bayreuth and face to face with the Holy Grail![53]

The amoral savagery of a child's approach to phenomena from Chaplin's point of view, within the character of the actual personage of his comedy, comes through with all the other winning traits of childhood.

Those charming traits of childhood which, like a lost paradise, have been forfeited for ever by adults.

This is the source of Chaplin's genuine ability to touch, which almost always manages to stop short of artificial sentimentality.

Sometimes this ability to touch can almost reach pathos. The finale of

The Pilgrim almost achieves a catharsis, when the sheriff, losing his patience, kicks Chaplin up the backside after Chaplin has failed to realise the sheriff's good intentions – to give him, a fugitive prisoner, the chance of crossing the border into Mexico.

After he discovers that Chaplin's fugitive convict has a child's nobility of soul, tricking people into thinking he is a preacher, and thereby saving money belonging to the small local church, the sheriff does not want to appear any less noble.

Leading Chaplin along the Mexican border, towards freedom, the sheriff uses every possible means to make Chaplin understand he should make good use of this chance to escape.

This Chaplin simply does not understand.

Losing patience, the sheriff sends him after a ... flower, growing on the other side of the border. Charlie obediently crosses the wire that divides freedom from fetters.

The satisfied sheriff rides off.

But Chaplin, honest as a child, catches up with him holding the flower.

The kick up the backside resolves this dramatic knot.

Chaplin regains his freedom

And the finale is the most inspired of all his films: Chaplin runs away· from the camera with his jerky gait, in a shrinking circle of light:

following the line of the border, with one foot in America and the other in Mexico.

As ever, the most remarkable details, episodes or scenes in the films are those that, apart from everything else, serve as an image or symbol of the author's method, which derives from the particular features of the storehouse of the author's individuality.

So it is in this case.

One foot is on the territory of the sheriff, law, the ball and chain; the other foot is on the territory of freedom from the law, from responsibility, the courts and the police.

The last shot of *The Pilgrim* is a virtual map of the hero's internal character: a cross-section of the conflicts in all his films, reduced to one and the same situation; a formula of the method by which he achieves his astounding effects.

Running away into the shrinking circle is a virtual symbol of entrapment for an adult who is half a child, in conditions and in a society that are wholly adult.

Wait a moment!

Let the shade of Elie Faure stand in our path as a grim warning against ascribing too much metaphysics to Chaplin's tap-dancing shoes!

The more so since I am interpreting the drama more broadly than the drama of 'the Little Man' in the conditions of contemporary society.

Fallada's *Little Man, What Now?*[54] is a kind of link between these two readings.

However Chaplin understood his own finale, there is nowhere for the Little Man to go to in modern society.

Just as a small child cannot remain like that forever.

It is a shame, but gradually you have to renounce these attractive features...

there, innocence has gone,

there, trustfulness,

and there, a carefree life,

and also to renounce features that are out of place in a cultured society...

there goes the reluctance to take your neighbour's interests into account,

there goes the reluctance to obey the rules of what is universally accepted,

and now the directness of childish egoism is reined in...

'Laughing, we distance ourselves from our own past' here too.[55]

Laughing and regretting.

But let us imagine for a moment that man has grown up and at the same time retained the whole complex of his infantile features in all their undisciplined glory.

And the first, the chief among them, is perfect egoism and the complete absence of the 'fetters of morality'.

So we have before us a shameless aggressor, the warlike Attila. Chaplin, who has now branded Hitler as the modern Attila, must have wanted to act ... Napoleon in the past.

He dwelt on this idea and this project for a very long time.

In this screenplay, instead of dying on the island of St Helena, Napoleon becomes a pacifist and manages to escape from the island to return secretly to France. He gradually succumbs to temptation and begins to plot a revolution.

However, just at the moment when the revolution was due to begin, news came from St Helena that Napoleon was dead. As you remember, his double lived there. But everyone believed that the actual Napoleon was dead. All his plans were ruined, and he died of grief. His last words were to have been: 'The news of my death has killed me.'

This rejoinder is even better than Twain's immortal telegram: 'Reports of my death have been greatly exaggerated.'[56]

Chaplin sees the film as a tragedy.

The film was conceived, but never made.

But the treatment is precise.

The Napoleon who returned turned out to be a Napoleon who was unrecognised and frustrated.

And in the end, he is tragically broken.

'... The news of my death has killed me!'

That is symptomatic!

In normal, human society, unrestrained and undisciplined infantilism is pinned down.

His Majesty the Child is restrained beyond the limits of a certain age.

A restrained Napoleon in Chaplin's hands might become the second bound Prometheus of the infantile dream.[57]

In the gallery of other Chaplin images Napoleon would become the image of the shattered ideal of infantilism.

Reflecting the recent period of Fascism, which has replaced the epoch of Chaplin's *Modern Times*, there has been a distinct shift in Chaplin's work.

Of course, only Chaplin could have made *The Great Dictator*.[58]

Chaplin could not have failed to immortalise such a nonsensical figure who had become the head of a state that had been blinded and a country that had lost its head.

An infantile maniac as head of state.

In this film, Chaplin's 'infantile method' of looking at life and constructing a comic film became the basis for the character of a living human being (if you can call the prototype of Adenoid Hynkel a human being) and the norms of the actual government of an actual state.

Chaplin's method of comic effects, which unfailingly triumph over the resources at the disposal of his infantile approach to events, has migrated to the bases of the character being depicted (*The Great Dictator*).

Not crushed now, as before, but victorious, unrestrained, rampant.

The author's method becomes a graph of the traits of his hero's character.

And a hero, moreover, who is embodied on screen in the author's own performance.

Here is the 'infantile' hero at the pinnacle of power.

Hynkel is examining the inventions of unsuccessful inventors that have been offered to him.

Here is a 'bullet-proof' vest.

Hynkel's bullet passes through it, meeting no resistance.

The inventor is killed outright and falls like a piece of useless junk.

Now, someone with a funny hat-cum-parachute jumps off the palace parapet.

The dictator lends an ear.

Looks down.

The inventor has been killed.

His retort is marvellous: 'Why do you waste my time like this?'

Surely this scene is straight out of the nursery?!

Children's freedom from morality, which is so amazing in Chaplin. Freedom from the fetters of morality, which give the author a unique ability to present any phenomenon as funny, has here become a trait of his hero's character; and a childish trait, when applied to an adult, is monstrous when it is the reality of Hitler, and crushingly satirical when it is applied to a parody of Hitler–Hynkel.

Earlier, Chaplin always played the part of the victim; just a little barber from the ghetto, whom he plays as a second role in *The Great Dictator*.[59]

The Hynkels of his other films were first a policeman, then the giant partner who wants to eat him thinking he is a chicken, in *The Gold Rush*, then lots of policemen and the conveyor-belt in *Modern Times* and the image of the terrifying environment of terrifying reality in this film.

In *The Great Dictator* he plays both. He plays the two diametrically opposed poles of infantilism:

the victor and the vanquished.

The line of the Mexican border in the final shot of *The Pilgrim* seems to

have cut Chaplin in two. Here is Hynkel. And there is the little barber.

And this probably explains why the effect of the film is so striking.

And this is probably why Chaplin in this film speaks in his own voice, for the first time.

For the first time, he is not in the grip of his method and vision, but that method and the purposeful willed performance are in his adult hands.

And this is because here, for the first time, civic courage has spoken with real clarity, loudly and articulately; he is not merely an adult, but a Great man, great with a capital letter.

Even if this does happen through the image of a funny, hopping little man, nevertheless Chaplin here makes his adult, mature, damning, denouncing and censuring speech against Fascism, in an adult way, in a big way – even majestically.

For here, it is *not the actual attitude* to this poison of humanity that is infantile, but for the first time *only the form of the exposition* of the damning verdict, at the heart of that attitude, is infantile.

The speech of the final appeal at the end of *The Great Dictator* is like a symbol of Chaplin's growth from Chaplin the child into Chaplin the tribune.

Once, during an interview about *Modern Times*, Chaplin said:

> Many people thought that the film contained some sort of propaganda, but it was only deriding the universal confusion which we all suffer from. If I were to try to tell the public what has to be undertaken in connection with all that, I doubt that I would be able to do this in an entertaining way with the help of a cinema film. I would have to do it seriously, from a speaker's platform.[60]

And Chaplin's film of *The Great Dictator* ends on a speaker's platform.

And the author of *The Great Dictator* himself becomes a tribune at anti-Fascist rallies, making a plea for the one thing that humanity must now do: destroy Fascism.

I began writing my notes on Chaplin in 1937.

In 1937 there was no *Great Dictator*.

And its target – the vile face of Fascism – had only just committed foul and bloody deeds inside its own country, and begun to raise its greedy, blood-stained paws over Europe.[61]

In that same year of 1937, I even stopped writing about Chaplin. The article defied all attempts to round it off: as is now apparent, there was no *Great Dictator* to make Chaplin's image – creator and man – complete.

Now we are fighting Fascism, waist-deep in blood.

And now we are side-by-side not only as friends, but as comrades-in-arms and allies fighting with Chaplin against humanity's common enemy.

And this struggle needs not only bayonets and bullets, planes and tanks, grenades and mortars, but also the flaming word, the powerful image of an artistic work, the crushing temperament of the artist and satirist whose laughter is deadly.

And so today –

by one method or another,

by one means or another,

by these paths or by others –

it is Chaplin, precisely Chaplin, with his not just naive but even *childishly wise view*, receptive to life,

who has created in *The Great Dictator* a marvellous and murderous satire exalting the victory of the Human Spirit over Inhumanity.

In so doing Chaplin firmly and convincingly joins the ranks of the greatest masters in the age-old struggle between Satire and Darkness, on an equal footing with Aristophanes of Athens, Erasmus of Rotterdam, François Rabelais of Meudon, Jonathan Swift of Dublin, François Marie Arouet de Voltaire of Ferney.[62]

And he is, perhaps, even ahead of the others, if you bear in mind the scale of the Goliath of Fascist Vileness, Evil and Obscurantism, which is being toppled by the sling of laughter of the youngest of the constellation of Davids –

Charles Spencer Chaplin of Hollywood, henceforth known as *Charlie the Grown-up*.*

*In English in the original.

1945

25. In Close-Up[1]

Everyone is perfectly well aware – although many have completely forgotten – that there are different levels of shot in cinema, called:

long shot, medium shot and close-up.[2]

It is equally well known that these different shots express different ways of looking at phenomena.

A long shot produces the sensation of the general scope of a phenomenon.

A medium shot puts the viewer in an intimately human relationship with the heroes on the screen; it is as though he is in the same room as they are, sitting on the same couch, having tea next to them at the same table.

Finally, with the help of a close-up (where the details are large), the viewer is introduced to the most concealed phenomenon on screen: a quivering eyelash, a trembling hand, fingertips withdrawn into the lace of a cuff. . . . They all, at the right moment, expose man in each detail by which he reveals or betrays his true self.

If you look at the phenomena within a film in three different ways, then you can look at the film itself in just the same fashion – in three ways. Moreover, that is how people do look at films.

The 'long shot' may serve here as a view of the film as a whole: its thematic importance, its topicality, whether it meets the requirements of the day, whether the questions it treats are posed in an ideologically correct way, whether it is accessible to the masses, its utility, its urgent significance, or whether it is worthy of the great name of a Soviet film.

This is the broadly social way in which our films are evaluated. This, too, is essentially the view that is reflected in the central organs of our press.

The viewer looks at the film in 'medium' shot, chiefly, as an average representative of the people who make our country live, be it a Komsomol member, a seamstress, a general, a student of the Suvorov Academy, a metro builder, an academician, a cashier, an electrician, a diver, a chemist, a navigator, a typesetter or a shepherd.

What primarily moves this viewer is the vivid play of passions: human proximity to the images of the person on screen, when that person is racked by understandable and familiar emotions; the peripeteia of this person's fate amid the welter of events; the stages of the struggle, the joys of success and the woes of adversity. A person, filmed in medium shot, in himself practically symbolises the viewer's affinity and proximity to the screen image.

The general outlines of the subject matter enter the viewer's consciousness incidentally. The generalised meaning of events is encapsulated in his emotions.

Blending with the screen hero through the living play of his experiences, the important and essential generality with which the film is concerned is set aside in the viewer's imagination. This viewer is first and foremost in the grip of the plot, the events and peripeteia.

He has absolutely no interest in who wrote the screenplay.

He sees a sunset, not the skill of the cameraman.

He cries with the film's heroine, not with the actress who is playing the role, however well or badly.

He is immersed in the mood of the music, without even realising that he is listening to music at that moment: it is the 'background' to the dialogue that engrosses him.

From the audience's point of view, there can be no higher praise than that.

This happens to its full extent only with films that are utterly truthful and artistically convincing.

In print, this point of view corresponds to the review essay.

It is this type of essay, retelling the story, that does not speak of actors performing various roles in its discourse about the screen images; rather it examines the actions and fates of the screen images created by them as though they were the actions of living people, who live a completely real life which has only by chance ended up projected on to the screen, instead of flowing past somewhere in the vicinity of the cinema itself.

In this type of review essay, we are interested in whether the character's actions have been right or wrong; you take one hero's side against the other; you look for the revelation of the internal motivating stimuli; you want to read about the characters on screen as you would about people behaving in actual reality.

This type of review, if only it avoids resort to a simple retelling of the story, is first and foremost the viewer's thought processes, as it were, being stimulated by the vivid impression of the work.

And there is a third way of viewing a film.

It would be better to say, not as it is, but as it ought to be.[3]

This way of viewing an actual film is in close-up: through the prism of concerted analysis, 'clause by clause', deconstructed cog by cog, laid out in its component parts and studied in the same way as a new model construction might be studied by engineers and specialists in their own areas of technology.

This view must be the view of a film taken by a professional journal.

This requires an evaluation of the film from the standpoint of the 'long' and the 'medium' shot, but it must primarily be examined 'in close-up' – using the same close-up for all its component links.

If in a 'long-shot' view the judgments of our public opinion are unerringly accurate, sometimes pitiless, but always correct; if, in an agitated or interested scrutiny of the events and characters in a film we often manage to rise above a simple, neutral retelling of the story, then, when it comes to a concerted professional view, 'drilling' into the merits and shortcomings of what has been produced – from the point of view of the high standards we are entitled and obliged to ask of our works – we are a long way from being a shining

example of perfection.

Without this 'third level of criticism', the growth, development and steady rise in the overall level of what we do will be impossible.

A high public evaluation cannot serve as a shield behind which bad montage or the actors' poor enunciation of words that we value so greatly can hide: these too finally determine the film's successful reception.

The viewer's interest in the plot cannot provide an amnesty for poor photography, nor can record box-office takings of a film whose exciting subject matter engrosses the viewer let us off the hook if the music is ill suited to the film, or the sound recording is of low quality, or (and how often this happens!) the work done at the laboratories and the mass printing [of copies] is bad.

I remember the screenings long ago in the early days of ARRK,[4] when a director would produce his work for viewing by the professional public with trembling trepidation. He was not trembling in dread of being 'cornered' by one of his colleagues after the screening.

He was trembling because he felt like a singer confronted by an auditorium of singers, like a boxer before professional boxers, like a matador in front of bull-fighting enthusiasts – 'aficionados' – knowing that any wrong note, any faulty modulation in the voice, any blow wrongly taken, or any bad timing would be noticed by everyone.

The smallest flaw in the internal truth, the smallest slip of the pen in the splicing of the montage, the smallest defect in the exposition, the smallest blip in the rhythm – all of these would instantly provoke the sharp reaction of disapproval from his audience.

This was because, while paying the tribute due to the picture as a whole, while sympathising intellectually and emotionally with the events within it, a professional critic would not forget that he was not only a viewer, but also . . . a professional.

He knew that the success of a film as a whole only very seldom means the perfection of all its component parts: the subject matter might engross, or the acting enthral, the plastic perfection of the work might win the viewer over. But that would not stop him, while genuinely delighting in its value, from being severe and demanding about the things that had failed to match up to that perfection in the remaining areas.

Then a strange period began.

Recognition of the film as a whole began to be considered simultaneously as an indulgence if it meant ignoring all its individual flaws and defects.

I remember another period of discussion – ARRK's decadent period[5] – when you could not speak in favour of a film that had been well received in the cinemas and say that it was photographically bland, for example, or uninventive in its representation.

You would be shouted down with accusations that you were discrediting a leading work of Soviet cinema art.

And the bogey rearing up before you would be the terrible and generally here entirely inappropriate accusation that you had denied the 'unity of form and content'!

Nowadays this sounds almost like a joke, but as a joke it was rotten. It blunted the insistent demands for quality in film.

It cooled the passion for an exacting art.

It destroyed the film-makers' sense of responsibility.

In many respects it inculcated indifference to the merits of the individual parts.

Glittering clarity and perfection of cinematic style began to grow dim and dull.

But now there is a time of peace.

Our sacred duty is to perfect the professional quality of what we are called upon to produce, without making concessions to time, place and conditions. And the struggle for the conditions in which the quality desired might be born is not the least of our duties.

Exacting rigour in the fitting out and perfecting of our working production conditions, which are capable of ensuring the quality that our production needs, is just as urgent a task for us as devoted service to an idea, the struggle for artistic forms and the quality of our works. We call upon everyone from the threshold of this time of peace to serve under these colours.

So, to take in 'close-up' what we have been called to do, to recognise, to criticise and advance – must be the urgent line of the newly resurrected journal *Iskusstvo kino* [The Art of Cinema].[6]

Acknowledging (where appropriate) the superiority of individual films in 'long shot', and enthralled by them as rank-and-file viewers (where this is possible) in 'medium shot', we shall be pitiless as professionals in what we demand of all the components of a film 'in close-up'.

Acting in this way, we shall not fear the cries of half-blind dogmatists, who frighten us with the spectre of a 'rupture in the unity of form and content', whenever we point out a qualitative discrepancy between the subject matter and its visual realisation.

This is first and foremost because genuine unity of form and content demands also the unity of qualitative achievement of both.

Only an art that is perfect is worthy of shining from the screens of our victorious time: the great age of post-war constructive creativity.

26. Mr Lincoln by Mr Ford[7]

If a fairy with nothing better to do should drop by and say, 'Sergei Mikhailovich, I have nothing else to do. Would you like me to perform a little piece of magic for you? Would you like me to wave my little wand and make you the author of any American picture that has ever been made?', I should not only accept, but should unreservedly name the picture whose author I should be delighted to be. It is the film *Young Mr Lincoln* [USA, 1939], by John Ford.[8]

Some pictures are more effective, richer.

Some pictures are more entertaining and enthralling.

Some are more stunning.

Even those by Ford himself.

Film enthusiasts would probably vote for *The Informer* [USA, 1935].

The general public would go for *Stagecoach* [USA, 1939].

Sociologists would go for *The Grapes of Wrath* [USA, 1940].

Young Mr Lincoln has not even been distinguished by the bronze statuette of the 'Oscar', the prize annually awarded by the Hollywood Academy to the best films.

And yet, of all the pictures made so far, I should like that film to have been mine most of all.

All of us who work in cinema are so used to admiring only ourselves that it is nothing less than a cause for celebration to have an opportunity to explain our admiration for a film made by someone else. I do so here from the bottom of my heart!

But ... why do I love this film so much?

First of all, because it has that most marvellous quality that a work of art can have: a striking harmony among all its component parts.

I love the wonderful harmony of the whole.

I think that our epoch yearns for harmony with a particular piquancy. We look at the past enviously, we feast our eyes upon the radiant harmony of the Greeks.

This yearning, of course, is not fruitless.

It is our country that has struggled for a quarter of a century already so that our state might prosper in harmony.

Our age will hardly be called, in Balzac's phrase, an 'age of lost illusions': even if for only one sixth of the world, our age is one of positive ideals; more, an age when these ideals are being realised.[9]

But there is no doubt that the globe, taken as a whole, is living through a time of lost harmony.

And an unprecedented world war, which has crushed our gardens and monuments of culture, is a particularly scandalous and at the same time appropriate culmination of this epoch.

This is precisely why harmonious works are such a rarity in our age, and why we find them particularly attractive. For the structure of their images expresses an active tendency, which responds and stands in opposition to our discordant time and forces peoples to search feverishly for reconciliation, to gather their representatives together at conferences, to join national associations and enter unions of nations.[10] Of the small number of works from our epoch that possess almost classical harmony, Mr Ford's *Young Mr Lincoln* holds one of the most honoured places.

But the amazing craftsmanship of the interplay between the rhythm of the montage and the timbre of the photography is only one of this film's qualities: the sound of the waxwing perfectly echoes the slow course of the turbid waters and the laborious swaying gait of the little mule, on which lanky Abe rides past the River Potomac.[11]

It is not just the amazing skill which makes a shot, stylised to resemble a daguerreotype, chime in unison with the moralising character of Lincoln's sententious speeches, or Henry Fonda's[12] eccentric behaviour save a genuinely touching situation from nuances of sentimentality; or a dramatic situation attain pathos, in the case of Lincoln's breathtaking departure into the countryside, in the film's finale.

I am talking here about something much more profound: the principles and the presuppositions from which this mastery, this actual harmony, grows.

Their source is the core of the popular and national spirit, the only bedrock for genuinely fine works.

The historical Lincoln himself grew up in the thick of his people, acquiring their most typical and charming features.

And the film itself seems to have grown entirely out of this person's charming character: he seems to embody the very best of the best progressive traditions of America.

And the harmony of a work of art is perhaps a figurative reflection of these great, universally human principles in one of the finest fields of human creative activity.

Thus, in the image of his historical hero, not only in his maxims but in the very structure of his work, John Ford touches on the principles that the historical Lincoln embodied, so profoundly expressing the aspirations of the better part of his people.

We see daguerreotypes, marvellously brought to life before us.

The same 'ineffable' check dresses – with narrow waists but billowing out lower down – the same tresses curling out from under the same caps, the same earrings vying with the hair in their ornateness of form; the same coats and toppers, canes and waistcoats; the same beards, forelocks, tufts of hair, ridiculous army uniforms and collars; all brought to life, as if the ancient gods had breathed life not into clay figures, but into these small pictures, all in real movement, not merely in living, but in the frantic, frantic movement of the merriment of a provincial fair.

It is these people, brought to life, playing tug of war with the rope

stretched across a muddy puddle that has been diligently stirred up, and into which one team, laughing, tries to pull the other, heaving desperately at the other end of the rope.

At the last moment, another figure approaches to help the team that has almost lost – he is tall, ungainly and from the same gallery of daguerreotype American portraits of the provincial youth of days gone by.

He pulls slightly to one side: his arms are very long and he puts this to good effect – and at a critical moment he grabs the wheel of a cart standing nearby.

At a critical moment resourcefulness can save the day, his utterly innocent expression seems to be saying.

And the handful of opponents fly headlong from the other end of the rope into the boggy mud of the huge puddle, to the delighted shouts of the supporters and spectators.

But the tall troublemaker of the animated daguerreotype is now cramming his face with home-made pies, baked by the village's industrious housekeepers, for a competition to see who can eat the most, a contest that is so typical of America.

And so, one by one, images of the daguerreotype era to come to life as if by magic in the reality of their great-great-grandson – the cinema screen.

For these are none other than the living screen images of the opening reels of the film about Abraham Lincoln that conveys an infinite sense of epoch, atmosphere and national character, confidently projected on to the canvas screen by John Ford.

And among them moves this seemingly overgrown kid – the retarded young Lincoln. Here he is interfering with the game of tug of war.

Now, he is 'out-eating' the other contestants in the cheesecake competition. And there he is, outstripping the others in the art of trimming a felled tree with a hatchet.

Apparently awkward and even idle, nevertheless it is he who always seems to be the most resourceful when it matters. It is he who always has the most practical technique for doing a job; it is he who always keeps going the longest; he who is always best prepared for struggle.

We see him as the ideal fighter at the very start of the picture.

He is sluggish, as was Ilya of Murom[13] in his youth, and with a deliberate drawl and slowness of movement, but all this is only to give him time to see, with a probing glance, the chink in his enemy's armour, a competitor's impetuous movement, or the weak point in his rival.

It is like the joke about the stammering merchant, whose stammer allowed him to pay the most businesslike attention to a tactical course for convincing his interlocutor, or to a new argument in a debate, or to a new tactical twist in a battle of wits.

The events of the plot in the picture do not lead to Lincoln's nationwide struggle to unify the state. They do not even get as far as Lincoln's bitter pre-election campaign, fought under the slogan of freedom against the slogans of reaction, and his election as President.

But from the very first moments of the tongue-in-cheek portrayal of the young Abe, in the midst of the fairground competitions, you can see the

fighter in him: a man of indefatigable will and energy who was at the same time an amazingly simple and straightforward man of the people, who seemed to embody the human and humanly marvellous words of Karl Marx's favourite saying about himself, 'Nothing that is human is foreign to me', for really only the person for whom everything human is not foreign can be completely close to everything touching people's lives.

But if Ford did not employ this as a prelude to subsequent scenes of Lincoln's political struggle on the road to the presidency, nor to gigantic canvases of Lincoln's struggle for democratic ideals in nineteenth-century America when its horizons were accessible, still it was not for nothing that the wily craftsman Ford presented us with these scenes and details as a necessary prelude to a film about Lincoln.

For a specific episode, almost anecdotal and almost worthy of a cheap detective novel, taken from the life of a great man of the future, captured very powerfully in one synthetic, serious image all the qualities of the great man that so distinguished this American colossus in his subsequent historical and political role.

★ ★ ★

But what do I, personally, know about the historical Mr Lincoln?

Probably no more than any reasonably educated person knows about him.

We can all name a few treacherous schemers from foreign history: Catherine de' Medici, Mazarin, Fouché ...[14]

A few cunning diplomats: Talleyrand, Metternich...[15]

A few undisguised villains: Cardinal de Retz, Cesare Borgia, the Marquis de Sade ...[16]

A few major commanders: Attila, Caesar, Napoleon.

And a far smaller number of great humanists.

But among these, occupying one of the foremost places, is of course the supremely modest lawyer from Illinois, later the first president of the United States of America: Abraham Lincoln.

We all know that the emancipation of the blacks and the successful conclusion to the fratricidal war between the North and the South were linked with his name.

If we study history in greater detail, we learn that Lincoln acted a little less decisively and boldly than we would have liked; and considerably more slowly and circumspectly than was perhaps necessary.

On the other hand, we know that the role played by the North under his leadership was not entirely selfless.

And we also know that many of these emancipators took their post-war revenge by enslaving and exploiting not only blacks, but whites as well.

But it is equally well known that it was the great image of precisely this tireless fighter, who crowned his triumphant journey in the name of freedom, justice, the union, and democracy and fell at the hand of an assassin in the box of the Ford Theatre in Washington, on 14 April 1865, that was and remains not only the bearer, but the living embodiment of the positive ideals of

277

freedom and justice for future generations of Americans.

There is an almost infallible yardstick for a nation's attitude towards its rulers and leaders. This is the nicknames and epithets with which statesmen go down in history.

At the end of the tenth century, the Carolingian dynasty ended with the typical figure of Louis V, 'the Idle'.[17]

The last Duke of Burgundy in the fifteenth century entered history with a different nickname – Charles 'the Bold'.[18]

And folk memory retained the image of Henry VIII's daughter in the ominous reflections of brutality – 'Bloody Mary'.[19]

But perhaps the shrewdest popular nickname was the one which the people christened the Tsar of Muscovy, Ivan Vasilevich IV.

The feudal lords whom he put to rout bewailed his bloodthirstiness, cruelty and ruthlessness. The people called him 'the Terrible'.

History records that Lincoln has fifteen nicknames.

They cover his outward appearance and the very essence of his historical role.

This is how contemporaries saw him:

'The Great Emancipator', 'President and Emancipator', 'the Martyred President', 'the Springfield Sage', 'the Man of his People', 'Bigheart', 'Honest Abe', the 'Old Man', 'Father Abraham', 'Old Abe', 'Uncle Abe', 'the Attorney and Wit'; the hostile (coming from the South): the 'Dictator'; the ironic: 'lanky'; or the unfriendly: 'the Crow'.

The last two relate to his appearance.

But what was that like?

American directors show amazing skill in picking the people whom they commission to embody characters from literature or from their own imagination.

How marvellous and each time unexpectedly diverse are the guises which the same John Ford makes the actor assume when playing the passenger (in *Stagecoach*), the priest O'Casey (*The Grapes of Wrath*) or the chief warder of the prison (in *The Prisoner of Shark Island* [USA, 1936]).

Victor McLaglen seems made for *The Informer*, while Thomas Mitchell seems at home as the drunken doctor in that same *Stagecoach* or again as the drunken doctor in *The Hurricane* [USA, 1937].

But I think that they are all – and this applies especially to John Ford – just students of the history of America itself, which chose with such striking, I would say artistic, intuition the very image and form of Lincoln to embody its ideal!

The world's press once wrote of Papanin that you could not dream of a more suitable image for the man who was to conquer the North Pole.[20]

But commission any master of 'anthropomorphy' of historical monuments to think of a suitable figure (free from any false pathos) to represent the ideals of American democracy, and he would never have thought of creating such an extravagant figure, whose appearance was simultaneously evocative of an antediluvian semaphore, a windmill and a scarecrow, even one dressed (as is obligatory in such cases) in a long frock coat, and crowned with a shaggy stovepipe topper.

But I think that it is precisely these external features of his appearance that make this historical figure so full of pathos and emotion: he is freed not only from all posing, but even from the simplest concern about himself. His whole life was spent in the most selfless service of his people.

Apart from the film, I know what Lincoln looked like from hundreds of photographs which had been carefully assembled in an album by an émigré from Hitler-occupied Hungary, who had been hospitably received in America.

Stefan Loran compiled it in reply to his ten-year-old son, who asked, 'Who was Lincoln?'[21]

The image of this fanatic looks out at us from every page of this album; changing and hunching up with the passage of years.

If concepts of freedom and democracy could be expressed by hieroglyphs, in the style of Chinese script, then the eccentrically bent silhouette of this tall stooping man, in frock coat and topper, with huge hands and disjointed movements, would be this hieroglyph.

You cannot fail to be amazed by the inner intuition and skill with which the mild-looking young Henry Fonda transforms himself into this likeness of Don Quixote, whose armour is the American Constitution, whose helmet is the traditional topper of a backwoods attorney, whose Rosinante is the swaying little mule, from which his extraordinarily long legs can reach the ground – the same ground that he devoted his energy, pathos and life to unifying.

That is precisely how he has been reborn in the picture, and we can see him move living across the screen.

The veracity of image and appearance in the picture can be attested by the millions of pages, written in America, about Lincoln (several thousand plays alone have been written about him!).

But three lines etched on my memory suffice to convince that this image from the past has been miraculously transformed into today's cinema image.

The first is a fragment of the first impression of the new President's first journey to New York State, after his election by the majority from the provinces, despite the antipathy of that state, which by then was pretty powerful.

The second is the story that dates from the time when this man already held power in his iron grasp.

And the third is a fleeting hint of reminiscence I once read, and which has captured the intimate pages of this White House resident's daily life, and some highly crucial moments in improving the fates of the nation, the state and the people in the heat of the Civil War between North and South:

I shall not easily forget the first time I ever saw Abraham Lincoln. It must have been about the 18th or 19th February, 1861. It was rather a pleasant afternoon in New York City, as he arrived there from the West, to remain a few hours, and then pass on to Washington to prepare for his inauguration. I saw him in Broadway, near the site of the present Post Office. He came down, I think from Canal street, to stop at the Astor House. The broad spaces, sidewalks and streets in the neighborhood, and for some distance, were crowded with solid masses of people, many thou-

sands. The omnibuses and other vehicles had all been turn'd off, leaving an unusual hush in that busy part of the city. Presently two or three shabby black barouches made their way with some difficulty through the crowd, and drew up at the Astor House entrance. A tall figure stepp'd out of the centre of these barouches, paus'd leisurely on the sidewalk, look'd up at the granite walls and looming architecture of the grand old hotel – then, after a relieving stretch of arms and legs, turn'd round for over a minute to slowly and good-humoredly scan the appearance of the vast and silent crowds. There were no speeches – no compliments – no welcome – as far as I could hear, not a word said. Still much anxiety was conceal'd in that quiet. Cautious persons had fear'd some mark'd insult or indignity to the President-elect – for he possess'd no personal popularity at all in New York City, and very little political. But it was evidently tacitly agreed that if the few political supporters of Mr Lincoln present would entirely abstain from any demonstration on their side, the immense majority, who were anything but supporters, would abstain on their sides also. The result was a sulky, unbroken silence, such as certainly never before characterized so great a New York crowd.

Almost in the same neighborhood I distinctly remember'd seeing Lafayette on his visit to America in 1825. I had also personally seen and heard, various years afterward, how Andrew Jackson, Clay, Webster, Hungarian Kossuth, Filibuster Walker, the Prince of Wales on his visit, and other celebres, native and foreign, had been welcom'd there – all that indescribable human roar and magnetism, unlike any other sound in the universe – the glad exulting thunder-shouts of countless unloos'd throats of men! But on this occasion, not a voice – not a sound. From the top of an omnibus, (driven up one side, close by, and block'd by the curbstone and the crowds,) I had, I say, a capital view of it all, and especially of Mr Lincoln, his look and gait – his perfect composure and coolness – his unusual and uncouth height, his dress of complete black, stovepipe hat push'd back on the head, dark-brown complexion, seam'd and wrinkled yet canny looking face, black, bushy head of hair, disproportionately long neck, and his hands held behind him as he stood observing the people. He look'd with curiosity upon that immense sea of faces, and the sea of faces return'd the look with similar curiosity. In both there was a dash of comedy, almost farce, such as Shakspere puts in his blackest tragedies. The crowd that hemm'd around consisted I should think of thirty to forty thousand men, not a single one his personal friend – while I have no doubt, (so frenzied were the ferments of the time,) many an assassin's knife and pistol lurk'd in hip or breast pocket there, ready, as soon as break and riot came.

But no break or riot came. The tall figure gave another, relieving stretch or two of arms and legs; then, with moderate pace, and accompanied by a few unknown-looking persons, ascended the portico-steps of the Astor House, disappear'd through its broad entrance – and the dumb-show ended.

I saw Abraham Lincoln often the four years following that date. He changed rapidly and much during his Presidency – but this scene, and

him in it, are indelibly stamp'd upon my recollection. As I sat on the top of my omnibus, and had a good view of him, the thought, dim and inchoate then, has since come out clear enough, that four sorts of genius, four mighty and primal hands, will be needed to the complete limning of this man's future portrait – the eyes and brains and finger-touch of Plutarch and Eschylus and Michel Angelo, assisted now by Rabelais.[22]

This colourful description comes from someone whom we know and love mainly for his improbable poems, his uncommon poetry.

But this quotation is taken from his lectures about the person whom he himself loved and admired.

He himself was a devotee of the approaching age of democracy and could not fail to admire and love Lincoln.

The extract was written by Walt Whitman.

And the extract itself comes from lectures he gave on the fourteenth anniversary of the President's death, 14 April 1879 in New York, and repeated later in Philadelphia and Boston.

My first encounter with the image of Lincoln was, of course, not personal but literary.

I think it happened a long time ago, on the pages of an old collection of stories about the American Civil War.

The President was more than simple and modest in his own way of life.

He even polished his own boots.

Someone ironically said to him: 'Real gentlemen never clean their own boots!'

'Then whose boots do real gentlemen clean?' Lincoln asked.

You can picture his calm, unwavering and shrewd gaze being levelled at his interlocutor, as he said this.

And you can imagine his interlocutor begin to fidget awkwardly, taken aback, confused, and to melt away.

And it is precisely that look that has been marvellously captured in the film: a look, as it were, of cosmic contempt for worldly vanity, which takes in even the smallest trifle while, at the same time, none of these chance trifles can obscure from view the great significance of what lies behind all the trifles of life, of routine, of mistakes and blunders, of treachery, of sins and misdemeanours, and of human pettiness – the cussedness of the conditions of life, the cussedness of the style of life, the cussedness of the order of things, which must be changed for the sake of man.

★　★　★

I never met Lincoln in person.

But humanity has a similar defender in our country.

Somewhat angular like him, and no less hunched.

His eyes are just as boundlessly human.

They are sometimes ironic, sometimes merry, sometimes cunning, but they always cut through the shroud of incidentals, and actively contemplate the very essence of evil which must be uprooted in the name of the good that

must replace this evil, in the interests and for the benefit of mankind.

Such are the figure, manner and ways of Maxim Gorky, who in his later years was amongst us, the younger generation.[23]

Lincoln and Gorky have in common their unreserved service to mankind's ideal.

The epoch is different, it is a different page of history, a different stage of social development; and of course Gorky came nearer than Lincoln did to the social ideal and the implementation of this social ideal, which was the practical realisation of socialism.

But how much they had in common!

There was the long journey in youth, from illiteracy to books and learning.

And the link with the people, from the heart of which they came – these two tall men, with eyes which had seen endless journeys and crossroads in their native countries, and the accumulation of the woes of millions labouring in slavery and thirsting for freedom and emancipation.

And Henry Fonda, amazing actor that he is, has caught this sorrowful gaze, the bend of this spine, the childlike simplicity, wisdom, and childlike cunning in a miraculous character.

But the maker of the film, John Ford, looked at the recreated images of the epoch with just such a gaze before realising them on screen.

It is as though Lincoln's riposte about the boots and gentlemen served both equally: as a prototype of that arch wisdom, simplicity and ability to see to the bottom of things, which the actor displays throughout the film; and as a tuning-fork for the inimitable intonation in which the director narrates the story.

The plot of the film is limited to Lincoln's youth.

But, as a background to the story of this youth, Henry Fonda manages to convey something much greater: everywhere, behind all the superficial facts of an apparently isolated episode from Lincoln's legal practice as attorney, stands the image of the all-enveloping pathos that fired Lincoln – the head and leader of the American people who was elected President at the most critical juncture in the history of the United States.

The image of that pathos, which memory has preserved in the shape of a once-read description of the plastic appearance of the United States' sixteenth President during the darkest watches of the night when the fate of his country was being settled.

In the sad eyes of the modest Illinois attorney, who came to the defence of two wrongly accused boys plucked by his long bony arms from the greedy claws of the lynch mob; in the sad eyes through which Henry Fonda looks at the crowd of fanatics there is something of this all-encompassing, wise orb, which many years later in the White House also stared unblinkingly straight in the face of the fanaticism and madness that had caused all the horrors of the fratricidal war between North and South.

And here, beyond the image of Lincoln, created by the joint skill of Henry Fonda and John Ford, stands one more image of the humanist and democrat, who at similar hours of the night, during similarly sleepless nights, and in the same White House adopted similar decisions about the struggle

with darkness, this time on a global scale: Franklin Delano Roosevelt.[24]

The white knight of democracy in a firm handshake with our country, jointly with the other freedom-loving nations, helped bring the great War to the threshold of victory.

And perhaps that reveals another secret, why I love this film so much.

It attracted me even before the War: I saw it first almost on the eve of the World War.

The perfection of its overall harmony and its rare skill in all the areas of means of expression immediately enthralled me.

And most of all it was the actual resolution of Lincoln's image.

But my love of this film did not cool and was not forgotten.

On the contrary: it grew and became stronger, and the film itself somehow became ever dearer to me.

And, while the war spread, vivid impressions of two other great humanists of the modern day became entwined in the central image of this film: one is now dead, and the other is about to bring this struggle to its victorious conclusion.[25]

And at this point the harmony of the film seems symbolic: in the harmony of the actual film, it seems that the ideal of the human harmony of human relationships has been realised in cooperation and joint struggle, for the sake of which millions of the best sons of humanity have laid down their lives.

27. How I Became a Director[26]

It was a very long time ago.

About thirty years ago.

But I remember very distinctly how it happened.

I mean how I became involved with art.

Two direct impressions, like two thunderclaps, decided my fate in this direction.

The first was a performance of *Turandot* in Fyodor Komissarzhevsky's production (Nezlobin's theatre, touring Riga in 1913).[27]

From that moment, theatre became the subject of my constant attention and frenzied enthusiasm.

At this stage, not yet having any plans to participate actively in theatre, I honestly intended to 'follow in my father's footsteps' and become an engineer and architect. I had been preparing for this since I was young.

The second one, overwhelming and definitive, which actually defined my unspoken intention to abandon engineering and to 'give myself' to art, was *Masquerade*, in the former Alexandrinsky Theatre.[28]

How grateful I later was to fate for giving me that shock before I passed my higher mathematics exams, with the full panoply of an institution of higher education, right up to integrated differential equations, of which (as, incidentally, is true of the other subjects) I can no longer remember anything.

However, it was precisely at that moment that my disposition towards disciplined thinking and my love of 'mathematical' precision and clarity developed within me.

The minute I fell into the whirlwind of the Civil War and left, for a while, the walls of the Institute of Civil Engineering, I instantly burnt my boats with the past.

After the Civil War, I did not return to the Institute, but I 'dived' into work in theatre without so much as a backward glance.

First it was as a set designer in the Proletkult First Workers' Theatre,

then as a director,

and later, with this same collective, as a film director for the first time.[29]

But that was not the important thing.

The important thing was that my drive towards that mysterious vital activity called art was unstoppable, voracious and insatiable.

In order to leave the front for Moscow, I enrolled in the Department of Oriental Studies of the Academy of the General Staff. For this, I mastered a thousand Japanese words and hundreds of fantastical outlines of hieroglyphs.

The Academy represented not only Moscow, but the possibility later of learning about the Orient, of immersing myself in the primary sources of the 'magic' of art, which are for me inseparably linked with Japan and China.[30]

How many sleepless nights were spent cramming words from an unknown language which had no associations with those European ones that I knew!

'Senaka' means 'spine'.

How could I remember that?

'Senaka' was 'Seneca'.

The next day I tested myself with my exercise book, covering the Japanese column with my palm and reading the Russian.

Spine?

Spine?!

Spine ...

Spine – 'Spinoza'!!! etc., etc., etc.

The language was very difficult.

And not only because it had no phonetic associations with the languages that I knew. But, chiefly, because the structure of thought for constructing phrases was completely different from the way of thought of our European languages.

The hardest thing was not remembering the words: the hardest thing was understanding the way of thinking – so different from ours – by which Oriental turns of phrase, sentences, word formations and word outlines are constructed.

I was later deeply grateful to fate for taking me through my probation and acquainting me with this unusual way of thinking in the ancient Oriental languages and verbal pictography! It was none other than this 'unusual' way of thinking that helped me later to investigate the nature of montage. And when this 'way' was later realised as the law of inner emotional thought, distinct from our generally accepted 'logic', it was precisely that which helped me to investigate the most obscure layers of the method of art.[31] But more of this later.

So my first fascination became my first love.

But the story had its darker aspects. It was not only turbulent, but tragic.

I always admired one feature of Isaac Newton: to ponder falling apples and to infer God knows what deductions, generalisations and conclusions from them. I liked this so much that I even supplied Alexander Nevsky with just such an 'apple', making this hero of the past deduce the configuration for the strategy of the Battle of the Ice from the outline of the vulgar tale of the Vixen and the Hare.[32] The armourer Ignat recounts this story in the film ...

However, at the dawn of my creative activity, a similar apple did me a good turn, in a pretty unobtrusive way.

Come to think of it, it was not an apple, but the chubby and glowing face of the son of an usher at the First Proletkult Workers' Theatre.

At one of the rehearsals I chanced to glance at the face of this little boy who used to come to see us in the rehearsal foyer. I was struck by the way this

boy's face mimetically reflected everything happening on stage, as though it were a mirror. And it was not only the mimicry or actions of one or more of the characters working on stage, but of all and everything simultaneously.

What surprised me most was his very simultaneity. I no longer remember whether this mimetic reproduction of what was seen extended also to inanimate objects, as Tolstoy wrote about one of his servants. (When speaking of something, he contrived to convey with his face the life of even inanimate objects.)

But one way or another, I gradually came to think deeply not so much about the 'simultaneity' of the reproduction of what the boy had seen, but about the actual nature of this reproduction.

1920 came.

There were no trams running then.

And the long journey from the hallowed boards of the theatre in Karetny Ryad, where such significant theatrical undertakings were born,[33] to my unheated room in Chistye Prudy greatly assisted my ruminations on the themes provoked by a fleeting observation.

I was by then already aware of James's famous formula that 'we are not crying because we are sad; but we are sad because we are crying.'[34]

I liked that formula first of all aesthetically, for its paradoxical quality; and, apart from that, for the fact that the corresponding emotion may be born out of a particular, correctly recreated, expressive phenomenon.

But if that is so, then, by recreating mimetically the signs of the actors' behaviour, the little boy must have been simultaneously and fully 'experiencing' everything that the artistes on stage were experiencing – either in reality, or in a sufficiently convincing representation.

An adult viewer mimics the performers in a more restrained way but, precisely because of that, he does so even more intensely *fictitiously*: that is, without any actual cause, and without committing a real deed, he experiences that whole marvellous range of nobility and heroism which the drama demonstrates to him; or he gives *fictitious* vent to the base instincts and criminal inclinations of his persona as a spectator – again not through action, but through those same real emotions which accompany a *fictitious* complicity in the evil goings-on on stage.

Anyway, out of all these notions, the element of 'fictitiousness' took hold of me.

And so art (for the time being in the particular case of theatre) allows someone to accomplish *fictitiously* acts of heroism through sharing in another's experience; he can *fictitiously* undergo mighty spiritual upheavals; he can *fictitiously* be noble with Franz Moor, shrug off the burdens of base instincts by joint action with Karl Moor, feel that he is wise, with Faust, or has God's protection with the Maid of Orleans; passionate, with Romeo; patriotic, with the Count de Rizoor; purge himself of the torment of inner problems of any kind through the generous participation of Careno, Brand, Rosmer or Hamlet, the Prince of Denmark.[35]

But more than that, as a result of such a 'fictitious' action, the viewer can experience completely real, concrete satisfaction.

After Verhaeren's *Les Aubes* he feels a hero.[36]

After *The Steadfast Prince* he senses a halo of victorious martyrdom around his head.[37]

After *Love and Intrigue* he sighs at the nobility he has experienced and the compassion he feels.[38]

Somewhere on Trubnaya Square (or was it at the Sretensky Gates?) I became feverish: it really was terrific!

What kind of device lies at the heart of this 'sacred' art, whose service I had joined?!

It is not just falsehood,

not just deceit,

it is delirium,

terrible, terrifying delirium.

For if you have this opportunity – to feel fictitious satisfaction – why trouble to look for it as a result of really, actually and genuinely effecting something that may be had just as easily at a small price without having to move? In a theatre seat, which you can leave with a sense of absolute satisfaction!

'Thus thought the young rake ...'

And as I walked from Myasnitskaya to the Pokrovsky Gates, the picture I had seen gradually turned into a nightmare ...

You should remember that the author was twenty-two, and that youth is inclined towards hyperbole.

Kill!

Destroy!

I do not know whether it was from the same chivalrous motives, or from the same half thought-out ideas, but this most noble impulse to kill, which was worthy of Raskolnikov,[39] did not lurk in my head alone.

Everywhere the reckless cry went up, echoing the theme of the destruction of art: by the liquidation of its main symbol – the image – by materials and documents; of its sense – by abstraction; of its organic nature – by construction; and its very existence – by abolition and replacement with something practical, real, based on life without the medium of fiction and fables.

LEF brought together people of different temperament, with different baggage, and different motives, on a common platform: a practical loathing of 'art'.[40]

But a young lad who has not even jumped aboard the express train of artistic creation, can achieve nothing, no matter how much he decries in his unbroken falsetto the social institution legitimised by centuries of art!

And there comes the sneaking thought.

First to master.

Then to destroy.

To learn art's secrets.

To rip off the veil of secrecy.

To master it.

Become a craftsman.

Then to tear off its mask,

to expose it, smash it!

And then a new stage of relationships begins: the murderer begins to play with his victim,

to win its trust,

to look at it closely and to study it.

That is how a criminal spies on his victim's daily timetable,

that is how he studies his habitual comings and goings,

makes a note of his routine,

his haunts,

the places he frequents.

At last he begins to talk with his marked victim,

becomes close to him,

even enters into a degree of intimacy.

And now and then he secretly strokes the steel of his dagger so that its cold blade brings him to his senses, just in case he comes to believe in this friendship himself.

So, art and I made circles around each other . . .

It enveloped me, enmeshing me in the wealth of its charm,

and I surreptitiously ran my fingers down my dagger.

In this case, it was the scalpel of analysis that served as a dagger.

Upon the closest examination, the dethroned goddess 'awaiting the final act', during the 'transitional period', might be useless for the 'common cause'.

She was not worthy of the crown,

so for the present let her scrub the floors.

Even so, it is nevertheless a fact that art influences.

And the young proletarian state needed to influence hearts and minds a hell of a lot, if it was to fulfil its urgent tasks.

I studied mathematics once –

seemingly for nothing (although I would never have supposed that it would later come in useful).

I crammed Japanese hieroglyphs once –

also for nothing, seemingly.

(Then I did not see much benefit in them: I could see that there were altogether different systems for thinking, but I never thought that this could somehow be useful to me!)

Well then, I should cram and learn the method of art too!

That has the advantage at least that the actual period of cramming could be its own reward.

And so, again to books and notebooks . . . Laboratory analyses and diagrams . . . The periodic table and the laws of Gay-Lussac and Boyle – Mariotte in the field of art![41]

But then came some utterly unforeseen circumstances.

The young engineer started work

and became terribly disconcerted.

For every three lines of his theoretical approach to the inner core of his new acquaintance – the theory of art – the beautiful stranger brought him seven veils of mystery!

It was an ocean of muslin!

A model straight from Pacquenne![42]

No sword can cut through a feather cushion. And it would not be possible to cut straight through this ocean of muslin, whatever kind of double-handed sword you tried to hack through it with!

Only a finely whetted, curved oriental scimitar, wielded with that deft movement of the arm typical of Saladin or Suleiman, can cut through a feather cushion.

But it takes practice!

The curve of a scimitar symbolises the long, circuitous route you must travel in order to dissect the secrets lying beneath the sea of muslin.

Never mind. We were still young. Time could wait. Everything was still before us ...

The magnificent creative intensity of the twenties seethed around us.

It ran in all directions, in the frenzy of the young shoots of crazy conception, delirious conceits, and unstoppable bravery.

And this was all a part of the furious desire to express in a new way, a new fashion, what we were experiencing.

The ecstasy of the epoch, despite the declarations, and contrary to the banished term 'creativity' (which had been replaced with the word 'work'), despite 'construction' (trying to throttle 'image' with its bony extremities), bore one creative (and that is the correct word) product after another.

Art, and its possible murderer, were for the present living together in the creative process, in the unique and unforgettable atmosphere that lasted from 1920 to 1925.[43]

But the assassin did not forget to seize his dagger. As I have said, the dagger in our case was the scalpel of analysis.

And let us not forget that the young engineer undertook an academic examination of the mysteries and secrets.

In any of the disciplines he had studied he assimilated the first rule, which was that, properly speaking, an academic approach begins at the point when the area of research acquires a unit of measurement.

And so, let us search for the unit for measuring influence in art!

Science has 'ions', 'electrons', 'neutrons'.

Let art have 'attractions'!

The technical term signifying the assembly of vehicles, waterpipes, machinery, was moved out of technical processes into everyday speech, the lovely word 'montage' meaning assembly.

The word may not yet be fashionable, but it has potentially everything it needs for popularity.

Well, who knows!

Let *the units of influence, combined into a single whole*, absorbing both these words, acquire this twofold designation that comes half from manufacturing, and half from the music-hall!

They are both from the core of urbanism, and in those years we were terribly urbanistic.

Thus was born the term 'the montage of attractions'.[44]

If I had known of Pavlov[45] at that time, I would have called 'the montage of attractions' 'the theory of artistic irritants'.

It is interesting to recall that this made the *viewer* the decisive element and, hence, this was the first attempt to organise the means of influence and bring all the varieties of influence to bear upon the viewer to a kind of *common denominator*,[46] (regardless of the field and dimension to which it belongs). This later helped me predict the special features of sound cinema and was decisive in determining vertical montage.[47]

Thus began my 'dyadic' activity in art, which always combined creative work with the analytical: partly commenting on a work by analysing it, and partly testing the results of this or that theoretical supposition on it.

As far as *an awareness of the peculiarities of the method of art* is concerned, both these varieties gave me the same thing. And for me, personally, this was the most important thing, no matter how pleasant the successes, or bitter the failures!

I have been labouring over the 'assembling' of the data that I have been extracting from my practical work for a good number of years. But I shall write about this in another place at another time.

But what became of my murderous intention?

The victim proved more cunning than its assassin: while the assassin imagined he would 'make away' with his victim, his victim fascinated its executioner.

Fascinated, absorbed, snatched up, and even swallowed him, for a fairly protracted period.

Wishing to be an artist 'for a bit', I lost my head in so-called artistic creativity, and only occasionally now does my incorruptible queen, my implacable sovereign, 'my cruel despot' – art – allow me a couple of days at my writing desk to jot down a couple of ideas relating to its secret nature.

When I was working on *Potemkin* I savoured genuine creative pathos. Well, anyone who has tasted genuinely creative ecstasy once will probably never be able to extricate himself from this pursuit in art!

1946/7

28. About Ivan Pyriev[1]

He is no relation of mine. Nor even, perhaps, what is called a friend, although he is a very old acquaintance. For me he is first of all a phenomenon – Ivan Pyriev, four-times winner of the Stalin Prize.[2]

Twenty-five years ago I worked on the boards of the theatre in Karetny Ryad, which is soaked in historical tradition, and was then called the Central Proletkult Arena.[3] Two lads who had served at the front auditioned there to join the company.

Two schoolfellows.

Two friends. Both from Sverdlovsk.[4]

One with unkempt hair and a fringe. The other was thinner, wiry and short-haired.

Both had come from the front. Both wore greatcoats. Both had rucksacks on their backs.

Both read some poetry to the late Valentin Smyshlyayev and myself.[5]

They did some improvisation. And were accepted into the company with delight.

One had blue eyes, was courteous and mild.

Later he could balance impeccably on a tightrope.

The other was crude and uncompromising. Given to loud declamations of poetry by Mayakovsky[6] and fist-fighting, more than to boxing, which, to his regret, was confined to strictly regulated movements and aesthetic rules...

Now they are both decorated prize-winners.

The first was Grigori Alexandrov.[7]

The second was Ivan Pyriev.

Both acted in my very first productions.

I worked with the first one for many years, right from the start.

The second one and I separated three years later.

In my first theatrical production (jointly with Smyshlyayev), *The Mexican*, based on a work by Jack London (Spring 1921), the show ended with a boxing-match in a ring.[8] Ivan Alexandrovich Pyriev had been brought into the show: his lean figure and explosive temperament were entirely suited to the role of the young victor, the Mexican revolutionary, Rivera.[9]

Before his departure from the Proletkult, Pyriev was filmed in my first film work: a short comedy inset into the production of *Enough Simplicity for Every Wise Man* (1923).[10]

Then I lost sight of him for several years.

And only a distant, penetrating pounding noise tells me that Pyriev is fighting with someone, somewhere.

But the sound changes tone: now it is hooves, pounding the road.

And soon it becomes the pounding that the screen delivers when it is dealing with themes that excite the country and the people.

Snobs and aesthetes may splutter that Pyriev's work is not always refined. But even they find it difficult to deny that it has a quality that rings true and hits the mark, or to dispute its thematic power, temperament and honest inspiration.

The fact stares us in the face: Ivan Pyriev has won the Stalin Prize four times.[11]

There are pictures that are more effective than Pyriev's *Tractor Drivers* and *The Wealthy Bride* [Bogataya nevesta, 1938], and some films perhaps demonstrate greater taste and skill.

But what other pictures have conveyed across the country and popularised so broadly in song and images the idea of the economic advantages of collective farming – the cornerstone of the future military successes that have been won before our very eyes?

Let us be pedantic. Some shots from *The Swineherd and the Shepherd* resemble Solomko's lacquered snuff-box paintings,[12] but what other picture has hymned the indissolubly united friendship between our country's peoples with such verve, optimism and exuberance?

Granted, the sketch of the film *The Secretary of the District Committee* is careless in places, showing all the faults and skimpings typical of wartime film-making.

But what other picture, in the very thick of the war, depicted on the screens of our country with such great spirit, brightness and animated anger the wartime struggle waged by Party leaders?

Does it matter that the studio fireworks, next to the dome of the rays from the coloured arc-lights, filmed above Moscow on that unforgettable evening when the War ended, are occasionally naive? What matters is that the film *At Six p.m. After the War* was the first film to project on the screen the private thoughts, hopes and aspirations that the Soviet people harboured, upon their emergence from the furnace of war; their joy at the end of the War and a new life of peace starting.

The popularity of Ivan Pyriev, four times winner of the Stalin Prize, is beyond doubt.

[He is] of the people. And for the people.

And the people are grateful to him.

The people have produced many different men.

From among themselves.

And for their own sakes.

There was Lenin, the genius.

And Gorky, the fiery falcon.

And Mayakovsky, the impassioned tribune.

And the same people have given birth to thousands of collective-farm brides, tractor-drivers, swineherds and shepherds. They have produced secretaries for regional committees, and soldiers for the Red Army.[13]

And they have borne Ivan Pyriev, the author of films in which they all still live, inspired by life.

The author himself seems heir to genuinely Russian ancestors, who culminated in one of the most typical figures of past Russian epic.

There is something of the strain of Vaska Buslai in his slightly lean, thin figure.[14] He would be a boxer, if he had the excessive musculature to correspond to his excessive frenzy for producing, whose motto would be 'whatever it is you hit, hit it hard'.

And chiefly, timeliness.

Such has been Pyriev's journey, theme and method.

Such a blow – the first, well-aimed, resounding, targeted and timely – was Pyriev's film *The Party Card* [Partiinii bilet, 1936]. This film is one of the textbook examples of film-making, with the power of its subject matter.

Our business is urgent.

There are many battles ahead.

And you have to hit in a hard, accurate and timely fashion. It is no calamity if not every blow has style. There are times when it is more important for the blow to be forceful than elegant.

Pyriev never for a minute wavers from this forcefulness of theme.

And the people owe him a great debt of gratitude for this.

For the people know, love and value those who have emerged from their midst.

29. Communist Party Central Committee Decree on the Film *A Great Life*[15]

The Communist Party Central Committee notes that the film *A Great Life* (Part Two, directed by Leonid Lukov, screenplay by Pavel Nilin), made by the USSR Ministry for Cinema, is ideologically and politically flawed; and artistically extremely weak.[16]

What are the flaws and shortcomings of *A Great Life*?

The film portrays only one insignificant episode from the first assault on the reconstruction of the Donbass, which is to give an inaccurate picture of the actual scope and importance of the reconstruction work carried out by the Soviet government in the Donetsk Basin.[17] Furthermore, the reconstruction of the Donbass is of minor importance in the film, where attention is focused on a primitive depiction of all manner of personal experiences and scenes from daily life. Hence the film's content does not correspond to its title. In addition, the film's title, *A Great Life*, reads like a mockery of Soviet reality.

Two different epochs in the development of our industry have evidently become confused in the film. To judge by the level of technology and the production culture depicted in *A Great Life*, the film reflects the period of the reconstruction of the Donbass after the end of the Civil War, rather than the Donbass of today with its progressive technology and culture, the result of Stalin's Five Year Plans. The film-makers have misled their audience into thinking that the reconstruction of the Donbass mines after their liberation from the German aggressors and the extraction of coal are not being carried out in the Donbass using modern, sophisticated technology involving the mechanisation of labour processes, but rather by the application of brute physical strength, superannuated technology, and old-fashioned work methods. This also perverts the film's sense of the post-war reconstruction of our industry, which is based on sophisticated technology and an advanced production culture.

In *A Great Life*, the task of rehabilitating the Donbass is portrayed in such a way that the workers' initiative in rehabilitating the mines received no support from the state, but was carried out by the workers in the teeth of opposition from state organs. This depiction of the relationship between state organs and workers' collectives is inherently false and erroneous, since, as is well known, any initiative or proposal put forward by the workers of our country has the broad support of the state.

In this respect, Party workers have been falsely portrayed in the film. The Secretary of the Party organisation at the reconstructed mine is shown in a deliberately ridiculous light since his support for the workers' initiative to re-

habilitate the mineshafts may, it could be said, place him outside the Party's ranks. The film-makers make it look as though the Party might exclude from its ranks people who have shown concern for economic reconstruction.

The setting for the reconstruction of the Donbass is falsely shown in the film, so that the Great Patriotic War appears to end with the liberation of the Donbass from the German aggressors. The film presents the matter as if the Army were already demobilised at the start of the reconstruction of the Donbass, and all the soldiers and partisans had returned to peacetime occupations. The War, which was actually at its height at the time, is spoken of in the film as though it were an event in the distant past.

The film *A Great Life* champions backwardness, coarseness and ignorance. The film-makers have shown workers who are technically barely literate and hold outdated views and attitudes being promoted *en masse* to management positions. This is entirely unjustified and incorrect. The director and scriptwriter have failed to understand that in this country it is the cultured and progressive types, the people who know their profession well, who are well regarded and swiftly promoted – not backward, uncultured people; and, now that Soviet power has created its own intelligentsia, it is wildly absurd to show the promotion of backward, uncultured people to management positions as though it were a positive phenomenon.[18]

The film *A Great Life* shows Soviet people in a false, distorting light. The workers and engineers who have reconstructed the Donbass are shown as backward people with very low moral qualities. For most of the time, the heroes of the film are idle, engaging in empty chit-chat or drunkenness. The best people, in the film's scheme of things, are inveterate drunkards. People who have served in the German police force appear as the main heroes. One person (Usynin) is shown as someone clearly alien to the Soviet system: he stayed with the Germans in the Donbass but his subversive and provocative behaviour is allowed to go unpunished. The film attributes to Soviet people morals that are completely alien to our society. Thus Red Army soldiers, wounded in the struggle to regain possession of the mines, are abandoned without help on the battlefield, and one miner's wife (Sonya) walks past the wounded soldiers with complete indifference and lack of concern for them.

The film's attitude to the young female workers who travelled to the Donbass is heartlessly derisive. They are quartered in a filthy, half-destroyed barracks, and entrusted to the care of a dyed-in-the-wool bureaucrat and cheat (Usynin). The mine management do not show even the most elementary concern for the workers. Instead of the damp, rain-soaked premises where the women are staying being made habitable, a guitar and accordion ensemble is sent to entertain them. This is a mockery.

The film is evidence that some workers in art, living among Soviet people, fail to notice their high ideological and moral qualities and are unable to turn them into convincing characters in their works of art.

Nor does the artistic level of the film stand up to criticism. Individual shots in the film are thrown together haphazardly, and there is no underlying conception linking them together. The different episodes are connected by numerous drinking bouts, cheap romances, amorous escapades and rambling conversations held in bed at night. The songs introduced into the film (music

by Nikita Bogoslavsky, words by A. Fatyanov and V. Agatov) are shot through with melancholy and are alien to the Soviet people.[19] All these feeble devices of the film-makers, who are catering for the broadest possible range of tastes, but particularly those of the backward, overshadow the film's principal theme – the reconstruction of the Donbass. The collective of talented Soviet workers has been misused by the film-makers. Ridiculous roles have been foisted upon the actors and their talent has been squandered on the portrayal of primitive people playing out everyday scenes of a dubious character.

The Communist Party Central Committee maintains that the Ministry for Cinema (Comrade Bolshakov)[20] has recently made a number of unsuccessful and flawed films in addition to *A Great Life*: Part Two of *Ivan the Terrible* (directed by Sergei Eisenstein), *Admiral Nakhimov* (directed by Vsevolod Pudovkin) and *Simple Folk* (directed by Grigori Kozintsev and Leonid Trauberg).[21]

How can so many cases of false and erroneous films be explained? Why have famous Soviet directors – Comrades Lukov, Eisenstein, Pudovkin, Kozintsev and Trauberg – who have made films of high artistic merit, met with failure?

The fact is that many skilled cinematographers, film-makers, directors and scriptwriters treat their obligations flippantly and irresponsibly, and do not work conscientiously on making films. The chief shortcoming in their works is their failure to study the subject that they have undertaken. Thus the director Pudovkin has undertaken to put on a film about Nakhimov, but he has not studied the details of the matter, and he has distorted the historical truth. The result is not a film about Nakhimov, but one about balls, dances, and scenes from Nakhimov's life. Consequently, key historical facts have been omitted from the film, such as the presence of Russians in Sinope, and the capture of a whole group of Turkish admirals in the Battle of Sinope, with Nakhimov in command. The director Sergei Eisenstein, in Part Two of *Ivan the Terrible*, has revealed his ignorance in his portrayal of historical facts, by representing the progressive army of Ivan the Terrible's *oprichniki* as a gang of degenerates akin to the American Ku-Klux-Klan; and Ivan the Terrible, a strong-willed man of character, as a man of weak will and character, not unlike Hamlet. The makers of the film *A Great Life* have demonstrated their ignorance in regard to the subject of the modern-day Donbass and its people.

One of the main reasons for the release of worthless films is the directors' and scriptwriters' ignorance of their subjects, and their flippant approach.

The Communist Party Central Committee maintains that the Ministry for Cinema, and above all its head, Comrade Bolshakov, are poorly managing the work of the film studios and the work of their directors and scriptwriters, and doing little to raise the quality of the films being released, uselessly squandering large resources. The leaders of the Ministry for Cinema are taking an irresponsible attitude towards the task they have been entrusted with, showing a lack of concern and care in regard to the ideological and political content, as well as the artistic merits of the films.

The Communist Party Central Committee considers that the work of the Artistic Council under the Ministry for Cinema is wrongly organised and that

the Council does not provide impartial and constructive criticism of films as they are being made. The Artistic Council has often demonstrated political apathy in its judgments on films and paid scant attention to their ideological content. Many members of the Artistic Council have failed to demonstrate any principle in their evaluation of films, assessing them instead on the basis of personal friendships with the film-makers. This alone can explain the fact that the Artistic Council, in its assessment of *A Great Life*, could not see its ideological content, and displayed a harmful liberalism in giving the film an unwarrantedly high evaluation. The absence of criticism in the field of cinema, the family atmosphere among the creative workers, is one of the main reasons for the production of bad films.

Workers in the arts must understand that those among them who continue to take an irresponsible and flippant attitude to their work may easily find themselves overboard as progressive Soviet art forges its way ahead, or find themselves withdrawn from circulation, because the Soviet audience has matured, its cultural requirements and demands have increased, while the Party and the State will continue to inculcate good taste in the people, and high expectations of works of art.

The Communist Party Central Committee decrees:

(i) In view of the above, to forbid the release of Part Two of *A Great Life*.

(ii) To propose that the USSR Ministry for Cinema and the Artistic Council of the Ministry learn the proper lessons and draw the necessary conclusions from the resolution of the Communist Party Central Committee on the film *A Great Life* and organise feature film production in such a way as to preclude all possibility of similar films being released in future.

30. Stalin, Molotov and Zhdanov on *Ivan the Terrible*, Part Two[22]

We were summoned to the Kremlin for a meeting at 11 p.m. At 10.50 we entered the reception room. At precisely eleven o'clock, Poskrebyshev came out to take us into the study.[23]

Stalin, Molotov and Zhdanov were at the back of the study. We went in, shook hands, and sat at the table.[24]

Stalin: 'You wrote a letter. The answer has been somewhat delayed. I thought of replying in writing, but then decided that it would be better to talk it over, as I am very busy and have no time; I decided after considerable delay to meet you here. I received your letter in November.'

Zhdanov: 'Yes, you were still in Sochi when you got it. [...]'

Stalin: 'Have you studied history?'

Eisenstein: 'More or less.'

Stalin: 'More or less? I too have a little knowledge of history. Your portrayal of the *oprichnina* is wrong. The *oprichnina* was a royal army. As distinct from the feudal army, which could at any moment roll up its banners and leave the field, this was a standing army, a progressive army. You make the *oprichnina* look like the Ku-Klux-Klan.'

Eisenstein: 'They wear white headgear; ours wore black.'

Molotov: 'That does not constitute a difference in principle.'

Stalin: 'Your Tsar has turned out indecisive, like Hamlet. Everyone tells him what he ought to do, he does not take decisions himself.

'Tsar Ivan was a great and wise ruler and, if you compare him with Louis XI (you have read about Louis XI, who prepared the way for the absolutism of Louis XIV?), he dwarfs Louis XI. Ivan the Terrible's wisdom lay in his national perspective and his refusal to allow foreigners into his country, thus preserving the country from the penetration of foreign influence. In showing Ivan the Terrible the way you did, aberrations and errors have crept in.

'Peter I was also a great ruler, but he was too liberal in his dealings with foreigners, he opened the gates too wide and let foreign influences into the

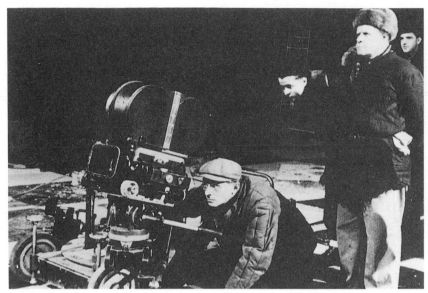

Filming *Ivan the Terrible*, Alma-Ata 1943, at night with no heating.

country, and this allowed Russia to be Germanised. Catherine even more so. And later – could you really call the court of Alexander I a Russian court? Was the court of Nicholas I really Russian? No, they were German courts.

'Ivan the Terrible's great achievement was to be the first to introduce a monopoly on foreign trade. Ivan the Terrible was the first, Lenin was the second.'

Zhdanov: 'Eisenstein's Ivan the Terrible comes across as a neurasthenic.'

Molotov: 'There is a general reliance on psychologism; on extraordinary emphases on inner psychological contradictions and personal experiences.'

Stalin: 'Historical figures should be portrayed in the correct style. In Part One, for instance, it is unlikely that the Tsar would kiss his wife for so long. That was not acceptable in those days.'

Zhdanov: 'The picture was made with a Byzantine tendency. That was also not practised.'

Molotov: 'Part Two is too confined to vaults and cellars. There is none of the hubbub of Moscow, we do not see the people. You can show the conspiracies and the repressions, but not just that.'

Stalin: 'Ivan the Terrible was very cruel. You can depict him as a cruel man, but you have to show why he *had* to be cruel. One of Ivan the Terrible's mistakes was to stop short of cutting up the five key feudal clans. Had he

destroyed these five clans, there would have been no Time of Troubles.[25] And, when Ivan the Terrible had someone executed, he would spend a long time in repentance and prayer. God was a hindrance to him in this respect. He should have been more decisive.'

Molotov: 'The historical events should have been shown in the correct interpretation. Take Demyan Bedny's play, *The Knights*, for example. In that play, Demyan Bedny made fun of the conversion of Rus to Christianity, whereas the acceptance of Christianity was a progressive event at that particular historical period.'[26]

Stalin: 'We are not of course particularly good Christians. But it is wrong to deny the progressive role of Christianity at that stage. It had great significance, as it marked the point where the Russian state turned away from the East and towards the West.'

On relations with the East, Comrade Stalin said that, 'recently liberated from the Tatar yoke, Ivan the Terrible was very keen to unite Russia as a bulwark against any Tatar invasions. Astrakhan had been subdued, but could at any point attack Moscow. As could the Crimean Tartars. Demyan Bedny has misrepresented the historical perspectives. When we moved the monument to Minin and Pozharsky nearer to St Basil's, Demyan Bedny wrote me [Comrade Stalin pointed at himself] a letter of protest to the effect that the monument should be scrapped altogether and Minin and Pozharsky consigned to oblivion.[27] I addressed my reply to "Ivan, ancestry forgotten". We cannot scrap our history.'

Then Comrade Stalin made a series of remarks about the treatment of the character of Ivan the Terrible, stressing Malyuta Skuratov's importance as a military leader and his heroic death in the war with Livonia.

Comrade Cherkasov, answering the claim that criticism was useful and that Pudkovkin had, following criticism, made a good film, *Admiral Nakhimov*, replied: 'I am sure that we shall do just as well, because I am working on the character of Ivan, not only in cinema but also in theatre; I like the character very much and I am sure that our reworking of the script may turn out to be correct and truthful.'

To which Comrade Stalin said: 'Well, let's give it a try.'

Cherkasov: 'I am sure that the reworking will be a success.'

Stalin (laughing): 'God willing, every day would be like Christmas.'

[...]

Eisenstein asked if there were specific instructions about the film.

Comrade Stalin replied: 'I am not giving instructions so much as voicing the thoughts of the audience.'

[...]

Comrade Zhdanov said that Eisenstein's fascination with shadows distracted the viewer from the action, as did his fascination with Ivan's beard: Ivan lifted his head too often so that his beard could be seen.

Eisenstein promised that Ivan's beard would be shorter in future.

Comrade Stalin, recalling the individual actors in *Ivan the Terrible* Part One, said: 'Kurbsky was splendid. Staritsky (played by Kadochnikov) was very good.[28] The way he caught flies was very good. He was a future tsar but caught flies with his hands. You need details like that. They reveal a man's true character.'

Stalin: 'Well then, that is sorted out. Comrades Cherkasov and Eisenstein will be given the chance to complete their project and the film. [He added] Pass that on to Bolshakov.'

Comrade Cherkasov asked about some details of the film, and Ivan's physical appearance.

Stalin: 'His appearance is fine and does not need changing. Ivan the Terrible's physical appearance is good.'

Cherkasov: 'Can we leave the scene of Staritsky's murder in the film?'

Stalin: 'Yes. Murders did happen.'

Cherkasov: 'There is one scene in the script where Malyuta Skuratov strangles Metropolitan Philip. Should we leave that in?'

Stalin: 'It must be left in. It was historically accurate.'

Molotov said that the repressions could and should be shown, but it should be made clear what caused them and why. This required a portrayal of how the state worked rather than scenes confined to cellars and enclosed spaces. The wisdom of statesmanship needed to be depicted.

Cherkasov voiced his ideas on the reworking of the script.

Stalin asked how the film would end. How the other two films – i.e. Parts Two and Three – could be better made, or how we envisaged doing this in general.

[. . . .]

Stalin: 'How will your film end?'

Cherkasov said that the film would end with the rout of Livonia, the heroic death of Malyuta Skuratov and the expedition to the sea, where Ivan the Terrible would stand surrounded by his soldiers and say: 'We stand on the seas and always will.'

Stalin: 'Which is what happened. And more besides.'

Cherkasov asked whether an outline of the future script needed to be shown to the Politburo for reading and approval.

Stalin: 'There is no need to submit it for approval. Sort it out for yourselves. It is always difficult evaluating a script; it is easier to talk about a finished work.' [Turning to Molotov] 'You of course very much want to read the script?'

Molotov: 'No, I specialise in a somewhat different area. Let Bolshakov read it.'

Eisenstein said that it would be better not to rush the production of this film.

Everyone heartily concurred with this remark. Comrade Stalin said, 'On no account rush it; as a rule we cancel films being made in a hurry and they never go out on release. Repin spent eleven years painting *The Zaporozhian Cossacks*.'[29]

Everyone came to the conclusion that it did indeed take time to make a good picture. With respect to *Ivan the Terrible*, Comrade Stalin said that, if it took eighteen months, two or even three years to produce it, then go ahead, make sure of it, let it be 'like a work of sculpture'.

Stalin: 'The overall task now is to improve the quality. Higher quality, even if it means fewer pictures.'

He said that Tselikovskaya had been good in other roles. She acted well, but she was a ballerina.[30]

We said that no other actress could make the journey from Moscow to Alma-Ata.

Comrade Stalin said that a director must be unyielding and demand whatever he needed, but our directors compromised too readily.

Comrade Eisenstein said that it had taken two years to find an Anastasia.

Comrade Stalin indicated that the actor Zharov had not brought sufficient gravity to his role in *Ivan the Terrible* and the result was wrong.[31] He was not serious enough for a military commander.

Zhdanov: 'He was not Malyuta Skuratov, more of a flibbertigibbet.'

Comrade Stalin said that Ivan the Terrible was more of a national tsar, more circumspect. He did not admit foreign influences into Russia; it was 'that Peter who opened the gates on to Europe and let too many foreigners in'.

The conversation ended with Comrade Stalin wishing us luck and saying, 'May God help you.'

We shook hands all round and went out. The discussion was over by ten past one.[32]

[There follows an appendix.]

Comrade Zhdanov also said that the film overdid the use of religious ceremonies.

Comrade Molotov said that this gave a mystical edge which should not have been so prominent.

Comrade Zhdanov also said that the scene in the cathedral with the 'bloody deed' was filmed too broadly, which was a distraction.

Comrade Stalin said that the *oprichniki* looked like cannibals when they were dancing, reminiscent of Phoenicians or Babylonians.

When Comrade Cherkasov said that he had been working on the character of Ivan the Terrible for film and stage, Comrade Zhdanov said: 'I have held power for six years myself, no problems.'

Comrade Cherkasov reached out for the box of cigarettes asking Comrade Stalin, 'Is it all right if I smoke?'

Comrade Stalin said, 'There's no ban on smoking, as such. Perhaps we should take a vote on it?' He allowed him to smoke.

Insert (on the script):

When the conversation came round to submitting the script for approval, Comrade Molotov said, 'There is no need to submit it for approval, especially as I expect Comrade Eisenstein will have thought out all the details about Ivan the Terrible by then.'

Stalin enquired after Eisenstein's heart and [said he] thought that he looked very well.

31. The People of One Film[33]

The Lomovs and Goryunov[34]

When I go to [Lomov] in his workshop, with its smell of glue, varnish, polish and all those other indescribable odours of sets that hit you, when they are being made,

when I see him in the midst of absurd artificial colours for someone's film of a carnival; papier-mâché pots, too big for humans, for someone's opera film; and the parts of an iconostasis, half carved and half moulded, for a picture of mine,

when I speak to him about the thickness of the layer of alabaster that is to go 'beneath the gilt' on utensils, or I agree to add some weight to the wax seals for the official documents that the foreign ambassadors are to bring to the court of Ivan or Sigismund,

when I see him sneaking off at the end of the working day into the sound workshop and listening intently to the recording of the ecclesiastical chants that have come to us from ancient times –

I feel that I have come into contact with the nameless hordes of the craftsmen of Ancient Rus, translated by some miracle into our day and age; the craftsmen who, bent by age, would fashion haloes and faces beneath the vaults of our temples, gild the cupolas of cathedrals, carve ivory crosses or weave gold wire into the intricately patterned decorations of jewelled vessels.

Granted, that is not enamel he is holding; granted, the foil is not gold, but paper; granted, the alabaster does not lie in layers on the icon boards, and granted, he is playing around with a blacking agent in his search for an artificial 'patina of time', and hanging on hooks are imitation icon-lamps; nevertheless, his eyes are filled with the same concentrated precision, beneath glasses that have been pushed back on to his forehead, and the folds on his forehead lie in those same thoughtful patterns that have been marked out for centuries on the brows of the subtle and skilled craftsmen of Russian applied art, as they tried out their ideas, embodying them with love and devotion, fanatically and cunningly, in their delightful handiwork.

His wife and comrade in arms, Lydia Alexeyevna, is a perfect match for him. Covered with needles, pins and lengths of thread, a keen glance from the corner of her eye would spot a slipping hem, an anachronistic 'spare' button, or the carelessly tied bands of a gold armlet, before it could be filmed.

I am prevented from talking – or rather, listening – to her only by the mad rush and the heaps of redundant, secondary matters which have nothing to do with directing, but to which we are condemned in the administrative confusion of our giant Potylikha, to which order has yet to be restored after the evacuation.[35]

The cunningly interwoven or poetic picturesqueness, with which popu-
lar speech invests humdrum events, floats before you in her narrative, in her
turns of phrase, in the figurative structure of her speech.

What could be more prosaic than the idea that a thread becomes invisible
when sewn in the nap of plush, or velvet?

But Lydia Alexeyevna would say: 'Velvet – it can conceal any thread.'

And this phrase captures the feeling of the depth of the texture of velvet,
which comes across as a dense, dark forest, concealing in its powerful em-
braces a shapely, slender, lost princess who slips unnoticed between its
powerful trunks. The plush, the velvet and the threads weave together an
image from a fairy tale and the invisible fibres reach out towards the style of
narrative that adorns Bersen's writings,[36] or Ivan's shrewd and ironic words
and thoughts, preserved in the Stoglav's decisions on ... artists.[37] This colos-
sus, who built a state, found the time to drop on his way such exhaustively
precise advice and wishes: 'Let those write who have the gift: and those with-
out it – perhaps they have other occupations?'

And how they work on a picture, those who have the 'gift'!

So, bent over for hours, Goryunov stands over the make-up chair.

Cherkasov, exhausted by the endless regluing of noses, beards and
moustaches, fell asleep some time ago, his head thrown back. He arrived at
Alma-Ata today, from Novosibirsk.

Hot or cold. Winter or summer – never a moment's rest: from the train
to the chair, into the 'sewing room', into rehearsals, into the workshop.

The mask for our great tragic actor (who could have believed that
Cherkasov, comedian and clown by nature and calling, would create a gallery
of considerable characters from Russian history?) does not move. The head
is thrown back on to its support.

Despairing of ever receiving the support requested by an 'order' 'sent
down' to the carpentry workshop three weeks ago, Goryunov knocked one up
with his own hands and fixed it to the chair today. He also knocked up with
his own hands the 'fairground booth' – a tarted-up hut beneath the walls of a
plywood Kazan, spread out along the sun-baked cliffs of Kaskelen.[38]

The 'Tsar' is asleep, and Goryunov and I are both pleased at this turn of
events. It is easier, looking with a second pair of eyes into the royal visage, to
select 'from all the possibilities' the correct angle for the slope of the brow, to
catch the 'course' of the line of the moustache, to catch the true 'flight' of a
lock of hair, the overall configuration of the 'movement' of the general mass
of hair.

For Goryunov, unlike many craftsman, has an acute sense of what is cru-
cial in wigs and make-up, hair and beards, moustaches and eyebrows. This is
first and foremost the dynamic image of movement, deriving from the ap-
pearance of the face and the pattern of the character's behaviour. As though
it were an emanation of the inner dynamic of the character, recast in the curls
of a lock of hair, in the flourishes of what is glued on, in the angle of some-
thing stuck on that plastically completes the motif set in his face, from the
whole variety of possibilities for the face chosen for a particular role. This is
probably why the Swedish newspapers sang such sweet eulogies to
Goryunov's beards and make-up in our picture.

Kilograms of resin, forests of hair and crepe pass through Goryunov's capable and nimble fingers in the endless hours spent searching for the [right] make-up. And during endless days and nights of filming night after night,[39] it is repeated day after day, verifying it to the nearest millimetre; the moulding for the characters' appearances is found only through such labours. There is no let-up in this work.

I remember well the day of the 'eruption' that Goryunov was subjected to when, together with Serafima Birman, he managed slightly to weaken the glue on the 'braces' that ran from Yevfrosinia Staritskaya's eyebrows to her temples.

One moral justification for this could have been the livid bruises which affected Serafima Germanovna's temples, as a result of many days' continuous filming. But artistically, no bloody stigmata of an actor's selfless devotion can serve as a justification.

Eyes smoulder with the wrong intensity from beneath eyelids that are differently drooped.

'Re-do the make-up!'

Now, running his fingers again and again along the Tsar's sticky nose, trying to find an anatomically accurate position for the bridge and the lateral indentations near the end of the nasal cartilage, which matches the proportions and rhythm of the slumbering Cherkasov's face, Goryunov is mocking. He quotes my earliest articles, articles from the period when I was fascinated only by a 'natural' type; articles brimming with fiery tirades against resin, stick-on beards and wigs...[40]

And in the evening ('evening' for us began at dawn after filming at night) I would sit with him and leaf attentively through prints from the work of Michelangelo or of less famous artists, trying to fathom the twist of Moses' beard, or the plan whereby the beards grew in El Greco's portraits: after a couple of hours, Amvrosi Buchma,[41] People's Artist, would come and we would 'look for' a beard for Basmanov the father, and later we would have to recreate a certain obscure, self-employed butcher in Alma-Ata as a Hanseatic merchant to give my film its 'western European complex'.

Y[akov] Raizman and N[adezhda] Lamanova[42]

I remembered Buonarroti's agonised letters, where he bemoaned his bent back and deteriorating eyesight, as he worked on the ceiling of the Sistine Chapel.

I quoted these letters from memory as I looked on the bent spines of these two tireless old folk who were capable of spending hours crawling the length of a dress hem, straightening the folds and looking for the line the material would naturally follow as it fell; or the line of a deliberate curving wayward tendril of a frill.

And the childlike sparkle of delight when the hope is captured and becomes reality?!

'Korovin used to tell me,' comes the insistent voice, 'that a work must never be finished completely...'[43]

Incompleteness is not Korovin's fantasy alone.

Here, in the East, around us in Alma-Ata, further afield in Tashkent and

Ashkhabad, this is a tradition.

This is the custom everywhere:

you will not find a single pattern on a cloak, a single pattern in a carpet, a single line of needlework around an embroidered skullcap [*tyubeteika*], a single intricate, blue china tile on the giant mosques, that is finished here in Central Asia. The custom has been instilled through weighty and ominous superstition: something that is completely finished fatally reflects the destiny of its creator.

'Serov used to tell me...'

Repin. Levitan (and I do not mean the radio announcer, but the 'Chekhov from a painting', Levitan the artist).[44]

This was said in a musty, dark, stuffy and mean interconnecting room.

A huge dress-making table occupied nine-tenths of it.

An unending procession of buckets of glue, bricks, and tin stovepipes fought its way through the remaining tenth. Rebuilding work, once more. There was the sound of running water.

With a characteristic movement of his shoulders, acute angles moving upwards, Yakov Ilyich [Raizman] expressed a silent, stoical irony in the face of the surrounding chaos.

Chaos, which proudly bore the name 'Costumery and Sewing Workshop of the Central United Studio, Alma-Ata'.

The cussed sign of this establishment (which was called CUS for short) united under the roof of the former opera house the two largest studios in the Soviet Union – Mosfilm and Lenfilm, which had been evacuated to Central Asia, away from the bombing.

And Yakov Ilyich Raizman himself sits before me among these fragments of primordial chaos, sipping from a green enamelled cup of 'plain' hot water.

He worked the greatest wonders in cloth for suits and overcoats in the theatre, the best craftsman of frock coats, the head of the best tailoring firm in Moscow for many decades.

With a similar look Bonaparte would, probably, have surveyed his surroundings as he strolled about the island of St Helena: plantation gardens, after the apartments of the Tuileries Palace.

With a similar look the ageing lion gazes into the distance, beyond the bars of the mobile menagerie, which has pointlessly pitched its carriages and its tattered Big Top in the very centre of the seething market of Alma-Ata.

It was drizzling. The first snowflakes fell with the rain. Bedraggled steppe eagles perched in their bare cages. The circles of their eyes blinked somnolently. This stinking enclosure, where a snow leopard, guinea fowl, steppe eagle, a mangy kangaroo and three monkeys lurked in the pale light of a kerosene lamp, was bare and quiet. Only the penetrating shouts from the jostling market that surged around it disturbed the reign of silence of the shabby cage sheltering the king of the beasts. You could write poems about the look in this lion's eye.

[His eyes] were unfathomable. Submissive. Yet full of that inhuman longing that only a beast can feel, when it has been wrenched from the torrid sands of its native desert, to suffer from bronchitis in the cutting autumn winds that blow through the deadly climate of Alma-Ata.

Yakov Ilyich wore a jacket of impeccable cut and a bow tie and, feeling the cold, had wrapped a checked scarf around his neck.

'Korovin used to tell me. . .'

By a miraculous turn of events resulting from Hitler's Attila-like greed, Messerschmidt's death-dealing invention, Guderian's short-lived successes[45] and our country's efforts to preserve the ranks of film-makers, Yakov Ilyich and I were thrown together here, by the evacuation.

The old man could not live idly.

And so his talent, time and skill are devoted to creating costumes for the productions of the united film studios of Moscow and Leningrad.

Fate deigned to make the production of *Ivan the Terrible* coincide with precisely those brief periods, when changing from frock-coats to the loose tunics of the Middle Ages, and from tuxedos to boyars' garments, it was Yakov who took command of this department.

There are few people whom I have loved in my life as I have loved and respected Yakov Ilyich, who died of an acute case of tuberculosis on New Year's Eve, 1944.

My memory of him is inseparably linked with my memory of another poet and master-tailor, Nadya – Nadezhda Petrovna Lamanova.

It was the greatest artistic pleasure to work with both of them.

Their acuteness of vision, their unsurpassed sense of line and form, of the proportion and realisation of the pattern in the reality of the texture, movement and line of material, the dynamic of a fold, the sculptured moulding of a figure.

Tireless zeal. The ceaseless sound of the first, tacking threads tearing, pale as mathematical formulae; the first 'patterns' made of calico and canvas. And, like these formulae, they were crucial, precise and strict; so that, progressing from the stage of the search for 'form' (Nadezhda Petrovna never used the word 'cut' when speaking of a garment), like a butterfly between the chrysalis stage and the sheen of a winged being – they were then realised in the muted bass of velvet, or playful tints of lamé, or the heavy chords of golden brocade. Material is repinned, reshaped, recut and rearranged endlessly, and before your very eyes costumes revert to fronts, backs, sleeves and collars before joining up again in a new, glorious nuance of the whole . . .

Who will describe you? Who will recount these tiring and intoxicating hours?

When the rough outline of an idea or the whimsical line of a sketch becomes a three-dimensional, sculptured costume beneath the precise strokes of the steel jaws of scissors, the experienced touch of an iron, armies of safety pins and the lines of thread and, above all, plastic talent?

Balzac loved to call his heroes like that: 'this Venus at the counter', 'this Frans Hals among restorers', 'this Benvenuto Cellini among gourmets', 'this Salvator Rosa of the accounts department'.[46]

If he had met the old folk Raizman and Lamanova, Balzac would have recalled Michelangelo, Titian and Callot,[47] so precise is the moulding of their costume, so strikingly balanced are they in their picturesque bulk, so eloquently does every least line speak of the desired form of its bearer. For these craftsmen do not only clothe the figures of those lucky enough to be handled

by them.

They create and recreate his image, correct any defects, remove what is anomalous, or, having picked it up, they do not tone it down but elevate it artistically to the most perfect image of character. Which was precisely why Lamanova had so long ago deserted 'secular' for theatrical tailoring, where there was even more room for the play of the emphasised, or carefully hidden, features of an individual than there was in the comedy of salons and drawing rooms.

Which is why, when suddenly encountering historical costume, the late Yakov Ilyich was so carried away by cutting them up and stitching them.

Once I needed some padding, for a pot-bellied boyar. Should I take this to Yakov Ilyich? You should have seen his delight when I resolved to turn to him with this request.

'Come back tomorrow. I'll have it ready!'

The next day, I squeezed between the bricks and the clay, the irons, and the fine spray being expelled with a characteristic sound in a watery cloud from puffed cheeks on to material; through the ceaseless, penetrating disputes of the Lvov tailoring workshop, which fate had also brought here, and into Yakov Ilyich's sanctuary.

In the corner stood a terrifying nude: terrifying because he was absolutely alive. Fat. Pot-bellied. And ... headless. The padding had been affixed to a dummy. I have never seen a spectacle more terrifying than the naked naturalism of the boyar's exposed belly, protruding above his skinny legs. It looked pink, sleek, and seemed to breathe, to heave. The ironic naturalism here echoed the ecstatic naturalism of the suffering Christs of Western Catholicism. The torn wounds. The skin scraped off the bars of ribs through which you could see the heart, swimming in blood. Real female hair, falling in Christ's locks from under the crown of thorns. Glassy eyes. They sink into your awareness from the dark recesses of empty churches in Spain or Mexico, and like a monstrous phantom follow you for hours on end, so that you wander across town squares and down empty streets in the full heat of the sun. But there was wax, paint, hair, and the odd tooth behind the half-opened, baked lips, and glass eyeballs.

In Yakov Ilyich's work, there was only the form, only the line of the sweep of the monstrous calico belly. It was pure bulk, stuffed with cheap cotton wool. Oh, and two straps, so that this piece of equipment could be borne upon a living person's shoulders.

In the other corner of the room was Yakov Ilyich, his laugh turning into a hacking cough.

It was, it turned out, a portrait.

Yakov Ilyich had remembered 'a former client'.

And that was in ... 1911!

The client had been a merchant.

And he was just as 'pot-bellied' as the boyar I wanted and whom I had briefed Yakov Ilyich about, using some patterns that were no longer in use. What a memory! What mastery of anatomy! To realise such a deformity in life was worthy of the series of Parisian bathhouses of that immortal lithographer – Daumier![48]

Volsky[49]

It would be wrong to think that only the archpriest Avvakum was capable of calls to self-immolation in the name of an idea.[50]

It would be misguided to think that only bearded Dositheuses, in their society of Old Believers, are capable of setting themselves on fire in their decorative huts, on opera house stages in the last act of *Khovanshchina*.[51]

A Russian can do this even if he has no beard.

And much later than the epochs close to what used to be called the Time of Troubles.[52]

A brilliant pianist.

A performer.

With the most acute hearing.

And that particular sensitivity that penetrates to the core of musical form and the spirit of the work being performed, which typifies only the most delicate of performers.

He could not fail to admire Rachmaninov.[53]

He could only admire him fanatically.

But fate, like a pitiless knife, cut the composer off from his homeland.

Only towards the end of his life did his homeland and his blood call the prodigal son to a reconciliation with his homeland.

And his homeland forgave her son, the genius, for his passing folly, for his temporary departure.

And preserves his name among the ranks of its glorious children with the kind word of blessed memory.

But during his lifetime there had been conflict.

A rupture.

And I remember the drama – no, the tragedy – of the young virtuoso pianist at that moment when the idol had become eclipsed, when the idol was in an orbit of hostile forces, when the idol was torn from its worshipper by an inexorable social contradiction.

There are moments in your life when you lower your hands.

There are times when your hands hang limply.

There are times when your hands fail you.

And the most tragic moment is when you reject your hands.

And sometimes, to reject your hands is to reject your whole way of life.

When a virtuoso pianist rejects his hands, he is not only abandoning his profession: he is striking out the whole outline of the future he once mapped out for himself.

Which was how the hands of our pianist were rejected – out of principle – taking great offence at the change of idols.

So the social tragedy of Rachmaninov's temporary departure from us became the personal tragedy of Boris Volsky, the pianist who rejected the path of a virtuoso.

So the world of music lost Volsky the pianist.

But the ever popular law of the conservation of energy obtained here too: the world of cinema acquired an invaluable sound recordist.[54]

The Ant and the Grasshopper [55]

An unwritten page from Ovid's *Metamorphoses*.

An ant which became a human.

I think that if an ant became a human, it would be bound to be an utterly ghastly person.

Blinkered.

Without any outlook.*

Travelling down well-worn paths.

Only following where others have gone before.

Acting with monstrous rigour when encountering a moral problem.

Fable writers were very subtle, making the economical ant the partner of the glamorous grasshopper.

It was always the grasshopper who lost in the comparison.

And yet how much more dangerous is the appearance of the ant – righteous, faithfully fulfilling truisms and nauseatingly virtuous in its works.

Do not smoke ... Do not spit. Do not drink water without boiling it first. Get off in the middle of the bus.

Get in at the back.

Never cross roads except at street corners.

Take not so much as one step away from the law that has been laid down in the name of orderliness.

There must be not one breach of the rules to take a flight of fancy.

Virtue is its own reward.

People of this type are a menace at production conferences.

A plague at open meetings of business and social organisations.

Heaven forbid that they should be present among the people's courts, or sit on the jury.

But, nonetheless, they inevitably turn up sitting on review commissions, and in people's courts.

Those armies of inspired women, who used hammers to smash Satan as represented by bottles of wine, in the drinking establishments of America, before the victory of Prohibition, are their geographically distant relatives.[56]

And the worst thing about them, of course, is their righteousness. Their inhuman, formal righteousness.

Nothing is more ghastly, alien and inhuman than the image of the absolutely, formally correct person, the embodiment of every virtue, the knights who fight for the letter of the law without fear or reproach...

To live with such a person, the embodiment of an ant, would make you weep.

But there is really no need to live with him. And what makes someone difficult to tolerate and live with may be irreplaceable qualities in a colleague at work.

After all, there are worse things than that.

Eugène Sue took the seven deadly sins and dashed off seven novels.[57] And all the novels were constructed on a wild outburst of each of the sins, which became the basis for the triumph of good over evil.

*In English in the original.

If it were not for Comtesse X's devotion to vanity, or Mr Y's devotion to gluttony, or the adulterous Monsieur Z, not half the blessings described on the pages of the respective stories would have happened.

If this is the case with the seven deadly sins, then this is all the more possible here.

Here, where we are talking of the seven deadly virtues!*

One way or another, Fira Tobak's[58] small, fragile body embodied all the vices of an ant-person that had miraculously been transformed into the virtues of a montage specialist.

Even her size.

Even her ability to drag, from floor to floor, cans of film, which sometimes towered above her in a pile.

Her moral rigour here, among the film cans, manifested itself as a painstaking system for rationally storing the 'cuts' separately from the 'ends', and them both apart from the systematised 'out-takes'.

Pedantry, which is normally intolerable, here enabled me to produce, like a rabbit from a conjuror's hat, as if by waving a magic wand, the very piece of film that I needed, at a moment's notice, from the chaotic lengths of film which had coiled themselves up into knots and lurked like snakes.

The well-trodden paths of a routine way of thinking ensure the systematisation of all these myriad elements of montage fragments that huddled in the round cupboards and rectangular drawers by the wall cupboards.

'Any piece at a moment's notice!' This was no empty phrase or idle boast: it was a terrifying whip, constantly poised to strike the editor who had the misfortune to work with the director – like the person whom malign forces pitched against the small defenceless Shrew – Fira.

It takes a phenomenal memory to be able instantly to picture where and when a section of sound-recording tape with the opening bars of a particular musical passage was placed; the direction the head was facing in the section of film with one of the minor characters that was taken from the material for Part One.

Will a long-since spoiled take, the part where the actor has stopped acting, but has by chance been caught at the right angle, fit, in terms of size? All this, in an atmosphere of wild impatience, angry spluttering and venomous interjections, if the right can is not found instantly or, worse, your memory or quick-wittedness plays tricks on you!

Fira Tobak had a tough time of it!

But the features of an ant's habits, down to the rare, retaliatory spray of formic acid, sustain her in this hard and thankless task.

'Any piece at a moment's notice!' – this motto above the army of tin cans was upheld by the harmful characteristics of the ant-woman, which had become a blessing to the editor-man.

But it is not for that alone that I tolerated the bad temper of the shortest and most valuable of my comrades these past eleven years.

*I do not remember where and who first gave this disrespectful appellation for human values. Perhaps it was like the sign outside the inn in Paris, opposite the Père Lachaise cemetery: 'Au Repos des vivants' [For the Repose of the Living]. (E's note)

The director, with whom Tobak worked, proclaimed a very long time ago a suspect programme for mathematical calculation in films, calculation that was just as strict and *a priori* as that used in the models of bridges or in earlier plans for working machinery.

Proclaimed at a time of widespread fascination for machinery, for urbanism, Constructivism and engineering, these programmatic slogans are still believed.

And because people believed in them, they almost immediately began to attack this principle of engineering, machinery and Constructivism, which you could see in every creative phenomenon of its champion.

His works contained dispassionate calculation, dry mathematical preconceptions, the angular sides of a construction, projecting through the fabric of living action.

It occurred to many to doubt the programmatic points of his theses.

But, for some reason, nobody doubted the devotion of the author of the theses to ... the theses themselves.

He aired them and put his name to them so frequently, so emphatically and so stridently ...

Valya Kuznetsova[59]

Her strange manner during conversation of stopping in mid-word and staring with wide-open eyes, slightly agape.

I expect that harpies, sphinxes and other evil spirits of antiquity let their gaze come to rest like that, lighting on a victim and paralysing it with their stare. You turn away.

That is how it is.

A strange, lanky figure comes into Valya's field of vision.

I could almost swear that when Valya Kuznetsova's gaze came to rest, there was the click of a shutter.

The profile was committed to memory. The profile was allotted a number and registered in her memory.

Then the eye came back to life, began to swivel, and Valya triumphantly exclaimed that this strange profile was 'the spitting image of von Paulus'.[60]

Valya's brain was full to bursting with similar ghosts of 'doubles'.

Sometimes these are doubles of well-known people: Paulus has three doubles, Göring has five, Mendeleyev one, Chkalov two (one has a somewhat uneven lower jaw), Repin one (and not only in profile!), and as many Gogols and Lermontovs as you could ask for.[61]

Sometimes there are anonymous 'types': courtiers. Knights. Archers. Ladies. Executioners. Monks.

Blacksmiths. Jesters. Chinamen.

True, there was one occasion when this wily Valya tried to 'palm off' on me an Estonian with a false moustache as a Chinaman in *Alexander Nevsky*, before I had driven her to find a real one – a professor of Chinese – to play the ambassador of the Golden Horde. But this was when we had only just met. And it was never repeated.

There is a complex card system in Hollywood, and an Americanised card-index directory for this very purpose.

In Potylikha there are relatively disorganised heaps of notes, descriptions and yellowing photographs.

Valya carries her version of Scotland Yard in her head.

She knows the addresses of some odd people who are unnaturally tall; she has sought out some lairs, wherein shelter some particularly ominous old women; she knows where the rag-and-bone man lives, with the head of a bald, sixteenth-century saint, as well as the precise address of a modest accountant who would do for the part of a cripple.

But her passion is for doubles.

Doubles of actors from other cities whom frequently one cannot easily get hold of; doubles of famous portraits; and finally, doubles of doubles on the off chance that the double too is unavailable somewhere...

Lukina[62]
Orchestra. Choir.

Choir! Orchestra!

This sounds like something integral, organic. Like something indivisibly corporeal.

Like Ivan, Peter, a cathedral, a bridge or a monument.

It would be more accurate to call this an anthill.

There were so many ambitions, individuals, insults, personal interests, extra-musical concerns, routine relations, human fates and lives that merged together, at different times, in the magical moments of performing music.

There was then an organism. A body. More than that: a single collective soul.

For the rest of the time it was chaotic.

No two people are alike. No two people act in the same way.

You feel sometimes that the instrument is growing into the person who plays it. Isn't that my old friend Yuriev playing on the trumpet?

Surely his laughter, jokes, boasts, and the witty remarks to the gallery that so alarm everyone around, bellow in the same mad way as his unique trumpet, which so pitilessly but brilliantly destroys the massive fabric of sound made by the other instruments in the overture to *Ivan*?

And surely Iosif Frantsevich Gertovich, with his profound humanity and his musical temperament, is a part of those tragically wailing passages of melody, where the double basses dominate, in Prokofiev's amazing music for the scene of Ivan's illness?

All these people are joined together in one orchestra.

Not the orchestra, but the people.

And before they can all be merged in collective action, guided by the conductor's magic wand, they have to be assembled, contracted for and, often, persuaded.

An individuality bristles with anarchy – it resents merging.

Firmness of character and tactful handling, the melodic flow of persuasion and the staccato of a strict 'call to order' are all necessary if this whole mass of separate units, whose creativity forms the collective creator – orchestra, choir – is to be brought together into a single counterpoint.

I think that the hands of Lukina, a brilliant musician, never ceased from

their virtuoso run on the keyboard, while she drew together the various members of the orchestra with infinite tact and yet with a will of iron, and interwove the choir with the orchestra, and both of them with the microphone, and the performers of the work with those who committed it forever to film; the conductor with the sound recordist, the composer with those who performed his work; and finally all of these with the director, highly wrought and nervy, impossible to please and naggingly demanding to the point of whimsy, tortured each second as even his own final ideas are merged with the elements of music and depiction. With the same skill and lightness of touch she managed to capture the desired nuance of the director's conception and to rephrase it – to think it through and to complete it – for his army of musicians, 'using their language', a series of images from their imaginations. While the director, who was not a musician and did not even have the most elementary musical 'jargon' at his fingertips, incoherently and with irritating imprecision descriptively mumbled an 'artistic instruction'.

32. From Lectures on Music and Colour in *Ivan The Terrible*[63]

... You tell the composer, who is to write the music for your film, what he must base his composition on. A really great composer may not discuss it with you at all, but will reply: 'I understand everything myself.' Avoid composers of that sort. But there are marvellous composers who say: 'Tell me exactly how much you want, and of what.' These are exasperating!... Have you read the script for *Ivan the Terrible*? There is a song about a beaver. Prokofiev wrote the score to a written text. I will tell you how this happened.

There were some lines of text and I felt it was important that these lines should be accompanied by music that perfectly matched the actress's emotional state and performance. The song could have been neutrally written, for the actress to perform it with a particular subtext; that is, thinking in a precise way what she was singing about. I was more interested in a different approach. I wanted the thought of the singer to be expressed first in the orchestra, then in her voice.

> Washing in the icy stream
> Of the Moscow River,
> Black of fur, swam a beaver
> Washing all the mud away.
> Then off it went, all clean, uphill;
> It climbed the towering hill.
> It dried itself, shook itself,
> And looked around, turned its head –
> Was someone coming, hunting?

These words were taken from a folk song. There are several variations of it. I found it for the scene where Yevfrosinia Staritskaya sings Vladimir a lullaby. I imagined that, if the old woman were singing this song, then the black beaver and the towering hill would be associated with her deepest thoughts. She was upset that Ivan was on the throne and she had to persuade her son to take his place. These neutral words would stir up within her associations with Ivan.

I told Sergei Sergeyevich [Prokofiev] my intention, and asked if he could do that for me.

As the song begins, you can hear the folk melody. 'The Beaver' – the same one. But when it comes to 'black of fur', that is where the first frisson

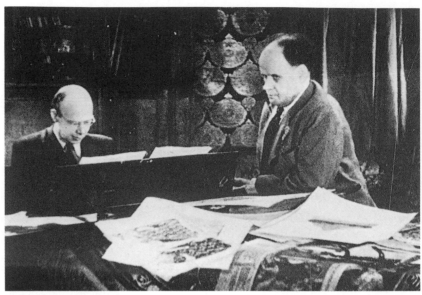

Eisenstein and Prokofiev.

should be felt. Sergei Sergeyevich asked, 'Where do you need this frisson?' 'On the word "black".' Later I said, 'Between the lines, when Yevfrosinia first feels afraid of the Tsar, so that it seems to be in her head.' Sergei Sergeyevich asked, 'And for how long will it be in her head?' And I replied, 'This long.'

'Washing all the mud away' – on these words, Yevfrosinia is overcome by hatred, and she forgets to sing this part. There are colloquial words in the music here, and these are not sung.

'Then off it went, all clean, uphill; it climbed the towering hill.' This reprises the theme of the coronation. This is a moment of elevation. Sergei Sergeyevich asked, 'How much of an accent do you need on "towering"?'

'This much,' I answered.

Further: 'It dried itself, shook itself, and looked around, turned its head.' I asked for this part to be treated as a Russian dance. And in that part of the song the old lady is terribly evil.

That was how the whole mood was developed musically in its psychological subtext. And when Yevfrosinia sings, and the music echoes her with unbelievable force, and when additionally the orchestra plays Ivan's theme, the effect of this piece is instantly horrifying.

And that is how a rhythmical drawing should be given to a composer.

'It dried itself, shook itself, and looked around, turned its head' – this moment does not have to turn into a staccato dance. But it is here that the old lady's intonation is very good. So what, you could say: he is still on the throne, settling scores. . . . But if this music was not for this moment, then you could treat these words fluidly.

'Was someone coming, hunting?' This line has to sound out. 'The hunters whistle, seeking a black beaver' – now the theme is of hunting. I asked Sergei Sergeyevich to make this part 'Wagnerian'.

'They want to kill and skin the beaver, for a fox fur trimmed with beaver.' These words convey the theme of Ivan's murder. Traditionally, the last line reads: '. . . for a gift for someone.' It is a ceremonial song. We therefore had 'as a cloak for Tsar Volodimir'.

The words 'for a fox fur trimmed with beaver' begin with that same intonation as the start of the song. It is most horrifying when Staritskaya whispers these words in Vladimir's ear, hunched right over him, as though it were a mere lullaby. He slowly wakes and begins to understand what the point of it is. And when she starts to wail, 'as a cloak for Tsar Volodimir', it becomes clear to him that he must murder Ivan. Then he begins to wail uncontrollably: this is picked up by the choir.

And so, at the end of the song, comes the return to the lullaby motif, which is then broken by a shout, the abrupt end of the song and terrifying chords. And Yevfrosinia starts shouting, 'I could endure the agonies of birth a hundred times over for you!'

This is how it happened, in a relatively *recherché* case. But in principle, each scene does and should have the same rhythmical structure. Where you set action to music or song, you lead it towards a purely musical resolution. Where this is not done directly through the music, there must be an inner, musical sketch.

When I worked with him, Sergei Sergeyevich always asked that his task be laid down as precisely as possible, and the more complex that task was, the more rigid its parameters and the more enthusiastically did he work. Such tasks gave him a genuine basis on which to begin work.

When objects on stage have been placed there earlier, you can no longer act 'however you like', but instead you construct your action to take account of these objects. It is hardest of all to work on an empty stage: then you have no element on which you can rely. You set yourself an artificial focus for movement – a place that serves as an anchor.

It is just the same when I work with an actor. He takes this rigid framework as his foundation, on which he develops his own personal understanding. When you say, 'There must be a dance motif here', then this apparently says everything. But here there could be anything at all; that is to say, the range here is all-encompassing, but it has certain limitations. It is very bad if an actor who has reached an agreement with the director about the outline of the role, only performs it satisfactorily. The actor must know how to invest it with all his emotional resources, so that the rhythm and spatial outline can be not merely observed, but filled with a plenitude of emotions.

. . . Just as Prokofiev liked composing for a very precise theme, and this fascinated him and was one of his particular strengths, this must also hold for actors. It is exactly the same for stage designers as well. Suppose that you have to give the set designer a plan of what you need, with an approximate setting. There we need a platform, here a flight of steps, and so on. A good set designer uses this as his foundation. You must never constrict his artistic imagination – how the steps will look, how they will join the colonnade, the style of the windows, and what will be behind them. This he must be left to do. In this regard, you can follow Meyerhold's example when he worked with the designer Golovin, on the set of *Masquerade*.[64] Using the precise *mise-en-*

319

scène of the director, the sets produced were unrivalled. But, when Meyerhold worked with a lesser designer on *La Dame aux camélias*, it transpired that the plan, as set out by the director, was still plainly visible – the designer had done no more than colour it in.[65] In cases such as these the director has either to go beyond the limits of the creative meaning that is his territory, or be content with a set of this kind. When you deal with an eminent designer, you can pose any problem. He will be as 'bound' by it as the director is 'bound' by plot and situation. In these the director senses an anchor. Which is why I have always written scripts for myself, although I cannot stand writing 'to myself'. . . .

Prokofiev had a striking talent for creating images in music. And I do not mean by this that he did so as an illustrator. How would a pedestrian composer write the music for an autumn landscape? He would take the rustle of leaves, then a light breeze would pick up, and blow about. But Prokofiev had first and foremost a very sophisticated perception of the visual image. The different shades of colour would also play a role in his transcription into musical imagery. Any composer can translate the rustle of leaves into his music. But to translate the rhythm of a shot's yellow tone into the accompanying musical tone takes talent. Prokofiev was amazingly adept at this.

I remember how he wrote the song 'Ocean Sea, Sea so Blue', which did not make it into the film. When it was being recorded with the orchestra, he used to say, 'Now that is the sea's depth you can hear, that is a splash, those are the waves, and that is the bottom.' But this does not happen all at once, and the whole orchestra does not do this at the same time. There are extraordinarily complicated, different passages, and the result is a collective image of the ocean. Some sounds evoke the sense of depth, or the feeling of a tempest . . . That is how we act when we film various objects from different points. You do not film a fortress, say, just from 'head-on'. You give it a turret, drawbridges, a moat, and from the combination of the different shot angles the result is an impression of a fortress. That is how Prokofiev worked in music. If the entire orchestra played only 'the depth', or only 'the blueness', the music would be comparable to filming from one angle: it would convey information, not emotion.

Whichever area of work we choose, they literally all meet up in our working method.

. . . Suppose that Prokofiev's music is difficult for an ordinary dance. Its range of application is different from that of Tchaikovsky, which seems to have been devised to make you move to it. Prokofiev's music is strikingly well suited to montage movement. As far as the rhythm of moving arms or legs is concerned, it is very difficult. When Prokofiev himself dances, he always treads on his partner's toes. He is so used to expanding a rhythm that he finds a normal, ordinary human rhythm difficult and his feet cannot manage it.

I understand something of rhythm, to judge from my films. But when I joined Meyerhold's directing workshops, I failed the part on rhythm.[66] All my marks in this subject were unsatisfactory. My work is on a different element of rhythm. Rhythmic gymnastics, which I failed, should properly have been called metrics.[67] This is not a living rhythm, which approaches regularity, but the tap of a metronome.

The same thing happened with dance. When I learned how to dance, I could not grasp certain figure-dances at all, and I was wildly delighted when the foxtrot appeared, where you can move however you like according to the sense of the music rather than the various steps.

There are the same distinctions in montage too. There is montage built on a uniform sense of rhythmical movement; and montage built on metrical relationships.[68] I do not know anything about the metrical length of the montage fragments in my constructions. These fragments come not by the metre, but by the feeling. I never check by calculation. But if you take Pudovkin, he has always used a metre rule, and he still does. On many an occasion, if there was any unused piece of film left, he could always determine precisely its place in the edited film. But he can also unite the metrical and rhythmical passages. Dziga Vertov also uses a typical, metric montage.

I do not mean that this method is flawed, but it is not organic. For no absolute measure for length exists: so much depends on the content within the frame. Whether a section is filmed in close-up or medium shot, or whether it is the third time that it appears in the montage – all these influence the length. There is no single gauge for length. Does this mean that you need to multiply the internal 'mass' of a section by the length of time it is to be seen? But this is a purely 'physical' method. And why do that, when you can sense it? You need to cultivate an internal sense of rhythm. In that way, you obtain precise rules of measurement.

... I was saying that Prokofiev liked a rigid montage framework in which to project his fantasy. But when working with a composer, the converse may be true, when you need to edit, using a finished piece of recorded music. Here it is essential to adjust the pieces of filmed material, which must be carefully examined to see that they match exactly the beats in the music. This is an awful job. You have to observe all the laws of plastic connection between the fragments, taking into account both the informational and the purely plastic aspects. All of this must be projected on to pre-recorded music. Sometimes you can just insert the pieces, but at crucial moments you can do next to nothing. If you do not work on the metrical relationships between depiction and music, that is, if there is no primitive, direct relationship between the musical and the visual accents, between the 'lines' of music and the montage segments of expression, that makes it doubly difficult. In this respect, work on the colour sections of *Ivan the Terrible* was very complex. The music for the dance of the *oprichniki* was commissioned earlier; it was filmed with that music and then edited.

I was talking about the external and primitive metrical correspondence between music and depiction; and about the more complex rhythmical correspondence. But the most splendid approach is the melodic approach – that is the most splendid correspondence.

In this sense, Disney is a unique master of the cartoon film.[69] Nobody else has managed to make the movement of a drawing's outline conform to the melody. In this Disney is inimitable. But when he made the transition to colour, it seemed he could not make it 'work' musically, even in *Bambi* [USA, 1942]. True, I have not studied his *Fantasia* [USA, 1940] in this sense. But in other works he failed to make a 'colour melody' to ensure that there was

not only an emotional correspondence between the colour and the music, but a precisely formulated musical correspondence. But that is the second stage, when colour is connected not so much to the melody as to the orchestral hues.

When you handle this whole range, when you make a colour film, it is as complex as hell. You have to handle extraordinarily large numbers of correspondences. But why should it be any easier for you than for the general who has to deploy infantry, artillery, tanks and transport? The most brilliant and intelligent strategy is built on a combination of different weaponry, on the relationship between the various types of forces in action. Which is why any respectable director must also know how to be a 'general'.

The trouble with colour cinema is that colour cannot meet expressive demands. If there are no demands for expressiveness in colour, then there are no parameters to support you. And there must be expressive movement of colour – it is very difficult, but necessary.

★ ★ ★

In the last lecture I spoke about music and how movement and action translate into a musical construction.

In this study, we saw that music demands to be set free from the purely routine and to transpose the theme on to a somewhat different plane, a somewhat different dimension.

Then in the example of the song about the beaver, we investigated how various sections of music are written, and so apparently you now have a full idea of how you tackle work with music.

Could you pick out the actual secret of the process? How the shift into music occurred, when we were doing this exercise?

That is the most important thing: not so much knowing about it, as feeling, because it will be the same thing in all the most serious cases.

When making a montage construction, you must also assemble and disassemble the segments, combining them until you reach the point where the combination 'begins to sing out' because, while you are merely using montage to explore the consistency of plot and the consistency of the various segments, you are doing nothing that could be termed 'artistic'. This is purely an informational report. But when the combination of sections starts to attain the regularity of a musical construct, you have the germ of what you need.

What is important to me is that you also understand that this same process applies to work on colour film. The most serious thing is to understand what makes 'music in colour' distinct from the ordinary colouring of a work.

Suppose that you have black, blue and red – for the colouring of costumes, furniture, and so on. What is important when you start handling colour film is that the themes of black, blue and red should become independent expressive themes. The real black polish of boots could be elevated to the meaning of blackness, which you are using in this case as a tragic colouring.

You have to know how to arrange things so that the blue colour of wallpaper or furniture upholstery does not remain merely the colour of wallpaper

or furniture upholstery, but that, whenever necessary, it should have its own emotional value, connected with a precise idea.

Colours are perceived very individually. Red evokes certain associations in some people, different ones in others.

Suppose that, for me, red was associated with certain revolutionary ideals and notions. Since their youth, people have been accustomed to red at festivities and demonstrations. But take another 'sector' where red drives a bull – or, equally, Churchill – mad. There are psychological predispositions at work there too.

There are more or less common facts about colours. Black is connected with darkness, night, cold and, like it or not, it evokes negative feelings. Since childhood, blue has for us been associated with the sky, fresh air, and with a whole number of accepted things, and it has a certain psychological effect. Yellow and gold are associated with sunlight and warmth. This does not mean that there is a catalogue of colours which invariably act in a certain way. Far from it.

It is also the case that different countries have different notions of colour. For example, white here is not associated with grief, whereas for the Chinese it is the colour of mourning.

What matters is that you have a conception of a coloured object, or a number of coloured objects, as a sense of the colour as a whole; this sense of colour can then be interpreted emotionally in its own way.

There is no difference at all between working with colour and with music. Once you have understood how you should treat the musical resolution, you have laid the groundwork for handling colour too. Because music in sound film begins at the point where the usual pairing of sound and image gives way to an arbitrary unity of sound and depiction; that is, when actual synchronisation ceases to exist. As long as the depiction of a boot is linked to the sound of a violin, then it can have no relationship to the creative process, but when the violin is separated from the boot, and rests on the face of the person speaking, that is when your action starts: there is something that you want to express. Ordinary synchronisation is done away with and you combine sound and image in the way that your creative intention suggests.

Almost the same thing happens with montage too. Essentially, as long as you simply film the whole scene just as it happens and in sequence, there is no artistic involvement with what you see. But when you begin to film using montage, you marry your understanding of the reality that you are filming to the sequence, to the change in scales, to the accentuation. A person filmed in long shot is generally just a person. But what do you do if you want to characterise him using montage? You define his features and show these details in a certain sequence. Suppose you show him groomed, powdered and so on, with an unbelievably 'luxurious' Lvov or Białystok hat and a German dust-coat over his arm. You thereby create a specific impression. Or show that his trousers are tattered and his shirt is badly worn. His character will be shown by a second series of details. This is where your dramatic presentation of the man starts. You reveal his character by the sequential portrayal of these things. If these details are thrown up by chance, and not sequentially, the impression of revelation is lost. That is, you take apart and put together the

usual pairing of elements in the way you think necessary.

This is done more easily in music, because sound goes by one route, and image by another. They might coincide, or they might not.

It will be harder with colour, because the colour is inherent in the object, and you cannot separate the two as you can sound. Therefore the filming requires a much greater sense of forethought.

For the moment, remember the rule: you take apart an existing link, and creatively try out various combinations. Always remember the violin for the shoes or boots. This is the original formula by which you may be guided.

I now want to finish what we embarked upon last time, regarding the feeling of music and dance, and then say a few words about rhythm.

By rhythm we mean a temporal correspondence between the different parts. Is that clear? Any questions?

From the floor: Just as in music there is a common plan, and a secondary one, which exists alongside the music, that must somehow correspond to the colour resolution. Now colour is resolved completely head-on. Even the attempt to achieve a colour resolution is primarily a question of colour. So it looks as though this is also one of the forms of musical connection.

Eisenstein: Right. Just as theme and accompaniment work in music. In contemporary music they often change places, the theme becoming the accompaniment. But the fundamental feature of course is that it works on two levels.

There is also polyphonic montage in colour. There is a line of colours, one black, one blue, and so on; there will be this second stage. I want you to understand for the present that what is relevant is not that there is a blue shirt in one episode, but that a blue shirt is, apart from that, also a definite blue sound among the colours;[70] that it is not only a manufactured item, but a perfectly defined complex of sounds. Since you have chosen a blue shirt, it is bound to influence the colour solution of the other elements. But the most that colour cinema is capable of at present is every now and then in one frame to make the other shirts not too dazzling. But to make three quarters blue, and one quarter gold – this has not yet been done – is difficult. Another reason for not doing it is that there is no thematic interpretation for blue and gold.

If you are not trying to resolve a dramatic problem using blue, be it a problem of expression or of content, then why increase or decrease the amount of blue? If it does not have any meaning, say, for the accumulation of blue sounds, which drown the gold sounds, if there is no connection here between the two, then there is no point in doing it.

Again, 'a little spot of music, for its own sake' is of no use to us. Music is fine in a film, when it has a dramatic function. It does not mean that it must repeat directly what the actor is doing. Imagine that the actor is angry. Does that mean that the orchestral music must be angry too? But what is possible and what is essential here?

Music is acting by other means.

You can see this in the example of the 'Lullaby'. The theme of Ivan is introduced on the word 'black'. This is not bound to happen because of the

actual lullaby, but because Serafima Germanovna Birman had to think that she was singing about Ivan when she reached the word 'black'. Without this, the lullaby would remain just a lullaby.

The music can be written when it has something to say – otherwise the music will have no dramatic progression. And you have to develop this feeling inside you.

You must know why you clothe someone in a red, blue or green shirt. What notions guide you when you clothe one person in dark fabrics and another in brighter tones. I am not saying that young people should wear red and older ones lilac. Lilac and silver give a sense of funereal splendour, while gold and blue create a more carnival mood. Again, I am not saying that if you need some festivity, then people should dress up in blue and gold. If you film a contemporary picture, and the hero is in the military, then he will be dressed in khaki and you cannot dress him in blue or show close-ups of his epaulettes.

Out of all the interesting colour combinations, you may find the one that in a specific case 'fastens on' to a specific theme.

The next point is very interesting too. When you make a film, you familiarise the viewer with a precise colour range that you use to convey a precise meaning. White cannot be termed the colour of a bad guy. Rather, white is associated with innocence. Yet in *Alexander Nevsky*, the enemy is wearing white. If you recall the episode in Pskov showing the knights – in that episode their white clothing is associated with brutality, with annihilation, burning; that is, what might be termed a conditioned reflex is developed. People in white robes are juxtaposed with all kinds of repugnant actions. And then when you see a white cloak isolated from these details, it will still be associated with evil. You reach an agreement with the viewer and instil in him what you need to, precisely by associating a feeling with this colour. 'Educational work' of this nature – bringing the viewer to the necessary understanding – must be done during the prologue. This corresponds to the exposition of the characters provided in the first act.

From the floor: When you were working with colour in *Ivan the Terrible*, did you ever find that you had somehow to link the colour resolution with the musical resolution on the same level? Suppose, for example, that in the colour resolution there were highly contrasting spots of red, white and black, and they perhaps moved very jerkily. Did there have to be any sort of link with this in the musical resolution? Was the music also full of contrast, jerky and moving around a lot, or was it the reverse: very fluid, soft and understated music, by way of contrast?

Eisenstein: I found this much less often. I personally think that our black-and-white cinema...[71] and so there is no special difference during the transition from the one to the other. There you work with a more limited palette, which forces you to move in extraordinarily precise...[72] They are harder to handle. With the transition to colour, the range of colours expands and the number of possibilities becomes much greater. With an abrupt, rhythmic drawing, when the music is really hammering it out, you can cut sections according to the rhythm of the music. They will coincide. In the film *October* there is the

lezghinka episode.[73] The 'Wild Division' is approaching Petrograd. They are met by workers' organisations, and they fraternise. The Petrograd lot do a Russian dance, and the 'Wild Division' respond with a *lezghinka*. Two rhythms meet. There the accumulation of montage was driven by the rhythm of the *lezghinka*. There was a precise coincidence. But it could have been done quite differently. You could cut a section for each musical accent, and add a new section with each beat. Or you could have a long section of conversation, accompanied by this chopped-up rhythm.

This also works with colour.

In the colour scene in *Ivan the Terrible*, the beginning of the dance was resolved with sections following musical accents; then comes a long section of conversation between Ivan the Terrible and Vladimir Andreyevich (the half-lyrical theme of the conversation) with the same music, which is then repeated. There you can separate the colour correspondence between the music and the coloration of the scene completely; and in the other part, you find almost pure, almost abstract spots. Each frame has been made almost black and white. You see the turn of gold brocade on the sleeve. The next turn is the red sleeve, the next is a hop. A splash of colour, a dance of spots.

Suppose it is a dance scene. At first all the colour themes are tied up in a knot. Then the red theme is gradually teased out, then the black, then the blue. What counts is that they are torn away from their original association with an object. Suppose that the red theme begins with a red sleeve; it is repeated with the red background of candles; when Vladimir Andreyevich goes to his death, the theme is picked up by the red carpet, which is cut up by the set and breaks off at the door. You need to distance yourself from the various red objects, take their overall redness and combine the objects according to their common feature. The Tsar's red shirt also works there in its hue in a certain section.

I wanted there to be red drops of blood in the black-and-white part, after the murder of Vladimir Andreyevich; but Fira Tobak would not have it, saying that would be Formalism.[74]

The theme of gold is associated with the crown of saints and Vladimir being dressed in golden robes.

The theme of black is the most interesting in this respect. It is here associated with death, appearing at first only in minor details, almost dividing the red from the gold. But what happens just before death steals up on Vladimir Andreyevich? Here there is already a premonition of death. Before dawn, people go to pray at matins. They wear their ceremonial golden robes. Gradually monks' habits move towards the gold, and the gold is swallowed up by the black.

Vladimir Andreyevich is dressed in royal robes. Up to a certain point, the Tsar wears a red shirt; thereafter, a black fur coat. Then its colour changes, to a monk's habit. The next episode, filmed in black and white, continues the 'black theme' by means of the overall expressiveness. Black and red are interwoven. The gold vanishes, and the blue vault of the sky with gold appears, as a symbol of the purpose behind everything that is happening, as the decisive atmosphere that stands higher than what has to be done.

From the floor: You said that the theme of black is the theme of death. What, then, does the red theme stand for?

Eisenstein: The red supplies an ominous theme and acts as blood. There is a retort, mentioning blood: 'You and the Tsar are of the same blood: hold this sacred.' Old Basmanov is strongly opposed to Ivan's patronage of Vladimir Andreyevich, and allows himself to intervene in the Tsar's conversation with him. This earns him the Tsar's reproof. And an argument begins, in which Basmanov tells the Tsar that it was the Tsar himself who taught him how to 'uproot your own saplings', to which Ivan replies that Vladimir is the Tsar's blood, and that does not concern him: 'You and the Tsar are of the same blood: hold this sacred.' Blood acts as a sign of kinship. Basmanov replies, 'But are you and I not bound by the – spilt – blood of another?' At these words, there is a red glow and the faces shine red. This is the first time that red appears associated with the theme of spilt blood. Thus the theme has been activated in the necessary direction.

From the floor: Can you say something about the theme of gold?

Eisenstein: It is a festive, regal theme. Frescoes of saints with haloes, golden cloaks with hues of red and orange. The royal raiment, in which Vladimir is mockingly dressed – it is not the colour that provides the mockery, but the music. The theme of the argument proceeds utterly magnificently, like a war theme, an *oprichnik* theme. Then it undergoes an ironic change; that is, the musical imagery is repeated in a mocking resolution: the fourth couplet has no words and the Russian theme is resolved with three saxophones. Thus the gold is stripped off musically, not visually. The stress is placed on the area of expressiveness. Sometimes you can help with speech, and sometimes with music.

From the floor: When Vladimir falls and Yevfrosinia explodes with a shout, what theme does she convey in colour?

Eisenstein: Everything black.

From the floor: And is the transition from black to colour essential?

Eisenstein: It happens immediately, in an explosion. The tempi are reduced as much as possible, reduced to a not very intense scene when Malyuta invites Vladimir to the feast. Then there is an explosion of colour. And since there is music, there is a strong rhythmic impact. If there were no colour or music, we would still have shown the first episode in grey, and the second in black and white. There is no difference in principle as regards the rhythmic schema that was devised. You merely have a much greater potential for expressing it. In one case, you could supply this in a brief montage. Here you can do so through music. Instead of black and white, you have a chance to use different colours.

From the floor: Are the colour sections the most important, the key moments in the general plan of the picture, or did you work using a different principle?

Eisenstein: One episode, consisting of two parts, was not finished. And that led to the idea of doing it in colour. This scene could equally have been resolved in black and white. But the opportunity arose to resolve it in colour, and this motif lent itself to a richer and more detailed treatment.[75]

From the floor: There are two themes in particular. Ivan's theme, which is resolved through his psychological condition – and there is a collision and combination of frames which are of varying coloration. How did that happen?

Eisenstein: Do you know what a leitmotif is? When a sword is mentioned in Wagner's *Die Walküre*, the theme of the sword is played in the music.[76] There is a part in Act One where a sword is struck into a tree, and this sword must be pulled out at the end. And just as the hero approaches the sword, the orchestra starts playing particular elements of the theme of the sword. And at the end, when he pulls this sword out, the theme is played in its entirety. There is also a leitmotif connected with the theme of Wotan and Siegmund. When Wotan grieves over his abandonment by his father, his theme begins. The music is 'affixed' to each element. Wagner does this magnificently, but in some cases this is taken to absurd lengths. This is the expressive, characteristic theme. For colour resolutions, it would be too primitive. Something along these lines was done in the Maly Theatre.[77] There the young Basmanov wore blue, or white; Malyuta red – that is, each had his own colour. This is a particularly primitive device.

What mattered to me was not that Ivan had a red or a black resolution but that at a particular moment in the drama's progression Ivan the Terrible should be seen in a corresponding colour resolution. At first he wears a red shirt. But by the time the drama has moved to the next stage, Ivan is in another colour – black. The moments on which the colour falls are important. At first Vladimir Andreyevich is in pink and gold. When the drama starts, he begins to cross over to gold. It is not the case that each has his own colour and so goes around in it: the idea is that colour is connected to theme, not character. When theme passes through a specific character, he appears in the correct colour resolution. This is the thematic line of the process.

And how does it all happen? Take the feast: how are we going to do it? Gold robes – fine; blue shirts – fine. A fiery moment. The Tsar is almost always resolved in black. On the occasion of a feast, he must wear an opulent brocade shirt. If there were no colour, this would have to be conveyed by texture. Here are a few considerations.

What else is possible? We know that there were saints on murals, and the saints could have gold haloes; and then there are the red flames of the candles. So we have black, gold and red. You start by abstracting the routine details, deciding how to use colour to express the outlines of the characters. A fur coat will introduce an element of awe and the sense of a fatal moment. So, supplemented by the fur, the black element increases. The black needs further resolution. There are the *oprichniki* who will be dressed in black. The

growth of black first turns into a black 'cloud' and then this 'cloud' becomes a group of *oprichniki*.

The same thing with red. A magnificent red shirt was made for the Tsar, from the trousers of the Emir of Bukhara. We were able to supply red through the red carpet, the candles and fire. There was one moment when we wanted to make the Tsar's shirt black and gold. This tradition survived from black-and-white photography. We even tried to film it. The results were wrong in terms of tonality, and so we switched to red.

So there is the flame of the candle, the red shirt, the red carpet, and so on. Does red appear in this scene? Yes – the sense of blood. It grows further until red is understood as the menacing theme of murder.

We had to think what colour to make the frescoes, set and ceiling. First were the frescoes of Theophanes the Greek.[78] I travelled to Novgorod to see them. In one church there is an amazing blue vault, the saints painted in sepia against a background of absolutely pure sky-blue cobalt. This kind of light blue is at present beyond the reach of cinema. The potential for filters is very circumscribed. But we did achieve some kind of dark blue.

It is pretty successful, and is roughly what was wanted. This 'light blue option' has lodged in my memory. As soon as I added it to the overall composition, it harmonised splendidly like a pure tone. Apart from that, remember what I said about the crucial atmosphere of dark blue: it appears when the drama is reaching the end. Then a light blue background springs up.

That is how these things are 'assembled'. You have to look at this scene, bearing in mind how I conveyed the conception that I had pictured to myself. The conception is embodied in the material with maximum expressiveness. As I pictured it to myself, so too was it done. . . .

From the floor: You said of the lullaby that music corresponds to the actor's action at a particular moment. You were talking about the audiovisual combination. In the sense of an ordinary combination, it corresponded because it was a lullaby.

Eisenstein: No. The music corresponded to the moods, not to the actions; to the thoughts, not to the actions; to the subtext, not to the actions.

From the floor: You said that music corresponds to the actions of the actor at a specific moment.

Eisenstein: No. You have misunderstood: that is not what I said. The whole emphasis was on how the music worked at revealing the thoughts, and so on, at a different level – while having the outward appearance of a lullaby.

From the floor: The second level was so that the actress's thoughts could be revealed through music, and in this sense there was a correspondence between music and action. A visual image came into being. You spoke of music that handles visual associations. At a specific moment we saw Staritskaya singing a lullaby to her son. We experience the visual images that are projected on to this portrayal. We picture the music which has been composed

in a way that absolutely contradicts the emotional aims of this scene in their purely visual expression: for example, there is the scene of the murder, and the background music for this action is easy and lyrical. We picture this theoretically. This music brings visual images to our minds. These are projected on to the screen images and begin to fight them. Can musical images be so strong as to displace the images that exist on the screen, make us stop us from following the action happening on screen and start to think in music? Are there examples of this?

Eisenstein: You film a man who is sleeping, and the music supplies everything that he is dreaming about at that time, in the way that Pimen dreamed of the clash of war: the old man is asleep, and there is the rumble of war. He is asleep, and you can hear the fall of Kazan. In *The Legend of the Invisible City of Kitezh*, there is a battle at Kerzhenets, which only happens in the music – the curtain is lowered.[79] There is no action.

I can understand the Jesuitical side of your question. You ought not to picture visual sensations too primitively. For example, if Staritskaya starts thinking about Ivan during the song about the beaver, that does not mean that at that moment she *sees* Ivan. If I had to have her see Ivan in front of her at that moment, I would have used a dissolve: here is Ivan, actually present. And then I would not use music, which somehow masks the visual images, but would resort to visible images.

There are three stages: the first is when a person is materially present; the second, when the presence is achieved by a dissolve, vaguely outlined; and the third, when the presence is indicated in the music. The first version of *Ivan the Terrible* had a scene in which Kurbsky was writing a letter. I built it around Ivan's genius driving Kurbsky mad. A typical psychological feature of the 'second stage'. In one of my earliest attempts he had a complete breakdown and began to imagine Ivan. His ghost appeared and Kurbsky threw himself at it with his sword. There, I needed Ivan's real presence in the form of a ghost. [*On the board he draws Ivan's ghost appearing to Kurbsky.*] These things should be handled through montage, using several shots to convey this sense. This could equally well have been done with a well-chosen camera angle. What mattered was that the actor saw, with his own eyes . . . But what about the beaver song? At one particular moment, a shadow should fall on it. Music can convey this moment of an imperfect concreteness as well.

From the floor: In discussions about *Alexander Nevsky* and the intonation and structure of the music, the music matched the composition of the shots, the dramatic action and the emotional content too. But if the music conflicts with the events on screen, should the musical structure and the compositional structure also be in conflict?

Eisenstein: In *Alexander Nevsky* there was an outline like this. [*Draws an outline.*] The link between the music and the depiction had to be taken into account in the composition. [*Draws an outline.*] What makes *Alexander Nevsky* remarkable is that it contains the first correspondences, which it should be more complex to find. [*Draws an outline.*][80]

From the floor: What makes that sort of correspondence more complex?

Eisenstein: It rarely happens. A full unison in an orchestra almost never happens; only at very powerful or very specific moments. It is akin to symmetrical compositions, or when the speaker addresses the viewer directly. It should happen at a moment that is divorced from the rest of the situation.

If you understand the transition of motif into line, your work with music and visual representation will be the same as, for example, your work with visual representation alone. [*Draws an outline.*] Here is a person – purely representational. The music is here supplied graphically, as context. You take these motifs already present in the person and you develop a structure, and the result is a motif that corresponds harmoniously with the figure – albeit a motif without a subject. [*Draws an outline.*] Now this was an environment without a subject, something like dust, or a cloud. But this environment could have been shown differently – for example, by a conventionally resolved outline of a horse. [*Draws an outline.*] Further, the line goes all the way round the figure – in this case it is conveyed by the outline of an awesome horse. The repetition of the motif of the figure occurs at the top; there it goes laterally. Representative movement is also repeated in the musical movement. At the most crucial points, you need a congruence, so that all the means of expression work in unison. If the means of expression replicate one another, then the typicality will be lost, just as the expressiveness of the profile will be lost by encasing it with parallel lines. It is as though you are playing on just one string.

But if the outline of the depiction is repeated in the musical movement, but worked out in a complex way, as it is in Prokofiev's orchestral works, it is as well to adhere to this outline closely. The treatment then can be as complex as you like – it cannot fail to sit correctly. The basic movement has been strictly defined, leaving you free to go wherever you please in the musical treatment. But if the basic movement fails to coincide with a complex treatment, the result will be confusion.

From the floor: Music extends through time. Can you speak of music as having a beginning and an end?

Eisenstein: This device was used in *October*. First a statue was taken to pieces. Then it flew back together again. The music for the film had been written, and the orchestral score was completed. It was also done backwards: that is, there was music for the statue being taken apart, and the same musical phrases were played backwards as it flew back together.[81]

From the floor: But the composition of the shots – can we look at it from any direction? Basically we have a drawing that reads from left to right. But what happens if we start looking at it not from this side, but from the right? . . .

Eisenstein: Read my article on *Alexander Nevsky*.[82] That deals with it, and it gives a precise explanation of how and why your eye moves.

The question is whether musical movement has a determinate direction in time, and whether you can state that the eye, as it perceives the composition of a shot, also moves in a determinate direction – e.g., from left to right? Anyone care to answer?

From the floor: The eye is generally accustomed to move from left to right.

From the floor: I will attempt an answer, but I am not sure that my judgment is correct. You can make someone look from right to left.

Eisenstein: That is precisely the point, exactly as I explained in some detail in my article. The point being that a more or less normal person follows the elements as they attract him in a shot. If you follow this sequence of shots in *Alexander Nevsky*, the stress always falls on the left-hand side, except the shot of Raven Rock where Alexander Nevsky stands in his cloak gazing in the opposite direction. There is the outline of threatening clouds and that marks the edge of the frame. Not many sane people would start at the other side. Some are bound to, but 90 per cent would be drawn first to the dark figure against the skyline. In all the other shots, the calculations were based on left–right movement. This 'educates' the eye.

Equally, you can make the eye read shots from top to bottom. For example, a descent down a mineshaft. You have to educate the eye to read downwards. This is done graphically. If you have marked out someone's gaze, you would probably show a person looking down in profile.

From the floor: Each work always has two camps. Each will have a defining colour. The whole film needs to be constructed in two key tones as far as colour is concerned. If there are minor themes present, can they be done in the key tones, but using a weaker colour?

Eisenstein: You mean that the bulk of dramatic works are based on conflict, and conflict is commonly expressed as two forces in opposition. This is not always obligatory and does not always take place, but works of the average sort are like that. And you say that this division in the conflict must be coloured differently: one side white, the other black.

From the floor: Must there be a conflict of colours where one colour beats the other?

Eisenstein: That will happen very crudely, and in colour film too ... But the point is that it is not only expressed in the colour scheme.

To take an example from real life. The Whites' camp began to break down into factions. (Suppose this was a picture from the Civil War period.) One part of the group has a tendency to join the Reds. And in the Reds' camp lurk enemies in disguise. After the Civil War, as you know, the struggle went much deeper. Compare the conflict in *The Little Red Devils* [Krasnye d'yavolyata, 1923], where this was shown almost in outline; and the complex conflict in *A Great Citizen*.[83]

What is vital is that you do not colour the characters a definite hue, and then play them off against each other. The cases where themes are in conflict and convey a colour resolution as they move through the different characters are especially interesting.

From the floor: Dealing with colour, we should also deal with the colouring. Creating the colouring for one shot is clear-cut. But since cinema is not a single frame, but many taken in combination, obviously it is possible to give the whole film a general colour resolution. In a construction where one colour emerges the victor, it becomes very difficult to achieve an overall colouring in the whole because the principal approach is different. From what you have said so far, the work as a whole has no colouring. Once the blue theme has come into being, it will continue to develop, and so on, and that is its colour resolution: how is all this to be linked together in a whole?

Eisenstein: A golden line is swallowed up by a black one. Parallel to this, a red line expands and a blue one starts somewhere. This is a typical polyphony, with many voices. As regards the colour tonality of individual frames, each time it is connected to the principle of a chord. Take shot 76 [in *Ivan*], for example; the gold has been practically devoured: the black has grown, and the blue has only just started and the frame must be balanced internally.

From the floor: I am talking about a purely pictorial colouring. There can be no colouring with a polyphonic resolution. How does the colouring of a film as a whole come about? From one colour's triumph over another?

Eisenstein: You will not get anywhere using mechanical terms – try instead more musical terminology, because everything here is linked to movement.[84] But we agreed that a mechanical film or an individual frame is essentially also not a fixed, but a temporal structure. Then what happens?

If we take *Christ Appearing to the Multitude*, by Ivanov, the construction there is a spiral, as you know.[85] So the movement of the eyes across the canvas is established. The arrangement of tones is also a given. Ivanov has resolved the departure into the distance, not only graphically but in colour too. Combinations of a different order are also possible: inward graphic movement, with the movement in colour going the opposite way. Graphic movement does not always take account of colouring.

For example, Surikov is a great artist, but from the point of view of colouring, and colour schemes, he is extraordinarily ill-disciplined and haphazard. Think of *Boyarina Morozova*.[86] The harmony is magnificent in an ordinary reproduction, and the penetration inwards is wonderfully expressed. But look at it in colour. The first thing to hit you is the terrible brightness and the scattered spots of colour. Surikov's spots of colour are not calculated, in the way that the plastic drawing is calculated; and the colour does not assist in the inward impetus; this is achieved partly by a trick of the perspective, in defiance of the colour. It is all extraordinarily bright and haphazard. If you recall the young boyar ladies and the beggars, they are almost all

treated as independent portraits, thrown together at random, judging by the colour.

What happens with Ivanov's *Christ Appearing to the Multitude*? Consider the graphic movement as a montage movement. Each flourish is a separate segment. Here, the people are in the foreground and the middle distance; then in the distance is Christ and a large strip of scenery. And this is developed the same way in colour; they begin saturated and then fade.

The overall colouring of the work is built up from separate parts in the same way as the overall colouring of a scene. Details are built up in colour. And the actual episode must be resolved in the same way as each section within it is resolved. How is this done?

Have you read my article about *Potemkin*, with the assembly of segments of montage – the meeting of the skiffs and the public at the Odessa Steps? The article is called 'Eh!'[87] Twelve shots, showing the meeting between the battleship and the skiffs, were dissected.[88] I wrote about how the foreground motif interacted with the background motif and how the two succeeded each other.

In the first shot, the whole field of vision is filled with the skiffs moving towards the battleship. That is the first subject. The second subject appears in the next shot: the frame is bisected by a colonnade. Then the verticals of the columns are repeated in the figures of people standing on the steps, and the arch, marked out by the columns, turns into the arrangement of the group – people standing in a circle. The arch turns into the outline of a parasol, and the movement of skiffs seems to be continued in the movements of eyes and heads. Then the parasol vanishes, the circle vanishes, and the motif works in reverse. The boat is in the foreground, and the balustrade is in the distance. The line of the boat's hull is echoed in the lower part of the frame in the line of the balustrade. The sail – the chief compositional vertical – is repeated in the figure of the lady in white seated in the boat. Then the light tones of the sky and the building fade into the tones of the grey hull of the ship and the brilliant white water, and the verticals of the sails, which fill the entire depth of the shot, are repeated in the vertical figures of the sailors in the foreground.

That is how one shot turns into another. The same motifs are altered and rearranged, in terms of both line and tone.

Absolutely the same thing happens when you work in colour.

Colour is too mobile in film. You obtain a general sense of colour, but it is extraordinarily difficult to determine it unambiguously. It would be profoundly wrong to determine the colour resolution of a film with one colour. You cannot sustain a pale blue for the entire film. There is bound to be the same division as there is in music: andante, which you resolve in pale blue, say; and allegro, in red and black. I can tell you how I planned to make a film about Pushkin, where the whole thing was constructed on the shift in colour.[89]

Have you understood the principle of the separation of colour from object? In order to understand and express any principle, you have to take an extreme case. Then the law becomes clear. You know the theory of limits? It is well known that you can find a consistent formula for a whole range of

quantities, if you pick an extreme case. The same principle also obtains in the resolution of our problems.

If you use a Gillette razor, you know the rule: 'tighten it as far as you can, then release it a half-turn.' That is roughly what we have to do too: take it to the limit, and then step back a little. . . .

But to continue the discussion of colour. What can the 'tightening up' be demonstrated on? How should we work in colour, so that the principle is taken to its limits? Where can you do the craziest things in colour? In what sort of pictures?

Cartoons. To take the problem to its extreme, you have to make a cartoon. When I began considering what had been done with colour in cartoons, I thought that to resolve it correctly, you could find the very nature of the principle there.

In my dacha I have some Vyatka dolls.[90] They are on a shelf upstairs. I lie and think: if I am to pursue work in cartoons, I would of course avoid the mice and pigs of Disney and follow Russian folklore. The models of folklore construction – Vyatka dolls. I began to look at them closely: what could be done with the colour? The first thing I thought was: you have a horse with little red and green circles on it; in the cartoon, the spots would come away from the horse and begin to lead a life of their own.

The second doll is a nurse. And now these red and green spots transfer themselves to the nurse, and the performance begins. The check on her skirt seems to exist purely for this. Then it goes further. The spots come away and run off. A spring landscape. An old man sitting beneath a bare tree. Red apples suddenly appear on its branches. Then these green circles become red – the apples ripen. The circles then fall off at a crossroads, on to a traffic light. A red light shines where there should be a green one – the red spots jumped up there, and all hell breaks loose.

Or this would not be a bad idea: a girl and a young man sit on a bench. She suddenly turns green, then he leaves and she turns red.

When I thought about all this, I observed one thing: what basic idea lies at the root of this invention? First, that colour has been differentiated from its object and, second, that colour has started to acquire different meanings, from the simplest abstract jumping spots to a traffic light, the expression of a face, and the colour of apples.

The principle has been correctly grasped here. That is how a razor is 'tightened and then released'.

From the very first attempt at defining how this should be done in an extreme case, it appeared that the key thing is to isolate, to take hold of this element. The key principle consists in separating colour from what necessarily lies beneath it, to draw it out into a general feeling and make this general feeling become a subject again.

What I tried to tell you when I began these lectures was essentially derived from this principle.

As regards Disney's treatment of colour, those pictures of his that I have seen remain only at the threshold of colour cinema.

Disney's most interesting – most valuable – contribution has been his skill at superimposing the 'drawing' of a melody on top of a graphic drawing.

In live-action cinema, what is difficult is teasing out the line of the composition from the real material. However, we were only able by chance to film the right cloud we needed. We tried forty times before that, but it was always wrong. Only once was the cloud right. We unpacked again in a hurry and managed to film it. But that cloud might never have come along.

But Disney is lucky. He can just draw the outline he wants. He has an incomparable feel for an intonational gesture in music, and he can weave this gesture into the outline of his figures. Disney is a genius at doing this. No one can do this, apart from him.

He is an unsurpassed master of outline, but to date his colour work has been unremarkable. The colour in *Snow White and the Seven Dwarfs* [USA, 1937] is terribly saccharine. In *Bambi* the drawing is wrong. In *Bambi* the shading is done the same way as it is in the Mickey Mouse films. But for a lyrical theme, rather than an ironic one, this work with a hatching pen is too harsh and bald.

I have seen sketches for *Bambi* which were done not with harsh outlines, but using a slightly wet brush and spots. This was much more pleasing than the film. It was done in the same gentle style as the Russian artist, Lebedev, who illustrated Marshak's books.[91]

If you have seen examples of Chinese painting, how they do birds and in particular monkeys, you will understand what I am talking about. They convey the thickness of the monkey's fur very well. To make *Bambi* completely lyrical, that sort of cartoon would have been better. Bambi itself has been perfectly executed, as far as the drawing is concerned. But in terms of the melody, it has been played on the wrong instruments. The melody is right, the timbre wrong.

Disney uses the 'Barcarolle' from *The Tales of Hoffmann*.[92] A peacock appears near a lake. A lake, a peacock and its tail. And all the movements are repeated. The complex musical passage has been remarkably caught in the splaying tail, which turns and is reflected in the water below. Disney's inventiveness for such things is inexhaustible. But it is less good when he turns to tonal resolutions. The pictorial form is always very poor. The figures are very good, but the landscape is poor – always poor. But with the transition to colour, the tone *per se* is always very well chosen. You have seen the grasshopper catching fish. You remember the amazing part where he skates across the water? How well the water and the fish are done, in terms of the body of colour. In themselves, these colours are very attractive, because they have the pallor of celluloid. But Disney's work in colour has been uneven so far. It is no more than his cartoon work, coloured in. There has been no sign in his technique of any new contribution, arising from his discovery of colour. He has not progressed to the next stage.

When you have been working in silent film and then progress to sound, there is some movement in your devices and constructions. I do not mean that this movement is always an advance. But style is always changing and developing. With Disney, however, everything has remained almost unchanged, except that it is now in colour. In *Bambi* there are a number of attempts at introducing a correspondence between colour and sound, but they are unsuccessful. Nevertheless his way of making the movement of a line coincide with

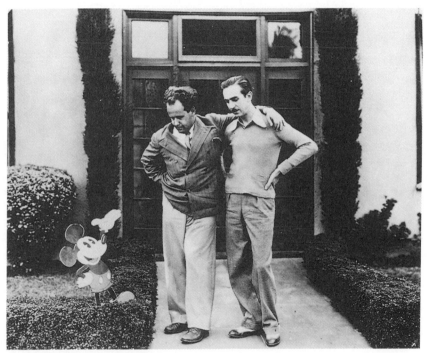

Eisenstein, Walt Disney and Mickey Mouse, Hollywood 1930.

that of a sound is as remarkable as ever! The melody moves forward, and all the different twists in the line repeat the melody, whether corresponding or not, whereas in cartoons a correspondence between melody and drawing is almost obligatory. But when Disney is working with colour, there is no correspondence between the oscillations and changes in the colour and the melodic outline. He cannot synchronise the colour and the music...

33. The Audience as Creator[93]

'It's what the audience wants', 'It's what the audience is crying out for', 'It's what the audience demands.' All over the world, in every cinema, in every film company, in every film studio, these are the phrases on everybody's lips.

They supply all the junk that is dumped on to the film markets in capitalist countries. You might suppose that the cinema in bourgeois countries actually takes a very close interest in the spiritual requirements of the viewing masses, and does all it can to meet them.

The reality of course is completely different. 'Serving the audience' in these countries is just as great a fiction as all that ballyhoo about the question of the freedom of the press, of speech and thought.

By 'serving the audience', bourgeois film-makers mean colluding wholesale with the crudest and most basic instincts and philistine tastes. Through this collusion, bourgeois film-makers try simultaneously to inculcate in the viewer's consciousness the same reactionary ideas that the masters of these countries, and those working in their film industry, preach through their hundreds of films.

Only in our country is the situation quite different.

That is because the viewer himself is the spiritual and material master of Soviet cinema. And not as an individual, buying his ticket at the box office, but as the people who inspire this art, and who, through the hands of Soviet film workers, create the art of cinema that they want and that they demand.

So he has no need to ask for anything. He does not have to ask for anything, but he can himself put questions. Put them to those whose job it is to realise his thoughts, feelings, aspirations and ideals, creatively.

And the requirements of our audience are harsh and uncompromising.

Who is the sternest critic? It must be the person who knows about the subject that is being represented in art. A boxer in the auditorium will not let the slightest technical mistake, committed by the boxer on screen, escape his notice; nor will a jockey fail to observe a fault in the screen jockey's posture; nor a foundry worker overlook any inaccuracy in the recreation of a production process; nor a district committee member tolerate an erroneous procedure.

And the strength of Soviet man consists in precisely that: knowing everything that the powerful Bolshevik Party has taught him; everything that Lenin's great teaching has communicated to him.

And this man, approaching cinema as a viewer, can ask, and knows what to ask. For he is the best and chief specialist and expert in what is happening on the screen in front of him.

Our screen, regardless of plot, genre, story and style, has one key theme: to reflect the great process of the growth and development of our country as it moves towards Communism, and the screen must assist in this in whatever way it can.

And who, if not our people, not as audience but, under the leadership of the Bolshevik Party, as creator of a great historical cause – who could possibly be better placed to investigate the truth and the veracity of the reflection of this subject on screen? For, when dealing with screen work, our people sit in judgment on their own creativity, and the screen work itself is one of the finest embodiments of the creative inspiration of our great people.

Our film audience is a creator-audience, sharing with the film-makers the creative authorship of the constellations of glorious films that the first great thirty years of Soviet power in Rus have brought to the screen.[94]

34. One and Indivisible (Thoughts on the History of Soviet Cinema)[95]

I see it as not only unique, but strikingly uniform.

And the more diverse its variations of style and genre have become over the course of the years, the more organically uniform it seems to be.

Uniform, first and foremost, because of its all-pervading ambition to serve its people.

Uniform in the consistency of its principles in pursuing this aim.

Uniform, because its fate is inseparable from those of our country, Party and people.

So it is not the individual diversity of our glorious Soviet cinema that I wish to describe now; rather, I should like to share some thoughts on this unity and the features of this unity, as we celebrate the thirtieth anniversary of the victorious October Revolution.

★ ★ ★

Looking back on the past from the positions we have reached, surveying the whole diversity of cinematic works from the heights we have achieved, we can see where the dynamic development of Soviet cinema springs from; the general features of this development and the range of the ideas that extend gradually, all the more fully and profoundly to encompass the ever broader and greater ranks of its creative works.

The nature of different films, seemingly haphazard and unexpected at times, presents now a harmonious picture of a general collaboration of all those who have worked, and are still working, in cinema, thanks to the concerted efforts of those taking it towards its perfectly distinct, and definite, uniqueness.

This path is Soviet cinema's unswerving approach to a consistent and fully fledged Socialist Realism.

It has not been an easy path. It has not been smooth, and it has often been inconsistent in the hands of particular masters.

And it has taken a heated and burningly impassioned line in the battles between the various ventures, positions of principle and points of view over what the realistic image and face of Soviet film should be.

The character of the struggle had two aspects.

It was implacable and ruthless in its dealings with everything unreconstructed and alien. 'Unreconstructed' meant pre-Revolutionary and bourgeois. 'Alien' was foreign and bourgeois, trying to influence the course of what had emerged as purely Soviet.[96]

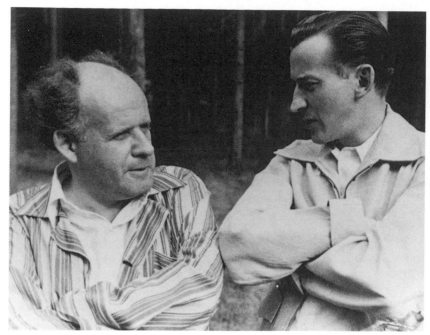

Eisenstein recovering from his first heart attack at his dacha outside Moscow in 1946.

In this struggle, the young generation of film-makers of October grew stronger and occupied the leading position.

And alongside these raged a struggle that was no less passionate or heated, albeit one of a different character and aspect. It was not only a struggle with outsiders; it was an internecine, intensely ideological struggle for purity of method, correctness of principles, and against any digressions into Formalism and deviations into aimless Naturalism; above all, we fought for the moral high ground, for the truthfulness it inevitably entailed, for the mutual perfecting of principle, for the healthy organicism and uncompromising ideological principles of the Soviet cinema that was equally dear to all.

Starting with the prophetic words of Lenin, over the past decades the Party has made steadfast progress, evolving an increasingly distinct policy to accelerate cinema's realisation of the Party's great tasks.

Here are programmatic instructions;
and the harsh judgment of errors;
praise and friendly encouragement;
providing a detailed system of specific instructions for every field, from the subject of ideological analysis to economic measures; from the most precise critique of the causes behind delusions to the broadest perspectives of development as a whole.

A whole series of legislative measures and decrees has been developed, demonstrating again and again the way in which the art of our cinema must develop and move forward, as it approaches its main, principal and unique aim – even more fully, even more consistently, even more self-effacingly to

serve our people – to be even more of a mass art, even more ideologically profound, even more truthful, even more artistically accomplished; to be an even more destructive weapon in the cause of the political struggle.

Lenin wrote of the tasks that faced the working class when it had seized state power and of the battles facing the Bolsheviks, who had led and would lead the working class from victory to victory: 'We must overcome resistance from the capitalists in all its forms, not only in the military and political spheres, but also ideological resistance, which is the most deep-seated and the strongest.'[97]

The first major state measure relating to our country's cinema was adopted under the banner of these words of Lenin: the nationalisation of cinema, which made our people masters of this greatest weapon in the ideological battle (27 August 1919).[98]

Under this aegis, our cinema is progressing and continues to progress.

Under this aegis, it grows and develops.

The transition from Socialism to Communism makes the tasks facing our cinema even more numerous.

But our cinema confronts the future fearlessly.

It has no cause to baulk at the new battles it must fight.

It is assured of the doughty support of the Party's wisdom.

The gigantic collective experience of the work done over the years is at its disposal.

And the general path of its progress and development – reflecting the historical path of the country's progress as a whole – has led unswervingly in the right direction.

We can already see that this path appears, in all its variety of style and genre, as a united collective path which has led unerringly to the point where, today, its spirit glitters from our standards.

But what does the picture of this general movement look like?

On the thirtieth anniversary of October, what is the outline of the principal achievements?

Of course, one approach would simply be to enumerate the films, categorising them by genre: historical, historico-revolutionary, adventure, comedy, children's, documentary.

Or by subject: collective farming, industry, the Komsomol.

Finally, in chronological order, by the release dates of the various films.

And fill these pages with endless lists: the names of films and actors and the dates the films appeared on the screen.

Even a list like that might give some idea of the breadth, depth and diversity of the subject matter our cinema has chosen to depict life in our country during these thirty years.

I will try to do it differently.

I will try to show how the principles that the different tendencies adhered to, the elaboration of the different genres, and the views of certain artistes vis-à-vis the development of our country, under the indefatigable leadership of the Party and government, have come together in the general homogeneity of Soviet cinema, as it was on the anniversary of October.

I think that the basis of what our cinema has achieved, in its thematic,

stylistic, ideological and artistic aspects, can be said to lie in the *profound sense that every moment of our daily active existence is of the greatest historical significance – the emergence of Communism in our country and of the Communist future of a liberated mankind, with the Soviet Union in the vanguard.*

This awareness of our country's worldwide historical mission is to be found in Russian culture which goes back deep into the centuries; in the importance of Moscow, which as early as the sixteenth century had already recognised its great international role and the task confronting the Russian state, and which today thunders before the whole world, in the speeches of the Soviet delegation on the platforms of the UN – 'puts paid' to the notion of history as something that came to an end some time in the past, and that the present is only feeding off the achievements of the past and will in its turn become a source of nourishment for a future that is as yet vaguely sketched out.

The sense that a constructive and creative Soviet life has a worldwide historical importance is something fundamental and basic that can be felt particularly distinctly beyond the diversity of genres and subjects of works that have been conceived, planned and realised in Soviet cinema.

History, in our films, has never been an archaeological graveyard; the present is bound to it with ties of blood.

The present has never been an accumulation of everyday trivia; it has always been filled with a sense of the importance of Socialist reality, from which a particular, singular fact of life has been plucked by the camera.

And if we look at the road our cinema has travelled from these positions, we can perhaps discern three powerful currents in it that strive to merge in the innovative attempts of our most recent achievements and in our even bolder plans for the future, which suggest themselves to the creative imagination on the basis of what has already been achieved.

The first current is the depiction of the present.

This was originally realised in newsreel accounts. In this it followed the direct instruction that Lenin gave to Lunacharsky in 1922, to the effect that 'the production of new films imbued with Communist ideas and reflecting Soviet reality should begin with the newsreel.'[99]

Then this current flowed into the cinema of contemporary themes. Feature films began to appear, in which real Russian people acted, shown going about their daily business.

The second current deals with historical-revolutionary subject matter and this brought our cinema, at the dawn of its emergence as an independent art form, its first major achievements and first glory. Later it extended into historical, Party subject matter.

And finally – the third current involves purely historical films.

Each of these currents, at certain moments during the development of our cinema, was borne aloft on the crest of the general wave, only to concede its position to another, as a new genre emerges, up to that moment when, right before our eyes, we could clearly see the outlines of their synthetic merging in films of a new type. Chiaureli's *The Vow* [Klyatva, 1946], Petrov's *The Battle of Stalingrad* [Stalingradskaya bitva, two parts, 1949] and Gerasimov's *The Young Guard* [Molodaya gvardiya, two parts, 1948] all prepared the way

for this new type.[100]

Here, in the actual type and structure of the films, the present is, at the same time, history, and history is the present; and the subject matter of both is historical and revolutionary.

It is noteworthy that today's higher aspirations for the stylistic development of our cinema should find echo in its first independent steps. While in its early infancy, among its first achievements we see the still disconnected, extremely distinct depiction of what was contemporary in the newsreels of the 'documentarists' and, alongside, the historico-revolutionary theme – in its general aspects in the mass epic in *The Battleship Potemkin*, and the individual dramatic in [the screen adaptation of] Gorky's *The Mother* by Zarkhi and Pudovkin.[101]

Each one of these genres – the contemporary, the historico-revolutionary and the historical – have enjoyed equality at different moments, or succeeded each other as the stylistic proponents of the leading position, not merely because of a 'search for something different' or with the aim of replacing what has 'begun to pall', taking off the quilted jacket and sheepskin of the Civil War and donning the velvet and brocade of historical films, or exchanging the breastplates and camisole of the historical film for the bayonet, bandolier and partisan beard of a war picture.

That is what happens in 'Hollywoods', where the aim is to squeeze the full box-office potential from a once popular film and then to launch into something quite different that might create a new fashion, a new sensation.

There, across the ocean, stetsons give way to powdered wigs, or Roman togas, or the ringlets of Assyrian beards; togas give way to trained lions; the lions, to the soutanes of lyrically treated Catholic priests; and the soutanes – to frock-coats, filmed in the manner of faded daguerreotypes – with the sole aim of 'variety of choice'.

We do it quite differently.

The advent of the historical theme in our cinema, for example, was wholly inspired by the great principles of re-examining our attitude to our past, to the history of our people, using the principles embedded in the resolutions of the Party concerning the history of our fatherland.

The spirit of historical concreteness, which is inseparable from pathos; the living veracity of the screen images of key figures from the past, instead of historical plots and abstractions; the reappraisal of unfounded conceptions of historical epochs – that was the response our cinema made to these instructions.

The Party calls for an ever deepening awareness and study of Leninism. And Soviet cinema has undertaken the magnificent task of recreating the image of Lenin on screen.

The profoundly inspiring and instructive depiction of Lenin's image on screen – in Shchukin's and Strauch's fine performances in films by Romm and Yutkevich – mark a new stage in defining and enhancing the theme of the Party.[102] This theme develops to the point where it shows on screen the historical roles of the Party leaders in the days before, during, and in the immediate aftermath of October; during the Five Year Plans, the War and post-war construction.

War films provided a direct continuation of this theme. Earlier artistic traditions had shown generalised images of 'the flower of the nation's youth' cut down in battle against the interventionists; 'generals' deciding overall strategies; and one particular city defending itself against the enemy. Now, however, the city has become defined – Stalingrad – and with that has come a cumulative image of all the hero-cities: the nation's youth emerged, concretely, as the Red Don soldiers, whose looks, names and surnames are known to us and who have become a cumulative image for the whole of Soviet youth in the struggle against German aggression; while the images of 'typical' generals in 'typical battle situations' have evolved into the latest film aesthetic of film portraits of the real leaders of our victorious armies in the context of an authentically recreated war.

The path cinema has taken can be seen as a path of assimilation and recognition of all the possibilities of film art; as a path forging the experience of those expressive means that have to be fully mastered if these gigantic tasks are to be carried out. Displaying at each level of its emergence a figurative response to burning questions that confront the Soviet viewer, our cinema has simultaneously prepared both the experience and knowledge needed to resolve these tasks of the future, which have since become the tasks of the present, and are being brilliantly resolved before our very eyes.

Looking in detail at the epic films of this new type that have been made to date; reading the new screenplays closely; examining the different ways their ideas have been realised – now plastically resolving the shooting 'in the manner of newsreel', or interspicing acted footage with newsreel, now cutting in a genuine document or introducing an invented character; now stopping on an emphatically acted scene or on a vignette of a real person, or now plunging into the vast reaches of epic development – you can feel everywhere the roots of the particular styles and genres of the different stages, different pictures and different approaches over the course of the years in which our cinema has been evolving.

Each detail, each device, woven into the resolution of these mighty tasks has a corresponding part in an experience that once built up; an experiment that was once set up and resolved.

The resolution of this problem would have been impossible, but for the skilful portrayal of the Revolutionary struggle – and some films that met the immediate demand to see the Revolution in action on screen contributed features of a similar skill, for a similar depiction, to the common treasure trove of cinema.

There was a demand to see Bolsheviks working underground, or during the Civil War, or setting up collective agriculture, fighting for the next Plan; in the uncompromising struggle against those who would encroach upon the Party's unity – and on screen there appeared the images of 'the generation of victors', Maxim and Shakhov, Furmanov in *Chapayev* by the Vasiliev 'brothers'; the heroes of *We from Kronstadt* and the heroes of *Counterplan*, the head of the political department from *Peasants*, the unforgettable image [created by] Maretskaya in *A Member of the Government*.[103]

The problem of showing a general in action planning his campaign had to be resolved – and the experience of history unfolded before us the skill of

such commanders of genius from the past as Alexander Nevsky, Bogdan Khmelnitsky, Peter the Great, Suvorov, Kutuzov.[104]

But the most important thing so far was forged and wrought in precisely these films: a sense was assimilated of the historical significance of events. The ability to convey the *Zeitgeist* was cultivated: the sense of historical generalisation. What had to be learned was how to depict a mass movement, the masses in the pre-Revolutionary struggle, the masses in the Civil War, the masses in the surge of [socialist] construction, in order to move towards the ability to show the heroism of our soldiers who saved the world from the Fascist plague, just as their ancestors twice saved Europe from the armies of Baty and Bonaparte.[105]

And every stage in cinema reflects each potential aspect of mass work, in each sector of its activity, creating for each of them a film, and collecting the experience for an extensive synthesising portrayal of the action of the masses.

Masses that are of diverse composition, form, nationality, but bonded like brothers by a single impulse, a single programme, a single Communist future.

The attention of cinema has been no less sharply focused on the lives of individuals: not only typical, but biographically defined personalities. Hence there have been films about Gorky by Donskoi, a film about Timiryazev in the image of Professor Polezhayev by Zarkhi and Heifitz; and Kalatozov's *Chkalov*.[106]

The secret of how to create living characters on screen had to be understood so that it would not be merely schematic human movement on the screen of contemporary-historical films; and as we all know, our cinema has great experience in dramatising the classics, assimilating the experience of how giants such as Gorky and Ostrovsky, Tolstoy and Chekhov created the image of a living man.[107]

Characters dear to us from *The Storm*, *A Petersburg Night* and *The Girl with No Dowry* have been translated on to the screen, alive and familiar, by Petrov, Roshal and Protazanov.[108]

An anti-Fascist theme informed *The Marsh Soldiers*, *Professor Mamlock*, *The Oppenheim Family*; the theme in *She Defends the Homeland* and *The Secretary of the District Committee* had the added theme of the War.[109]

From innumerable angles and positions, the screen has come closer to an understanding of how to seize, impress and depict in living form the hardest thing to capture: the present.

From an 'intellectual' solution to the problem through pure documentarism, to the profound artistic revelation of reality in films treated in an especially matter-of-fact way (Abram Room's *Potholes* [Ukhaby, 1927], Yuli Raizman's *The Pilots* [Letchiki, 1935] and *The Virgin Soil Upturned* [Podnyataya tselina, 1939], Sergei Gerasimov's *The Teacher* [Uchitel', 1939] and Heifitz and Zarkhi's *In the Name of Life* [Vo imya zhizni, 1946].

From attempts to approach the present day through musicals and humour (Grigori Alexandrov and latterly Ivan Pyriev) right up to attempts to apply to this portrayal glorified forms of the thriller type (Boris Barnet's *The Exploit of a Scout*).[110]

Next comes the assimilation of the present by means of lyrical pathos and

structure, written in a way that is at times inclined towards poetry (Alexander Dovzhenko).[111]

And untiringly, year after year the persistent work on creating a personal cinematic language, a personal cinematic semantics and poetics; on perfecting the means of expressiveness, not with the aim of 'art for art' or 'art for its own sake', but in the interests of a more powerful, ideological and emotional influence for our films.

It is as though we see before us a massively powerful laboratory, where each is working hard assimilating the particular part of the general stylistic development of Socialist Realist cinema that has been assigned to him.

I doubt if there is a single nuance to which a particular creative individual has not devoted itself.

I doubt if there is a single well-known film that has not made its contribution to the truly boundless treasure-house of this collective experience.

And it is staggering to see how insistently, unwaveringly and regularly our cinema as a whole has progressed and is progressing, towards *the sublime realisation and conversion of the reality of our times – the best pages from the history of mankind – into living images of our present, which is both history and the threshold to an even more magnificent historical future.*

Fortunate is the country whose present is not a brief halt between a past, that it wants to forget, and a future that it is frightened to behold, seeing in it only crisis, impending collapse and hopeless decay.

Fortunate the people who take pride in their mighty past, firmly acknowledge the paths of their future and therefore take deep breaths today, hearing in the sounds of their own songs the great roaring chorus of centuries victoriously traversed, as they merge and find echo in the voices of the future that is emerging.

Fortunate the art born of such a country and such a people.

Fortunate in the knowledge of the unity of its past, present and future.

Fortunate in serving the people actively and bringing it alive in images.

It is to this country alone, to this people alone and to those peoples and countries alone who travel with us, along our path, that the Future of Emancipated Mankind belongs.

35. Ever Onwards! (Instead of a Postscript)[112]

I try not to read other people's letters.

Reading other people's letters is considered reprehensible.

We were taught that when we were young children.

But there are letters written by other people that I do leaf through, that I do glance at, that I do peruse.

Artists' letters.

Letters by Serov, Van Gogh, Michelangelo.[113]

Particularly Michelangelo. The molten mass of words pours out on to the parchment with the same feverish passion as his monumental 'slaves' breaking out from their unfinished blocks of stone, as his 'sinners' cast down into hell, as the unstirring figures at the base of the statues on the Medicis' tomb, overcome by heavy dreams.[114]

Then these letters are a groan.

The complaints that fill the pages of letters written while he was working on the ceiling of the Sistine Chapel seem a groan.[115]

Months spent in an unnatural, bent position, his head forced back between his shoulders, arms streaming, feet spattered with lead, and plaster flaking into inflamed, bloodshot eyes.

The instrument slips from his hand. Dizziness. And the feeling that the scaffolding is swaying, bringing the flight of his creative imagination into contact with the unyielding rigidity of the vault's surfaces.

But then the months of agonies pass.

The scaffolding comes down.

Stiff limbs are flexed.

The backbone straightened.

His head is proudly lifted.

The creator looks up.

The creator looks at his creation.

And the vaults give way before him. Stone gives way to sky.

And it is not chance, it seems, that the sky, covered with Buonarroti's frescoes, has come to life with a cycle of images showing the creation of the universe and the birth of Adam.

In these frescoes, the human spirit of a new epoch seems to emerge triumphant at the peak of its powers, the aim of the best of those working during the Renaissance.

Like Adam, the first-born, this man of the new era squares his shoulders

and sets off through the centuries to the threshold of a new Renaissance – the threshold of our age.

Who, of our contemporaries, dares to compare himself with the titanic creators of the Renaissance period?

Where are those works of painting and sculpture which could stand side by side with them? Where is that forest of statuary which, belonging to a more progressive age, could eclipse David or Colleone? [116] Where are the frescoes next to which 'The Secret Evening' would fade? Where are the canvases to outshine the Sistine Madonna?

Has the creative spirit of peoples really waned? Has the creative will of humanity really weakened? Is the universe – one sixth of which has abandoned the exploitation of man by man – really reaching its twilight, rather than unprecedented achievements?

Of course not!

So what is happening?

And where should we look for those monuments to human creativity that would be a fitting testimonial to our age, just as the Parthenon is to the glory of Greece, Gothic architecture is to the Middle Ages, and the giants of the Renaissance to the age of Rebirth?

Our age preserves its appearance through an art that is as remote from frescoes as a skyscraper is from a basilica. As remote from stained glass as a Flying Fortress is from Leonardo's most daring designs. As unlike Benvenuto Cellini's sculpture as the poisons of the Borgias are from the destructive force of the atom bomb, or Brunelleschi's intuition is from Einstein's precise, formulaic calculations.[117]

By their very nature, these works will not be comparable with the works of past epochs, for the same reason that an epoch that managed to create a Socialist country in the twentieth century – something denied to all preceding ages of human history – is incomparable.

And in its internal features, this art will not be comparable to the art of the past, for it will not be a new kind of music to rival the music of the past, nor painting to outdo earlier painting, nor theatre to surpass theatre of the past, which has been left behind, nor drama, sculpture or dance bettering the drama, sculpture or dance of times past.

And instead, there is a new variety of art, welding painting and drama, music and sculpture, architecture and dance, landscape and man, visual image and spoken word, into one whole, a single synthesis.

The realisation of this synthesis, as of an organic unity never before seen, is doubtless the most important achievement of the aesthetic of cinema over its fifty-year existence; for the name of this art is cinema.

But the idea of an all-embracing real synthesis as the basis of a new art could only be born at the moment when this new art was almost simultaneously given freedom, equality and brotherhood, in their highest sense, as conveyed by the doctrine of a Socialism triumphant, and the amazing technology that cinema employs.

At the dawn of culture in early and primitive forms, the Greeks had a similar synthesis. And many dreamers recalled this ideal to a new realisation in life.

Just as, at other times, challenges were issued by Diderot, Wagner or Scriabin.[118]

The times were different.

But they bore an identical stamp.

They were times yet to be aroused by the clarion call for an end to exploitation of one part of humanity by another; an end to the enslavement of one people by another who has colonised them; and an end to the oppression of one people by another who has subjugated them.

They were times before this multi-million strong land had come into being, when this was not a dream but the reality, not a theory but the practice, not a mirage but the actuality.

Only after implementing the reality of the defeat of centuries-old injustice and unlawfulness could there be a bias towards new aesthetic norms and perspectives, that were worthy of the new social and socialist practices which had already become mankind's property.

Not for nothing did the leaders of this country proclaim, during the first moments of its existence, that cinema was the most important of the arts.[119]

And not for nothing do those who work in this most important of the arts immediately recognise it as the most progressive; as the art most worthy of expressing the age of the triumphant Socialist Revolution; as the most perfect art for embodying the image of the new man, in the epoch of a new Renaissance.

But just as the paths and means of this new art could not be measured against anything from the past, so the underlying methods and methodology were new, unusual, out of the ordinary and distinct from what had succeeded earlier.

And here is a kind of rebirth of the creative collectivism that preceded the individualism of the titans of the Renaissance.

But this is not the result of anonymous immersion of self, as was the case with the hundreds of stonemasons and sculptors working on cathedrals, whose images still enthral us to this day, but whose names have vanished in obscurity.

This is, rather, a fully fledged commonwealth of talents, which are expressed distinctly and directly, and of individuals with their own strictly defined character, some of whom are detained as if by chance on tonal work, acting, photography, costumes, sound, photographic or laboratory work, or directing.

And the spirit of these films speaks for the millions (or why else would millions watch them?) and has impressed this same principle of collectivism and collaboration on their very creativity; and this principle must become just as typical a feature of this democracy as the ideal of 'the strong personality' was in past epochs; 'iron chancellors', from the vanished era of the 'master race' doctrines.[120]

And this collective creativity means that there is no solitary Michelangelo spending months on his scaffolding, his spine bent back.

No fewer than scores – hundreds! – of people work on a film.

One is hunched over blueprints and calculations. Another's bloodshot eye is seeking out the correct shade for a colour filter, from a vast spectrum

of possibilities. A third's highly developed ear analyses the most expressive sound of simultaneously playing soundtracks, while a fourth is searching for an equivalent to them in the plastic succession of the shots.

And so it has been for all the ten, twenty, thirty, forty, fifty years of this feverish, mad, endlessly hard and marvellously ecstatic work which we know as film-making.

But now, on the threshold of the next half-century, let us like Michelangelo also straighten our collective backs, tear our eyes away from the laboratory tanks, colour filters, movieolas, floodlights, shooting stages, scripts and scores.

Let us raise those eyes to the ceilings, the result of half a century's work. Look at the vaults overhead. What can we see?

Just as, then, immortal frescoes revealed the infinity of the sky, where so recently there had been vaulting and masonry, so now we can see the endlessly unfolding horizons of new perspectives and possibilities.

Just as, then, the new Adam – Renaissance Man – was woken by the image of ancient Adam, so here, as we approach the completion of its first half-century, a vision of cinema's new possibilities stands before us, waiting to be realised.

It is breathtaking to tilt your head back and look at the future. We seem to stand at the apex of a half-century pyramid of our art's existence.

Its achievements are colossal and numerous.

The foundations are broad and capacious.

Its steep sides soar upwards.

Its summit proudly pierces the sky.

But, as you gaze up, the summit seems a new starting point, from which a new giant will grow outwards into the four corners of the heavenly vault, its sides and edges ready to take captive the unfettered expanses of the imagination as they sail upwards.

The appearance of the new consciousness and new world advancing towards us, which the future screen has been called upon to reflect, is just as new and immense.

Will it still be a screen?

Surely the screen will dissolve before our eyes, in the latest achievements of stereoscopic cinema, its three-dimensional representations taking over the entire interior and space of the theatre building – not just the rear wall of the auditorium – which it hurries along into the limitless expanse of the surrounding world, in the wonders of television technology?!

And surely this implosion of the very nature and essence of visual spectacles is nothing unexpected, since it has been called into being by technology at the very moment when it is to provide a new structure of aesthetic requirements, born out of the intersection of new stages of social development and the mastery of new equipment for managing nature; equipment that promises the same shift in awareness now as occurred at the dawn of culture, when man made his first ever tool.

A new type of art blazes across the sky as the forerunner of these new forms of consciousness; born of mankind, in the process of capturing nature with these new tools of unprecedented and unforeseen power.

I should be very surprised if the sum of traditional arts satisfied the new humanity!

If the eye, aided by infra-red night-vision goggles, can see in the dark;

and the hand, guided by radio, can guide shells and planes to the furthest reaches of other skies;

and the brain, aided by electronic calculators, can in a few seconds do sums that previously took armies of ledger clerks months of work;

and consciousness, which in the tireless (now post-war) struggle is now forging an increasingly precise and specific image of a genuinely democratic international ideal;

and the presence of the giant Land of the Soviets, which has forever destroyed the enslavement of man by his fellow –

surely all these demand of art completely new and unprecedented forms and dimensions, far beyond the limits of the palliatives – traditional theatre, traditional sculpture and traditional cinema?

Broadening consciousness, so that it perceives these new tasks. Whetting the cutting edge of thought, so that it can resolve these tasks. Mobilising past experience in the interests of what is to come.

Tirelessly creating.

Recklessly searching.

Bravely looking ahead into the new era of the arts, which we can only guess at.

That is what the challenge should be, in these days, weeks and post-War years.

Work, work and work

in the name of the great art born of the greatest ideas of the twentieth century – Lenin's teaching – in the name of this art, which has, in its turn, been created so that these greatest of ideas could be brought to the millions.

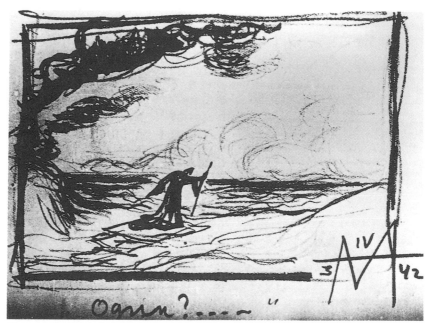

Eisenstein's sketch for the final scene of the unfinished third part of *Ivan the Terrible*. Ivan is alone on the shore of the Baltic Sea.

Notes

Throughout these notes Eisenstein is referred to as E. The following are the abbreviations used for the most frequently cited sources in these notes.

ESW 1 R. Taylor (ed. and trans.), *S. M. Eisenstein. Selected Works: Vol. 1. Writings, 1922–34*, London, British Film Institute, and Bloomington IN, Indiana University Press, 1988.

ESW 2 M. Glenny and R. Taylor (eds.), *S. M. Eisenstein. Selected Works: Vol. 2. Towards a Theory of Montage* (trans. M. Glenny), London, British Film Institute, 1991; paperback edn, 1994.

ESW 4 R. Taylor (ed.), *S. M. Eisenstein. Selected Works: Vol. 4. Beyond the Stars. The Memoirs of Sergei Eisenstein* (trans. W. Powell), London, British Film Institute, and Calcutta, Seagull Books, 1995.

FF R. Taylor and I. Christie (eds.), *The Film Factory: Russian and Soviet Cinema in Documents, 1896-1939* (trans. R. Taylor), London, Routledge and Kegan Paul, and Boston MA, Harvard University Press, 1988; paperback edn, London and New York, Routledge, 1994.

Film Form J. Leyda (ed. and trans.), *Film Form. Essays in Film Theory*, New York, Harcourt Brace Jovanovich, 1949, and London, Dennis Dobson, 1951.

IFF R. Taylor and I. Christie (eds.), *Inside the Film Factory. New Approaches to Russian and Soviet Cinema*, London and New York, Routledge, 1991; paperback edn, 1994.

IP S. I. Yutkevich *et al.* (eds), *Izbrannye proizvedeniya v shesti tomakh* [Selected Works in Six Volumes], Moscow, Iskusstvo, 1964–71.

IS R. N. Yurenev (ed.), *Izbrannye stat'i* [Selected Articles], Moscow, Iskusstvo, 1956.

1934

1. Source: S. Eizenshtein, 'Teatr i kino', *Iz istorii kino 8* [From the History of Cinema 8], (Moscow, 1971), pp. 153–67. This is the text of a lecture delivered by E to the fourth course in the Faculty of Direction at the State Institute for Cinema [GIK, later VGIK] on 22 September 1934.

2. Nikolai P. Okhlopkov (1900–67) was a Soviet actor and director. He worked with Meyerhold (see n. 9) from 1923 to 1930 and headed the Moscow Realistic Theatre, to which E is referring, from 1930 to 1937. In 1930 he also directed the film *The Path of the Enthusiasts* [Put' entuziastov]. He later played Vasili Buslai in E's *Alexander Nevsky* and Vasili, a 'typically' ordinary Russian worker revolutionary, in both *Lenin in October* [Lenin v oktyabre, 1937] and *Lenin in 1918* [Lenin v 1918 godu, 1939; awarded the Stalin Prize, 1941], directed by Mikhail I. Romm (1901–71).

3. Maxim Gorky's play *The Mother* was produced by Okhlopkov at the Realistic Theatre in 1933.

4. Meyerhold's production of the adaptation of Martinet's *Earth Rampant* by Sergei Tretyakov (1892–1939) in March 1923 used bicycles, motorcycles and an army lorry on stage. See n. 9.

5. The White Sea–Baltic Canal was one of the showpieces of the period of so-called 'socialist construction', using forced labour for prestige construction projects, and a focus for propaganda activities. The reference here is to a proposal to stage Pogodin's play *The Aristocrats* [Aristokraty], which dealt with the re-education of 'criminals' through their labour on the Canal project.

6. A call first made by Mayakovsky in his poem 'Order to the Army of the Arts' [Prikaz po armii iskusstv], written in December 1918.

7. E produced Tretyakov's *Gas Masks* [Protivogazy] in the Moscow gas plant for Proletkult in 1923. It was this production, E was later to claim, that made him finally realise the limitations of theatre and the advantages of cinema. See n. 20.

8. *Wise Man* [Mudrets] was Sergei Tretyakov's reworking of the classic play *Enough Simplicity for Every Wise Man* [Na vsyakogo mudretsa dovol'no prostoty] by Alexander N. Ostrovsky (1823–86); see also 1935 n. 99. The play was staged by E for Proletkult in 1923. See *ESW 1*, especially pp. 33–8, 82–3.

9. Vsevolod E. Meyerhold (1874–1940) was arguably the most innovative and influential Russian stage director of his day; see n. 4. E regarded him as his spiritual father and preserved Meyerhold's personal archive for posterity after the latter was purged in 1938.

10. Yudif S. Glizer (1905–68) was the wife of E's lifelong friend and collaborator Maxim M. Strauch (also Shtraukh, 1900–74) and became a leading stage actress, notably at the Mayakovsky Theatre.

11. See n. 3. above

12. Biomechanics was the term used by Meyerhold for the system of economical movement with maximal effectiveness that he developed for the actors in his theatre.

13. E's production used to maximum effect the central hall and stairway of the Proletkult Theatre, which was situated in the mansion that had belonged before the Revolution to the millionaire art collector Ilya Morozov. Coincidentally the theatre was situated just across the road from the 1st Goskino Cinema on Arbat Square where *Potemkin* had its premiere in January 1926.

14. Meyerhold's production of *Les Aubes* by the Belgian dramatist Emile Verhaeren (1855–1916) was staged at the First Theatre of the RSFSR on 7 November 1920, the third anniversary of the October Revolution.

15. Alexei Faiko's 'romantic melodrama' *Lake Lyul* was produced by Meyerhold in November 1923. Faiko described the plot as follows:

> Location: somewhere in the Far West, or perhaps the Far East. Many characters. Crowd scenes. White, yellow and black races. Hotels, villas, shops. Advertisement hoardings and lifts. A revolutionary struggle on an island. An underground movement. Conspiracies. The basis of the plot – the rise and fall of the renegade, Anton Prim.

According to Edward Braun, 'the dialogue of the play was terse and the structure episodic, designed to convey the breakneck tempo of life in the "big city", the dominant motif of the whole production.' Faiko described the production as follows:

> The back wall of the theatre was bared. Girders stuck out and wires and cables dangled uncompromisingly. The centre of the stage was occupied by a three-storeyed construction with receding corridors, cages, ladders, platforms and lifts which moved both horizontally and vertically. There were illuminated titles and advertisements, silver screens lit from behind. Affording something of a contrast to this background were the brilliant colours of the somewhat more than lifelike costumes: the elegant toilettes of the ladies, the gleaming white of starched shirt-fronts, aiguillettes, epaulettes, liveries trimmed with gold.

M. A. Valentei *et al.* (eds), *Vstrechi s Meyerhol'dom* [Encounters with Meyerhold]

(Moscow, 1967), pp. 298 and 306, cited in E. Braun, *The Theatre of Meyerhold. Revolution on the Modern Stage* (London, 1979), pp. 185–6.

16. Rabis was the acronym for the umbrella trade union embracing all workers in the arts.

17. Valentin S. Smyshlyayev (1891–1936), originally an actor and director with the Moscow Art Theatre, worked in the 1920s with Proletkult as a director. The project E is here referring to is *The Mexican*, a stage version of a story by Jack London which was produced by E and Smyshlyayev in January–March 1921. E also designed the sets and costumes. See *ESW 1*, p. 33.

18. E is referring to the adaptation of Balzac's *The Human Comedy* [La Comédie humaine] at the Vakhtangov Theatre, which had its premiere on 1 April 1934. The sets were designed by Isaak M. Rabinovich (1894–1961), whose other designs included Wilde's *Salome* at the Moscow Kamerny Theatre in 1918 in the production by Alexander Ya. Tairov (1885–1950) and Protazanov's film *Aelita* [1924] (both with Alexandra A. Exter (1882–1949)), Prokofiev's opera *Love for Three Oranges* [Lyubov' k trem apel'sinam, 1927] and the premiere production of Puccini's *Turandot* at the Bolshoi Theatre in 1931. The Vakhtangov production was by the actors A. D. Kozlovsky (1892–1940), who spent his entire career at the Vakhtangov, and Boris V. Shchukin (1894–1939), who also starred in the play and was to become one of the leading screen actors in the 1930s. The music for *The Human Comedy* was by Dmitri D. Shostakovich (1906–75).

19. The Popular Comedy Theatre, using elements of circus, puppet theatre and improvisation aimed at producing mass spectacles. It operated from 1920 until 1922 under the direction of Sergei E. Radlov (1892–1958), a pupil of Meyerhold, and Vladimir N. Solovyov (1887–1941).

20. The article referred to is 'Srednyaya iz trekh' [The Middle of Three], *Sovetskoe kino*, 1934, no. 11/12 (November/December), pp. 54–83. It was translated by Jay Leyda and Paya Haskelson in *Film Form*, pp. 3–17.

21. Valerian F. Pletnyov (1886–1942) wrote a number of plays for Proletkult. When E left the organisation after the dispute over the authorship of the screenplay for *The Strike*, he and Pletnyov indulged in a vitriolic exchange of letters which have been translated under the title 'Falling Out of Proletkult' in J. Leyda (ed.), *Eisenstein 2: A Premature Celebration of Eisenstein's Centenary* (Calcutta, 1985), pp. 1–8.

22. *The Storming of the Winter Palace* was re-enacted in 1920 under the direction of Nikolai N. Yevreinov (1879–1953) with a cast of ten thousand in an attempt to realise his vision of a merger between art and life through heroic man. For Radlov, see n. 19.

23. The *Chelyuskin* was a Soviet steamship, built in Denmark in 1933. For its maiden voyage later that year it left Murmansk in an attempt to sail in a single navigation season to Vladivostok via the northern sea route. It became ice-bound in the Bering Strait and was carried into the Chukchi Sea, where it was crushed by ice and sank on 13 February 1934 with 111 passengers and crew. The large-scale rescue operation was concluded exactly two calendar months later. The five pilots involved, the *Chelyuskin* heroes [Chelyuskintsy], were the first people to be awarded the title of Hero of the Soviet Union and were given a heroes' welcome when they returned to Moscow.

24. *LEF* was the journal of the Left Front of the Arts from 1923 until 1925. *Novyi LEF* [New LEF] was published in 1927/8 and represented a more specifically radical programme. See also 1945 n. 40.

25. *The Iron Flood*, based on the novel by Alexander Serafimovich (1863–1949), was staged by Okhlopkov in 1934, using small stages that protruded into the auditorium and, through powerful lighting and sound effects, creating the illusion that the audience were participating in the stage action.

26. In 1934 E was preparing a production of the play *Moscow 2* [Moskva – 2-ya] by Natan A. Zarkhi (1900–35) for the Theatre of the Revolution. The project was cut short by Zarkhi's death in a car accident in June 1935.

27. Vladimir R. Gardin (1877–1965) was a pre-Revolutionary Russian director, actor and scriptwriter who stayed after the October Revolution and in 1919 founded the

Moscow State Film School. His films were often vilified by the avant-garde for their traditionalism, and *Cross and Mauser* [Krest i mauzer, 1925] and the costume drama *The Poet and the Tsar* [Poet i tsar', 1927] came in for particular criticism. By the time of E's lecture Gardin had also played the leading role, that of the elderly worker Babchenko, in *Counterplan* [Vstrechnyi, 1932], directed by Friedrich M. Ermler (1898–1967).

28. Emil Jannings (1884–1950), German stage and screen actor who, like Gardin, often played elderly roles, for example in *The Blue Angel* [Der blaue Engel, 1930] where he played an old schoolteacher infatuated with, and eventually humiliated by, the night-club dancer Lola-Lola, played by Marlene Dietrich (1901–92).

29. *The Storm* [Groza, 1934], based on the play by Ostrovsky (see n. 8), was directed by Vladimir M. Petrov (1896–1966) for the Leningrad studio of Soyuzfilm and was released in March 1934.

30. In the tradition that derives from the *commedia dell'arte* the 'red clown' [*ryzhii*] is the comic clown, while the 'white clown' is the tragic figure.

31. This scene appears towards the end of *October*.

32. E and others repeatedly attacked the claims by Dziga Vertov (1896–1954) and his Cine-Eye group to show 'life caught unawares' [*zhizn' vrasplokh*] by underlining his selectivity in terms of both material and people depicted and by pointing out that he reshaped reality through montage.

33. 'Za kadrom' [Beyond the Shot], written as a postscript to N. Kaufman, *Yaponskoe kino* [Japanese Cinema] (Moscow, 1929), pp. 72–92. Translated by Leyda as 'The Cinematographic Principle and the Ideogram' in *Film Form*, pp. 28–44, and as 'Beyond the Shot' in *ESW 1*, pp. 138–50.

34. On the concept of overtonal montage see 'The Fourth Dimension in Cinema', *ESW 1*, pp. 181–94.

35. Nikolai P. Batalov (1899–1937) worked at the Moscow Art Theatre from 1924 and made his first screen appearance in the same year in *Aelita*. He played the part of the son, Pavel Vlasov, in *The Mother* and appeared in a number of other films. Vera F. Baranovskaya (1885–1935) trained at the Moscow Art Theatre and acted there from 1903 to 1915. She played the title role in *The Mother* and also appeared in Pudovkin's *The End of St Petersburg* [Konets Sankt-Peterburga, 1928]. She emigrated to Czechoslovakia in 1928 and died in Paris.

36. Lev V. Kuleshov (1899–1970) first developed the notion of montage and was regarded by other Soviet film-makers as the 'father of Soviet cinema'. *The Great Consoler* is based on the life of the American writer O. Henry. For *The Storm*, see n. 29 above. *A Petersburg Night* was directed by Grigori L. Roshal (1899–1983). All three films were released in 1934.

37. Rabis would have acted as agent for the majority of actors in Soviet films at the time.

38. Eduard K. Tisse (1897–1969) worked as cameraman on all E's films.

39. See especially the Cine-Eye manifesto 'Kinoki. Perevorot', *LEF*, 1923, no. 3 (June/July), pp. 135–43; translated in *FF* as 'The Cine-Eyes. A Revolution', pp. 89–94.

40. RAPP, the Russian Association of Proletarian Writers, was the driving force behind the so-called 'proletarian episode' in Soviet cultural history, which accompanied the First Five Year Plan between 1928 and 1932. The 'proletarian' campaigns ostensibly aimed to remove all artists who did not have impeccable proletarian origins, but also served to create an atmosphere of fear and tension from which the Party was able to appear to 'rescue' creative artists with the decree of April 1932 (see n. 41), which initiated the doctrine of 'Socialist Realism'. See also 1935, n. 15.

41. RAPP and the other proletarian cultural organisations were dissolved by a Central Committee decree of 23 April 1932, translated in *FF*, p. 325.

1935

1. The All-Union Creative Conference of Workers in Soviet Cinema was held in Moscow from 8 to 13 January 1935 under the slogan 'For a Great Cinema Art'. It was intended partly as a belated celebration of the fifteenth anniversary of the nationalisation decree of August 1919 and partly as a means of establishing for cinema the guidelines on Socialist Realism adopted at the Congress of Soviet Writers in August 1934. At this time E had not completed a film since 1929 and the abortive *Bezhin Meadow* project was just beginning. He was thus under considerable pressure to prove his credentials at the All-Union Creative Conference and he made two speeches, both of which are translated here. The texts were originally published in the minutes of the conference: *Za bol'shoe kinoiskusstvo* [For a Great Cinema Art] (Moscow, 1935), pp. 22–49 and 160–5. The translations here are, however, taken from versions corrected and expanded by E, preserved in TsGALI 1923/1/1124–7, and first published in *IP 2*, pp. 93–130.

2. Delivered to the opening session of the Conference on 8 January 1935.

3. Reference to the opening speech by Sergei S. Dinamov (1901–39), a Party activist and literary critic who specialised in American literature. Dinamov was arrested and shot in 1939.

4. 'Samoe vazhnoe' [The Most Important Thing], *Izvestiya* [The News], 6 January 1935; a fuller version is reprinted as 'Samoe vazhnoe iz iskusstv' [The Most Important of the Arts] in *IS*, pp. 89–94.

5. E did this in the article 'Srednyaya iz trekh' [The Middle of the Three]; see 1934, n. 20.

6. All four films were made in 1934: *Chapayev* was directed by the unrelated Vasiliev 'brothers', Sergei D. (1900–59) and Georgi N. (1899–1946); *The Youth of Maxim* [Yunost' Maksima] was made by the Leningrad directors, Grigori M. Kozintsev (1905–73) and Leonid Z. Trauberg (1902–90), as the first part of what was to become known as their 'Maxim Trilogy'; *Peasants* [Krest'yane] was directed by Friedrich Ermler. For *Happiness*, see '*Happiness*' below, pp. 52–5.

7. For the Cine-Eye group, see 1934 n. 32. Their principal manifestos of the period are translated in *FF*, pp. 69–72, 84, 89–94, 112–16, 129–31, 150–1 and 200–3.

8. For an account of Kuleshov's workshop and the development of the notion of the 'model' actor [naturshchik], see M. Yampolsky, 'Kuleshov's Experiments and the New Anthropology of the Actor', *IFF*, pp. 31–50.

9. Marfa Lapkina was the peasant woman who played the leading role in E's film *The General Line*.

10. I.e. the Cine-Eyes.

11. See 'The Dramaturgy of Film Form' and 'The Fourth Dimension in Cinema', *ESW 1*, pp. 161–94.

12. Some of these options are explored by Yuri Tsivian in 'Eisenstein and Russian Symbolist Culture: an Unknown Script of *October*' in I. Christie and R. Taylor (eds), *Eisenstein Rediscovered*, London and New York, Routledge, 1993, pp. 79–109.

13. See 'The Principles of the New Russian Cinema', *ESW 1*, pp. 195–202.

14. See *ESW 1*, pp. 151–60, but especially p. 158.

15. RAPP (the Russian Association of Proletarian Writers) was founded in 1925 as a literary pressure group, but laid aggressive claim to sole legitimacy and hegemony in all artistic matters in the name of proletarian culture. It attacked and hounded those who did not agree with its dogmatic positions, which included an insistence on the creation of credible proletarian heroes ('living man') instead of aesthetic experimentation, which was branded as 'Formalism'. See also 1934, n. 40.

16. *ESW 1*, p. 158.

17. Ivan I. Anisimov was a literary scholar who worked as a film critic in the late 1920s and early 1930s.

18. Vladimir A. Sutyrin was a film critic and scriptwriter, a leading member of ARRK, the

Association of Workers of Revolutionary Cinematography, during the 'proletarian hegemony' of the early 1930s and editor of the principal monthly journal on Soviet cinema, *Proletarskoe kino* [Proletarian Cinema]. He later headed the Screenplay Department of the Mosfilm studio.

19. The 'fellow-travellers' were those literary figures who had reservations about the Revolution but did not actively oppose it.

20. Sergei I. Yutkevich (1904–85), Soviet film director, who emerged at the 1935 Conference as one of E's principal opponents, extolling the virtues of the 'Leningrad school' of film-makers to which he, with Ermler, Kozintsev and Trauberg, belonged, at the expense of the school of 'montage poetry' to which he assigned E. After E's death, Yutkevich became Chairman of the Committee to Preserve Eisenstein's Heritage. *The Last Masquerade* [Poslednii maskerad] was directed in 1934 by Mikhail E. Chiaureli (1894–1974) for the Georgian film studio.

21. It was not unusual for leading directors from the centre, especially those actively involved in teaching, to travel to provincial studios in this consultative capacity, and E acted as consultant on Chiaureli's film, visiting Georgia between October and December 1932. E had been appointed head of the Faculty of Direction at VGIK on 1 October 1932.

22. Stalin was of course also a Georgian Bolshevik, and People's Commissar for Nationalities in the years immediately after the October Revolution.

23. *Counterplan* [Vstrechnyi] was directed by Yutkevich and Ermler for Rosfilm in 1932.

24. See *ESW 1*, pp. 151–60.

25. A reference to the abortive project for a Mexican film, *Que viva México!* See H. M. Geduld and R. Gottesman (eds.), *Sergei Eisenstein and Upton Sinclair: The Making and Unmaking of Que Viva Mexico!* (Bloomington, IN, 1970).

26. The Paramount company commissioned E to make a sound film in Hollywood but he was unhappy with the script he was offered. Instead he proposed a film adaptation of the novel by Blaise Cendrars, *L'Or*, the story of the Swiss settler Johann Sutter and his search for gold. Paramount rejected this script, *Sutter's Gold*, because it was not the adventure story they had been expecting, but a study of the effects on man of the greed stimulated by the California gold rush.

27. E resurrected this project after his return to the USSR in May 1932. In July 1933 he signed a contract with the Moscow studio to produce a script for a film adaptation of the novel *The Black Consul* [Chernyi konsul] by Anatoli K. Vinogradov in collaboration with the author. In December 1934 Paul Robeson (1898–1976) and his wife visited Moscow at E's invitation to discuss the project and, after a further visit in December 1936, Robeson promised E that he would be available for filming in the second half of 1937. By that time, however, the filming of *Bezhin Meadow* had been stopped and E was in a state of disgrace that lasted until Shumyatsky (1935 n. 67) had been removed from office in January 1938.

28. *The Golden Mountains* [Zlatye gory] was Yutkevich's first sound film, directed for Soyuzkino in 1931. There is no trace of E's introductory remarks in his archive.

29. Natan Zarkhi (see 1934 n. 26) wrote the script for the films *The Mother* [Mat', 1926] and *The End of St Petersburg* [Konets Sankt-Peterburga, 1927], directed by Vsevolod I. Pudovkin (1893–1953) for the Mezhrabpom-Rus studio.

30. *The Storm*: see 1934 n. 29. *A Petersburg Night*: see 1934 n. 36.

31. Johann Kaspar Lavater (1741–1841), Swiss poet, philosopher and theologian. A Protestant pastor, Lavater was an associate of Goethe and Herder and corresponded with both. E is here referring to his *Physiognomische Fragmente zur Beförderung der Menschenkenntnis und Menschenliebe* [Physiognomical Fragments in Pursuit of Human Knowledge and Human Love] (4 vols., Leipzig, 1775–8), translated into English as *Essays on Physiognomy* (1789–98).

32. See the keynote speech delivered by Maxim Gorky to the First Congress of Soviet Writers on 17 August 1934. It was this conference that adopted the guidelines of Socialist Realism for Soviet literature and, by implication, the other arts as well.

33. James Fenimore Cooper (1789–1851), American author of a collection of stories about the colonisation of North America published as *The 'Leather Stocking' Tales*, and including 'The Pathfinder', 'The Deerslayer' and 'The Last of the Mohicans'.
34. Titles of novels by French writers Victor Hugo (1802–85), Honoré de Balzac (1799–1850) and Eugène Sue (1804–57).
35. Paul Féval (1817–87), French writer of popular novels.
36. The following section of the text was substantially expanded by E after the Conference.
37. Alexander A. Potebnya (1835–91), Professor at Kharkov University and one of the founders of modern Russian linguistics.
38. Serafima G. Birman (1890–1976) was later to play the part of Yevfrosinia Staritskaya in E's *Ivan the Terrible*. Their correspondence is preserved in TsGALI.
39. Source: S. G. Birman, 'Akter i obraz' [The Actor and the Image], *Zaochnyi Kul'tzaem Moskovskogo kluba masterov iskusstv* [The Extramural Cultural Loan of the Moscow Club of Masters of the Arts], (First issue, Moscow, 1934). (E's reference)
40. Wilhelm Wundt (1832–1920), German physiologist, one of the founders of experimental psychology. He founded the first Institute for Experimental Psychology in 1879 in Leipzig, where he was professor from 1875 to 1917. His *magnum opus* was *Grundzüge der physiologischen Psychologie* (2 vols., 1873–4), translated as *Principles of Physiology* (London, 1904).
41. Lucien Lévy-Bruhl (1857–1939), French philosopher and sociologist, who developed the notion of 'primitive mentality' as something distinct from that of contemporaries in such works as *La Mentalité primitive* (Paris, 1922), translated as *Primitive Mentality* (London, 1923); and *Le Surnaturel et la nature dans la mentalité* (Paris, 1931), translated as *Primitives and the Supernatural* (London, 1935). The Klamaths were the native inhabitants of the mountains of northern California and southern Oregon.
42. Source: I. Mandelshtam, *O kharaktere gogolevskogo stilya* [On the Character of Gogol's Style], (1902) p. 118. (E's reference)
43. Herbert Spencer (1820–1903), British sociologist and philosopher, one of the founders of Positivism, who expounded the principles of evolution and the notion of the 'survival of the fittest' before Darwin; an advocate of *laissez-faire* in its extreme forms. The work that E is referring to here is presumably *Essays: Scientific, Political and Speculative* (3 vols., London, 1868–74).
44. F. Engels, *Socialism, Utopian and Scientific*, trans. E. Aveling, London, 1892, p. 29.
45. Olivier Leroy, French anthropologist whose *La Raison primitive* [Primitive Reason] was a critique of the ideas of Lévy-Bruhl.
46. Cf. E's open letter to Goebbels of 9 March 1934 in *ESW 1*, pp. 280–4.
47. Engels, *Socialism, Utopian and Scientific*, p. 35.
48. The 'agitpropfilm' emerged in the Civil War period as a documentary method of agitational and propagandist explanation. E is therefore taking a sideswipe here against documentary film in general.
49. 'Defamiliarisation' [*ostranenie*] was a device much used by the Formalist school and especially by Viktor B. Shklovsky (1893–1984). It involved heightening the sensation of an object by placing it in unfamiliar surroundings, or describing it from an unfamiliar viewpoint, in order to make the reader or spectator re-examine it. It should not be confused with the Brechtian notion of 'alienation' [*Verfremdung*].
50. The Academy of Cinema was a two-year course for scriptwriters and directors organised under the auspices of VGIK, the State Institute for Cinematography, in 1935. See pp. 74–97.
51. Nikolai Ya. Marr (1864–1934), Russian Orientalist and linguistic theorist. His ideas conflicted with established scholarship and he therefore declared that all traditional and Indo-European linguistics were not only antiquated but incompatible with Marxism. As an alternative he postulated a completely new 'Japhetic' theory of linguistics.
52. Le Corbusier, pseudonym of Charles Edouard Janneret (1887–1965), Swiss architect, one of the major influences on Constructivism and on contemporary town planning,

whose buildings in Moscow include that for Centrosoyuz. Ivan V. Zholtovsky (1867–1960), Soviet architect whose work was based on the revival of Classical and Renaissance styles.

53. Cinema had, of course, arrived in Russia some forty years previously, but the official line for much of the Soviet period was that serious or worthwhile cinema had only begun with the Soviet period, dating from the nationalisation decree of August 1919.

54. Delivered to the closing session of the Conference on 13 January 1935. On 11 January an award ceremony in the Bolshoi Theatre left E with the minimal honour of the title of Honoured Artist, while giving the highest accolade, the Order of Lenin, to Boris Shumyatsky, Vsevolod Pudovkin, Friedrich Ermler, the Vasiliev 'brothers', Grigori Kozintsev, Leonid Trauberg, Alexander Dovzhenko and Mikhail Chiaureli. But this was not purely and simply a snub to E, since his last completed film, *The General Line*, had been finished six years previously.

55. Pavel A. Blyakhin (1886–1961), Soviet scriptwriter, whose works included *The Little Red Devils* [Krasnye d'yavolyata, 1923]. His speech, relating to the awards of 11 January 1935, was printed in *Za bol'shoe kinoiskusstvo* (Moscow, 1935), pp. 157–9.

56. Konstantin Yu. Yukov (1901–38), Soviet film critic, one of the leading members of ARRK, the Association of Workers in Revolutionary Cinematography, and one of Shumyatsky's assistants who, like him, was purged in 1938.

57. Jacques-Louis David (1748–1825), French neo-classical painter. E is here referring to the official portraits painted by David during the Napoleonic era.

58. Lenin's *Materialism and Empiriocriticism* was written and published in 1909. This commemorative meeting therefore took place in 1934.

59. A. Deborin, 'Problema poznaniya v istoriko-materialisticheskom osveshchenii' [The Problem of Cognition in a Historical Materialist Light], *Pod znamenem marksizma* [Under the Banner of Marxism], 1934, no. 4, p. 125. (E's reference). Abram M. Deborin (1881–1963) was a Russian Marxist philosopher.

60. In all their films at this time Kozintsev and Trauberg (see 1935 n. 6) used Andrei N. Moskvin (1901–61) as cameraman and this undoubtedly gave their work a distinctive 'look'. Moskvin later worked with E on the studio shots for *Ivan the Terrible*.

61. George Sand, pen name of Aurore Dudevant (1804–76), French writer. The quotation is an extract from one of her letters to her fellow writer Gustave Flaubert (1821–80).

62. Familiar form for 'Sergei': i.e. Yutkevich.

63. Luke 12:31. This translation is from the Authorised Version, which is the nearest equivalent to the Russian translation used by E. The New English Bible translation is: 'No, set your mind upon his kingdom, and all the rest will come to you as well.'

64. Alexander P. Antonov (1898–1962), Soviet stage and film actor, who originally worked in a factory in the Simonov district of Moscow. He studied theatre with E and worked with him in the Proletkult Theatre, then as assistant on *The Strike* and *The Battleship Potemkin*, in which he played the fallen hero, Vakulinchuk.

65. Sergei D. Vasiliev: see 1935 n. 6. In his speech to the 1935 Conference, Vasiliev expressed the fear that E's theoretical work might lead to 'isolation from practical work'.

66. Cf 'Wolves and Sheep', p. 48.

67. Boris Z. Shumyatsky (1898–1938), Old Bolshevik and diplomat who was put in charge of Soyuzkino in October 1930 and thus controlled Soviet cinema for most of the 1930s, when he tried to establish on the Hollywood model what he termed a 'cinema for the millions' that combined ideological indoctrination with entertainment. In pursuit of this goal he had little sympathy with E, whose previous films had appealed within the Soviet Union only to elite audiences and who had not finished a film since 1929. Their disagreements over *Bezhin Meadow* are documented in *FF*, pp. 378–81 and below, pp. 100–5. Shumyatsky was arrested and denounced in January 1938 as a member of the 'Trotskyite-Bukharinite-Rykovite fascist band', and shot in July of the same year.

68. Friedrich Ermler (see 1934 n. 27) accompanied Shumyatsky on his trip to the USA later in 1935 to study Hollywood production methods.

69. E is here referring to the awards decree of 11 January 1935: see 1935 n. 54.

70. Source: 'Pravda nashei epokhi', *Pravda*, 12 January 1935.

71. See Lenin, 'Art Belongs to the People. Conversation with Clara Zetkin', translated in *FF*, pp. 50–2.

72. The anniversary being somewhat belatedly celebrated in January 1935 was the fifteenth anniversary of the decree nationalising Soviet cinema that Lenin had signed on 27 August 1919. See R. Taylor, *The Politics of the Soviet Cinema, 1917–1929* (Cambridge, 1979), p. 49. The principal celebration centred on the All-Union Creative Conference of Workers in Soviet Cinema, held under the slogan 'For a Great Cinema Art', and on the awards ceremony held in the Bolshoi Theatre in Moscow on 11 January 1935: see 1935 n. 54. The slight to E involved undoubtedly resulted at least in part from the personal antipathy between E and Shumyatsky (see 1935 n. 67), but it also reflected his failure to prove himself thus far as either a sound or a Socialist Realist film director.

73. This article was written in 1935 but was not published during E's lifetime. The original manuscript, with additions by Pera Atasheva but without the title ['Volky i ovtsy. Rezhisser i akter'], is held in TsGALI, 1923/1/1146. It was first published in *IS*, pp. 300–2, and the version translated here is taken from *IP 2*, pp. 304–6, which is in turn taken from the archival original.

74. See 1935 n. 54. E's speeches to the Conference are translated in this volume on pp. 16–46. This extract is to be found on p. 45. Other speeches are translated in *FF*, pp. 348–55.

75. A paraphrase of the title of Jack London's novel *The Iron Heel*.

76. The problem of the relative significance of the actor and the director loomed large at this time for several reasons: the advent of sound film had increased the potential for character development on screen; the adoption of Socialist Realism required a more convincing portrayal of 'real' screen characters with whom the mass audience could identify; the official rejection of the supremacy of montage as 'Formalist' and 'unintelligible to the millions' enhanced the significance of the actor at the expense of the director. The film press was full of articles examining the proper role of the actor in film. This article is at least in part E's retort to those who had accused him of being unable to work with actors and of suppressing the individuality of the actor.

77. The notion of the 'iron screenplay' [zheleznyi stsenarii] derives from the practice endorsed by the Soviet cinema authorities in which the director adhered strictly to the approved screenplay: this ensured political reliability and encouraged economy. Each instruction would be numbered, hence E's reference to a 'numbered iron screenplay'. E himself preferred to work from the loose framework of a 'libretto', enabling him to make what he refers to here as '"discoveries" at the last rehearsal': the most spectacular example of his deviation from an agreed script is probably *The Battleship Potemkin* and its emergence from the broader project for *The Year 1905*, but the problems over *Bezhin Meadow* (see pp. 100–5) arose at least in part because E's spontaneous creativity made it difficult, if not impossible, for the authorities to maintain any political control over the production of the film.

78. E is referring to the work 'Morning in the Pine Forest' [Utro v sosnovom lesu] (1889), painted by Ivan I. Shishkin (1832–98), known for his paintings of Russian nature. The painting, which depicts four black bears playing around a rotting tree trunk, now hangs in the Tretyakov Gallery in Moscow. Shishkin was a founder member of the group of Russian realist painters known as the Wanderers or Itinerants [Peredvizhniki] because they organised travelling exhibitions to bring art closer to the population at large.

79. Valentin A. Serov (1865–1911) was a fellow member of the Wanderers group of painters, whose landscapes were less stylised than Shishkin's. E analyses Serov's portrait of the actress Maria N. Yermolova in *ESW 2*, pp. 82–105.

80. Written in 1935 for the tenth anniversary of the release of *The Battleship Potemkin* and

published in *Komsomolskaya gazeta* [Communist Youth League Paper] on 27 June 1935 under the title 'Bronenosets "Potemkin". S ekrana v zhizn''. The original has not been preserved.

81. Nina F. Agadzhanova-Shutko (1889–1974) wrote the script for *The Battleship Potemkin*. It was originally conceived as one episode in a film cycle dealing with a whole range of events from *The Year 1905*, one of the films commissioned from Goskino by the Anniversary Commission established to supervise the celebrations of the twentieth anniversary of the so-called 'revolutionary year' of 1905. In the end *Potemkin* was the only part of this cycle that was completed and released.

82. Lieut. Peter P. Schmidt (1867–1906) was one of the leaders of the Sevastopol mutiny of 1905. He had earlier helped to form the Odessa Mutual Aid Society for Merchant Seamen, one of the first labour organisations in Russian shipping. On 20 October 1905 he was arrested by the authorities for addressing a political meeting in Sevastopol, whereupon he was promptly elected a life member of the Sevastopol Soviet of Workers' deputies. He was released on 3 November and, four days later, granted retirement with the rank of Captain, Second Class. On 14 November he boarded the cruiser 'Ochakov' and raised the red flag; the following day he was re-arrested. He was sentenced to death at his trial in February 1906 and executed on 6 March with other leaders of the mutiny.

83. Unable to restock with fuel and provisions, the crew of the 'Prince Potemkin of Tauride' sailed to the port of Constanţa in Romania, where they went ashore on 25 June 1905.

84. The mutiny on the Dutch battleship 'De Zeven Provinciën' occurred in 1933; see J. C. H. Blom, *De muiterij op De Zeven Provinciën* [The Mutiny on the 'Zeven Provinciën'] (2nd edn, Utrecht, 1983); and G. J. A. Raven and N. A. M. Rodger (eds.), *Navies and Armies. The Anglo-Dutch Relationship in War and Peace, 1688–1988* (Edinburgh, 1990), pp. 98, 101, 109.

85. Source: 'Styazhateli' [The Possessors] – the working title for the film released as *Happiness* [Schast'e] on 15 March 1935 by the Moskinokombinat (later Mosfilm) studio. The film was scripted and directed by Alexander Medvedkin (1900–89). The article was first published in *IP 5*, pp. 231–5, from a manuscript in TsGALI, 1923/1/1114. The working title refers to the debate within mediaeval Russian monasticism as to whether the monasteries should own and cultivate land (the 'possessors') or depend on alms (the 'non-possessors').

86. E has in mind his review of the film *Peasants* (see 1935 n. 6), which was published in *Izvestiya* on 11 February 1935.

87. *Chapayev* (see 1935 n. 6) portrayed the relative roles of a political commissar and military leader in the Civil War period. Its combination of excitement and adventure made it one of the most popular films of the 1930s as well as winning it official approval. It was promoted as a model for other film-makers to follow.

88. K. Marx and F. Engels, *The Communist Manifesto* (Harmondsworth, 1967), p. 84: 'The bourgeoisie has subjected the country to the rule of the towns. It has created enormous cities, has greatly increased the urban population as compared with the rural, and has thus rescued a considerable part of the population from the idiocy of rural life.'

89. *The Gold Rush* [USA, 1925], directed by Chaplin for United Artists, starred him as the Lone Prospector and Mack Swain as Big Jim McKay.

90. The Russian word used by E here is *styazhatel'*, meaning 'possessor'; see above, n. 85.

91. I.e. Pieter Breughel (or Bruegel) the Elder (*c.* 1525–69), sometimes called 'the peasant Breughel, Dutch painter known for his satirical landscapes after the style of Hieronymus Bosch (*c.* 1450–1516).

92. Roscoe Arbuckle (1881–1933), American comic actor, was known as 'Fatty'.

93. The rest of this passage has been lost.

94. Reference to N. Shchedrin, pseudonym of Mikhail Ye. Saltykov, also known as

Mikhail Ye. Saltykov-Shchedrin (1826–89), Russian writer and civil servant. Shchedrin's work was characterised by its use of grotesques in the service of social criticism, and he exercised a significant influence on both Chekhov and Gorky.

95. The 'Kappelites' [kappelovtsy] were named after the White Guard general during the Civil War of 1917–21, Vladimir O. Kappel (1883–1920). In December 1919 Kolchak made Kappel commander of the Eastern Front but he died during the retreat from Irkutsk in 1920. The remnants of Kolchak's troops in Transbaikalia and the Soviet Far East took on the name Kappelites.

96. Written in March 1935 and published as 'Charodeyu grushevogo sada' [To the Magician of the Pear Orchard] in the collection *Mei Lan'-fan i kitaiskii teatr* [Mei Lan-Fan and Chinese Theatre] (Moscow/Leningrad, 1935), pp. 17–26. This translation is from a fuller 1939 typescript in E's archive, with his own corrections (TsGALI 1923/2), reprinted in *IP 5*, pp. 311–24.

97. Mei Lan-Fan (1894–1961), a household name in his own country, was the only Chinese actor to become known outside China. He derived his reputation from his delicate playing of *dan*, the female characters, and was the first to combine the dramatic techniques of the five roles in Peking Opera, elevating the female role to the position previously held by the *laosheng*, or elderly male role. E first met Mei Lan-Fan on 12 March 1935 when the latter was visiting Moscow (where he also met Stanislavsky, Piscator and Brecht) with his theatre troupe. On 29 March E began shooting a short documentary film about the theatre and its style of acting, but the project came to nothing.

98. The Maly Theatre ('Lesser', as opposed to the Bolshoi or 'Grand'), one of the two Imperial theatres in Moscow, was known as the 'house of the actor'.

99. Alexander N. Ostrovsky (see 1934 n. 8) was administrator of the Maly Theatre in Moscow as well as being a playwright. He wrote more than fifty plays depicting, in a manner that was to prove a model for twentieth-century realist drama, the life of the merchant class and the common people. His best-known works are *The Storm* (1859); *Enough Simplicity for Every Wise Man* (1868), staged by E in 1923 as *Wise Man* (see *ESW 1*, pp. 33–8); *The Forest* (1871); and *The Snow Maiden* (1873).

100. See especially 'The Fourth Dimension in Cinema', *ESW 1*, pp. 181–94.

101. Source: 'Bolsheviki smeyutsya (Mysli o sovetskoi komedii)', a manuscript preserved in TsGALI 1923/1/1175. First published in Russian in *IS*, pp. 294–9; reprinted in *IP 5*, pp. 79–84. See also: *ESW 1*, pp. 195–202 and *ESW 4*, pp. 185–96.

102. The reference is to a campaign in the émigré press in Paris following the disappearance in Spring 1930 of General Kutepov, an associate of Denikin in the Civil War and later leader of the Russian émigré organisations in France.

103. E delivered this lecture on 17 February 1930. It was originally intended to accompany a showing of *The General Line* [*The Old and the New*] but the film was banned four hours before the performance. The text of the lecture is printed as 'The Principles of the New Russian Cinema', *ESW 1*, pp. 195–202.

104. Jean Chiappe (1878–1940), Prefect of the Paris police from 1927 to 1934, when he was sacked by Prime Minister Daladier for his extreme right-wing sympathies. His dismissal led to a mass demonstration of right-wing forces in Paris in February 1934, which in turn led to the fall of the Daladier government. In 1940 Chiappe was nominated by the Vichy government as High Commissioner to Syria. En route to Damascus his aircraft was shot down by the RAF. Because he signed the exclusion order for E from France in 1930, he features prominently in *ESW 4*, pp. 188, 197, 255, 259, 818.

105. Marcel Cachin (1869–1958), one of the founders and veteran activists of the French Communist Party.

106. E's recollection here differs slightly from *ESW 1*, p. 202.

107. This detail is not mentioned in *ESW 4*.

108. E is referring to *MMM* [Maxim Maximovich Maximov], a script he had prepared in 1933.

109. *The Pilgrim* was made by Chaplin for First National in 1922.
110. Anton P. Chekhov (1860–1904), Nikolai V. Gogol (1809–52), Mikhail E. Saltykov-Shchedrin (see 1935 n. 94) were all nineteenth-century Russian writers who deployed humour in various forms to criticise the hypocrisy, petty tyranny and spiritual and moral bankruptcy of tsarist society.
111. 'Socialism in one country' was the slogan associated with Stalin and the period of socialist construction that began with the First Five Year Plan, 1928–32.

1936

1. Source: 'Programma prepodavaniya teorii i praktiki rezhissury. O metode prepodavaniya predmeta rezhissury'. *Iskusstvo kino* [The Art of Cinema], 1936, no. 4, pp. 51–8. The author's original has not been preserved. E began working on this programme in 1928 when he first started working at the state film school (GTK, from 1925 to 1930; GIK, from 1930 to 1934; VGIK, from 1934 onwards), where in 1932 he became head of the Faculty of Direction. His first outline of a teaching programme was published in 1933 as 'Granit kinonauki' [The Granite of Film Science], *Sovetskoe kino* [Soviet Cinema], 1933, no. 5/6, pp. 58–67; no. 7, pp. 66–74; no. 9, pp. 61–73. The present article is a more concrete and detailed version of the 1933 draft, revised by E in the light of comments and criticisms.
2. *Leninskii sbornik*, Vol. IX, p. 277. (E's reference)
3. Ibid. (E's reference)
4. V. I. Lenin, 'What are the "Friends of the People"?', *Collected Works* (Vol. 1, Moscow, 1960), p. 83.
5. This phrase may be understood to cover two things. E saw the 'practical reconstruction of social reality' as the main task of the Soviet artist at this time, in the light of both the notion of the 'social command' and the doctrine of Socialist Realism, but he also viewed the practical activity of the working masses as a form of creativity.
6. E was much concerned with the 'interrelationship between all the disciplines of the Faculty'. On 8 March he had delivered a lecture at VGIK, 'On the Synchronisation of Disciplines in the Faculty of Direction'. The text is preserved in the VGIK archive.
7. E is here using the word 'audience' [auditorium] to mean the student audience, rather than the eventual cinema audience for the students' work.
8. *Leninskii sbornik*, Vol. XII, p. 325. (E's reference)
9. E here uses the Russian word 'razvedchik', which can denote a scout, reconnaissance aircraft or secret agent.
10. Rudolf Bode (1881–?), German gymnastics teacher and founder of expressive gymnastics as a reaction against the ideas of Emile Jaques-Dalcroze (1865–1950), with whom he originally studied. His book *Ausdruckgymnastik* [Expressive Gymnastics] was published in Munich in 1922. See also 'The Montage of Film Attractions' (1924), *ESW 1*, p. 51. Meyerhold: see 1934 n. 9. Biomechanics: see 1934 n. 12. The effect was to subjugate the actor's mind and body to the discipline of gymnastic control and the actor himself more completely to the dictates of the director.
11. E is here concerned to instil, through the study of literary examples and actual practice, the techniques of analysis or what he calls 'guided perception'.
12. In 'The Granite of Film Science' (see 1936 n. 1) E made direct reference to Lenin's views on the importance of the Classical heritage.
13. E is using these terms in the Marxist sense. He makes reference to Engels' analysis of them in 'The Granite of Film Science'.
14. This is E's rather pretentious term for selecting and rejecting facts as a result of the process of 'guided perception', or analysis.
15. E is referring to the film-train headed by Alexander I. Medvedkin (see 1935 n. 85), which toured the Donbass region in the early 1930s. See the interview with Medvedkin in *IFF*, pp. 165–75.
16. E means here that the reconstruction will be from a particular 'correct' standpoint.

17. There are numerous references to Leonardo, Zola and Gogol in both *ESW 2* and *ESW 4*.

18. Thomas A. Edison (1847–1931), American inventor of, among other things, the telegraph transmitter and receiver, the phonograph and the incandescent lamp. He also developed the kinetoscope, the immediate predecessor of the cinematograph. Henry Ford (1863–1947), the pioneer of motoring for the masses, founded the Ford Motor Company in 1903.

19. Soviet studios had produced thematic plans for their overall annual production programme since the mid-1920s. This became a requirement after 1930. E is here encouraging the practice at the micro level of the individual film, even though he was himself notorious for not planning ahead, at least as far as the financial side of a film project was concerned.

20. GUKF, the Chief Directorate for the Cinematographic and Photographic Industry, was the central organisation controlling the Soviet film industry from 1933 to 1937. Moscow, Leningrad and each of the Union Republics had their own studio organisation below this, but all were responsible to GUKF for planning matters and dependent on it for resources.

21. Before being approved for public release, Soviet films were at this period and for many years later shown to an audience of 'representative' workers to test audience reaction.

22. E is still using the term 'kinofabrika' [film factory] here, although GUKF decreed on 4 January 1936 that they should henceforth be renamed 'kinostudiya' [film studio], in accordance with Shumyatsky's professed desire to create the Soviet equivalent of Hollywood. We have used 'film studio' in the translation to avoid confusion with other kinds of factory than those producing films.

23. The title of this section echoes, probably subconsciously, the title of the 1929 book *Kino na Zapade i u nas* [Cinema in the West and at Home] by the then People's Commissar for Popular Enlightenment, Anatoli V. Lunacharsky (1875–1933), who himself wrote the scripts for a number of Soviet popular films. In 'The Granite of Film Science' E provided a long list of the films that he thought should be studied.

24. E was himself known affectionately as 'the old man' [starik].

25. Alexei G. Stakhanov (1905–77) was a miner from the Donbass whose alleged overfulfilment of production targets was held up as an example for others, hence 'Stakhanovite' and 'Stakhanovism'.

26. The MTS, machine tractor station, was the centralised repository for the mechanical equipment used for collective farming.

27. As we shall see, in E's plan each year furnished the student with additional levels of qualification. The Russian for 'technical assistant to the director' is *tekhnicheskii pomrezh*.

28. In a lecture to the Faculty of Direction at VGIK on 22 June 1936 E observed: 'What is *mise-en-scène raisonnée*? It is *mise-en-scène* "at the discussion stage", when at every stage the purpose of the exercise is discussed. The term is taken from French practice: a *catalogue raisonné* is a research catalogue.' (VGIK, Faculty of Direction, Eisenstein Archive, folder 22)

29. E has in mind the following passage from Engels' *Socialism. Utopian and Scientific*: 'Human common sense, a highly esteemed companion in the domestic situation, between four walls, experiences the most surprising adventures when it merely ventures out into the distant path of research.' (K. Marx and F. Engels, *Izbrannye proizvedeniya* [Selected Works] (vol. 2, Moscow, 1955, p. 121). Citing this quotation in 'The Granite of Film Science', E added: 'Metaphysical thought using the canons of formal logic is just as hopeless in questions of composition'; *Sovetskoe kino*, 1933, no. 7, p. 66.

30. Plato (420–327 BC), Greek philosopher. Aristotle (384–322 BC), Greek philosopher. Lucian (*c.* AD 115–after 180), Greek satirist. Marcus Phibius Quintilian (*c.* 35–*c.* 95), Roman teacher of rhetoric, author of *Institutio oratoria* [The Education of an Orator] (12 vols., Rome, AD 95). Marcus Tullius Cicero (106–43 BC), Roman orator, philosopher and statesman. René Descartes (1596–1650), French mathematician and philosopher, author of the remark 'Cogito, ergo sum' [I think, therefore I am].

Benedict Spinoza (1632–77), Dutch philosopher. Gotthold Ephraim Lessing (1729–81), German philosopher, dramatist and critic. E discusses his *Laocoön* in *ESW* 2, pp. 153–62.

E has the initial for Engel wrong: Johann Jakob Engel (1741–1802), German writer, author of *Ideen zu einer Mimik* [Ideas on Mime] (2 vols., Berlin 1785–6). See also *ESW* 2, p. 36. Guillaume-Benjamin-Arnaud Duchenne (1806–75), French neurologist and author of *Mécanisme de la physionomie humaine ou Analyse électro-physiologique de l'expression des passions* [The Mechanism of Human Physiognomy or the Electro-Physiological Analysis of the Expression of the Passions] (Paris, 1876). E also referred to Duchenne's work in 'The Montage of Film Attractions' (1924) in *ESW* 1, p. 51, and again in 'Laocoön' in *ESW* 2, p. 114. Louis Pierre Gratiolet (1815–65), French physiologist who specialised in the structure of the brain, author of the book *De la Physionomie et des mouvements d'expression* [On Physiognomy and Expressive Movements] (Paris, 1865). Charles Darwin's (1809–82) theory of evolution was propounded mainly in his *The Origin of Species* (properly entitled *On the Origin of Species by Means of Natural Selection*), published in 1859, and *The Descent of Man, and Selection in Relation to Sex*, published in 1871. Vladimir M. Bekhterev (1857–1927), Russian psychiatrist and neurologist, one of the founders of Russian experimental psychology and principal proponent of the notion of reflexology. His two major works were *Ob obshchikh osnovakh refleksologii kak nauchnoi distsipliny* [The General Principles of Reflexology as a Scientific Discipline] (Moscow 1917) and *Kollektivnaya refleksologiya* [Collective Reflexology] (Moscow, 1921). See also 'Constanţa', *ESW* 1, p. 68, and 'Perspectives', *ESW* 1, p. 155. Giovanni da Udine (1487–1564), Italian painter who collaborated with Raphael, author of the book *L'Art et le geste* [Art and Gesture] (Paris, 1910). E cites this work in 'Vertical Montage', *ESW* 2, p. 369. Havelock Ellis (1859–1939), British writer, author of *Studies in the Psychology of Sex* (London, 1897). William James (1842–1910), American psychologist and philosopher and brother of the writer Henry James. Author of *The Principles of Psychology* (2 vols., New York, 1890), *Pragmatism* (New York, 1907) and *Essays in Radical Empiricism* (New York, 1912). Ludwig Klages (1872–1956), German philosopher, psychologist and founder of biocentric metaphysics, developed a methodology for a 'science of expression'. His major work was *Der Geist als Widersacher der Seele* [The Spirit as Antagonist to the Soul] (3 vols., Leipzig, 1929–32). He also wrote *Ausdrucksbewegung und Gestaltungskraft* [Expressive Movement and Creative Power] (Leipzig, 1913). E also discusses his work in 'The Montage of Film Attractions' (1924) in *ESW* 1, p. 52, and 'The Dramaturgy of Film Form' in *ESW* 1, p. 162. Theodor Piderit (1826–?), German physician and psychologist, author of *Mimik und Physiognomie* [Mime and Physiognomy] (1886) and specialist in human expressiveness. Carl Gustav Carus (1789–1869), German physician, naturalist, painter and philosopher who corresponded with Goethe. Carus was one of the first to recognise the importance of the subconscious and his ideas in many ways presaged those of Klages. His most important work was *Symbolik der menschlichen Gestalt* [The Symbolism of the Human Character] (1853). Rudolf Bode: see 1936 n. 10 and *ESW* 1, pp. 51, 163. Walter Bradford Cannon (1871–1945), American physiologist, author of *Mechanical Factors of Digestion* (New York, 1911) and *The Wisdom of the Body* (New York, 1932). Sigmund Freud (1856–1939), Austrian psychologist, founder of psychoanalysis. See also *Beyond the Stars*, pp. 104–6. Carl Leshley (1890–?), American psychologist who studied the relationship between human consciousness and behaviour. Ivan P. Pavlov (1849–1936), Russian physiologist and Nobel prizewinner, known for his experimental work on animal behaviour and, in particular, conditioned reflexes.

31. François Delsarte (1811–70), French student and theorist of stage gesture and movement, teacher of Emile Jaques-Dalcroze (see 1936 n. 10) and precursor of modern dance. Prince Sergei M. Volkonsky (1860–1937), the principal proponent in Russia of Delsarte's teachings, author of *Vyrazitel'nyi chelovek* [Expressive Man].

32. In preparatory materials dating from 1928, E, analysing this particular problem, wrote: 'As distinct from the formula "expression is a 'sign'"' (Klages) of action (intention) or an "assimilation" (Bekhterev) with action, I maintain that expression is neither a static sign nor an assimilation but the process of the action itself.' (TsGALI, 1923/2)

33. In 'The Granite of Film Science' E had cited Engels once more in relation to this point: The key to this has also been indicated by Engels: 'We are in a position to evoke a specific action by creating the conditions under which it occurs in nature' (*Dialektika prirody* [The Dialectics of Nature] (Moscow, 1950), p. 182). The theory of conflict also tries as closely as possible to understand and set out the conditions in which and under which 'the expressive manifestation occurs in nature, so that on the basis of a knowledge of them and the laws that underpin them, it is in a position to construct and reconstruct the necessary expressive manifestations in the images of art.' (*Sovetskoe kino*, 1933, no. 7, p. 68)

34. E is here referring to the school of Russian literary theorists who preached the primacy of form over content and who published the collection *Poetika kino* (Leningrad, 1927), translated as 'The Poetics of Cinema' (ed. R. Taylor), *Russian Poetics in Translation*, no. 9 (Oxford, 1982). The theory of *ostranenie* ['defamiliarisation' or 'making strange'] is associated with Viktor B. Shklovsky (see 1935 n. 49), prominent Formalist theorist of literature and film.

35. Reference to a group of Leningrad film-makers directing for the Leningrad studio that had by this time become Lenfilm and including the FEKS group (Kozintsev and Trauberg), Ermler and others who allegedly put style and form before content.

36. See 'To the Magician of the Pear Orchard', pp. 56–67.

37. Nikolai Ya. Marr: see 1935 n. 51.

38. See 'Beyond the Shot' in *ESW 1*, pp. 138–50.

39. The first two parts of *Towards a Theory of Montage* are entitled 'Montage in Single Set-Up Cinema' and 'Montage in Multiple Set-Up Cinema'; see *ESW 2*, pp. 11–223.

40. E examines these various types of montage in 'The Fourth Dimension in Cinema' (1929) in *ESW 1*, pp. 186–94.

41. 'Polizhanrizm' [polygenrism] is the word used here by E to denote a multiplicity of genres.

42. The subject of pathos is at the heart of E's *Nonindifferent Nature* (Cambridge, 1987).

43. See 1936 n. 15.

1937

1. Source: 'Oshibki "Bezhina luga"' [The Mistakes of *Bezhin Meadow*], in the booklet *O fil'me 'Bezhin lug' S. Eizenshteina* [On S. Eisenstein's Film *Bezhin Meadow*] (Moscow, 1937), pp. 53–63, which was also reproduced, minus the references to Stalin, in *IS*, pp. 383–8. A slightly different version was published in *Sovetskoe iskusstvo* [Soviet Art], no. 18, 17 April 1937, p. 3. This translation is from the booklet. The filming of *Bezhin Meadow* had been stopped on 17 March 1937 on official orders.

2. Here E uses the word 'tipichnost''. For 'tipazh', the idea developed by E in the 1920s, see *ESW 1*, pp. 198, 200–1.

3. GUK [Gosudarstvennoe upravlenie kinofotopromyshlennosti], the State Directorate for the Cinema and Photographic Industry, was the state body responsible for all aspects of Soviet cinema. It was headed until January 1938 by Boris Z. Shumyatsky: see his piece on *Bezhin Meadow*, 'O fil'me *Bezhin lug*' [The Film *Bezhin Meadow*], *Pravda*, 19 March 1937 (two days after filming was stopped), translated in *FF*, pp. 378–81. Mosfilm was the Moscow film studio for which E directed both *Alexander Nevsky* and *Ivan the Terrible*.

4. See 1936 n. 1.

5. The Central Committee meeting of 23 February to 5 March 1937 launched the period of the purges and show trials known as the 'Yezhovshchina' after the People's Commissar for Internal Affairs and General Commissar for State Security, Nikolai I.

Yezhov (1895–1939). While the Committee was in session, two of the principal surviving Old Bolsheviks, Nikolai I. Bukharin (1888–1938) and Alexei I. Rykov (1881–1938), were arrested for 'anti-Soviet rightist Trotskyite' activity. They were tried and shot in March 1938. The Committee meeting listened to a lengthy denunciation by Stalin of 'spies and wreckers' in industry, the administration and the Party, which served as the spur for the 'Yezhovshchina'. Seventy per cent of those attending the meeting were subsequently arrested and shot, most of them within the following eighteen months. In June 1937 Marshal Tukhachevsky and a group of the highest generals in the Red Army were secretly tried for treason and shot. The process of 'criticism, self-criticism, examination and self-examination' was supposed to flush out remnants of the spies, saboteurs, wreckers and other alleged 'enemies of the people'.

6. Source: 'Iz istorii sozdaniya fil'ma *Aleksandr Nevskii*', *IP 1*, pp. 159–60, from TsGALI, 1923/2. Written in 1937, the centenary of the death of Alexander S. Pushkin (1799–1837), Russia's greatest national poet and formulator of her literary language. Between 1940 and 1944, E worked on a project for a film about Pushkin to be entitled *The Love of a Poet* [Lyubov' poeta] and inspired by the novel *Pushkin*, written at the end of his life by Yuri N. Tynyanov (1894–1943); see *ESW 4*, pp. 712–24.

7. Pushkin's letter to the children's writer Alexandra O. Ishimova (1806–81), dated 27 January 1837, was his last letter, written on the morning of his fatal duel.

8. E is referring to Pushkin's review of M. N. Zagoskin, *Yurii Miloslavskii, ili Russkie v 1612 godu* [Yuri Miloslavsky, or the Russians in 1612] in *Literaturnaya gazeta* [Literary Gazette], 21 January 1830.

9. This review of *Lenin in October* [Lenin v oktyabre, 1937] was first published as 'Obraz gromadnoi istoricheskoi pravdy i realistichnosti' in the newspaper *Za bol'shevistskii fil'm* [For Bolshevik Film], 27 December 1937. The film was directed for the Mosfilm studio by Mikhail Romm; see 1934 n. 2.

10. The title role was played by Boris V. Shchukin (see 1934 n. 18), a stage actor at the Vakhtangov Theatre, follower of Stanislavsky's 'Method' and one of the first actors to portray Lenin on the screen.

11. Ilyich was Lenin's patronymic and is used in Russian to refer to him affectionately.

12. The reference is to Lev B. Kamenev (1895–1938) and to Grigori Ye. Zinoviev (1883–1936), two Old Bolsheviks who sided with Stalin after Lenin's death but in 1926 joined forces with Trotsky to form the 'United Opposition'. Both were expelled from and readmitted to the Party several times. After the assassination of the Leningrad Party leader Sergei M. Kirov (1886–1934) in December 1934, Kamenev and Zinoviev were among the leading defendants at the first major show trial in August 1936, after which they were both shot. The 'vile treachery' depicted in *Lenin in October*, to which E is here referring, centres on their opposition in July 1917 to Lenin's view that the Bolsheviks should themselves seize power.

13. Alexei Ya. Kapler (1904–79), scriptwriter for both *Lenin in October* and *Lenin in 1918* [Lenin v 1918 godu, 1937].

14. On 12 December 1937 the first elections under the new Soviet Constitution (see following note) were held in the USSR. On the eve of the elections, in a set-piece occasion in Moscow's Bolshoi Theatre, Stalin, who had been nominated by 3,346 electoral districts but could only stand in one, accepted the nomination for the Stalin district, which, perhaps not surprisingly, covered central Moscow. His acceptance speech was an indication that a further wave of purges and show trials was in the offing.

15. In December 1936 the USSR adopted a new Constitution, known colloquially as the 'Stalin Constitution', which he described as 'the most democratic in the whole world'. It was supposed to mark the country's transition from the dictatorship of the proletariat to a socialist society.

16. Nikolai P. Okhlopkov; see 1934 n. 2.

1938

1. Source: 'Aleksandr Nevskii i razgrom nemtsev', *Izvestiya* [The News], 12 July 1938.
2. The Tatars' domination of Russia began with the establishment of Mongol rule under Genghis Khan over most of the country in 1219–25 and the Battle of Kalka in 1223 was the crucial turning-point, but the thin layer of the ruling class could not at that time effectively subjugate the Russians. The Golden Horde began that subjugation in 1236 under Genghis Khan's grandson, Batu, and their victories led to Russia's exploitation, cultural decay and isolation from the rest of Europe, lasting for over two centuries until the liberation of Moscow from Tatar rule by Ivan III in 1480 (although the decline in Mongol influence can be dated to their defeat at the Battle of Kulikovo Field in 1380). The Mongols defeated an army of German and Polish knights at the Battle of Liegnitz (now Legnica) in 1241 but drew back from Europe partly to be involved in the selection of a successor to Khan Ogedei, who had just died. On their way back to Russia the Mongol armies were savaged at the Battle of Olmütz (now Olomouc). Wenceslas [Vaclav] I Przemysl was King of Bohemia from 1230 to 1253.
3. The Teutonic Order of Knights was founded near Acre (also known as Ptolemais and now called Akko) in 1190 (and not, as E claims, at the beginning of the twelfth century) as a fraternity to serve the sick, and became a chivalric military order in 1198. The Order settled in Transylvania but was expelled in 1225 and settled in Prussia in 1230. In 1237 the order was united with the Livonian Order (founded in 1201). The Teutonic and Livonian Knights were defeated at the battle on the frozen surface of Lake Peipus in 1242. This battle scene lies at the heart of E's film.
4. The Brown House in Munich was the original headquarters of the National Socialist German Workers' Party.
5. Livonia covered the area from the Gulf of Riga to Lake Peipus between Riga, now capital of Latvia, and Dorpat, now Tartu in Estonia. The Zhmuds came from an area known as Samogitia in what is now the western part of Lithuania between Kaunas, Klaipeda and Šiauliai.
6. In the film *Alexander Nevsky* Tverdila Ivankevich represents the figure of the traitor, saboteur or wrecker, who featured so largely in the propaganda campaigns that accompanied the show trials and the purges of the 1930s.
7. In 1019 Prince Yaroslav I empowered the *veche*, or town assembly, of Novgorod to elect its own prince, mainly as a military commander. But, after 1270 the *veche* elected only a mayor and sovereignty resided in the town itself, which was then styled 'Lord Novgorod the Great' [Gospodin velikii Novgorod].
8. These 'people's volunteers' are also referred to as the 'peasant levy'.
9. In Russian the term for the military formation known in English as a cavalry wedge is 'svin'ya' or 'pig'.
10. At the Battle of Cannae in 216 BC Hannibal defeated the Romans by trapping their army in a pincer movement. This is regarded as the first time that the tactic had been used.
11. An old Russian measurement approximately equivalent to a kilometre.
12. See the postscript to the film, cited in 'My Subject is Patriotism', p. 120.
13. First published in an anonymous English translation in *International Literature*, 1939, no. 2, pp. 90–3. The original Russian typescript is preserved in two versions in TsGALI 1923/1/1194 and the fuller of the two, here translated by Richard Taylor, was first published in *IP 1*, pp. 161–4. The shorter Russian version was first published in *IS*, pp. 389–92.
14. *The Strike* and *The Battleship Potemkin* dealt with the underground struggle in the tsarist era, *October* with the Revolution of 1917 and *The General Line* (reworked and released as *The Old and the New*) with collectivisation.
15. The Spanish Civil War had begun in 1936 with a revolt by military commanders in Spanish Morocco, including Franco, against the policies of the Republican government. The British and French governments pursued an official policy of non-intervention and for three years Spain became a battleground for the competing

ideologies of fascism, backed by Germany and Italy, and socialism, backed by the USSR. When the Civil War ended in March 1939 well over half a million people had been killed.

In September 1938, under the Munich Agreement, Britain and France agreed to the secession of the German-speaking Sudetenland from Czechoslovakia. In March 1939 German troops occupied the rest of the country: the Czech lands became the protectorate of Bohemia and Moravia and a puppet government was set up in Slovakia.

In 1931 the Japanese occupied Manchuria, the north-eastern and most highly industrialised province of China. In February 1932 they installed the last Chinese Manchu emperor as ruler of the puppet state of Manchukuo, which was recognised only by Japan and its allies but which survived until 1945, when it fell into the hands of the Chinese Communists and was to prove a key element in the Civil War against the Kuomintang government.

16. Stalin had given Soviet Jews the homeland of Birobidzhan, in the Soviet Far East, in 1934, but few of them ever settled there.

17. Soviet cinema had produced a large number of films warning, either directly or indirectly, against the rise of Nazism and anti-Semitism, such as *Professor Mamlock* [1938] and *The Oppenheim Family* [Sem'ya Oppengeim, 1939]. See K. R. M. Short and R. Taylor, 'Soviet Cinema and the International Menace, 1928–1939', *Historical Journal of Film, Radio & Television*, vol. 6 no. 2, October 1986, pp. 131–59.

18. This sequence is discussed at length in *ESW 2*, pp. 379–99.

19. See 1938 n. 10.

20. In August 1939 Soviet and Mongolian troops had repelled an attack by the Japanese Sixth Army along the Khalkin-Gol River, which had been intended to lead to the Japanese occupation of the eastern part of the Mongolian People's Republic.

21. *Alexander Nevsky* was released in the Soviet Union on 1 December 1938.

22. The passage between square brackets does not appear in the Russian original but was added for the published English translation in 1939.

1939

1. Source: 'Sluzhim narodu', *Izvestiya*, 11 February 1939. On 1 February a decree of the Presidium of the Supreme Soviet of the USSR had awarded the Order of Lenin to both the Mosfilm Studio and E for the film *Alexander Nevsky*.

2. Alexander P. Dovzhenko (1894–1956), Ukrainian Soviet film-maker, best known for his silent film *Earth* [Zemlya, 1930]. *Shchors* [1939] was allegedly inspired by a conversation that Dovzhenko had with Stalin. See *FF*, pp. 383–5.

3. In November 1938, after completing *Alexander Nevsky*, E began working on the script for *Perekop*, a film dealing with the decisive victory in the Civil War of the Red Army under their commander, Mikhail V. Frunze (1885–1925) at the battle of Perekop in the Crimea in 1920, and based on a manuscript by Lev V. Nikulin (1891–1967) and Alexander A. Fadeyev (1901–56). Since his Proletkult days E had been acquainted with Isaak E. Babel (1894–1941?), author of the *Red Cavalry* short stories, Frunze himself, Semyon M. Budyonny (1883–1973), the founder of the Red Cavalry, Kliment Ye. Voroshilov (1881–1969) and other veterans of the campaign, and had gathered a considerable amount of material. He was still producing sketches for the film in October 1941 and it is not known why the project was never completed.

1940

1. Translated from the minutes of a speech delivered by E at the Creative Conference on Problems of Historical and Historical-Revolutionary Film in 1940 (TsGALI 1923/1/1241), printed in *IP 5*, pp. 110–28. E wrote an article based on his speech: 'Sovetskii istoricheskii fil'm' [Soviet Historical Film], *Pravda*, 8 February 1940.

2. This film was directed by Olga I. Preobrazhenskaya (1881–1971) and Ivan K. Pravov

(1899–1971) and released on 19 September 1939. Unusually for a film of that time, it received very mixed reviews: see, for instance, *Pravda*, 4, 7 and 17 September 1939; *Kino*, 5, 11 and 17 September; *Literaturnaya gazeta*, 20 September 1939.

3. *Lenin in 1918*: see 1934 n. 2.

4. Reference to Dom Kino [Cinema House], a centre for those involved in all aspects of cinema which opened in Moscow in 1934. Similar establishments were opened in the other large cities of the USSR. They provided facilities such as conference rooms and viewing theatres, libraries and restaurants. Major films were previewed and discussed at Dom Kino before being released.

5. William Shakespeare was born, and Michelangelo (see also 1946/7 n. 113) died, in 1564. Ivan the Terrible died in 1584, however, when Shakespeare would have been twenty, not thirty as E claims here. Giordano Bruno (1548–1600), a Dominican friar who came to favour the astronomical views of Copernicus, was burnt at the stake in 1600. *Twelfth Night* was written between 1599 and 1601 and first performed in 1601, while *Hamlet* was probably written in 1601–2 and probably first performed in 1602. *Lear* was written in 1605–6 and first performed on 26 December 1606, and *Macbeth* was written at the same time and first performed in 1611. Boris Godunov died in 1605. The Three Musketeers, in the eponymous novel by Alexandre Dumas (1802–70), were swashbuckling heroes from the France of the early seventeenth century. Ivan Susanin (d. 1613) was a hero of the early seventeenth-century Russian war of liberation against the Poles (see also 1940 n. 26, and 1946/7 n. 27) who sacrificed his life to save that of the newly elected Tsar Mikhail Fyodorovich Romanov in 1613. His story provided the subject for the opera *A Life for the Tsar* by Mikhail I. Glinka (1804–57).

6. Johann Wolfgang von Goethe (1749–1832), German poet and dramatist. Alexander S. Griboyedov (1794–1829), Russian dramatist, founding father of Russian stage realism and therefore essentially a more 'modern' figure than Goethe.

7. The actual title of Goldschmidt's book is *Ascaris. Eine Einführung in die Wissenschaft vom Leben für jedermann* [Thread-Worm. An Introduction to the Science of Life for Everyman]. See *ESW 4*, pp. 611–13.

8. *Viva Villa!* was directed by Jack Conway for MGM and starred Wallace Beery as Villa.

9. Francisco 'Pancho' Villa (1878–1923) was a Mexican bandit and general, who supported Madero against Díaz (see 1940 n. 10) in 1910, played a leading part in the ensuing Mexican Civil War, and was assassinated in 1923. Emiliano Zapata (1883–1919) was leader of the left wing of the revolutionary peasantry during the Mexican Civil War. His 'Plan de Ayala' proposed radical agrarian reform akin to later Soviet policies. He was known variously as the apostle of agrarian reform and, because of his brutality, as the Attila of the south. He was assassinated in 1919.

10. Porfirio Díaz (1830–1915), Mexican dictator, made the mistake of telling a journalist in 1908 that he personally favoured democracy for Mexico. Francisco Indalesio Madero (1873–1913), a millionaire ranch-owner, took him at his word and stood against him in the 1910 presidential election. Madero's imprisonment on the eve of the election led to widespread popular resentment, the resignation of Díaz in 1911 and seven years of revolution and civil war. Madero, a liberal, became president until his assassination in 1913.

11. Possibly a paraphrase of the remark by the British historian E. A. Freeman (1823–92) that 'History is past politics, and politics is present history.'

12. *A Great Citizen* [Velikii grazhdanin] was directed by Ermler (see 1934 n. 27) for Lenfilm and released in February 1938. It was based on the life of Sergei Kirov: see 1937 n.12.

13. Buskins were high thick-soled boots worn in ancient times by tragic actors. The dressing-gown and nightcap are used here by E to represent the mundane and the everyday.

14. Samson was the executioner at the time of the French Revolution, cited by Pushkin as one example of the phenomenon of horror stories popular in France at the time.

15. A. S. Pushkin, 'O zapisakh Samsona' [On Samson's Notes], first published in *Literaturnaya gazeta*, 1830, no. 5; reprinted in *Polnoe sobranie sochinenii* [Complete Collected Works], vol. 7 (Moscow, 1964), p. 104.

16. E is here referring to the period of the Weimar Republic in Germany from 1918 until Hitler's accession in 1933. *Bismarck* was a relatively straightforward biographical documentary film about the German Chancellor, released in 1926. *Fridericus Rex*, which was based on the life of Frederick the Great, was unashamed propaganda for the restoration of the monarchy: it was directed for UFA by Arsen von Cserépy and released in 1922.

17. Charles Stewart Parnell (1846–91), leader of the Irish Home Rule movement who used parliamentary obstruction and encouraged the 'boycotting' of unpopular landlords to further his cause, eventually winning over Gladstone to Home Rule. Parnell was cited in 1890 in the O'Sheas' divorce case, which brought about his political downfall and hastened his premature death.

18. Thomas Carlyle (1795–1881), Scottish historian and man of letters, who believed in the importance of the individual in history. He saw Cromwell as the greatest English example of the heroic ideal and in 1845 edited *Oliver Cromwell's Letters and Speeches. With Elucidations*.

19. T. Carlyle, *Carlyle's Cromwell, Abridged and Newly Edited* (London, 1905), p. 368.

20. Because of his Calvinistic upbringing, Carlyle tended to place greater emphasis on the role and responsibility of the individual in history than subsequent generations of historians have done.

21. *Chapayev*: see 1935 n. 6.

22. *Lenin in October*: see 1934 n. 2.

23. The project for a film about the Civil War under the title *Perekop* dates from the spring of 1939, between *Alexander Nevsky* and the project for *Fergana Canal*. Frunze: see 1939 n. 3.

24. The references are to Pushkin's *Boris Godunov*, written in 1825 but not performed until 1870. 'I have attained the greatest power' are the opening words of Boris's monologue in Scene 7 in which he laments the loneliness and unhappiness of high office. 'The people is silent' [Narod bezmolvstvuyet] is the final stage direction of the play: some translators have chosen to render the direction as 'The people are speechless'.

25. *Peter the First* [Petr Pervyi] was directed in two parts by Petrov (see 1934 n. 29) for Lenfilm: Part One was released on 31 August 1937 and Part Two on 7 March 1939.

26. *Minin and Pozharsky* [Minin i Pozharskii, 1939] was directed by Pudovkin (see 1935 n. 29) and Mikhail I. Doller (1889–1952) and is based on the tale of the prince and the peasant who united to defend Russia against the marauding Poles. See also 1940 n. 5 and 1946/7 n. 27.

27. *The Mother* [Mat'] was directed by Pudovkin in 1926.

28. *Juarez* [USA, 1939] was directed by William Dieterle (1893–1972).

29. The actual title of this film was *The Life of Emile Zola* [USA, 1937] and it was also directed by Dieterle. Both this film and *Juarez* were part of a series of biopics for Warners and starred Paul Muni (1895–1967) in the title roles.

30. According to the editors of the Russian edition of E's works, this is a reference to a film by James Cruze (1884–1942); it therefore seems probable that it is *Sutter's Gold* [USA, 1936], another film project that had originally been assigned to E.

31. *The Battleship Potemkin* was in fact originally conceived as one part of an epic film, *The Year 1905*.

32. I.e. the 'Maxim trilogy'; see 1935 n. 6.

33. In the original treatment of the plot the film was to have ended with Alexander Nevsky paying tribute to the Tatar Khan.

34. Sokolniki is a north-eastern suburb of Moscow with a large pleasure park, including an ice-rink.

35. Ilya Ye. Repin (1844–1930), Russian painter associated with the Wanderers, who organised travelling exhibitions of their Realist paintings in an attempt to broaden the appeal of art.

36. Nicolas Poussin (1594–1665), French landscape painter.
37. F. Engels, 'Wanderings in Lombardy', written in the spring of 1841 and published in *Athenäum*, no. 48, 4 December 1841. This translation is from K. Marx and F. Engels, *Collected Works. Vol. 2. Friedrich Engels: 1838–42* (Moscow and London, 1975), p. 173.
38. The words 'spirit of nature' are in English in Engels' original German. The spirit of nature, represented by the pantheistic figure of Pan, appears in Shelley's works, particularly in *Queen Mab*.
39. The Drachenfels, near Königswinter, and the Rochusberg, near Bingen, were two beauty spots famed in the nineteenth century for their spectacular views across the Rhine Valley. See K. Baedeker, *The Rhine from Rotterdam to Constance* (10th edn, Leipzig, 1886), pp. 81–2, 120.
40. F. Engels, 'Landscapes', was first published in *Telegraph für Deutschland*, no. 122, July 1840. This translation is from Marx and Engels, *Collected Works. Vol. 2*, pp. 95–6.
41. The Dordrecht Synod of 1618–19 condemned the nonconformist sectarian views of the Arminians and reasserted strict Calvinist dogma.
42. Marx and Engels, *Collected Works. Vol. 2*, p. 97.
43. Nikolai K. Roerich (1874–1947), Russian painter, graphic artist and set designer, who worked with Sergei P. Diaghilev (1872–1929) for the Ballets Russes. Roerich was inspired by Russian folk motifs and designed the sets for Diaghilev's productions of *The Polovtsian Dances*, based on the opera *Prince Igor* by Alexander P. Borodin (1833–87), in 1909 and for the first performance of *The Rite of Spring* by Igor F. Stravinsky (1882–1971) in 1913. For Serov, see 1935, n. 79.
44. Vasili I. Surikov (1848–1916), Russian painter associated with the Wanderers (see 1935 n. 78).
45. In May 1939 E drafted a project for a film about the proposed Fergana Canal irrigation scheme in Uzbekistan, to be called *The Great Fergana Canal* [Bolshoi Ferganskii kanal]. The project developed into a proposal for a trilogy, for which the script, written in collaboration with Pyotr A. Pavlenko (1899–1951) – who had also worked on the script for *Alexander Nevsky* – was completed by August. E spent the period from mid-August to the end of October shooting test takes in Uzbekistan. On 26 July 1939 he wrote to Prokofiev, asking him to compose the score for the film and enclosing a libretto. In his covering letter E explained that the main theme of the film was the struggle between sand and water, with victory for water being assured only by man's intervention.
46. Vincent Van Gogh (1853–90), Dutch painter, whose purest and most transparent paintings were in fact done after he had left the Netherlands and moved to the South of France.
47. 'Quattrocento': Italian for the fifteenth century.
48. *The Volochayev Days* [Volochayevskie dni, 1937] was directed by the Vasiliev 'brothers'; see 1935, n. 6. *Aerograd* [1935], set in the Soviet Far East, was directed for Mosfilm by Dovzhenko (see 1939 n. 2).
49. *Engineer Kochin's Mistake* [Oshibka inzhenera Kochina] was directed for Mosfilm by Alexander V. Macheret (b. 1896) and released in December 1939. See also 1940 n. 143.
50. Jacques Callot (1592/3–1635), French etcher whose masterpiece, completed in 1633, was entitled *Les grands misères de la guerre* [The Great Miseries of War]. For 'The Tale of the Vixen and the Hare' see *ESW 4*, pp. 751–71.
51. *Peter the First*: see 1940 n. 25.
52. See *ESW 2*, especially pp. 209–23, 316–21.
53. The first version of this article was completed on 12 March 1940 (TsGALI 1923/1/1251). There are five versions altogether in E's archive, written between March and October 1940. The article was published as 'Voploshchenie mifa' in *Teatr* [The Theatre], 1940, no. 10 (October), pp. 13–38. This translation is from the version published in *IP 5*, pp. 329–59, which is based on the *Teatr* article with some alterations from the last version edited by E.

Following the signature of the Nazi–Soviet Pact in August 1939, E had been invited to stage a production of the opera *Die Walküre*, the second part of the cycle *Das Ring des Nibelungen* by Hitler's favourite classical composer, Richard Wagner (1813–83), for the Bolshoi Theatre, which had by then acquired the status of official showpiece for Soviet opera and ballet productions, as well as being the setting for some of the major political speeches of the 1930s. For E the invitation had a certain poignancy, because *The Battleship Potemkin* had had its premiere there on 24 December 1925: see *ESW 4*, pp. 181–2. E's production of *Die Walküre* had its own premiere on 21 November 1940. There is an apocryphal story that two German officers sitting in prime seats were appalled at the production and one was heard whispering to the other that this was a terrible example of *Kulturbolschewismus* [cultural Bolshevism].

54. *The Lay of Igor's Host* [Slovo o polku Igoreve] is a twelfth-century Russian epic poem. *David of Sasun* is a tenth-century Armenian epic. *Dzhangar* is a fifteenth-century Kalmyk heroic national epic, describing a land called Bumba where there is eternal happiness and universal contentment and wellbeing. *Manas* is the Kirghiz national epic, consisting of more than half a million verse lines, which was passed down orally through the generations and began to be recorded in writing only in the second half of the nineteenth century. Shota Rustaveli was a twelfth-century Georgian poet, whose principal work was *Vityaz in a Tiger Skin*. Nizamaddin Mir Alisher Navoi (1441–1501) was an Uzbek writer, scholar and musician, regarded as the founder of Uzbek literature. His masterpiece was the *Treasury of Thoughts*, published in 1498–9. Abu Muhammad Elyas Ibn Yusuf Nizami Gandzhavi (*c.* 1141–1209) was an Azerbaijani poet and thinker. His principal work was a collection of narrative poems under the title *Khamseh* [Quintet].

55. Authorship of both *The Odyssey* and *The Iliad* is traditionally ascribed to the Greek epic poet, Homer (*c.* 700 BC). *The Divine Comedy*, one of the principal works of the Florentine poet Dante Alighieri (1265–1321), describes hell, purgatory and heaven.

56. R. Wagner, 'Eine Mittheilung an meine Freunde' [A Communication to My Friends] (1851), in *Gesammelte Schriften und Dichtungen* [Collected Writings and Poems] (Vol. 4, Leipzig, 1872), pp. 381–2.

57. The *Edda* is the codification of ancient Scandinavian mythology: there are two versions, both originating in Iceland, one in verse in the eleventh century and one in prose in the 1220s.

58. Wagner, 'Eine Mittheilung', p. 354.

59. Wagner participated in the Dresden Uprising of May 1849, along with the Russian anarchist Mikhail Bakunin (1814–76), after which he fled to Switzerland, where he lived until 1858.

60. E gives no source for this quotation.

61. Here E is echoing the interpretation offered by George Bernard Shaw in *The Perfect Wagnerite* (London, 1898).

62. From Wotan's pivotal monologue, addressed to his favourite daughter Brünnhilde, in *Die Walküre*, Act Two.

63. Prometheus, according to legend, made men from clay and then stole fire from heaven to animate them. As punishment, Zeus chained Prometheus to a rock. Each day an eagle consumed his liver and each night the liver was replaced, thus exposing Prometheus to perpetual torture.

64. This letter, written from Wagner's exile in Zürich, was dated 25/26 January 1854 and sent to August Röckel (1814–76), Music Director at the Dresden Court Theatre from 1843 to 1848, in Waldheim, where Röckel was imprisoned as one of the leaders of the 1849 Dresden Uprising.

65. *Parsifal*, first performed in 1882, is an allegorical tale of the victory of Christianity over Paganism.

66. The only other mention of this project for what E called a 'kind of modern *Twilight of the Gods*' is in one of two interviews he gave while passing through Berlin in the spring of 1932 en route from America to Moscow: 'Aus einem Gespräch mit Eisenstein'

[From a Conversation with Eisenstein], *Berliner Tageblatt*, 8 May 1932, reprinted in *Filmwissenschaftliche Mitteilungen* (Berlin, GDR), 1967, no. 3. In both this and the other interview – 'Eisenstein ohne Tonfilm' [Eisenstein without Sound Film], *Film-Kurier*, 28 April 1932, pp. 1–2 – E stated, however, that his immediate intention after his return to the USSR was to make a 'large-scale travel film of Russia'.

67. Wagner's second wife Cosima was the daughter of the Hungarian composer Franz (or Ferenc) Liszt (1811–86).

68. Ovid, *Metamorphoses*, Vol. IX, 'Cannus and Byblis', lines 454 ff., trans. B. Moore (vol. II, Francestown NH, 1978), pp. 894–904. The *Metamorphoses* were the best known work of the Roman poet Ovid (43 BC–AD 18).

69. F. Engels, *The Origin of the Family, Private Property and the State* (London, 1940), p. 36.

70. According to Genesis, xix, 30–8, following the destruction of Sodom and Gomorrah and the translation of Lot's wife into a pillar of salt, his daughters, fearing permanent spinsterhood, got their father drunk and slept with him, their descendants being the tribes known as the Moabites and the Ammonites.

71. The first edition of *The Communist Manifesto* was published in German in 1848.

72. Bayreuth was the site for Wagner's music-drama theatre, designed and built specifically to realise his ideal of a *Gesamtkunstwerk*, or 'total work of art'. The theatre was built with a pit that concealed the orchestra from the audience so that the various elements in the performance would merge more easily into a single whole. The auditorium has a single ascending bank of seats – no boxes, no circles – in order to give everyone an equally good view of the stage. This was egalitarian, artistically revolutionary and a throwback to the Greek amphitheatre. It also resembled a conventional cinema. Wagner's royal patron was Ludwig II (1845–86), King of Bavaria from 1864.

73. See 1940 n. 56.

74. E dates this remark to 1851.

75. Adolphe Appia (1862–1928), Swiss designer, associated with Emile Jaques-Dalcroze (see 1936 n. 10) and known principally for his Wagner stagings. His two major books were *La Mise-en-scène du drame wagnérien* [The Staging of Wagnerian Drama] (Paris, 1895) and *Die Musik und die Inszenierung* [Music and Staging] (Munich, 1899). His designs for *Tristan und Isolde* were finally staged at La Scala, Milan, with Toscanini conducting, in 1923.

76. Ludwig Tieck (1773–1853), German Romantic writer.

77. Wagner gave *Die Walküre* the subtitle *Erster Tag des Festspiels* [The First Day of the Festival Play], because his earlier opera *Das Rheingold* was intended as a *Prologue* [Vorspiel] to the main components of the *Ring* cycle.

78. Houston Stewart Chamberlain (1855–1927), British-born Germanophile political philosopher and proponent of racialist doctrines, whose first published work was *Notes sur 'Lohengrin'* [Notes on *Lohengrin*] (1892). He later married Wagner's daughter, Eva.

79. E gives no source for this quotation, but it is probably from Chamberlain's *The Wagnerian Drama* (London, 1923).

80. J. F. Runciman, *Wagner* (London, 1905).

81. In Goethe's *Faust*, Part One, the basic plot is laid out in a dialogue between God, the archangels Raphael, Gabriel and Michael, and Mephistopheles in the Prologue in Heaven, which is in fact the *second* prologue, the first being the Prologue for the Theatre.

82. Yggdrasil was the great ash tree of Norse legend, the cosmic tree that was central to the world, its boughs encompassing both Heaven and Earth. After the apocalyptic destruction of the gods, the new world would be created by those who had sheltered inside the tree. *Edda*: see 1940 n. 54.

83. E gives no source for this quotation, but it presumably comes from K. J. Simrock, *Die Edda, die ältere und jüngere* [The Edda, Old and New] (1851).

84. *La Faute de l'Abbé Mouret* [1875; translated as *The Sinful Priest* (London, 1960)] was one of the twenty novels in the Rougon-Macquart cycle by Emile Zola (1840–1902). See also *ESW 1*, pp. 95, 288–9 and *ESW 2*, pp. 196–8.

85. Vsevolod M. Garshin (1855–88), Russian poet and playwright. Walt Whitman (1819–92), American poet.

86. Henry Thode (1857–1920) was a German art historian, Professor at Heidelberg from 1894 till 1911. (E's reference.)

87. Giotto di Bondone (1266/76–1337), Florentine painter, one of the founders of Renaissance realism.

88. Giovanni di Fidanza Bonaventura, St Bonaventure (c. 1217–74), leading mediaeval theologian and Minister General of the Franciscan Order, author of the *Lignum Vitae*. Taddeo Gaddi (c. 1300–66), Florentine painter, student of Giotto.

89. Maurice Maeterlinck (1862–1949), Belgian Symbolist dramatist. His *The Bluebird* [L'Oiseau bleu] was first performed in Moscow in 1908.

90. Josephin (né Joseph) Péladan (1858–1918) founded the Rosicrucian Order in 1892. See *ESW 4*, pp. 80–2. His *Les Idées et les formes. Introduction à l'esthéthique* [Ideas and Forms. Introduction to Aesthetics] was published in Paris in 1907. He wrote a number of other treatises under a variety of female names, such as Princesse A. Dinska, Miss Sarah and Miss de Valognes.

91. Marr: see 1935 n. 51.

92. Sir James Frazer (1854–1941), Scottish anthropologist: see also *ESW 4*, pp. 372, 593–4, 608. J. Frazer, *The Golden Bough*, Part IV, Vol. 2, Chapter V, Section 2 (3rd edn, London, 1936), p. 108.

93. In Classical mythology the cypress was the funeral tree. Philemon and Baucis, husband and wife, entertained Jupiter and Mercury when everyone else refused them hospitality. Asked to make a request in return for their hospitality, they asked that they might both die at the same time. When they were of advanced age, Philemon was changed into an oak and Baucis into a linden tree. The following quotation is from Ovid's *Metamorphoses*, Vol. VIII, 'Philemon and Baucis', lines 712–19, trans. B. Moore (1978) Vol. 1, pp. 317–18.

94. The Shakespearean reference is to the spirit Ariel in *The Tempest*. Before the action of the play begins Ariel has been rescued by Prospero from the power of the witch Sycorax, who had confined him 'into a cloven pine' for a dozen years (Act One, Scene Two, lines 335–7). Charles Sorel (c. 1597–1674), French writer. *Le Berger extravagant* dates from 1627.

95. Ivan V. Michurin (1855–1935), Russian agronomist with no formal education and self-styled 'Russian Luther Berbank', whose practical techniques of vegetative hybridisation influenced the disastrous agrobiological theories of Trofim D. Lysenko (1898–1976). Luther Berbank (1849–1926), American agronomist and plant breeder.

96. In Norse mythology Ask and Embla are the equivalent of Adam and Eve: Ask was made by Odin [Wotan] from ash wood, Embla from elm.

97. See Mrs J. H. Philpot, *The Sacred Tree or the Tree in Religion and Myth* (London, 1897). (E's reference)

98. The 'harlequin' is the Russian term for the 'flies', the space above the stage, concealed from the audience, where scenery can be lifted clear of the stage by the manipulation of ropes.

99. See 1940 n. 72.

100. Grock was the stage name of Charles Adrien Wettach (1880–1959), the Swiss-born clown. He was a virtuoso on thirteen instruments and used his expertise in a routine to demonstrate a humorous inability to play any of them.

101. See the discussion of audiovisual counterpoint in *ESW 1* and in *ESW 2*, pp. 229–34 and 281–95.

102. Letter to A. Röckel, 25 January 1854. (E's reference)

103. See also *ESW 1*, p. 163. The source is J. W. von Goethe, *Conversations of Goethe with Eckermann* (London, 1930), p. 303. The conversation took place on 23 March 1829: 'I have found a paper of mine among other things,' said Goethe today, 'in which I call architecture "petrified music".' A similar metaphor is employed by Schelling in his *Philosophie der Kunst* [The Philosophy of Art], where he refers to architecture as 'frozen music'.

104. Pyotr V. Williams [Vilyams] (1902–47), Soviet artist and set designer for E's production of *Die Walküre* at the Bolshoi.
105. In Egyptian mythology Isis was the sister-wife of Osiris. The body of her brother-husband was hacked into fourteen pieces; Isis managed to reconstitute thirteen of them and make herself pregnant, giving birth to Horus. Isis became a cult figure in post-Egyptian Classical mythology, where it was accepted practice to clothe statues in vestments. Admirers believed that, by removing the vestments from the statue and donning them themselves, they would achieve identity with the deity. On the other hand, it may be that E is here merely cross-referring to the Wagner quotation that follows and to Wagner's remark that 'too frank a revelation of the author's intention may merely cloud one's understanding'.
106. E gives no source for this quotation.
107. Wagner, 'Eine Mittheilung', p. 355.
108. Details of this publication have not been traced.
109. Letter dated 23 August 1856. (E's reference)
110. See the discussion of *Alexander Nevsky* in 'Vertical Montage', *ESW 2*, pp. 379–99, and of Disney in J. Leyda (ed.), *Eisenstein 3: Eisenstein on Disney* (Calcutta, 1986), especially p. 7.
111. The cross-fertilisation between cinema and theatre runs like a thread through the articles included in both *ESW 1* and *FF*.
112. Source: 'Dvadtsat'', in the book *20 let sovetskoi kinematografii* (Moscow, 1940), pp. 18–31, and reprinted in *IP 5*, pp. 98–109. The author's original version has not been preserved.
113. Letter from Pushkin to Rayevsky written in July 1825 in French, here translated into English from E's own Russian version. For the originals see A. S. Pushkin, *Polnoe sobranie sochinenii v 10 tomakh* [Complete Collected Works in 10 Volumes], (Moscow, 1949), Vol. 10, p. 162 (French) and p. 775 (Russian).
114. A reference to the painting of what is in fact a six-legged man by the Italian Futurist Giacomo Balla (1871–1958). E also mentions this painting in 'The Dramaturgy of Film Form' (1929): see *ESW 1*, p. 165; and in 'Laocoön', see *ESW 2*, p. 110.
115. The great proponent of Tactilism was the Italian Futurist, Filippo Tommaso Marinetti (1876–1944).
116. Fernand Léger (1881–1955), French Cubist painter. Surikov: see 1940 n. 41. Serov: see 1935 n. 79. E discusses Serov's portrait of the actress Yermolova in *ESW 2*, pp. 82–105.
117. Pablo Picasso (1881–1973), one of the leading Spanish artists of the twentieth century. Amédée Ozenfant (1886–1966), French painter associated with Le Corbusier and the doctrines of Purism and machine aesthetics. Max Ernst (1891–1976), German-French painter, associated with Dada and Surrealism. Giorgio de Chirico (1888–1978), Italian painter, founder of Metaphysical Painting, hailed as a master and precursor by the Surrealists.
118. Pushkin to Rayevsky, ibid. (E's reference)
119. A. S. Pushkin, 'O tragedii' [On Tragedy], vol. VII, p. 38.
120. 'Classness' [klassovost'] was one of the key characteristics with which Socialist Realist art, and its progressive predecessors, were supposed to be imbued. The others were, variously, 'peopleness' [narodnost'], 'Partyness' [partiinost'] and 'ideaness' [ideinost']. See C. V. James, *Soviet Socialist Realism: Origins and Theory* (London, 1973), especially Ch. 4.
121. Cf. 'The Mistakes of *Bezhin Meadow*', p. 101, and 'Speeches to the All-Union Creative Conference of Soviet Filmworkers', pp. 40–6.
122. Chiaureli: see 1935 n. 20. Nikolai M. Shengelaya (1903–43), Georgian director and one of the founders of Georgian cinema, whose films included *Eliso* [1928], *The Twenty-Six Commissars* [Dvadtsat' shest' komissarov, 1932] and *The Golden Valley* [Zolotistaya dolina, 1937]. *Arsen* was directed by Chiaureli in 1937.

123. The minnesingers, or *Minnesänger*, were mediaeval German poets, mostly of noble birth, who sang of love.

124. Alexander O. Drankov (1880–?) was a pre-Revolutionary cinema entrepreneur known for his sensational exploits, including films. He was also *The Times* photographic correspondent in St Petersburg. After the Revolution he emigrated to America, where he tried unsuccessfully to get into Hollywood and ended his days running a small café.

125. Reference to the obsession with 'Americanism' or 'Americanitis' [amerikanshchina] that characterised the early post-Revolutionary work of Kuleshov (see 1934 n. 36) and his associates. See, for instance, *FF*, pp. 72–3.

126. This was one of the claims made by Vertov (see 1934 n. 32) and his Cine-Eye group. See *FF*, pp. 69–72 and 89–94.

127. Between 1922 and 1925 Vertov directed for Goskino a series of twenty-three newsreels under the generic title *Kinopravda* [Cine-Truth], which was a play on the title of the Party newspaper *Pravda* [The Truth].

128. E is here referring to Vertov's film *The Cine-Eye ('Life Caught Unawares')* [Kinoglaz ('Zhizn' vrasplokh')], directed in 1924, which he had criticised at the time in his article 'The Problem of the Materialist Approach to Form', *ESW 1*, pp. 59–65, especially pp. 62–5.

129. Pudovkin: see 1935 n. 29; *The Mother*: see 1940 n. 27.

130. *Chapayev*: see 1935 n. 6.

131. Ostrovsky: see 1934 n. 8; Shchedrin: see 1935 n. 94; Pushkin: see 1937 n. 6.

132. The two-part film, directed by Vladimir M. Petrov (1896–1966) for Lenfilm, was actually called *Peter the First*: see 1940 n. 25.

133. *The Peasants*: see 1935 n. 6.

134. E is here referring to the spate of films produced for the twentieth anniversary of the October Revolution, such as *Lenin in October* and *Lenin in 1918* (see 1934 n. 2) and *The Man with a Gun* [Chelovek s ruzh'em, 1938], directed by Yutkevich (see 1935 n. 20) for Lenfilm.

135. The 'Maxim trilogy': see 1935 n. 6.

136. *A Great Citizen*: see 1940 n. 12.

137. Reference to the subsequently derided period of 'chamber cinema' [kamernoe kino] at the beginning of the 1930s when some Soviet film-makers produced work that concentrated on ostensibly narrow or intimate subject matter, albeit usually with wider significance. One example would be *The Great Consoler* [Velikii uteshitel', 1933], made by Kuleshov (see 1934 n. 36) for Mezhrabpomfilm. In the later 1930s, as we have seen from E's account, the emphasis moved away from 'intimate' or 'chamber' films to the epics identified here.

138. E is here alluding to his own *Nonindifferent Nature*, edited and translated into English by H. Marshall (Cambridge, 1987).

139. Dovzhenko directed *Shchors* for the Kiev Studio in 1939. For the inspiration he claimed lay behind the film, see *FF*, pp. 383–5.

140. E is misquoting himself here: see p. 40.

141. E's own unfinished films *Que viva México!* and *Bezhin Meadow* would of course have been counted among these.

142. The Russian word used is 'pyatiletka', which was the term used for the five-year plans.

143. *Volga-Volga* was a musical comedy directed by E's one-time assistant Grigori V. Alexandrov (1903–84) for Mosfilm in 1938, while *Tractor Drivers* [Traktoristy], also a musical comedy, was directed by Ivan A. Pyriev (1901–68) for the same studio in 1939.

144. *The Teacher* [Uchitel'] was directed by Sergei A. Gerasimov (1906–85) for Lenfilm in 1939 and dealt with the life and times of a collective farm teacher who is eventually elected to the Supreme Soviet. The film was awarded the Stalin Prize (Second Class) in 1941. For the Maxim trilogy, see 1935 n. 6. Peter Shakhov is the name of the main character in *A Great Citizen*: see 1940 n. 12.

145. *Engineer Kochin's Mistake* (see 1940 n. 46) dealt with the role of the NKVD in uncov-

ering foreign espionage and sabotage, a favourite theme of Soviet propaganda during the purges. The reference to musical comedies is applicable to the works of Alexandrov and Pyriev in particular.

146. See 1937 n. 15.

147. The reference is to the estate at Boldino near Nizhny Novgorod that Pushkin received as a gift from his father on the occasion of his engagement to Natalia Goncharova in 1830. When he first went there to sort out the details in the autumn of 1830, Pushkin was confined to the district until the end of the year by the quarantine measures necessitated by a cholera outbreak. It was in this period that he wrote his series of 'little tragedies', including *Eugene Onegin*, and, in his first burst of prose writing, *The Tales of Belkin*. He spent each subsequent autumn on the estate and did most of his writing there: in 1832 he produced his *History of the Pugachev Rebellion* and in 1834 he completed both *The Queen of Spades* and *The Captain's Daughter*. E is explicitly suggesting that the autumn of 1939 is comparable to Pushkin's 'Boldino autumn' of 1830. He is also implicitly suggesting that the transition to 'prose' cinema that occurs in the 1930s has laid the foundation for a similar flowering in the art of Soviet cinema. His remarks here are in a direct line of progression from his speeches to the January 1935 conference (see, in particular, pp. 40–1) and his *mea culpa* 'The Mistakes of Bezhin Meadow': see pp. 100–5.

148. See 1938 n. 20.

149. Presumably a reference to the Nazi–Soviet Pact of 23 August 1939, signed by the Foreign Ministers of the USSR and Nazi Germany, Molotov and Ribbentrop respectively. The published terms of the agreement included guarantees of neutrality if either party was at war, while secret clauses carved up Poland and the Baltic states (Lithuania, Estonia and Latvia) between them and gave the Soviet Union a free hand in Finland and Bessarabia (now Moldova).

150. The All-Union Agricultural Exhibition opened in Moscow in 1937. It developed later into the site of the All-Union Exhibition of Economic Achievements, VDNKh.

151. See 1937 n. 15.

152. The notion that the population of these areas was suffering under the oppressive yoke of the Poles was a prominent justification in Soviet propaganda of this time for the occupation and division of Poland following the Nazi–Soviet Pact in 1939/40.

153. See 1940 n. 42. After his return to Moscow, E was recommended to drop one part of the proposed film and he subsequently abandoned all further work on it, accepting in December 1939 an invitation to produce Wagner's *Die Walküre* at the Bolshoi Theatre.

1941

1. Source: 'Nasledniki i stroiteli mirovoi kul'tury', *Pravda* [The Truth], 30 April 1941.

2. E was awarded the Order of Lenin for *Alexander Nevsky* on 1 February 1939. On 23 March 1939 he was awarded the title Doctor of the Arts. On 15 March 1941 he was awarded the Stalin Prize; hence this self-description and the reason he had been asked to write this bombastic piece.

3. Source: 'Kino protiv fashizma', *Pravda*, 8 October 1941.

4. *Confessions of a Nazi Spy* was directed in 1938 by the Ukrainian-born Anatole Litvak (1902–74) for Warners and released in 1939. It starred Edward G. Robinson as an FBI agent who breaks up a Nazi spy ring in the USA. It gained added verisimilitude by the use of actual newsreel footage of rallies of the pro-Nazi German-American Bund.

5. Chaplin's *The Great Dictator*, in which he played the double roles of the dictator Adenoid Hynkel and the Jewish barber, was released on 15 October 1940. Ironically in this context, Chaplin had been so horrified by the Nazi–Soviet Pact that he had originally intended to include Stalin in his denunciation of dictatorship in the Jewish barber's closing speech in the film; see D. Robinson, *Chaplin: His Life and Art* (London, 1985), p. 489.

1942

1. Written on 1 May 1942 and first published as *'Ivan Groznyi*. Fil'm o russkom renes-sanse XVI veka', *Literatura i iskusstvo* [Literature and Art], 4 July 1942. A typescript is preserved in TsGALI, 1923/1/1334.
2. Balzac: see 1935 n. 34. *Lost Illusions* [Les Illusions perdues] was the title of a novel written between 1836 and 1843.
3. Catherine de' Medici (1519–89), Italian-born queen to Henri II of France and mother of three subsequent French kings. Her strong antipathy towards Protestants is credit-ed as one of the causes of the St Bartholomew's Eve massacres of 23/24 August 1572.
4. The 'Sun King' was Louis XIV (1638–1715), who reigned from 1643 and oversaw the consolidation of the absolutist French state.
5. Voltaire (1694–1778), French philosopher and writer. Blaise Pascal (1623–62), French mathematician and writer. The Duc de Richelieu (1585–1642) was the lead-ing French statesman of his time, minister to Louis XIII and a Cardinal of the Catholic Church.
6. Rudolf III (1576–1612) was Holy Roman Emperor at the height of the Catholic reac-tion to the Reformation.
7. Peter I, the Great (1672–1725), Emperor of Russia, attempted to Westernise the country in the face of powerful opposition. In 1703 he founded the new capital of St Petersburg as 'Russia's window on the West'. He was the subject of the two-part film *Peter the First*: see 1940 n. 25.
8. I.e. *The Great Dictator*: see 1941 n. 5
9. Louis XI (1423–83), King of France from 1461 to 1483. Charles VIII Knutsson (1409–70), King of Sweden at various times between 1448 and 1480 and King of Norway in 1449–50, united the Swedes in their national struggle against Danish domi-nation.
10. Prince Andrei Kurbsky (1528–83) was a military commander and close associate of Ivan IV. In 1556 he was elevated to the rank of boyar, one level below the nobility, but lost the Tsar's favour after 1563. When his appointment as commander on the Livonian front was not renewed, Kurbsky fled in April 1564 to Sigismund II Augustus of Poland-Lithuania and led his armies against Ivan. He later wrote a *History of the Grand Duke of Muscovy*.
11. An *oprichnik* was a member of the *oprichnina*, a special administrative elite created by Ivan the Terrible to carry out his orders directly.
12. The notion of Moscow as the Third Rome played an important part in legitimising the role of both state and church in Russia at that time by emphasising the continuity of Orthodox faith from Rome, which fell to the Barbarians, through Constantinople/ Byzantium, the capital of the Eastern Empire and seat of the Patriarch of the Orthodox East, which had fallen to the Turks in 1453. In this way the Russian Orthodox Church came to represent the 'true believers', and the Grand Duke, by supporting the Church, came to be depicted as a pillar of the 'true faith' and the bulwark defending Christian civilisation against the 'barbarians' to the east and south.
13. Cesare Borgia (1476–1507), son of Pope Alexander IV, and general, who tried un-successfully to conquer Italy for himself. He was much admired by Machiavelli. The Malatesta family ruled Rimini in the Middle Ages. Niccolò Machiavelli (1467–1527), Florentine Renaissance diplomat and theorist of the modern state, whose book *The Prince* (1513) is concerned with the realities, rather than the theory of power. St Ignatius Loyola (1491–1556), Spanish founder of the Jesuits, a missionary order which worked directly under the Pope. Bloody Mary was the epithet for Mary I (1516–58), Queen of England, daughter of Henry VIII and Catherine of Aragon. A Roman Catholic, she reversed the religious changes made by her father and caused several hundred Protestants to be burnt at the stake. She was succeeded by Elizabeth I.
14. The Nazi–Soviet Pact (see 1940 n. 149) had been nullified by the German invasion of the USSR on 22 June 1941.

15. Written in 1942 in Alma-Ata and first published as 'Dikkens, Griffit i my' in the collection *Griffit* [Griffith] (Moscow, 1944), pp. 39–88. E reworked the article for a proposed edition of his works and this present translation is from this version, preserved in TsGALI 1923/2 and published in *IP 5*, pp. 129–80.

16. Charles Dickens (1812–70), English novelist. His novel *The Cricket on the Hearth* was dramatised by Albert Smith (1816–60) for stage production at Christmas 1845.

17. D. W. Griffith (1875–1948), American film director, generally considered to be the most important figure in the history of American cinema and one of the key figures in the development of world cinema as an art form. His prolific output was characterised by the conscious use of inherently cinematic techniques such as crosscutting, parallel action, camera movement, the close-up and rhythmic editing. He exercised a considerable influence on the Soviet montage school of film-makers, including E.

18. Reference to the Radio City Music Hall in New York City.

19. Reference to the title of Griffith's film *Way Down East* (1920), released in Russia as *The Waterfall of Life* [Vodopad zhizni].

20. Griffith's film of *The Cricket on the Hearth* was released in May 1909.

21. *Judith of Bethulia*, for which Griffith also wrote the script, was made in late 1913 but only released in 1914.

22. Lillian Gish (1896–1993) starred in a number of Griffith's most important films, including *Way Down East*, in which she was rescued from an ice-floe. Curiously, her autobiography, published in 1969, was entitled *The Movies, Mr Griffith and Me*.

23. *Dombey and Son* is also discussed on pp. 203–4.

24. *Intolerance*, released in 1916 after two years in the making, was partly a response to the controversy over the racial bias widely perceived in *The Birth of a Nation* (1915). It was the most influential of Griffith's films on Soviet film-makers, not least because of its subject matter. *Intolerance* was released in Russia as *The Evil of Life* [Zlo zhizni].

25. *America*, released in 1924, was the last of Griffith's great silent epics and depicted the American War of Independence. It starred Louis Wolheim (1880–1931), who also appeared in Lewis Milestone's film version of Erich Maria Remarque's novel, *All Quiet on the Western Front* [USA, 1930].

26. G. K. Chesterton, *Charles Dickens* (London, 1906), p. 148.

27. *By the Hearth* [U kamina] and *Forget about the Hearth, the Fire There Has Gone Out* [Pozabud' pro kamin, v nem pogasli ogni] were two films based on a popular romance and directed by Pyotr I. Chardynin (1873[1877?]–1934) in 1917 for the Khanzhonkov studio. To E these films were a synonym for the vulgarity of pre-Revolutionary Russian cinema. *Nava's Charms* was a popular novel by the Russian Symbolist writer Fyodor K. Sologub (1863–1927). It was never filmed. Ivan N. Khudoleyev (1869–1932), Russian stage and screen actor and director, one of the 'kings of the screen' of the Kharitonov studio. Continued to act and direct in Soviet cinema and became a teacher at the state film school. Osip I. Runich (dates unknown), Russian actor whose first screen role was as Nikolai Rostov in *War and Peace* [1915]. Vitold A. Polonsky (1879–1919), Russian film actor who played the part of Lanin in both *By the Hearth* and *Forget about the Hearth* [both 1917]. Vladimir V. Maximov (1880–1937), one of the most popular actors in pre-Revolutionary Russian cinema, who played the part of Yuri Meshchersky in both *By the Hearth* and *Forget about the Hearth*. Vera V. Kholodnaya (1893–1919), Russian screen actress who trained originally as a ballerina and had become the most popular actress in Russian cinema by the time of her death in an influenza epidemic. From 1916 she appeared mainly in Chardynin's films and played the part of a circus artiste in *Forget about the Hearth*. Ivan I. Mosjoukine (also Mozzhukhin, 1890–1939), one of the most popular actors in pre-Revolutionary Russian cinema, who specialised in demonic, neurasthenic characters caught between duty and passion. Emigrated in 1920 and worked afterwards mainly in French cinema. Natalia A. Lisenko (1884 or 1886–?), Russian actress, wife and screen partner of Mosjoukine. By 1920, when she emigrated with him to France, she had acted in more than forty films.

28. The references are to the following German Expressionist films of the early 1920s: *Nosferatu the Vampire* [Nosferatu, 1922, director: F. W. Murnau]; *The Street* [Die Straße, 1923, director: Karl Grune]; *Warning Shadows* [Schatten, 1922, director: Arthur Robison (the German version bore the subtitle 'Eine nächtliche Halluzination' [A Nocturnal Hallucination]); *Dr Mabuse the Gambler* [Dr Mabuse der Spieler, 1922, director: Fritz Lang]. All four are analysed in S. Kracauer, *From Caligari to Hitler. A Psychological History of the German Film* (Princeton, NJ, 1947).
29. *Looping the Loop* [1928, director: Arthur Robison] and *The Secrets of a Soul* [Geheimnisse einer Seele, 1926, director: G. W. Pabst].
30. *The Gray Shadow* [Seryi ten'] was the Russian release title for *The Black Secret* [USA, 1919]; *The House of Hate* [USA, 1918] – both serial films directed by George B. Seitz (1888–1944); *The Mark of Zorro* [USA, 1920, director: Fred Niblo] inaugurated the series of swashbuckling films starring Douglas Fairbanks Sr and may be said to have created the genre.
31. In an article published in *The Times* on 26 April 1922, on the occasion of a visit to London by D. W. Griffith, A. B. Walkley wrote:

> He is a pioneer, by his own admission, rather than an inventor. That is to say, he has opened up new paths in Film Land, under the guidance of ideas supplied to him from outside. His best ideas, it appears, have come to him from Dickens, who has always been his favourite author... Dickens inspired Mr Griffith with an idea, and his employers (new 'business' men) were horrified at it; but, says Mr Griffith, 'I went home, re-read one of Dickens's novels, and came back next day to tell them they could either make use of my idea or dismiss me.'

32. S. Zweig, *Three Masters: Balzac, Dickens, Dostoyevsky* (London, 1929), pp. 51–3. Dickens himself commented on the success of his reading tour of the USA in letters written in January 1868, cited in J. Forster, *The Life of Charles Dickens* (London, 1887), vol. 2, pp. 237–8.
33. Zweig, *Three Masters*, pp. 74–8.
34. Forster, vol. 2, p. 272.
35. G. H. Lewes, 'Dickens in Relation to Criticism', *Fortnightly Review*, 1 February 1872, p. 149.
36. Cited in Forster, vol. 2, p. 16.
37. Forster, pp. 16–17.
38. Forster, p. 17.
39. The opening of the last chapter of Dickens' *A Tale of Two Cities*.
40. This is the opening paragraph of Dickens' *Oliver Twist*, Chapter XXI, 'The Expedition'. E has further broken down all these extracts into what he regards as basic montage fragments.
41. The first part of the second paragraph of the same chapter.
42. The continuation of the same paragraph.
43. The first two sentences, and the beginning of the fourth, in the fourth paragraph.
44. The rest of the fourth paragraph.
45. This passage consists of all except the last two lines of the sixth paragraph of Chapter XXXII, 'Relating Chiefly to Some Remarkable Conversation, and Some Remarkable Proceedings to Which It Gives Rise', of *Nicholas Nickleby*.
46. Reference to the title of the film *Berlin, Symphony of a City* [Berlin, die Symphonie einer Großstadt, Germany, 1927], directed by Walter Ruttmann (1887–1941).
47. This description of Coketown constitutes the latter part of the second paragraph of Book I, Chapter V, 'The Key-note', of *Hard Times*.
48. *The Crowd*, which vividly portrayed the anonymity of life in the big city, was directed by King Vidor (1894–1982).
49. This extract comes towards the end of Chapter XIV of *Oliver Twist*.
50. Extracts from the end of Chapter XIV of *Oliver Twist*.
51. Extract from the middle of Chapter XV.

52. These quotations are from the concluding part of Chapter XVII.
53. *Broken Blossoms* [USA, 1919, released in Russia as *The Broken Lily* (Slomannaya liliya)] was set in Limehouse in London's East End and starred Gish (see 1942 n. 22) and Richard Barthelmess (1895–1963), who also appeared in *Way Down East*. Gish appeared with her sister Dorothy (1898–1968) in the title roles of *Orphans of the Storm* [USA, 1922, released in Russia as *Two Orphan Girls* (Dve sirotki)], set against the background of the French Revolution.
54. Dickens was a lifelong amateur actor.
55. E. Elliott, *Anatomy of Motion Picture Art* (Territet, Switzerland, 1928).
56. Jay Leyda identified the close similarity between E's account and that of Lewis Jacobs in his *The Rise of the American Film* (New York, 1939), pp. 101–3.
57. L. Arvidson (Mrs D. W. Griffith), *When the Movies Were Young* (New York, 1925), p. 66.
58. E uses the Russian word *poedinok*, meaning either a 'duel' or 'single combat'. The implication is that these are detailed depictions of fragmentary actions (i.e. montage fragments), which, through the parallelism of the action of the play, become elements in a collision of montage fragments (or 'duels between the individual characters').
59. J. Webster, *The White Devil* (ed. J. R. Brown, London, 1960), pp. 54–7. E gives this as Act II, Scene 3, but it is in fact Act II, Scene 2.
60. W. A. Brady, 'Drama in Homespun', *Stage*, January 1937, pp. 98–100. William A. Brady (1863–1950) was an American theatre producer and manager, and from 1915 to 1920 President of the National Association for the Motion Picture Industry. He produced more than 250 Broadway plays – including *Way Down East*, which was one of his most notable successes – and at one time managed both Tallulah Bankhead and Douglas Fairbanks Sr.
61. Brady, 'Drama in Homespun'. Denman Thompson was the pen-name of Henry Denman (1833–1911).
62. A paraphrase of Brady's reminiscences cited above. Neil Burgess's *The Country Fair* was a stage adaptation of the novel by Charles Barnard, originally published in 1889. It was in turn filmed by Maurice Tourneur in 1920.
63. Brady, 'Drama in Homespun'. Augustus Thomas (1859–1934) was a journalist and playwright and the author of the three popular local colour melodramas named, which date from 1891, 1899 and 1893 respectively.
64. See Brady, 'Drama in Homespun'; and also his *Showman* (New York, 1937).
65. Brady, 'Drama in Homespun'. The 'triangle building' is better known as the Flatiron Building.
66. Brady, 'Drama in Homespun'.
67. *The American Procession. American Life since 1860 in Photographs* (New York and London, 1933), pages not numbered.
68. See 1940 n. 81.
69. Cited here from M. Twain, *Mark Twain's Library of Humor* (New York, 1969), p. xi.
70. George H. Derby (1823–61) was a US Army engineer, wounded at Serro Gordo in 1846. He wrote under the pseudonym of John Phoenix.
71. Extracted from 'Phoenix at Benicia' (1855), reprinted in F. P. Farquhar (ed.), *Phoenixiana* (San Francisco, CA, 1937), p. 175. The exclamations inserted in parentheses are E's.
72. *The Struggle* [USA, 1931] was Griffith's last (and only sound) film, made independently with the proceeds of an unexpected tax rebate. It dealt with the horrors of alcoholism but its by now dated and naive-seeming sincerity caused hostile audience reaction and merciless ridicule from critics, and the film was quickly withdrawn from release.
73. Griffith made *The Sorrows of Satan* for Cecil B. DeMille in 1926 but the film was a box-office disaster. Marie Corelli (née Mary Mackay, 1855–1924), immensely popular British author of twenty-eight romantic and sentimental melodramatic novels, published *The Sorrows of Satan* in 1895.
74. See *ESW 1*, p. 144.

75. *ESW 1*, p. 145.
76. *ESW 1*, p. 141.
77. V. A. Bogoroditsky, *Obshchii kurs russkoi grammatiki* [A General Course in Russian Grammar] (Moscow and Leningrad, 1935), p. 203. (E's reference). Vasili A. Bogoroditsky (1857–1941) was one of the leading Russian philologists.
78. The Russian words used here are, respectively, *pokazyvat'*, *predstavlyat'*, *znachit'*, *oznachat'* and *oboznachat'*.
79. G. Seldes, *Movies for the Millions: An Account of Motion Pictures, Principally in America* [reprint of *The Movies Came from America* (New York, 1924)] (London, 1937), pp. 23–4.
80. G. Seldes, *The 7 Lively Arts* (New York and London, 1924; reprinted New York, 1957), pp. 288–9.
81. N. Minin, *Uchebnaya teoriya slovesnosti* [Handbook of the Theory of Philology] (St Petersburg, 1872), pp. 51–2. (E's reference). The *Shorter Oxford English Dictionary* definition is very similar.
82. The historian is Terry Ramsaye in his *A Million and One Nights: A History of the Motion Picture* (New York, 1926), pp. 758–9. He does not in fact use the term 'a giant metaphor' but instead remarks, 'The concept denoted by the word *Intolerance* is an abstraction of thought. A motion picture which has to be thought about is in the same status as a joke which has to be explained.'
83. The four historically separate parts of *Intolerance* (the Modern, French, Babylonian and Judaean stories) were linked by a shot of Lillian Gish rocking a cradle with the repeated title '... endlessly rocks the cradle, Uniter of Here and Hereafter', which was in fact a merger of two separate Whitman phrases. According to Ramsaye, *A Million and One Nights*, p. 758, Griffith saw the cradle scenes as ' "a golden thread" denoting the continuity of the human race'.
84. *The Earth* was directed by Alexander Dovzhenko (see 1939 n. 2) and released by the Ukrainian cinema studio, VUFKU, in 1930.
85. Cited in R. E. Long, *David Wark Griffith* (1920).
86. Potebnya: see 1935 n. 37.
87. F. Mauthner, *Beiträge zu einer Kritik der Sprache* [Essays on a Critique of Language] (Leipzig, 1923), Chapter XI, 'Die Metapher' [Metaphors], pp. 487–8. (E's reference)
88. A. A. Potebnya, *Mysl' i yazyk* [Thought and Language] (1913), p. 181. (E's reference). Potebnya's work was first published in Kharkov in 1862. In his theory of linguistic poetics Potebnya defined three component parts of both the poetic word and the poetic work: i) outer form (sound); ii) meaning (semantics); and iii) inner form (image). This is clearly relevant to E's arguments about montage in this article.
89. A. A. Potebnya, *Iz zapisok po teorii slovesnosti* [From Notes on the Theory of Philology] (Kiev, 1905), p. 204.
90. Reference to Richard M. Werner (1854–1913), the Austrian literary historian.
91. Potebnya, *Iz zapisok*, p. 203.
92. *Die Gemälde* [The Painting], novella by the German Romantic writer Ludwig Tieck (see 1940 n. 76); translation by William Powell.
93. Potebnya, *Iz zapisok*, p. 490.
94. J. Vandryes, *Le langage* [Language] (Paris, 1921). There is a translation by Paul Radin, *Language. A Linguistic Introduction to History* (New York, 1925), and this section can be found there on pp. 145–6. We have preferred our own translation from the Russian.
95. A. S. Shishkov, *Rassuzhdeniya o starom i novom sloge rossiiskogo yazyka* [A Discourse on the Old and New Style of the Russian Language], Part V of his *Sobranie sochinenii i perevodov* [Collected Works and Translations] (St Petersburg, 1825), p. 229.
96. *The Palace and the Fortress* [Dvorets i krepost', 1923] was directed by Alexander V. Ivanovsky: see also *ESW 1*, pp. 43, 45.
97. See 1940 n. 27.
98. See also *ESW 1*, pp. 68, 172, 174; and *ESW 2*, pp. 57, 88, 116.

99. I.e. *Way Down East*: see above, n. 22.

100. For *Chapayev*, see 1935 n. 6.

101. *Storm over Asia* [Potomok Chingis-khana, literally: The Heir to Genghis Khan, 1929] was directed by Pudovkin.

102. *Ivan* [1932] was directed by Dovzhenko (see 1939 n. 2).

103. *We from Kronstadt* [My iz Kronshtadta, 1936], directed by Yefim L. Dzigan (1896–1981).

104. See 1940 n. 139.

105. *Three Songs of Lenin* [Tri pesni o Lenine, 1934] was directed by Vertov. See 1934 n. 32.

1943/4

1. Written in October 1943 as a preface to an edition of E's drawings for *Ivan the Terrible* that he was hoping to see published. The project never came to fruition and the piece was first published as 'Neskol'ko slov o moikh risunkakh. K izdaniyu stsenariya *Ivan Groznyi*' in *Mosfil'm*, vol. 1 (Moscow, 1959), pp. 207–12. This version is translated from the author's typescript in TsGALI 1923/2, published in *IP 1*, pp. 196–8. Thousands of E's drawings for *Ivan the Terrible*, some of them pornographic, survive in E's archive and in private collections. Some were published in the album *Risunki Eizenshteina* [E's Drawings] (Moscow, 1961).

2. For Kurbsky, see 1942 n. 10.

3. In the author's typescript there follows a deleted passage: 'at the memorial meeting in 1941 on the anniversary of Lenin's death' (i.e. on 21 January). Yelena Glinskaya was Ivan's mother; the name of the actress whose voice is heard in the film has not been traced.

4. Written in 1943–4 and first published in abridged form in the collection entitled *Charl'z Spenser Chaplin* (Moscow, 1945), pp. 137–8. The full text, taken from the author's original in TsGALI 1923/2, was first published in *IS*, pp. 205–33, and reprinted in *IP 5*, pp. 494–521. This translation is from that edition.

5. Chaplin (see 1935 n. 109) made *The Kid* for First National in 1919–20, and it was released in February 1921.

6. Chaplin began *Modern Times*, his last silent film, a satire on the impact of industrial production techniques for United Artists, in September 1933 and completed it in January 1936. It was released in February 1936.

7. There may well be a play on words here between the old Russian word *oko*, meaning 'eye', and *okovy*, meaning 'fetters'.

8. Gustave Flaubert (1821-80), French novelist, best known as the author of *Madame Bovary*.

9. Denis Diderot (1713–84), French man of letters, editor of the *Encyclopédie*, to which many Enlightenment writers contributed. Jean Le Rond d'Alembert (1717–83), French mathematician and philosopher and contributor to the *Encyclopédie*.

10. Arthur Rimbaud (1854–91), French Symbolist poet, driven into exile because of his affair with his fellow poet Paul Verlaine (1844–96). Paul Gauguin (1848–1903), French Post-Impressionist painter who went into voluntary exile in Tahiti in 1895.

11. E's views on the nature of the comic, and specifically his rejection of the views of the Idealist philosophers Immanuel Kant (1724–1804) and Henri Bergson (1859–1941), are developed in the first volume of his as yet untranslated textbook on *Direction* in the section entitled 'The Soldier's Return from the Front'.

12. George Meredith (1828–1909), English poet, novelist and essayist.

13. H. A. Overstreet, *Influencing Human Behaviour* (London, 1926), pp. 9, 11–15.

14. Eugène Labiche (1815–88) and Auguste Eugène Scribe (1791–1861) were French dramatists, prolific authors of *vaudevilles*, with entertainment as their primary purpose. Scribe is regarded as the creator of the 'well-made play'.

15. Overstreet, *Influencing Human Behaviour*, pp. 26–7.

16. Ibid., p. 260.
17. The phenomenon of 'self-criticism' [*samokritika*] was an essential component of the purges of the 1930s and 1940s.
18. Overstreet, *Influencing Human Behaviour*, pp. 260–2.
19. Chaplin was, of course, not American but British by birth.
20. From an interview given by Chaplin to A. J. Urban, first published in the Italian journal *Intercine* in 1935, translated and published in *Iskusstvo kino*, 1936, no. 4, pp. 62–3, and reprinted in the collection *Charl'z Spenser Chaplin*, pp. 184–7. The quotation here is from *Intercine* (Rome), October 1935, p. 19.
21. For Dickens, see 1942 n. 16. The references here are to characters in various of his novels. Little Paul is the sickly child who dies at the end of Chapter XVI of *Dombey and Son*, which is also discussed on pp. 203–4.
22. Lewis Carroll (pseudonym of Charles L. Dodgson, 1832–98), English mathematician and writer of poems and books for children, most notably *Alice's Adventures in Wonderland* and *Alice through the Looking Glass*. Edward Lear (1812–88), English artist and author of humorous verse, such as *The Owl and the Pussycat*. Algernon Charles Swinburne (1837–1909), English poet and critic. Dante Gabriel Rossetti (1828–82), English poet and painter, one of the founders of the Pre-Raphaelite movement. John Ruskin (1819–1900), English author and art critic, pre-Raphaelite and social reformer.
23. 'Infantilism' was used by Lenin as a term of abuse for those he disagreed with: see his *'Left-Wing' Communism. An Infantile Disorder* (1920), reprinted in *Collected Works* (Vol. 31, Moscow, 1966), pp. 17–118.
24. André Malraux (1901–76), French novelist who later became a minister under de Gaulle. E met Malraux in Paris in 1929: see *ESW 4*, pp. 213–16. When Malraux visited Moscow in 1934 he and E signed a contract with the Mezhrabpomfilm studio for a film version of *The Human Condition* [La Condition humaine] but the project was never realised. The title plays in part on Balzac's *The Human Comedy*: see 1935 n. 34.
25. *Buffo* is the Italian for 'comic', as in *opera buffa*, or 'comic opera'.
26. *The Kid*: see 1943/4 n. 5. Chaplin worked on *City Lights* for United Artists from December 1927 to January 1931, when the film had its premiere; *The Gold Rush*: see 1935 n. 89; *A Dog's Life* was made for First National and released in 1918. In all these films Chaplin played the part of the downtrodden tramp figure.
27. Chaplin made *The Pilgrim* for First National in 1922, playing the part of an escaped convict. The film had its premiere in New York in February 1923.
28. Chaplin played both Mr Pest and Mr Rowdy in this film made for Essanay and released in November 1915.
29. The title is in English in the original. *Shoulder Arms* was made for First National and released on 20 October 1918, three weeks before the Armistice.
30. In the traditions of the *commedia dell'arte* the white clown, usually Pierrot, was the tragic figure, while the red clown represented the comic element.
31. Presumably a reference to the play *Chaplinade* (1920) by the Franco-German playwright Iwan Goll (pseudonym of Isaac Lang, 1891–1950), whose earlier work formed part of German Expressionism but who later returned to France and became a Surrealist.
32. Elie Faure (1873–1937), French art historian, whose five-volume *Histoire de l'art* [History of Art] was published between 1909 and 1921; the English translation was published in New York, 1921–30. He apparently included an article entitled 'The Art of Charlie Chaplin' in his *The Art of Cineplastics* (1923).
33. E's mistake: this scene appears in *Easy Street*, made for Mutual in 1917.
34. Shchedrin: see 1935 n. 94. Fyodor M. Dostoyevsky (1821–81), leading Russian novelist.
35. H. Graham, *Ruthless Rhymes for Heartless Homes* (Edward Arnold, London, 1909).
36. Ibid., p. 6.

37. Ibid., p. 8.
38. Ibid., p. 48.
39. Ibid., p. 58.
40. 'Sleepy' [Spat' khochetsya], a short story by Chekhov (see 1935 n. 110).
41. Lev N. Tolstoy (1828–1910), leading Russian novelist, author of *War and Peace, Anna Karenina*, etc.
42. The Brothers Grimm, Jakob (1785–1863) and Wilhelm (1786–1859), German philologists and folklorists, best known for their collection of fairy tales. They also initiated a vast dictionary of the German language which was subsequently completed by German scholars only in 1961.
43. Maxim Gorky (pen-name of Alexei M. Peshkov, 1868–1936), Russian realist writer who later became one of the founding fathers of Socialist Realism, referred to several times in both *ESW 1* and *ESW 2*.
44. The reference is to Yelena Kononenko (1903–81), journalist, children's writer and author or *My i dety* [Ourselves and Children] (Moscow, 1948). The extract cited by E is from 'Namby-Pamby' [Nezhenka].
45. C. W. Kimmins, *The Springs of Laughter* (London, 1928), p. 95.
46. Ibid.
47. C. W. Kimmins, *The Child's Attitude to Life* (London, 1926), p. 60.
48. Charles Baudelaire (1821–67), French poet. Jean-Gaspard Deburau (né Jan Kaspar Dvořák, 1796–1846), French mime who developed the character of Pierrot at the Théâtre des Funambules, Paris: see also *ESW 4*, pp. 250, 371, 689, 827.
49. Baudelaire, 'On the Essence of Laughter, and generally of the Comic in the Plastic Arts' (1855), translated here by P. E. Charvet in *Baudelaire: Selected Writings on Art and Artists* (Cambridge, 1972), pp. 156–7. St Denis, the first bishop of Paris, martyred in the third century AD by decapitation. According to legend, the saint picked up his head and carried it from Montmartre, the supposed site of his martyrdom to the Abbey of Saint-Denis. When Cardinal de Polignac pointed out the distance the saint had to walk with his burden, Madame du Deffand made the remark, since become proverbial, 'Il n'y a que le premier pas qui coute' [It's only the first step that counts].
50. Ambrose G. Bierce (1842–1914), American humorist, one of E's favourite authors: see also *ESW 4*, pp. 370–2.
51. A. Bierce, 'Fables from Fun' (1872–3), in *Collected Works* (Vol. XI, New York and Washington DC, 1911), pp. 330–1.
52. Vassa Zheleznova is the eponymous character in the play by Gorky (see 1943/4 n. 40). See also *ESW 4*, pp. 9, 800.
53. *Parsifal*: see 1940 n. 65.
54. *Little Man, What Now?* [Kleiner Mann, was nun?] was written in 1932 by the German playwright Hans Fallada (pseudonym of Rudolf Ditzen, 1898–1947).
55. A paraphrase of the remark by Marx in his *Critique of Hegel's 'Philosophy of Right'*: 'Why does history move in this way? So that mankind, laughing, can distance itself from its own past.'
56. The last words of Napoleon I Bonaparte (1769–1821), Emperor of France 1804–14, were in fact 'Tête d'armée' [Head of the army]. Mark Twain (pseudonym of Samuel Langhorne Clemens, 1835–1910), American humorist. The actual quotation is: 'The report of my death was an exaggeration'; reported in *New York Journal*, 2 June 1897.
57. Prometheus: see 1940 n. 59.
58. See 1941 n. 5.
59. In *The Great Dictator* Chaplin played both Adenoid Hynkel, the dictator of Tomainia, and his double, the Jewish barber.
60. The Russian editors give the *Intercine* interview (see 1943/4 n. 20) as the source for this quotation, but the cited passage does not appear there.
61. In 1936 Hitler had ordered the reoccupation of the Rhineland, which had been de-militarised under the 1919 Treaty of Versailles. The first military expansion outside the accepted frontiers of the German Reich came in March 1938 with the *Anschluß*, or

annexation, of Austria. The Sudetenland followed after the Munich Agreement in September 1938 and the rest of Czechoslovakia was annexed in March 1939. Following the invasion of Poland, Britain and France declared war on Germany on 3 September 1939.

62. Aristophanes (*c.* 444–*c.* 385 BC), Greek comic dramatist, whose plays include *The Clouds* and *The Birds*. Desiderius Erasmus (1466–1536), Dutch humanist, author of *Praise of Folly*. François Rabelais (1495–1553), French satirist, author of *Gargantua* and *Pantagruel*: see *ESW 1*, pp. 246–50 and *ESW 2*, p. 178 Jonathan Swift (1667–1745), Irish-born satirist, author of *Gulliver's Travels*. Voltaire: see 1942 n. 5. Ferney was the place of his retreat.

1945

1. Source: 'Krupnym planom', *Iskusstvo kino*, 1945, no. 1, pp. 6–8.
2. For which the Russian is, respectively: 'obshchii plan' (literally, 'general level'); 'srednii plan' (medium level); and 'krupnyi plan' (large level).
3. This is a paraphrase of Lunacharsky's 1933 definition of Socialist Realism.
4. ARRK, the Association of Revolutionary Workers in Cinema, was founded in 1929 under the influence of the radical proletarian writers' organisation RAPP as the more militant successor organisation to ARK, the Association of Revolutionary Cinematography, which had been established in February 1924 and included Kuleshov, Pudovkin and E among its most influential members. See 1934 n. 40. E is presumably here referring to ARK and to the screenings it arranged in the middle 1920s.
5. E is here referring to the so-called period of 'proletarian hegemony' in cinema that marked the cultural revolution accompanying the forced collectivisation and rapid industrialisation of the first Five Year Plan period, 1929–32. This was in fact the only period when ARK was called ARRK.
6. *Iskusstvo kino*, since 1936 the principal monthly journal of Soviet cinema. From 1931 to 1932 it was known as *Proletarskoe kino* [Proletarian Cinema] and from 1932 to the end of 1935 as *Sovetskoe kino* [Soviet Cinema]. It ceased publication during the Great Patriotic War, 1941–5.
7. Written in 1945 as the first chapter of a projected collection of essays on John Ford in the series *Materialy po istorii mirovogo kino* [Materials on the History of World Cinema] and first published in *Iskusstvo kino*, 1960, no. 4 (April), pp. 135–40. This version has been translated from the text in *IP 5*, pp. 272–83, which is in turn based on the typewritten original in TsGALI 1923/2.
8. John Ford (1895–1973), one of the leading Hollywood directors, whose films did much to shape the creation myth of modern America.
9. Much was made in Soviet propaganda of the fact that the USSR was the largest country on Earth and covered one sixth of the planet's land surface. Hence the title of the film *A Sixth Part of the World* [Shestaya chast' mira, 1926], directed by Dziga Vertov (see 1934 n. 32).
10. The Charter of the United Nations Organisation was signed in San Francisco on 26 June 1945.
11. The Potomac is the river on which Washington DC is situated.
12. Henry Fonda (1905–82), American screen actor, who played leading roles for John Ford in both *Young Mr Lincoln* and *The Grapes of Wrath*.
13. Ilya of Murom is the hero of the oldest known Old Russian *bylina*, or folk epic. He was reputed to have become, after a slothful childhood and adolescence, the principal *bogatyr*, or knight errant, at the tenth-century court of St Vladimir I of Kiev, to have killed the monster Nightingale the Robber, and driven out the Tatars.
14. Catherine de' Medici: see 1942 n. 3. Cardinal Jules Mazarin (1602–61), French minister who helped to build up a strong monarchy in France, despite opposition from the nobility. Joseph Fouché (1759–1820), created Duke of Otranto in 1806, originally a

supporter of Robespierre, was later instrumental in his overthrow. He was Napoleon's Minister of Police (1799–1802 and 1804–10) and instigator of a system of internal espionage, but also maintained contact with opposition groups.

15. Charles-Maurice de Talleyrand-Périgord (1754–1838), French Foreign Minister 1797–1807 and French representative to the Congress of Vienna. Metternich, Prince Klemens (1773–1859), Austrian Foreign Minister 1809–48 and Chancellor 1821–48, presided over the Congress of Vienna in 1815 after the Napoleonic Wars.

16. Jean-François-Paul de Gondi (1613–79), Cardinal de Retz, was one of the leaders of the aristocratic rebellion of 1648–53, known as the Fronde, against Anne of Austria, who was acting as Regent for her son Louis XIV, and her chief minister, Cardinal Mazarin. In 1652 de Gondi was made a cardinal and took the name de Retz. Cesare Borgia (1476–1507), Italian general, son of Pope Alexander VI, suspected of murdering his own brother. He later became Captain-General of the Church and controlled large tracts of Italy. Marquis de Sade (1740–1814), French erotic writer, author of *Justine* [1791] and *Juliette* [1798]. See *ESW 4*, pp. 510–66.

17. Louis V (*c*. 967–87) was known as 'le Fainéant' or 'the Idle'.

18. Charles II of Burgundy (823–77), known as 'le Chauve' or 'the Bold', ruled from 843.

19. Mary I: see 1942 n. 13.

20. Ivan D. Papanin (1894–86), headed the 'North Pole', the first drift-ice polar research station, in 1937–8.

21. Stefan Loran has not been traced.

22. Whitman: see 1940 n. 85. The quotation is from W. Coyle (ed.), *The Poet and the President: Whitman's Lincoln Poems* (New York, 1962), pp. 36–8.

23. Gorky: see 1943/4 n. 43.

24. Franklin D. Roosevelt (1882–1945), American President during World War II.

25. According to the Russian editors of E's works, the 'two other great humanists' referred to here were Gorky and Roosevelt, who in fact died on 12 April 1945, a month before the War in Europe ended.

26. Written in 1945 for a collection of essays by various directors entitled *Kak ya stal rezhisserom* [How I Became a Director] (Moscow, 1946), reprinted in *IS*, pp. 355–62 and *IP 1*, pp. 97–104. The original typescript is no longer preserved, but the typescript of an earlier draft, with E's pencilled corrections, has been preserved in TsGALI 1923/2.The first version of the article contained the following comments by E on his films:

> *The Strike* analysed the nature of cinema's means of influencing.
>
> *Potemkin*, whose success is often attributed to its distance from so-called 'formal research', nevertheless had just such an aim: the question of convention and limitation of film as a whole, as distinct from to the method then (and even more so now) practised, of 'stringing together' a number of small episodes, instead of [creating] structural integrity. I would not dispute that this conscious task was rewarded with an additional bonus by creative inspiration, and, even more so, those fundamental features of the film, for which it earned a benevolent audience.
>
> *October*. Disregarding utterly the question of the film's integrity, I was engrossed with problems of film linguistics. Interested in the metaphor of the lions who leap up in *Potemkin*, as an inspiration, I immediately set out to research the nature of film language from every angle, in my experiments in the film. I thus also came up against embryonic elements of what were to grow into the conception of 'intellectual cinema'. Working simultaneously on *The Old and the New*, I probed elements that could exert an emotional influence in particular depth; this was formulated in the concept of 'overtonal montage'.
>
> When I had finished investigating montage, and foreseeing a unity of laws both in montage and shot, which I examined as stages, I dedicated all my work (from its formally academic point of view) to the question of the nature of shot composition: *Que viva Mexico!* – my film about Mexico.

As if punishing me for virtually leaving montage out of the scheme of things, this picture is frequently open to the most diverse of montage interpretations by different editors, although it does bear up to audience perception, probably simply because it was planned primarily on the basis of the shot.

Alexander Nevsky naturally posed questions about audiovisual unity experimentally, just as *Ivan the Terrible* posed the problem of a character's coming into being and the developing plot, in response to the arrogance of a purely 'actorly' cinema, which had my ears ringing with questions about over-complicated plot and characterisation, which were supposedly beyond the reach of us 'epic poets', who principally work with a so-callled 'weak plot and no characters to speak of...'

27. The reference is to the original play *Turandot* by Carlo Gozzi (1720–1806). Fyodor (also Theodore) F. Komissarzhevsky (1882–1954), Russian theatre director and designer, went into exile in Britain after the Revolution. E discusses Nezlobin's theatre in *ESW 4*, pp. 265, 451. The company toured *Turandot* in 1912 and not, as E maintains, 1913.
28. This lavish production of *Masquerade* [Maskarad] by Mikhail Yu. Lermontov (1814–41), with music by Alexander Glazunov (1865–1936), was directed by Vsevolod Meyerhold (see 1934 n. 9) and had its premiere on 25 February 1917, in the midst of the February Revolution.
29. See 1934 n. 21.
30. See both *ESW 1* and *ESW 2*, passim.
31. See the discussions of 'inner monologue' in *ESW 1*, especially pp. 21–2, 246–9, and of Japanese ideograms, ibid, especially pp. 138–50.
32. See *ESW 4*, pp. 751–71.
33. The first season of the Moscow Art Theatre in 1898 had opened in the Hermitage Theatre on Karetny Ryad [literally, Carriage Row].
34. William James: see 1936 n. 30.
35. Franz and Karl Moor are the brothers whose dispute forms the basis of the play *The Robbers* [Die Räuber] by Schiller (1759–1805). The other references are to *Faust* by Goethe (see 1940 n. 6); Schiller's *The Maid of Orleans* [Die Jungfrau von Orleans]; *Romeo and Juliet* and *Hamlet* by Shakespeare (see 1940 n. 5); *Brand* and *Rosmersholm* by Henrik Ibsen (1828–1906). The Count de Rizoor and Careno have not been traced.
36. See 1934 n. 14.
37. *The Steadfast Prince* by the Spanish dramatist Pedro Calderón de la Barca (1600–81) had been staged by Meyerhold at the Alexandrinsky Theatre in Petrograd in April 1915.
38. Reference to the play *Love and Intrigue* [Kabale und Liebe] written in 1782–3 by Schiller.
39. Raskolnikov is the principal character in *Crime and Punishment* by Dostoyevsky.
40. LEF, the Left Front of Art, was a literary organisation which from 1923 to 1928 united former Futurists with left-wing writers. It published an eponymous journal, edited by the Futurist poet, playwright and scriptwriter, Vladimir V. Mayakovsky (1893–1930). E had once been close to LEF and his article 'The Montage of Attractions' (see *ESW 1*, pp. 33–8) was published in *LEF*, 1923, no. 3. See also 1934 n. 24.
41. Joseph Louis Gay-Lussac (1778–1850), French chemist who demonstrated that, when gases combine, their relative volumes bear a simple numerical relationship to one another and to the volume of their combination. Robert Boyle (1627–91), British scientist who established that the volume of a gas varies inversely to the pressure put on it, given constant temperatures. Edme Mariotte (1620–84), French scientist who, independently of Boyle, established the same principle.
42. Pacquenne was presumably the name of a dress-making establishment.
43. See 1934 n. 21.

44. See *ESW 1*, pp. 33–8.
45. Pavlov: see 1936 n. 30.
46. See *ESW 1*, pp. 115–22, 138–50, 185–6.
47. See *ESW 2*, pp. 327–99.

1946/7

1. Written in 1946 and first published in *IP 5*, pp. 454–6. For the Soviet film director Ivan A. Pyriev, see 1940 n. 143.
2. The Stalin Prize was renamed the 'State Prize of the USSR' after Stalin's death.
3. See 1934 n. 21 and 1945 n. 33.
4. Sverdlovsk has now reverted to its pre-Revolutionary name of Yekaterinburg.
5. Smyshlyayev: see 1934 n. 17.
6. Mayakovsky: see 1945 n. 40.
7. Alexandrov (see 1940 n. 143) had worked with E in Proletkult and as assistant director on his silent films. After their separate returns from Mexico and the USA Alexandrov achieved fame and popularity with a series of musical comedy films.
8. See *ESW 1*, p. 33, and ESW 4, pp. 368, 412, 442.
9. Presumably a reference to the Mexican painter, Diego Maria Rivera (1886–1957), known in particular for his murals depicting the social and political history of Mexico on the National Palace of Fine Arts, Mexico City. A member of the Communist Party and one of the instigators of Mexican Socialist Realism, Rivera visited the USSR in 1927. Murals painted for the Rockefeller Center, New York, by Rivera in 1933 were destroyed because they included a portrait of Lenin.
10. See *ESW 1*, especially pp. 33–8 and 82–3.
11. Pyriev was awarded the Prize for *Tractor Drivers* [Traktoristy, 1939] in 1941, *The Swineherd and the Shepherd* [Svinarka i pastukh, 1941] in 1942, *The Secretary of the District Committee* [Sekretar' raikoma, 1942] in 1943 and *At Six p.m. After the War* [V shest' chasov vechera posle voiny, 1944] in 1946.
12. Sergei S. Solomko, pre-Revolutionary Russian illustrator.
13. E is here alluding to the titles of some of Pyriev's films.
14. Vaska Buslai was one of the characters in E's *Alexander Nevsky*, played by Nikolai Okhlopkov (see 1934 n. 2).
15. This document was not, of course, written by E but has been included because it provides the context for the document that follows. The decree 'On the Film *A Great Life*' [O kinofil'me *Bol'shaya zhizn'*] was one of a series issued in September 1946, tightening Party control over all aspects of Soviet cultural life after the relative relaxation of the war years. This decree was issued on 4 September 1946 and the text has been translated from N. B. Volkova, S. V. Drobashenko and R. N. Yurenev (eds.), *Sovetskoe kino 1917–1978. Resheniya partii i pravitel'stva o kino. Tom 2: 1937–1961* [Soviet Cinema 1917–78. Party and Government Decisions on Cinema. Vol. 2: 1937–61] (Moscow, 1979) pp. 95–100.
16. Part One of *A Great Life* [Bol'shaya zhizn'], released in February 1940, had been awarded the Stalin Prize, Second Class, in 1941. Part Two was made in 1946 but only released in December 1958. The official reception of the two parts of the film thus paralleled that of the two parts of *Ivan the Terrible*. Leonid D. Lukov (1909–63) and Pavel F. Nilin (1908–81) collaborated on a number of other films but their place in the history of Soviet cinema has been assured by their being the object of this decree.
17. The Donbass, in the eastern Ukraine, was a major mining centre and the site of one of the major hydro-electric construction projects of the 1930s, and had to be restored after the wartime German occupation.
18. One of the effects of the policies of rapid industrialisation and forced collectivisation and of the purges carried out in the 1930s was to create a new generation of *vydvizhentsy*, people who owed their advancement to Soviet power. Their role was enhanced by the devastation of the Second World War and the shortage of skilled and qualified manpower that the huge population losses created.

19. Nikita V. Bogoslovsky (b. 1913) was a student of Glazunov (see 1945 n. 28) who wrote film music from 1938 onwards.
20. Ivan G. Bolshakov (1902–80) was appointed Chairman of the Committee for Cinema Affairs in 1939 and became the first Minister for Cinema in 1946.
21. *Admiral Nakhimov* was directed by Pudovkin in 1946 (see 1940 n. 26) for the Mosfilm studios and released in January 1947, while *Simple Folk* [Prostye lyudi] was made by Kozintsev and Trauberg (see 1935 n. 6) for the Lenfilm studios in 1945 and not released until August 1956.
22. This account of the meeting on the night of 25 February 1947 was taken down immediately afterwards by E and Nikolai P. Cherkasov (who had played the title roles in both *Alexander Nevsky* and *Ivan the Terrible*) and first published under the general heading 'Groznye teni 1947 goda' [The Terrible Shadows of 1947] in *Moskovskie Novosti* [Moscow News], 7 August 1988, pp. 8–9, from which this translation has been made.
23. Alexander N. Poskrebyshev (1891–1965) was Stalin's principal secretary until his arrest in 1952.
24. Vyacheslav M. Molotov (né Skryabin, 1890–1986), an Old Bolshevik and one of Stalin's closest advisers; Chairman of the Council of People's Commissars 1930–40; Commissar (from 1946 Minister) for Foreign Affairs 1939–49, 1953–6. Andrei A. Zhdanov (1896–1948), also an Old Bolshevik and close adviser to Stalin; Secretary of the Party's Central Committee 1934–48, from 1944 in charge of ideological affairs, pursuing a hard-line cultural policy and dealing especially severely with any signs of Western influence in the immediate post-war years, as is amply demonstrated by the tone of this document and the previous one.
25. During the Time of Troubles (see 1946/7 n. 52) Russia was dominated by feudal clans known as the boyars, whose power both Ivan the Terrible and, in his turn, Peter the Great, set out to destroy.
26. Demyan Bedny (pseudonym of Yefim A. Pridvorov, 1883–1945) wrote the libretto for an opera, *The Knights* [Bogatyri], which was heavily criticised after its first performance in 1936.
27. Kuzma Minin (d. 1616), a butcher from Nizhny Novgorod, and Prince Dmitri M. Pozharsky (1578–1642) were joint leaders of the Russian resistance to the Polish and Swedish invasion. A monument to them, erected by public subscription in Moscow's Red Square in 1818, was moved to its present position after the construction of the Lenin Mausoleum in 1930. See also 1940 n. 26.
28. The part of Prince Andrei Kurbsky (see 1942 n. 10) was played by Mikhail M. Nazvanov (1914–64) and that of Vladimir Staritsky, Ivan's cousin, by Pavel P. Kadochnikov (1915–88), who had played his first screen role at the age of twenty.
29. Repin: see 1940 n. 35.
30. Lyudmila V. Tselikovskaya (b. 1919) played the part of Ivan's wife, the Tsarina Anastasia Romanovna. She had been trained at the Shchukin Theatre Institute in Moscow and had worked in the Vakhtangov Theatre there from 1941. Stalin's remark that she was a ballerina is not therefore to be taken literally.
31. Mikhail I. Zharov (1899–1981) played the part of Malyuta Skuratov in the film after a long and distinguished film acting career in the 1920s and 1930s. He did not make another film until the 1960s.
32. I.e. 1.10 a.m. the following morning, 26 February 1947.
33. This document consists of fragments from an unfinished project in which E intended to provide a character portrait of all the people who had worked with him on *Ivan*. The first section ('The Lomovs and Goryunov') was first published in *IS*, pp. 146–9. This translation is from *IP 5*, pp. 480–93, which is taken from the manuscript in E's archive (TsGALI 1923/2). Notes and comments made by E on this manuscript are dated 10 May 1946, 18 and 25 March 1947.
34. V. Lomov was in charge of the props; his wife Lydia Alexeyevna Lomova worked in the wardrobe; V. Goryunov was in charge of the make-up.

35. Potylikha was the site of the Mosfilm studios to the south-west of Moscow. Both Mosfilm and Lenfilm had been evacuated to Alma-Ata during the War to form the Central United Cinema Studio, TsOKS.
36. Apparently a reference to Ivan N. Bersen-Beklemeshev, a boyar and Russian diplomat who was condemned and executed in 1525 for criticising Tsar Vasili III.
37. The Stoglav, literally the 'Hundred Chapters', comprised the resolutions of the Church Assembly summoned by Ivan the Terrible in 1551.
38. Kaskelen, just west of Alma-Ata, was where the capture of Kazan was filmed.
39. Because of wartime electricity shortages in Alma-Ata most of the indoor shooting for *Ivan* had to be done overnight. The punishing work schedule that this entailed is assumed to have been a major contributory factor to E's first heart attack in February 1946.
40. See *ESW 1*, pp. 198–201
41. Amvrosi M. Buchma (1891–1957) played the part of Alexei Basmanov, father of Fyodor, in *Ivan*. He was named People's Artist of the USSR in 1944.
42. Yakov Ilyich Raizman (no relation to the director Yuli) worked in the wardrobe for *Ivan* and Nadezhda P. Lamanova (1861–1941), designer of theatre sets and costumes, designed some of the costumes for *Alexander Nevsky*.
43. Konstantin A. Korovin (1861–1939), Russian painter and set designer, one of the leading figures in Russian Impressionism.
44. Serov: see 1935 n. 79. Repin: see 1940 n. 35. Isaak I. Levitan (1861–1900), Russian painter, also a member of the Wanderers group.
45. Willy Messerschmidt (1898–1978), German aircraft engineer and designer, who produced the Me109 fighter for the Luftwaffe during World War II. Heinz Guderian (1888–1954), German general, perfected the technique of *Blitzkrieg* and commanded the Second Panzer Division on the Eastern Front in 1941. He was dismissed at the end of 1941 for having failed to break through to Moscow. He became Chief of the General Staff after the failure of the July Plot against Hitler in 1944 but was again dismissed on 28 March 1945 for failing to check the advance of the Red Army on Berlin.
46. Balzac: see 1935 n. 34; also frequently mentioned in *ESW 1*, *ESW 2* and *ESW 4*. Frans Hals (1582/3–1666), Dutch painter. Benvenuto Cellini (1500–71), Florentine sculptor and goldsmith. Salvator Rosa (1615–73), Neapolitan painter and etcher.
47. Titian (Tiziano Vecellio, c. 1485–1576), Venetian painter. Callot: see 1940 n. 47.
48. Honoré Daumier (1808–79), French caricaturist, painter and sculptor, also discussed in *ESW 1*, *ESW 2* and *ESW 4*.
49. Boris A. Volsky was the sound recordist on *Alexander Nevsky* and both parts of *Ivan*. In E's papers there is a draft outline of a chapter on Volsky entitled 'Millimetres of Music' [Millimetry muzyki].
50. Archpriest Avvakum (c. 1621–82) was one of the leading members of the Russian religious sect known as the Old Believers, who believed in self-immolation rather than compromising their principles.
51. The last act of *Khovanshchina* [1872–80], the opera left unfinished by the Russian composer Modest Mussorgksy (1839–81), was completed by Nikolai A. Rimsky-Korsakov (1844–1908). The opera, first performed in St Petersburg in 1886, is set in the Russia of Peter the Great, and in the last act, their cause lost, the Old Believers, led by Dositheus, build a funeral pyre and immolate themselves.
52. The Time of Troubles [*smutnoe vremya*] is the term used to describe the period of confusion that reigned in Russia after the death of Ivan the Terrible in 1584 and before the first Romanov, Mikhail Fyodorovich, ascended the throne in 1613.
53. Sergei V. Rachmaninov (1873–1943), Russian composer and pianist, who emigrated after the Revolution and settled in the USA.
54. In the manuscript draft this piece continues:

> We share a cult of Sergei Sergeyevich [Prokofiev]. Volsky is recording (in his booth). Volsky and the placement of the microphones. Volsky and the cut-up

notes on the movieola. Music – by the millimetre. How I pester Volsky (Short insight into my method of marrying Heaven and Hell [in English in the original] – the music and the image).

55. In E's manuscript there is an alternative title for this section about Esfir V. Tobak (b. 1908), the assistant editor on *Bezhin Meadow, Alexander Nevsky* and *Ivan*, entitled 'Fira – A Human Unit, but in Size a Half-Unit' [Fira – chelovekoedinitsa, khotya rostom poluedinitsa].

56. Cf. the reference to Carrie A. Nation in *ESW 4*, pp. 369, 846.

57. Sue: see 1935 n. 34.

58. Fira is the affectionate diminutive form of Esfir.

59. In one draft version this section about assistant director Valentina V. Kuznetsova was entitled 'A Scotland Yard for Moscow Artists' [Skotlyand-yard dlya artistov Moskvy].

60. Field Marshal Friedrich von Paulus (1890–1957) commanded the German Sixth Army that surrendered during the Battle of Stalingrad (now Volgograd) on 31 January 1943.

61. Hermann Göring (1893–1946), Reichsmarschall and Air Minister who built up the German Luftwaffe before the Second World War. Dmitri I. Mendeleyev (1834–1907), Russian chemist who formulated the periodic law of atomic weights and drew up the periodic table. Valeri P. Chkalov (1904–38), Soviet test pilot. Chkalov became famous as the co-pilot of non-stop long-distance flights in the mid-30s. The first of these on 20–22 July 1936 from Moscow to Udd Island via Kamchatka covered 9,374 km in 56 hours 20 minutes – Chkalov was made a Hero of the Soviet Union two days later – and the second, from Moscow to Vancouver, Washington, over the North Pole, covered 8,504 km in 63 hours 16 minutes. Chkalov was awarded the Order of Lenin twice and the Order of the Red Banner for his exploits. Repin: see 1940 n. 35.

62. Larisa A. Lukina was an editor in the Music Department of the Mosfilm studios.

63. These extracts come from lectures delivered to the Faculty of Direction at VGIK on 12, 18 and 19 March 1947, kept in typewritten form in TsGALI 1923/2 and first published in *IP 3*, pp. 591–610.

64. See 1945 n. 28.

65. Meyerhold directed Dumas' play at his own theatre in March 1934, with I. I. Leistikov as designer.

66. See *ESW 4*, pp. 264–70.

67. E is here referring to eurhythmics: see 1936 n. 10.

68. See *ESW 1*, pp. 183–94.

69. Walt Disney (1901–66), leading American cartoon film-maker, inventor of such characters as Mickey Mouse and Donald Duck. See also 1940 n. 110; and J. Leyda (ed.), *Eisenstein on Disney* (Calcutta, 1986).

70. E was searching for a common denominator for audiovisual counterpoint in the later 1920s: see *ESW 1*, pp. 115–22, 138–50 and 185–6.

71. There is a gap in the manuscript at this point.

72. Ditto.

73. The *lezghinka* is a traditional folk dance from the northern Caucasus.

74. For Tobak, see 1946/7 n. 55. Formalism began as an aesthetic movement in the 1920s but became during the purges of the 1930s an all-purpose term of abuse for artistic experimentation that allegedly represented 'art for art's sake'.

75. This 'opportunity arose' because of the Agfacolor film stock removed as war booty from German film studios and laboratories by the Red Army in 1945.

76. See 'The Incarnation of Myth', pp. 142–69.

77. E is here referring to the production at the Maly Theatre in 1944 of the play *Ivan the Terrible* by Alexei N. Tolstoi (1882–1945): see *ESW4*, pp. 681–9, 870–1.

78. Theophanes [Feofan] the Greek (*c*. 1330–*c*. 1415), whose origins were in Byzantium, was one of the leading icon painters in mediaeval Russia.

79. Opera, first performed in 1904, composed by Nikolai Rimsky-Korsakov: see 1946/7 n. 51.

80. Cf. the last section of 'Vertical Montage', *ESW2*, pp. 371–99.
81. E is referring to the score by Edmund Meisel (1874–1930), composed for the German release of *October*. See *ESW1*, p. 131.
82. *ESW2*, pp. 371–99.
83. *The Little Red Devils*, directed for the Georgian film studio by Ivan N. Perestiani (1870–1959), is generally seen as the starting point for the Civil War genre in Soviet cinema. For *A Great Citizen* see 1940 n. 12.
84. For the link between movement and music see 'How I Learned to Draw (A Chapter about My Dancing Lessons)', *ESW4*, pp. 567–91.
85. The painting, by Alexander A. Ivanov (1806–58) is now in the Tretyakov Gallery, Moscow. See *ESW2*, pp. 103, 155, 328 and especially p. 388, where E makes substantially the same point as he is making here.
86. This 1887 painting, by Vasili I. Surikov (1848–1916), associated with the Wanderers (see 1940 n. 35), also hangs in the Tretyakov. See *ESW2*, pp. 99–103.
87. '"Eh!" On the Purity of Film Language', *ESW1*, pp. 285–95.
88. E's memory is at fault – there were fourteen shots in the analysis: see *ESW1*, p. 295.
89. In addition to a film version of *Boris Godunov*, planned in 1940, E worked on a projected film biography of Pushkin under the title *A Poet's Love (Pushkin)* between 1940 and 1944: cf. *ESW4*, pp. 712–24, and see W. Sudendorf, *Sergej M. Eisenstein. Materialien zu Leben und Werk* (Munich, 1975), pp. 230–1.
90. Formerly Khlynov and latterly Kirov, Vyatka, as it was known between 1780 and 1934, became a railway and industrial centre but remained famous for its toys, especially those made of wood.
91. Vladimir V. Lebedev (1891–1967), St Petersburg painter, graphic artist and illustrator, best known for his illustrations for the works of Samuil Ya. Marshak (1887–1964).
92. 'Barcarolle' describes the rhythm of a Venetian boat song, ostensibly imitating the motion of a gondola. This rhythm was used most famously by Jacques Offenbach (1819–80) in his opera *The Tales of Hoffmann* [Les Contes d'Hoffmann], which Disney used for the soundtrack of his 'Silly Symphony', *Birds of a Feather* [USA, 1931], to which E is here referring.
93. Written on 7 November 1947 and first published posthumously as 'Zritel'-tvorets', *Ogonek* [The Torch], 1948, no. 26; reprinted in *IS*, pp. 72–3. This version has been translated from *IP 5*, pp. 299–300, which has in turn been taken from the corrected manuscript in TsGALI 1923/2.
94. After his immersion in Russian mediaeval history for both *Alexander Nevsky* and *Ivan the Terrible*, E took to referring to the contemporary Soviet Union as Rus, the mediaeval name for Russia.
95. Written in November 1947 and first published in abridged form as 'Edinaya (Mysli ob istorii sovetskogo kino)' in *Iskusstvo kino*, 1952, no. 11 (November), pp. 10–14. This version is translated from the full text published in *IP 5*, pp. 198–206, based on the typescript in TsGALI 1923/2.
96. Cf. Stalin's remarks on foreign influences in the conversation on *Ivan the Terrible*, pp. 299–304.
97. V. I. Lenin, 'Speech Delivered at an All-Russia Conference of Political Education Workers of Gubernia and Uyezd Education Departments, November 3, 1920' in *Collected Works* (Vol. 31, Moscow, 1966), p. 370.
98. This is the date on which Soviet cinema was officially nationalised, although the actual process of state ownership and control took some considerable time to achieve effectively.
99. *Partiya o kino* [The Party and Cinema] (Gospolitizdat, Moscow, 1939). (E's note) Translated in: *FF*, pp. 56–7, where the source is given as G. M. Boltyanskii (ed.), *Lenin i kino* [Lenin and Cinema] (Moscow/Leningrad, 1925), pp. 16–19.
100. Chiaureli: see 1935 n. 20. Petrov: see 1934 n. 29. Gerasimov: see 1940 n. 144. The fact that E can write in November 1947 about films that had not yet been fully released

is eloquent testimony to the long production process that exacerbated the post-war shortage of new films, known in Russian as the *malokartin'ye*. Hence the need to fill Soviet cinema screens with films acquired from Germany as war booty: these included some anti-British Nazi propaganda films.

101. *The Mother*: see 1940 n. 27; Pudovkin: see 1940 n. 26; Zarkhi: see 1934 n. 26.

102. Reference to the films *Lenin in October* and *Lenin in 1918* (see 1934 n. 26), in which the role of Lenin was played by Boris Shchukin (see 1934 n. 18); and to *The Man with a Gun* (see 1940 n. 132), directed by Sergei Yutkevich (see 1935 n. 20), in which Lenin was played by E's childhood friend Maxim Strauch (see 1934 n. 10).

103. References to the Maxim Trilogy (see 1936 n. 6); Peter Shakhov was the name of the principal character, based on Sergei Kirov (see 1937 n. 12), in *A Great Citizen* (see 1940 n. 12); *Chapayev* (see 1935 n. 26); *We from Kronstadt* (see 1942 n. 103); *Counterplan* (see 1935 n. 23); *Peasants* (see 1935 n.6); Vera P. Maretskaya (1906–78) in *A Member of the Government* [Chlen pravitel'stva, 1939], directed by Alexander G. Zarkhi (b. 1908) and Iosif Ye. Heifitz (also Kheifits, b. 1905).

104. Reference to E's own *Alexander Nevsky*; *Bogdan Khmelnitsky* [1941; awarded the Stalin Prize 1942], directed by Igor A. Savchenko (1906–50); *Peter the First*: see 1940 n. 25; *Suvorov* [1941; awarded the Stalin Prize 1941], directed by Pudovkin (see 1940 n. 26) and Mikhail I. Doller (1889–1952); *Kutuzov* [1944; Stalin Prize 1946], directed by Petrov (see 1934 n. 29).

105. The references here are to the eventual expulsion of the Tatars and to the victory in 1812 over Napoleon.

106. Mark S. Donskoi (1901–81) directed the so-called 'Gorky trilogy' for the children's studio, Soyuzdetfilm: *Gorky's Childhood* [Detstvo Gor'kogo] and *Among the People* [V lyudyakh] (both 1938; both awarded the Stalin Prize, 1941) and *My Universities* [Moi universitety, 1939]. Professor Polezhayev, played by Nikolai Cherkasov, was the main character in *The Baltic Deputy* [Deputat Baltiki, 1936], directed for Lenfilm by Zarkhi and Heifitz (see 1946/7 n. 103). *Valeri Chkalov* [1941], directed for Lenfilm by Mikhail K. Kalatozov (né Kalatozishvili, 1903–73), portrayed the exploits of the Soviet test pilot, Chkalov (see 1946/7 n. 61).

107. See also 1935 n. 15.

108. *The Storm*: see 1934 n. 29; *A Petersburg Night*: see 1934 n. 36. *The Girl with No Dowry* [Bespridannitsa, 1937] was directed for Rot-Front (the brief successor to Mezhrabpomfilm) by Yakov A. Protazanov (1881–1945), from the play by Ostrovsky (see 1934 n. 8).

109. *The Marsh Soldiers* [Bolotnye soldaty, 1938] was directed for Mosfilm by Alexander V. Macheret (see 1940 n. 46) from a script by Yuri K. Olesha (1899–1960) and deals with the struggle of German Communists against the Nazis in the 1930s. Both *Professor Mamlock* [1938], directed by Gerbert M. Rappaport (1908–83) for Lenfilm, and *The Oppenheim Family* [Sem'ya Oppengeim, 1938], directed by Roshal (see 1934 n. 36), also for Mosfilm, dealt with contemporary Nazi anti-Semitism. *She Defends the Homeland* [Ona zashchishchaet rodinu, 1943], directed by Ermler (see 1934 n. 27) for the evacuated Lenfilm at the Central United Studio in Alma-Ata where E filmed *Ivan*, dealt with the partisan movement. For *The Secretary of the District Committee*, see 1946/7 n. 11.

110. For both Alexandrov and Pyriev see 1940 n. 41. Boris V. Barnet (1902–65) made *The Exploit of a Scout* [Podvig razvedchika, 1947] for the Kiev Film Studio. His work is discussed by Bernard Eisenschitz in *IFF*, pp. 151–64.

111. E is here presumably referring to the following films by the Ukrainian director Dovzhenko (see 1939 n. 2): *Liberation* [Osvobozhdenie, 1939], *The Battle for Our Soviet Ukraine* [Bitva za nashu sovetskuyu Ukrainu, 1943] and *Victory on the Ukrainian Right Bank* [Pobeda na Pravoberezhnoi Ukraine, 1945], all three made in collaboration with his wife Yulia I. Solntseva (1901–89).

112. Written in 1947 as 'Vsegda vpered! (Vmesto poslesloviya)' for the thirtieth anniversary of the October Revolution but not submitted for publication as E decided to rework it

as a Postscript to a collection of his writings; the article was never reworked and the collection never published. In its present form the article was first published in *Iskusstvo kino*, 1952, no. 1, pp. 107–9, and reprinted as the Postscript to *IS*, pp. 412–16. This version is translated from *IP* 5, pp. 207–12, which is in turn taken from the manuscript in TsGALI, 1923/1/1384.

113. Serov: see 1935 n. 79. Vincent van Gogh (1853–90), Dutch post-Impressionist painter. Michelangelo Buonarroti (1475–1564), one of the leading Florentine artists of the Renaissance and a guiding force behind Mannerism. See also 1940 n. 5.

114. Reference to the statues in the Medici Chapel attached to the church of San Lorenzo in Florence, which Michelangelo worked on from 1520.

115. Michelangelo worked on the Sistine Chapel in Rome from 1508 to 1512.

116. Michelangelo's statue of David was executed between 1501 and 1504 and now stands in the Accademia in Florence. Bartolomeo Colleone (1400–75) was an Italian *condottiere* whose statue, sculpted by Michelangelo, was erected on the Piazza San Giovanni e Paolo in Venice.

117. The Flying Fortress was the nickname given to the Boeing B-17G bomber because of its .50-calibre machine-guns. Over 12,000 aircraft were produced, mainly for the USAF, which used them for high-level daylight bombing raids over Europe. Cellini: see 1946/7 n. 46. Filippo Brunelleschi (1377–1446), Florentine architect and sculptor. Albert Einstein (1879–1955), mathematical physicist who developed the theory of relativity.

118. Diderot, see 1943/4 n. 9. For Wagner, see pp. 142–69. Alexander N. Scriabin [Skryabin] (1872–1915), Russian composer and pianist who tried in his works to create a mystical synthesis of music, painting and philosophy; in this he was influenced by theosophy. His 'Poem of Fire', also known as 'Prometheus' (1913), has a line in its score for a keyboard of light intended to throw colours on to a screen while the music was being played.

119. A remark attributed to Lenin: see *FF*, pp. 56–7.

120. E is here implying a connection between the German Chancellor and statesman, Otto von Bismarck (1815–98), known as the 'Iron Chancellor', and nineteenth-century notions of German racial supremacy that culminated in the racial doctrines underpinning National Socialist ideology.

Index

This index covers the main text and important references in the endnotes, but not the Introduction. As in the endnotes, Eisenstein is referred to as E. Film titles are followed by the name of the director.